ART *Today*

6th Edition

RAY FAULKNER

EDWIN ZIEGFELD

HOWARD SMAGULA

ART Today

The Cover: Christo. *The Pont-Neuf Wrapped, Paris, 1975–1985*

On September 22, 1985, a group of 300 professional workers completed Christo's temporary work of art.

They had deployed 440,000 square feet of woven polyamide fabric. The fabric was restrained by 42,900 feet of rope and secured by 12.1 tons of steel chains encircling the base of each tower, 3 feet under water.

In crews of 40,600 monitors worked around the clock maintaining the project and giving information, until the removal of the project on October 7, 1985.

A total of 3 million people walked across *The Pont-Neuf Wrapped*—220,000 in the first 10 hours.

All expenses related to *The Pont-Neuf Wrapped* were borne by Christo, as with all the artist's projects, through the sale of his preparatory drawings and collages as well as of earlier works.

Begun under Henri III, the Pont-Neuf was completed in July 1606, during the reign of Henri IV. No other bridge in Paris offers such topographical and visual variety—today as in the past. Between 1578 and 1890, the Pont-Neuf underwent continual changes and additions of the most extravagant sort—such as the construction of shops on the bridge under the direction of the eighteenth-century architect Germain Souflot; and the building, demolition, rebuilding, and once again demolition of the massive rococo structure that housed the Samaritaine's water pump.

Wrapping the Pont-Neuf continued this tradition of successive metamorphoses by a new sculptural dimension and transformed it—for fourteen days—into a work of art itself. Ropes held down the fabric to the bridge's surface and maintained the principal shapes, accentuating relief while emphasizing proportions and details of the Pont-Neuf. The bridge has joined the Left and Right banks and the Île de la Cité, the heart of Paris, for over two thousand years.

ART *Today*

AN INTRODUCTION TO THE VISUAL ARTS
Sixth Edition

Ray Faulkner
Late of Stanford University

Edwin Ziegfeld
Formerly Columbia University

Howard Smagula

HOLT, RINEHART AND WINSTON

New York Chicago San Francisco Philadelphia Montreal Toronto London Sydney
Tokyo Mexico City Rio de Janeiro Madrid

For Jacqueline, Alexis, and Stefan
H. J. S.

Editor-in-Chief Susan Katz
Publisher Robert Woodbury
Acquisitions Editor Karen Dubno
Senior Project Manager Françoise Bartlett
Art Director Gloria Gentile
Production Managers Annette Mayeski, Stefania Taflinska
Photo Researchers Elsa Peterson, Susan Shavlow
Text Design Art Ritter
Art Layout Connie Szcwciuk
Front and Back Cover Photographs Wolfgang Volz,
 © Christo
Cover Design Gloria Gentile

Library of Congress Cataloging-in-Publication Data

Art today.

 Bibliography: p. 445
 Includes index.
 1. Art, Modern—20th century. 2. Decorative arts—
History—20th century. I. Faulkner, Ray Nelson, 1906–
1975. II. Ziegfeld, Edwin, 1905– . III. Smagula, Howard
J., 1942– .
N6490.A7194 1987 701 86-14815

ISBN 0-03-064039-3

Address correspondence to:
383 Madison Ave.
New York, NY 10017

CBS COLLEGE PUBLISHING
Holt, Rinehart and Winston
The Dryden Press
Saunders College Publishing

Composition by York Graphic Services,
 York Pennsylvania
Printing and binding by R. R. Donnelley & Sons Company,
 Willard, Ohio

Preface

Art Today is about the many significant roles played by the visual arts in contemporary life. Being aware of art's contribution to the quality of our lives and environment can lead to greater personal enjoyment and a deeper understanding of the world around us.

This book is intended as a basic introduction to art for college students as well as other interested readers. Since students relate particularly well to timely, relevant issues, the emphasis of *Art Today* is on contemporary art and the way it reflects our lives. Hundreds of historic examples of art are interwoven throughout the text, however, broadening our perspective and allowing us to compare the art of our time with that of the past. *Art Today* brings together the theories, practice, materials, techniques, and history of art, presenting examples from a variety of cultures and time periods.

This sixth edition of *Art Today* includes considerable new material in order to live up to the book's title. More than 50 percent of the illustrations are new, and many of these document the latest developments in the visual arts. This edition contains 420 black and white figures and 42 color plates. There are added discussions on creativity and how to evaluate and discuss works of art and greatly expanded sections on film, video, computer art, and still photography. Greater in-depth discussion of individual works of art is also a hallmark of this edition, offering readers models for their own personal evaluation of art.

In order to quickly establish a foundation of knowledge and a working vocabulary, the visual elements and principles of art have been moved to the beginning of the book. Other important new features of *Art Today* are a concluding chapter, "Style, History, and Meaning," which provides an overview of art through the ages, and an illustrated chronology table, which charts major periods and monuments and relates them to important historical events.

To establish the premise that *Art Today* is concerned with vital issues, Chapter 1, "Art and Society," describes the role visual perception, creativity, and aesthetics play in our everyday lives. Since much of the book deals with how we look at works of art and how we might interpret and evaluate them, a section on art criticism and a detailed case study of a well-known masterwork are part of this introductory material.

The main body of *Art Today* is organized into four major sections. Part I, "The Language of Vision," examines how artists use the visual elements such as

shape, texture, line, space, time, motion, light, color, and the basic principles of design. In order to assess the many varieties of art we will encounter, it is necessary first to understand the visual means, or grammar, through which artists communicate their concerns and express their ideas.

Part II, "Art and the Environment," explores the impact visual artists such as architects, product designers, and visual communications professionals have had on our contemporary world.

"The Home and Community," Chapter 5, is a logical place to begin this relevant study. Everything is tied to these significant environments—our psychological as well as physical well-being, our patterns of social development, and many of the things that give life meaning and pleasure. Chapter 6, "Functional Design," outlines the criteria for excellence in product design. Chapter 7, "Visual Communications," investigates the role of art professionals who design magazines, packaging, book covers, television commercials, and exhibits. Through the advertising media, powerful visual images and languages are being created that effectively communicate with millions of people daily.

Part III, "The Artist-Craftsperson," provides us with insights into the many materials and techniques artists and craftspeople use in the fabrication of their work. Chapter 8, "Wood, Metal, and Plastics," examines some of the oldest art-making materials known (wood and metal), as well as some of the newest (plastics).

Chapter 9, "Ceramics, Glass, and Fiber Arts," deals with materials and craft processes that are intimately bound to the necessities of life. Feeding and clothing oneself are inescapable concerns. Throughout history ceramic utensils and woven textiles have celebrated these ancient rituals and, in the process, have elevated them to great heights. Today, artists using these traditional materials have freshly responded to them, sometimes in surprising ways. They have answered the challenge imposed upon them by mass production techniques in two ways: by designing works that take advantage of machine fabrication processes and by producing unique, handcrafted works of special relevance and meaning.

By contrast, the work discussed in Chapter 10, "Film, Video, and Computer Art," represents the newest of art forms and techniques. Yet these media offer the adventurous artist unparalleled control of images and movement. How these processes work and how they have changed the way visual artists think and work is one of the most intriguing developments in the last hundred years.

Chapters 11 through 16 make up Part IV, "The Fine Arts." In this category are "The Drawing and the Print"; "Painting"; "Sculpture"; "Photography"; "Architecture"; and "Style, History, and Meaning." Besides covering the techniques and materials of these art forms, works are examined in terms of their aesthetic impact, use of the visual elements, and the principles of design.

Chapter 16, "Style, History, and Meaning," addresses the question of visual style and cultural meaning in a work of art. For instance, why did Egyptian art visually embody stable, solid forms while work of the French Impressonists expressed the opposite: amorphous shapes and a feeling of constant change and flux? The answers lie in an understanding of the broad social and philosophic issues of the era.

"Style, History, and Meaning," while not intending to be a comprehensive, evenly chronological presentation of art, nevertheless highlights most of the major stylistic periods with an emphasis on the modern era. The aim of this chapter is to orient the student and reveal the broad psychological, cultural, and economic bases upon which the visual arts are based.

Immediately following the text and working in concert with it is a comprehensive chronology, which traces the cross-cultural stylistic development of art from prehistory to the present. In order to provide the interested student with a broader perspective on art history, political and scientific events and discoveries are listed along with major artists and important works of art. To facilitate comprehension, important terms are highlighted in boldface type and defined the first time they appear in the text as well as in the glossary following the chronology.

True understanding and appreciation of art involves more than knowing the names and dates of historic movements. It means developing personal attitudes, values, responses, and preferences as well as being able to integrate them into an expanding body of knowledge. I believe that *Art Today* will provide the basis for a lifetime of learning and enjoyment through a better understanding of the visual arts.

ACKNOWLEDGMENTS

Thanks must go to the many people who have lent encouragement, support, and advice to this comprehensive project. Colleagues, artists whose work appears in this book, and countless museums, galleries, and private collectors made major contributions to *Art Today*.

I am also indebted to Kathryn Hughes for her invaluable editorial advice, which helped shape the text and kept me on an even keel throughout the complex process of writing a book of this length and breadth. Marcia Parrino must also be mentioned for her capable help with preliminary picture research.

Equally important in terms of contribution to *Art Today* are the many reviewers who read the manuscript at various stages of its development and offered suggestions, many of which are incorporated in the text. They include Ronald D. Ali, Indiana University of Pennsylvania; Karen White Boyd, Murray State University, Kentucky; Genevieve H. Cory, Canada College, California; Anthony G. DeFurio, Indiana University of Pennsylvania; Douglas DeVinny, University of Wisconsin—Parkside; Steve Eliot, Broward Community College, Florida; Mary E. Griesell, Lewis and Clark Community College, Illinois; V. J. Hagenbuckle, St. Petersburg Community College, Florida; G. Heindal, Ohio State University; Harry D. Korn, Ventura College, California; David A. Lauer, College of Alameda, California; Carolyn Loeb, Central Michigan University; Charles J. Marino, University of Southern Colorado; Paul Marshall, Bergen Community College, New Jersey; Margaret A. Miller, University of South Florida; Virginia Mollner, El Camino Community College, California; Helen J. Muth, Southwest Missouri State University; David M. Quick, Southwest Missouri State University; Henry M. Sayre, Oregon State University; James C. Shane, Grambling State University, Louisiana; David Sharp, Eastern Michigan University; Qurentia Throm, Valencia Community College, Florida; Thomas E. Toone, Utah State University; Callie B. Warren, Alabama State University.

Finally, I wish to thank the staff at Holt, Rinehart and Winston. Their professional commitment and personal concern contributed greatly to the Herculean task of publishing an art book of this scope. Karen Dubno, my editor, proved tireless in her attention to important details and provided much significant guidance to its overall direction as well. I am grateful too to Françoise Bartlett, Gloria Gentile, Annette Mayeski, Stefania Taflinska, Elsa Peterson, and Susan Shavlow. To all of these people my warmest appreciation and thanks.

Oakland, California H. J. S.
November 1986

Contents

Chapter 1
Art and Society

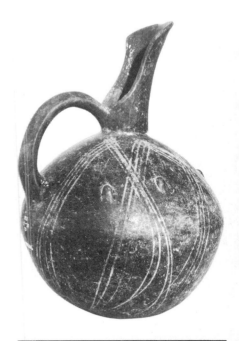

In this era of electronic communications and international cultural activity, it is interesting to speculate about the prehistoric past when art as we know it today did not exist. Certainly there were no *museums*; no one felt the slightest need to be *cultured* or even formally educated; and discussions of *taste* centered on the day's food supply. Yet the few objects and artifacts that have, against all odds, survived reveal a remarkable sensitivity to our own artistic concerns: Most exhibit expressive form, pleasing line, and attractive visual organization (Fig. 1). The essence of the artmaking process—keen problem-solving ability and creative imagination—was incorporated into every aspect of existence for these ancient peoples. The ability to discern and to respond to subtle changes in the environment was often a matter of life or death.

The prehistoric era was an important formative phase in the history of civilization. Architecture was born when humans ingeniously formed shelters out of native materials; when clay was first hardened in a fire, the resulting ceramic cooking and storage vessels made possible new ways of living; symbolic sculptural figures (Fig. 2) and magical cave paintings psychologically and spiritually knit the community together and helped explain the otherwise unexplainable. "Art" as a specialized activity did not exist then, because its creative spirit was everywhere.

Activities such as communal singing, ritualized movement, and shamanistic storytelling and artifacts such as striking costumes and richly decorated utensils were an everyday part of life for ancient societies. Meaningful art experiences were not relegated solely to the walls of museums or cultural centers—they were an integral part of the community. Through this artistic activity, humanity expressed its desire to master the outer environment and inner psyche and thus give meaning and direction to life. Ultimately, art is the primary language of humankind through which tangible physical form is given to conceptual thought. This artistic sensibility and our consciousness of history and of self are cited most often as the characteristics distinguishing humanity from other forms of life.

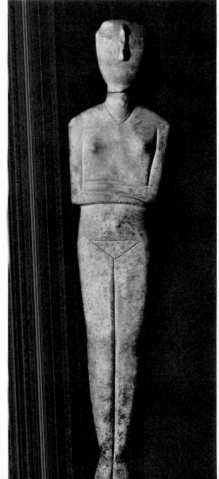

above right: **1.** Spouted jar. Yortan, Anatolia. 3rd millennium B C. Bronze, height 9¾″ (24.8 cm). Courtesy of the Trustees of the British Museum.

right: **2.** Idol. Amorgos, Cyclades Islands. c. 3000 B.C. Marble, height 30″ (76.2 cm). Ashmolean Museum, Oxford.

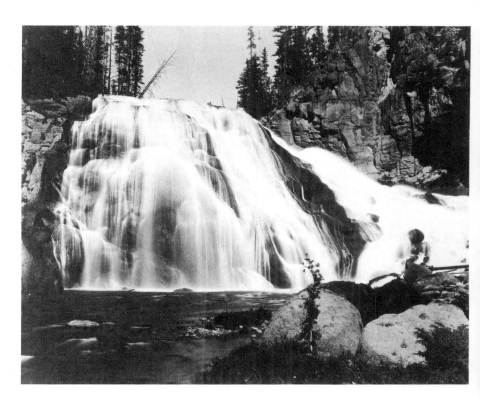

3. Frank Jay Haynes.
Gibbon Falls, 84 feet,
Yellowstone National Park.
c. 1886. Albumen-silver print,
17¾ × 21⅝″ (45 × 55 cm).
Museum of Modern Art, New York
(gift of Alfred Jarstzki
by exchange).

AESTHETICS

Because art is the record of how men and women have responded consciously to their environments, the development of aesthetic thought goes hand in hand with the evolution of civilization. **Aesthetics** is the study of the creation, appreciation, and critical thinking of art. Although this branch of philosophical thought traditionally was concerned with definitions of beauty, it now embraces all aspects of the arts from a variety of perspectives: psychology, sociology, anthropology, art criticism, and cultural history. The development of aesthetic thought goes hand in hand with the evolution of civilization, for art is the record of how men and women have responded consciously to their environments.

In essence *aesthetic* refers to what we perceive to be beautiful and pleasing. Everyone appreciates the sheer visual delight of a dramatic sunset, rippling light on the surface of a lake, or brilliantly colored wildflowers. When these natural wonders (Fig. 3) capture our attention they heighten our perception. We seem to see more than we normally do and derive great pleasure from this perceptual activity. Although the term *aesthetics* is closely associated with works of art, it is by no means exclusively bound to them. Our innate love of beauty permeates every aspect of our lives and influences us consciously and unconsciously in countless ways. Few decisions in life are untouched by aesthetic concerns: where we choose to live; the type of profession we are attracted to; the clothes we wear; the car we purchase; our leisure time activities; and, most important, the person we choose as a partner in life. These decisions are affected in large part by broad aesthetic concerns. How we choose to live and the values we embrace in life also are intrinsically bound to our aesthetic choices. In this way beauty and meaning are part of everyday life, not abstract qualities that pertain only to works of art.

Originally humanity needed keen visual perception for survival. Life depended on the ability of hunter-gatherers to read visible signs and respond in flexible ways. Today few people hunt, fish, and gather food for survival, but we still rely on our wits to secure a job and hold it. Perceptual ability, in the broadest sense, is a requisite for economic survival in the postindustrial age. Without it we are unemployable. Works of art celebrate and heighten our perceptual gifts as a species; and, in a contemporary world that has insulated us from many primal human experiences, art puts us in touch with a myriad of feelings and thoughts difficult to reach in other ways. These special aesthetic experiences anchor us to our dimly remembered past and perhaps make it possible to enter more securely the rapidly unfolding world of the future.

CREATIVITY

Although we tend to associate the word *creativity* with art and artists, all of us, to some extent, exhibit creative behavior. Essentially the creative process involves the ability to revisualize or assemble something in a new way. Sometimes we are forced into this mode of thought by problems we cannot solve in traditional ways. For instance, when good friends drop over unexpectedly a creative cook can often fashion an imaginative meal out of limited means. Although the surprised host may wish for certain foods and special ingredients, the reality of the situation forms a catalyst for the kind of creative problem solving that overcomes limitations.

The gap between reality and what we wish for is one of the primary motivations for art making. Human creativity attempts to bridge that gap and thus transform our dreams into actuality. Any beneficial invention or concept of social significance in the history of the world has involved *imagination* and *vision*. This creative vision is what has taken us from the forest floor to the dazzling heights of hundred-story skyscrapers (Fig. 4). We perceive reality one

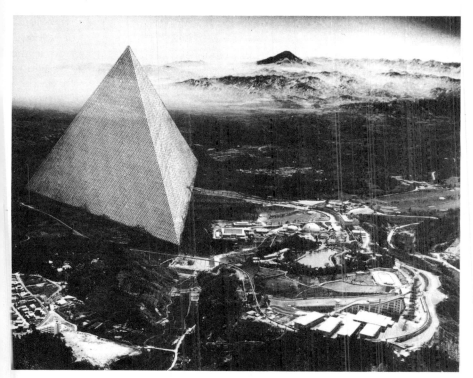

4. R. Buckminster Fuller and Shoji Sadao. *Tetrahedron City*. Yomiuriland, near Tokyo, Japan. c. 1970. Photomontage, 11 × 14″ (30 × 36 cm). Museum of Modern Art, New York (gift of the architects).

way—but we would like it to be another way. The story of art unfolds in this gap between what we *see* and what we *envision*. The ability to couple creative imagination with intelligent logic makes us unique as a species. Without these attributes the collective life of humanity—ongoing now for some three hundred thousand years—would have amounted to nothing more than the static biological continuation of our species.

Despite the fact that creative problem-solving ability is one of the most practical skills anyone can possess today, sadly our society and institutions do little to encourage it. Schools for the most part emphasize the learning of facts over the learning of concepts; little attention is paid to the integration of information—the mark of a truly educated and effective individual. Creative problem-solving techniques and programs (such as art classes) that emphasize broad-based thinking skills do not exist in most curriculums. Yet in our fast-changing society these adaptive modes of thinking will be far more valuable in the long run than the rote memorization of information and figures—much of which will be irrelevant and outmoded by the time the student graduates.

Creative thinking is not as difficult a process as many people believe. Children do it naturally until institutions convince them that "play" is less important than "work" and getting the "right answers." The toll in human potential taken by these systems is awesome. Ironically many of the great figures in history (who are studied reverently by children in these institutions) exhibited throughout their lives the ability to play or be playful with ideas, tools, and materials. This is not to suggest that serious work, some of it repetitive and demanding, is unnecessary in a child's education, but that the more we blur the lines between creative play and serious study, the more meaningful and effective the learning process becomes.

Recently a large university with a special research center devoted to the examination of creativity conducted an experiment to define the link between children's play and learning. In this experiment the subject, a young child, was seated at a large table. Beyond the reach of the subject was a box filled with candy. If the child could tip the box over without getting up from the seat, he or she could have the candy. Placed within easy reach of the child on the table top were wooden sticks and C-clamps—screwlike devices that could be used to join the sticks together and make a tool long enough to reach the box.

Before the experiment the children were divided into four separate groups: a control group that was told and shown nothing; another group that heard a lecture about C-clamps and what they could be used for; a third group that saw demonstrations of these tools and materials; and a fourth group that was simply allowed to play with C-clamps and wooden sticks. The group that was allowed to freely play with the materials solved the problem with the greatest speed. Creative play—which is really a child's "work"—was, in this experiment at least, the most effective teaching method. We adults, as well as children, can accomplish much if we allow our natural curiosity and sense of wonder about the world to emerge and enter into the process of creative problem solving.

The ability to be flexible, open minded, and integrative in our thinking is perhaps more important to the future of humanity than we might imagine at first. Potentially grave economic, social, and technological dangers await our children and grandchildren. Without the willingness and ability of future generations to break ineffective and dangerous patterns of thought humanity literally may have no future. In the two hundred short years between 1880 and 2080—an instant in the earth's geologic time—we will have consumed all the easily accessible fossil fuel and used up water deposits that accumulated over hundreds

of millions of years. If we continue at the present rate of technological "progress," we also will have exterminated hundreds, perhaps thousands, of plant and animal species during this time span. Our brains, which are propelling us toward this dark destiny, must become our salvation. If we do not begin to educate people who can integrate diverse bodies of knowledge, be open to new ideas, and tolerate other points of view—all attributes of creative thinking—the human mind will turn out to be a time bomb with a relatively short fuse.

This is not to suggest that art and the creative thought associated with artistic processes will offer easy answers to such complex problems. But in the future much will depend on our ability as a species to come up with solutions to pressing questions and to better understand one another and the world we all inhabit. Through this kind of creative thinking perhaps we can all finally put our collective energies into developing a rational design for living.

ART CRITICISM

Few people fail to have some kind of response when they confront a work of art. Initially they may be pleased by what they see (their preconceptions may have been met) or they may be puzzled and find they dislike the artwork (the art may not meet their expectations). These are perfectly natural first responses. But if critical thinking and viewing stops at this beginning stage, only the surface is scratched and much may remain to be experienced and felt. Essentially the goal of art criticism is to gain deeper understanding of works of art and through understanding be led to greater aesthetic pleasure and awareness.

One popular myth about art criticism is that it analyzes a work of art to death. This may be true in some instances but the effect of significant criticism is to increase the enjoyment we derive from works of art. Innately our minds want to comprehend and take pleasure in knowing. Usually increased knowledge about art functions as a catalyst, opening new doors of perception. Effective art criticism enlarges our capacity for enjoyment and aesthetic pleasure in many ways. We all know the old saying regarding art, "I know what I like." In truth it means "I like what I know." At its most effective, criticism enlarges the sphere of what we know and thus increases our range of possibilities.

Throughout this book many works of art are illustrated, commented upon, and compared. Some analyses will not seem as valid as others. Every individual's perceptions are conditioned by a multitude of factors. We each see something different—this is part of being human. This is also one of the most exciting aspects of art: Everyone will bring unique perceptions to the work and view it personally in terms of his or her own experiences in life.

Ultimately, responding to visual art is a personal experience, but some basic guidelines can help us judge what we see in an informed, objective way. Criticism consists of four sequential stages: *observation, analysis, interpretation,* and *evaluation.* In each stage or operation we might ask ourselves certain questions when we encounter a new work of art. These questions proceed from simple to more complex concerns that involve some knowledge of art and the forming of value judgments.

Observation What do I see? How could I describe this work of art? What is the subject? If it is **abstract**, does it remind me of anything? Does the artist use recognizable images? Am I familiar with the artist? What materials is the work

made of? What culture produced it? Does it relate to other artworks I am familiar with? Can I relate this work to others I have seen?

Analysis What kinds of relationships exist among the various elements of the artwork? If it uses recognizable subject matter, are the images related to a specific theme? Do the shapes, colors, and visual rhythms follow certain patterns? What kind of spatial reading do I get from this work? Is the space flat, shallow, or deep? Does it have perspective? What are the unifying elements of the work? What gives it compositional balance and unity? What features stand out and enliven the work of art through variety and spontaneity? How have the materials and techniques been used to reinforce its thematic content?

Interpretation After I look closely at this work of art and analyze it, what meanings does it have for me? How does it relate to the beliefs and concepts of the artist and the society that produced it? What impact do the forms and themes of the artwork have on me? What ideas does the work seem to present? Can I explain how the use of certain colors and organizational devices express what I believe to be the artist's intentions? What feelings, memories, and associations does the work evoke?

Evaluation Is this artwork significant to me? Why or why not? How would I rank this work of art in comparison with others by the same artist? Is this work a good example of its **style**? How does this work relate to the wide range of artworks produced over time? In what way is this work relevant to my life and the realities of the present day?

In the future, as you look at new works of art and follow this sequence of *observation, analysis, interpretation,* and *evaluation,* you will no doubt formulate many significant questions of your own.

A Case Study: Seurat's *A Sunday Afternoon on the Isle of La Grande Jatte*

Writing about something is an exercise that helps us focus our thoughts and determine our true feelings about it. Spoken language rarely has the clarity and weight of well-considered written thoughts. Writing a short essay about a work of art is an excellent way to explore your mind and put preconceptions to the test. For this reason, as an exercise you may wish to write about a new work of art you encounter in this book. As an example of how we might apply the questions and process of art criticism, we will examine Georges Seurat's painting *A Sunday Afternoon on the Isle of La Grande Jatte* (Fig. 5).

If we were to visit the Museum of the Art Institute of Chicago, *La Grande Jatte* would catch our attention because of its size alone—it measures slightly over 10 feet (3 meters) across and is almost 7 feet (2 meters) high. Although this painting is not particularly large by today's standards, it is significantly larger than most of the other paintings of the same era.

Perhaps the second most distinctive feature of this work of art is the fact that it was painted by placing thousands of short strokes of varied, intense color next to one another. This technique is called *pointillism* or *divisionism*. All of these dots of color are organized and arranged into shapes that when viewed at a distance present us with an image of people enjoying their weekend by strolling on a small island in the river Seine, which flows through the city of Paris.

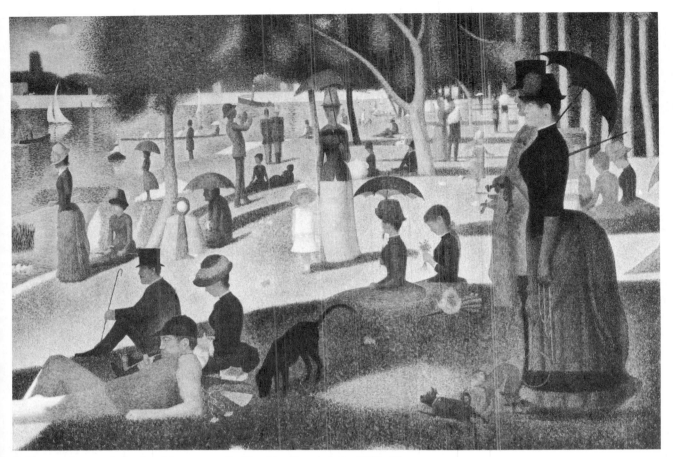

5. Georges Seurat. *A Sunday Afternoon on the Isle of La Grande Jatte.* 1884–85
Oil on canvas, 6'9" × 10'3⁄8" (2 × 3 m). Art Institute of Chicago
(Helen Birch Bartlett Memorial Collection).

Despite the fact that "realistic" imagery is used, this view has a stiff, formal air of
unreality. Shapes are refined and simplified; superfluous details are excluded.
Emphasis is placed on the profiles of carefully posed individuals who seem
frozen and stilled. If we had previously passed through the Egyptian wing of the
Art Institute, we would note a resemblance between the elegant and formally
composed figures in Egyptian art and Seurat's Parisians.

 If we are familiar with other artworks by this late-19th-century post-impres-
sionist, we would notice certain stylistic similarities that show up in most of
Seurat's mature work. The basis of his art ran counter to many of the aesthetic
interests of the **impressionists,** who were intent on recording the fleeting na-
ture of sunlight and expressing concepts of speed and change in the modern era.
Seurat's work—and *La Grande Jatte* in particular—presents us with a monu-
mental and timeless view of the world. This view was similar in many respects to
the Egyptians'.

 As we analyze the painting, we begin to notice the subtlety with which Seurat
transformed this ordinary afternoon in the park into a mysterious world of
poetic beauty. Despite the outward appearance of a lively weekend crowd shar-
ing the joys of nature, on close inspection, we see that Seurat has created an
arrangement of individuals deeply immersed in their own inner world of
thought and reflection. From the reclining, pipe-smoking man in the left fore-

ground to the mother and child walking side by side, all of the human players in this visual drama seem silently frozen and lost in solitary contemplation.

Seurat makes extensive use of the parasol as a recurring visual motif. The crescent shape of these silhouetted parasols shows up five times and sequentially links the foreground, middle distance, and background. Many other similar shapes appear in the painting: The various hats of the women and men, the bustle of the woman to the right in the foreground, even the tails of the dogs and the monkey echo the curved arcs of the umbrellas.

Although *La Grande Jatte* does not make use of strict symmetrical design—in which the vertically divided left and right half of a composition are mirror images of one another—the keen sense of stability and order in this painting is characteristic of symmetry. The woman with a parasol standing next to the small child is placed *exactly* in the center of the painting, measured from left to right. The prominent couple in the foreground on the right is visually balanced by the trio seated on the grass to the left of the painting. As we look from the strolling couple in the foreground to the figure in the center, to the three people on the grass, and back again to the man and woman on the right, our eye traces a triangular path (Fig. 6). It is no coincidence that the triangle is one of the most stable forms in nature. By using both symmetrical and asymmetrical elements in this composition, Seurat enhances the paradoxical mystery of this scene, which is both seemingly random and carefully ordered.

Seurat's color plays as important a role in this painting as the compositional devices and use of shapes. From a distance, large portions of the surface appear to be flat areas of color. Details and shading are kept to a minimum. But as we walk closer, to within a few feet of the painting, areas that appeared to be solid transform into small, carefully divided strokes of color. Many colors are placed next to their opposites on the color wheel—red next to green, yellow with violet, and so on (Fig. 7). Seurat's unique use of color further extends an air of meaningful contradiction to this artwork. Despite the outwardly calm and low-

6. Georges Seurat. *A Sunday Afternoon on the Isle of La Grande Jatte.* Compositional analysis.

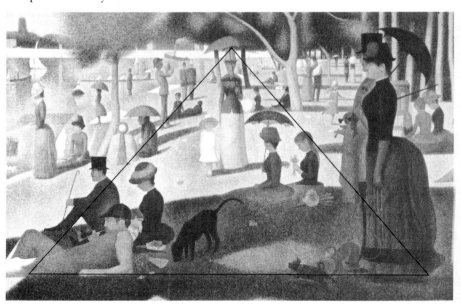

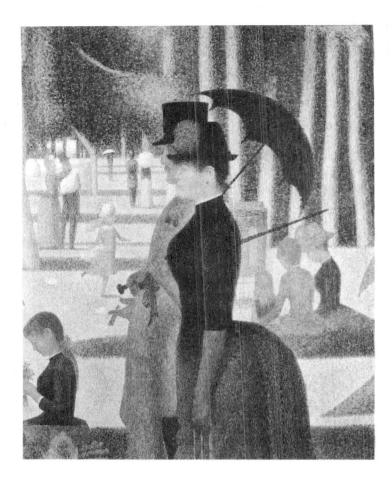

7. Georges Seurat.
*A Sunday Afternoon on the
Isle of La Grande Jatte*.
Detail revealing
the pointillist technique
developed by the artist.

key color of *La Grande Jatte*, beneath the surface volatile juxtapositions of color form the basis for its optical effects.

Interpreting Seurat's **mural**-size canvas involves assembling all the information we have gained from observation and analysis and trying to fit these elements together to come up with a partial explanation of what this work of art could mean to us. It is important to realize that works of art do not necessarily have only one meaning. Depending on the observers' point of view in terms of era and culture, they will discover a variety of meanings. In fact, this is one important characteristic of historical masterpieces: They survive the changes of time and perception and continue to be meaningful.

In many ways, Seurat's painting expresses the fascination his era held for scientific discovery. In particular, Seurat was intrigued with research that revealed hidden structures buried beneath the veneer of outward appearances. The integration and inclusion of contradictory elements appears to be one of the most important themes of *La Grande Jatte*. It is an artwork that bridges and connects two different worlds. On one hand it simulates the world of visual appearances—a growing tendency in art since the end of the Middle Ages. On the other it expresses the modern era's dependence on conceptualization and the movement toward abstraction.

La Grand Jatte also expresses the psychological duality of Seurat's era, in which the Western world left behind the agrarian age and entered the brave new world of industrialization. The setting of the painting is quite significant. The very concept of a park—an artificially maintained green belt surrounded by

densely packed urban housing—is a product of the industrial age. Trees, green grass, and lake are "manufactured" elements that re-create the natural forests, meadows, and ponds of the countryside. Seurat's formal arrangement of figures stiffly parading through this oasis of greenery might symbolize the uneasiness and imposed social order the new urban dwellers must have felt in their environment. Even the notion of a day off devoted to recreation was a product of the emerging machine age. Many farm chores are responsibilities that continue seven days a week.

The strange quality of isolation and aloneness that is projected by all of the painting's figures—who seem surrounded and lost in an impenetrable "personal space"—also can be read as a reaction to the conditions of the new urban environment. Rural dwellers were attracted to the cities by jobs, a promise of money, and hope for a better life. Their families had for centuries worked the land and been part of a tightly knit social structure. Now they found themselves far from home, living and working in close proximity with strangers from distant provinces, many of whom did not share their customs. Without the support of family, close friends, and long-time neighbors, they were likely to feel alienated. Similar defensive psychological stances visible in *La Grande Jatte* can be seen today in modern cities: In crowded subway cars and buses, most riders assume the introspective, solitary attitudes visible on Seurat's large canvas.

Perhaps no element of this painting more concretely expresses Seurat's awareness and knowledge of scientific developments than his unique use of color. Seurat did not merely illustrate concepts of contemporary life, he used them in the visual fabric of his art with a logical, mathematical precision. Seurat devised a divisionalist technique of color application from his interest in the latest research on color perception. This research theorized that the eye has three primary color receptors—red, yellow, and blue—and derives all colors from mixtures of these primary hues. From a distance, *optical* mixtures would occur. For instance, if small dots of red were placed next to dots of blue, the colors would optically mix to form a third color, purple. In a sense, Seurat was the father of color television and color printing. Both processes make use of optical mixtures of primary hues to form the full spectrum of color. This analytical and theoretical use of color in art was expressive of society's interest in the economic benefits gained through scientific research. Seurat's conscious breakdown of color into basic components also could be likened to the economic efficiencies that were realized by the division of labor in 20th-century assembly lines and work processes.

Certainly *La Grande Jatte* evokes a wide range of feelings and associations, not all of which can be explained rationally. These elements of mystery and complexity may be the most significant aspect of the work to us in the latter half of the 20th century. We are surrounded by scores of electronic devices; yet most of us cannot explain how they work. Modern society functions in such complicated patterns that no one person can comprehend the whole. We each play individual roles, like the individual strokes of color in *La Grande Jatte,* which when grouped form larger coherent patterns and shapes. Behind Seurat's mastery of formal composition and his scientific use of color lies an expressive beauty and profundity shared by many works of art produced from the beginning of civilization to the present day.

Although making this kind of analysis may seem beyond our ability at this point, information logically introduced by the text will enable you eventually to interpret works of art with increased confidence. Ultimately, the goal of all of the

information in *Art Today* is to provide you with the conceptual tools and experience to personally evaluate and enjoy a variety of art works from various time periods.

THE ARTIST

Although many of the discussions in this book will focus on works of art, it is important to realize that the *artist* is the only possible source of artistic creation. In fact, the primary determinant of whether an object is a work of art centers around one question: Was it made by a human being? This factor distinguishes between *aesthetic objects* occurring naturally—such as beautiful rock crystals—and works of art intentionally made by people. Sometimes these organic forms may be more beautiful than a painting or sculpture. Beauty, however, is not the only criterion and intention of art. Without the conscious, guiding hand of humanity—which in the artistic process reflects its awareness of life, death, and thousands of other perceptions—we would not have art. While the crystal possesses pleasing order, form, and color, it cannot reflect the human condition. No hand formed this natural wonder and gave it being. Art and the labor of the artist is directed toward a beauty and awareness that goes beyond visual pleasure alone. In essence every work of art is a record of our existence in the world; collectively, they form the truest monument to civilization and humanity.

It is no overstatement of fact to say we live in a visually dominant society. Included in this vast array of visual material is much printed information about art and artists. Without leaving our home or classroom, we can review and study vivid images of artwork from around the world and from various historical periods. Although seeing reproductions cannot replace original experience, this proliferation of illustrations nevertheless has produced a heightened public awareness of art and artists. Some of the most famous modern artists have even achieved the status of cultural heroes. This was certainly the case with Pablo Picasso. More than any other 20th-century artist, this Spanish-born painter captured the imagination of the Western world. By the 1950s his fame was firmly established and his name had become a household word, one that was synonymous with revolutionary artistic ideas. Scores of books were written about him, and thousands of articles appeared in the popular press. The paradox of this famous artist—whose avant-garde image was exploited and promoted by an emerging communications industry—was that although millions of people knew of him, few understood or appreciated his work. In large part what titillated the interest of the public and was picked up by the press was the huge sums of money commanded by his artwork.

Along with Picasso's financial success went social acceptibility and power. Statesmen and wealthy industrialists vied for his attention, invited him to exclusive parties, and enjoyed the spontaneous behavior of an artist whom they believed to be a creative genius. Picasso played to the hilt his assumed role of artistic "genius." He was politically radical, outspoken on a variety of subjects, and given to upredictable, sometimes wild, behavior. In sum, his actions and values ran counter to the prevailing social norms of a society becoming increasingly organized, controlled, and conformist. Picasso could flaunt social conventions and get away with it. In a sense he was society's safety valve and emotional release. Picasso did what most people could only fantasize about. He most visibly exemplified the dream of freedom that art represented for people tied to 9-to-5 jobs and the drudgery of everyday life in the industrial age

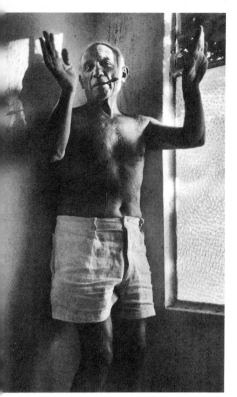

8. Pablo Picasso in a casual moment.

(Fig. 8). Not only did Picasso lead a life of artistic freedom but he also made an extraordinary amount of money from his art. For an industrial society founded on the accumulation of wealth and consumer goods, Picasso represented the pinnacle of success. This is not to suggest that his artistic worth as an artist is questionable because of his economic success. Rather, it is a comment on the perceptions and criteria of the artist's public and should make us think about the social and economic roles artists have played throughout history.

Paleolithic (Old Stone Age) animal drawings found in the dim recesses of caves were probably not the work of "professional artists"—that is to say, people whose primary job consisted of making these images. The drawings reveal an intimate knowledge of animals, no doubt gained from firsthand hunting experiences. But evidence suggests that some vocational specialization was occurring even at this early point in civilization's development: "Sketches," "practice drawings," and corrected examples are found alongside other surviving images. This evidence suggests the emergence of a special class of person—the artist-magician. On his or her shoulders rested the responsibility of caring for the psychological and material needs of the tribe. When Paleolithic artists painted an animal on the wall they were, in their minds at least, creating a real animal (Fig. 9). The *art* of creating an animal image was closely bound to the *act* of capturing a live animal. Probably, in terms of Paleolithic thought, no solid boundary between art and reality existed. Each was an extension of the other.

During the Paleolithic Age (15,000–10,000 B.C.), cave art was probably not directed toward purely aesthetic ends but rather toward fulfilling practical needs such as success in hunting and food gathering. As such, art during this period was practiced in the service of life.

9. Paleolithic cave painting. Lascaux, Dordogne, France. c. 15,000–10,000 B.C.

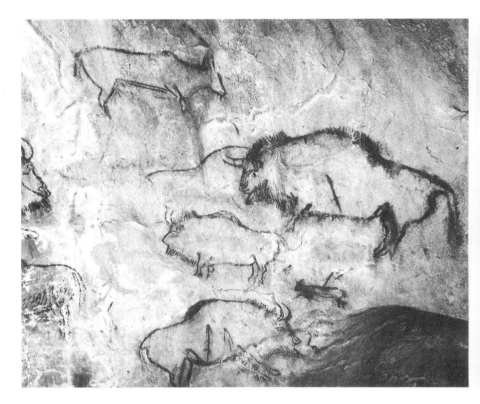

Art Today

During the rise of organized civilizations in the Near and Far East the only form of economic support for artists came from priests and the ruling class. Working in temple or palace workshops (sometimes as slaves), these art makers were seen as laborers by their employers, not as developers of cultural taste. Few opportunities for **thematic** expression existed for these artists—their work was generally limited to producing votive gifts to the gods and royal memorials. Since both the priesthood and royal house were interested in preserving the status quo (and their power), innovation and change were strongly discouraged. For this reason the art of ancient Egypt, for example, changed slowly over thousands of years.

During the late archaic period of Greece (about 480 B.C.) a change occurred in the relationship between the artist and the patron. Art was no longer being directed exclusively toward religious purposes; the increased skill of the artist-craftsperson had in turn inspired religious feelings toward the work itself. The aim of Greek artists at this time was to celebrate the intrinsic beauty of the human form and achieve its idealized representation (Fig. 10). Although these naturalistic figurative sculptures were intended as cult statues and funeral monuments, it is clear they served other, purely *aesthetic*, purposes.

With the rise in power of wealthy Greek city-states and the ascendency of elite civic figures, the artist was no longer economically dependent upon the priests. The works of art commissioned by these new patrons were not meant to possess magical power, and even when they served religious purposes they were not considered sacred themselves. As soon as humanity won for itself some freedom from the pressing concerns of survival, the role of art (and consequently the role of the artist) became directed more toward aesthetic perception and the celebration of beauty.

10. Myron.
Discobolos (Discus Thrower).
Roman copy after
Greek original of c. 450 B.C.
Marble, life size.
National Museum, Rome.

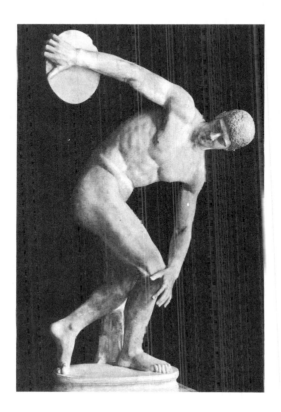

Despite the shift in patronage from priests and religious rulers to state and secular leaders, the economic and social lot of artists remained basically unchanged. They were poorly paid, viewed as expendable workers, and often were forced to lead a nomadic life in the pursuit of work.

After the reign of Alexander the Great (Alexander died in 323 B.C.), the artist's status in Greece gradually changed for the better. Because of Alexander's overwhelming success as a military figure and conqueror, his successors—conscious of the publicity value of hero worship—sought inspired artists who could commemorate them through art and thus secure them fame and immortality. This heightened demand for art and the increasing accumulation of wealth in private hands led to bigger rewards and greater public esteem for artists. Education of a philosophic and literary nature became more accessible to groups of artists-craftspeople, and signatures first began to appear on works of art. (Earlier work was virtually never signed.)

Until the flowering of Renaissance thought in the 15th century recast the artist in the role of philosophical commentator and cultural shaper, his or her role had been that of a skilled worker. During the Middle Ages artists were trained in guilds similar to those that taught weaving and carpentry. Their education in these workshops was practical, not theoretical. The process of artistic training was entirely a collective experience. Students learned by apprenticing themselves to more experienced artists and worked on projects collectively. Some prepared the canvas, others mixed the colors, and some only worked on details such as skies. In many ways art was an assembly-line process. Not until the end of the 15th century with Michelangelo's stubborn desire to complete an entire artwork himself from beginning to end can the beginning of a modern sensibility be felt. Even his inability to cooperate with assistants points away from workshop collectivism toward the emergence of the artist as an independent thinker.

But independence carried to its logical extreme exacts a stiff economic price. Who would pay for independently conceived works of art? The guild system—although not allowing for a particularly luxurious life—provided monetary stability and some job security. Post-Renaissance artists acquired increased artistic independence and began to operate more and more as small-business owners; commissions were secured through personal contacts and many of the best customers came from the increasingly wealthy merchant class. Released from the constrictions and security of the guild system, artists struggled to find a market for their services and to deal with problems every business deals with: overhead, production schedules, and cash flow. Because of changes in aesthetic fashion coupled with the artist's need to grow and develop, art could be a risky venture. Even Rembrandt, a highly successful artist during much of his life, was deeply in debt when he died.

With the modern era comes the concept of the artist as a lone heroic figure of genius. In the past a strong interdependent relationship had existed between the significance of the subject matter and the fame of the artist. But with the dawn of this new age the importance of the *artist* overshadows thematic concerns in art. In fact, a cult of individuality was established whereby the subject matter of the work of art was primarily the unique personal vision of the artist. Often these expressive, autobiographical concerns transcended cultural tradition and flouted established rules. Unlike medieval artists who for the most part communicated messages of accepted belief, artists of the past century assumed—as far as society was concerned—the role of cultural rebel, questioning and challenging our notions of conventional wisdom and faith. The modern notion of artis-

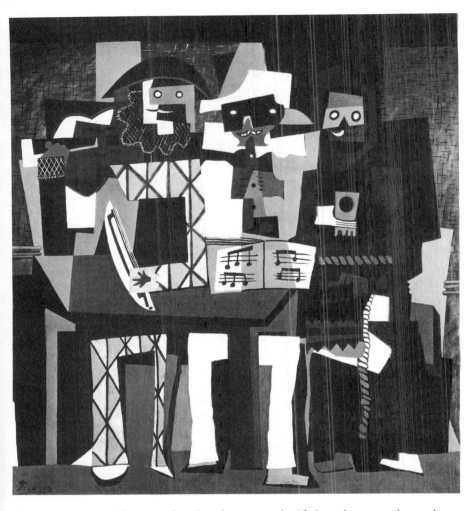

11. Pablo Picasso.
Three Musicians. 1921. Oil on
canvas, 6'8" × 6'2" (2 × 1.88 m).
Philadelphia Museum of Art
(A. E. Gallatin Collection).

tic genius as an inborn and uniquely personal gift has done much to shape contemporary society's expectations of art and the artist.

Picasso was a clear embodiment of these cultural conceptions. His individuality was legendary; his creative vision (the development of **cubism**) greatly reshaped the visual world (Fig. 11); and his controversial activism—both aesthetic and social—forced us to reevaluate our thinking and question the wisdom of the past. He was, in sum, the quintessential cultural hero of the 20th century.

Artists today operate with unprecedented freedom of expression and pursue a multitude of individual directions. Unlike other historical periods that recognized no particular value in intellectual originality and spontaneity, our time places a premium on these attributes. Along with this great freedom for the artist comes an awesome responsibility: What inner perceptions and expressive motifs are important to the artist's public as well as to the artist? There is no single answer to this question. We live in a world of exceptional diversity. Each artist must struggle with questions of meaning and value; and in turn, we as viewers must respond *individually* to works of art and over time determine their worth. All of the works of art—both historic and contemporary—illustrated in this book comment to some extent on these important questions of personal and public value and meaning. Contemplating them with an open mind helps us to understand our own individual role in society and may lead to the better understanding of other peoples.

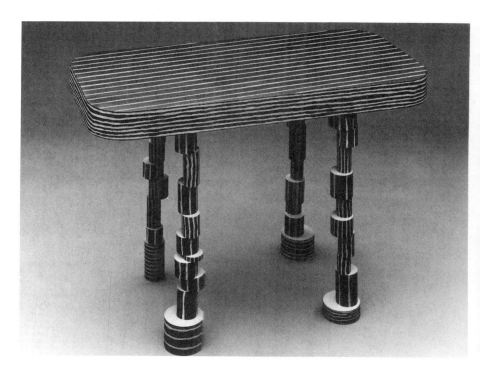

12. Tom Loeser.
Earthquake Table. 1983.
Acrylic paint on wood,
20 × 30 × 16″ (51 × 76 × 41 cm).
Courtesy of Esther Saks Gallery,
Chicago; private collection.

ART IN TODAY'S WORLD

Along with the complexity and diversity of contemporary life has come a synthesis between what were until recently considered separate fields: "fine art" and "applied art." Artists now are producing works that easily defy catagorization. Sculptors and craftspeople are making innovative art that fulfills both aesthetic and practical concerns (Fig. 12); painters are creating striking textiles; and architects are called on to design home furnishings that enhance everyday living (Fig. 13). Actually the schism between the notion of "art for art's sake" and professional work directed toward practical applications is the result of increased

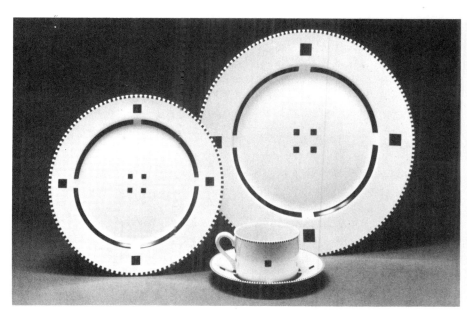

13. Gwathmey/Siegel.
"Tuxedo" line
of ceramic dinnerware. 1985.
Courtesy of Swid Powell Design.

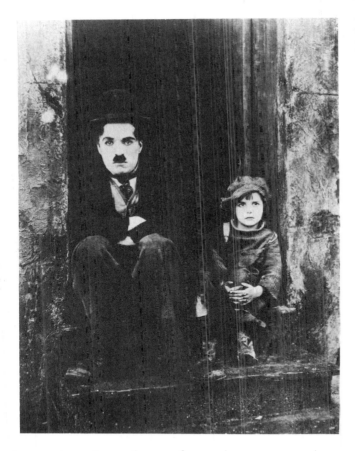

14. *The Kid.*
Charles Chaplin and Jackie Coogan.
1921. Film Stills Archive,
Museum of Modern Art, New York.

specialization in modern society. Past cultures of necessity were more integrated; artists in metalworking guilds, for example, often designed and made utilitarian goods as well as "fine art" statuary. Today we are developing less rigid concepts about issues such as "fine" and "applied" arts and are learning to appreciate the contributions all visual arts professionals make to our lives.

Even if you were never to view in person original paintings, drawings, and sculpture (a highly unlikely possibility) the world of art would still exert a powerful influence on you. Evidence of artistic activity is seen everywhere in the modern world: the dazzling color computer graphics that announce network television shows; large-scale public art and architecture; this book for instance, required the services of many visual arts professionals such as photographers, graphic designers, and printers. Look around you. People trained in the art of textile design created the fabrics out of which all of your clothes were made. The desk or table you sit at, the pictures you hang on your wall, and all of the goods which surround you were designed by people trained in the visual arts. Because all of these things are so much a part of the contemporary landscape, they are usually taken for granted and go unseen. We may, perhaps, feel that the world of art exerts little influence on our lives. Nothing could be further from the truth; in fact, it would be difficult even to imagine the modern world without the many contributions of the visual artist. Without inspiring architecture, films (Fig. 14), illustrated magazines, great paintings, sculpture, and well-designed consumer goods it would be a colorless, dismal world at best.

It is the underlying premise of this book that to respond to and create art is a natural response to living, and that life and art form inseparable and mutually sustaining relationships.

The Language of Vision

Part I

THE LANGUAGE OF VISION

When we first confront a work of visual art—a painting, for example—we may not consciously care about its formal organization or aesthetic content. We are swayed by its sensuous forms, intrigued with its subject matter, and dazzled by the rich interplay of colors. As we return again and again to the painting, we naturally want to understand how the various components work together to produce such a unified, coherent experience. Knowledge about the inner workings of art does not replace our intuitive enjoyment but can reaffirm and add to that pleasure.

Every effective work of art—whether it is visual, literary, or musical—attracts us by its seemingly effortless unity of organization. When we go to a live rock concert for example, the experience is often total. One song leads into the next; the lighting shifts to respond to the mood of the music; and rhythms change and flow in an ordered way. If the group is successful these distinct elements are not apparent—the experience seems complete and unified.

Ironically, the more successful an artistic work is, the less we notice the many **structural** elements that mold it. Everything seems compressed into one satisfying experience. When we view a particularly effective work of visual art we experience the same basic feeling of unity and order we felt at the concert. Through the skillful manipulation of *visual elements* such as shape, texture, line, space, time, motion, light, and color the artist can express a wide range of concepts, moods, and meanings.

All art has *organization,* the arrangement of interdependent parts to form a coordinated whole. Organization can also be referred to as **design, composition,** or *order;* but *organization* is a more appropriate and inclusive term. It suggests that the process of artmaking is fundamental to the way we think and respond to the world; and it implies a purposeful integration of all factors.

The chapters in this section, "The Language of Vision," explore the structural elements of visual form—the organizing principles artists have at their disposal to express social concerns, personal feelings, cultural ideas, and visual perceptions. It is important to remember, however, that the goal of the artist is to make

us forget about the separate parts and experience the totality of the statement.

An understanding of the basic principles of design can help to relate varied experiences that might otherwise remain disconnected. To be comprehensive and flexible, the principles should develop out of the widest possible variety of perceptions: human responses to diverse relationships of shape, line, texture, space, light, and color; the characteristics of materials, new and old; design in nature, in a tree or a rock or in the movements of waves or clouds; and contemporary and historic art from all the world's cultures. The following discussion aims to provide a better understanding of how successful works of art integrate many elements into one unified experience.

Chapter 2

Shape, Texture, Line, Space, Time, and Motion

The visual elements are rarely perceived as isolated entities; most of the time they are seen in relation to their immediate surroundings, and these relationships determine the total effect. If the Great Pyramid were transported from the expansive sands of the Egyptian desert to a Rocky Mountain valley, it would still be large and imposing. But in comparison with the surrounding peaks, the Great Pyramid would seem smaller and less impressive. Or try to think of the historic colonial town of Williamsburg set down on a New Mexican desert. The soft light of Virginia now embraces these buildings, but the brilliant southwestern sunlight might make the colors seem weak and the ornament too delicate.

The relationship of the visual elements to one another is equally important. Figures 15 and 16 demonstrate that identical shapes may not always appear to be the same size in different surroundings and that parallel lines do not always look parallel. What we *see* is always greatly affected by context. The center circle in the top part of Figure 15 appears diminished by the larger circles surrounding it, whereas the center circle in the illustration below appears larger. Historically,

below left: **15.** The two central circles are exactly the same size.

below: **16.** The vertical lines are parallel.

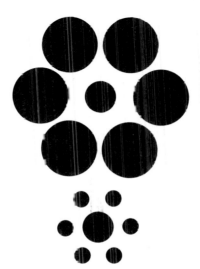

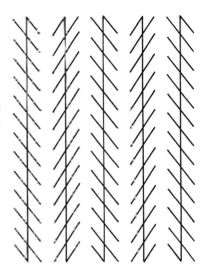

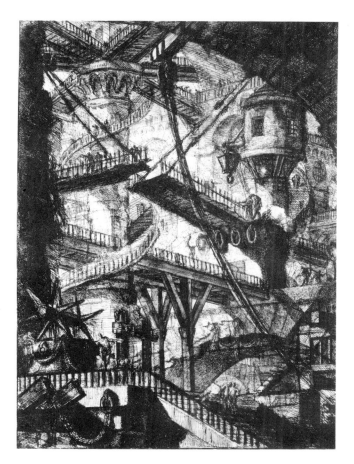

17. Giambattista Piranesi.
The Drawbridge. 1745. Etching,
21⅞ × 16⅛″ (55 × 41 cm).
New York Public Library (Astor,
Lenox, and Tilden Foundations).

artists have always been fascinated by illusion. In Piranesi's etching of the interior of a prison (Fig. 17), stairs and bridges crisscross and lead the eye in so many contradictory directions that the space becomes mysterious and vague. Another illusionistic concept is evident in Escher's *Three Spheres* (Fig. 18), in which similar lines depict disturbingly different shapes and space relationships. Because of subtle changes in the direction of the lines, the top form appears as a globe, the middle one has a flat top, and the bottom one has been so squashed that the roundness of the form is almost but not quite lost. The resulting ambiguity is both fascinating and disconcerting; the viewer endlessly searches for certainty in a world in which reality is often contradictory.

SHAPE

Shape is a term that refers to both three-dimensional and two-dimensional **forms.** Sculpture makes use of the arrangement of various solid masses; and painting employs flat, two-dimensional areas that are created by enclosing lines or when changes of color or tone set one area apart.

Basically, forms tend to fall into two major groupings or "families," geometric and organic. Geometric shapes are usually sharply angular and regular: rectangles, triangles, and circles drawn with a compass are all examples of geometric shapes. Organic shapes are less angular and mechanical in appearance: They are based on curvilinear rather than mechanical principles. Often, they appear to have evolved according to the laws of organic growth. Historically, artists have

The Language of Vision

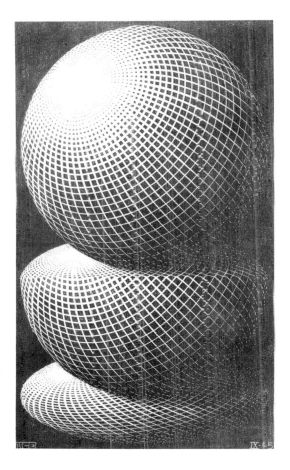

18. M. C. Escher.
Three Spheres. 1945.
Wood engraving; composition
11 × 6⅝″ (28 × 17 cm),
sheet 15¼ × 9¾″ (39 × 25 cm).
Museum of Modern Art, New York
(purchase fund).

always made extensive use of both geometric and organic shapes, often using elements of both in the same work of art.

 Usually, the type of form determines the psychological effect of the work of art. Geometric, rectangular forms usually seem clear and definite, assured and certain, perhaps rigid and unyielding, because a right angle is always 90 degrees. Sometimes, however, the organization of rectangular forms can lead to an illusion of forms moving in and out (Fig. 19). If forms move in abrupt contrasts up

19. Josef Albers.
Sanctuary. 1942. Lithograph,
19 × 23¾″ (48 × 60 cm).
The Contemporaries, New York
(by permission of
Mrs. Anni Albers and
the Albers Foundation).

20. Josef Albers.
Aquarium. 1934. Woodcut,
7⅛ × 10¼″ (18 × 26 cm).
Philadelphia Museum of Art
(Print Club
Permanent Collection).

and down, crosswise and lengthwise, the effect is one of considerable activity (Fig. 20) because diagonal elements are introduced.

Triangular and other diagonal forms are generally more dynamic than rectangular forms, and their expressive range is extensive. When low and broad, as in the Egyptian pyramids, their gentle movement suggests stability and permanence. But tall, slender pyramids lead eyes and spirit rapidly upward as in the Washington Monument or the steeple of the Bruton Parish Church (Fig. 21). If

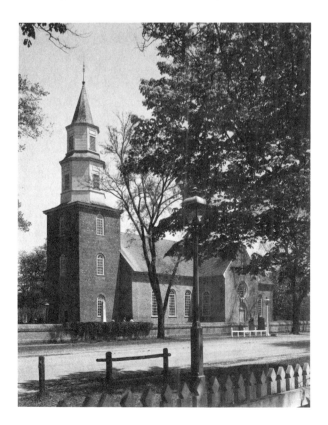

21. Bruton Parish Church,
Williamsburg, Va.
1710–1715.

The Language of Vision

left: **22.** Jean (Hans) Arp.
Automatic Drawing. 1916.
Brush and ink on brownish paper,
16¾ × 21¼″ (43 × 60 cm).
Museum of Modern Art, New York
(given anonymously).

a pyramid stands on its apex, it becomes unstable, suggesting top-heaviness, uncertainty, or imminent change.

Biomorphic, organic curves abound in nature. Pears and squash, eggs and amoebas, the shell of a snail or the inner structure of a leaf, and most parts of the human body are but a few examples. These forms seem directly related to life and growth. They have been copied or modified in many kinds of art; and they have been completely abstracted (Fig. 22). But even without specific reference to any particular growing object, they recall the essence of nature.

Sculptural Shape

below: **23.** Wei Dynasty (Chinese).
Camel (tomb figure). A.D. 586–557.
Unglazed pottery with polychrome,
9¾ × 9½″ (25 × 24 cm).
Metropolitan Museum of Art,
New York (Rogers Fund).

The Chinese **ceramic** camel in Figure 23 was originally created from an un-formed mass of clay with as little prior meaning as bread dough. Although the subject matter—a camel—is easily identifiable, the result is not a literal copy. The sculptor was able to exaggerate meaningfully those features of a camel that most express its essence: the small head and large neck, the peculiar differences between the front and hind legs, and the humped back (even though a saddle pack covers it, one knows full well that it is there). Yet the head, neck, body, and legs also are strengthened because their similarity to such basic volumes as *cylinders, cones,* and *spheres* is stressed. This is an example of one of the many paradoxes in art. The sculptor particularized the shapes to emphasize the essence, or "camelness," of the subject, and at the same time simplified the shapes to relate them to many other forms. By such means the sculpture is imbued with individuality and a timeless, universal quality.

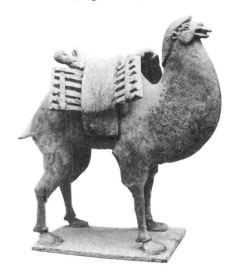

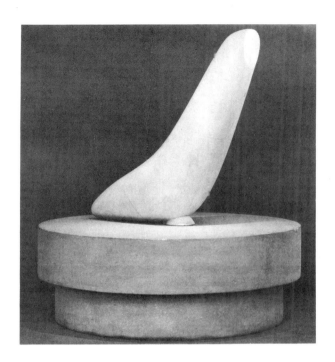

24. Constantin Brancusi. *The White Seal (Miracle)*. 1936. Marble, height 42¾″ (109 cm). Solomon R. Guggenheim Museum, New York.

More recently, Constantin Brancusi created a modern sculptural work out of the same basic forms as those of the camel. *The White Seal (Miracle)* (Fig. 24) juxtaposes various elemental shapes and materials. The cylindrical stone base becomes a visual stage for the upward yearning movement of the marble forms that depict the stylized form of the seal. Brancusi did not set out to create a faithful sculptural rendering of a seal; instead, he has suggested the graceful, streamlined curves of this aquatic animal—as in the depiction of the camel, its essence. Through the sensitive use of elemental forms and sculptural materials, the artist evokes the shape and movement of a natural form.

Shape in Painting

Painters also deal with forms, and much of what we said about sculpture— such as reducing complex, specific shapes to archetypal essences—also pertains to painting. Shapes and combinations of shapes often give the *illusion* of three-dimensional images in many paintings.

Through the controlled use of recognizable shapes, outlines, and forms built up through **cross-hatching** lines, John Tweddle has created a remarkable variety of visual effects in his painting *Then, Now, and Forever* (Pl. 1, p. 39). Tweddle successfully combines outlined shapes, such as hands and feet placed against amorphous black shapes, with an **illusionistically** rendered image of Christ surrounded by angry, menacing heads. Elements of flat decorative pattern are juxtaposed with three-dimensional effects in this work.

Tweddle has manipulated various two-dimensional shapes to achieve curious emotional results. Emblematic images typical of our era such as rockets, oil derricks, and a tanker truck are placed alongside a **symbolic** image thousands of years old—Christ suffering on the cross. Bolts of white lightning flank Christ on both sides and visually contain two angry figures. The rounded corners of the rectangular shape in the center allude to a television screen—a particularly potent 20th-century symbol. Numerous elements of the painting create potent

dualities. The space inside the "TV screen" is more three-dimensional than the flatter areas that surround it. Also the inner image is darker in color and more somber than the brighter yellow and red colors outside it.

The yellow flamelike shapes that radiate out from the edge of the center image form an interesting relationship with the adjacent light blue shapes that echo the flames. This effect is called a negative/positive shape or **figure-ground** relationship. It is possible to read these interlocking shapes in two ways—as yellow "flames" against a blue background or as blue shapes against a yellow ground. Both readings bounce back and forth in our minds. Many shape relationships in painting make use of this figure-ground relationship.

The more we look at this complex but well-ordered painting the more layers of meanings and visual relationships become visible. Tweddle has produced a provocative tragicomic image that makes us reconsider the contemporary world in relationship to its historical religious heritage.

Sometimes a painter may wish to use both flat and three-dimensional form simultaneously. Such is the case with Frank Stella's painted construction *Ouray* (Fig. 25). Artworks such as this are often referred to as *shaped canvases;* Stella exploits the possibility of combining three-dimensional forms (the nonrectilinear shape of the canvas) with intrinsically flat patterns. He juxtaposes a solid, shallow form shaped like a Greek cross with hypnotically repetitive patterns painted on its surface. *Ouray* symbolizes a contemporary sensibility that seeks to combine and synthesize many different elements into a unified experience.

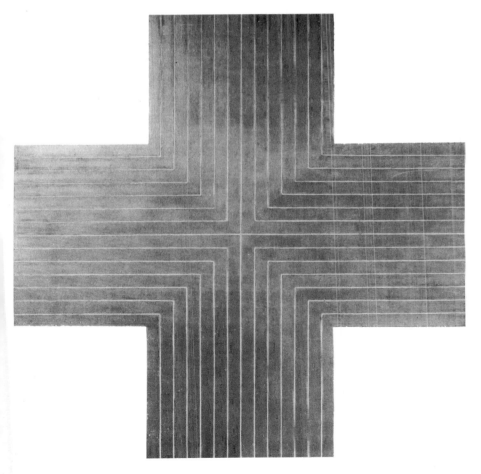

25. Frank Stella. *Ouray.* 1960–61, repainted 1963. Copper paint on canvas, 7'6" (2.29 m) square. Courtesy Leo Castelli Gallery, New York.

Many artists today have developed processes and forms that seem to express the very essence of our dynamic age. Willem de Kooning is a contemporary painter who regards movement and change as quintessential aspects of the 20th century. In *Easter Monday* (Pl. 2, p. 40) his vigorous brush strokes and mutating shapes lay bare a violent struggle to discover order and form in a world marked by conflict and change. Although de Kooning's paintings for the most part do not use realistic illusion, *Easter Monday* offers us far more than arbitrary shapes on an amorphous background. Underneath the turbulent surface a tightly controlled, interlocking geometric structure links the many complex forms and movements into one energetic but harmonious whole.

TEXTURE

Texture in art refers to surface qualities such as bumpy, smooth, choppy, coarse, or fine. Everywhere we look textures, both *visual* and *tactile,* enliven the natural and human-made world: leafy trees, a nubby tweed jacket, the surface of a quiet pond, a smooth marble table top. Visual textures such as those found in most paintings and drawings are three-dimensionally flat, but because of contrasts of light or dark they evoke perceptions of tactile texture. Actual or three-dimensional texture in art usually is employed in forms of architecture, sculpture, and crafts. Some paintings today, however, make use of a combination of three-dimensional and visual texture.

Over the centuries, artists have developed a keen interest in and love of opulent textures. Oriental rugs represent some of the most elaborate examples of visual textures in the entire world of art. The antique Kazak rug shown in Figure 26 successfully incorporates many repetitive forms and decorative motifs into

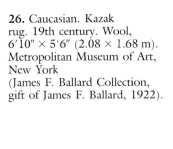

26. Caucasian. Kazak rug. 19th century. Wool, 6′10″ × 5′6″ (2.08 × 1.68 m). Metropolitan Museum of Art, New York (James F. Ballard Collection, gift of James F. Ballard, 1922).

The Language of Vision

27. Edouard Vuillard.
The Suitor. 1893.
Oil on wallboard panel,
12½ × 15″ (32 × 39 cm).
Smith College Museum of Art,
Northampton, Mass. (purchase).

one harmonious surface. The various borders function as a containing structure for the visually resonant rectangles and triangles, and the large octagonal center section.

No less compelling in terms of visual interplay is Edouard Vuillard's painting *The Suitor* (Fig. 27). The profusion of multipatterned surfaces imparts an intimate, almost haunting quality to an ordinary domestic scene. The placement of texture upon texture greatly affects our spatial perception of the scene. The man at the top of the composition emerges mysteriously from the background while the woman in the foreground, in her intensely patterned dress, hovers over the scene.

Three-Dimensional Textures

Three-dimensional textures often endow surfaces with significance, but, as always in art, specific relationships largely determine the final effect. In the living room of the Tugendhat house (Fig. 28), one of the early examples of the

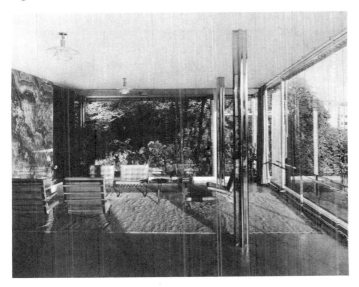

28.
Ludwig Miës van der Rohe.
Interior, living room.
Tugendhat House,
Brno, Czechoslovakia. 1930.

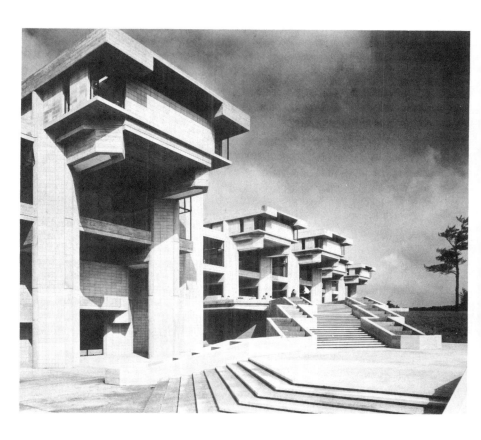

29. Paul Rudolph.
Southeastern Massachusetts
Technological Institute,
North Dartmouth, Mass. 1966.

international style, Ludwig Miës van der Rohe set off sleek, shiny, plain surfaces
of glass, metal, and concrete against the equally hard but visually exciting tex-
tural pattern of a marble wall and the softer intricacy of trees and plants beyond
the windows. In this way the harshness of many of the materials was mitigated,
their severity both heightened and compensated. Paul Rudolph's buildings for
the Southeastern Massachusetts Technological Institute (Fig. 29) are composed
of massive, strongly modeled and articulated forms. The corrugated surface of
the concrete blocks and the projecting and recessed elements provide textural
interest on both small and large scale to humanize the almost overwhelming size
of the structure. In each of these buildings textures were organized purposely
and coherently to express the architect's concepts.

Sculptors, working in the most physically tactile branch of the arts, have great
concern for materials and textures. Meret Oppenheim's *Object* (fur-covered cup,
saucer, and spoon) (Fig. 30) is striking in its unexpected use of animal fur on
eating utensils. What would ordinarily be perceived as a pleasant and sensuous
material becomes disturbing. Oppenheim was able to transform our normal
appreciation for this luxurious substance by simply placing it in an unlikely
context. Our visual response triggers sensory responses: We can almost taste the
fine hairs in our mouths and see bits of food clinging to the fur.

Another sculptor who makes significant use of visual pattern and three-
dimensional textures is the contemporary artist Jackie Winsor. In *Fifty Fifty*
(Fig. 31) Winsor achieves an effect of ordered elegance through the regular,
geometric alternation of solid wood and empty space. The resulting large cube
is, by volume, 50 percent air and 50 percent wood. The repetitious pattern is
both lively and soothing, and the interpretation of positive and **negative space**
creates an exciting dialogue, conceptually as well as visually.

above: **30.** Meret Oppenheim. *Object* (fur-covered cup, saucer and spoon). 1936.
Cup diameter 4⅜" (11 cm), saucer diameter 9⅜" (24 cm),
spoon length 9⅜" (24 cm). Museum of Modern Art, New York (purchase)

below: **31.** Jackie Winsor. *Fifty Fifty.* 1975. Wood, 40 × 40 × 40" (101 × 101 × 101 cm).
Collection Paula Cooper, New York.

LINE

The drawing of three youths by Pablo Picasso (Fig. 32) has no shading or modeling; yet without these devices the artist has convincingly presented us with a scene of people in the corner of a room. The three-dimensional quality of the figures and of the space in which they exist as well as the differences between flesh, hair, textiles, furniture, and architecture are represented by line alone. More remarkable is the feeling of tender sensitivity communicated with relatively few curved and straight lines.

When Picasso's drawing is compared with the brusquely angular painting *Mahoning* by American artist Franz Kline (Fig. 33), the range of effects possible with line becomes apparent. Picasso's piece is delicate and sensuous in its manner and style; Kline's is powerful, dynamic, and bristling with raw energy. Even if subject matter is not considered and these pieces are viewed upside down, the effect is very much the same. *Line quality* can do much toward establishing the mood or effect the artist seeks to communicate. Picasso's lyrical drawing evokes a decidedly 19th-century pastoral atmosphere, while Kline's energetic piece suggests the architectural scale and speed of 20th-century urban life.

Although line is often perceived as a means of recording movement through space, it can also be manipulated to achieve an extraordinary range of tones and the illusion of three-dimensionality. Dürer's **intaglio print** *St. Jerome Seated Near a Pollard Willow* (Fig. 34) illustrates the full tonal potential of line. Dark, shadowed areas in the print are achieved by closely spaced, overlapping lines, or cross-hatching. This can be clearly seen in Dürer's treatment of St. Jerome's

32. Pablo Picasso line drawing. Present location unknown.

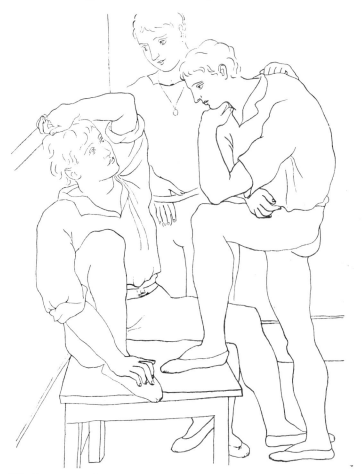

above: **33.** Franz Kline. *Mahoning.*
1956. Oil on canvas, 6'8″ × 8'4″ (2 × 2.5 m).
Whitney Museum of American Art, New York.

right: **34.** Albrecht Dürer.
St. Jerome Seated Near a Pollard Willow. 1512.
Drypoint, 8¼ × 7¼″. Museum of Fine Arts,
Boston (Anna Mitchell Richards Fund).

35. Mark Tobey. *Broadway.*
c. 1935. Tempera on masonite,
26 × 19¼" (66 × 49 cm).
Metropolitan Museum of Art,
New York (Arthur H. Hearn
Fund).

arms, where short intersecting lines create the illusion of overlapping muscles
and show us the direction of the arms in space. *Hatching* makes use of parallel
lines and can be seen in sections of the tree trunk to the right. Through the
careful control of line proximity and direction, Dürer creates a seemingly infinite
range of tones—from the darkest to the lightest—and the illusion of three-
dimensional space.

Every object and being in this scene from Christian legend appears to be
visually connected. Lines that describe one form flow effortlessly into another.
Rocks, saint, lion, and willow occupy the same thematic and visual space.
Through carefully staged graphic means Dürer tells a story of temptation, strug-
gle, and spiritual deliverance. After living for many years as a pious hermit in the
desert of the Holy Land, Jerome reported great suffering from temptations of
the flesh. To control his rampant passions he fervently applied himself to the
study of Hebrew, thus beginning his important work as a scholar devoted to
interpreting the Scriptures. The lion curled up at his feet—looking as docile as a
pet cat—symbolizes St. Jerome's taming of, as he put it, "the fires of lust."
Dürer's engraving functions as a complex, transformative vision. The willow
root on the bottom left of the print presents a vague mirror image of the sleep-
ing lion; St. Jerome is not only framed by the rocky crag but seems embedded in
it. The scholarly saint, sleeping lion, and twisted tree root evoke an otherworldly
feeling where the human spirit and nature are blissfully united.

As we have seen in the Dürer print, although the element of line is capable of
expressing subtle visual and psychological nuances, it is also used commonly in

everyday life when we write a note or letter. **Calligraphy,** which means "beauti-ful writing," has been a significant art form for centuries. In Japan and China writing and painting are similar activities—no clear differences exist between them.

Mark Tobey was an American painter whose work was greatly influenced by Oriental calligraphy. During the 1920s he studied Chinese brush painting and in 1934 he traveled to Japan and China to study Zen Buddhism. Later in Chi-cago and New York he expressed the feelings of these bustling metropolises in a series of paintings that used overall line patterns against fields of color. *Broadway* (Fig. 35) evokes the lights, movement, and dynamism of the Manhattan theater district through serpentine white linear patterns set against a dark background. Tobey charges the lines in this painting with an energy and force that is at once meditatively abstract and descriptive.

SPACE

Three-Dimensional Space

Space is everywhere around us. It is the three-dimensional expanse in which living creatures and inanimate objects exist. It is the distance, void, or interval between things, similar to a moment of silence in music or a dramatic pause in a well-delivered speech that can impress us more than words. Space envelopes us completely, yet because of its constant presence, we rarely notice its existence.

Nowhere is the feeling of space more pronounced than in the desert; there, the blinding heat of the day gradually gives way to the cool inky blackness of the evening sky. Along with the rapidly dropping temperature we experience an expanding awareness of space; time seems to slow to a halt. It comes as no surprise that holy men and women of the past sought the purity and timeless-ness of this terrain. Here, little stands between our inner perceptions and an enlarged sense of the universe.

Downtown urban areas such as New York City or Chicago affect us differ-ently. Space is compressed and contained within a dynamic maze of sidewalks, streets, crowds, and towering office buildings; the pace is harried and frantic; ordinary time seems speeded up.

Space and three-dimensional *forms* are inseparable elements because all forms are cradled in space; and, at the same time, our perception of space is governed by the forms or lack of forms within it. Space is closely allied to time perception; events seem to proceed slowly in the desert and move with great rapidity in the city. These two concepts—space-form and space-time—are particularly impor-tant in architecture. People live and move in space, and their actions are affected by the forms they encounter.

Illusion of Depth

For centuries artists in the Western world were concerned with ways of sug-gesting space realistically on the flat surface of a painting. It was the discovery of the principles of perspective in the 15th century that provided a technique whose mathematical precision suggested science. **Linear perspective** is based on two easily observable principles: Objects that are far away from the viewer ap-pear to be smaller than those which are near; and parallel lines (such as those of railroad tracks when you gaze down them) appear to converge until at a certain

distant point they disappear. This point is known as the **vanishing point** (Fig. 36a). All linear perspective used in painting employs these two guiding principles.

Renaissance artists, because they viewed the space of a painting as a window onto the world, were quick to make use of these **representational** devices. In Raphael's *The School of Athens* (Fig. 37), we can see how this 16th-century Italian artist employed one-point perspective to create an illusion of great depth. All architectural lines in this painting converge at the horizon—the vanishing point—which is behind the two central figures. Also, as the figures recede into space, they appear smaller.

A variation of one-point perspective that also needs to be mentioned is two-point perspective (Fig. 36b). This is a somewhat more complex system of creating spatial depth that includes two or more vanishing points.

In the 20th century we are accustomed to this way of perceiving and construing spatial recession because in photographic prints, especially of urban subjects, sets of parallel lines converging toward vanishing points can be identified readily. Western artists have made considerable use of linear perspective during the last five centuries and through its use have achieved an effect of great "naturalness" and illusion.

When these principles of linear perspective are applied to specific objects or particularly to human or animal forms which move away from us in space, the result is referred to as **foreshortening**. Viewing a reclining figure offers an example of this visual phenomenon. Andrea Mantegna's painting *The Dead Christ* (Fig. 38) is perhaps one of the most famous illustrations of how foreshortening can be used with dramatic results. Viewed from an angle almost parallel to the figure, Christ's body seems to be too short for its breadth. Mantegna chose this specific use of perspective because of the believable distortion of form that heightens the mournful qualities of this painting.

It is important to remember that linear perspective is not essential for the production of great art. In many periods—the Middle Ages, for example—art of the highest caliber was produced without recourse to it. A great deal of Oriental painting makes use of *isometric perspective*, in which distant forms are made smaller but parallel lines do not converge, and of *inverse perspective*, in which lines, instead of converging, diverge. Whereas linear perspective closes space in relation to the observer, inverse perspective opens it, and a sense of spatial freedom is achieved.

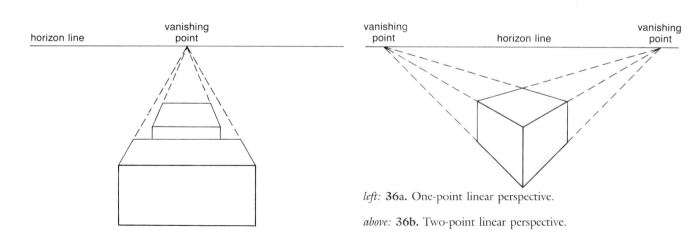

left: **36a.** One-point linear perspective.

above: **36b.** Two-point linear perspective.

The Language of Vision

Atmospheric perspective is another illusionistic device used by both Eastern and Western artists. Basically it is a means of depicting space by the weakening of values and intensities as they recede from the viewer. Atmospheric perspective is based on the fact that conditions of moisture in the air make distant objects appear less distinct and cooler in color than objects close at hand. Claude Lor-

above: **37.** Raphael.
The School of Athens. 1510.
Fresco, 26 × 18′ (7.9 × 5.5 m).
Stanza della Segnatura,
Vatican, Rome.

left: **38.** Andrea Mantegna.
The Dead Christ. c. 1490–1500.
Oil on canvas,
27 × 32″ (69 × 81 cm).
Brera Gallery, Milan.

39. Claude Lorrain.
The Herdsman. c. 1635.
Oil on canvas,
3'11¾" × 5'3⅛" (1.2 × 1.6 m).
National Gallery, Washington, D.C.
(Samuel H. Kress Collection).

rain's painting *The Herdsman* (Fig. 39) illusionistically takes us back in space by sequentially making distant objects lighter and less distinct. The nearby herdsman and his flock are rendered in the darkest tones, and gradually, as our eyes probe beyond the objects in the foreground, an ever-increasing haze (the buildup of atmospheric moisture) obscures far-away mountains.

Other visual devices such as *size manipulation, vertical location,* and *overlapping forms* also are used frequently by painters to create spatial illusions. When a number of objects are portrayed in a painting, the larger ones generally appear to be closer to the viewer. This is an optical effect that we all know well. A person standing nearby *looks* larger than someone who is a block away. In actuality, a larger image of the person who is closer appears on the retina of the eye. Frequently the size of objects in a painting relates to their relative thematic importance.

The Herdsman is a good illustration of the effect the *vertical placement* of elements can have. When objects are clearly at or below eye level, the farther down in vertical position they are in the picture, the nearer they appear to be. Conversely, when objects are far above eye level—clouds for instance—the higher they are, the closer they appear to be.

When one form overlaps and partially obscures a second, the first form seems nearer. Picasso made effective use of *overlapping forms* in his deceptively simple drawing shown in Figure 32. We know that the middle figure is behind the others because their bodies overlap his and he is therefore partially obscured. With a few skillfully drawn lines that make use of the illusionistic device of overlapping forms, Picasso has created a space so tangible that we feel we could reach into it.

In reviewing all of these spatial concepts and illusions, it is important to recognize that there is no *one* way to conceive of space in painting or drawing. Each method responds to the perceptions and cultural realities of place and time. Furthermore, each artist interprets cultural guidelines differently, so, in fact, we have as many spatial concepts as there are artists.

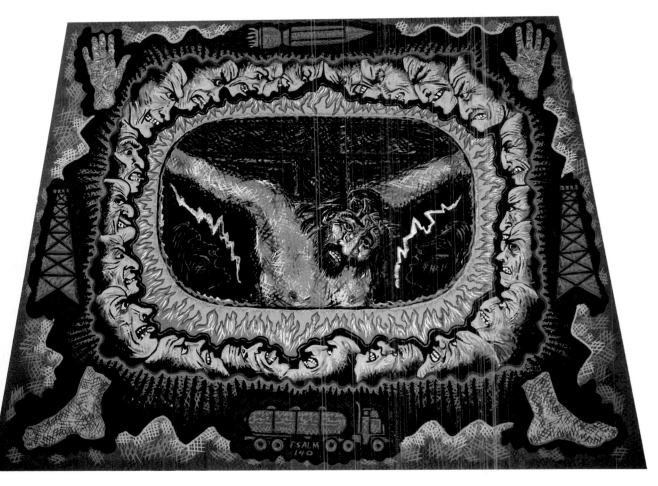

Plate 1. John Tweddle. *Then, Now, and Forever.* 1982. Oil on canvas, 97 × 67" (29.6 × 20.4 m). Blum Helman Gallery, New York.

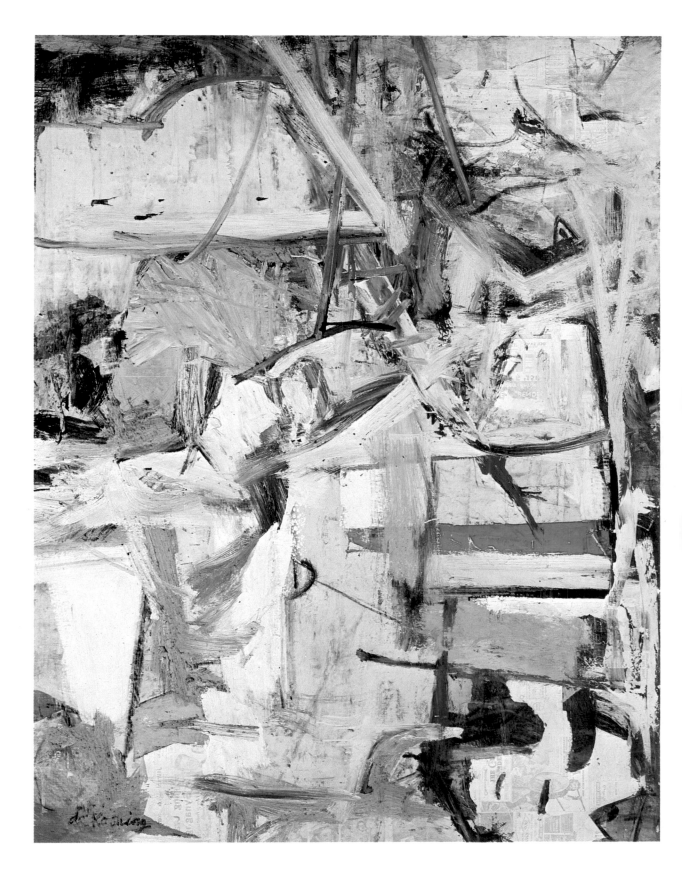

Contemporary Concepts of Space

Recently, artists and architects have become increasingly concerned with broad *environmental* aspects of space. Today, many feel that it is no longer possible, nor desirable, to view a work of art as an isolated object. Some of the most successful contemporary artworks need the social context of an interested and informed public to complete the artistic process. Many artists in the 1970s took advantage of this evolving sensibility to create works of art that side-stepped the gallery-collector-museum syndrome, making bold new statements.

Robert Smithson was a contemporary sculptor who became interested in the way a *site*, or specific location, could be used to enhance sculptural concerns. One of his most successful pieces spatially activates an enormous area of land beside Utah's Great Salt Lake. During the winter of 1970, Smithson, constructed *Spiral Jetty* (Fig. 40) with large earth-moving equipment. This 1500-foot-long (457.5 meters) earthen pier spirals into the shallow, saline lake in diminishing loops. Before beginning this work Smithson had researched the history of the spiral shape, tracing its recurrence back through many historical periods and diverse cultures. The artist believed the spiral symbolized a unified duality of inner-directed and outward-bound movement. Concepts such as this one have played an important role in recent art activity. Today the artist may be as interested in the conceptual underpinnings of a work of art as in the way it looks.

Standing on a bluff in Utah overlooking this mysterious work of art, one is struck by the way in which it visually unifies land, water, and sky in one sweeping motion. The concept of movement is important to *Spiral Jetty* and functions on many levels: the waves that constantly lap against the earthen jetty; reflections of wind-blown clouds that appear within the water-filled spiral; and the passage of our own life and times, which represents but a micro-second in the geological history of the earth.

opposite: **Plate 2.**
Willem de Kooning.
Easter Monday. 1956. Oil and newspaper transfer on canvas, 8' × 6'2" (2.4 × 1.8 m).
Metropolitan Museum of Art, New York (Rogers Fund).

right: **40.** Robert Smithson.
Spiral Jetty. 1970.
Black rock, salt crystals, earth, and red water (algae); coil 1500' (457.2 m) long, 15' (4.57 m) wide.
Great Salt Lake, Utah.

Modern architecture has also appropriated sweeping concepts of space. In recent times, through the use of new construction materials such as structural concrete, architects such as Frank Lloyd Wright have created buildings similar in feeling to Smithson's *Spiral Jetty*. Wright's Guggenheim Museum (Fig. 41) is a prime example of contemporary architectural space that uses the spiral to symbolize movement and organic growth. Paintings and sculpture are displayed along the wall and on the gently sloping, downward-spiraling ramp. A large, circular skylight is placed at the central zone of the building, flooding the interior space with soft, indirect light. Viewers usually ride the elevator to the top and effortlessly make their way downward in ever-widening circles. The space is at once expansive and encompassing, admirably highlighting the Guggenheim's collection of modern European and American art.

Dennis Oppenheim is an environmental sculptor who has chosen to work with psychological as well as three-dimensional space. His highly symbolic environmental artworks often relate to ancient rituals. Oppenheim's aesthetic position, in fact, can be likened to that of a contemporary shaman or tribal magician. One of his most curious environmental spaces is titled *Attempt to Raise Hell* (Fig. 42). When entering the museum or gallery where this piece is installed, one is confronted by a rather strange sight and sound. A small, metal-headed puppet dressed in an ill-fitting green corduroy suit sits next to a large, suspended bell. Every one hundred seconds a special timer switches on a powerful electromagnet hidden inside the puppet's head. Instantly, the puppet's head smashes violently against the rim of the bell and snaps back to its original position. A resonating sound permeates the gallery space for well over a minute. Just as the haunting sound fades to a whisper, the switch is momentarily closed and the cycle begins again. The psychological effect of this somewhat sinister ritualistic event is indicated by the artist's exhibit notes: " . . . the sound fills the room as well as the mind."

In chapters to follow, other contemporary concepts of space will be further explored. In a sense, all artists—whether they lived hundreds of years ago or are working today—have incorporated their unique sense of space into their artwork. Personal visions always interact with cultural ideologies of an era to produce a synthesized commentary on the world.

TIME AND MOTION

Time and *motion* are basic elements not only of the visual arts but of our perception of the world in general. Rather than being separate entities, they are mutually dependent on each other. Our notion of time is directly tied to celestial rhythms such as the rising and setting of the sun: The 24-hour day and 12-month year are based on the motion of the earth turning on its axis and the movement of the planet around the sun. Quite naturally artists have tried to manipulate time and arrest motion since the beginnings of art. The making of the simplest static image implies a freezing of time and a means of preserving the moment—magical acts as far as early humankind was concerned.

With the development of cubism in the 20th century, artists found a new way to present concepts of time visually. Rather than describe how something looks from *one* perspective they advanced the idea of simultaneity and *multiple* points of view. Marc Chagall's painting *I and the Village* (Fig. 43) takes us back in time to evoke a series of memories of the artist's youth in his native Russia. Painted one year after Chagall moved to Paris, this artwork simultaneously juxtaposes a

top: **41.** Frank Lloyd Wright. Solomon R. Guggenheim Museum, New York. 1959.

above: **42.** Dennis Oppenheim. *Attempt to Raise Hell.* 1976. Mixed media. John Gibson Gallery, New York.

42

The Language of Vision

multitude of dreamlike images based on Russian folk tales, Jewish proverbs, and the architecture of his little village.

With the development of new technological tools such as photography, motion pictures, and television, artists now have the means to literally capture images and to work directly with motion. These time-motion–based media are discussed in detail in Chapters 10 ("Film, Video, and Computer Art") and 15 ("Photography").

Although fountains had been designed for centuries as a form of kinetic sculpture, it was not until the 20th century that art forms were developed that become directly involved with movement. Until then artists had worked with the suggestion or symbolism of movement. Basically, up until the machine age visual artists saw little reason to work with the element of actual motion. But the inherent dynamics of this new age with its speeding locomotives, airplanes, and cars inspired some early modernists—particularly the futurists—to visualize the concept of speed.

Giacomo Balla's futurist painting *Dynamism of a Dog on a Leash* (Fig. 44) achieves the feeling of motion by presenting us with multiple images of the objects in motion. Instead of one leash we see four placed in rhythmic, sequential order. The dog's feet and tail are an indistinct blur rather than a clear image frozen in time. Through visual repetition Balla indicates movement.

George Rickey is a contemporary American artist who deals almost exclusively with actual, not implied, motion in his sculptural works. They tilt, sway, swing, whirl, and turn.

left: **43.** Marc Chagall. *I and the Village.* 1911.
Oil on canvas, 6′3⅝″ × 5′9⅝″ (1.9 × 1.7 m).
Museum of Modern Art, New York
(Mrs. Simon Guggenheim Fund).

below: **44.** Giacomo Balla.
Dynamism of a Dog on a Leash (Leash in Motion). 1912.
Oil on canvas, 35 × 45½″ (89 × 116 cm).
Buffalo Fine Arts Academy (George F. Goodyear Collection).

Almost 7 feet (2 meters) high, *Six Lines in a T* (Fig. 45) is a stainless-steel outdoor **kinetic** sculpture which gracefully moves in the wind. Six pointed rods are carefully counterbalanced on a steel post and pivot freely. Depending on the velocity and direction of the wind, they balance and sway to various quick and slow rhythms. Because *Six Lines in a T* is always moving, its composition is constantly changing. Art always reflects the concerns and sensibilities of its time; it is no wonder that our fast-paced society has inspired artists to incorporate elements of time and motion into their work.

SUMMARY: USING THE VISUAL ELEMENTS

Artists throughout history have celebrated the physical and symbolic beauty of trees in countless landscape paintings, etchings, and drawings.

Let us examine how three distinguished artists from different time periods—Leonardo da Vinci, Rembrandt, and Piet Mondrian—have employed the visual elements to express various concerns and attitudes.

Leonardo's *Copse of Birches* (Fig. 46), a red-chalk drawing on paper done about 1508, reveals the clarity and boldness of vision that characterized the mind of this Renaissance genius. When this drawing is reproduced, the empty space that surrounds the tightly compacted view of the forest's edge is often cut off, destroying Leonardo's intent. The contrast between the dense, unbridled growth of the forest and the ambiguous, vacant space of the paper is striking. The viewer of the drawing stands within this open, "cultivated" space looking at the beginning—or end—of the natural environment.

Leonardo has made appropriate use of the various visual structures—repetitive patterns, organic forms, and the eloquent interplay between positive and negative space—to create a multidimensional statement about the world. During the 1400s European civilization was beginning to establish a new relationship with nature. More and more land was cleared for cultivation; simple, hand-powered machines were built to perform the labor of many hands; and the

below: **45.** George Rickey. *Six Lines in a T.* 1965–66. Stainless steel, 6'8" × 11' (2.03 × 3.35 m). Storm King Art Center, Mountainville, N.Y.

below right: **46.** Leonardo da Vinci. *Copse of Birches.* c. 1508. Red chalk, 7½ × 6" (19 × 15 cm). Copyright reserved. Reproduced by gracious permission of Her Majesty Queen Elizabeth II.

hidden wonders of the human body were revealed by scientific investigation. All of these endeavors were recorded in Leonardo's notebooks, priceless journals that chronicled the inventions and discoveries of his era.

Rembrandt's **etching** *Three Trees* (Fig. 47), completed at a later date—1632—reveals a different concept of compositional form and line quality. Here a world largely settled and to a great extent tamed is revealed. Off in the distance of this landscape, spires of tall buildings appear and a gridwork of canals crosses the fields. Rembrandt documents the extent to which humankind has altered the landscape to serve the needs of an expanding population. The three trees in the foreground—which emerge to form a unified trinity—stand as vestigial sentinels of nature. In the lower left portion of the composition a fisherman, almost hidden within the thicket of lines, tries his luck in a shallow pool; his wife watches from the bank. But nature has not been totally subjugated. Rembrandt dramatically portrays the immense power and pyrotechnics of a summer thunderstorm retreating in the distance. This print is a masterful visual meditation on the opposition of light and darkness. Boldly using straight parallel lines to represent the windblown sheet of rain, Rembrandt silhouettes the trees against a luminous sky so bright it casts the foreground into deep shadow.

Three Trees heralds the emergence of the modern age, in which the individual perceives the inherent power of a highly organized society yet feels the great potential for loneliness and personal alienation this kind of civilization brings with it.

Piet Mondrian's semiabstract painting titled *Tree* (Fig. 48) brings us to 20th-century pictorial concepts. Mondrian was a Dutch painter, born in 1872, who was trained in traditional painting at the Amsterdam Academy. His early work, therefore, showed great affinity to Rembrandt's style of painting. But by 1908 Mondrian responded to innovations taking place in the art world, his color shifted from somber earth tones to dramatic hues of orange, blue, and red. He continued to paint landscape subjects but transformed them into bold-faceted **planes** of abstract color and linked various shapes with interconnecting lines.

above left: **47.** Rembrandt. *Three Trees.* 1643. Etching, 9¼ × 11⅜″ (23 × 29 cm). Museum of Fine Arts, Boston (Francis Bullard Collection).

above: **48.** Piet Mondrian. *Tree.* 1912. Oil on canvas, 37 × 27½″ (94 × 70 cm). Museum of Art, Carnegie Institute, Pittsburgh.

Tree, painted in 1912, clearly alludes to the emerging sensibility of cubism. Like cubism, this painting expresses a search for a new visual vocabulary to express the realities of a new age. Mondrian finely balances in this painting an awareness of illusionistic reality and conceptual truth. He presents us with a generalized portrait of a generic tree rather than the visual particulars of any one tree. Throughout the painting there is a great feeling of surface unity expressed by the linear maze that covers the surface, linking part to part. Rather than invent an abstract tree, Mondrian, through years of accurately painting nature, has created a multiperspective synthesis of a tree. He has distilled organic shapes and growth patterns into one concise canvas that conceptually more than illusionistically *evokes* the essence of a tree.

Mondrian's cubist *Tree* comments on the increasingly important role abstract, conceptual thinking plays in contemporary life. In order to make sense out of the modern age, the artist's imagination had to draw upon a world of new forms and abstract symbols. Thus an ordinary tree, the subject matter of art for centuries, was transformed by Mondrian into a new set of visual forms held together by the syntax of cubism.

Each of these artworks, whose theme is trees, expresses different perceptions and ways of viewing the world. Yet the visual elements—forms, lines, textures, and spaces—are universally constant. Together these "building blocks" form an infinitely mutable and expressive language that can be re-formed constantly to convey new feelings, new concepts, and new relationships between ourselves and the world. As we reshape the form and function of our environment, artists—as they always have done—will play both a reflective and an expressive role in this process. No doubt painters, sculptors, and artists of the future will find unusual and surprising ways to use the visual elements of form, line, texture, and space to communicate ideas of personal and social significance.

Chapter 3

Light and Color

Recently, at Sakkara, an Egyptian archaeological site only several miles from downtown Cairo, an unusual statue was discovered that convincingly expresses humanity's obsession with light. In a small, hidden room next to Zoser's pyramid, a statue of the king—believed to be the incarnate son of the sun god Ra—was found in an unusual sitting position. Tiny holes were drilled in the limestone wall of the chamber that carefully channeled sunlight directly into the statue's rock-crystal eyes. For 4,600 years, the sun's rays had penetrated the darkened tomb daily, setting it ablaze with refracted light.

The ancient Egyptians were by no means the only people obsessed with the phenomenon of light. Since the dawn of humanity, the very existence of light—and with it, color—has presented us with a curious paradox. Light is at once the most ordinary and the most baffling of natural experiences; even today scientists do not completely understand its behavior. Without it, sight and the entire range of the visual arts would not exist. Despite their powerful impact, light and color are the least tangible of visual elements. Unlike three-dimensional forms and textures, which we can physically feel, light cannot be touched—or even directly perceived, for that matter. Only when rays of light strike a substance and are reflected by it are we aware of its presence. This chapter will explore the various ways light and color have affected our aesthetic and philosophical thinking throughout time.

LIGHT

Since the development of the printed word, countless volumes have been written about the subject of light and visual perception. The **classical** Roman philospher Plotinus attributed great power to sight: He conceived of the eye as the *projector* of "object"-feeling rays rather than merely a receiver. To Plotinus and other early thinkers the eye was a miniature sun actively engaged in the formation of the visible world rather than a passive instrument that registered the reflection of light. Surprisingly, recent scientific findings that underscore the brain's important role in image perception and processing make this early theory seem less laughable today. The human eye, unlike other sensory receptors, is a direct extension of the brain and plays a primary role in the *creation* of perceptual images.

49. René Magritte.
The Empire of Light II. 1950.
Oil on canvas, 31⅛ × 39″ (79 × 99 cm).
Museum of Modern Art, New York
(gift of Dominique and John de Menil).

Humankind has always looked on light as a powerfully symbolic phenome-
non as well: Medieval philosophers equated light with the highest knowledge
and truth. Even today our vocabulary reflects this meaning. In the dictionary
enlighten is defined as "to illuminate or supply with light" *and* "to shed the light
of truth upon." René Magritte is a modern European painter who makes use of
both perceptual and symbolic aspects of light in his painting titled *The Empire of
Light II* (Fig. 49). The means he uses to achieve this rich interplay of visual and
psychological overtones are quite economical. An ordinary daylight sky with
scattered clouds against a blue background is juxtaposed with a late-night scene
of suburban houses and dimly lit windows. The radiating glow of an old-fash-
ioned street lamp casts a shallow pool of light across the darkened sidewalk
while the sky is ablaze with sunshine. Day and night seen simultaneously baffle
the mind. This painting underscores the complex physical and emotional re-
sponses evoked in us by light and seeks to explore its mysteries.

Light and Vision

Visible light is a form of electromagnetic radiation. Infrared rays, radio and
television transmission waves, and X-rays all are forms of this type of energy
radiation. The range of light visible to our eyes is but a minuscule portion of the
entire electromagnetic spectrum, or range. As you read this, you are subject to a
wide range of electromagnetic radiation that your eye cannot register: cosmic
rays, emanations from power lines, even the heat from your stove or radiator.

Perception of light is affected by the interaction of several factors, including
the light source itself, the reflective properties of the object that is observed, and
the biological nature of seeing, which is a complex system of information pro-
cessing involving the eye and brain. Given the direct neurological link between
these organs, it is not implausible to conclude that "seeing is thinking."

Visible light is a force that most living organisms react to both consciously
and unconsciously. The surface qualities of any material that is struck by light
determines the visual effect we see. Transparent and translucent substances, such

as water and certain plastics, allow the penetration of light and produce optical effects—the blue color of lakes and oceans, for example. Opaque objects, depending on their pigmentation, selectively absorb some of the light and reflect other portions of it, which we perceive as the color of that object. Special materials such as faceted gem stones and glass prisms absorb and refract the light, breaking it up into its various color components. Smooth, polished surfaces such as metals and mirrored glass reflect most of the light that strikes them; conversely, dark, rough surfaces absorb and diffuse light.

Architecture has made extensive use of light-controlling techniques for centuries. Ever since humankind improved on the cave for shelter, builders have been obsessed with the effects of light upon the form and function of architecture. Italian architecture made use of the strong light of Italy and created deeply penetrating forms and sharply defined edges to convey a sense of visual authority and power to the viewer. The texturally complex exteriors and dimly lighted interiors of northern European cathedrals responded to the softer light in that region.

In some ancient civilizations, light itself was elevated to the status of a deity. In the blazing, sun-drenched valley of the Nile, the early Egyptians, not surprisingly, were highly attuned to the daily rhythms of the sun. Everything depended on this primal light source. All religious beliefs, all images, all gods, in fact all life itself in this culture could be traced to the sun—believed by the Egyptians to be the eye of the god Ra.

Although we generally think of Egyptian architecture as solid, massive, unchanging—qualities seemingly at odds with the ephemeral fluctuating nature of light—many features of Egyptian buildings suggest an obsessive concern with light: The obelisk shape represented a ray of light and was often capped with a highly reflective gold-leaf covering; alabaster statues were polished to mirrorlike surfaces; pyramids originally were sheathed with smooth white limestone that must have appeared dazzling in the strong desert light; and many temples were carefully designed to become progressively dimmer as one penetrated deeper into the mystery of the inner sanctuary (Fig. 50). The contrast between the cool, darkened inner spaces and the broad expanse of brilliant, hot desert is stunning.

Despite Egyptian architecture's apparent preoccupation with massive, static forms, often the play of sunlight activates and enlivens building surfaces. In many of the **bas-relief** carvings (Fig. 51) that adorn the walls, light is used with the precision of a fine drafting pen. The contradiction between stable building

below left: **50.** Interior of an Egyptian temple.

below: **51.** Egyptian bas-relief carving.

shapes and carefully etched, ephemeral traceries, which appear and disappear with the regular movement of the sun, has puzzled Western scholars for centuries. Often the compass orientation of specific temples indicates a strong desire to orchestrate and control sunlight as it rakes across certain wall carvings. After thousands of years, light still brings these surfaces to life. Through the silent language of ancient hieroglyphics (picture-writing, a forerunner of the alphabet), light-struck walls eloquently speak of long-forgotten kings and ancient religious beliefs. It would come as no surprise if future archaeological research revealed that the thematic arrangement of these carvings was connected to the daily journey of the sun: Long, oblique rays of the rising morning sun might spotlight deities associated with its daily "rebirth"; subsequently, the more perpendicular light of the afternoon could be programmed to illuminate religious images associated with that phase of the sun's cycle.

The contrast of light was very important to Egyptian artists and architects. Without the dramatic changes in the lightness or darkness of the bas-relief we just looked at, the visual impact of this artwork would be minimal. The term used to describe the relationships between light and dark surfaces is **value**. Controlled variations of value are what make all of the black and white illustrations in this book "readable" as images. Gradations of value on two-dimensional surfaces—particularly in drawings—have been used by artists for centuries to create illusions of three-dimensional form.

The drawing in Figure 52 reveals how tonal values can be manipulated to create the illusion of a sphere resting on a flat surface. Because the surface of the globe gently curves, no sharp outlines are evident—one tone gradually shifts and fades into another. This technique of representing three-dimensional form by value gradation is referred to as **modeling** or **chiaroscuro** (an Italian word that means "light-dark"). Many drawings and paintings make use of this kind of tonal modeling to achieve a variety of visual effects.

Contemporary artists and architects also are fascinated with the visual magic of light and reflection. Modern steel skeletal structures have relieved walls of their load-supporting burden and have allowed great expanses of glass to take the place of opaque masonry and concrete. As early as 1922—when Miës van der Rohe proposed an all-glass-enshrouded skyscraper—modern architects have envisioned bold new roles for 20th-century materials such as steel and glass.

52. Through the careful control of tonal gradation the illusion of a solid sphere is created.

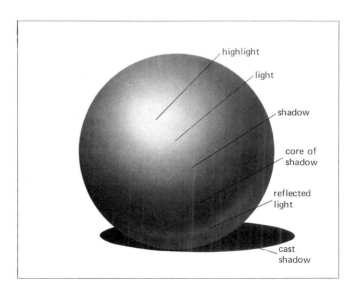

highlight

light

shadow

core of
shadow

reflected
light

cast
shadow

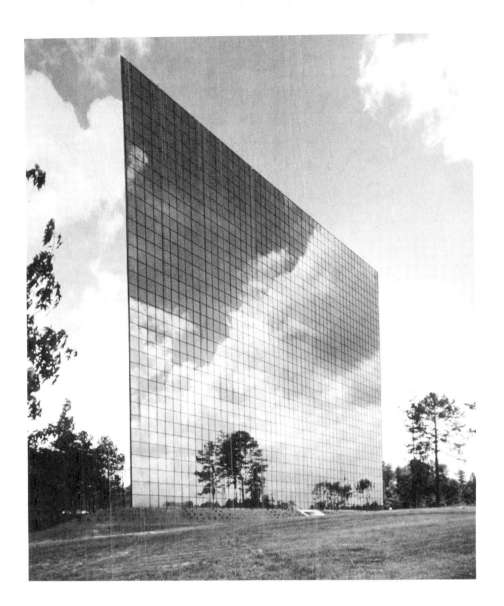

53. 3D/International.
Century Center,
Office Building No. 5, Atlanta.

Ancient dreams of transparency and luminosity are now within the realm of possibility. Factors such as glare and heat buildup hindered the widespread use of glass until the 1950s, when processes to tint glass were developed. Nowadays sophisticated methods of vacuum plating glass with microscopically thin metallic coatings—including gold—have greatly transformed the nature of this material. By controlling the thickness and composition of the coating, builders can produce large sheets of glass that will exclude most of the radiant heat and admit generous amounts of light. When seen from the outside, however, this metal-coated glass appears quite mirrorlike and opaque.

The architectural firm of 3D/International has made superb use of this glass and its special properties in the Century Center Office Building No. 5 in Atlanta, Georgia (Fig. 53). Seen from the angle shown in the illustration, this building appears to be an enormous mirrored wall reflecting sky, clouds, and landscaping planted at the base of the building. Only during evening hours when interior office lights shine through the thinly coated, metallized glass does the illusion of a mirrored surface fade.

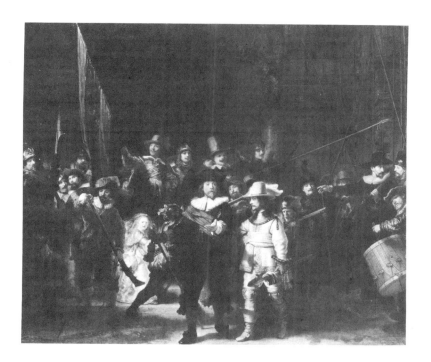

54. Rembrandt. *Sortie of Captain Banning Cocq's Company of the Civic Guard (The Night Watch).* 1642. 12'2" × 14'7" (3.7 × 4.4 m). Rijksmuseum, Amsterdam.

Research continues at a promising pace in the architectural glass industry; we can only speculate on the wide range of new glass colors, translucencies, and textures that will be developed and made available to architects in the future.

Rembrandt's 17th-century canvas *Sortie of Captain Banning Cocq's Company of the Civic Guard* (Fig. 54) reveals a concern for light and illusionistic lighting effects rarely matched in the history of Western art. The figures are in essence *created* by light, not merely revealed by it. Rembrandt was sensitive to the symbolic power as well as the perceptual beauty of light; his aim was not only to create believable illusions but to evoke our feelings as well. The work presents us with a dramatic moment frozen in time. Light, in all of its conceptual and physical wonder, inevitably determines the spatial structure of this painting. Figures are brought forward and made to recede by the careful manipulation of light and dark tones. The visual drama that unfolds before us in this painting owes much to Rembrandt's keen sense of theatrical staging and imaginative lighting design. For this reason his paintings are still studied by contemporary students of theater and theatrical lighting.

Since Rembrandt's day, technology has transformed the materials and tools that artists now have available. Scientific discovery has enlarged the realm of possibilities for today's artist. Since the invention of the light bulb and the advent of widely distributed electric power, our perception of light itself has dramatically changed. With the flick of a switch we can transform any space from darkness to light.

Contemporary artists such as Chryssa are attracted to the expressive possibilities of these new power and light sources. In her mixed-media sculpture *Fragment for the Gates to Times Square* (Fig. 55), layers of glowing, multi-colored neon light tubes are preshaped and positioned inside a transparent box to create intriguing calligraphic patterns. As one walks around this freestanding sculpture, various patterns of colored light appear, dissolve, and reappear. Thus centuries-old concerns for the effects of light are realized in a new way in this contemporary sculpture.

The Language of Vision

55. Chryssa. Fragment for the *Gates to Times Square*. 1966. Neon tubing and Plexiglas, 43 × 37¼ × 27¼" (109 × 94 × 69 cm). Courtesy of Pace Gallery, New York.

Today's painters and graphic artists also regard light as a vital element in their work. In most historic paintings and prints, the illusion of light was based primarily on the way light behaved in nature. Since the development of modern lighting technology, however, artists have conceived of new approaches to the representation of light. In the untitled painting illustrated in Figure 56, Arnold Schmidt achieves a strong optical effect of pulsating lights by carefully manipulating the direction and width of parallel dark lines so that they merge into a

56. Arnold Schmidt. *Untitled.* 1965. Synthetic polymer paint on canvas, 4'1⅛" × 8'1⅛" (1.22 × 2.44 m). Museum of Modern Art, New York (gift of Mr. and Mrs. Herbert Bernard).

seeming source of radiant energy. By incorporating strong tonal contrasts and controlled gradation between colors, Schmidt creates an illusion of shadows and light. This approach to painting was popular in the mid-sixties and often was referred to as **optical**, or **"op" art.** The refinement of technology has had a pervasive effect on today's art, giving artists and designers a vast array of new conceptual resources.

COLOR

The ability to perceive color has played an important role in human evolution. Early peoples first employed color as a means of survival to identify edible plants and locate animals; they no doubt used color-based camouflage to hide from enemies and to conceal themselves from game. Vivid color was present everywhere in the natural environment—red sunsets, fall foliage, and fields of brilliant flowers are but a few examples. Naturally, color was incorporated into the earliest known artwork, such as cave painting, where earth pigments were employed as colorants.

Color exerts a powerful influence upon our psyche. Although individual responses to specific colors vary from person to person, nearly everyone has decided color preferences. Association plays a strong role in determining our reaction to color; for example, seeing a certain blue that was used in the wallpaper of a childhood bedroom may evoke pleasant, secure memories today. Color has the power to make us anxious, revive our spirit, calm us, and in general, affect our mental state and therefore our health. Psychologists are compiling more and more evidence about the role of color in determining our moods. Designers of hospitals in particular are quite aware of the psychological and symbolic nature of certain colors: Some newly designed medical facilities have rejected bleak settings of white and institutional green for color schemes of rosy reds, warm oranges, and vibrant blues. The feelings projected by these new colors are life giving and optimistic. Thus they help to transform our perception of hospitals from places of sickness and degeneration to centers of recovery and health.

Color also plays an important role in industrial safety. Hazardous zones are often painted red to alert workers. Oil refineries and industries that use dangerous liquids color code various pipes and conduits to identify the contents. If trouble should develop in the facility, this graphic labeling system can identify toxic substances immediately and aid in damage control. One aesthetic side effect to this practice is that otherwise unsightly equipment is transformed into multihued environments rivaling many modern environmental artworks.

Color preference has much to do with society's perceptions of status and wealth. Before the development of synthetic aniline dyes, certain colorants were so rare and costly they were available only to the very wealthy. "Royal" purple got its name because the dye was once so expensive only kings could afford it. By the late 1800s the chemical industry was producing cheaply the means to color a vast array of textiles and products. Soon the poorest person could afford what in the past had been the rarest of commodities—brilliant color. This fact in large part determined the reaction—by the wealthy classes at least—away from intense color toward subdued hues. The status value of vivid color, now that it is available to all, has changed. Today, socio-economic factors no longer play such a rigid role in choices of color. Personal preference and the specific application of color are usually the determining factors. The ubiquitous presence of neon light, color printing, brilliantly dyed clothing, and the chromatic intensity

of modern television makes it hard to imagine what it would be like to live in a less colorful world.

Color Perception

The classic theory of color perception was formulated by Herman von Helmholtz in the 19th century. This German scientist believed that three specialized types of receptors in the retina distinguished the **primary colors** red, blue, and yellow. Helmholtz postulated that by the neurological mixing of these basic colors in varying proportions the full spectrum of color sensation was transmitted from the eye to the brain. This mechanistic theory does not, however, explain various phenomena such as color afterimages that the eye sometimes sees or the sensation of black

The experiments of Dr. Edwin Land—the inventor of Polaroid photography—point toward an entirely new theory of color perception. Dr. Land believes that the eye and brain system divides the visible spectrum of light into two groups of longer and shorter wavelengths and establishes an accurate division point midway between the groups. By comparing the differences between long and short light waves, we can distinguish colors across the entire field of vision. The brain translates wavelength differences of light into color perception through complex neuroprocessing.

Put simply, color vision seems to be implemented largely through the brain's activities and is not exclusively a result of light striking the color receptors in the retina. This would help explain our ability to discern accurately colored objects seen under widely varying lighting conditions, such as the warm yellow light of a table lamp or the much cooler blue light of fluorescent fixtures. These discoveries further reinforce the realization that the eye is an extension of the brain and visual perception is closely allied to the process of thought itself.

The Nature of Color

When we stand in the sun at noon on a clear day, we are exposed to what is commonly called white, or colorless light. However, this form of visible radiation actually contains all of the colors of the spectrum: violet, blue, green, yellow, orange, and red. These colors and their intermediate gradations are so balanced and blended, however, that the effect is that of colorless or white light. A classic scientific demonstration confirms that sunlight is actually made up of many different colors: When white light is passed through a glass prism it is refracted, or broken up, into all of its component colors (Fig. 57).

57. White light refracted through a prism separates into the colors of a rainbow.

When white light strikes an object, some of the colors are absorbed and others are reflected. A lemon, for instance, absorbs almost all color rays except the yellow, which, reflected to our eyes, give the lemon its characteristic color. Leaves reflect primarily green rays, and therefore we say that leaves are green.

Color is one of the most mutable and variable elements in the visual arts. This is due to the fact that light is not a fixed entity but is constantly changing in both intensity and color. A lemon viewed on a picnic table in bright sunshine is radiating a different spectrum of light than the same lemon seen the night before under incandescent illumination. However, we rarely notice these shifts because our visual system has the ability to adjust automatically to many sources of light and compensate visually. A special instrument that objectively measures the color of light, however, would reveal that sunlight and incandescent light differ dramatically in their *color temperature* (the scientific term for the measurement of the light's position in the spectrum). If by mistake you ever have used color film designed for indoor use out of doors, you are aware of the unnatural shift of color in the processed prints. Indoor film emulsions are formulated for the color temperature range of artificial light; used outside, this film takes on an unpleasant blue tone. Color film, unlike our eye, cannot compensate automatically for different light sources and color temperatures.

Color Formation

Although most artists are concerned with the mixing of colored **pigments**— the *subtractive system*—it is also necessary to mention the *additive system*, which describes the intermixing of colored light. Plate 3 (p. 57) illustrates the reverse of the scientific prism experiment. When transparent red, green, and blue filters are placed over the lenses of slide projectors, the overlapping primary colored beams produce white light. Some surprising results are obtained through these mixtures. For instance, when red and green light are mixed, the color produced is yellow. Designers who work with theatrical lighting employ this system extensively.

Subtractive color formation (Pl. 4, p. 57) is much more familiar to us and is employed more regularly by artists and designers. For the most part our discussion of color in this chapter will pertain to subtractive formation.

Qualities of Color

Even to begin to discuss color with a reasonable degree of accuracy, we need at least three terms, which correspond to the three dimensions or qualities of color: *hue, value,* and *intensity.*

Hue is what we most frequently think of when color is mentioned. It refers to the specific color, such as red, blue, or green (Pl. 5, p. 57).

Value has to do with the lightness or darkness of a color, that is, the amount of light reflected or transmitted by the object (Pl. 6, p. 58). Any hue can vary in value: Red can become light pink or dark maroon.

Intensity indicates a color's degree of purity, strength, or saturation (Pl. 7, p. 58). If we added some gray we would be changing a color's intensity, not its hue.

Hue: The Position of Color in the Spectrum The color wheel in Plate 5 (p. 57) is formed by bending the sequence of colors obtained from a prism and

Plate 3. Using the additive principle of light, the three primary colors—red, blue, and green—when overlapped, create the secondary colors of yellow, cyan, and magenta. When combined they produce white light.

Plate 4. In the subtractive principle, the process is reversed. Yellow, cyan, and magenta are considered the primary colors, and when they are overlapped they produce red, blue, and green. When combined they create black.

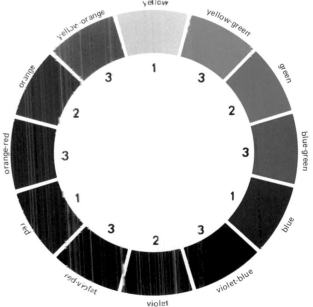

Plate 5. The traditional color wheel shows a sequence of hues in the following order beginning with yellow at the top and going clockwise: yellow, yellow-green, green, blue-green, blue, violet-blue, violet, red-violet, red, orange-red, orange, yellow-orange. The primary colors—red, yellow, and blue—are labeled with the numeral 1. From these three hues are formed the secondary colors (2). Tertiary colors (3) result from combining a primary with a secondary.

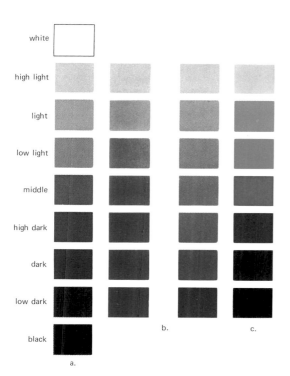

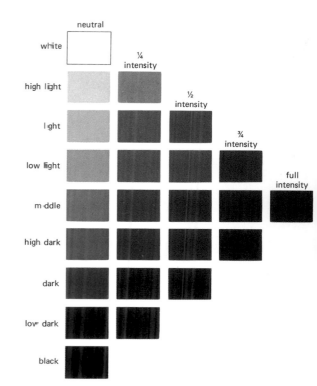

above left: **Plate 6.** The value scale illustrates shades of gray from pure white to deepest black (a). Hues in the color wheel can also be arranged in a similar scale such as orange-red and blue (b). At their normal value, all of the hues in the color wheel can be ordered in a vertical scale, with gradations from yellow to purple or violet (c).

above right: **Plate 7.** The intensity or saturation scale shows the full range of brightness of which a hue is capable: from pure color at full intensity to the varied tones made possible by successive stages of dilution or graying.

right: **Plate 8.** Victor Vasarely. *KEZDI-III.* 1966. Acrylic on canvas, 33″ (84 cm) square. Courtesy Vasarely Center, New York.

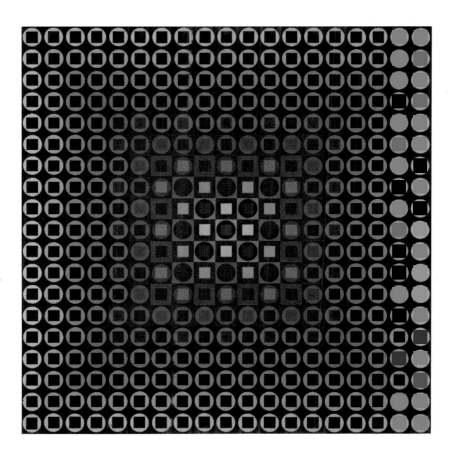

58

Plate 9. Josef Albers. Study for *Homage to the Square, Early Diary*. 1954. Oil on masonite, 15″ (38 cm) square. Sheldon Memorial Art Gallery, University of Nebraska-Lincoln.

60

blending the end colors into a connecting red-violet hue. The twelve distinct hues on the wheel can be subdivided into three categories: *primary* hues, labeled (1), *secondary* hues (2), and *tertiary* hues (3).

The **primary** hues of red, blue, and yellow are so called because in theory they cannot be mixed from any other hues, but in combination will produce every other nonprimary color.

Secondary hues such as green, orange, and violet stand midway between the primary hues on the color wheel; they are produced when two primaries are mixed in the proper amounts.

Tertiary hues are located between primary and secondary hues; their names—yellow-green, violet-blue, and orange-red—indicate their components.

When placed next to one another, hues provide a wide range of effects ranging from restful harmonies to dynamic contrasts. Some combinations, such as blue, blue-green, and green produce a soothing, restful sequence. But if blue is juxtaposed with orange, an exciting contrast results.

Two terms are used to describe these basic relationships between colors:

Analogous hues, such as blue, blue-green, and green, are close to one another on the color wheel.

Complementary hues, however, lie directly opposite each other. Blue and orange, and red and green, are complementary color combinations.

When two pigments opposite each other on the color wheel are mixed together, they seem to neutralize each other and turn a muddy gray. But if these same colors are painted onto cards and placed next to one another, each hue will seem brighter, as though its inherent power has been released through the juxtaposition. This effect, known as *simultaneous contrast,* is used extensively by contemporary artists and advertising designers. Strong contrast relationships—whether through the use of complementary colors or the opposition of black and white—exaggerate differences and produce powerful results. Black looks blacker next to white; red appears more vivid next to green.

Op artist Victor Vasarely makes effective use of both analogous and complementary hues in his complex painting *KEZDI-III* (Pl. 8, p. 58). By exploiting the degree of harmony or contrast between the colors of the circles and squares and between them and the background grid, he has made some of these forms stand out clearly or recede. Through his control of color relationships, he has deliberately created areas that are spatially ambiguous because the viewer cannot always keep them in sharp focus.

Until his death in 1976, Josef Albers relentlessly explored the interactive nature of color. In his "Homage to the Square" painting series, Albers convincingly demonstrated that our perception of one color is dependent upon all the color viewed in the entire field of vision. According to Albers' artistic research, color is never absolute, but its effects vary in accordance with the surroundings. In his *Homage to the Square* (Pl. 9, p. 59), he consciously explores both the *qualitative* and *quantitative* aspects of color perception. Albers is not only concerned with the exact shade of color (a qualitative assessment) but also with the way the amount of color present in our visual field affects perception (a quantitative factor). To a certain extent, the optical effects produced in an Albers painting correspond to Dr. Land's experiments, which led him to believe that the visual system perceives color by the comparative interplay of light wavelengths over the entire visual field.

opposite: **Plate 10.** Paul Gauguin. *L'Appel.* 1902. Oil on canvas, 4'3¼" × 2'11½" (1.3 × 0.9 m). Cleveland Museum of Art (gift of the Hanna Fund).

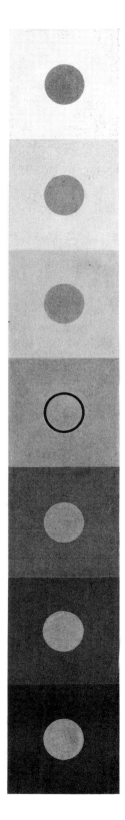

58. The gray scale shows gradations in value from white to black.

If we could somehow lift the light blue inner square off the orange field in Albers' painting and place it on top of another color, we would "read" this blue differently. Without physically changing the color, we have altered the conditions in which the color is perceived.

The longer we look at the Albers work in Plate 9 (p. 59), the more we become aware of the mutable interplay of color. For instance, the edge where the light blue color meets the orange square appears intensified. The orange deepens. Both colors are excited by each other. Where the orange mass meets the light red, a different effect is created: The orange appears lighter, more yellow in hue. Using only three carefully selected solid colors, Albers demonstrates the complex, interactive nature of color perception.

Value: The Lightness or Darkness of a Color The lightness or darkness of a color depends on the amount of light reflected or transmitted. The value scale in Plate 6 (p. 58) shows several colors and their degrees of lightness or darkness.

The values of the primary hues shown in the color wheel are known as *normal values;* that is, they are the values at which each hue reaches its greatest purity or strength. When we ordinarily think of a hue, its normal value usually comes to mind; yellow, for instance, is usually thought of as a light, bright yellow. To be sure, there are dark yellows, such as olive drab, and light yellows, but these are not the most characteristic values. *Tints* are values above the normal; *shades* are values below the normal. Thus pink is a tint of red, and maroon is a shade of the same hue; sky blue is a tint, and navy blue is a shade.

The value of a color is raised by making it reflect more light. To lower the value, the amount of light it reflects is reduced. With pigments this is done most readily by adding white or black, which also usually changes the hue and intensity as well as the value. The lightness or darkness of values seems to change with different backgrounds. In Figure 58 the gray circles are identical in value, but they look darker against white, lighter against black.

Sometimes artists purposely make use of close-valued hues to achieve certain aesthetic ends. Li Ch'eng, a Chinese landscape artist who worked in the 10th century, used close tonal values to create a soft, dreamlike vision in his painting titled *A Solitary Temple Amid Clearing Peaks* (Fig. 59). Buddhist religious teaching stresses a world view of spiritual unity, which the artist is able to represent visually in this quiet meditative painting. By working with an almost monochromatic palette, Li Ch'eng was able to express an Oriental concern for idealized forms and timelessness through two-dimensional surface unity. Softly merging tones allow the viewer's eye and imagination to freely wander up and down the surface, going from cloud-enshrouded mountaintops to a calm lake at the base of the painting. Through the use of disciplined tonal control, Li Ch'eng blends mountains, trees, waterfalls, and temples into one ageless, visual unity.

Intensity: The Degree of Color Purity or Saturation Many people are confused by the differences between value and intensity. While value refers to the lightness or darkness of a given color, intensity refers to how much of the hue is present in a color sample. Mixing a fully **saturated** red with any other color reduces the amount of red present and therefore diminishes its intensity. Intensity can also be lessened by thinning the color with water, oil, turpentine, and so forth. Although the intensity of any hue value can be varied, the fullest intensity occurs when each hue is at its normal value, as illustrated in the outer circle of the color wheel. Both the value scale in Plate 6 (p. 58) and the intensity scale in Plate 7 (p. 58) clearly illustrate this effect.

The Language of Vision

As we noted in Albers' painting (Pl. 9, p. 59), the apparent intensity of a color can be affected by the hue surrounding it. Colors usually appear more saturated when seen against white, gray, or black backgrounds, or when they are placed near an area of their complementary hue. The same phenomenon occurs if they are used with unsaturated colors of their own hue. Thus, green looks more intense when viewed against a colorless background, a red background, or one that is gray-green.

Integrated Effects of Hue, Value, and Intensity Although the three dimensions of color may be studied separately, it is only through their smooth integration and complex interplay that the full impact of color is realized.

No one can doubt the important role color plays in our lives. Our world is permeated with both natural and artificial colors that evoke complex feelings and thoughts: azure skies, orange and blue neon signs, lush green meadows, and red traffic-signal lights. Naturally, color is a powerful means of expression and visual communication. Many popular sayings reveal the pervasive influence color has on our emotions: "green with envy," "blue Monday," and "red with rage."

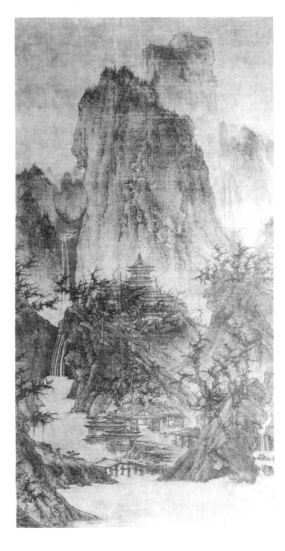

59. Li Ch'eng (?).
A Solitary Temple Amid Clearing Peaks. A.D. 919–967. Hanging scroll, ink and slight color on silk; 44 × 22" (112 × 56 cm). Nelson-Atkins Museum, Kansas City, Mo. (Nelson Fund).

Paul Gauguin was a French postimpressionist painter noted for his pioneering work with emotionally charged, expressive color. Unlike many of his contemporaries of the late 1800s who were interested in accurately recording sunlight and natural hues, Gauguin used color *symbolically* to express his personal feelings and attitudes toward people and places. Disillusioned with life in northern Europe—which he found materialistic and spiritually corrupt—Gauguin became obsessed with the idea of Tahiti as an innocent paradise on earth and abandoned his family for the tropics.

L'Appel (Pl. 10, p. 60) expresses the artist's response to the lush tropical growth, balmy climate, radiant light, and peaceful setting he found in the South Seas. Gauguin's painting is anything but a naturalistic rendering of the island's landscape; the vibrant reds are far too intense to occur naturally. Gauguin heightens the experience of warmth and beauty he no doubt felt in this tropical island.

Gauguin was a master at color integration and orchestration. Changes in value and intensity signal shifts in distance. As the foreground recedes, it coloristically fades to light pinks and oranges. Far in the background, nestled in cool, receding tones of green, deep violet, and blue, are flecks of reds and pinks that help unify this painting from the standpoint of color. Set against this rainbow-hued landscape are the warm brown flesh tones of native women. However, their skin tone is not the result of mixing one solid color on the palette. Gauguin integrated several colors to achieve a more lively effect; earth reds, green, yellow, and oranges all are skillfully combined.

Throughout *L'Appel* Gauguin makes extensive use of hues that are opposite each other on the color wheel. This sort of usage is referred to as a *contrasting color scheme,* which is based on the simultaneous use of warm and cool colors. If we look at the reproduction of *L'Appel* again, we will notice that most of the colors in the top half of the painting are in the cool range of the spectrum; conversely, the bottom, or foreground, is made up predominantly of warm colors such as red, orange, and yellow. The fully clothed figure of the woman in the center of the canvas chromatically links the cool blues, greens, and deep violets of the background to the warm colors of the foreground. Starting with her blue headdress, the color sequence progresses to light violets and cool pinks, culminating in a fully saturated red section at the bottom.

Despite the use of strongly contrasting colors—which can sometimes produce disquieting results—the feeling in this painting is one of lush beauty and lively harmony.

Using Color

No absolute laws govern an artist's use of color. Color seems to be most meaningful when it grows out of and contributes to an artistic function or when it directly relates to certain materials, forms, and spaces. When used sensitively, color can perform many functions and evoke an infinite range of responses. Although consistency and order are basically desirable qualities in the fine arts, color can be boring if not enlivened by unexpected or even discordant elements. However, designers, especially those professionals concerned with architectural interiors, make use of several formalized color schemes to create easily recognizable, ordered relationships.

Related Color Schemes Monochromatic color schemes are the simplest because they use only one hue. Blue, for example, could range in *value* from

almost black to near-white and in *intensity* from saturated cobalt to an ashen gray.

Analogous schemes are based on colors that are adjacent to or near each other on the color wheel and all contain a common hue. Examples are blue-green, blue, and violet-blue. The advantage of analogous schemes is that they offer artists more variety than do monochromatic systems.

Contrasting Color Schemes This system is based on opposing hues that include both warm and cool colors. More visual stimulation and balanced color opposition are possible with these organizational systems. Many schemes make use of various complex combinations, including:

Complementary schemes, which are built from any pair of hues directly opposite each other on the color wheel, such as orange and blue, or yellow and violet.

Double-complementary schemes, which use two adjacent hues with their respective complements, such as orange-red and orange with blue and blue-green.

Triad schemes, which use any three hues that are equidistant from each other on the color wheel—red, yellow, and blue; or yellow-orange, blue-green, and red-violet.

SUMMARY: THE INTEGRATION OF THE VISUAL ELEMENTS

Although we have looked at visual elements such as light, color, space, and form separately in order to understand better the roles they play in the formulation of art, they rarely are experienced in isolation. Often the nature of the design problem determines which elements are emphasized and how they are assembled. Most artists aim for a wholly integrated scheme whereby thematic content, materials, and visual elements are smoothly joined.

One artist of today who manages to incorporate an abundance of complex, deeply felt images and beautiful visual effects in his paintings is Georg Baselitz, a neo-expressionist German painter who lives in a huge, converted abbey south of Hamburg. Like that of many of his European contemporaries, his art is deeply wedded to representational rather than abstract forms; he paints unusual images of people walking, talking, and staring at us with expressions of anguish. Some are shown upside down, others are mysteriously suspended on fields of intense color. Baselitz' special interest is to evoke the desolate, haunted, guilt-ridden feelings of Germany just after the war. American art during the postwar period evolved under a different, quieter set of circumstances; much of the work produced on this side of the Atlantic reflected a more detached, self-oriented point of view. But German artists born after 1945 inherited economic uncertainty, shame, cultural pride, and an irrepressible desire to comment on their predicament through the act of painting. Much new European art is above all an **imagistic** art of meditation upon the recent past.

All of Baselitz' paintings are thematically narrative in structure but stop short of illustration; they offer just enough evocative information to prod us into completing the story and supplying our own answers to the visual riddles contained in the painting: Who is this person? How does the situation depicted in this painting relate to my own life and world?

The vision and economy of means found in Baselitz' canvas in Plate 11 (p. 93) are unusual. Much of the aesthetic effect of this painting derives from its color: The complex but well-ordered profusion of yellows, oranges, and reds approaches the intensity and power of medieval stained-glass windows. Except for the warm, neutral gray area—which offers a counterpoint to the saturated hues—the painting seems to radiate yellow from deep within rather than merely off its surface. In many ways this artwork calls to mind Vincent van Gogh's symbolic use of intense color to convey, as he put it, "the terrible passions of humanity."

Baselitz employs many compositional and thematic means to reinforce his simple but effective use of color, such as the awkward falling/floating posture of the suspended figure and the distended, sickly stomach of the woman. Where the head meets the gray rectangle, a merging of the two areas occurs at the point of visual impact; and the fluttering red brush strokes team up with the vigorously painted gray area beneath the figure to create an anxious, unsettling feeling throughout the whole painting. Baselitz makes use of many basic visual elements, such as form, color, space, and texture to create a powerful composition; this power reaches far beyond formalistic concerns and engages us in a meditative dialogue between historic memories and present-day concerns.

In Matthias Grünewald's painting of the resurrection of Christ (Pl. 12, p. 93), all of the visual elements are fused into one expression of spiritual transcendence and aesthetic illumination. Three and a half centuries have not diminished its power or brilliance. In fact, this 16th-century altar painting has something strikingly modern about it that borders on the uncanny.

No doubt much of the contemporary quality of this work can be traced to the intense light that surrounds the head of Christ. This light does not derive from any naturalistic source that might be found in the artist's time; rather, it suggests powerful 20th-century energies such as high-voltage electricity and atomic power. Grünewald was not portraying any worldly light source, however, either of the 16th or of the 20th century. He was conveying through imaginative visual means the cosmic radiance of God as envisioned by a premodern man. Gregory Palamas, a 14th-century religious scholar, explained that "God is called Light, not so much for His spirit or essence, as for His very energy."

The image of the transcendent Christ serenely floating above the vanquished Roman soldiers commands our attention. Light and color are the key. Within the multihued light source behind Christ's head is the thematic and compositional essence of the painting. The focus is on the edges of the face, which are absorbed into the center of the dynamic radiation; similarly, the top of Christ's robe is painted a matching yellow and fades into a red-orange hue that echoes the color found in the middle band of the aura. The twisting cloth shroud that visually connects the top half of the painting to the lower section is painted with values of blue similar to the luminous halo that visually dominates the composition. Grünewald deals with light and illumination on many levels in this work.

In essence the design of this painting is bold and simple. Although every part of it holds our interest, we repeatedly return to the spherical source of light at the top. For purposes of analysis, the work can be divided into top and bottom halves. Christ's robe functions as a transitional shape, linking timeless divine space to the earthly reality of the world. As we follow the movement of the drapery from the upraised arm on the left, it is gradually transformed by color and light and conceptually comes down from a place beyond time to the world of the present.

The posture of Christ is rigorously frontal and formalized; the symmetry expressed by the centrally positioned head and the upturned hands conveys a

feeling of stability and omnipotent power. Conversely the figures of the soldiers in the bottom section are arranged asymmetrically in disarray and disorganization.

The distant figure to the far right is captured in mid-air, stumbling toward us. Grünewald uses these diametrical concepts to communicate enormous power through them; eternity is curiously bonded to a frozen moment on earth.

Spatially the upper section is staged in a fathomless void; only vague pinpoints of light, representing distant stars, relieve the blackness of this undefined sky. By way of contrast, Grünewald has positioned the soldiers in an illusionistically three-dimensional space that is shallow, tightly interlocking, and complex.

Even the artist's treatment of the painted surface—which is texturally smooth and blended—is designed to reinforce the visual and thematic drama taking place; nothing detracts from this **iconographic** program. Grünewald's organization of visual patterns supports the sharp contrast between sacred and secular space previously mentioned. If we compare the way the two faceless figures in the foreground are painted to the image of Christ, we notice that far more detail appears in the lower section. By comparison few details of this nature are lavished on Christ; a generalized, more universal image is painted that reinforces the painting's thematic program.

Every visual element of this painting is directed toward its theme—the resurrection of Christ and the triumph of the spiritual over the worldly. Superfluous detail is supressed, and thematic elements are staged with an economy and effectiveness that is remarkable. Through Grünewald's arresting vision we are witnessing an event: a controlled explosion of light, color, and dynamic forms that propels the risen Christ from his earthly tomb into a luminous kingdom of brilliant radiance and calm repose. Paintings such as this show how artists are able to articulate complex, emotionally charged concepts and feelings through the "language of vision"—the visual elements.

Chapter 4

The Principles of Design

By nature, we have an innate need to produce order. When life becomes too chaotic and disorganized, we tend to do something about it—we clean up our room, straighten the jumbled mass of papers on our desk, or try to plan our week more efficiently. But when order is carried to extremes, the consequences are also dire: Eating the same food every day, wearing the same clothes, doing the same predictable activities can lead to boredom, even depression. Besides organization, we also have a great need for variety and spontaneous activity. Often unexpected changes in our routine and environment enliven our minds and spirits. Clearly, we need to combine order and variety harmoniously.

An interesting expression of this balance exists in the biological workings of our own bodies. Despite a changing environment and a range of physical activities, from active to quiet, the body's systems maintain a constant equilibrium of temperature, blood pressure, and oxygen intake. Even our physical form relates to certain concepts of design and order. Our bodies are, depending on our posture, both symmetrical and asymmetrical.

Although we tend to think of the human body as one entity, it is made up of many parts, each with a different function: arms, nose, hands, feet. Each part of the body grows visually and organically into the next anatomical section, with no abrupt changes. Our form is an expression of unity *and* variety.

Our appreciation of beauty in works of art is greatly influenced by these aspects of biological growth and unity. If we cut an orange in half crosswise (Fig. 60), the visual result is remarkably pleasing and ordered. Around the outer edge of the cross-section is a thin orange line (the skin) that is almost the same color as the inside of the fruit. A cream-colored pulpy material surrounds the triangular segments, which point toward the center—made of the same material as the pale outer ring. The size of the segments is carefully regulated; although they vary, none of them is either significantly larger or smaller than the others. This organization is aesthetically pleasing to us, far more pleasing than if each segment were exactly like the others and arranged in mechanical perfection.

Often successful examples of art and design incorporate this organic principle of regularity and variation. We take particular delight in comparing the way elements fit together with varying degrees of order and variability. Bret Weston's photograph titled *Reeds and Pond* (Fig. 61) expresses this concept elo-

quently. Weston has carefully organized the composition of various elements so that it closely resembles a modern abstract line drawing through its combination of connecting lines and dynamic rhythms. Much of the order of the photograph depends on the consistent thickness of the reeds and the mirroring effect of the glasslike pond. However, variety also plays an important role. The subtle interplay of chance arrangements lends an unpredictable, rhythmic element to the composition and makes it much more interesting than if the reeds were all evenly spaced and bent. Through the artist's careful manipulation of camera angle and awareness of lighting, an intricate balance between order and randomness, variety and unity is achieved.

In this chapter we will discuss the design principles that underlie the ways in which artists combine the visual elements to create effective works of art. These design principles usually are identified as *unity* and *variety, scale* and *proportion, balance, rhythm,* and *emphasis.*

Although the study of design principles is quite helpful in furthering our understanding of art, it is important to recognize that these are basic *principles,* not hard and fast rules. Because of this, their limitations are those of any generalization. Any governing principle can offer only a partial and inexact interpretation. Notable exceptions to any of these basic guidelines exist—in fact, some works of art meaningfully and consciously break the rules. Within these limitations, however, awareness of design principles can help us appreciate works of art. Understanding the fundamentals of visual organization is important in the education of any art professional. It is no less useful a discipline for the viewer who wishes to gain a deeper understanding of art and design.

The significance of design in the visual arts cannot be underestimated. It forms a kind of universal grammar through which artists structure and communicate their ideas. Just as the very same words can be rearranged by two writers to produce very different meanings, so artists can manipulate similar forms to produce different visual results. Figures 62 and 63 serve as examples. Figure 62 is a diagram of the Kandinsky painting *White on Black,* in which a number of white rectangular forms appear on a black background. Figure 63 shows these exact forms arranged differently on the same background. The difference is apparent. Kandinsky's original design is based on a 90-degree vertical and horizontal grid, and most of the shapes are arranged in relationship to this structuring device. Figure 63 exhibits no such apparent order but rather is characterized by random juxtapositions and groupings.

The universal structure of design is used by artists of widely differing cultures and personal backgrounds to visually communicate their ideas. A comparison of the designs of the *Great Buddha* at Kamakura, Japan, and Mark di Suvero's *New York Dawn* (Figs. 64, 65) shows how design can be the vehicle for a variety of multicultural expressions. In the *Buddha,* a feeling of relaxed equilibrium is achieved through even balance and symmetry. Drapery folds hang in graceful rhythms which meet at the joined hands. The visual effect produces quiet contemplation, peace, and introspection, which are in keeping with the religious beliefs the sculpture embodies.

New York Dawn, by contrast, is composed of an asymmetrical arrangement of rough, angular forms and materials. Although this composition is more varied and dynamic than the *Buddha,* it does possess balance and order. Wires, chain, and steel supporting rods provide both physical and visual tension to the piece and serve to tie various forms and materials together. Through the **cantilevered** forms extending precipitously into space, di Suvero alludes to Manhattan's immense power, scale, and inherent danger. Both objects—the *Buddha* and *New*

62. In this diagram of Kandinsky's painting *White on Black,* the forms are arranged on orderly horizontal and vertical axes.

63. The same forms arranged randomly produce a different visual effect.

The Language of Vision

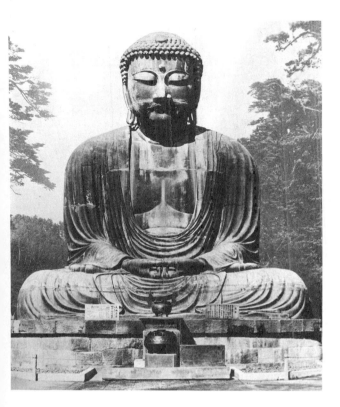

above left. **64.** *Great Buddha,* Kamakura, Japan. 1252. Bronze.

above: **65.** Mark di Suvero. *New York Dawn (for Lorca).* 1965. Wood, steel, and iron; 6'6" × 6'2" × 4'2" (1.9 × 1.8 × 1.2 m). Whitney Museum of American Art, New York (gift of the Howard and Jean Lipman Foundation, Inc.).

York Dawn—are clear, expressive compositions, but our emotional response to each is different. The basic language of design is common to all cultures and time periods; all artists employ these means, choosing those forms and organizations that best express their concepts in a vital and persuasive manner.

Design also plays a crucial role in making our environment more understandable by providing an underlying structure through which a variety of parts can be related meaningfully to the whole. A well-organized lecture can present a multiplicity of ideas and facts with clarity. In a poorly planned presentation, these same facts may seem meaningless, unrelated, and confusing. Every successful work of art has a basic organizational plan upon which a large measure of its effectiveness depends.

Everything made by people is designed to some degree. In the case of utilitarian products such as automobiles and machine tools, poor design can result in unnecessary injury and death. But in most cases ineffective organization results only in such inconveniences as broken handles and malfunctioning equipment. Good product design not only creates pleasing appearances but takes into account the functional operation, ease of use, correct placement of operating controls, and well-marked dials and switches. Architects and city planners try to design buildings and urban areas for convenience of use and movement. In the 20th century, with such a variety of demands made on buildings by people pursuing any number of divergent activities, this is not an easy task to accomplish. Our world is greatly dependent on a complex matrix of interlocking systems—transportation, electric power, water, telecommunications—which, if not carefully organized, would break down constantly and prove unreliable. Without the ordering presence of design, life as we know it would be impossible.

UNITY AND VARIETY

One of the challenges artists and designers face is how to achieve both *unity* and *variety* in an integrated way. If unity overwhelmingly predominates, we may have a dull and uninteresting design; if variety gets out of hand, we run the risk of chaos. The key is to balance these two opposites and provide unity *and* variety. Certain organic specimens offer stunning examples of unity in variety. The greatly enlarged cross-section of a twig (Fig. 66) reveals a wide variety of shapes and parts fused into a biologically efficient, aesthetically pleasing organization. Structurally, two types of shapes are integrated in this organization: the geometric, six-sided outer form and the rounded shapes within. At the center a large elliptical shape is surrounded by tiny cellular forms. Arranged around the core are five-sided, semirounded organic shapes that help provide a smooth visual transition between oval shapes and the more geometric six-sided outer form. On all levels of the life chain, we can find similar instances of diverse parts functioning as a whole. In art also, unity and variety are fundamental design elements providing both aspects of order and diversity.

66. A magnified cross-section of a twig reveals great order and variety of forms.

Unity

The perceptual and thematic unity and consistency that we perceive in a successful work of art or design is important for several reasons. First, its high degree of organization serves to attract and hold our attention in a visually active and random world. Second, it aids our understanding by making a work of art easier to "grasp" than one that is characterized by uncoordinated diversity. Third, unity aids our comprehension by providing the viewer with a central theme or key through which the work can be comprehended.

Quite often unity develops organically out of a clear, compelling purpose or idea rather than being added like an ingredient in a recipe. People respond to consistency. Advertisers find it helps promote sales; graphic designers realize it aids understanding; and painters, sculptors, and architects aim for a unified experience that is always the mark of a significant work of art. But the fine arts are concerned with a special kind of unity, one that brings together paradoxes and contradictions, and achieves the synthesis of mystery and clarity.

Although there are many ways to arrive at visual unity, we will discuss the following methods: *enclosure, simplification, repetition* and *harmony of parts*. They are basic conceptual building blocks of organization and structure.

Enclosure Frames around paintings and fences that enclose gardens are examples of elementary unifying devices. A frame separates a painting from its surroundings and visually holds it together. Fences and garden walls shut out distracting views and focus one's attention within bounds. In Masaccio's painting *The Trinity with the Virgin, St. John, and Donors* (Fig. 67), a series of frames within frames orders the composition and directs our eye toward the most significant element in the painting—the crucified figure of Christ.

Simplification By limiting the number of elements in a work of art, the artist reinforces unity because there are few distractions from the basic idea. Through this means the artist also can focus our attention on the one or two aspects of the artwork that are most significant. Alexander Liberman's painting in Figure 68 could hardly be more simple or more unified. In this **minimalist**

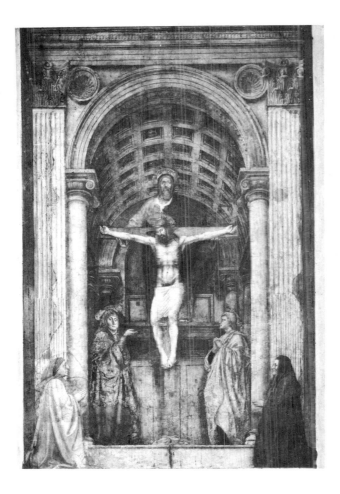

67. Masaccio. *The Trinity with the Virgin, St. John, and Donors*. 1425. Fresco. Santa Maria Novella. Florence.

painting the viewer's attention is drawn to the thin, precise white circle and the dark background it is placed upon. Although this deceptively simple work may appear too unified and "flat," it has variety because of the contrast between the fine white line and massive dark ground.

68. Alexander Liberman. *Minimum*. 1950. Enamel on composition board, 4' (1.22 m) square. Museum of Modern Art, New York.

Repetition Similarity of shape, size, or color ties parts together visually, especially if there is a strong compositional and thematic relationship between the parts. Jasper Johns' painting *Three Flags* (Fig. 69) offers a fascinating array of striped patterns all based on the overlapping, repetitive use of three American flags. By successively reducing the size of the two inner flags, the artist creates one complex but unified image out of three relatively simple organizations.

Johns is fascinated with the process of repetitive seeing. This is one of the reasons he chooses to create artworks—often called pop icons—out of images we have seen over and over again. It is his contention that we have become so accustomed to these common images we no longer really see them. *Three Flags* attempts to show us something we think we know in a way that causes us to reevaluate our thinking.

Harmony of Parts Many works of art capture our attention through the use of components that share some common qualities but are not identical. Piet Mondrian's *Large Composition with Red, Blue, and Yellow* (Pl. 13, p. 94) uses only rectangular forms, primary colors, and careful proportioning. Despite severe restrictions of shape and color, this composition sets up harmonious and lively relationships that are quite engaging and complex. Mondrian presents us with a specific visual experience that has much to do with color. The purity of the primary colors is one of the painting's most notable features. The artist keeps the composition in lively balance by carefully controlling the quantity and placement of each color as well as its exact hue. Because of the simple geometric design, Mondrian allows us to compare and contrast these bold colors and observe their chromatic "personalities" and effect on us.

Together, these preceding devices form the basic unifying principle of composition in the visual arts. It must be remembered, however, that they are imprecise "rules of thumb" and almost never result in a rewarding work of art when applied by rote. Meaningful unity is achieved only by fusing inherent contradictions and significant differences. Without the dynamic interaction of unity and variety, we would be left with visually bland and tasteless designs and works of art.

69. Jasper Johns.
Three Flags. 1958.
Encaustic on canvas (three levels), 30⅞ × 45½ × 5″ (78 × 116 × 13 cm). Collection Mr. and Mrs. Burton Tremaine.

Variety

Many works of art derive their power to charm and engage our minds precisely *because* of their opposing elements. *Variety*, the partner of unity, arises from contrast and juxtaposition: diversity of materials and differences of forms, textures, and color. All of these differences enrich the psychological and visual content of the work and invite us to participate actively in the search for unity among the various parts. Joseph Cornell is an acknowledged master at combining unlikely forms, objects, and thematic concepts to create unusual and provocative works of art. All of his three-dimensional **assemblages** invite us into an aesthetic world that is oddly familiar yet unforgettably haunting—a world that conjures up half-remembered childhood fantasies and "treasure collections" from our youth. His work also serves to illustrate the way our mind works as it strives to relate and categorize everything it perceives.

Object (Roses des Vents) illustrated in Plate 14 (p. 95) is typical of Cornell's work. In this sculptural artwork, many contrasting elements are juxtaposed, interwoven, and brought into harmony. To begin with, Cornell organizes two-dimensional shapes within a three-dimensional form—a shallow box. Maps and drawings are placed carefully on top of and within a rectangular, three-dimensional case. In the box's compartments can be found an extremely diverse range of materials and shapes: a coiled spring, bits of rocks, map pins, charts, seeds, and even a small seashell. The upper lid of the construction is papered with portions of antique European maps carefully pieced together to achieve a unified look. Twenty-one compasses are evenly lined up and inset within the bottom lid. Despite the fact that compasses are designed to point only north, these compasses crazily point in every direction; when the box is moved, they respond by gyrating wildly. Their close proximity has caused them to interfere with each other's magnetic fields. Despite these contrasts of form and function, a gridlike framing structure occurs everywhere: the latitude and longitude lines in the upper maps, the rectangular trays in the center section, and the even rows of compasses lined up on the bottom. Thematically, many of the materials are related to geography and direction finding. Parts of celestial charts, obscure diagrams, and territorial maps are placed in sections throughout the artwork. The compasses in particular set up strong associations with geography, map reading, and processes of orientation. When we examine these aids closely, however, they offer little help. The large chart on the top, which appears continuous, is actually constructed out of three different maps describing diverse geographic regions. Cornell brings together a wide range of objects and materials that fascinated him as a child. "Everything can be used," said the artist, "but of course one doesn't know it at the time. How does one know what a certain object will tell another?"

Although Cornell makes use of a wide variety of maps, pictures, objects, and two- and three-dimensional forms, the world we enter when we view one of his pieces is essentially a unified world because he has organized the various elements to a high degree.

SCALE AND PROPORTION

The terms *scale* and *proportion* are linked together because they both refer to aspects of size in works of art. These words, however, have different and distinct meanings. The **scale** of anything is determined by the size relationship between

above: **70.** The growth pattern of a small shell assumes a spiral form.

above right:
71. Natural forces in the universe have formed this spiral galaxy measuring light years across. Photo taken with 200-inch telescope, Hansen Planetarium, Salt Lake City.

the observer and the perceived object. The constant standard by which the scale of anything is measured is the size of our own body. Playing with small children makes us feel larger by comparison; attending a party given for professional basketball players would make us feel short.

Proportion refers to the size relationship of parts of a whole or to objects perceived as a whole. For example, coming upon a white-spired 19th-century church surrounded by 20th-century skyscrapers makes a strong impact upon us. They seem greatly out of proportion to each other.

The scale and proportion of a work of art play an important role in determining whether we find it aesthetically pleasing. In many ways—both obvious and subtle—the scales and proportions of the environments we encounter condition us from birth. Physical and biological laws that affect all forms of life and inorganic matter also determine our psychological and artistic perceptions. We are intimately affected by the realities of organic chemistry, gravity, and physics; these factors determine not only how we developed as a species but what aesthetics we respond to in works of art.

Whether we look at the natural world with the naked eye or with the aid of sophisticated instruments such as the electron microscope or modern reflecting telescopes, we repeatedly see certain forms and proportional relationships—the spiral shape, for instance. Figures 70 and 71 illustrate natural occurrences of spirals that could not be more remote in terms of scale, distance from each other, and processes that formed them. Both the seashell (Fig. 70) and the spiral galaxy (Fig. 71) exhibit a shape based on an infinite mathematical progression known as the *Fibonacci series*. This series—originally devised by Leonardo Fibonacci, a 13th-century mathematician from Pisa, Italy—produced mathematical ratios that describe the ever-enlarging spiral shape of both a shell and an enormous galaxy. The progression develops in this manner: 1, 1, 2, 3, 5, 8, 13, 21 . . . , and so on. Each number generated is the sum of the two numbers preceding it.

The spiral—which is a visual symbol for all kinds of growth, organic and inorganic—also can be derived through application of another proportional system called the *Golden Section* or *Golden Mean* (a ratio of 1:1.618033).

The Greeks discovered this mathematical relationship about the middle of the 5th century B.C. It is achieved by dividing a given length into two segments such that the ratio of the original segment to the larger division is equal to the ratio of the larger division to the smaller division. The size relationships generated by this ratio are particularly harmonious and pleasing: measurements of the Parthenon and many other buildings of antiquity were based firmly on this "key" to proportion. Even today the Golden Section (Fig. 72) still is used frequently by designers, painters, and architects to determine size relationships and spacing.

Le Corbusier, the well-known 20th-century Swiss-French architect, developed a relational scale system based on the proportions of the human body that he called the *Modulor* (Fig. 73). When Le Corbusier was a young architecture student, he was fascinated with one question: What is the rule that proportionally orders and connects all things? This search is reminiscent of Einstein's quest for a general field theory in physics that would unify knowledge of all of the basic forces of the universe. Although such a law eluded Le Corbusier—as it did Einstein—he reasoned that since architecture is designed for people, he would base his system of scale and proportion on the size of the human body.

In Le Corbusier's book *Modulor 2*, which describes the development of the Modulor system, he wrote that as a young man, in the course of his travels, he

. . . noticed the constant recurrence, in all harmonious architectures, whether primitive or highly intellectual, of a height of about 2-10 to 2-20 metres (7 to 8 feet) between floor and ceiling: houses in the Balkans and in Turkey, Greek, Tyrolean, Swiss, Bavarian houses, old French Gothic wooden houses and the 'petits appartements' of the Faubourg Saint-Germain and of the Petit Trianon itself—Louis XV, Louis XVI; also, the tradition of the Paris shops from Louis XV to the Restoration, with their attics repeating the same height of 2-20 m. The height of a man with arm upraised, a height very much to the human scale.

below: **72.** Proportions of the Golden Section.

right: **73.**
Diagram from Le Corbusier's book, *Modulor 2*, 1955.
Reprinted by permission of Harvard University Press.

Acceptance of the Modulor system, which sought to reintroduce human scale into modern architecture, was slow in coming. Although Le Corbusier's designs were in keeping with the harmonicus laws of nature, they were often out of step with archaic municipal regulations. While reviewing the local regulations regarding one of Le Corbusier's buildings, an official noted that it did not comply with the official code. Because of his fame, however, the authorities told him, "We authorize you to go against regulations because we know you are working for the good of humanity."

Long before Le Corbusier's development of a modular architectural system based on the scale of the human body, Renaissance artist Leonardo da Vinci investigated, through a famous series of anatomical drawings of humans and animals, significant proportional relationships that exist in nature. Before scholarship became as specialized as it is today, scientific and aesthetic study of the world were integrated.

Leonardo conceived of painting as much more than the making of pleasing images—for him art was a process of philosophical inquiry that delved into the *inner workings* of nature. He wrote in one of his journals:

> If you disparage painting, which alone imitates all the visible works of nature, you disparage a most subtle science which by philosophical reasoning examines all kinds of forms: on land and in the air, plants, animals, grass, and flowers, which are all bathed in shadow and light. Doubtless this science is the true daughter of nature . . .

During the Renaissance, the study of the nature of humanity was a major field of inquiry. Inspired by an entry on human anatomy in a scholarly book, Leonardo's famous *Study of Human Proportions According to Vitruvius* (also known as *The Venice Drawing*) (Fig. 74) carefully positions the body within a diagramatic

74. Leonardo da Vinci.
Study of Human Proportions According to Vitruvius
(The Venice Drawing). c. 1485–90.
Pen and ink, 13½ × 9¾″
(34 × 25 cm). Accademia, Venice.

The Language of Vision

75. Georgia O'Keeffe.
Cow's Skull: Red, White, and Blue.
1931. Oil on canvas,
40 × 36″ (102 × 91 cm).
Metropolitan Museum of Art,
New York (Alfred Stieglitz
Collection).

circle and square. With a logical precision, Leonardo investigates the harmony of proportions and the inherent order of the human form. Diagrammatic lines carefully note the relationship between head size, body length, and proportional distance between nose and chin—as well as the surprising fact that our height is equal to the length of our outstretched arms.

Today, with the aid of sophisticated tools such as electron microscopes, the physiological marvels of the human body are being explored scientifically even to the molecular level. But contemporary artists such as Georgia O'Keeffe (Fig. 75) are still being guided and inspired in their work by the underlying visual principles upon which organic life is based.

BALANCE

A sense of balance is fundamental to a person's ability to function in the world both physically and psychologically. If the balance organs in our ear become impaired, our spatial orientation is dramatically upset; likewise, if the order of our life becomes imbalanced through too much pressure at work or lack of clear

76. Alexander Calder. *Nine Snowflakes*. 1970. Hanging mobile of painted metal, 18½ × 42 × 23″ (47 × 107 × 58 cm). Courtesy of Pace Gallery, New York.

goals, we lose our mental equilibrium and sense of well-being. It is only natural, therefore, that some kind of balance is sought in art. But too much balance leads to boredom. Works of art are generally more stimulating if they challenge us to discover things about them. The illustrations in this section show a number of ways to obtain balance, each of which is particular to the expressive content of that work of art.

Although the classic image of equilibrium that usually comes to mind is a scale with equal weights, balance can be a process of constant shifting and adjustment. Take skiing, for example. This sport depends completely on balance. Making a run on any slope requires the ability to continually shift one's weight to maintain balance, change direction, and stop. This process metaphorically parallels life itself, where change is a constant and static balance leads to stagnation.

Balance is a powerful unifying principle, for its purpose is always to bring the parts of a composition into a well-ordered relationship. Alexander Calder's mobile (Fig. 76) offers a clear example of the possible artistic relationship between *physical balance* (weight distribution) and *visual balance*—the ways elements of a composition are meaningfully distributed. In this sculpture, Calder considered the physical weight of each of the metal circles and the balancing points on the supporting rods. There is a strong correlation between their visual shape and their physical balance. As this kinetic sculpture slowly turns in the wind, it reveals balanced, well-ordered relationships from any angle. This work is so finely balanced that, if one were to remove even the smallest section, the whole sculpture would fall into disarray.

For the purposes of our discussion there are three basic types of balance: *symmetrical*, *asymmetrical*, and *radial*, each of which expresses its own distinctive characteristics and effects. Many variations are possible within each type; often works of art make use of two or more variations at once.

Symmetrical Balance

Sometimes called *formal* or *static* balance, symmetrical balance (Fig. 77) is the type in which one-half of a composition is the mirror image of the other. When we create a table setting, often we place a candlestick on each side of a floral centerpiece to create a symmetrical arrangement. Because of the body's bilateral symmetry, many of the utilitarian objects we design—clothing, tables, desks— are symmetrically balanced. Although strictly symmetrical paintings are the exception rather than the rule, sometimes this formalized arrangement, as in Duccio's *Maestà* (Fig. 78), offers a powerful means of organizing forms. The mirrored image repetitions of haloed saints and figures set in niches creates a certain formal dignity and stateliness that emphasizes the thematic importance of the Madonna and Child in the center.

Symmetrical balance is quite easy to achieve—perhaps too easy. Used by unskilled artists and amateurs, this form of balance often leads to obvious and uninteresting compositions. In fact, heavy reliance on rigid symmetry often marks the work of beginning art students.

In our living environment, an absolutely centered painting on a wall or door placed in the middle of a room often proves to be a dull and unworkable arrangement. Thus formal balance, quite useful in some instances, should be employed only when it is genuinely purposeful.

SYMMETRICAL BALANCE

ASYMMETRICAL BALANCE

77. Symmetrical balance is achieved when identical forms are equally distant from the center. In asymmetry, forms not of the same visual weight are counterbalanced by being placed at unequal distances from the center.

78. Duccio di Buoninsegna. *Maestà*. 1308–11. Tempera on wood, 6'11" × 13'10" (2.1 × 4.2 m). Cathedral Museum, Siena.

The Muse Inspiring the Poet (Fig. 79) is one of Henri Rousseau's most touching and lyrical paintings. In this case the use of symmetry (or *near*-symmetry, since it is not exact) aids the intentions of the artist. Much of the beauty of this painting can be attributed to the direct, evenly balanced way in which these figures are organized on the canvas.

During the early 1900s Rousseau was befriended by many up-and-coming young writers and painters, including the poet and critic Guillaume Apollinaire and the artist Pablo Picasso. After much persuading, Rousseau convinced Apollinaire to pose as the "poet" for this painting and got Marie Laurencin, one of Picasso's favorite models, to play the "muse." Beneath the sheltering branches of two symmetrically placed trees stand the poet and his muse. Apollinaire is painted in a suit with tools of the poet's trade in hand; Marie Laurencin is dressed in a flowing, classically inspired robe and is crowned with a garland of flowers. A row of flowers on the bottom evenly balances the profusion of leaves on the top of the painting. The organization is balanced, measured, and formal. What lends a sense of whimsical vision and endearing naïveté to this painting are the stiff poses, obvious symbolism, and awkward brushwork. Rousseau's use of near-symmetry produces an effect that distinctly differs from Duccio's strictly symmetrical *Maestà*. Instead of dignified repose, Rousseau's painting inspires warm feelings of tenderness and concern.

Asymmetrical Balance

A work of art in which the visual weights on each side are in some way equivalent but not identical makes use of *asymmetrical* balance, also referred to as *informal* or *active* balance. Although the human figure, viewed from an at-rest,

79. Henri Rousseau.
The Muse Inspiring the Poet.
1909. Oil on canvas,
4′11½″ × 3′2¼″ (1.46 × 0.97 m).
Öffentliche Kunstsammlung,
Kunstmuseum Basel.

frontal position, is bilaterally symmetrical, the relationships are asymmetrical when the body is engaged in any kind of action. Using the seesaw as an example of how visual equilibrium can be achieved without mirrorlike duplication of shapes (Fig. 77), imagine a small girl sitting at the far end of the board easily balancing her much larger and heavier father, who sits near the center of the fulcrum, or **axis**.

Generally the effects of asymmetrical balance differ from those of symmetrical stability. Asymmetry stirs us more quickly and more vigorously and arouses a curiosity to explore the work of art and find out what keeps it in equilibrium.

Nicholas Africano's painting *The Face of Hyde Haunted Him* (Fig. 80) is a splendid example of the way artists use asymmetrical balance to create dynamic and interesting visual compositions. For some time now, Africano has been painting narrative scenes of domestic romance, Wild West adventures, and literary dramas. This particular work of art is part of a larger series titled *Dr. Jekyll and Mr. Hyde; A Crisis Between Knowledge and Faith*. Unlike the Rousseau painting, which uses a symmetrical balance, Africano's work makes use of asymmetrical organization: The floating head, placed slightly off center, mysteriously confronts the strangely shadowed figure of Dr. Jekyll. The interaction of flat background, head, figure, and shadow create a shifting sense of balance that reinforces Africano's seriocomic tale of dual personality and uncontrollable transformations of the human psyche.

Many design requirements of art suggest the use of asymmetrical balance. Most advertisements in magazines make use of informal arrangements because they know that an active design attracts and holds our attention. Often painters and sculptors who wish to depict dynamic motion turn to this form of compositional balance.

80. Nicholas Africano. *The Face of Hyde Haunted Him*. 1982. Acrylic and wax on canvas, 5'10" × 7'8" (1.78 × 2.34 m). Holly Solomon Gallery, New York.

Marcel Duchamp's *Nude Descending a Staircase No. 2* (Fig. 81) quite effectively conveys a sense of kinetic motion by depicting multiple images of a figure walking down a staircase. When this painting was shown at the famous New York Armory Show in 1913, critics were outraged by its use of semiabstract, multiple images. One went so far as to refer to it as "an explosion in a shingle factory." No doubt the vigorous asymmetrical design contributed to the power of the painting.

Radial Balance

In radial balance the major parts radiate from the center like spokes in a wheel. The center is thus a potential focal point, but it may or may not be emphasized. Usually there is a sense of circular movement connected to this form of balance.

81. Marcel Duchamp. *Nude Descending a Staircase, No. 2.* 1912. Oil on canvas, 4′10″ × 2′11″ (1.4 × 0.8 m). Philadelphia Museum of Art (Louise and Walter Arensberg Collection).

82. Rose window,
Chartres Cathedral. 1194–1260.
Stained glass.

The medieval stained-glass rose window in Chartres Cathedral (Fig. 82) is a notable design employing radial organization. When symmetrical, as in this example, the effect tends toward the formal: A calm feeling of majestic rotation around the central core is produced.

RHYTHM

Often when we are observing and analyzing paintings, sculptures, or even the graceful movements of a trained dancer, we notice that effective works of art are characterized by a sense of smooth flow from section to section and the way all the parts form a whole. A successful work of art unifies continuing, constantly developing patterns; as in the dance, these elements are found in all phases of visual art.

Repetition, alternation, and *progression* are all forms of **rhythmic** continuity; they are as fundamental in the rhythms of nature as in art. Steady repetition occurs in the beat of our hearts; alternation occurs in the ebb and flow of tides, in the cycle of day and night, and in the changing of the seasons. Examples of progression are seen in every tree and river system: Small branches lead to sturdier limbs; small streams tend to flow into larger rivers.

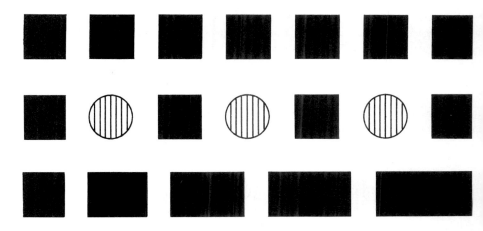

83. Repetition, alternation, and progression are the three fundamental forms of rhythm in the visual arts.

The diagrams illustrated in Figure 83 show the three basic modes of continuity found in the visual arts. The identical forms repeated on the top communicate repetition; alternation results when the black squares are interspersed with striped circles. On the bottom a black square undergoes a sequential change as it gradually gets larger; this is referred to as progression. Used singly or in combination, these devices help our eye move easily over a complete work of art by providing smooth transitions between various elements.

The Benedictine basilica at Ottobüren, Germany (Fig. 84), makes striking use of repetitive forms. Convoluted, exuberant, immensely energetic decorative shapes recur in both the architectural details and the lavishly painted ceilings. Even the **baroque capitals** on the **columns** and moldings contribute the same rhythmic movements as the paintings. As a style it may well seem overly complex and theatrical, but it certainly expresses a vision with strong emotional appeal.

In reaction to the studied austerity and simplicity of many modern structures, some contemporary architects are returning to more complex and ornate building designs that historically refer to other time periods. Although decorative architectural elements are back in style, it is unlikely that we will ever again see anything quite like the Benedictine basilica at Ottobüren.

84. Benedictine basilica, Ottobüren, Germany. 1767.

Repetition is also the essence of successful advertising campaigns. A slogan or trade name used again and again psychologically conditions us to remember a certain product or respond favorably to it. In architecture, textile design, and in many other art forms, repeating the same motif, usually at equal intervals, can give pleasing results. Repetition must be handled carefully, though, or else the metronomic rhythm will become irritating or go unnoticed. The steady ticking of a clock, after a time, blends into the background. Alternation, the repetition of two or more different elements, is more dynamic than a single unit steadily repeated.

The very essence of one of the most popular art forms today—film—relies on rhythmic *progression*. What we actually see when we view a movie is sequential still photographs flashed before our eyes at the rate of 24 frames a second. Because of the eye's ability to retain an image momentarily (called *retinal retention*), we perceive a flowing, seamless movement in the film rather than staccato still images. Through careful editing alternation adds interest to the flow of filmic information. Close-ups are juxtaposed with distant views, and quick movement contrasts with still scenes.

The fade-in and fade-out are key transitional devices used by all films to create unified visual experiences. Two different scenes that need smooth transitions are overprinted in the processing laboratory so that one gradually gets lighter and the other gradually gets darker. When they are superimposed and projected, the effect is simple but highly effective. As the scene we are watching gets light and "fades out" the incoming image progressively gets stronger and "fades in."

One contemporary artist who successfully employs this essentially cinematic device in painting is Andy Warhol. His **silkscreened** *Red Explosion* illustrated in Plate 15 (p. 96) effectively communicates the feeling of an event taking place in time through the means of visual progression. Warhol makes excellent use of the capacity of silkscreen printing to reproduce more or less the same image through photomechanical means. However, to achieve the desired effect he does not strive for technical perfection; in fact, Warhol purposefully makes use of mistakes that could occur easily in this stencil-printing process. For instance, if the ink is pulled across the silkscreen frame unevenly or the medium varies in density, some part of the image might appear too light and another might print too darkly. *Red Explosion* reveals the careful manipulation of both types of silkscreening "mistakes." Reading from the top left frame across and then down row by row (the way we read in English), the frames change progressively in two ways. As we approach the bottom, they begin to overlap more and more; and as they are superimposed, they become darker and darker until the final frame is almost solidly black. Through this serial progression, Warhol conveys the potential horror of a thermonuclear blast. Color plays an important role in this contemporary disaster painting. A cheery, glowing red hue—the color of fireplace embers—gradually shifts into a somber and menacing darkness that might symbolically signal the dimming of our civilization.

EMPHASIS

The principle of emphasis is basic: Something in an artwork must dominate it and stand out. Historically, emphasis usually has been interpreted as referring to centrality—to a kind of high point, or climax, occurring in the work. While in certain instances this still holds true today, in recent years many works of art have avoided compositional centrality. David Smith's *Hudson River Landscape*

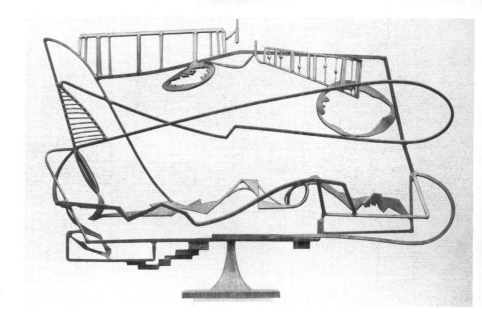

85. David Smith.
Hudson River Landscape. 1951.
Steel, 4′1½″ × 6′3″ × 1′4¾″
(1.3 × 1.9 × 0.43 m)
Whitney Museum of American Art,
New York.

(Fig. 85) is such a work. Although no one section of this sculpture dominates, the lively movement of forms creates an emphasis on the entire *compositional field*. Smith's work of art is based on the totality of the artist's vision, which suggests the meandering flow of a river. All of the surging, restless lines interconnect and create one encompassing organization. Jackson Pollock's painting *One (Number 31, 1950)* (Fig. 86) also presents us with a composition in which every section of the canvas is as important as every other part. The painting has no central images in the traditional sense, but centrality exists in Pollock's unified vision and overall design. Emphasis is present in these modern works but it demands a different interpretation than it is usually given.

A good example of traditional design emphasis is Jan van Eyck's *The Madonna of Canon George van der Paele with Saints Donatian and George* (Fig. 87). The

86. Jackson Pollock.
One (Number 31, 1950).
Oil, Duco, Dev-o-lac,
and aluminum paint on canvas;
8′10″ × 17′5⅜″ (2.7 × 5.3 m).
Museum of Modern Art, New York
(gift of Sidney Janis).

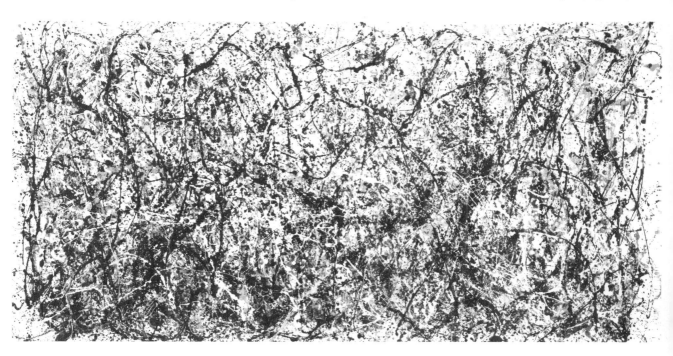

87. Jan van Eyck. *The Madonna of Canon George van der Paele with Saints Donatian and George.* 1434–36. Oil on panel, 4′1⅛″ × 5′2⅛″ (1.25 × 1.58 m). Groeningemuseum, Bruges.

center of interest in this painting is the Madonna and Child, who are placed in the center on a double-tiered platform. The oval of the Virgin's face echoes the larger oval formed by her silhouette, and this too gives a pronounced visual emphasis to these figures. Their importance in the hierarchy of the Church has greatly influenced their compositional placement. The figures on each side, although they enjoy honored positions within the Church, are clearly subordinate to the Madonna and Child. **Arches**, columns, staffs held by the side figures, and the vertical direction of the carpet divide the painting into three parts and help spotlight the central figures.

In Nathan Oliveira's contemporary painting *Standing Man with a Stick* (Fig. 88), the center of interest is also obvious. A lone figure stands in the center of the canvas roughly and heavily painted, erect, but not quite balanced. By setting

88. Nathan Oliveira. *Standing Man with a Stick.* 1959. Oil on canvas, 5′8⅞″ × 5′⅜″ (1.75 × 1.53 m). Museum of Modern Art, New York (gift of Joseph Hirshhorn).

this stark figure against an almost featureless background, Oliveira creates a mood of emptiness and existential alienation. Yet, for all the painting's apparent simplicity, the figure has been reinforced and emphasized in a number of ways. Large expanses of space surround the image and magnify its isolation; on both sides of it, dark areas—subordinate to the figure—strengthen the lone standing form, and passages at the base and head oppose the pronounced vertical. Within the predominantly gray form are touches of warm color, contrasting with the generally neutral background. Thick **impasto** paint textures used for the figure contrast with the more subtle textures in the background, which echo and are subordinate to the thick paint in the central figure.

Although both the van Eyck and Oliveira paintings are very different in effect, the emphasis in both these works is achieved through similar means: by the central position of the figure and by the repetition and contrast of some of its parts.

Emphasis, or dominance, can be asserted in many ways—in form, color, visual direction, texture, and position, for instance. Limiting the number of elements is also an effective device, since many objects of the same size and character tend to compete with one another. Size is another way to achieve emphasis. A large sofa commands more attention than a chair, an office building more than a house. Making important figures larger in a painting than less significant ones is an obvious but effective means of securing attention.

Finally, the way shapes or elements are grouped gives them a certain significance. Dominant forms placed in proximity are reinforced by their nearness and are usually more powerful than any one of them seen alone. In painting, the major forms—figures, buildings, or trees—are often organized in one central grouping. Emphasis is thus a mediating element that integrates and controls unity and variety while serving both.

All artists make use of the basic principles of design to fulfill their intent and to communicate to the viewer. Of course, this kind of knowledge alone does not insure artistic success; these principles are *guidelines*, not rigid formulas. Unlike science or mathematics, art and design do not have inviolate rules. Artists do not studiously *apply* design principles as they work. Rather, the underlying organizational structure emerges as the work evolves. Usually during the creative process, artists stop active work and critically review the piece with an objective eye. During such moments of evaluation, they are both consciously and unconsciously checking their work in terms of the general principles we have outlined in this chapter. Of course, these guidelines are reviewed in relationship to the ideas, feelings, or thematic content artists wish to communicate. But if the artistic concept is trivial or unclearly formed, no amount of formal organization can save it. Conversely, the best of ideas and intentions without a clear and effective design program leaves us unmoved.

SUMMARY: THE INTEGRATION OF DESIGN PRINCIPLES

Although we have discussed the principles of design separately in order to understand them better, artists often use many of these organizational concepts simultaneously. This is not an easy task. We could liken it to a form of visual juggling—many elements must be kept smoothly flowing and working in harmony.

Many great works of art result from the reconciliation of opposites: simplification/complexity; repetition/uniqueness; and unification/diversity. Often in a well-organized work of art the different parts interact without losing their individuality, fusing into an undeniable totality. To illustrate this point we will examine two stylistically very different artworks and the way they both use the principles of design.

Henri Rousseau was an amateur Sunday painter when he retired from his job as a French customs clerk in 1885 to devote himself wholeheartedly to art. Rousseau is somewhat of an enigma—an unschooled, seemingly naïve individual whose mature work rivals the most sophisticated and accomplished art produced during the last hundred years. Many of his paintings are undeniably full of imagination and technical accomplishment.

The Dream (Fig. 89), completed by Rousseau in 1910, reveals a highly improbable scene: In the middle of a verdant jungle teeming with tropical vegetation, exotic animals, and birds, a female nude reclines on a red velvet couch. The juxtaposition of these two entities is visually striking and unusual. Yet Rousseau, through his organizational ability, has brought these two worlds—the civilized and the wild—together in surprising harmony. The contradictory elements of *The Dream* do not clash unhappily but provide juxtapositional commentary on each other. The clear red surface of the sofa and the woman's alabaster body contrast with the jumbled profusion of dark vegetation. The concepts of *unity* and *variety* are both represented in this painting. Without these elements to offer relief, the mass of foliage might prove visually tiresome. Also, this human presence heightens the organic wildness of the jungle. Rousseau further orders the canvas by subtly dividing it into two major sections. These divisions, as well as

89. Henri Rousseau.
The Dream. 1910. Oil on canvas,
6'8½" × 9'9½" (2.04 × 2.98 m).
Museum of Modern Art, New York
(gift of Nelson A. Rockefeller).

the format of the canvas, come close to the Golden Section. The tree at the top of the right side of the sofa continues upward, visually segmenting the figure and couch and creating an *asymmetrical* composition. The tall tree to the right of the mysterious flute player forms another subsection.

Repetition of form plays a primary role in the organization of this painting. The radiating *rhythms* of the various leaves and branches are continued throughout the jungle section. Although the basic pattern remains consistent, there is an extraordinary variety of leaf shape and size. The more one studies this imaginative scene, the more one sees emerge from the jungle growth: The eye of an elephant with upturned trunk peers out at us from above the sofa; a monkey holds onto a tree branch with upturned arms; and most mysteriously, the tail of an apparently large snake—looking much like a long pointed leaf—is well camouflaged in the lower right. Curiously, the lion to the right appears to acknowledge our existence as it stares directly at us; its companion meets the gaze of the nude figure.

In terms of *emphasis*, the focal point of the painting is most certainly the pale-skinned woman reclining on the red couch. This section, through its contrast of color, texture, and form, clearly commands our attention and becomes one of the most compelling elements in *The Dream*. Visually we keep comparing the figure to the lush foliage and subtly hidden creatures lurking in the jungle.

Rousseau charmingly explained the thematic meaning of the painting by stating simply that the woman on the couch dreamed herself to be in a jungle. But without his ability to order and organize all of the many visual aspects of this painting, his vision would collapse into a meaningless, chaotic collection of forms.

On the surface, Arshile Gorky's 1947 painting *The Betrothal II* (Fig. 90) is far removed in organization and content from *The Dream*. Yet the paintings are similar in that they both make use of organic forms, portray landscape spaces, and deal with imaginative worlds. Gorky's artistic dream is to reveal the abstract world of organic life ordinarily hidden from view yet affecting us every minute of every day we live.

Both *unity* and *variety* play important complementary roles in this painting. The well-defined, sensuous forms in the foreground are contrasted powerfully against the relatively simple background. This juxtaposition enlivens the composition and creates a dynamic visual dialogue between the linear organic shapes and the amorphous backdrop.

The dimensions of Gorky's *The Betrothal II* are, like Rousseau's *The Dream*, based on the *proportion* of the Golden Mean. Within the canvas, Gorky makes effective use of great *scale* differences found in the organic shapes. Some bulky shapes are joined together by the thinnest of lines, creating a remarkable visual and psychological tension.

In keeping with the dynamic, fast-paced visual effects of this canvas, Gorky chose the active mode of *asymmetrical balance* rather than the more quiet effects of *symmetry*. Without the constantly shifting equilibrium created by Gorky's use of active balance in the composition, this painting would not convey the feeling of quick motion and change that it captures so effectively.

Repetition is clearly evident in all of the main shapes in the foreground. Visual rhythms based on organic growth principles harmoniously unify the composition. Similar curves, arcs, and straight lines are used to define all of these biomorphic shapes. Yet to avoid monotony, Gorky constantly shifts the size relationships of these forms—some are miniscule, some moderate, and others quite large.

The Language of Vision

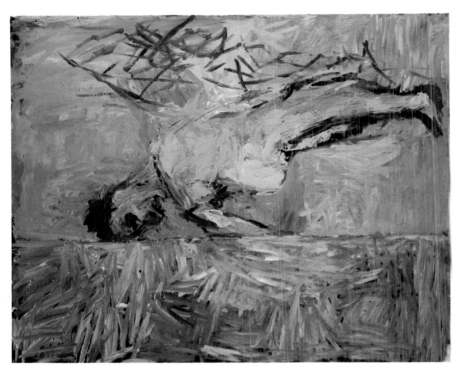

above: **Plate 11.** Georg Baselitz.
Frau am Strand (Woman on the Beach). 1983.
Oil on canvas, 6'6½" × 8'2½" (1.99 × 2.5 m).
Courtesy Sonnabend Gallery, New York.

right: **Plate 12.** Matthias Grünewald.
The Resurrection of Christ, from the right panel of
the *Isenheim Altarpiece.* c. 1510–15.
Oil on panel, approx. 8'10' × 4'8" (2.69 × 1.42 m).
Musée d'Unterlinden, Colmar.

PIET MONDRIAN 26

opposite: **Plate 13.** Piet Mondrian. *Large Composition with Red, Blue, and Yellow.* 1928. Oil on canvas, 4'3¾" × 2'3½" (1.2 × 0.7 m). Sidney Janis Gallery, New York.

above: **Plate 14.** Joseph Cornell. *Object (Roses des Vents).* 1942–53. Wood, Plexiglas, compasses, miscellaneous objects, maps; 2⅝ × 21¼ × 10⅜" (6.7 × 53.7 × 26.2 cm). Museum of Modern Art, New York (Mr. and Mrs. Gerald Murphy Fund).

Plate 15. Andy Warhol. *Red Explosion*. 1963.
Acrylic enamel and silkscreen, 8′8″ × 6′8¼″ (2.6 × 2 m). Private collection.

90. Arshile Gorky.
The Betrothal II. 1947.
Oil on canvas, 4'2¾' × 3'2"
(1.3 × 0 97 m).
Whitney Museum of American Art,
New York.

Rousseau's painting has a clear *focal point*—the image of the nude. However, Gorky's canvas does not have a single center of emphasis. This would interrupt and impede the sensuous flow of space and visual movement found in this abstract painting. Not all works of art make use of focal points or centers of emphasis. For centuries some styles of Eastern art have made use of *overall* patterns in their compositions.

The effectiveness of Gorky's work and that of other modern painters who make use of overall compositional effects (Jackson Pollock's "drip" paintings, for example) underscores what was mentioned earlier: Inviolate rules of design do not exist; the basic principles offer an organizational *framework* through which artists seek unique solutions to problems of personal expression.

As we have seen through the many examples offered in this section, the principles of design are highly variable guidelines that can be applied to all forms of art regardless of culture or time period. Together with the visual elements of shape, texture, light, color, line, time, and motion, they comprise the "language of vision," a language that transcends geography and history. When these elements and principles are used by artists to communicate their feelings and perceptions of the world, quite often the art that emerges embodies the creative power and energy potential of life itself.

Art and the Environment

Part II

ART AND THE ENVIRONMENT

No one would dispute the fact that our environment plays one of the most significant roles in determining the quality of our lives. During our childhood development, the social and physical nature of our surroundings profoundly affects the kind of person we become and subtly but surely shapes our destiny as adults. Studies have revealed that stimulating, well-organized environments support optimum intellectual, psychological, and physical growth. Conversely, environments that deprive children of coherent visual and social stimuli have been known to impede physiological development. Of course, much depends on the individual's innate ability and personality traits, but certainly environmental factors play a significant role in our becoming responsible adults.

The impact of the visual arts on the nature and quality of our environment is profound and affects everyone—perhaps more than we are aware of. In fact it would be difficult, if not impossible, to avoid these influences, even if we wanted to. The work of numerous artists, architects, and designers confronts us everywhere, in our homes, communities, and work places; these art professionals determine the form and function of the countless products that we use and take for granted; and they work with communication specialists to create graphic designs that keep us informed and entertain us during leisure hours. This section, "Art and the Environment," explores the many ways visual art contributes to our lives by transforming the environment around us.

Chapter **5**

The Home and Community

THE HOME

Because our home and surrounding community are important environments in our lives, this chapter will look at these living spaces and the factors that determine their design. Whether we live in a home specifically designed for us or in a standard apartment or dwelling, our living space and furnishings are expressions of our individuality. Certainly the community in which the home is located plays an equally important role. Thoughtful planning of parks, recreational facilities, shopping areas, transportation systems, and public art projects can do much to enhance the quality of life in any community. Creating attractive, efficient spaces for living is a complex task that involves the teamwork of experts in such diverse fields as architecture, economics, design, city planning, and sociology. Everyone has a stake in these environmental decisions and developments because they affect everyone's life.

A College Dormitory

For many of us, a college dormitory is the first independent living situation we can call our own. Usually this means living in a large apartment-house—like building and sharing a small room with another student. Often the lack of privacy and the anonymous nature of the housing affect us adversely. Architects and designers have been aware of the environmental shortcomings of traditional dorm life for some time now and, with the cooperation of some college administrations, have begun to do something about them.

Bennington College, a small, select liberal arts school located in a scenic region of Vermont, charged architect Edward Larrabee Barnes with the task of designing student housing that would provide a more communal, homelike atmosphere than most large apartment dorms. The college also was interested in an architectural style that would fit graciously into Bennington's rambling campus, made up of old barns, Vermont colonial-style frame houses, and 1950s modern buildings. Above all, the college was concerned that these new dorms maintain the feeling of close-knit community that permeates the school and is reflected in its small student-to-teacher ratio and concern for the individual.

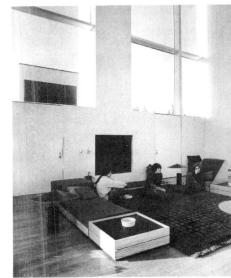

"The most important thing right at the beginning," Barnes stated, "was to agree on the size of the house. This size was what we wanted: Thirty people is absolutely right and human, an organic group, like a family. I think it has a real effect on student life."

Although the series of dormitories Barnes built was decidedly modern, it was designed to relate to and work visually with the existing traditional architecture of Bennington College (Fig. 91). In terms of their steeply pitched roofs and wooden construction, the buildings subtly echo features found in country barns and colonial houses throughout Vermont.

Mindful of many students' need for privacy in order to study and work effectively, Barnes designed the complex with a predominance of single rooms with shared bathrooms. But upstairs in a large loftlike space are communal living rooms with modular furniture, striking fireplaces, and large vertical windows offering spectacular views of the surrounding mountains (Fig. 92). Groups of students regularly gather here for house meetings, to entertain friends, or simply to "hang out." Individuals can also find a reading corner if they find the isolation of their rooms oppressive. In this way Barnes provided for a variety of living spaces offering both privacy *and* communal activity.

Of course, the individual dorm room itself is at the heart of the architectural statement in terms of importance and practicality. In order to make the rooms as attractive and pleasant as possible, Barnes decided to emphasize the extraordinary geographical setting Bennington enjoys: Each single room is organized around a large plate-glass window that offers a spectacular view of the surrounding mountains. In terms of spatial arrangement and floor plan, the rooms, for the most part, are cube-shaped in design; this not only offers the most efficient use of space to the student but also allows the window to function as a focal point of interest. All of the rooms are equipped with movable modular furniture that can be arranged to suit a variety of individual needs and preferences (Fig. 93). Prior to occupancy, the dorm rooms have an austere white, "minimal" look to them, but within weeks of occupancy each student tailors the look of his or her room according to taste. Posters, artwork, personal belongings, and family

memorabilia soon fill the empty white rooms and provide a homelike atmosphere. Wisely, Barnes designed a dormitory for Bennington College that provides a warm, communal setting for students, thus helping to smooth their transition from family life to independent living.

The Homes of Three Architects

When architects design their own homes, they are usually free to express their own convictions about how a personal dwelling should look, work, and "feel." Unlike designs of most apartment buildings and mass-produced houses, they do not have to appeal to large numbers of prospective tenants or owners—they simply have to satisfy their own needs and interests. For this reason, the houses architects build for themselves are particularly revealing about their attitudes toward living spaces and their aesthetic philosophies. In many cases, they are design showcases and ongoing experiments in form, structure, and style. Often they prove to be prophetic architectural statements that influence mass housing in the future. The three homes we will discuss in this section are as stylistically different and individual as the distinguished architects who built them.

Frank Lloyd Wright was an influential American architect whose design work in the 1920s was instrumental in the evolution of today's contemporary ranch-style home. Among other things, Wright was interested in the development of homes that seem to be organically rooted to the earth.

Philip Johnson's glass and steel house, built in 1949, exemplifies the **international style** of architecture and contrasts strikingly with the rough-hewn masonry and wood of Frank Lloyd Wright's "natural" home.

Frank Gehry's house is a highly unusual structure that sets out to speculatively redefine the form and function of a house in a highly personal way. His work is representative of the **postmodern** approach to design that blends traditional architectural forms with unusual avant-garde elements.

Frank Lloyd Wright's Home Near Spring Green, Wisconsin Taliesin North (Figs. 94–96), designed by Frank Lloyd Wright, is a striking complex of buildings set just below a hilltop in rolling, wooded farmland. It gets its name—*Taliesin*—from a Welsh term meaning "shining brow," an apt name for a home placed near the top of a sunlit hill. Begun in the 1920s as a home for Wright's mother, it was expanded into a spacious dwelling for his family, a private studio, a school of architecture, and a farm. Only a portion of the Wrights' living quarters, built in 1925, is discussed here.

The architect's purpose was to develop a structure that seemed to be an outgrowth of its natural environment. Wright chose his materials and shaped his home so that it appears rooted to its site (Fig. 94). Local stone, laid by country masons in patterns reminiscent of the quarry in which it was found, extends into garden courts and paths, forms the lower walls, and thrusts upward in the massive block to the left. The other walls are lighter, wood-framed screens against the elements, and they are surfaced with plaster that is colored and textured with sand from the river below. Exterior wood walls were treated with transparent preservatives to make them a slightly violet gray or a deep, warm orange, and the shingled woods were allowed to weather to a natural brown.

The exterior, however, is but a prelude to the interior, where Wright demonstrated what he meant when he spoke of interior space as being the essence of architecture (Fig. 95). The floors, walls, fireplaces, and ceilings are of the same stone, wood, and plaster that make up the exterior. Although they give a secure

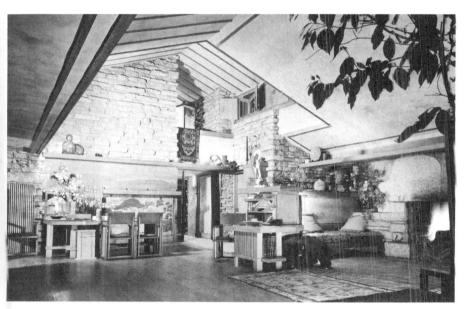

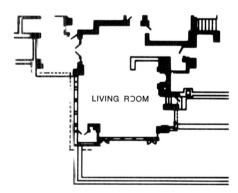

LIVING ROOM

sense of shelter, the space seems open and unconfined, never boxlike. The interior is sensitively modulated, not rigidly partitioned. Walls of varied heights and materials activate the space by inviting exploration in all directions, and on two sides they open wide onto terraces. The ceilings are a complex interplay of low, flat areas related to broad shelves a little above head height that give a sense of human scale. Above the shelves the sloping ceiling soars upward, following the lines of the roof. Wide and thin strips of wood accentuate the different planes. The house was positioned and windows were placed so that sun comes into every room sometime during the day and to allow views of the fields, hills, and sky. Taliesin North literally and symbolically grows upward and outward from its solid foundation into the outdoor space of which it is an integral part.

Although this house has well-planned circulation and areas for living, it transcends such practical matters in fulfillment of Wright's philosophy of Organic Architecture (Fig. 96). In Taliesin North the visible forms are so completely integrated with the specific purpose of the building, the materials from which it

is constructed, and the environment of which it is a part that the structure develops a life pattern of its own.

Taliesin North springs from Wright's belief in an "organic" architecture that integrates the layout of a building to its site, makes use of natural materials such as indigenous stone from the area, and takes into account the environmental conditions of the region. In short, all of the features of the house embody Wright's philosophy while at the same time fulfilling practical functions.

Philip Johnson's Glass House The home that Philip Johnson designed for himself in New Canaan, Connecticut (Figs. 97, 98), is quite different from Frank Lloyd Wright's organic home in many respects. Whereas Wright loved the "folksy" look and feel of pioneer American structures—the settler's cabin, for example—Johnson's aesthetic appreciation is directed toward a machine age sensibility as seen in his precise spaces, state-of-the-art fabrication techniques, and high-tech materials. What they share, however, is their strong commitment to an architectural style derived from well-formed attitudes about building materials, siting, and the life style one wishes to live.

The most stunning feature of the Johnson house is that every exterior wall of this simple cubelike structure is constructed entirely of glass (Fig. 97). Although it was built decades ago, in 1949, it looks as modern today as most of the newer buildings we see. This house has influenced many other structures, but few to date have equaled it in terms of purity and refinement.

Johnson's glass house—unlike Wright's—is not planned for a family; it is a bachelor's residence and as such needs to accommodate no one but its owner. One of the main reasons behind the transparent prism effect is Johnson's desire to live literally surrounded by the trees and landscaping he loves. To dematerialize the house and keep himself in visual touch with the outside world of nature, Johnson turned to glass as his primary building material.

Although most of the 1800 square feet (167 square meters) of enclosed living space is completely open, zones for different activities are suggested by three free-standing dividers (Fig. 98). Kitchen space is separated from the dining and living areas by nothing more than a walnut cabinet 3½ feet (1.07 meters) high. The sleeping area is divided from the living space by another walnut storage unit 6 feet (1.83 meters) high. The only interior element that goes from floor to ceiling is a hollow brick cylinder 10 feet (3.05 meters) in diameter that contains the bathroom and opens into a fireplace. The living area is furnished with only five carefully selected pieces of matching furniture (Pl.16, p.113) that sit on a white wool rug; this rug, in turn, pristinely rests on a large expanse of dark polished brick floor. Johnson purposely keeps the furnishings simple to create a luxurious and open sense of space. A large figurative sculpture and a potted plant are the only decorative elements to be seen. More furniture and art objects would distract from the unparalleled view of nature this house makes possible, lessening its visual impact. In a curious way, the *inside* of the glass house was planned with the *outside* in mind.

Extensive exterior lighting systems controlled by dimmers make enjoyment of the outdoors possible even during hours of darkness. On snowy winter evenings with the interior lights turned off and gently falling snowflakes illuminated from outside, people inside the house feel as if they are floating skyward.

This house is only one of several carefully positioned buildings on a large, tree-bounded estate. The others include a guest house as securely enclosed with brick as the main house is opened with glass (Pl.17, p.113); an underground museum that is all but hidden under a low mound of earth; and a naturalistic

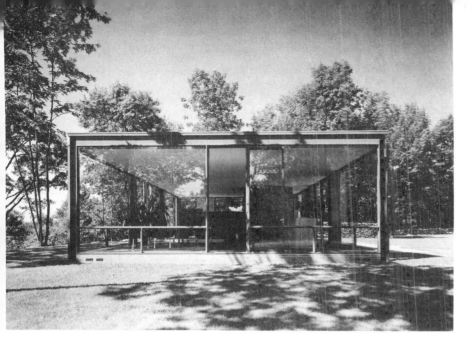

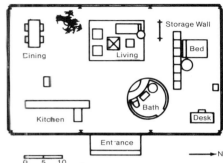

lake with a summer pavilion. Landscaping consists primarily of a beautifully tended lawn and screens of trees and shrubs placed at strategic points.

The Johnson house is representative of the *international style,* a movement in architecture that emerged in the 1920s and is still an influential force. Study of the glass house and other examples of this style shows that they emphasize volumes and space rather than solid mass, openness and flexibility rather than compartmental enclosure. These qualities are also fundamental in Organic Architecture, but the international style differs from it by a marked emphasis on regularity, precision, and visual simplicity. Regularity comes from repetition and standardization of predominantly rectangular forms. Precision comes from machine technology. Simplicity is achieved through the elimination of everything unnecessary.

As its name implies, the international style developed out of widespread 20th-century technology and ideals rather than out of local traditions or geographic environments. It is a "world-oriented architecture" that aims to coordinate basic, generalized human needs and the techniques of standardized industrial production. Philip Johnson made no attempt to create the informality and "naturalism" inherent in the design and furnishings of the Wright house. Nor was he particularly concerned with such factors as economical heating and cooling. But he achieved what he wanted—a formal, precise, highly disciplined design of great clarity.

Frank Gehry's Santa Monica Home Frank Gehry's work incorporates some of the most recent elements found in progressive architecture today, such as the development of highly idiosyncratic styles and the innovative use of decorative elements long absent from the vocabulary of modern building design. This movement—called postmodern by some—signals a turning away from the clear, formal, precise spaces associated with the international school. Instead, Gehry's work, like that of many contemporary artists in various media, presents unusual combinations of forms, materials, and processes. Standardized approaches have given way to an eclecticism that is often conceptually and visually dazzling in its ability to evoke strong feelings through unusual juxtapositions.

The Home and Community

No building better represents Gehry's unique approach to architecture than his own house in Santa Monica, California—a revamped, two-story, asbestos-shingled structure situated in an ordinary suburban neighborhood.

Two factors that originally attracted the architect to this house were its unprepossessing location and naïve "sweetness." Gehry was fond of describing it to his colleagues and friends as just a "dumb little house with charm." But major renovations soon changed that; today it is anything but ordinary. People riding through the anonymous neighborhood of Spanish and ranch style houses are startled by its raw-boned presence and industrial demeanor. Gehry is infatuated with the way building materials such as corrugated metal siding, chain-link fence, and exposed wooden studs can create exciting, unusual effects. Sometimes, in deference to the widespread use of these inexpensive, common industrial materials, Gehry will wryly refer to his architectural style as "Cheapskate Modern." But Gehry is fascinated not so much with the materials themselves as with the effects they create. During the early 1970s, when he first began leaving wood studs exposed, he reflected: "I noticed that these dinky little stick-built tract houses always looked better in structure, before they were plastered, before they were covered up. The quality of immediacy was, if you will, like a brush stroke on a painting by de Kooning."

At first, Gehry's intention was to leave the outside of the Santa Monica house intact and completely redo the interior by stripping it down and exposing the hidden structural elements. But once Gehry got going on this special experiment, he kept at it until the entire exterior of the house was enclosed with corrugated roofing steel and chain-link fencing (Fig. 99), which made it look like a cross between a farm shed and a high school baseball field. Gehry's neighbors were up in arms; one particularly irate party threatened to sue (although the legal grounds of the suit were never mentioned). Once when Gehry went away on a two-week vacation, neighbors called the authorities and reported the building abandoned.

99. Frank O. Gehry and Associates. Gehry residence, Santa Monica, Calif. 1978–79.

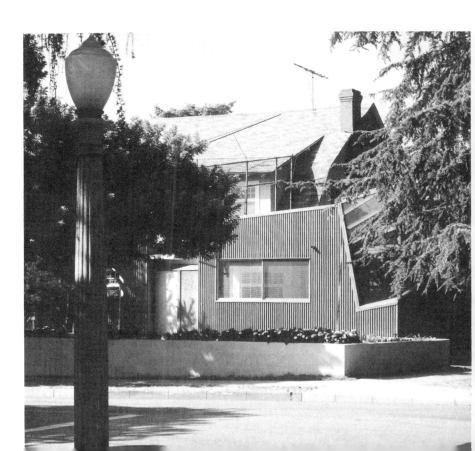

The final result of Gehry's renovation is a metal wrapping that surrounds the original house, creating the effect of a building within a building (Fig. 100). When you enter the house from the street—through a corrugated metal door—the door of the original house quizzically confronts you. Many similar experiences occur as you walk through the house. Gehry insists on reminding us that we are not entering a space once but many times. Seen from the outside, the kitchen (Fig. 101) takes the shape of a wired glass cube that is crashing through the walls. The inside (Pl. 18, p. 114) has the look of a commercial facility and comes equipped with industrial-grade laundry bins and cupboards; a chain-link sports backstop hovers above the glass ceiling and makes many visitors wonder where they are. This house has a surreal quality that is unlike any other.

One of the most disconcerting spatial effects is to look out of the dining room window and realize that what you thought was the house next door is actually the one you are in. Gehry's house doubles back on itself and at times appears to be engaged in the process of swallowing itself. Every aspect of this design makes us question what we previously thought we knew about architectural space. Strangely angled walls, false perspectives, unfinished surfaces, and exposed electrical cable all lend an improbable air to this special design experiment. Gehry is interested in the *process* of architecture and the *discovery* of new meaning in spaces rather than in creating finished forms.

Visitors attribute this live-in work of environmental art to a host of historic influences that include the **surrealist** artist René Magritte; the Italian metaphysical painter, Giorgio de Chirico; and Simon Rodia, who designed and built the Watts Towers in Los Angeles. Few people feel ambivalent about this architectural work—they either love it or hate it. Gehry's young children happen to love it. To them the house is a combination amusement park, playground, and clubhouse. If messy food such as ice cream is dropped on the kitchen floor (which is schoolyard-grade asphalt), it can be cleaned simply by hosing it down. For these young children, as well as for the stream of architects and writers who regularly

below left. **100.** Frank O. Gehry and Associates. Axonometric drawing, Gehry residence, Santa Monica, Calif. 1978–79.

below: **101.** Frank O. Gehry and Associates. Gehry residence, Santa Monica, Calif. 1978–79.

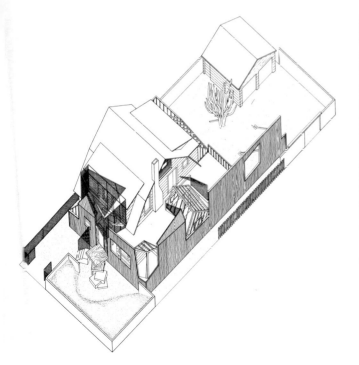

visit, the whole house is a series of stimulating contradictions and wonderful puzzles. It is at once cluttered and starkly simple, high-tech and "down home," pretentious and unassuming. No one can accuse it of being boring.

Because of the fame and notoriety the experimental Santa Monica house has won for Gehry, he constantly has to reassure his regular commercial clients that he is as responsible as any professional architect: He finishes work on time, secures the necessary permits, and works within specified budgets. Gehry feels that many big commercial clients are scared off by his unconventional image. The challenge he now faces is to develop an innovative but viable style of corporate architecture to match, in spirit, his novel experiments with space and unusual building materials. To make his point humorously, when he was named Architect of the Year by the California chapter of the American Institute of Architects, Gehry titled his presentation ceremonies speech "I'm Not Weird."

A Planned Development

When architects gather at professional meetings, talk eventually turns to the problem of design in the mass-housing market. Most developments, they agree, are characterized by lackluster design and low-quality construction details. Of course, economic factors play an overriding role in today's housing market. Few people can afford a custom-designed home on a spacious lot, especially since the average income has not risen as fast as the cost of new housing over the past decade. Statistical predictions seem to indicate that even fewer families in the future will be able to make the American Dream—the detached, single-dwelling house—a concrete reality.

The architectural firm of Fisher Friedman Associates specializes in high-quality housing developments that achieve standards of design excellence and "livability" not often seen in mass markets. Over the last decade, this group has consistently proved that planned developments need not suffer from the many problems which have limited their effectiveness in the past: poor land use, uninspired design, and the pervasive feeling that all of the units were stamped out of a giant cookie cutter.

The Ethan's Glen townhouse complex (Figs. 102–104), situated only eighteen minutes from downtown Houston, has impressed even the most difficult-to-please architectural critics with its distinctive sense of style and function and its effective use of land. Perhaps the single most important element in the success of Ethan's Glen is the remarkable way the houses are situated amid clusters of tall pine trees. A recreational lake also was created and was placed at the center of the complex. It is the focal point of the development. From the beginning, architects and project developers worked together to create an environment conducive to enjoyable living. Instead of bulldozing down most of the trees and building around the deep gully that ran through the tract, the designers suggested preserving as many of the trees as possible and using the natural ravine to create a visually attractive lake.

The solution to the problem of saving as many trees as possible in this development lies in the clever use of hidden parking: Under each cluster of eight townhouses a half-level-deep space was excavated, so that the units were raised a half level (Fig. 102). The creation of underground garages spared the groves of trees, which would have been cleared for above-ground parking. Also, the plan ingeniously avoids an unsightly parking-lot look to the grounds while affording the residents the luxury of protected, easy access to their cars.

The interior design of the houses is no less effective than the solution to parking. Interesting angles and unusual spaces avoid the boxlike look and feel of most assembly-line developments (Fig. 103). The exterior of the houses is finished in natural cedar shingling, which weathers well without the need of painting. Each two-story unit has its own private outdoor space partitioned by harmonious dividing walls and fences. In many ways this development combines the best features of detached and multiunit housing. By grouping the individual units, the architects created shared space between clusters, producing a parklike setting. At the heart of the development is a small but exquisite recreation center and swimming pool (Fig. 104), which becomes the focal point for leisure activity when the weather is warm.

Because of all these features, Ethan's Glen is viewed by its residents as a community. Although this particular housing development does not fall into the low-cost category, nevertheless it offers a more than reasonable return to the buyer in terms of community life style and comfortable living. Above all, it represents responsible land use and efficient planning, which one hopes will become the norm in the future.

Prefabricated Housing

Architects long have been aware of the need for less expensive ways of building. In recent years, many have explored the possibilities of prefabrication as a

below left: **102.** Elevation diagram, Fisher Friedman Associates. Ethan's Glen, Houston. 1977.

bottom left: **103.** Fisher Friedman Associates. Ethan's Glen, Houston. 1977.

below: **104.** Fisher Friedman Associates. Swimming pool, Ethan's Glen, Houston. 1977.

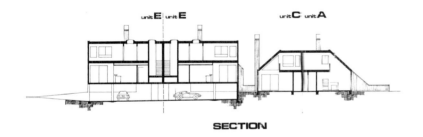

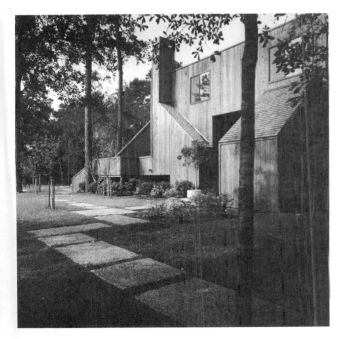

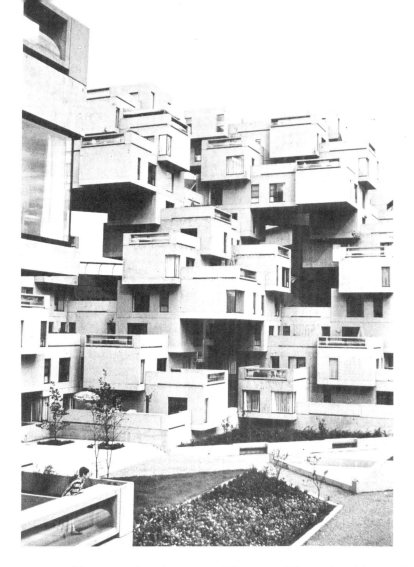

105. Moshe Safdie.
"Habitat 67," Montreal. 1967.

means of lowering housing costs. The assembling of architectural structures from standardized, factory-built components can reduce expenses, shorten construction time, and maintain quality control. Prefabricated houses, however, often have a monotonous uniformity that limits their appeal. Many of them suffer form unimaginative, inflexible design approaches, and some of them are poorly engineered. In spite of these problems, the search continues for practical systems that use standardized parts to produce individualized results.

In 1967, Israeli architect Moshe Safdie designed and built an experimental prefabricated community called "Habitat 67" (Fig. 105) in Montreal, Canada. The objective was to provide, through total factory preassembly, all the essentials of a complete living environment: privacy, living and sleeping spaces, fresh air, human scale, and sunlight. "Habitat 67" consists of 354 modular construction units that form a total of 158 family dwellings. The apartments contain from 1 to 4 bedrooms, and each unit is provided with its own garden terrace. Each modular section measures 17 feet 6 inches by 38 feet 6 inches by 10 feet (5.3 by 11.7 by 3.1 meters). New fabrication methods were developed to precast these units out of steel-reinforced concrete; once cast, they were fitted on an assembly line with plumbing, floors, windows, and electrical wiring. Preassembled kitchens and bathrooms were lowered into place through the tops of the

odular box units. What saved "Habitat 67" from becoming a visually boring
mposition is the way in which the units are arranged. The seemingly custom-
ade, interlocking structure of the complex belies the fact that it is constructed
t of identical units.

Safdie's experimental work with modular housing offers hope that factory
brication methods can be used to create pleasant, desirable housing for large
mbers of people living in urban settings. These concepts of total prefabrica-
on are being explored as one solution to the overwhelming need for more and
s costly shelter that also avoids the sterile sameness we have come to associate
th contemporary housing developments.

ommunity Housing

A home normally is located in some sort of community; rarely is it a totally
olated dwelling. This brings additional problems and concerns for architects
d owners. Building ordinances usually regulate some factors to ensure safe
nstruction: adequate window area, the covering of only a certain percentage
'land, and the location of the house on the lot. A few communities go further
'prescribing minimum size and cost. Most people, however, have the freedom
construct any style of home they wish (within their budget, of course). Most
ten, people like to feel that their house visually relates to the rest of the com-
unity. But the basis of a true community goes far beyond appearances—it
sides in a sharing of common backgrounds, values, and concerns. For this
ason various groups find that living in close-knit communities enhances the
ality of their lives and offers substantial benefits, both social and economic.
hen this sense of community is threatened by outside forces, often the opposi-
on is formidable and demonstrates the importance of the neighborhood in
ousing.

Cabrillo Village The building of Cabrillo Village (Figs. 106–108) is an
spiring story of what can be accomplished by a group of determined people
ited by a common cause. With the help of two socially responsive architec-
ral firms—the Mutlow Dimster Partnership and Barrio Planners—farm work-
s in Saticoy, California, built a modern housing addition to a neighborhood
ey have lived in since the 1930s. Originally Cabrillo Village was a transitory
mp for migrant farm workers, but some of these workers wished to avoid the
rdships and educational disadvantages of constant movement. They settled
re permanently and, over the years, built a variety of simple board-and-batten
bins and shelters. In 1975 the local growers, alarmed by the farm workers'
creasing demands for higher pay and arguments over human rights, tried to
ict them on the grounds of violations of housing, health, and safety codes.
ecause of the workers' solidarity and knowledge of their civil rights, this
rved more difficult than was expected. Thinking they would buy out the
orkers, the growers offered each family a $500 cash incentive to move. But
stead of using this money to pack up and move, the farm workers pooled it,
rmed a nonprofit cooperative, and bought their simple houses and the 8.5
res (3.43 hectares) that surrounded them.

Recently, with loans and grants from the Farmers' Homes Administration,
hn Mutlow of the Mutlow Dimster Partnership, in cooperation with Barrio
anners, designed a 35-unit housing complex for newcomers and relatives of
ople already living in the village. Although most of the owners would have
ferred single-dwelling houses, the Farmers' Homes Administration contract

106. Mutlow Dimster Partnership with Barrio Planners. Diagram, Cabrillo Village, Saticoy, Calif. 1981.

specified multiple dwellings. In order to provide attractive housing within the guidelines of the funding agency, Mutlow designed quadruplex units, each with a private inner courtyard (Fig. 106). Through careful placement of windows, side yards, and inner patios, a feeling of privacy and individuality was maintained in the multiple units. In terms of exterior style, the architects were sensitive to the aesthetic preferences of their clients (many of Hispanic origin) and incorporated flat roofs, massive forms, and earth colors to give the impression of solid Mexican adobes. Bands of white stucco run along the roof lines and reinforce the concept of traditional Southwest native architecture. Nestled in a valley with a backdrop of picturesque mountains, the units conjure up a historical romantic yet modern version of Hispanic communal life (Fig. 107).

Since many of the dwellers work in the fields and earn modest incomes, Mutlow incorporated a variety of energy-conservation features into the units to reduce heating and cooling expenses. All of the units have clerestory windows facing the living room walls so that the sun can heat the interiors during the winter. In units that face south, large sliding-glass windows allow the heat to be absorbed by the quarry tile (made and installed by the villagers) that covers thick concrete-slab floor. In order to achieve solar heating in the north-facing units, the architects have suspended an 18-inch-diameter (46-centimeter) dark red tube filled with water (Fig. 108) in front of the upper clerestory; this collects the day's radiated heat and stores it until evening, when a ceiling fan above the

107. Mutlow Dimster Partnership with Barrio Planners. Cabrillo Village, Saticoy, Calif. 1981.

Art and the Environment

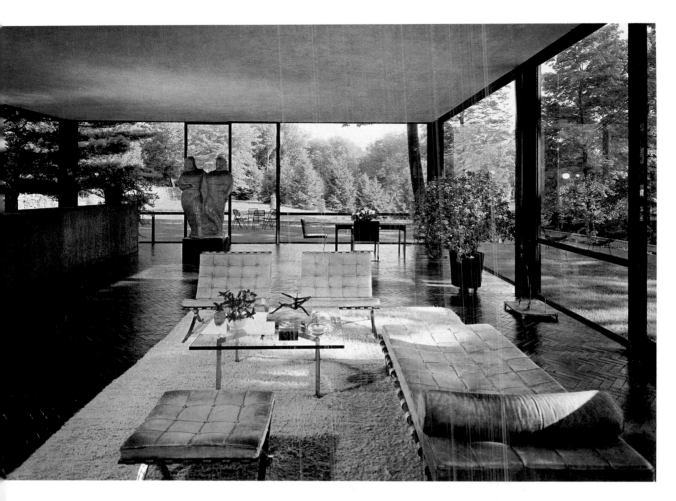

above: **Plate 16.** Philip Johnson. Interior, glass house, New Canaan, Conn. 1949.

right: **Plate 17.** Philip Johnson. Guest house of glass house, New Canaan, Conn. 1949.

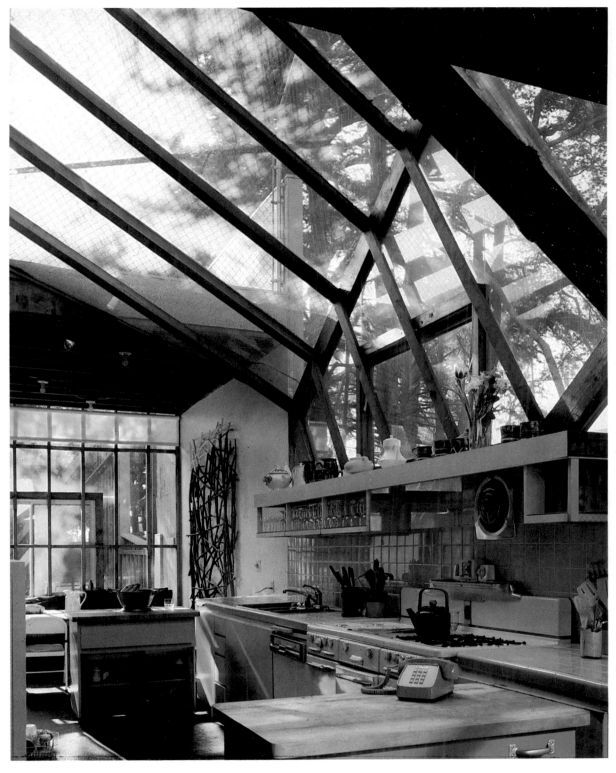

above: **Plate 18.** Frank O. Gehry and Associates. Interior, kitchen, Gehry residence, Santa Monica, Calif. 1978–79.

opposite: **Plate 19.** John Portman and Associates. Interior, Renaissance Center, Detroit. 1977.

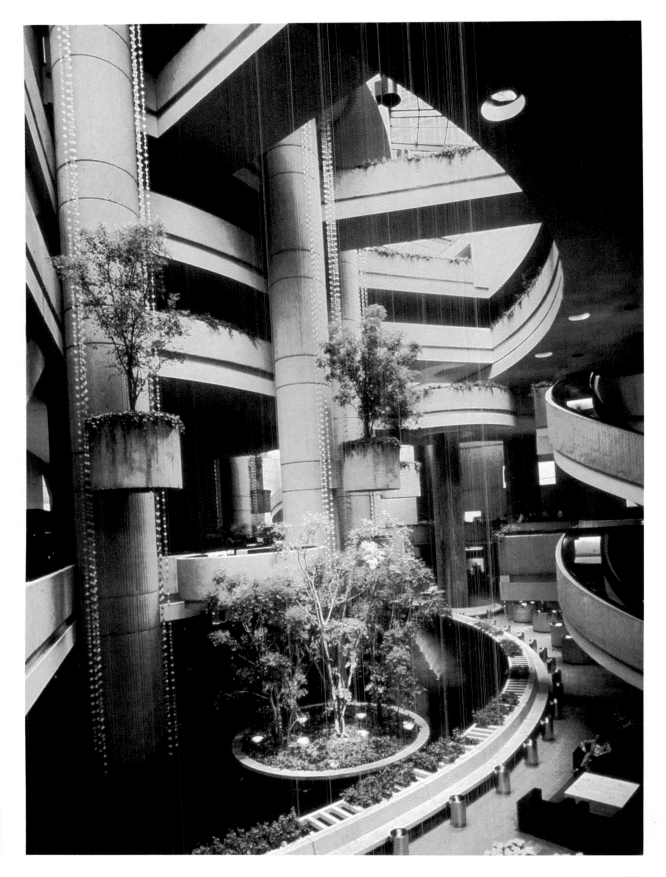

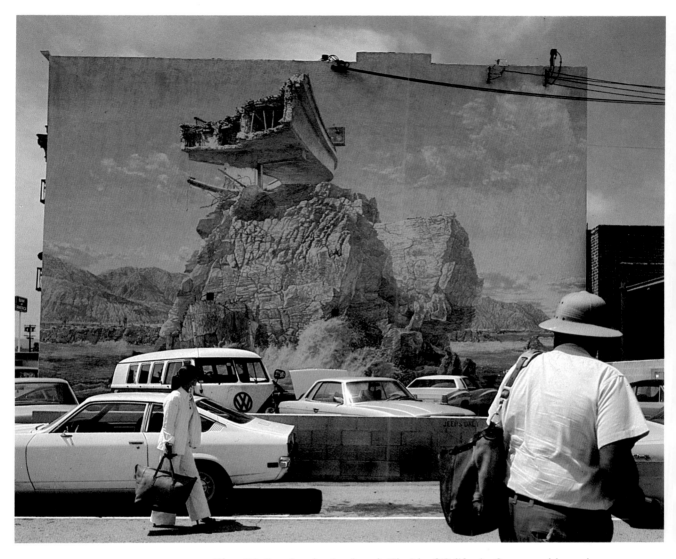

Plate 20. Los Angeles Art Squad. *The Isle of California*. Supermural located on Butler Avenue, Los Angeles.

tube helps disperse it and heat the house. Solar heating panels on top of the garages provide hot water for washing clothes and bathing.

The interior space is attractively and efficiently organized, allowing for the families to arrange their furnishings in a variety of ways. In order to accommodate families of varying sizes, six different interior plans were developed by Mutlow and associates. Two-, three-, and four-bedroom units are interspersed throughout the 35-unit complex, providing variations on the basic modular plan. In all, the residents are pleased with their new community addition and plan to add 34 houses and a community center (built by the same architects) as part of the second-phase development. Cabrillo Village is an inspiring example of what people can accomplish with the aid of socially responsible architects.

Renovation

Recently our country has begun to question its priorities in terms of "progress" and the appreciation of its architectural heritage. Highly active historical preservation societies have sprung up in cities both large and small. Instead of tearing down older buildings that give a sense of continuity and security to our world, architects have devised cost-effective ways of preserving their venerable façades and creating modern living spaces within.

108. Mutlow Dimster Partnership with Barrio Planners. Interior, Cabrillo Village, Saticoy, Calif. 1981.

above: **109.** Gruzen and Partners Peter Samton. Renovated townhouse, New York. 1969.

above right: **110.**
Gruzen and Partners Peter Samton. Exterior view from garden, townhouse, New York. 1969.

One such example of creative planning is the renovation of a Manhattan brownstone by architect Peter Samton (Figs. 109–111). Samton faced three major problems in dealing with the existing building (Fig. 109): This type of preexisting housing has narrow building widths (16 feet, or 4.88 meters), dimly lighted interiors, and small, awkward, compartmented rooms. The architect devised several cost-effective solutions to remedy these inherent drawbacks. The most significant structural change was to demolish a small extension of the building at the back and construct a large greenhouselike addition. This increased the size of the small apartments and allowed natural light to penetrate into the previously dim interior (Fig. 110).

Many of the small, compartmented rooms of the original building were done away with by tearing down walls to create a generous sense of open space. Demarcations of interior "space" were made by using rows of low cabinets. These formed partitions and also solved the problem of storage in limited space. Contrary to the plan in most houses, the sleeping areas and children's playrooms are located on the bottom floor, and a large living room, kitchen, dining room, and study are placed on the top story. During renovation work, layers of plaster were chipped away from the walls, revealing the brick walls underneath. Cleaned and refinished, they provide texturally interesting surfaces and visual continuity throughout the building.

The beauty of this renovated town house is largely based on the clean, open space of the interior, the large expanse of window wall in the rear of the building, and the careful selection of furniture, which was scaled in proportion to the limited living space. Samton overcame the narrow, constricting feeling of the old quarters by removing non–load-supporting interior walls to flood the space

with light. Working with relatively limited financial resources and a restrictive superstructure, architect Peter Samton proves in this instance that beautiful, satisfying, practical living spaces are possible under challenging circumstances (Fig. 111).

It is important to realize that each of the houses described in this chapter has its own *individual* beauty and functional qualities. Philip Johnson's glass house allows the well-to-do architect-owner to indulge himself in the visual glories of his beautifully landscaped estate. It was built with little regard for the cost or practical necessities that are overriding concerns for most of us. Cabrillo Village, by contrast, was constructed with great concern for building and operating costs and serves the needs of low-income families in a rural farming community. In terms of fulfilling its architectural program or requirements, it functions as well as Johnson's extravagant glass house. The brownstone renovation—a middle-income-level home—responds to its Manhattan location by maintaining a protective façade facing the street but opens up to the more protected and sheltered rear areas. Each house responds architecturally to its function, location, and building materials and to the particular needs of its owners.

Beauty in architecture defies exact explanation and definition; but several basic factors contribute to the attractiveness of all of the houses discussed in this chapter. In each, the design of the whole is harmonious; every section and part contributes to the effectiveness of the entire house. Materials are used efficiently and expressively to create living environments that fit the practical needs of the inhabitants as well as their psychological needs. Many of the houses employ the elements of design discussed in previous chapters: Shapes are distributed to

111. Gruzen and Partners
Peter Samton. Interior, townhouse,
New York. 1969.

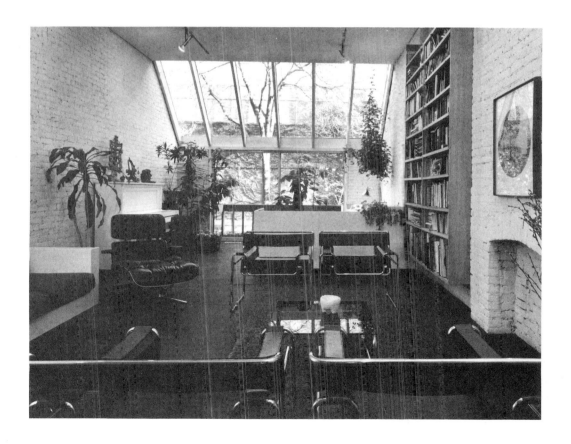

create dynamic or quieter symmetrical compositions; light and color play important roles in terms of creating pleasant spaces to live in; and in many cases the final form of the house is greatly determined by its specific function. But along with practical considerations, such as ease of movement and adequate storage facilities, one of the most important factors we look for in a home is the pleasure it extends to our everyday life. Thus the final, and perhaps most important, criterion of domestic architecture is the aesthetic enjoyment we derive from a house.

The homes examined so far in this chapter are called modern because they respond to the needs and living patterns of contemporary life. Many of them put to good use architectural elements found in the past but they do not slavishly imitate historic work—Cabrillo Village is a fine illustration of this point. Following a sound basic principle of architecture, they were designed *from the inside out*: The exterior developed from the interior, which in turn is related to contemporary living patterns. This approach leads to architecture that is self-renewing rather than static, and living spaces that respond to our continually evolving psychological and physical needs.

Furnishing the Home

Furnishings should reflect the personal interests, needs, and budgets of each household. For this reason, it is not possible (nor for that matter desirable) to make any pronouncements about what furniture is suitable or unsuitable. Certain guidelines, however, appear to make sense as far as many people are concerned. One of the most important aspects of the problem is to direct our concerns toward *furnishing* rather than superficially *decorating* or filling a living area.

Before we can make reasoned decisions about furnishings, we must first take into account the primary use for which each space will be used. Will the room be used for relaxation, reading, conversation, listening to music, or sleeping? Each activity makes its own demands in terms of furnishings.

One of the most consistent problems encountered in many homes is overfurnishing, which tends to make rooms seem small and crowded. Sofas, tables, and chairs often proliferate far beyond utilitarian need. Space is a precious commodity in a house, particularly with large families, and is often needlessly sacrificed to unnecessary furniture, clutter, and duplication. In the case of one-room dwellings, the guideline cannot be too rigorously enforced. This is not meant to advocate a Spartan approach to the problem but merely to suggest a careful analysis of everyday need in terms of furniture. A few high-quality items usually are preferable to many lackluster pieces.

Choice of furnishings depends on suitability *and* what the user considers attractive. In this age of pluralism and wide choice, no one style or approach can be deemed the best. One important factor that plays an important role in determining what types of furnishings to employ is the character of the home itself. In the case of Philip Johnson's glass house, the simple, refined furniture echoes the light, airy precision feeling of the structure with its emphasis directed outward toward the landscape.

The architectural style, geographical location, and aesthetic sensibility of the house shown in Figures 112 and 113 offers a dramatic counterpoint to Johnson's steel and glass bachelor's retreat. Consequently, the furnishings chosen for this seaside house—in the historic New England whaling town of Nantucket,

above left. **112.** Louis Mackall. House, Nantucket, Mass.

above: **113.** Louis Mackall. Interior, house, Nantucket, Mass.

Massachusetts—reflect the cultural heritage of the region and the practical needs of an active family with young children.

When Louis Mackall, the architect, was at the initial planning stage with his clients, they expressed a strong interest in building a house that embodied many of the qualities of traditional Cape Cod architecture—heavy interior beams and natural cedar shingling—but wanted to avoid copying older structures found in this region. Mackall was able to work out a design that appropriated elements of traditional and modern architecture, and he fused them into one unified composition.

Happily, the furnishings chosen by the owners reflect the same feeling for fine craftsmanship and tradition that is visible in the exterior. Many elements of the home show a genuine interest in the geographical heritage of the region and are appropriately incorporated into the design. Whaling artifacts from their collection are hung from the hefty 10-inch by 10-inch (25-centimeter) oak beams that support the second floor. Simple wooden furniture mixes well with the display of seashells and hand-carved birds above the tall fireplace. Many of the interior details of the house were hand crafted by the architect in his Connecticut workshop. Mackall observes: "People are surrounded by objects which are there only because people can afford them. But eventually they realize that their whole environment is foreign to them, that they have no personal attachment to anything in it. That's why so many people are turning to handcraft—making things for themselves, or having things made for them."

Although the furnishings of the Johnson and Mackall houses are quite different, they are both successful from a design standpoint because they are unified and appropriate to the style of building, and because they express the interests of their occupants. Consequently, they satisfy the aesthetic, psychological, and physical needs of the owners. Principles of design, such as balance, rhythm, and unity, are very much in evidence in both interior designs. But the specific application of these basic precepts always will be in constant flux in accordance with individual preferences and economic circumstances.

The topic of the home today is such a large and diverse subject that we can hope only to touch on some of the main points of interest and offer an introduction to this important area of our lives. The single-family dwelling is still high on the list of preferences for most individuals, but, because of rising costs and lack of available land, this form of housing is often unobtainable. Even when such a home is available, more often than not the building is but one of an endless repetition of identical structures crowded together on lots that are too small for them. Alternatives such as the renovation of older buildings and cluster housing like Ethan's Glen are becoming more and more commonplace in the housing market. Both forms of architectural development provide a strong sense of community solidarity and help make people aware of their responsibility of effective land management. Increased costs of commuting also have prompted a swing away from housing developments located great distances from employment centers and the squandering of land on poorly planned developments. We can hope that in the future, architects and designers working in concert with local communities and responsible developers will offer the public even more options in terms of affordable, efficient housing.

THE COMMUNITY

Next to the home, our community environment affects our lives more profoundly than any other single force. In many ways communities have changed over the past few centuries far more than the shape and function of our dwellings. Many of us live in houses that are not too different from those of our great-grandparents (Fig. 114), but the physical appearance and function of large modern communities have changed radically.

114. Stanley Tigerman. *The Best Home of All.* 1979. Mixed media drawing, 2'6" × 5' (0.7 × 1.5 m). Exhibition project perspective.

Art and the Environment

Prior to the 1880s, the world was divided into two categories—the "civilized" and the "primitive." So-called civilized society was based on organized agriculture and the surplus production of food. Tillable land and food products were the ultimate basis for wealth and power. "Primitive" peoples survived by hunting, fishing, and growing enough food on small plots of land for immediate consumption. At the center of organized agrarian life was the village. It was the basis of the local farming economy as well as the center of family life, culture, religion, and politics. When these small, decentralized villages grew, they did so at a slow, organic pace. Usually they were constructed out of local building materials and expressed the economic, social, and psychological needs of the inhabitants at the time they were built. For these reasons, ancient Italian hill towns, medieval English market villages, and gemlike, whitewashed Greek communities situated along the Mediterranean (Fig. 115) have a visual unity and beauty difficult to attain in the fast-paced modern world. Walking through these living monuments is a heady experience. The sights and sounds, the small shops,

115. Santorini, Greek mountain village on an island in the Aegean Sea.

the twists and turns of the narrow roads, all provide rich, deeply satisfying experiences. In a sense they are works of environmental art and design, characterized by intimate human scale and lively, inviting spaces.

When the shift from agricultural production to the manufacture and distribution of products took place, factories and the large, centralized cities they spawned brought with them dramatic changes in the structure, location, and function of most of our communities. Today a majority of people in America live in vast, sprawling urban centers that have at their core a profusion of glass-sheathed skyscrapers packed tightly together. Mile upon mile of anonymous housing, strip shopping centers, and garish building signs are incorporated into these cities. In view of the problems of poor public transportation, a growing sense of spatial dislocation, and decaying buildings, cities have turned to a group of multidisciplinary professionals called *urban planners* to help solve these problems. These people are entrusted with the responsibility to develop transportation and communication systems, safe housing standards, adequate public health facilities, and pleasant environmental surroundings in which people can live, work, and play.

Until fairly recently, the expansion of building has proceeded as if the world's supply of land was unlimited. This false assumption led to extravagant squandering of precious land and natural resources. We now realize that there are about 135 million square miles (349,650,000 square kilometers) of land on this earth, but only 10 percent of this area can be cultivated intensively. With astute planning and advanced technology, another 10 to 20 percent could be made useful and habitable according to contemporary estimates. Population is another matter. In 1920 the number of people living in the United States was 105 million, but by the 1980s that figure had doubled; more than one-half lived in cities that occupied only 1 percent of the land. Estimates for the year 2000 indicate that there will be about 330 million people in the United States and that 80 percent will be living in cities. In 1895 only four automobiles were registered in the United States. Now it is estimated that roads and parking spaces for cars occupy from 60 to 70 percent of the land in Los Angeles. The result of this growth is that cities have mushroomed upward and outward but often without comprehensive, enlightened planning; overcrowded slums and overburdened transportation systems have made city life a grim experience for many.

In view of these recent developments, planners and progressive communities have taken a keen look at the recent past—most notably the failure of planning—and have reevaluated strategies accordingly. Today, we have a much broader perception of the social and economic impact urban and regional planning have on our lives. Early modernists believed wholeheartedly in the ethical superiority of "utopian" planning. In the 1920s people had an unbridled faith that more and better technology (that is, "progress") could solve all of the environmental and social problems of humankind. We hope we know better today. There are no easy technological solutions to complex human problems. Many experts are now of the opinion that effective community planning is a matter of infinite sensitivity to, and delicate balancing of, social needs, rather than formula-prone programs applied wholesale. Too much intervention of the wrong kind can be as bad as too little. Witness the low-income public housing projects of the 1950s, most of which destroyed the last vestiges of real neighborhoods and replaced them with instant, high-rise superslums and utter personal anonymity. The human spirit cannot long survive under these environmental conditions.

These admitted failures of seemingly well-thought-out urban renewal projects have redirected the thinking of architects, planners, and local governments away

Art and the Environment

from strictly physical solutions and moved them toward broad sociological and economic concerns.

People cannot be told how they must live; planners must take into account the complex forces behind individual and group behavior. Often ideas that look fine on paper are unworkable within the context and realities of everyday life.

We can learn much from historic precedent. Naturally formed, older communities are like living organisms—they exist in a state of delicate equilibrium. Too much well-meant but misguided interference can upset decades of orderly, meaningful growth. Sometimes massive and abrupt changes in the economic and social balance of a community can have disastrous results. When businesses close down and industries relocate, repercussions are felt in the living environments of cities and towns. Unemployment and overcrowding can leave in their wake physical and spiritual ruination of staggering proportions—witness New York's South Bronx, which today in many parts sadly resembles war-torn Europe in 1944 (Fig. 116). Clearly our society is in need of far-reaching, enlightened planning to prevent or perhaps mitigate such exceptional problems.

Mixed-Use Development

Since the population and corporate exodus that occurred in the late sixties and early seventies, many individuals and businesses have conceded that cities offer cultural and economic opportunities unobtainable in less urbanized regions. Of late, the rallying cry has been to stay and rehabilitate rather than evacuate.

116. Devastation in the South Bronx, New York. 1974.

Recalling the disastrous housing and urban renewal projects of the fifties, planners and developers are incorporating a new concept into urban design, called *mixed-use development*, or *MXD*. Basically, this plan calls for buildings and complexes to be built that provide for a *variety* of functions and uses. Actually, like many developments in art, this concept is not so new. Ancient Greek *agoras*, or marketplaces, medieval towns, and many historic cities in Europe have long incorporated commercial, residential, and recreational facilities within one area.

The Urban Land Institute, a nonprofit research corporation, views MXD as a particularly effective "tool for treating blight and decay." Their recent report on the subject lists the various ways in which MXD is useful in combating urban deterioration,

> by introducing residential, transient, and/or recreational activities to areas that were "dead" during nonworking hours;

> by maintaining and improving the MXD's own facilities over time;

> by blending with established residential neighborhoods where other types of high-density developments were unacceptable;

> by having a far greater catalytic effect on community development than single-purpose projects;

> by providing a means for organizing metropolitan growth.

To be sure, it is difficult to incorporate all of these desirable design traits into one complex. However, the concept of mixed-use developments is a sound one and appears to achieve more desirable social and aesthetic results than single-use buildings or homogeneous complexes.

The Detroit Renaissance Center: MXD in Action During the early 1970s, Detroit's plight as an inner city seemed particularly poignant. The steady flight of businesses and middle-class families to the suburbs seemed to assure the eventual decay and abandonment of a large part of this once proud industrial center.

Spurred on by Henry Ford's vision of a rejuvenated city, the Detroit Renaissance Committee was formed by business leaders from 51 prominent corporations based in the area. In terms of scale and capital investment, few private developments can equal this dramatic complex of five glass-sheathed towers that rise like a futuristic vision alongside the river in downtown Detroit (Fig. 117). The project was so large that a consortium of 28 banks was necessary to handle the $200 million loan needed for construction costs.

The most attractive and popular area in the Renaissance Center is the large, multilevel public space located under the hotel tower (Pl. 19, p. 115). Rather than provide small, enclosed, compartmented rooms, John C. Portman and Associates, the planners and architects, developed one large multipurpose area that accommodates a lively mix of restaurants, cocktail lounges, meeting spaces, and hotel reception areas. Semicircular promenades at the perimeter provide the observer with the opportunity to look out over a vast wonderland of open spaces. A square concrete column several stories high with water running down all four sides introduces relaxing sound and visual elements to the whole area; natural light mixes with artificial illumination; and generous areas of greenery and small fountains lend a feeling of luxury and pleasant stimulation to this enclosed marketplace. So attractive is this square that crowds of office workers and shoppers constantly fill it to near capacity at all hours of the day.

Art and the Environment

117. John Portman and Associates. Renaissance Center, Detroit. 1977.

Parks as Environmental Art

As U.S. cities became more densely populated, the need for large, open spaces in which to play and relax became more important. The physical size of these outdoor areas today ranges from immense wilderness tracts and large urban parks to small inner-city parks only a few thousand square feet in size. All offer opportunities for relaxation and self-discovery.

Recently, a new design concept has taken hold in the minds of planners and civic leaders—the "vest-pocket" park. Unlike the large-scale urban park, the small neighborhood and downtown park is designed to accommodate people where they live and work. Parks are designed for people and therefore must be placed where people congregate daily. This concept of widely scattered small-scale parks also makes sense from an economic standpoint. Office workers who return to their tasks after a relaxing lunch in a vest-pocket park might be more productive. Midtown shoppers who have an enjoyable place in which to rest and

have a cup of coffee will more likely continue shopping, whereas those who become fatigued will probably go home.

One such small urban space that offers an outstanding example of inspired architectural design is Paley Park, located in the heart of Manhattan just east of Fifth Avenue on Fifty-third Street (Figs. 118, 119). Built on a relatively small vacant city lot, it establishes a tranquil and meditative setting in the midst of one of the most heavily trafficked areas in the world. The focus of this special park is a twenty-foot-high "waterfall." It provides hypnotically soothing sound and lively visual effects that help mask the abrasive noise and movement outside this minisanctuary.

Every design aspect of Paley Park reinforces the concept that beautiful and effective urban park spaces need be neither large nor excessively costly. When you enter this space in the spring, the quality of light and psychological feelings of the city are transformed by the dense green canopy of leaves overhead, formed by the close planting of hearty trees. A practical, inexpensive floor is created out of mahogany granite pavement stones laid in a simple but intriguing pattern. Instead of the formality of benches lined in regimented rows, a much more attractive setting is achieved with lawn chairs arranged around marble-top tables as in a charming European cafe. Cool drinks, hot coffee, and pastry are sold from a small kiosk near the entrance. Costs for these simple refreshments are reasonable, making it possible for many people to enjoy its benefits. Although brick walls completely surround and enclose Paley Park, English ivy, an evergreen, grows over the bricks to create a soothing effect of "vertical lawns."

All of these features contribute much to our enjoyment of this space, but the catalyst that lifts the park into the category of an environmental work of art is the waterfall. The sound and sight of the cascading water works magic in the minds of thousands of harried visitors as they step into this special space that coexists with the frantic world just outside its gates. Paley Park does what any good work of art might do—it makes us aware of our need for beauty and tranquillity in a world of noise and confusion.

Public Art

Ever since prehistoric times, community artworks and statues have expressed the myths, beliefs, and visions central to each society's pattern of living. Much evidence exists that these forms of "public art" came into being long before privately owned and commissioned objects. From Neolithic times on, many peoples in all parts of the world have enriched their community environment with public paintings, mosaics and large-scale sculpture that symbolized their ideals and accomplishments. Recent times have seen an outpouring of interest in new and traditional forms of public art all over the country. It is a rare city today that cannot boast of at least one modern piece of sculpture or mural gracing a public square or city park.

Recent mural painting in the United States is greatly influenced by the ubiquitous presence of large-scale advertising billboards. Some of the largest and most striking "supergraphic" mural paintings done in modern times were executed by a group of artists called the Los Angeles Art Squad. Spearheaded by Vic Henderson, an artist from Venice, California, this group redefined the possibilities of the community mural in the early seventies.

Excited by the spatial freedom of working out-of-doors rather than in the confines of a gallery, Henderson and company took to the streets in a big way. Within several years a number of enormous, impeccably painted fantastic visions

appeared on commercial building walls throughout southern California. One of the most compelling murals in terms of scale, theme, and technical skill is the *Isle of California* (Pl. 20, p. 116) located on Butler Avenue in Los Angeles. This enormous work of art covering the entire side of a building depicts the popular myth that when the big earthquake comes to California, a substantial portion of the state will split off and sink into the sea. The Los Angeles Art Squad humorously reacts to this fear by placing an interstate highway sign just visible on top of the isolated fragment of freeway: The sign indicates the proximity to Blythe, California, near the Arizona border—more than 250 miles (402 kilometers) from Los Angeles!

The wealth of detail in this painting is extraordinary and quite effective. Steel-reinforcing rods are visible in the wrenched-off freeway section; the mountains in the background are the same parched hills one sees in western Arizona; puffy clouds hang suspended in a desert-clear blue sky; and ocean breakers crash against the newly formed island and Arizona coastline. One of the long-standing fears and folk myths of southern California is dealt with imaginatively in this large-scale work of invention, wit, and painterly skill. A special feature of these kinds of public artworks is that they meet the spectators in the outside world. No imposing museum edifice stands in the way of experiencing the visual wonder and contemplating the flirtation with doom expressed here. Part of the magic of this mural lies in the way it sneaks up on us; whether we are driving down the avenue or approaching it on foot, the scale and imagery of this painting make us stop and consider the meaning of public painting and the symbolic nature of art.

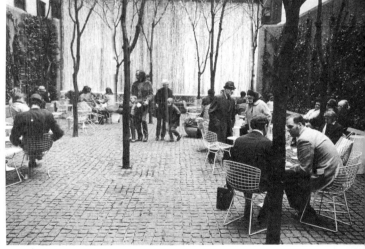

left: **118**. Paley Park, East 53rd Street, New York.

below: **119**. Paley Park, East 53rd Street, New York.

120. Claes Oldenburg. *Late Submission to the Chicago Tribune Architectural Competition of 1922: Clothespin (Version Two)*. 1967. Pencil, crayon, and watercolor on paper; 22 × 23¼″ (56 × 60 cm). Des Moines Art Center, Iowa (gift of Gardner Cowles by exchange, and partial gift of Charles Cowles).

Claes Oldenburg's *Geometric Mouse* An inherent problem of contemporary public sculpture is that, in its desire to please as many people as possible, it sometimes loses its ability to make us think and see anew. Large-scale, brightly painted abstract steel sculptures now appear with regularity on many a public green and corporate plaza. Supposedly reflecting their patrons' "good taste" and culture, many end up as anonymous additions to anonymous architecture. Claes Oldenburg, however, is one artist who has largely built his career upon the premise of *public sculpture parody*. Reacting in large part to the inherent pretentiousness of many civic monuments, Oldenburg's large-scale outdoor constructions express a decidedly *antimonumental* feeling. For many years this artist worked on a series of satiric, witty, tongue-in-cheek watercolor drawings illustrating his proposals for highly unlikely public monuments: a skyscraper-high clothespin that towers over Chicago (Fig. 120); free-standing sculptural shirts and ties that would fit King Kong; cigarette butts the size of small cars; and a ten-story-high cement-block monument that would effectively seal off one of the busiest intersections in New York City. Oldenburg is interested in examining the symbolic elements of a goods-conscious consumer society. Since the mid-sixties gallery goers have been vastly amused with his drawing proposals for monuments that criticize in subtle ways our societal delusions and pretensions. Recently, Oldenburg has had the opportunity actually to build some of his more practical fantasy monuments: Enormous metal clothespins, 100-foot-high (30.5 meters) baseball bats, gigantic nylon ice bags, and a large-scale metal sculpture

of Mickey Mouse now stand in corporate plazas, beside federal office buildings, and in museum courtyards.

Geometric Mouse (Fig. 121) is a 15-foot-long (4.6 meters), 12-foot-high (3.7 meters) painted steel and aluminum sculpture owned by the Walker Art Center in Minneapolis. It is simultaneously a beautifully assembled sculpture of refined geometric shapes in primary colors and a wry parody of this type of standard-issue public art. Popular culture and mass-media concepts are skillfully combined with "high art" materials and forms. The result is a curious mixture of aesthetic overtones that questions our civilization's social priorities and aesthetic standards. The geometric mouse head becomes a telling symbolic portrait of Oldenburg the artist: Mickey Mouse is characteristically portrayed in films as a cartoon antihero, well-intentioned but mischievous; he is a consummate prankster and questioner, not unlike Oldenburg himself. Viewing this formally beautiful, thematically playful sculpture, one is not quite sure where to place it in terms of most monumental public sculpture. This ambiguity is actually its strength, enabling it to do what any really effective work of public art should do: make possible thoughts and feelings that focus our perceptual understanding of our immediate environment and the world at large.

Three Public Art Projects The extraordinary range of public art one encounters today allows for a rich dialogue among all kinds of artistic tastes and interests. Commissions are being granted to formalist works of art; art incorporating popular, realist imagery; and highly unusual artforms that make use of new technology to reach tens of thousands of viewers in nontraditional ways.

121. Claes Oldenburg.
Geometric Mouse, Scale A. 1969–73.
Steel, aluminum, automotive paint;
12 × 15 × 7′ (3.6 × 4.5 × 2.1 m).
Walker Art Center, Minneapolis
(intended gift of Shirley and Miles
Fiterman).

122. Luis Jimenez. *Sodbuster*. 1982. Fiberglass resin, epoxy coating. Fargo, N.D.

Luis Jimenez' polychromed fiberglass sculpture *Sodbuster* (Fig. 122), in Fargo, North Dakota, commemorates the pioneering virtues of the plains farmer. What distinguishes this sculpture from most public artwork of the past decade is its commitment to realist imagery. It is a far cry from the large, abstract metal sculptures that have proliferated in recent times. Jimenez makes stunning use of brilliant color to create an artwork that takes its inspiration from popular imagery rather than from rarefied museum art. Considering the subject matter of the sculpture and its siting in the heartland of America, *Sodbuster* relates particularly well to its surroundings and its audience.

Michael Heizer's public work in New York City, *Levitated Mass* (Fig. 123), is quite different from *Sodbuster*. It refers to **minimal** art and *earthworks* in its concern for sparse geometric shapes and conceptual aspects of the land. Heizer is closely associated with the development of environmentally based art; his early pieces were constructed on the desert, far from population centers and seen by relatively few individuals. *Levitated Mass* was commissioned by IBM for its new office building in the heart of Manhattan. Seemingly suspended above a swiftly rushing sheet of water, *Levitated Mass* is an eleven-ton (ten-metric-ton) horizontal slab of natural granite surrounded by a containing wall. This piece has a wild, untamed feeling in striking contrast to the finely honed geometric stone used in its construction. Standing above it and looking down, one is reminded of a mountain stream rushing forward, uncontrolled. Although the work is sited in mid-Manhattan, Heizer brings some of the feelings and experiences of mountain and desert to this urban center, aesthetically refreshing us in the process. Although we are viewing this sculpture immersed in the artificial environment of a city, he skillfully reminds us of the innate power and majesty of the natural world.

The harnessing of electricity and other 20th-century technology has greatly expanded the arena of public art. Keith Haring is one contemporary artist who has utilized the artistic potential of these new tools to reach large numbers of people in a creative new way. Through the intermediary services of The Public

Art Fund, a nonprofit corporation, Haring recently was given access to the
enormous animated display board in New York's Times Square. When he pre-
programmed the light board's control computer, an animated sequence of sim-
ple but archetypal line drawings of human figures surprised and delighted
crowds of visitors who regularly pass through this popular crossroads (Fig.
124).

This group of works of art is representative of the kind of thinking taking place in the public sector. Not all public art pleases us, but pleasing everyone is an impossibility. In fact, the usual controversy that surrounds much good public art might be a sign of aesthetic success rather than an indication of failure, as is often imagined. When a sculpture can produce community dialogue and enable people to test concepts, greater understanding and tolerance of different views can be fostered. In this way, the commissioning of challenging murals, sculptures, and environmental works of art might contribute to the maintenance of our democratic way of life.

All of the elements of community planning and public art affect great numbers of people and differ in some respects from aesthetic considerations of homes, which basically concern only those who live in them. Environmental art constantly influences the lives of *all* citizens. In fact, the economic and spiritual well-being of a city or town depends, to some extent, on sensitive, enlightened planning. Nothing embodies and expresses the ideals and values of a city or town more than its civic buildings, parks, public sculptures, murals, and cultural institutions. For this reason, these elements must be nurtured carefully; without them the community is less able to make a substantial contribution to the quality of our lives.

Chapter **6**

Functional Design

Before the coming of the machine age, most of the objects made by craftspeople and artisans were both highly *functional* and *aesthetically* pleasing. Economic factors, for the most part, did not allow the creation of any but the most necessary objects, and quite often they were fine examples of formal beauty as well. Even the most common ceramic water jars (Fig. 125) were pleasing to look at and easy to carry. Tribal symbols and designs on these vessels often enlivened the surface and reminded people of their cultural heritage. Most important, the jug was functional: It efficiently transported and stored water—one of the prime necessities of life.

By contrast, most of the thousands of objects available for sale in even the best of stores today lack utility and beauty. Quite often, decoration is superficially applied and consists of "pretty" images designed to cover up the lack of real design thought in the product. We are swimming in a sea of products, many of which are useless, operate inefficiently, and break down readily. So much for technological "progress." It is amazing to think that relatively poor, 14th-century peasants in northern Europe—who could neither read nor write—wore clothes made of honest, home-spun cotton hopsack that was superior in look, feel, and strength to many of the garish, ill-conceived synthetic-fiber textiles flooding the market today. What went wrong?

The answer seems to lie in the speed with which technology has outstripped our ability to understand and control events and social processes. Machine-tool adoption and mass distribution of goods have moved with great rapidity. More change has occurred over the last one hundred fifty years—since the Industrial Revolution—than in the five hundred years that preceded it. Over specialization in the work place is part of the reason so many products are poorly designed. Today, people usually perform one small isolated role in the entire manufacturing process. In the past, a maker of useful goods oversaw most aspects of the operation, from the selection of raw material to the sale of the finished product. User-oriented communication existed at every stage of production. Mass advertising, which artificially stimulates consumer demand, did not exist. Therefore, useless goods (except those luxury items for the wealthy) stood little chance of being made in preindustrial days.

125. Pueblo (Hopi), Arizona. Canteen. Redware with red, black, and white painted decoration; 9¾ × 6½" (25 × 17 cm). Museum of the American Indian, Heye Foundation, New York.

Of course, we cannot return to that system today. Society as we know it could not exist for long without the coordinated efforts of many specialists; going back to archaic methods would prove too costly and inefficient. What is needed is a clearer understanding of machine-age design methodology, in order to make the present system work more effectively. But before discussing present-day concerns, let us observe an earlier craft culture.

BEFORE THE MACHINE

Communities that still depend primarily on what they make with their own hands are becoming increasingly rare. In Guatemala craftspeople in villages still work with hand looms, potter's wheels, and other simple equipment to supply most of the textiles and utensils needed by the community. These objects are used almost exclusively by the families who make them or are sold or bartered in nearby markets. Until very recently little was produced that was not used within the area. This kind of society has little need for disposable goods—people simply cannot afford this waste. Everything is designed to last.

The sturdy cotton cloth in Figure 126 comes from a remote Guatemalan village and is typical of most weaving done in the region. This textile was not created as a decorative wall hanging—as we might display it—but as a practical means for carrying tools, food, or even small babies. Although much care was devoted to the ornamental design of stylized figures, the cloth was woven for a useful purpose—the transportation of goods. This weaving is not the result of a single designer's inspiration; it is the expression of cultural traditions that extend far back in time. The designs found on this weaving are deeply embedded in the

126. Guatemalan. Hand-woven cloth. 1936.

127. Paul Revere.
Teapot. c. 1775–1800. Silver.
Metropolitan Museum of Art,
New York (bequest of A. T.
Clearwater).

life and history of these Central American people. Not surprisingly, all of the other weavers in the locale follow similar patterns. But rather than *identical* designs, each piece of cloth bears the subtle mark of its weaver. By interpreting the design—within certain well-defined limits—the weavers feel they are contributing something uniquely personal to the process rather than following rigid formulas. But although no two weavings are identical, they conform closely in terms of image content and style. These thematic interpretations have stood the test of time and meaningfully reflect Guatemalan customs and beliefs. Design weaknesses have been eliminated and strengths are reinforced until the results look "right." This adherence to the folk process in many ways accounts for their beauty. A slow-changing, nontechnological society has little reason to modify greatly a satisfactory design. Instead, gradual evolutionary changes occur which serve to keep forms vital. At the other extreme, rapid change not based on real need or improvement leads to senseless, unsatisfying results.

The fact that such an essentially utilitarian article as the Guatemalan textile is enriched with whimsical images of animals and human forms suggests that all aesthetic enhancement has a hidden function—it lends meaning to our lives by making us truly aware of our existence. Signs, symbols, and ornaments are elements that can be found on everyday objects from all time periods, geographical locations, and cultures. Even when the struggle for survival in a hostile environment takes up much of a people's effort, individuals have found the time and energy to invest their utilitarian goods with beauty as well as efficiency. At stake in this process is a greater consciousness of our life and in this consciousness a struggle for meaning that extends beyond practical concerns.

The desire for *social* function as well as practical need is apparent in many goods, both historical and contemporary. Various artifacts become a means for exhibiting status and wealth. Paul Revere's silver teapot (Fig. 127) reflects standards of skilled workmanship and refined ornamentation characteristic of an advanced craft society. Unlike the Guatemalan textile with its pleasing irregularities—with its variations and subtle design differences—Revere's teapot is a

virtuoso performance of skill calculated to impress all who view it. Neither the intricate, embellished silver vessel nor the simple weaving is inherently superior. Both serve the needs, aims, and social functions of their respective cultures.

Works of art and artifacts have always reflected the social and economic history of their intended audience. During the 16th century, Japanese aristocrats paid large sums of money to master potters who made them vessels with all the outward appearance of inexpensive peasant ceramic ware; these understated bowls and jars were cherished for their "simplicity" and were used in a highly refined social gathering called the *tea ceremony*. These ceremonies began as informal meetings of cultivated aristocrats; over time they led to the development of a cult dedicated to ritualistic simplicity. The commissioners of tea ceremony utensils demanded qualities outwardly quite different from those appreciated by the patrons of Paul Revere.

The celebrants of the tea ceremony were reacting against the showy tastes and lavish tendencies of a rising merchant class just coming into power. Therefore the austere Shinto water pot shown in Figure 128 expressed the old guard's philosophical disdain for ostentatious displays of wealth. Although the water pot appears antithetical to the richly ornamented silver teapot they embody the same cultural codification: Both vessels symbolize the yearning for social superiority and status.

The design of all implements used in the tea ceremony had to incorporate two important philosophical qualities before they become aesthetically "functional": *sabi*, "reticent and lacking in the assertiveness of the new"; and *wabi*, "quiet simplicity." Certainly, the water pot illustrated here is beautiful in an informal

128. Momoyama period (Japanese). Jar: flowers and grasses. 1573–1615. E-shino ware, buff stoneware with ash gray glaze and design printed in iron oxide; height 7″ (18 cm), diameter 5″ (13 cm). Seattle Art Museum (Eugene Fuller Memorial Collection).

and rustic way, but it also indirectly expresses the insecurity of an essentially conservative social order fearful of loss of power. This suggests that all utilitarian products of civilization—particularly those of today's pluralistic society—fulfill a multitude of psychological, social, and utilitarian needs.

THE INDUSTRIAL REVOLUTION

By the time of the Industrial Revolution, which was well underway by the 19th century, many of the technical and aesthetic concepts of craftsmanship were in a state of flux. Thousands of individual craft workers were initially put out of work by the advent of power machinery and mass production; goods and manufacturing methods were now directed toward producing identical objects available to great numbers of people rather than unique objects custom made for individuals. In the process, hand-craft traditions practiced over centuries were abandoned or greatly transformed. Because the changes came so rapidly and replaced a way of thinking that took thousands of years to form, society did not know how to design in collaboration with the modern machine. Although much understanding has been gained over the last hundred years, recent developments in technology—the computer, for instance—make it necessary constantly to reevaluate our thinking in relationship to various tools.

Handcraft and the Machine

It is revealing to look at the issue of ornamentation during the early stages of the machine age. The industrialist's first concern was a product's low unit cost, and this was achieved by producing large quantities with minimum labor. A hundred spoons could be made by machine more quickly than a craftsperson could make one, and they could be sold for a fraction of their former price. But cheapness was the main virtue of the early stages. Through long years of traditional work with their materials, craftspeople had become competent designers, but by fighting instead of accepting the machine, they left it without a master. Design degenerated; ornament, as profuse as it was senseless, took its place. Ornamentation had been used meaningfully in the hand crafts, because it took time and skill. But the machine could cover any object with curlicues in a few seconds. Because it was so fast and easy, ornament became an obsession (Fig. 129) and was indiscriminately applied to everything. It became the symbol of "art"; even worse, it was often used to disguise cheap materials and poor workmanship. Contemporary trends toward severe simplicity are in part the last vestiges of a reaction against 19th-century abuse of ornament.

Over time, however, conditions changed. Manufacturers began to realize that quality was as important as quantity and cheapness. Some artists recognized that the realities of mass production called for a new design approach. Through their help, machine technology began to be harnessed to raise the aesthetic level of many products appearing on the market.

One early artist who helped bridge the gap between fine hand craftsmanship and machine technology was Louis Comfort Tiffany, an American glass designer. When electric light bulbs began to replace the older gas lamps, unique problems were presented to designers and manufacturers of the era. Gas lamps were fixed to the wall and provided a gentle, radiated illumination. Electric illumination by contrast was harsh and brilliant and, with electrical cords, could be placed anywhere. Tiffany devised a series of organically inspired hanging

129. American Chair Company. Patent chair with centripetal springs and railroad seats. 19th century.

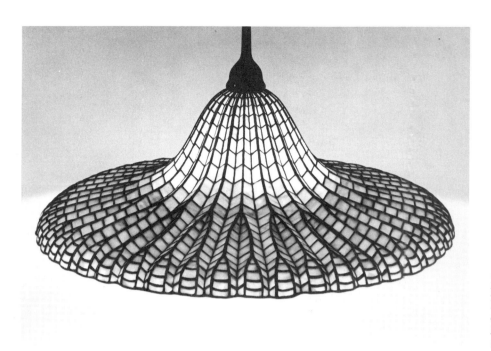

130. Louis Comfort Tiffany. Hanging "Lotus" lamp. c. 1905. Favrile glass and metal, diameter of shade 31½" (80 cm). Museum of Modern Art, New York (Joseph H. Heil Fund).

lamps (Fig. 130) that solved many of the problems associated with electric light and power. His beautifully colored opalescent glass shades softened and diffused the light; the cord-suspended fixture could be placed anywhere light was needed.

By the early 1900s, the thinking of some progressive designers had been shaped firmly by the new machine technology and the demands of mass production. In 1918 Gerrit Rietveld designed an unusual chair that was a radical departure from hand-crafted furniture of the past. His experimental "red-blue chair" (Fig. 131) uses standard-size lumber easily assembled into simple, rectangular shapes. Rietveld ignored the functional need for comfort to make a powerful statement about design for mass production by using simple, standardized shapes. Admittedly, this is not a chair to sit in; it is rather a sculptural manifesto for machine-inspired design. Rietveld's chair incorporates no labor-intensive shaping or joining processes, and it is strikingly devoid of superimposed ornamentation or organic allusion. This severe design reflects the nature of "functional" thinking, which was to exert a powerful and lasting influence upon 20th-century product design.

The Machine Aesthetic: Industrial Design

In many ways, the history of industrial design is linked to the **Bauhaus,** a German design school founded in 1919 by Walter Gropius. During its relatively short span of operation—which ended in 1933 when it was closed by the Nazis—it attracted Europe's most outstanding students and teachers in the fields of painting, craft, architecture, and design. Among the many distinguished international figures who taught there were Ludwig Miës van der Rohe, Paul Klee, Wassily Kandinsky, Josef Albers, and Marcel Breuer.

Under the direction of architect Walter Gropius, the school's curriculum and philosophy called for the complete integration of the arts and technical science. Ultimately, the school believed that social as well as aesthetic gains could be

derived from this new alliance; for only through a full acceptance and enlightened use of the machine could products be manufactured that would achieve high standards of design at minimal cost. The Bauhaus' dream was to make well-made, beautiful products available to large numbers of people.

Quite often this dream was realized. Many of the industrial designs created by this pioneering school look as contemporary today as they did sixty years ago. Marcel Breuer's bent metal chair (Fig. 132) is a case in point. Conceptually it relates to Rietveld's cubist-inspired chair in its simplicity and standardization of easily manufactured and assembled elements. It is, however, far more comfortable to sit upon and visually elegant, which accounts for the fact that the chair is still available today, selling for well under a hundred dollars. Few pieces of furniture can approach it in terms of elegance, comfort, and price.

Design and Engineering

Every product that appears on the market today has been influenced by the work of professional designers. Spurred on by the enormous sales slump of the Great Depression, manufacturers in the 1930s turned to industrial designers who reshaped products to make them look more attractive and to cut their production costs. By midcentury industrial design had become a major factor in the entire economy of the industrialized world.

As products and manufacturing processes became more complex and jobs more specialized, industrial designers found they were needed to play an interpretive role among various members of the industrial production team. Their job evolved from cosmetically "streamlining" the exterior casing of a product to being involved with the total design on many levels. Henry Dreyfuss—a leading designer and the developer of the classic Bell telephone—was a strong proponent of this comprehensive approach. In *Designing for People*, one of the best books about the profession, he states:

> The Industrial Designer began by eliminating excess decoration, but his real job began when he insisted on dissecting the product, seeing what made it tick, and devising

below left: **131.** Gerrit Rietveld. *Red-Blue Chair.* 1917. Painted wood. Stedelijk Museum, Amsterdam.

below **132.** Marcel Breuer. Side chair. 1928. Chrome-plated steel tube, wood, cane; height 32″ (81 cm). Museum of Modern Art, New York (purchase).

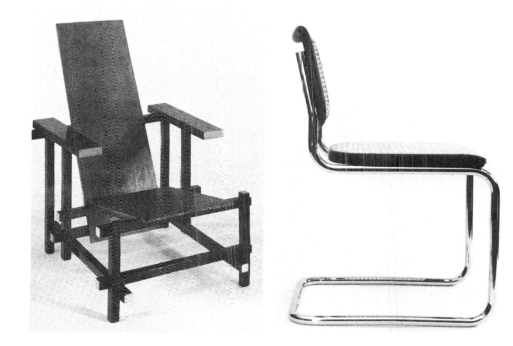

means of making it tick better—then making it look better. He never forgets that beauty is only skin deep. For years in our office we have kept before us the concept that what we are working on is going to be ridden in, sat upon, looked at, talked into, activated, operated, or in some way used by people individually or en masse. If the point of contact between the product and the people becomes a point of friction, then the Industrial Designer has failed. If, on the other hand, people are made safer, more comfortable, more eager to purchase, more efficient—or just plain happier—the designer has succeeded. He brings to his task a detached, analytical point of view. He consults closely with the manufacturer, the manufacturer's engineers, production men, and sales staff, keeping in mind whatever peculiar problems the firm may have in the business or industrial world. He will compromise up to a point but he refuses to budge on design principles he knows to be sound. Occasionally he may lose a client, but he rarely loses the client's respect.

The story of Dreyfuss' professional relationship with the Bell Telephone Company is an interesting one and significant in terms of the maturation of the entire industrial design profession. During the 1920s, most manufacturers conceived of designers as "commercial artists" who embellished their products. Engineering departments determine how products worked mechanically and then called on designers to create a cosmetic casing to increase the attractiveness of the object and boost sales. Dreyfuss, however, wanted to go beneath the surface requirements to create something that worked as well as it looked.

In 1927 the telephone company introduced the first desk phone with the hearing and speaking sections in one piece (Fig. 133). Neither the public and Bell telephone, however, were completely satisfied with the product; it was awkward looking and difficult to use.

Several years after the desk phone's introduction, a representative of the phone company called upon Dreyfuss in his spartan office—which consisted at the time of a borrowed card table and folding chairs—to offer him a thousand-dollar commission to submit his conception of the ideal desk phone. Nine other designers and artists were also asked to submit drawings and models. Despite his need for the money and the prestigious job offer, Dreyfuss turned it down because he felt that the telephone should, in his words, "be developed from the inside out" and this required close collaboration with Bell engineers. A year later the phone company conceded that Dreyfuss was right. Although some of the designs submitted looked interesting, they were impractical to manufacture and uncomfortable to use. Working with company technicians, Dreyfuss developed a desk phone in 1930 (Fig. 134) that, with minor changes, is still being used today.

right: **133.** Bell Telephone. Desk set. 1928. AT&T Corporate Archive, reproduced with permission.

far right: **134.** Bell Telephone. "500" type desk set. 1949. AT&T Corporate Archive, reproduced with permission.

Art and the Environment

Product Design and Ethics

Victor Papanek is an unusual designer and college educator who believes that an overwhelming percentage of today's products are made to look good from a formal aesthetic perspective, but in fact contribute little to society in terms of real utility. Papanek believes that designers of mass-market goods have a moral responsibility to the environment—a responsibility that goes far beyond the success or failure of a product in the economic marketplace. In his book *Design for the Real World* he states that the designer's

> social and moral judgment must be brought into play long *before* he begins to design, since he has to make a judgment, an a priori judgment at that, as to whether the products he is asked to design or redesign merit his attention at all. In other words, he has to decide whether his design will be on the side of the social good or not.

The real problem in a complex, open-market society such as ours is just what constitutes "social good" and what does not. This difficult question has no clear answer. But in matters of product safety, the line is drawn more distinctly; Papanek is extremely critical of much so-called safety equipment. This outspoken critic claims that many industrial safety designs are inadequate. All too commonly found on the market, he believes, are hard hats that offer minimal impact protection from falling objects, safety glasses with lenses that scratch, shatter, and crack the nose bridge under a moderate blow. Papanek's litany of unsafe designs is quite long and includes steel-reinforced "hard shoes" that do not provide enough impact resistance to be useful, cabs in long-distance trucks that vibrate so much they damage a driver's kidneys in four to ten years, and—most sobering of all—the poor crash safety record of almost every automobile now on the road. To be sure, the question of how much protection should be built into a car is a complicated issue involving economics, psychology, and politics; but Papanek nevertheless raises questions about product safety that are usually ignored in the marketplace. The value of his critique is to make us question issues of *use* and *need* rather than merely focusing on looks alone.

Papanek also believes that enormous segments of the world population are almost totally ignored by manufacturers and most industrial designers: people in low-income groups; underdeveloped nations; children; and the elderly and invalids who need special furniture and appliances to make a difficult life easier. To fulfill these special needs he and his design students have, over the years, devised any number of truly useful and ingenious products that combine social function with low cost—also an important factor. If the expense of a product is well beyond the means of an individual, its design excellence and usefulness are academic issues. With this in mind, Papanek refuses to copyright or patent his socially useful designs and is happy to supply manufacturers with detailed plans if they wish to make them.

One of the most beautifully conceived and elegantly simple designs Papanek has ever come up with would never win any awards of excellence for looks alone. In fact it is intriguingly homely. When Papanek presented a slide showing of his work at a design school in Ulm, Germany, most of the art professors walked out in protest when it was shown. Nearly all of the students stayed, however, spellbound by this unusual designer and his striking products.

What caused all the fuss was a radio receiver Papanek and George Seegers, a graduate student, designed for developing nations. It could be manufactured on a cottage-industry basis in the early 1970s for the unbelievably low cost of 9

135. Victor Papanek and George Seeger. Radio receiver ("Nine-Cent Radio") designed for use in the Third World. It is made of a used juice can and uses paraffin wax and a wick as power source. The rising heat is converted into enough energy to power this non-selective receiver. Once the wax is gone, it can be replaced by more wax, paper, dried cow dung, or anything else that will burn. Manufacturing costs, on a cottage industry basis: 9 cents. Designed at North Carolina State College, 1969.

cents per radio (Fig. 135). The basis of this product is the availability of discarded metal cans—one of the most common items found throughout the world. Papanek's design is a paragon of simplicity that takes into account the realities of the environment for which he is designing. For instance, no tuning dial is necessary because most emerging countries have only one government-operated station. A single transistor powers the ear-plug speaker, which uses no batteries, making use instead of a simple thermocouple that converts heat from a paraffin wax flame into electricity to amplify the signal. Once the wax is consumed, the can can be refueled with more paraffin or with native fuels such as dried cow dung, bark, or wood. UNESCO, a development agency of the United Nations, distributed this kit to remote villages in Indonesia so that news, educational information, and emergency communications could be broadcast to outlying areas on a permanent basis.

When Papanek spoke at the design school in Ulm, he admitted that the radio lacked the "formal design" look we have become accustomed to in the West. However, the social value behind its ugliness might far outweigh the reasoning behind many of today's "beautiful" products, whose main utilitarian function is to generate cash flow.

Some people at Ulm suggested painting the can "Bauhaus gray," but this would add to the cost: When millions are made, even a few cents per unit adds greatly to the total cost. Furthermore, Papanek did not feel he had the right to determine what represented "good taste" to cultures far removed from our own. In response, the people of Indonesia have decorated their radios with lively ornamental motifs that reflect *their* social and cultural values, not ours (Fig. 136). Although Papanek's radio may not be beautiful in terms of surface finish, it has qualities of design thinking behind it that are elegant in their cost-effective cleverness and simplicity. In many needy areas of the world these products will make a strong contribution to the social good. Also, Papanek has

136. Victor Papanek's Nine-Cent Radio with users' decorations, Indonesia. 1969. UNESCO, New York.

allowed for infinite finish variation and customization—two features that are attractive to any consumer in any society.

International Product Design

Since the formation of the Common Market economic system in Europe decades ago, goods and products have traveled across international borders with increasing frequency and ease. No industrialized nation in the world today is entirely self-reliant. All depend to some extent on the exchange of products and services to bolster their economy. This is certainly true even in a country as large and self-sufficient as the United States. We watch the morning news on Japanese television sets, drink coffee imported from Colombia, climb into German-built cars—which run on Middle Eastern oil—and drive to our place of business. Other countries, in turn, rely on American products and know-how in everyday life.

In order to gain international acceptance in a highly competitive world, the products destined for export must be unusually attractive, efficient, and well-made. Industrial designers play an important role in the sales of these goods and thus affect the entire economies of nations. More and more manufacturers realize that quality of design, ease of function, and durable construction are the keys that unlock foreign and domestic markets. In this way artists and designers play a vital role in the economic well-being of a country—and greatly affect its quality of life.

American Design Along with Henry Dreyfuss, Charles Eames is ranked among the most distinguished designers America has produced. In 1940 this American architect-designer, along with Eero Saarinen, won the "Organic Design in Home Furnishings" contest sponsored by the Museum of Modern Art in

New York. The idea behind the competition was to promote modern design instead of the pseudostyles then in vogue. Over the next thirty years, Eames devoted himself to designing a variety of beautiful and comfortable pieces of furniture, many of which have become true classics of design.

His *Chaise Lounge* (Fig. 137) is a paragon of comfort, strength, and attractiveness. Eames believed that we sit and use furniture differently today than did people in the Victorian era. We expect a certain measure of informal accommodation in our furniture. The chaise lounge is designed to offer total comfort and relaxation from the pressures of the modern world. This distinguished designer also believed that modern furniture designs should have sculptural, elegant qualities that would allow them to fit easily into any contemporary interior. Technically this lounge is well constructed and makes appropriate use of a variety of materials, yet, like any thoughtfully designed art object, it has wholeness and unity. In structure it utilizes a nylon-coated frame supporting a body-contoured base covered with thick cushions of urethane foam wrapped in polyester fiber; it is luxuriously upholstered in black top-grain leather. It is not inexpensive, but its quality design features and fine materials should allow for a lifetime of use and enjoyment.

Although American industry enjoyed obvious advantages over its war-torn European competitors following World War II, that certainly is not the case today. Competition is keen, and U.S. corporations must come up with products that offer high performance and attractive looks. One of the leading technical areas of specialization in the United States is the computer industry. Recently the Hewlett-Packard Corporation introduced a remarkably powerful, com-

137. Charles Eames. Chaise Lounge. 1968. Leather, urethane foam, polyester fiber batting, nylon glides, nylon-coated base and frame; 2′4¾″ × 6′3″ × 1′5½″ (0.73 × 1.9 × 0.4 m). Herman Miller, Inc., Zeeland, Mich.

pletely portable, battery-operated computer that weighs only 8½ pounds (3.9 kilograms) (Fig. 138). A true lap computer, the HP-110 measures only 13 inches wide by 10 inches deep by 2⅞ inches high (33 by 25.4 by 7.3 centimeters), allowing it to be carried anywhere.

One of the most intriguing features of the HP-110 is the way its flat liquid-crystal-display (LCD) screen forms the top cover of the machine when it is in the closed position. An 80-character by 16-line screen displays the digital or verbal information to the operator and can be tilted in a nearly 180-degree arc to cut down on ambient light reflection. When the screen is lifted into use position, it also reveals a full typewriter-style 75-key keyboard and special function keys.

Designing this special computer required the integrated skills of both technical engineers and industrial designers. The fine performance and visual features attest to the skills of these professionals.

Italian Design The success story of Italian design during the last several decades is nothing short of remarkable: Italian architects, industrial designers, and graphic artists have created such high-quality products and services that demand for them is truly international. Architects from Turin fly to Brazil to build apartment and commercial complexes; the skillful designs of Italian graphic artists appear throughout the European continent; and some of the most elegant and beautiful furniture from design studios in Milan is shipped all over the world. Italy's furniture industry, in fact, is considered to be a world-class model for light manufacturing operations. Certainly this industry alone has accounted for a dramatic upsurge in the gross national output of Italy. Between 1970 and 1980, export value rose nearly ten times, making this country one of the leaders in world production; currently Italy exports 25 percent of its furni-

138. Hewlett-Packard HP-110 computer. 1984. 3 × 13 × 10″ (7.6 × 33 × 25.4 cm), weight 8 lbs 8 oz.) (3.86 k).

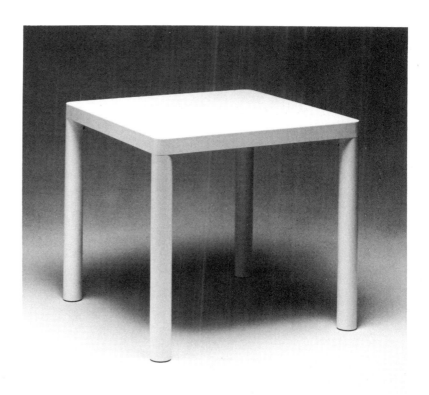

139. Anna Castelli Ferrieri.
Table, Item 4500. 1982.
Injection-molded plastic.
Kartell USA.

ture production, valued at $1.5 billion. Most of this success can be attributed to
the imaginative, disciplined designers Italy produces. According to the president
of Unionleggo, a confederation of smaller furniture manufacturers: "Our tradi-
tion of culture, good taste, style, and design is our treasure—it can be our
winning ace."

Like many producers of consumer goods, the Italian furniture industry has
had to respond to recent changes in the world economic climate. High energy
costs, a drop in domestic housing starts, and increased labor expense have all
created austere conditions in the marketplace. In order to stay competitive de-
spite these hardships, some manufacturers are calling for an even closer relation-
ship between designers and producers to raise the level of innovation, quality,
and cost-effectiveness still higher. Many knowledgeable observers believe that to
stimulate domestic and foreign demand for Italian furniture, designers must pay
even greater attention to aesthetic, functional, and technological features.

Kartell, a large furniture manufacturer committed to innovative, state-of-the-
art plastic fabricating techniques, commissioned Anna Castelli Ferrieri to design
a bright, attractive, moderately priced table that would disassemble easily for
shipment and could be set up instantly by the customer—without tools (Fig.
139). Ferrieri worked closely with Kartell's production engineers to design this
square plastic table, which was the first large-scale piece of furniture entirely
injection molded out of a sturdy, scratch-resistant material. (Injection molding
is an industrial fabrication process that offers many cost-effective benefits. The
savings can be passed on to the customer.) The legs are of an ingenious design;
to attach, they slip into cones that are a part of the molded base and thus require
no screws or adhesives to hold them firmly in place.

Although in this country the mental image conjured by the thought of plastic is often synonymous with "cheap," Italian designers have worked imaginately with this material for decades, refining its uses and forms. In their design studios this much-maligned material takes on unaccustomed traits. It becomes elegant, sturdy, beautifully colored and well suited to the expectations and demands of modern life. One reason for their success is that these designers approach their material with honesty and respect, two necessary ingredients for any good relationship. Rarely is plastic used to "fake" the appearance of wood or metal. Because of the design process, Ferrieri's table comes in a variety of muted or lively colors and can serve, for instance, as an informal kitchen table for a young married couple setting up a new household.

The aesthetic range of home furnishings from Italy is remarkably wide. Everything from exotic "new wave" designs featuring military camouflage paint to the most understated and tasteful designs is manufactured and marketed by this enterprising industry. Featured among the many choices of styles available to the consumer is the high-tech industrial look expressed by the *Tizio* lamp that Richard Sapper designed for Artemide, Inc. (Fig. 140). This particular product

140. Richard Sapper
for Artemide Inc., New York.
Tizio lamp. 1970. Metal alloy,
Durethan, halogen bulb;
maximum arm reach 37″ (94 cm).

is considered so visually striking and effective that it has been chosen to join the prestigious permanent design collection of New York's Museum of Modern Art.

By means of carefully balanced arms and counterweights, illumination can be placed exactly where it is needed. When the lamp is turned toward the wall it produces soft, indirect lighting; it also can be used as a spotlight to light a darkened corner or to provide direct, dramatic illumination.

To achieve this wide range of effects, *Tizio* makes use of a relatively new type of light source, the halogen bulb. To power this lamp, a special transformer is needed to step down a normal 110-volt alternating current to 12 volts direct current. Transformers are heavy because of their large core of wound wire, so Sapper incorporated this functional element into the base and thereby provided the weight necessary to support the overhanging arms. Rather than cover up and smooth over the working parts of this lamp, the designer *emphasized* those aspects in a bold yet elegant way.

Although many products are distinguished by their incorporation of new technical inventions—the halogen light bulb in *Tizio*, for instance—sometimes designers creatively refine existing materials and open up new uses for them. Superstudio is a group of Italian designers based in Florence whose creative collaboration on a number of architectural, city-planning, and product-design projects has won them world acclaim. This group believes that industrial objects must be conceived and thought of within the context of a complex global environment. For this reason, modular system structures make up the backbone of their design theory. The furniture shown in Figures 141–144 clearly reveals this thinking. By means of changing proportions and dimensions, the same materials are used to create four distinct pieces of furniture: a table, a desk, a bench, and a console. Simplicity is the keynote to these designs. Even the materials are simple—ordinary plywood covered by plastic laminates. But because of a sensitivity to concepts and details, the result is anything but ordinary. Superstudio silk-screened a gridlike surface pattern that visually relates to the modular design of the four pieces of furniture. By paying great attention to design details, the use of materials, and functional concerns, this unusual collective of Italian designers has created a furniture system of refinement and elegance.

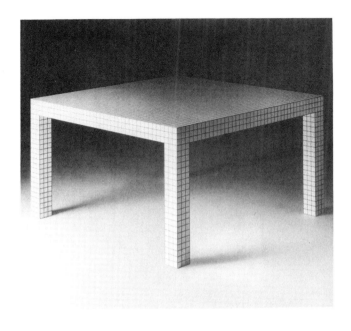

141. Superstudio. Quaderna table. 1970. Plywood construction covered with white plastic laminate, silkscreen printed with black squares; 43¼ × 43¼ × 28″ (110 × 110 × 71 cm). ICF, New York.

 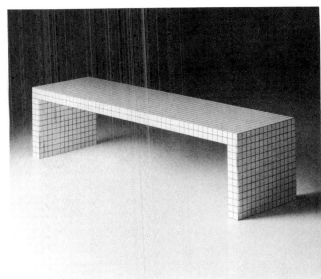

above: **142.** Superstudio. Quaderna desk. 1970. Plywood construction covered with white plastic laminate, silkscreen printed with black squares; 5'10¼" × 2'7½' × 2'4" (1.78 × 0.8 × 0.71 m). ICF, New York.

above right: **143.** Superstudio. Quaderna bench. 1970. Plywood construction covered with white plastic laminate, silkscreen printed with black squares; 1'4⅜" × 4'10½' × 1'3¼" (0.42 × 1.49 × 0.39 m). ICF, New York.

below: **144.** Superstudio. Quaderna console. 1970. Plywood construction covered with white plastic laminate, silkscreen printed with black squares; 5'10¼" × 1'4⅜' × 2'8¾" (1.78 × 0.42 × 0.83 m). ICF, New York.

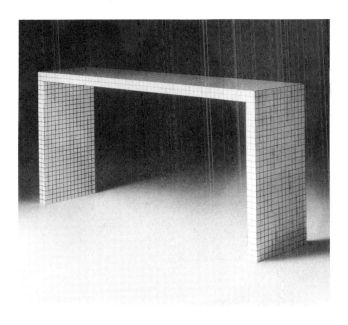

Piero Gatti, Cesare Paolini, and Franco Teodoro are a trio of young Italian architects who have designed an inexpensive and highly unusual chair called *Sacco* (Fig. 145). Believing that the cost of much quality furniture was beyond the means of many young people embarking on careers and living on modest incomes, they developed this relatively inexpensive and whimsical easy chair. Inside an inner envelope of Nailpelle are thousands of impact-resistant polystyrene pellets that move and conform to the shape of the person sitting in the chair. Many combinations of colors and textures are possible with *Sacco;* the manufacturer need only change the fabric covering the inner envelope to produce as many variations as are required.

The range of designs and products from Italy is enormous—everything from the most lavish custom-built furniture to inexpensive mass-produced articles almost everyone can afford. What links the best of these products is the quality of *thought* behind them: They are superior by design.

Japan—Designing for Contemporary Life Styles Japanese product design—although greatly affected by market tastes in the United States and Europe—is influenced by two interrelated factors, one indigenous to its culture, the other geographic. Japan enjoys a strong historical tradition of simple, elegant packaging; and because they are a small island nation with limited resources and space, the Japanese are particularly directed toward compact, cost-

145. Gatti, Paoline, and Teodoro. Sacco easy chair. 1969. Envelope of Nailpelle, fabric, or leather containing polystyrene pellets; 40″ high (101.6 cm). ICF, New York

146. Sony's FH-7
portable audio components. 1984.
23 × 14½ × 11⅜"
(58 × 37 × 29 cm),
weight 36 lbs. 6 oz. (16.5 k).

effective design solutions. This national heritage is reflected in the many well-designed products that compete in the international marketplace—electronic goods in particular. Over the past few decades, Japanese designers have directed their skills toward refinement and user efficiency rather than bold innovation. Japanese producers are market driven and focus to a remarkable degree on the present and future needs of the consumer.

The story of how the Sony corporation developed the transistor radio and revolutionized the consumer electronics industry is an interesting one. It also reveals a special facility Japanese designers have for adapting technology to the needs of people. Bell Laboratories, a U.S. company, developed the transistor in 1947. It saw no particular consumer applications for this new device and sold the manufacturing license to the founders of Sony for only $25,000 in 1952. Several years later, hand-held radios were a hit throughout the world; the rest is history. Today, Japanese product designers and electronic engineers have thoroughly refined this technical breakthrough and now manufacture state-of-the-art audio and visual components that sell for much less money and are considerably more compact than components appearing in the marketplace only ten years ago (Fig. 146). Accurate, powerful audio amplifiers can now be held in the palm of a hand and installed in a variety of locations.

Some professional observers, however, perceive limits to the "thinner and smaller" design philosophy. Kiyoshi Sakashita, director of Sharp's product design operations, sees the emphasis of his division's efforts shifting from technological hardware to human factors in the near future. In other words, designers will have to pay even greater attention to how people use these machines and how these products relate to their evolving life style. The manager of industrial design for Panasonic's video recorder division agrees, and states: "For the future we must change our base of operations. I think from now on, designers must research and assess *human value*."

Now that the impact of the second wave of industrial technology (electronics and information processing) has been felt, the designer must consider the utility of many possible new products and take into account their social impact as well. Many leading designers in Japan believe that the design focus on appearance will take a back seat to the human elements of function and utility. This has certainly been the case in the automobile market. Consequently, consumer products of the future might be more sophisticated technically, and less obtrusive visually.

Contemporary Office Design

With the rapid adoption of computers and high-speed data networks, some experts have predicted that a healthy percentage of office/knowledge workers in the future will accomplish their tasks at home in front of their terminals, saving commuting time and money. Although such a plan makes sense for special groups such as the physically disabled and parents with small children, it seems unlikely that the majority of workers would be interested in such a scheme. For one thing, loss of personal contact would further separate individuals isolated too much as it is by a society short on nurturing and supportive institutions. For many people, work is the basis of communal life. If such a stay-at-home work plan were implemented, it is easy to imagine people alone, staring at their diabolically glowing video screens and slowly going mad. Research in West Germany and Scandinavia indicates, furthermore, that an operator working at home linked to the office by a data terminal would not necessarily be more productive. The problem boils down to a simple fact: People do not want their home, work, and leisure environments to be the same. What they would like is a physically and psychologically supportive work space in which they might work efficiently and happily.

Contemporary designers of office space need to take into account the delicate balance between a corporation's need for productivity and the individual's need for dignified, humane working environments. Crowded, noisy, distracting spaces found in most open office plans may appear cost effective and efficient on paper, but in practice—particularly with skilled information managers—this design approach may prove expensive in the long run by greatly reducing productivity. The development of new information-processing machinery might make many of the reasons behind the open office plan invalid. Immediate *physical* access to various personnel and departments may no longer be necessary. With communication and access to information potentially improved by technology, corporations might give a higher priority to the individual needs of their most valuable resource—people.

The architectural firm of Kevin Roche and John Dinkeloo helped a company do just that when it planned the new Union Carbide corporate headquarters building in Danbury, Connecticut (Fig. 147). Their unusual design provided for a total of 2358 private offices, all a most generous size (in an egalitarian gesture, Union Carbide gave all managerial levels the same size office space) and all with windows facing toward a beautifully wooded parkland. Automobile parking space is cleverly located in the center of the building so no one has a view of cars and asphalt. The most extraordinary feature of the entire complex, however, is the interior design of the offices themselves. Each one was personally selected by employees from among fifteen widely varying designs! Before the move from the old corporate headquarters in downtown Manhattan, fifteen full-scale mockups went on display—like stage sets—and employees were given the opportunity to view them at leisure and make their choices, including choice

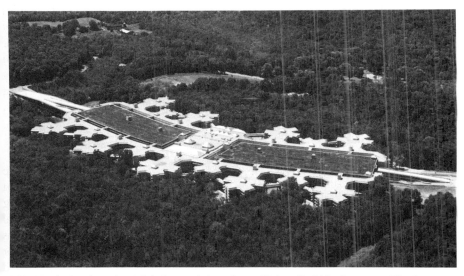

147. Kevin Roche John Dinkeloo and Associates. Union Carbide Corporate Headquarters, Danbury, Conn. 1982.

of various light fixtures, area rugs, and furniture. No one complained about the lack of selection—designs ranged from the proper and traditional to the modern and high-tech (Figs. 148, 149). Restrained design intervention by the architects and respect for individual choice seem wise in this particular design problem. When people feel they have had a hand in the design of their surroundings, generally they are more satisfied with the results.

It is true that most of the offices at Union Carbide were designed for middle- to upper-level management employees rather than for line staff, and that the company's outlook was not entirely altruistic: They hope that increased worker

below: **148.** Kevin Roche John Dinkeloo and Associates.
Traditional office, interior, Union Carbide Corporate Headquarters. Danbury, Conn. 1982.

below right: **149.** Kevin Roche John Dinkeloo and Associates.
Modern office, interior, Union Carbide Corporate Headquarters, Danbury, Conn. 1982.

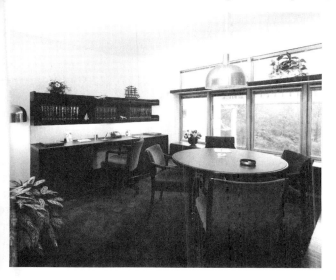
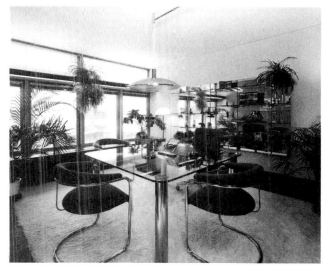

productivity and the ability to attract and hold key personnel will more than pay for the added costs of this design. Taking all these factors into consideration, it might be argued that this kind of quality design and architectural thinking does not *cost,* it *pays.*

Throughout this chapter one of the key factors shown to determine high-quality utilitarian design has been coordinated teamwork. Today many designers and architects are forging new alliances with engineers and business people, creating highly skilled work teams able to analyze and resolve design problems from multidisciplinary points of view. Although manufacturers and the designers who work for them are by necessity vitally concerned with product sales and profitability, they have also come to realize that human values pertaining to aesthetics, utility, and lasting satisfaction hold the key to long-term earnings and economic health. To a great extent, we, the consumers of these products, decide the ultimate success or failure of a design in the marketplace; and it is also up to us, as users, to make certain that our relationship to new goods and machines is a personally beneficial and healthy one.

Chapter 7

Visual Communications

The physical environment of the late 20th century is dominated by an incredible array of illustrated printed material, visual signs, and corporate symbols. These messages inform us about products and services, safely control the flow of automobile traffic, and add much to our enjoyment of leisure time. Most of these visual communications are planned and created by specialized artists known as graphic designers. Their job is to focus the public's interest on a product, service, or idea—not an easy task, considering the enormous amount of visual information competing daily for our attention.

The quality of graphic design and the creative flair found in certain advertising campaigns and packaging designs often determine the success or failure of multimillion-dollar corporate ventures. Few businesses today fail to appreciate the important role that good visual communications play in their operations. From the development of an easily "read" product trademark to the efficient visual organization of offices, design professionals play an indispensable role in modern commerce.

The range of work done in graphic design is enormous. Major divisions in this field include typography, trademarks, packaging, posters, book design, magazine advertisements, television commercials, and display design. Increasing consumer sophistication, the complex nature of many goods and services, and the intense competition of advertisements all have given rise to a strong reliance on the printed word. Typography—the style, arrangement, and visual appearance of alphabetic letters—is found in all areas of graphic design. Sometimes visual "images" are created through typography alone, but in many cases it teams up with pictorial images to create effective verbal-visual communications.

TYPOGRAPHY

Although it may be true, as Confucius said, that a picture is worth a thousand words, it is important to remember that the printed word conveyed this thought to you. Of course, *both* visual and verbal means of communication are important. To rely exclusively on either one or the other would greatly diminish our

150. Herb Lubalin. SH&L typeface. c. 1962. Sudler & Hennessey, Inc., New York.

power to convey a variety of messages and concepts effectively. Sometimes the creative use of typography alone (Fig. 150) can create a striking visual image so the designer need not choose between the two forms of communication.

As you look at the different kinds of typefaces used in magazines, you will probably think that there are hundreds of different ones. There are—but almost all of them relate to one of four basic families.

𝕭𝖑𝖆𝖈𝖐 𝕷𝖊𝖙𝖙𝖊𝖗　　ROMAN　　SANS SERIF　　*ITALIC*

Black letter type, introduced by Gutenberg in imitation of hand lettering, is the earliest. It is seldom used today.

Roman, based on the inscriptions carved on Roman monuments, was developed in the 15th century. Some lines are thick, others thin; and most of the letters have *serifs* (small ornamental projections at the tops and bottoms).

In *sans serif* (or *Gothic*), all lines have equal thickness; there are no serifs, or at most only vestiges of them.

Italic, of recent origin, has slanted letters, like those in the first word of this sentence.

Three other distinctions are worth mentioning. The *weight* (lightness or heaviness) of type is described in four standard classifications:

lightface　　standard　　**boldface**　　**extrabold**

Letters also vary in *width;* and, again, there are four categories:

extended　　standard　　condensed　　extra-condensed

By combining the many traditional and modern typefaces in existence with varying weights and widths, a graphic designer can produce an almost limitless number of creative visual effects.

In the field of marketing, because of the great similarity among many products such as light bulbs, toothpaste, and soft drinks, trademark differentiation is needed to create instant product recognition. Manufacturers often seek to promote brand loyalty and continued sales through constant advertising repetition and the development of a conceptual "image."

This consistent image is often created by designing a visually distinctive trademark to be used in all of a manufacturer's advertising, as well as on its packaging, company trucks, and business stationery. For instance, the distinctive label and color of the Coca-Cola Company is recognized instantly throughout the world (Fig. 151) and has maintained a stylistic consistency over the years.

Corporate Design: A Case Study

Recently, Milton Glazer, the dean of American graphic designers, was asked to renovate the corporate design program of the Grand Union supermarket food chain. What intrigued Glazer about this assignment was its enormously diverse range: Everything from store layout and corporate logo to house-brand labels was to be included in this remake. Viewing the results of Glazer's work offers us the opportunity to understand better how a graphic designer contributes to the effective operation of a large corporation.

Glazer's job with Grand Union came about because of his work redesigning the layout of *L'Express,* a French news magazine. Sir James Goldsmith, the entrepreneur-owner of *L'Express,* also owns the Grand Union supermarket chain, and he was so impressed with Glazer's remake of the magazine that he asked him to redesign the food corporation. Although Glazer has been primarily a magazine designer, he has been fascinated with food and markets for years and believed the Grand Union commission offered an interesting challenge.

Grand Union's Corporate Logo One of the first important decisions Glazer had to make was to determine the trademark, or "logo," for the company. Since the corporation had been in business for quite some time as "The Grand Union," it seemed unnecessary to develop a trademark independent of the company name. Therefore Glazer chose a bold, sans-serif typeface and placed an enlarged red dot within the "A" in "Grand" (Fig. 152). As we can see,

above: **151.** Coca-Cola is a soft drink known throughout the world by its distinctive bottle and label.

left: **152.** Milton Glazer. Grand Union logotype. 1981.

153. Milton Glazer.
Grand Union storefront. 1981.

Glazer's plan allows many variations and color combinations for these two words, but the red dot consistently appears in all of them. This theme and graphic device also is used promotionally within the store, as well as in all newspaper advertising: Large signs proclaiming "When you see the dot, you save a lot" point out money-saving specials to customers.

Even the façades of some of the newer stores incorporate the distinctive Grand Union logo. At the Paramus, New Jersey, store, the name is emblazoned on a large awning (calculated to evoke nostalgic memories of old-time grocery stores), which transforms the building's façade into a large identifying sign (Fig. 153). In all, the consistent use of the Grand Union logo creates a feeling of corporate unity and achieves high consumer recognition.

Grand Union's Packaging Design Glazer's strategy in terms of packaging house-brand products was to relate to the competition rather than develop a consistent "in-house" look. Since the company strives to offer products that are equal in quality yet priced lower than nationally advertised brands, it made sense to reflect that philosophy in a variety of attractive labels and packages.

Figure 154 illustrates a group of designs used on a range of Grand Union jams. Although the logo of the store appears on all of these products to identify them as money-saving house brands, this aspect of the design has been played down. Instead of designing generic labels, Glazer achieves a distinctive "country" feeling—communicating old-fashioned values of wholesomeness and quality—through the delicate overall pattern in the background and the 19th-century script used for the names of the flavors. To identify the contents of the jars further, illustrations of the fruit are also featured on the label.

Variety and imagination characterize Glazer's approach to packaging design in the Grand Union project; every product is different and requires its own special approach. To package lasagna noodles effectively, Glazer shifts into a visually upbeat, ethnic style (Fig. 155). A dynamic checkerboard of red, green, and white, the national colors of Italy, lend an authentic, festive note to this clever package. In order to titillate our taste buds and increase sales potential, Glazer realistically creates the illusion, through a cut-away view, that the pack-

left: **154.** Milton Glazer. Grand Union jam packaging. 1981.

above: **155.** Milton Glazer. Grand Union lasagne packaging. 1981.

age contains the finished product—baked lasagna. The only thing missing in this persuasive package design is the aroma of this dish.

Throughout the Grand Union chain of supermarkets, Glazer's skill as a thinker and designer are very much in evidence. To alleviate the boredom of row upon row of aisles, he occasionally opens spaces into "piazzas"; specialty areas, such as bakeries and wine departments, have been designed as attractive stores within stores (Fig. 156). Free recipes are offered to the customer in each department as part of the company's commitment to "be on the consumer's side."

Judged from both an economic and aesthetic point of view, Milton Glazer's project to redesign the corporate program of the Grand Union has met with unqualified success. Sales have responded favorably to the new look, and customers report that they find the new design features of the stores enjoyable and helpful. This proves that quite often the key to corporate excellence and profitability is highly dependent on effective visual design.

156. Milton Glazer.
Deli Corner at Grand Union. 1981.

GRAPHIC DESIGN

Although typography alone is capable of conveying a strong visual "image," nothing communicates as universally as a pictorial image. European traffic signs are a good example of the way symbolic images can be used as a language. Because of the geographical proximity of its many nations with many different languages, Europe has long recognized the need for non verbal visual communication: Highway signs throughout the continent employ easily recognizable symbols. Recently, because of increased international trade in this country, the U.S. Department of Transportation sought to develop a system of signs for foreign travelers that would be used at airports and train stations throughout the country. The American Institute of Graphic Arts was called upon to undertake a study of international signs and symbols and to make recommendations. After a study of existing systems, the institute's compilations went to five distinguished designers who determined the message categories, for example, public services, concessions, travel document processing, and general regulations. The design firm of Cook and Shanosky Associates was then commissioned to work out the details. Figures 157, 158, 159, and 160 reveal the legibility and effectiveness of some of their final designs. By presenting simple pictographic images of familiar objects and activities, signs enable travelers of any nationality easily to determine where to locate a phone (Fig. 157), rent a car (Fig. 158), find the customs inspection area (Fig. 159), or where smoking is prohibited (Fig. 160).

Book Design

Books are packages of a sort, containing large amounts of carefully organized verbal and visual information. The cover is an all-important point-of-sale feature that can call attention to the subject and entice the casual browser into picking up the book and examining the contents. The jacket cover of *First Person America* (Fig. 161), designed by Paul Gamarello, admirably conveys the thematic contents of this book. To communicate the fact that much of the book's written material consists of first-person reports recorded in the 1930s, Gamarello has incorporated historic photographs of people taken during this era. A particularly effective integration of typography and image occurs in this design; images of people have cleverly replaced the upper-case letters *I, O,* and *M* in the title, informing the potential book buyer that this is the recorded history of everyday people.

Although the design of recognizable trademarks, symbols, and packages acts as a strong consumer incentive to buy, producers know that attractive packaging

left, top to bottom: **157.** Cook and Shanosky. Telephone symbol designed for U.S. Department of Transportation. 1982.

158. Cook and Shanosky. Car rental symbol designed for U.S. Department of Transportation. 1982.

159. Cook and Shanosky. Customs inspection symbol designed for U.S. Department of Transportation. 1982.

160. Cook and Shanosky. "No Smoking" symbol designed for U.S. Department of Transportation. 1982.

Art and the Environment

alone is not sufficient means of reaching mass markets in today's competitive world. That is why they turn to the field of advertising.

ADVERTISING

Advertisements are so much a part of contemporary life that we tend to take them for granted. Until the Industrial Revolution and the rise of mass production, however, they were limited to potter's trademarks and other simple identifying symbols. The invention of movable type made printing affordable, and, in the 16th century, posters and handbills started appearing with regularity in England.

Today, advertising is an international phenomenon of tremendous proportion; and, although it is a necessity to modern business, it is also costly. One full-page black-and-white advertisement in a widely circulated magazine can cost over $75,000. A 30-second prime-time spot on network television is even more costly and can run into hundreds of thousands of dollars. With this kind of money at stake, ineffective advertisements are high-priced mistakes. Hiring the best visual communicators—at commensurately large salaries—therefore makes sense for many large companies.

More than a few corporations are now budgeted to spend over $100 million a year on advertising; the logistical support, management, and evaluative procedures behind this communications effort are truly enormous. Advertising agen-

161. Paul Gamarello. Jacket design for *First Person America*. Reproduced by permission of Random House, Alfred A. Knopf, Inc.

cies—companies that conceive, design, and implement ad campaigns on a fee basis—are complex organizations encompassing many departments: research, production, artwork, copy writing, legal counsel, public relations, and accounting, to mention only a few. Of course, all of the behind-the-scenes work that goes into an advertisement is extremely important, but visual artists are often responsible for much of the thematic content and final form of advertisement. Without them, the cleverest jingle or most persuasive copy would look unappealing and fail to gain our attention.

Illustration

Illustrations play a vital role in the success of most advertisements. Often a striking photograph or piece of artwork captures our imagination in a way that becomes unforgettable, significantly aiding the purpose of the message. Also, virtually every magazine and newspaper we encounter today uses some form of image to accompany the text. Not only does this artwork, consisting mainly of photographs and painted or drawn illustrations, make the reading material more interesting, it also aids in the comprehension and assimilation of complex information as well. Illustrational artwork plays an important role in setting the mood for a story or attracting our attention to magazine covers and advertising campaigns.

One of America's best known illustrators was Norman Rockwell. For decades his humorous, nostalgic, and poignant magazine cover illustrations for the *Saturday Evening Post*—now defunct—amused and charmed millions of people throughout the country. Rockwell was a modern descendant of a long line of genre painters dating back to the 17th century who through their art told stories and recorded everyday occurrences. All of the illustrations this artist did depict some aspect of Americana and render it with high wit and details of stunning realism. And it is through the careful editing and lucid presentation of these details that the originality of Rockwell's gift as an illustrator is most strongly felt.

100th Year of Baseball (Fig. 162) is a *Post* cover the artist did in 1939. It is loaded with choice visual and thematic elements. The pitcher's striped socks, belt, and cap vividly stand out against the white background; his squinting eye shows dogged determination; and his uplifted leg frames the intently peering face of the cigar-chewing umpire. All of these elements have been fused into an elegant composition that celebrates with high style the hundredth anniversary of America's favorite pastime.

Although many illustrations in magazines and books are executed with paint, pen, watercolor, and pastel, photography is used quite often to create effects as dramatic as those of the traditional media. In the hands of an experienced photographer the camera is capable of creating a variety of visual effects and moods. News illustration usually demands sharp, straightforward images that communicate with a minimum of ambiguity and a maximum of clarity. However, sometimes the particular needs of an advertising client call for an illustrational photographic approach that evokes mystery, elegance, and a flair for dazzling visual effects. The L'Oreal magazine advertisement shown in Plate 21 (p. 165) makes use of just such elements to capture our attention even among other ads clamoring for readership.

Producing an advertisement such as this calls for the team effort of many individuals. Marketing specialists analyze the relationship between the audience for whom the message is directed and the client's product. Many meetings are

above: **Plate 21.** Shadow Riche color photo for advertisement of L'Oréal cosmetics. George D'Amato, art director; Herb Green, writer; Irving Penn, photographer. Used by permission of Irving Penn and L'Oréal Corporation.

below: **Plate 22.** Poster advertising The Marina at Bay Street Landing. Steve Erenberg, art director; Ed Lindloff, artist.

The Marina at Bay Street Landing, St. George, Staten Island

Plate 23. Cambridge Seven Associates. Interior, National Aquarium, Baltimore. 1981.

held between the advertising agency that produces the ad and the corporate sponsor. Everything is planned and researched; little is left to chance. The enormous costs involved to produce and run a major ad preclude a hit-or-miss approach. The art director, in this case George D'Amato, is largely responsible for the way an ad looks and supervises the creation of the illustration, layout, and typographic design.

Initial planning for an advertisement is not necessarily concerned with its look. The task and role of communication must first be considered, and then a specific graphic solution is developed. It is not enough for an ad to look appealing; it must also present the desired message to the potential customer in an effective way—above all, it must sell.

This particular advertisement and campaign was developed when L'Oreal, a French-based cosmetics company, became interested in creating a new look for its product through revised packaging design and magazine advertising. Because of their European background, L'Oreal decided upon a strong, visually uncluttered, posterlike design approach reminiscent of graphic styles seen in Germany, Switzerland, or France. The goal of this new visual look was to develop a "trademark" image for the company—one that would, in time, be instantly recognizable to its customers.

Irving Penn, a well-known fashion photographer, was asked to interpret the design concept visually and create the illustrations. Penn's dramatic close-up of a woman holding a compact mirror that reflects her made-up eye dominates the design of this ad. Through this illustration the client succeeds in doing far more

162. Norman Rockwell. *100th Year of Baseball.* Cover for Saturday Evening Post, July 8, 1939. National Baseball Hall of Fame and Museum, Inc., Cooperstown, N.Y.

than telling us about the attributes of the product: It shows us quite clearly and alluringly the benefits of using "Shadow Riche" eye makeup. Penn's lighting and composition effectively reveal the iridescent, satinlike quality of this eye shadow. Soft purples blend with warm, dusty reds to create an intriguing interplay of color and light. In order to avoid distracting from the striking image of the eye, which appears to be surrealistically floating in space, the fingers holding the mirror are cast in shadow. Furthermore, to reinforce the emphasis on the eye and its makeup, and to create a feeling of luxury and elegance, much of the space in this design is open and left white. Copy is also kept to a minimum and tersely promises "the most eyeopening results" for the woman who uses this product.

Everything about this magazine ad is designed to appeal to a style-conscious audience interested in luxury and the enhancement of feminine beauty through the use of cosmetics. Penn's meticulously composed and lighted photograph becomes the illustrational centerpiece through which the advertisement communicates to its intended audience and, the client hopes, garners sales.

The applications of illustration in the graphic design world are not limited to large circulation magazines and clients with six-figure advertising budgets. Barry Rubin, a certified public accountant from Minneapolis, commissioned the design team of Brian Stewart and Brooke Kenny to create the distinctive and appealing business letterhead shown in Figure 163. A cartoon line drawing of Mr. Rubin is shown, standing above his name, efficiently directing "traffic," which in his line of work is numbers and figures. As the numerals leave the disordered pile on the left, they obey his direction and dutifully line up in the

163. Letterhead design for Barry Rubin, C.P.A. Brian Stewart, art director; Brooke Kenny, artist. Courtesy Schweitzer Rubin Gottlieb & Karon, Minneapolis.

right in ordered columns. This friendly and whimsical approach to a business letterhead allows Rubin to "humanize" and enhance his public image as an accountant (a profession usually pictured as sober, serious, and perhaps a bit humorless) and thus put potential clients at ease. Of course, too much humor inserted into a business situation might cast doubt upon the effectiveness of a professional operation, but this ad strikes a fine balance between humor and serious professionalism.

Accountants are not the only new clients for the creative services of graphic designers and illustrators. The *Boston Globe,* a New England newspaper founded in 1872, recently decided to introduce greater visual means to improve news accessibility to readers who have become accustomed to the sophisticated graphics of electronic media. An entirely new design and illustration staff was set up to implement this new visual look. Initially, editors were skeptical about the role of this artwork in journalism, but soon they grew to welcome the lively drawings, charts, and typography which worked in concert with their articles.

Since the *Globe* services a traditional region of the country, it was decided to begin the new design efforts in the Sunday edition with its many special inserts. In addition to sections on business, travel, learning, real estate, and the arts, the newspaper publishes a weekly magazine as part of its Sunday edition. This section is printed in rotogravure, a type of printing with much better resolution than that used for the news section; this allows for more subtle visual nuances in the reproduction of artwork.

The illustration that accompanied an article in the Sunday magazine titled "The Brattleboro Rat" (Fig. 164) is a particularly effective image. It extends across both pages and makes a powerful visual statement because of its large size in relation to the text. The artist and designer convey the uneasy feeling that we are too close for personal comfort to this dreaded animal. The article, however, assures us that the laboratory rat in this story—which lives in a research facility in Brattleboro, Vermont—is a benign animal indispensable to modern scientific research. The bold close-up view of the animal calls our attention to the article and may entice us to read it.

164. Douglas Smith. *The Brattleboro Rat.* Scratchboard, 20½ × 9″ (52 × 23 cm). Published in the *Boston Globe Sunday Magazine,* December 13, 1981. Collection the artist.

The Poster

Long before the development of mechanical printing, the hand-made poster was a primary means of public communication. During the 15th century in Italy, the images of notorious criminals sought by authorities were painted on public walls in what must have been the first "wanted" posters. Placed within town squares and alongside busy roads, posters have visually communicated information for centuries. Even today, with a vast array of newspapers, magazines, and electronic media, posters are often the most effective means of conveying information. For one thing, they are displayed publicly for weeks on end and are accessible to a variety of people; in essence they are a truly *popular* form of communication. But in order to communicate effectively, they must be clear, distinctive, and easy to read and assimilate even from a distance.

Since the 1960s, the poster has enjoyed a healthy revival as a communications art form, when it was used to publicize the performances of rock bands. Today, museums, libraries, and other cultural institutions make widespread use of the poster to inform people of educational exhibitions, art displays, and even special public television programs.

Paul Davis, one of the most acclaimed graphic artists and illustrators working today, created the artwork and design seen in Figure 165 for Masterpiece Theatre, a series of programs appearing on the Public Broadcasting System and sponsored by the Mobil Corporation. This moody and romantic interpretation of Benjamin Disraeli—a flamboyant 19th-century British statesman and writer—appeared all over New York City to advertise an upcoming television show based on his life story. No doubt many viewers were persuaded to watch this particular program because they were intrigued by Paul Davis' beautiful and compelling portrait of Disraeli. Who was this man? And what passions lay behind those eyes? Few visual art forms besides the poster could convey this message so forcefully.

Posters not only inform us about upcoming events, they also can play an important role in the creation of something that exists as an idea or possibility. Because of the powerful graphic nature of posters they lend themselves particularly well to the *visualization* of concepts. Recently a New York City—area land developer turned to the poster format to help sell a waterfront housing project that at the time existed only in plans and blueprints.

In order to reach and interest potential buyers for this development, the Bay Street Landing Company worked with the Pace Advertising agency to plan an approach that would produce the desired results. Because the focus of this marina and housing project was the harbor and proximity to water, boat owners and sailing enthusiasts were the target audience. The yearly boat show in New York City attracts thousands of yachting people; the development company decided to create a poster and distribute it at this event (Pl. 22, p. 165). Since many advertisers at this show give out handsomely designed brochures, the poster format, with its larger size and greater visual impact, was chosen as a means of successfully competing with other give-away material. The image had to be attractive to entice viewers and to be taken home and looked at more than once. One of the reasons this piece of advertising works is that it does not look like a typical ad. The front of the poster has almost no verbal information; instead it draws us into a kaleidoscopic visual world that centers on the rhythms of the sea, an emphasis on the color blue symbolizing water, sails filled with steady breezes, and soaring seagulls. An orange sun appears on the top left corner balanced by a midnight blue sky and crescent moon to the far right. The

DISRAELI

sky, water, and cut-away view of the ocean depths on the bottom are rendered in various shades of blue and blue-green, which focuses on the prime selling point of the Marina location—the sea and open spaces.

The creators of this piece of visual communication were above all selling "life style" and directing their appeal to a select segment of the market with financial means and an interest in boating. The poster presents us with an imaginary view of what we might see outside our window if we lived in the Marina at Bay Street Landing. Lower Manhattan stands majestically before us as a sailboat heads toward the twin World Trade Center towers. Surrounding this central image are small vignettes picturing the range of activities and experiences living at the Marina would make possible: A couple clink champagne glasses in celebration; squash and tennis facilities are indicated; a sea bird nests on the beach; and a lone lighthouse stands sentinel on a steep bluff. In essence the poster promises the "good life" for those fortunate enough to be able to buy one of these residences. Even the style of illustration—which is done with pen and ink and watercolor—projects a friendly, nostalgic feeling that harks back to an imagined

time when the pace of life was slow enough to savor carefree days of leisure with friends and family. Today the Marina at Bay Street Landing is fully built and occupied, it is hoped by families enjoying the range of activities envisioned in the poster. This is an example of how graphic designers and illustrators make solid economic contributions to our society by supplying clients with the "vision" necessary to make dreams come true.

Television Commercials

Many aspects of our civilization today emphasize speed and efficiency; these attributes, more often than not, appear to be quintessential elements of modern life. Billboards and posters are by no means the only forms of visual communication that need to operate within narrow time frames. Television commercials have somewhere between ten and sixty seconds in which to capture our attention, make their point, and close the deal by becoming lodged in our memory. *Retention* and *concept recognition* are the terms by which media researchers describe the goals of short advertising messages. Because of the strict time limitations and the fact that commercials must compete for attention with other commercials as well as with regular programming, many of the best are models of efficient design, and condensation. Viewed from an analytic perspective, many achieve the status of *haiku*-like parables—brief, revealing commentaries on our consumer-based society.

One of the more amusing and memorable advertising spots of recent times is a ten-second production for Federal Express that won an *art director's award* for its creative concept and clever visualization (Fig. 166). The scene opens with a stocky, muscular man in a business suit quietly standing next to an outdoor phone booth; tall buildings rise in the background. An unseen announcer's voice is heard (this is known as a *voice-over* in the profession) saying, "Federal Express is so easy to use. All you have to do is pick up the phone." At this cue, the heavy-set man turns toward the phone booth, puts his arms around it, and wrenches it free from the pavement. Accompanied by the sight and sound of broken watermains gushing, the words *Federal Express* appear on the screen and are held there for several seconds to imprint them on our memory. Much of the power of this short clip derives from the literal enactment of "picking up the phone." Fantasy blends nicely with the hard-nosed business concerns of this corporation, which paid thousands of dollars to plan, film, and show this message on network television. Humor alone is not enough; it must be blended skillfully with the message or selling point to form a memorable mental image desirable to the advertiser.

166. Federal Express storyboard. 1984. Michael Tesch, art director; Joe Sedelmaier, film director. Reproduced by permission of Federal Express.

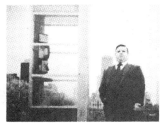

1. ANNCR: (VO) Federal Express is so easy to use,

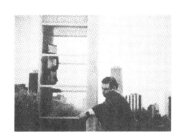

2. all you have to do is pick up the phone.

3. (SFX RRRRRRIIIIIIPPPPP!!)

4. (SFX: WATER)

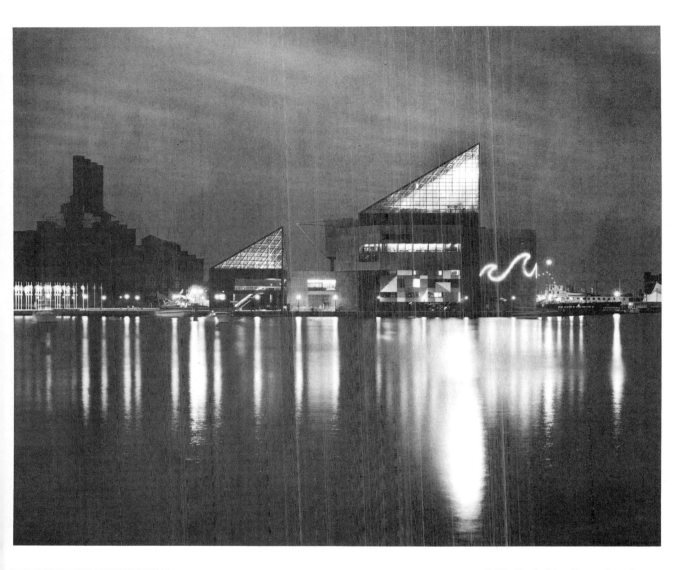

EXHIBIT DESIGN

Because of the increasingly complex nature of contemporary society, visual communications now play an important role in simplifying and presenting all kinds of information to the public. Exhibit design—which takes the form of store window arrangements, commercial expositions, and educational displays at museums—is a form of graphics that has grown considerably over the last few decades. Today, specially trained professionals, working in firms that specialize in this area, design everything from fantasy windows in elegant stores to scientific and technical displays for various public institutions.

A Total Design: Baltimore's National Aquarium

When the National Aquarium in Baltimore first opened, it attracted so many visitors to its specially designed exhibit that it had to be closed for a ten-day refurbishing after only five months of operation. Although the exterior is quite spectacular (Fig. 167), the building was planned primarily with an eye to the

167. Cambridge Seven Associates. National Aquarium, Baltimore. 1981.

168. Cambridge Seven Associates. National Aquarium, Baltimore. Mural wall, 9 × 90′ (27.4 × 274.3 m), with 63 backlit transparencies, each 3′ (0.91 m) square, depicting diversity of adaptation through close-up details of marine animals. Conceived and designed by Peter Chermayeff of Cambridge Seven Associates, architectural and exhibition designers, using photographs commissioned from Stephen Althouse.

special exhibits it would house. Peter Chermayeff, principal designer of the Cambridge Seven—the architectural firm that designed this complex—stated that architecture per se was not the primary issue. The building's exterior form was largely determined by the series of experiences that would take place inside. Chermayeff and his associates worked carefully on the aquarium's sequential plan so that walking through the many fascinating exhibits inside would be, in his words, "so involving that you forget about the architecture."

The carefully choreographed display graphics begin the moment visitors enter the building. Chermayeff conceived of the aquarium as much more than a building to house marine life; he envisioned the entire architectural complex as a means of allowing the visitor to experience water as an element as well as the basis for aquatic life. These concepts are visually introduced to the visitor, for instance, by large-diameter floor-to-ceiling plexiglas tubes containing bubbling blue water.

Chermayeff's design plan leads the viewer on a carefully prescribed path; as spectators make their way into the building, they pass first through a darkened tank area containing dolphins and then, by criss-crossing escalators, through a huge central atrium offering a tantalizing preview of things to come (Pl. 23, p. 166). The range of perceptual experiences is astounding. Taped sounds of marine life are heard; a blue neon "wave" covers an entire wall; large, projected images of sea creatures fade in and out; backlit mosaics of color transparencies reveal anatomical features of many sea creatures (Fig. 168); visitors can peer down from above into large fish tanks (Fig. 169); and to cap off this exhibit, a 24-foot-long (7.3 meters) whale skeleton hangs from the ceiling.

The Cambridge Seven creatively has rethought the form and function of an aquarium display. Rather than assembling all of the displays in one or two large rooms where visitors might wander about at random, the Cambridge Seven chose to create a guided path. The benefits to this approach are twofold: A much more coherent experience can be presented (somewhat like a good book or film), and more efficient and cost-effective use of space can be achieved.

As we have seen from the many examples presented in this chapter, graphic designers are essentially concerned with effective visual communication. Since 20 to 90 percent of what we learn comes to us through visual pathways, the role played by these skilled professionals will probably increase in the near future. For the most part, graphic designs do not give us profound lasting aesthetic experiences as the fine arts do, but they do significantly affect our daily lives. Package designs are constantly at hand; thousands of magazines flood the market; it is impossible to leave our homes without confronting billboards and store signs; and television is a firmly ingrained part of life for most Americans. There is no getting away from these visual influences even if we wished to do so.

As the applications of graphic art continue to evolve, the genre will no doubt become more sophisticated as we viewers of these commercial messages become more conscious of differences in the quality of design.

169. Cambridge Seven Associates. Interior, National Aquarium, Baltimore. 1981.

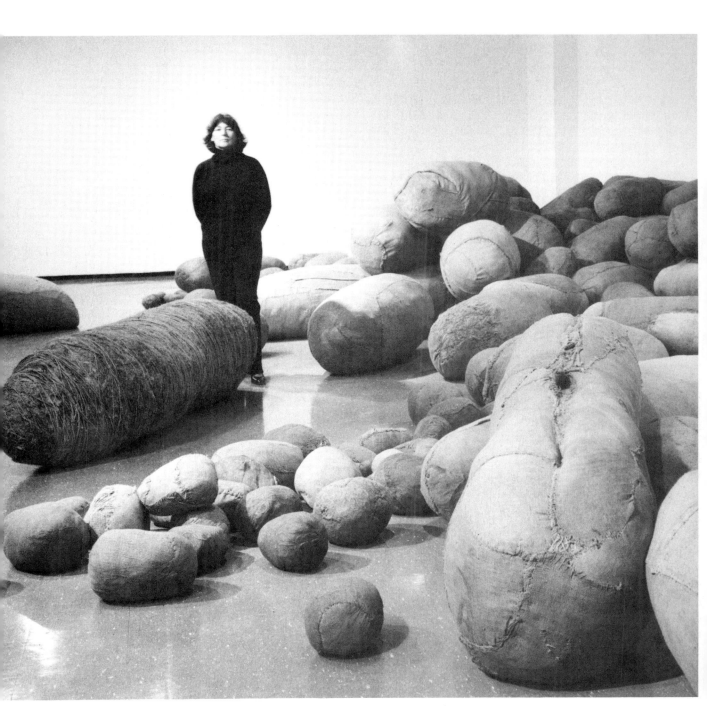

The Artist-Craftsperson

Part III

THE ARTIST-CRAFTSPERSON

The creation of all sorts of products—from industrial goods such as automobiles to hand-crafted objects such as ceramics—is greatly defined by two factors: the imagination and skill of the makers *and* the materials and techniques at their disposal. Both the physical properties of various raw materials and the processes used to form and shape them play an enormous role in determining the way things look and work. By examining how artists and craftspeople have refined their thinking about materials and techniques we can gain a better appreciation of contemporary methods and sensibilities.

One of the primary concerns of the artist is to achieve in a work a sense of appropriateness and "wholeness." Clearly, the specific materials and processes used in the fabrication play an important role in the attainment of these goals. A major problem in art is selecting the right materials and handling them with sensitivity and respect. Each material has its own range of characteristics, its special properties and limitations, and its inherent beauty.

Equally important is the element of craft. Without control of the shaping and forming of materials there is little chance of artistic success. All art begins with the mastery of technique. This is the *process* side to art making.

Technology is constantly expanding the materials and artistic processes available to the adventurous artist today. Film, video, and computer graphics are art forms that did not exist merely a hundred years ago. In the case of the computer, this new tool only now is being explored by visual artists and holds great possibilities for the future.

Often artists supply the vision necessary to make appropriate use of new technologies and materials. When designer Marcel Breuer approached furniture corporations in the 1920s with a proposal to manufacture metal chairs economically, he was laughed out of the offices: Wood was the only material used at the time. Today, steel and other metals form the backbone of most office and institutional furniture.

The choice of materials and techniques available to the contemporary craftsperson and artist is staggering. In fact, few substances and processes are not used by creative individuals today. Each substance has certain qualities and

characteristics that are exploited by the artist; each technical method of forming creates a certain "look" that, in conjunction with the artist's vision, helps define the work of art. But it is important to remember that all materials are, to some extent, mutable in appearance and can produce a variety of effects. For example, silk can be spun fine and woven into gossamer-thin and lustrous fabric, or it can be spun coarse and made into thick, rough-textured cloth. From this, we can establish the following general criteria to help determine the appropriateness of various materials:

the *use* to which the artwork will be put

the *visual* effects that are desired

the *innate* nature of the material

the *processes* that determine the visual outcome

Another major factor is the artist's *creative individuality*. Artists respond differently to materials, depending on their personal likes and dislikes. Sometimes they go against the innate nature of the material with surprising and successful results. But the dialogue between artist and material is always a lively and surprising one. This chapter will discuss the interactive relationship between the physical nature of many widely used materials and the techniques with which artists, designers, and craftspeople transform them into unique forms.

Chapter **8**

Wood, Metal, and Plastics

Wood and metal are two of nature's most abundant and useful resources. With the development of a highly sophisticated chemical industry, a wide range of plastics also has been added to the list of easily formed and worked materials. New uses constantly are being discovered for each of these versatile substances, reflecting the imagination and innovative ability of many artists and designers.

George Nelson's office furniture (Fig. 170) uses all three of these materials in an aesthetic and functional combination. Many aspects of the design minimize clutter and yet give ready access to everything that is needed. Brightly polished aluminum was chosen for the slender but strong desk legs and frames. A deep file bin of oiled walnut or ash extends across the back of the desk, and shallow wood drawers line up along the front. A roll-up top of the same woods can be moved forward to cover the file and the top of the desk, locking it at night. The

170. George Nelson and Robert Propst. Action Office System. 1964. Wood with aluminum, laminated plastic, and vinyl; 2.7 × 5.5 × 2.7' (0.8 × 1.7 × 0.8 m). Herman Miller, Inc., Zeeland, Mich.

lightweight, easily moved chair has an aluminum base, a one-piece seat and back of molded plastic, and cushions covered with a colorful, easy-care synthetic fabric. A high, convenient storage unit has space for both files and bookshelves and provides an additional work surface.

In this series of office furniture, each of the materials used—wood, metal, and plastic—was chosen because of its visual characteristics and structural properties. It is well worth examining these three materials in depth for their aesthetic values and functional applications.

WOOD

Wood is still the first choice for many sculptors, craftspeople, and manufacturers because it is easily obtainable, fairly durable (at least it ages more gracefully than many materials), relatively inexpensive, and—perhaps most important—easy to work with. Some metals and plastics also have these characteristics, but wood has a distinct organic beauty to it that is especially welcome in a mechanized society.

Characteristics of Wood

One of the most appealing visual qualities of wood is the way it reveals its organic origin in the *grain*. These constantly varying patterns enliven the surfaces of wood and lend a distinctive aesthetic quality to this organic material that Lawrence Hunter uses to great advantage in the beautiful walnut table shown in Figure 171.

Wood grain differs with various kinds of wood. Birch, maple, mahogany, walnut, ebony, teak, pine, redwood, fir, and many others have their own distinctive patterns. Furthermore, the grain is greatly affected by the way in which the wood is processed—whether it is sawed across the grain, with the grain, or at an angle.

171. Lawrence Hunter. Table (detail). 1965. Walnut. Present location unknown.

The *color* of wood also varies according to the kind of wood and the method of treatment. A few woods are naturally almost white or black, some are grayish or greenish, but most have tones of yellow, orange, or red. Oak tends to be yellowish; rosewood, cherry, and mahogany are red; walnut and teak are brown. With bleaches and stains, however, the natural color of wood can be changed to create a variety of visual effects.

Shaping Wood

Few materials are shaped and formed as easily as wood. Depending on the hardness or softness of the type used, wood can be carved easily and naturally by hand or machined to high tolerances by sophisticated machines. From pole-shaped trunks in its natural state, wood can be cut into planks or thin slabs for siding, table tops, and house construction; it can also be sliced into very thin veneers or made into plywood. Even the byproducts of the lumber industry are useful in creating wallboard, paper, and synthetic fibers. With proper forestry management, wood is a renewable resource.

The vocabulary of shapes that can be produced with tools such as saws, knives, chisels, lathes, and planes is almost limitless.

Applications

Antoni Gaudí was a Spanish architect who worked mainly in Barcelona at the turn of the century; he created startling new architectural forms that parallelled those of **art nouveau,** a movement characterized by organic shapes and a love of ornamental detail. Visually, his buildings seem to owe more inspiration to twisting organic forms found in nature than to **post-and-lintel** construction. Following the Spanish craft tradition, Gaudí not only designed buildings but also produced special architectural hardware and furniture especially for these spaces. His Battlo bench (Fig. 172) first was made out of oak in 1905–07. (B. D. Ediciones in Barcelona reproduces this piece by hand today.) In design it is a

172. Antoni Gaudí. Battlló bench. 1905–07. American oak, carved with hand gouge, dipped in water dye solution, two in-depth coats of pistol-sprayed polyurethane with intermediate sanding, one coat of nitrocellulose-Duco, hand blended and waxed; 3'4½" × 5'6⅞" × 2'7⅞" (1.03 × 1.7 × 0.81 m). Furniture of the 20th Century, New York.

173. Mark Lindquist.
Ascending Bowl No. 2. 1980.
Wood (spalted maple burl);
height 10″ (25 cm), diameter 12½″
(32 cm). Collection Alice and
William Clark.

perfect complement to Gaudí's architecture. Each section flows sinuously into the others, creating sensuous sculptural forms. In many ways it is the antithesis of industrial age fabricating methods and forms, requiring hand carving, joining, and finishing. But this was Gaudí's aim: a design that visually and conceptually ran counter to the prevailing forms of the 20th century.

Mark Lindquist is a contemporary artist who uses wood to express personal concerns through traditional forms such as the bowl. Art collectors from across the country eagerly await the creation of his slowly evolving, deceptively simple, hand-carved and lathe-turned wooden vessels. Working quietly in his New Hampshire studio, Lindquist makes extensive use of *spalted,* or split, wood and burls from his collection of old and unusual wood supplies, some pieces dating back a hundred years or more. The availability of this wood no doubt accounts for the special aesthetic quality of his work—it is at once remarkably ancient and appropriately contemporary. Lindquist, who is an accomplished musician as well as a gifted craftsperson, describes the process of wood turning on his lathe to be "not unlike reading music and playing a percussion instrument." An artist must consider and respond to the grain and brittleness of the wood during every step of this slow and arduous process. After art school, Lindquist became an apprentice to a potter who introduced him to Oriental culture as a way of looking at life and art. Much of this philosophy can be seen in Lindquist's concept of the bowl form in Figure 173. "The simpler the form," this artist observes, "the more uncluttered the surface for the wood to display itself."

Wood is also one of the most widely used sculptural materials; its shaping properties appear limitless. Another unusual and imaginative use of lathe-turned wood is found in F. L. Wall's *Fire Extinguisher* (Fig. 174).

Although the shape of this sculpture mimics the form of a working fire extinguisher, the prominent wood grain of the cylinder and nozzle make it appear comical—all the more so when we realize that fire extinguishers often are used to put out wood fires.

174. F. L. Wall. *Fire Extinguisher*. 1982. Turned oak and copper, 36 × 18 × 9″ (91 × 46 × 23 cm). American Craft Museum, New York.

Sculptors also delight in shaping a rough piece of lumber with saws, cutting into it here and there, and slowly assembling a work of art that expresses the artist's own aesthetic sensibility. William King did just this in his sculpture titled *Bill* (Fig. 175). By carefully selecting and shaping various odds and ends of lumber that he found lying about his studio, King created a humorous and whimsical many-planed portrait.

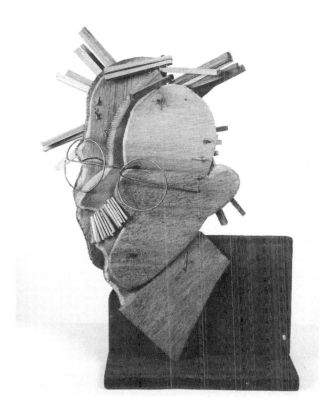

175. William King. *Bill*. 1978. Wood construction, height 19½″ (50 cm). Terry Dintenfass, Inc., New York.

183

No discussion of the properties of wood would be complete without mention of its widespread use in everyday furniture; and few examples in this category approach the effectiveness of the classic Windsor chair (Fig. 176). Its design is based on two of the most common forms of lumber—the slab and the pole—supplemented by two pieces of bent wood. Projecting boldly beyond its supports, the writing arm demonstrates that wood is remarkably strong for its weight. So does the seat, which will support up to 300 pounds (136 kilograms), even though it is less than 2 inches (5 centimeters) thick and is supported only near the corners. Four slender legs carry this weight to the floor. Notice especially the very slight spindles in the back, held in place by the two pieces of bent wood. Although extremely lightweight and airy, this structure will withstand the considerable pressure of a sitter who leans against it. Not only is wood *strong in compression* (it holds its shape under pressure, as demonstrated by the legs), but it is also *strong in tension* (it resists breakage when bent or pulled, as in the back of the chair). The basic design of the Windsor chair seems so well thought out that contemporary designers continue to explore its potentials (Fig. 177).

Veneer, Plywood, and Laminated Wood Layered constructions of thin sheets of wood, thicker boards, or paper greatly extend wood's usefulness. *Veneers* are sheets of wood as thin as 1/28 inch (9 millimeters), produced by slicing, sawing, or rotary cutting large logs. They can be glued to thicker lumber to make "veneered wood," to other veneers as in plywood and laminated wood, or to paper for wall coverings. *Plywood* is a sandwich composed of an odd number of veneers glued together with the grain of adjacent sheets at right angles to each other. *Laminated* wood is a type of plywood in which the grain of successive layers goes in the same direction. It bends easily with the grain and is very strong in one direction, which makes it especially suitable for parts of furniture.

below: **176.** American. Windsor writing chair. 18th century. Museum of Fine Arts, Boston.

below right: **177.** Hans Wegner, designer; Johannes Hansen, cabinetmaker. Spindleback chair. 1947. Oak. Present location unknown.

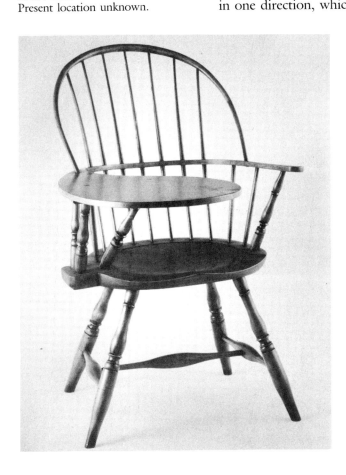

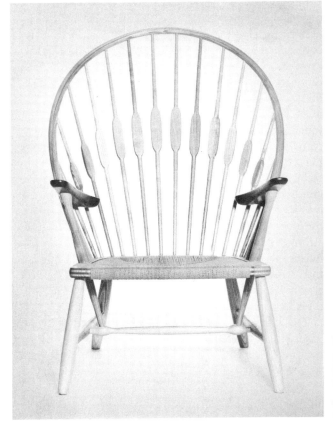

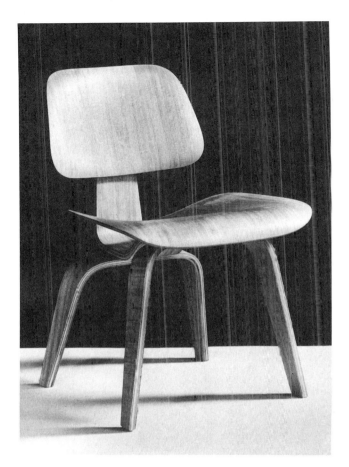

178. Charles and Ray Eames.
Dining chair. 1946.
Molded plywood;
2.6 × 1.6 × 1.8′ (0.8 × 1.6 × 1.8 m),
seat height 1.5′ (0.5 m).
Herman Miller, Inc., Zeeland, Mich.

Figure 178 shows one of the most successful chair designs of the 20th century. For ages, wood has been *bent* to create skis, snowshoes, and chairs; but designer Charles Eames, experimenting in his own apartment, found that he could *mold* plywood into new shapes through heat. When his apartment oven exploded, he continued his work in a bakery and later in a well-equipped laboratory. The organic shapes of the *plywood* seat and back echo those of the human body and are surprisingly comfortable for uncushioned seating. *Laminated wood* is an ideal material for the legs. Each part of the chair expresses its special function as clearly as do the parts of the Windsor chair, and yet the chair is convincingly unified. Above all, it has a sculptural quality.

Designed for machine production, these chairs are based on three significant technological developments. First, the wood is rapidly, precisely, and permanently molded under heat and pressure. Second, the parts of the chair are joined by shock welding, a technique in which synthetic resin sheets are placed between the parts and sufficient heat is transmitted electronically to produce a bond stronger than the wood. Third, the wood is impregnated with resin, which makes it water resistant and hardens the surface against scratches and dents. Not many examples of contemporary or historic design work show as complete mastery and integration of the problems of utilitarian needs, materials, and processes as does the Eames chair.

This is just a brief introduction to the many forms, processes, and possibilities inherent in wood. Although many new and versatile materials are spawned by technology each year, few, if any, are as easily formed, useful, and beautiful as wood. Wood is strong in relation to its weight and bulk, and it is easy to repair

with simple hand tools. Many new processes are making it resistant to rot and decay, fire and insects, as well as to shrinking, swelling, and warping. No doubt wood will continue to be a favorite with artists and craftspeople well into the future.

METAL

Metallurgy—the art and science of metals and their alloys—is one of the oldest processes known to humanity.

Gold was probably the first metal to be discovered and shaped because it occurs, uncombined, in a natural state and can be removed from rocks in which it is embedded with simple hammering and washing. It is one of the most malleable substances in the world and can be beaten to the thinness of one three-hundred-thousandth of an inch (84.6 micrometers, or millionths of a meter). Highly resistant to tarnishing and oxidizing, it will retain its brilliant surface indefinitely. Perhaps for this reason the Mycenaeans of ancient Greece buried some of their royalty with paper-thin gold face masks (Fig. 179) that portrayed, in a stylized way, the features of the departed princes. No doubt the idea of covering the dead with gold face masks was inspired by the Egyptian practice, as illustrated by the famous gold coffin of Tutankhamen. Not only did this metal seem to be "alive" because of the way it reflected and played with light, but also its remarkable powers of resisting tarnish symbolized—to both Egyptians and Mycenaeans—an eternal life beyond the grave.

The discovery of copper smelting marked the beginning of the true age of metallurgy and established the basis for the refinement of metals, which continues to the present day. Similar to ceramic kilns in many ways, early smelting furnaces were fueled by charcoal, with a bellows providing an artificial draft to increase the heat. By the addition of small amounts of tin (about 10 percent) to the copper, *bronze* was formed—a much stronger substance than either tin or copper alone. This was so important to civilization that it marked the beginning of a new era—the Bronze Age. The great importance of this metal to the pro-

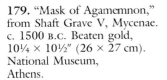

179. "Mask of Agamemnon," from Shaft Grave V, Mycenae. c. 1500 B.C. Beaten gold, 10¼ × 10½" (26 × 27 cm). National Museum, Athens.

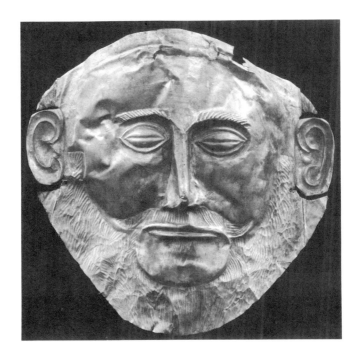

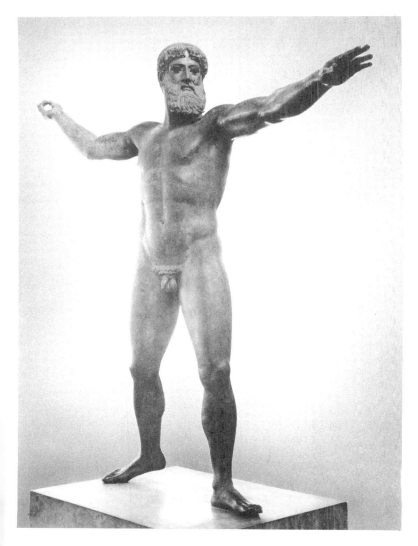

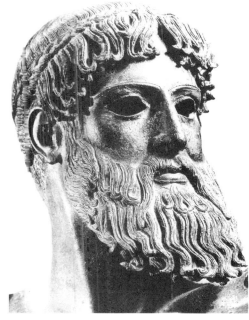

left: **180.** Poseidon or Zeus. Greek, c. 460–450 B.C. Bronze, height 6′10″ (2.1 m). National Museum, Athens.

above: **181.** Poseidon or Zeus, detail.

duction of works of art is its superb casting qualities, without it large sculptures—such as the statue of *Poseidon* found in the sea near Artemision, Greece—would have been impossible (Fig. 180). Due in large part to bronze's great strength and durability as a metal, this work of art has survived for over two thousand years. Technically as well as artistically, it is a tour de force. Poseidon, the god of the sea in Greek mythology, is revealed as a majestic figure of unparalled power, hurling a trident or thunderbolt. The left arm is level and extends forward to both indicate the direction of the missile and give a sense of physical balance to this action. This is not a portrayal of a mortal athlete—for example, a javelin thrower—but of a powerful god who controls the lives of mortals with ease and grace. The calm, remote expression of the face (Fig. 181) contrasts with the active stance and idealized musculature of the body. In juxtaposition to the smooth surface of the body, the sharply detailed face with its stylized beard—suggesting ocean waves breaking—indicates the omnipotent, potentially menacing nature of a god.

The casting of such statues required great skill on the part of the ancient Greeks. A large sculpture such as this one could never be made in one solid piece because of various technical problems and cost. *Poseidon* was executed by casting

Wood, Metal, and Plastics

sections separately and fusing them together to form a hollow main body. This was called piece molding, and it made use of the **lost-wax,** or **cire-perdue,** process. This foundry technique was developed early in the third millennium B.C., when simple solid molding procedures were unfeasible. This process consists of making a model of the piece exactly as it was to appear when finished. Over this form a gelatin piece mold (synthetic rubber is used today) is prepared. This becomes a *negative* or exterior mold of the sculpture. The inside of the negative mold is coated with wax to the depth of about 1/8 inch, then wet plaster is poured into the mold; at this point the gelatin or synthetic rubber outer wall is removed, leaving the wax shell and the plaster core. A complex network of wax rods is attached to the shell. Later, during the pouring of the molten metal these rods form a system of canals for the bronze to enter and the air to escape. The wax model and plaster core is coated with a plaster-silica mix, reinforced with wire and placed in a kiln to burn out the wax. What remains is the core separated by a narrow space from the surrounding mold. Molten metal is poured into the 1/8-inch gap that once held the wax through the channels created by the burned-out wax rods. When the core cools the outer mold and core are removed. The metal rods attached to the surface of the sculpture are cut off, and the rough surface is filed down. Because the inner mold is not destroyed in the casting process multiple copies can be made relatively easily.

Planning and fabricating large free-standing bronze statues such as *Poseidon* remained nevertheless a highly complex procedure. Constructing the core supports and molds for each statue required the constant attention of the most skilled craftspeople of the era. Early metal workers had to figure out how thick to make the metal so that it would support its own weight, and specially shaped furnaces had to be custom built for each large statue in order to fuse the carefully assembled pieces.

The greater tensile strength of bronze also allowed sculptors to achieve bolder compositional effects than they could have achieved with marble or stone. Few marble statues extend so precipitously into space as does the bronze *Poseidon.* Marble sculpture begins with a block of hard material which must be chipped away at laboriously, whereas cast bronze—which begins with soft, pliable wax— can be molded into any form. The range of detail possible through the lost-wax process accounts for the finely inscribed details of *Poseidon's* features, beard, and hair, details extremely difficult if not impossible to achieve with marble carving. To a great extent, much of the aesthetic effect of this statue—perhaps the finest surviving piece from antiquity—can be related to the material of which it was fabricated and the technique by which it was formed.

Metals and Their Qualities

Like woods, metals have achieved widespread acceptance and use in art because of their ability to be formed, joined, and finished in a variety of ways. But they significantly differ from wood in two important instances. First, they are seldom found in a pure, usable state and therefore must be refined; the purified metals bear almost no resemblance to the ores from which they were extracted. Second, metals are inorganic and therefore do not rot or decay, although many rust or corrode.

Iron and *steel* are the most widely used metals of our age and can be worked easily by hand or machine. Recently, alloys have been developed that expand the usage of these popular metals: stainless steel and Cor-Ten, a metal that develops a self-protecting skin when exposed to air and moisture.

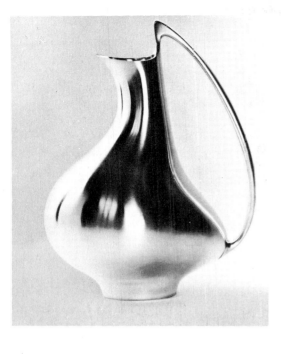

left: **182.** Henning Koppel. Pitcher. 1952. Sterling silver. Georg Jensen, New York.

above: **183.** An assortment of silverware. Georg Jensen, New York.

Silver, sometimes found in a natural state, is, next to gold, one of the most ductile and malleable of metals. As a pure metal it is too soft for most uses, but small additions of copper increase its toughness and hardness. Silver's beautiful, white appearance and ease of handling make it a logical choice for table implements such as Henning Koppel's sensuous pitcher (Fig. 182) and the silverware shown in Figure 183.

The distinctive qualities of metals greatly expand our range of visual and tactile enjoyment. Throughout history, they have performed an indispensable role in both functional and decorative applications.

Applications

In order to demonstrate the extraordinary range of forms, shapes, and aesthetic effects that are obtainable with various metals and forming methods, we will examine three diverse objects quite different in appearance: an early American woodworker's tool hand forged out of steel; a cubist sculpture formed out of bent sheet metal and wire by Pablo Picasso; and contemporary bronze doors for St. Peter's Basilica in Rome by Giacomo Manzù.

During America's bicentennial celebration in 1976, Hans Namuth's photographic essay on historic tools was featured along with the actual objects in an exhibition at the Water Mill Museum in New York State. Most of the objects featured in this show were never fabricated with art in mind, but many of them can be viewed and appreciated today as sculptured works because of their economy of form and effective use of materials. Namuth's photograph (Fig. 184) reveals, as honestly as the subject it portrays, the simple beauty and exquisite proportion of this hand-wrought metal measuring tool. Both sides of this dual caliper can move independently and thus hold two different, interrelated measurements that could determine, for example, the maximum and minimum dimensions of a lathe-turned table leg. This tool was essentially formed by heating metal rods until they became red hot and soft. Blows from heavy blacksmith's hammers then formed the pieces of metal into the utilitarian and beautiful shapes we see here.

184. Tool: double caliper. Iron, hand forged. Collection of Harold Fountain.

Using a pair of tin snips instead of charcoal, and sheet metal instead of paper or canvas, Pablo Picasso created *Guitar* (Fig. 185) in 1912, a three-dimensional counterpart to his cubist drawings and paintings of the same period. Both his metal sculpture and his two-dimensional work explore the interpenetration and reorganization of form. During this time Picasso was working with the idea of juxtaposing and organizing transparent as well as opaque planes so that it would seem possible to look into solid objects from several angles at once.

The guitar sculpture is a paradigm of simplicity. A common metal can cut into strips at the bottom to anchor it becomes the hole in the sounding board, and wavy wire rods form the strings. Picasso has reassembled this ancient instrument in a new way to show us how it looks from a variety of perspectives at once. In

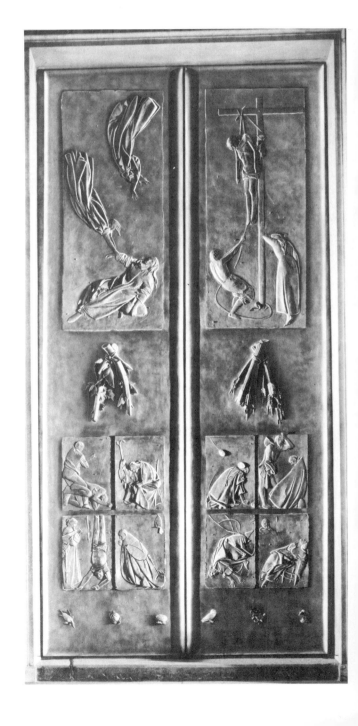

above: **185.** Pablo Picasso. *Guitar.* 1912, early. Sheet metal and wire, 30½ × 13⅛ × 7⅝″ (78 × 33 × 19 cm). Museum of Modern Art, New York (gift of the artist).

right: **186.** Giacomo Manzù. *Doors of Death.* 1964. Cast bronze, 25′3½″ × 12′3¾″ (7.7 × 3.6 m). St. Peter's Basilica, Vatican, Rome.

this pioneering use of sheet metal, one of the outstanding artists of the 20th century has demonstrated that the search for significant form goes hand in glove with the physical materials and processes used to realize it.

In 1949 Giacomo Manzù, one of Italy's most distinguished modern sculptors, won the competition to produce a pair of doors commissioned by the Vatican for St. Peter's Basilica. The subject of the project assigned to Manzù was the "Glorification of the Saints and Martyrs of the Church." To carry out this commission he chose to use the same ancient lost-wax bronze casting technique used by the ancient Greek artisans to create the statue of *Poseidon*.

Although steeped in the heritage of Western art, especially that which related to life in the Mediterranean countries, Manzù was born of poor parents in the provincial town of Bergamo and was largely self-taught. For Manzù the commission was an honor, for it placed him in the artistic company of Michelangelo, Raphael, and Bernini, all of whom worked at St. Peter's, but the theme of legendary, historical saints came to seem irrelevant to him. After a period of inactivity Manzù found in Pope John XXIII, also from a poor family of Bergamo, the inspiration and courage to develop a strong and appropriate theme directly out of his own individualistic sense of human value. Simplification—both of content and form—became the artist's goal.

Manzù makes effective use of the wax employed in the process to vigorously shape and cut this pliable material with a variety of sculptor's tools and implements. The finished piece *Doors of Death* (Fig. 186) exhibits a remarkably fluid and contemporary approach to an age-old technique. In the completed doors the traditional attributes of sainthood and such accessories as palms, lights, rays, and halos are absent. Timelessness and universality have been achieved through perfection of form only, not through classic decorative devices. A humanist at heart, Manzù is religious in an unorthodox way, and like many Europeans of his generation he was much affected by the outrages against humanity perpetrated during World War II. To him the real witnesses to faith are the anonymous, ordinary people of the world, and it is their suffering and martyrdom that Manzù wanted to commemorate in his doors for St. Peter's.

All of these examples reveal the remarkably versatile character of various metals and the many ways in which they can be worked. It is almost as difficult to imagine a world without metal as it is to imagine one without color.

PLASTICS

Plastics are some of the newest substances we have synthetically created to meet our needs. Chemists have transformed such unlikely materials as cotton, wood pulp, soybeans, milk, natural resins, salt, silica, coal tar, and formaldehyde into a variety of substances with many properties. Some plastics resemble glass but are shatter resistant, others are formed into flexible, brightly colored strips that can be woven into chair seats and backs. Through alteration of chemical formulas and fabrication processes, plastics can also be formed into amazingly durable dinner plates and high-pressure plastic laminates that resist scratching and staining.

The history of plastics goes back to 1868, when *celluloid* was made (from a highly improbable fusion of cotton, nitric acid, and camphor) as a substitute for the ivory used in billiard balls. However, progress was relatively slow until the 1920s. Since then, each year brings many new developments in substances tailor made to meet the fantastically diversified and specialized demands of contempo-

rary society. The annual production of plastics has risen from 4 million tons (about 4,000,000 metric tons) in 1958 to many times that amount today. The end is still not in sight as manufacturers bring out new compounds each year.

Characteristics and Uses of Plastics

Plastics are grouped into families on the basis of their chemical composition, but within each family there is considerable variety. Several of the twenty or so groups will serve to introduce the greatly diversified qualities and uses of plastics.

The *acrylic* group of plastics is noted for its exceptional clarity and for its transmission of light when transparent, but it also comes in a considerable range of translucent and opaque colors. Louise Nevelson, a contemporary American sculptor, took advantage of many intrinsic qualities of this family of plastics in the construction of her *Transparent Sculpture VI* (Fig. 187). Although this mate-

187. Louise Nevelson. *Transparent Sculpture VI*. 1967–68. Plexiglas, 19 × 20 × 8″ (48 × 51 × 20 cm). Whitney Museum of American Art, New York (gift of the Howard and Jean Lipman Foundation Inc.).

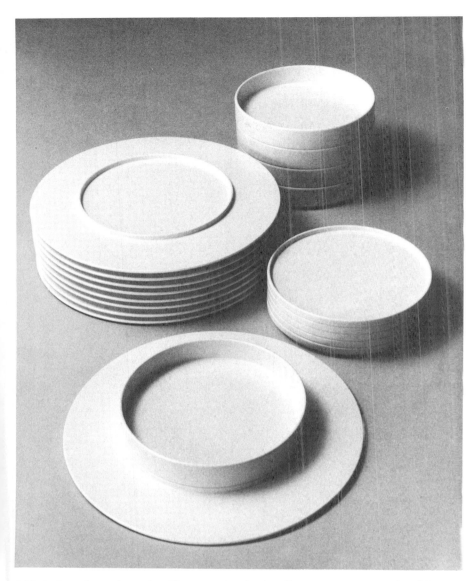

188. Lella and Massimo Vignelli. "Kyoto" melamine dinnerware. 1980. Produced by Casigliani. Milan.

rial resembles glass, it is far less brittle and can be drilled and sawed with relative ease. Light reflecting along the edges of its geometric shapes, as well as the visual rhythms created by the tapped screws which hold it together, create a lively visual presence, despite its transparency.

Melamines are among the hardest of plastics. They retain a lustrous finish and are unaffected by detergents, cleaning fluids, and oils. Their range of textures and lightfast colors is great. These qualities suit them to laminated surfaces on desks and tables (Fig. 170) and to colorful dinnerware (Fig. 188).

Urethane polymers can be produced as resilient or rigid foams and as coatings and adhesives. They also can be injection molded, cast, or machined into almost any shape the designer may wish. The foams can be given densities matching those of wood, and they can be worked, finished, and repaired much like wood.

189. Aagard Anderson.
Dripping chair. 1961.
Poured urethane.
Museum of Modern Art, New York
(gift of the designer).

The chair illustrated in Figure 189 was not intended to be a model for a line of mass-produced furniture; it is rather a creative experiment to test the properties of a relatively new material, urethane foam. The designer was interested in this plastic's distinctive fluidity. Even when completely formed, the chair still seems to be in the process of changing shape.

Certain forms of plastics can be molded quickly and economically or cast into boat hulls, automobile bodies (Fig. 190), independent units of architectural structures, whole rooms or parts of rooms, furniture and tableware, packaging, and diverse industrial components. Foam plastics can have twice the resilience of foam rubber; they also can have their own protective skin, making other surface coverings unnecessary. Also, plastics can be hand worked into sculptural creations, as illustrated in the Bruce Beasley work in Figure 191.

190. An auto body
(acrylonitrile-butadiene-styrene)
being molded from a single sheet of
ABS 25 × 10′ (7.62 × 3.05 m).
Borg-Warner Chemicals, Inc.,
Parkersburg, W. Va.

191. Bruce Beasley.
Stamper's Lighthouse. 1967.
Cast lucite, 30 × 24″ (76 × 61 cm).
Hansen Gallery, San Francisco.

Designing in plastics is challenging because there are no historical precedents, as there are for wood, metal, ceramics, glass, and textiles. Furthermore, the raw materials are chemicals with little intrinsic character, and they can be made to do almost anything. As is typical under such conditions, designers first directed their energies toward making these new materials look like old familiar ones that consumers were accustomed to purchasing. It is still common to find table tops and flooring materials that unconvincingly imitate wood, cloth, marble, tiles, and bricks. Gradually, however, the inherent qualities of plastics are being accepted and sympathetically revealed to make a new and positive contribution to our living.

Woods, metals, and plastics are remarkably varied substances that can be processed in a multitude of ways to produce an endless number of objects for use and for aesthetic pleasure. In enjoying and appraising them, we might concentrate on how well—or how poorly—the materials have been selected and formed in terms of their purposes. The best works of art and design are those that communicate effortlessly the artists' intentions through a smooth integration of concept, material, and process.

Chapter **9**

Ceramics, Glass, and Fiber Arts

Until the machine age changed the face of society and with it traditional jobs and work patterns, ancient craft processes linked humanity's everyday life with its distant origins. Vessels used to store food and eat from were made by hand and often beautifully formed and meaningfully decorated; textiles that swaddled babies at birth and clothed the departed for their final journey were woven by members of the immediate community. Meaning was invested in the most ordinary of these handmade goods; they celebrated and took part in the humblest of rituals such as eating, drinking, and dressing.

Despite the enormous amount of machine-made goods that surround us and at times threaten to bury us, contemporary handcrafts such as ceramics, hand-blown glass, and weaving are being discovered and appreciated by more and more people today. Craftspeople freed from the obligation of producing utilitarian goods in great quantity are now able to make hand-crafted objects that are appreciated for the special qualities they possess. Other designer-artists choose to work with industrial manufacturing processes to produce high-quality mass-market products that most of us can afford. The machine, rather than spelling the end of fine handmade works, has instead redefined the process of craft.

CERAMICS

It might be said that the history of civilization is written indelibly in ceramics, partly because objects made of fired clay have withstood the ravages of time far better than almost any other artifacts, and partly because this art form is intimately connected with one of the most basic ingredients for life—food. For early peoples, ceramic vessels offered definite advantages over receptacles made of organic materials such as animal skins and gourds: They were impervious to rotting and protected the contents from rain and animals. Long before the refinement of metal, early tribes found the heat-resistant qualities of ceramic pots indispensable for cooking and for heating water—activities for which skins and gourds were ill suited.

right: **192.** Cyprus. Jug. Archaic period, 7th or 6th century B.C. Ceramic, height 10″ (25 cm). Director of Antiquities, Cyprus.

far right: **193.** Peter Voulkous. *Untitled.* 1981. Stoneware, 34½ × 16 × 16″ (88 × 41 × 41 cm). Courtesy Thomas Segal Gallery, Chicago.

Some experts of early art believe that the shape and decoration of many primitive pots were dictated in large part by the vegetable materials and skin sacks that preceded ceramics. Moreover, the shape of the round-bottomed pots of Neolithic periods in Africa, Asia, and Europe—along with their imprinted, patterned decoration—suggests that some of the first pots were made by lining a wicker basket with clay and placing it in the fire. After the wicker burned away and the fire cooled down, a nearly waterproof vessel with the lively imprint of the woven grasses was left behind.

Somewhere it was discovered that various clays, turning different colors in firing, could be used for colorful enrichment, and that some common materials, such as ashes, would produce glassy coatings called **glazes**. Glazes were used in Egypt before 3200 B.C. on tiles, jewelry, and small pieces of sculpture, but they were not widely used on pottery until centuries later.

Many of the basic materials and processes in ceramics were discovered centuries ago, and the artistry of ancient potters (Fig. 192) was notable. This art soon reached the stage where significant advancements became few and far between. The 20th century has to its credit the refinement of clays and glazes, faster and more accurate methods of firing, and mass-production techniques. It has applied power to turn machines, found new sources of heat, and greatly developed the chemistry of ceramics to meet such new demands as the heat-resistant nose cones of spacecraft and insulators for high-voltage electricity. Because of the efficiencies of modern manufacturing methods, almost everyone today can own ceramic dishes, whereas in 1750 only the wealthy could afford a set of ceramic dinnerware.

Recently, many artists—sculptors in particular—have taken a fresh look at the age-old materials of glass and ceramics, redefining some of the guiding principles of these ancient mediums while also seeking innovative forms and techniques. In many cases we have bold, new statements such as Peter Voulkos' stoneware pot (Fig. 193) and Daniel Rhodes' *Guardian Figure* (Fig. 194). Seeking expressive originality rather than smooth perfection, these artists have created works that are deliberately rough and asymmetrical. When ornament is

194. Daniel Rhodes. *Guardian Figure.* 1966. Clay reinforced with fiberglass, height 5′0″ (1.78 m). No longer in existence.

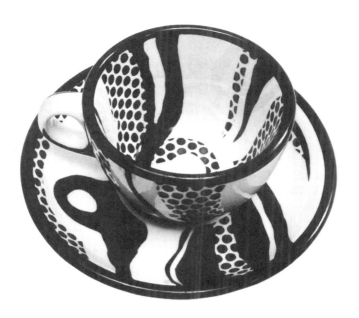

195. Roy Lichtenstein. Ceramic cup and saucer. 1966. Courtesy Leo Castelli Gallery, New York.

used in ceramic art, often it is contemporary in mood and wryly amusing, as in Roy Lichtenstein's cup and saucer (Fig. 195). But despite these changes in attitudes and form the basic components are still traditional *clays* and *glazes*.

Clay

Minute particles of decomposed granite-type rocks form clays suitable for ceramics. They are found all over the world and vary as much as woods and metals, but their common microscopic characteristic is a flat, flakelike structure that causes them to slide together and adhere to one another whether they are wet or dry. Clays vary in their plasticity—the ability to hold a shape while being formed—which changes in accordance with the size of the clay particles. In general, the smaller-particle clays are more plastic. They also differ in the temperatures at which they will vitrify, or harden, and in the colors they develop when fired. Some turn red, others tan or brown. Some remain gray, and a few become white.

Ceramic wares can be categorized in terms of the clays used and the temperatures at which they are fired. Both of these factors affect the color, shape, glaze, thickness, durability, and enrichment of the piece.

Earthenware includes brick and floor tiles, flowerpots and terra-cotta sculpture, and some vases, bowls, and dishes. Made from coarse surface shales and clays, earthenware is fired at low temperatures (1740–2130°F, 935–1150°C).

Stoneware, frequently used for ornamental vases and bowls, some of the better "pottery" dinnerware, and sculpture, is made from finer clays and fired at higher temperatures (2130–2300°F, 1150–1245°C) than earthenware. When fired, stoneware generally becomes tan or gray, and the clay particles are partially to completely fused, or made impervious to water.

Porcelain is used for high-grade dishes and ornamental wares. Usually made from mixed clays containing large amounts of kaolin (very pure, fine, white clay) and feldspar (a mineral component of mostly crystalline rocks), porcelain is fired at high temperatures (2300–2786°F, 1245–1515°C). The result is a completely vitrified, or glasslike, substance that is waterproof, strong, and white or bluish-white in color.

The Artist-Craftsperson

Although stoneware and porcelain are standard categories, they tend to merge with each other rather than maintain separate distinctions. For example, some clay bodies that fall between stoneware and porcelain, and one very common hybrid, china, deserves mention.

China, from which much commercial dinnerware is made, is white in color, durable, and not expensive. The term was originally used for European ceramics that imitated Chinese porcelains. China is fired at medium temperatures (2200–2280°F, 1190–1235°C) and is semivitreous.

Clay is formed by a variety of methods. One of the simplest techniques is to *pinch* it into shape. Another method involves rolling the clay into ropelike strands that are then built up into layers of *coils* and smoothed together. The *slab method* involves rolling clay out like biscuit dough, cutting it into pieces, and fastening them together (see Fig. 194).

Throwing (Figs. 196–199) is perhaps the most intriguing method for forming clay. A ball of clay is "thrown," or placed onto the middle of the potter's wheel, a heavy, flat disc that is rotated by hand, foot, or motor. When the potter has a squat, symmetrical, truncated cone of clay centered, he or she begins to open it

196–199. Four stages in forming a vase.

196. Placing the ball of clay on the wheel.

197. Centering the clay.

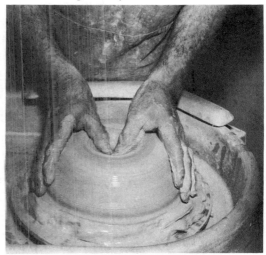

198. Raising the clay into a cylinder.

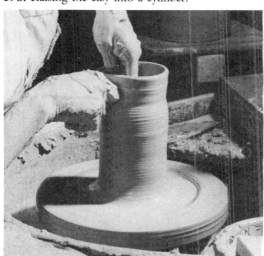

199. Shaping the vase.

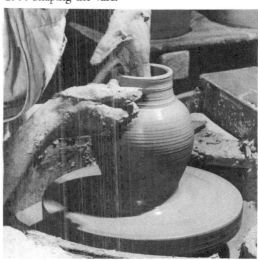

by pressing both thumbs into the middle while the fingers keep it from spreading too much. Then a cylinder is formed by pressure on the inside with one hand and on the outside with the other while the clay is drawn upward. From this point, the potter shapes the pot by varying the pressure on the inside and outside. An almost unlimited variety of round, symmetrical shapes is possible. The potter's skill, imagination, and taste, and the available clays are the important controlling factors. The cookie jar in Figure 200 is a typical example of wheel-thrown pottery.

Clay objects must be dried carefully and slowly to prevent warping or cracking. In drying, they may shrink as much as 10 percent, and they may shrink another 10 percent in firing. Before firing in a kind of oven called a *kiln,* they are called *greenware.* At this stage they break easily and soften or even disintegrate in water.

Firing at sufficiently high temperatures completely changes the character of clay. This change is called *maturing.* As mentioned, various clays are fired at different heats. At temperatures suitable for earthenware, porcelain will harden but will not vitrify; and at the high heats needed to mature porcelains, earthenware clays lose their shape and sag. Successful firing demands careful control. Temperatures must not be allowed to rise too high or stay too low.

Most ceramic objects are fired twice. *Biscuit firing* hardens the ware, and this is the only firing that such unglazed pieces as flowerpots get. *Glaze firing* produces a glossy or lustrous coating. A few objects are hardened and glazed in one firing, and some glaze effects or types of ornament require several firings.

Glazes

Most ceramics are covered with glazes, glasslike coatings joined to clay objects at high temperatures. Their major utilitarian function is to give pottery a hard, durable, easily cleaned, and usually waterproof surface.

The colors of glazes range from soft, earthy tones to those of gemlike brilliance. Their surface can be very smooth or have uncounted kinds of other textures. They can be thin and transparent, translucent, or thick and opaque.

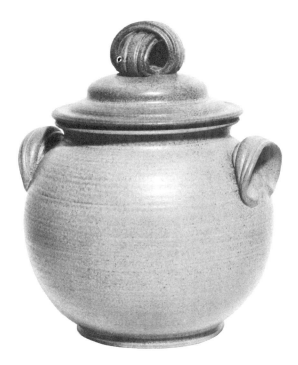

200. Arthur Baggs. Cookie jar. 1938. Salt-glazed stoneware, 13⅛ × 10½" (33 × 27 cm). Everson Museum of Art, Syracuse, N.Y.

201. Christina Bertoni.
Cosmic Dish. 1982.
Earthenware, diameter 7"
(18 cm). Private collection.
Courtesy Impressions, Boston.

These qualities are determined by the ingredients used in the glazes and by the methods of firing and cooling the pieces. Endlessly fascinating to potters, glazes range from such simple types as the salt glaze on Arthur Baggs' earthenware cookie jar (see Fig. 200) to glazes that are technically and visually complex.

The luster-painted majolica plaque illustrated in Plate 24 (p. 215) reveals the enormous range of colors and visual efforts possible with ceramic glazes. This work of art is all the more remarkable when we understand something of the exacting technical procedures used to realize it. The term *majolica* is thought to be derived from the Spanish island of Majorca. Much of this type of painted ware was exported from Majorca to Italy, where it greatly influenced Renaissance artists in the mid-15th century. The rich and subtle glazes and drawing are built up in two stages. After a first firing with tin-bearing glazes, the pieces were often painted with multihued luster glazes and refired at a lower temperature. Despite the technical restrictions imposed on the artist, Niccolo da Urbino managed to achieve as fresh an image on this ceramic plaque as if he had been painting in oils.

Glazes, however, are not the only form of visual enrichment possible in ceramics. When clay is *leather hard* (firm enough to be handled safely but not so dry that it powders or chips when cut away) three-dimensional decoration can be added. *Sgraffito*, a process with a very long history, is produced by coating the leather-hard piece with a thin layer of liquid clay, called a *slip*, and scratching through the dry outer layer to expose the contrasting body underneath. Christina Bertoni creates powerful geometric effects using the technique of sgraffito on her bowl titled *Cosmic Dish* (Fig. 201).

Ceramic Sculpture

Although many artists working in the medium of ceramics are committed to the creation of traditional forms and pots, in recent years a greater number have been taking advantage of clay's plasticity and glaze possibilities to create works that venture out of the normal craft arena into the sculptural world.

above: **202.** Robert Arneson. *Pablo Ruiz with Itch.* 1980. Glazed earthenware, height 7′3½″ (2.22 m). Nelson-Atkins Museum of Art, Kansas City, Mo.

above right: **203.** Richard Shaw. *House of Cards No. 3.* 1979. Porcelain with overglaze transfers. 19½ × 9¼ × 9½″ (50 × 24 × 24 cm). Oakland Museum, Calif.

Robert Arneson and Richard Shaw are two well-known West Coast ceramic artists whose work has evolved from traditional concerns of form and function in clay to purely aesthetic ceramic objects that relate more to sculpture. Arneson has built a career on the premise that ceramics can be funny. Although he generally uses sculptural images of himself, in this instance (Fig. 202), he turns to one of the cultural heroes of our age—Pablo Ruiz Picasso. To reinforce the idea that we have elevated the image of this enormously successful artist to that of an art world demigod, Arneson places him upon a classical Greek column. Picasso is shown scratching himself, as any itching mortal might do. By calling attention to Picasso's human nature, Arneson comments on our tendency to elevate successful artists to superhuman status. Instead of viewing high art in a deadly serious way, this artist explores the realm of high-spirited visual comedy.

Richard Shaw's work is humorous but not in the slapstick vein of Arneson's art. Shaw's technical virtuosity is characterized by incisive wit and elegant refinement of form and process. Recently, Shaw was the recipient of a National Endowment for the Arts grant to work out the color process of transferring photographic images onto clay. In his *House of Cards No. 3* (Fig. 203), Shaw combines thin porcelain copies of playing cards with fool-the-eye replicas of bound books. Part of the conceptual magic of these pieces rests in the technical mastery behind them. A photo-silkscreen technique is used to create glaze decals, which are fused onto biscuit-fired clay at low temperatures. In *House of Cards* this process is so convincing that even on close examination it is hard to believe that the porcelain sculpture is not made of real playing cards.

Some ceramic artists have pushed the conceptual and theoretical limits of their discipline even farther than Arneson and Shaw. John Mason has been involved with various aspects of ceramics and sculpture for several decades. At the Whitney Museum's large show of ceramic sculpture in 1982, Mason exhibited a piece that was very much about the process of ceramics but challenged traditional notions about this art form. In the garden of the museum, Mason set up an unusual ceramic installation sculpture that consisted of twelve arches, each 3 feet high and 6 feet long (.91 by 1.83 meters), placed in a special arrangement that measured over 80 feet (24.38 meters) in length (Fig. 204). The only material used to construct this environmental piece was firebrick, a ceramic material with great heat-resistant properties that is used in the construction and insulation of kilns. Mason has arranged the arches carefully, much as they might be positioned in an ancient furnace used to fire ceramics. Old notions about the separation in ceramics between functional, craft-related art and the fine arts have been broken down in Mason's recent work. He has combined the kinds of forms and special experiences one might find in contemporary sculpture with traditional involvement with ceramic material to open up many new possibilities for this medium. In the next decade it will be interesting to see how artists continue to recombine the centuries-old techniques and concerns of ceramics with contemporary concepts.

GLASS

Glass is perhaps the oldest synthetic material known to the world. Throughout history it has played an important role in human activity. The use of glass has never been so important as in the 20th century; today, the manufacture of

204. John Mason. *Twelve Arches.* 1981. Firebrick, each 3′ × 6′ × 9″ (0.91 × 1.83 × 0.23 m); overall installation 80′ (24.38 m) long. Private collection. Courtesy May Hutchenson Gallery, New York.

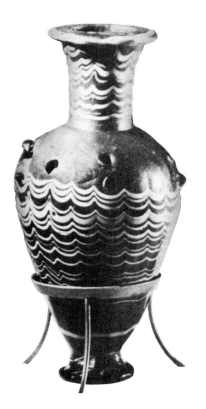

this magically transparent substance is perfected to the point that entire buildings can be clad with it.

The making and shaping of glass developed slowly, and some processes resembled those used in ceramics. Thus some of the first vessels were probably made much like coil pottery, by winding rods of hot, softened glass around a core of sand or by dipping molded sand into a vat of molten glass (Fig. 205). By 1200 B.C the Egyptians knew how to press glass. The blowpipe was not invented until shortly before the birth of Christ and has changed remarkably little from its first form. Comparable in importance to the invention of the potter's wheel, the invention of the blowpipe caused an early "industrial revolution." With the new, efficient tool, glass descended a little from the category of a rare luxury, but not until the Industrial Revolution of modern times did it become a product for common use.

The strangest and most distinctive physical characteristic of glass is that it is actually a "supercooled" liquid that at ordinary temperatures becomes so viscous it is rigid. Technically speaking, glass is not a solid. In contrast to clay, glass does not undergo a chemical change when it ceases to be a substance that will flow and becomes one that will not. This would be of little concern except that glass actually looks like a liquid, which is an important factor in its design.

Glass can be blown, cast, molded, pressed, "drawn," rolled into sheets, or spun into threads; it can be enhanced by cutting, engraving, etching, sandblasting, and enameling. No wonder it remains one of the most spectacularly useful and beautiful of materials. Were it not for the fact that glass is made out of some

above: **205.** Egyptian. Vase.
19th dynasty, 1400–1360 B.C.
Dark blue glass with multicolor
trailed decoration. Corning
Glass Works, Ltd., Corning, N.Y.

right: **206.** A skilled craftsperson
blowing glass by hand.

The Artist-Craftsperson

of the most common substances in the world, its unique properties would make it as valuable as gold.

To the artist-craftsperson, one of the most popular means of forming this material is glassblowing. When glass is blown by hand, the blowpipe (a hollow metal rod) is dipped in molten glass and then withdrawn with the desired amount clinging to the end. It is rolled on a polished slab, then blown into a bubble (Fig. 206). Working with the simple tools used for centuries—workbench, blow iron, shears, calipers, and wooden paddles—a craftsperson skilled in "offhand blowing" expertly develops the final form by rolling, twisting, and shaping with tools while the glass is hot and plastic. Because glass can be worked only at high temperatures, the object is frequently reheated in small ovens. Stems, feet, handles, or blown ornaments are formed separately and laid on.

John Nickerson's bowl in Figure 207 is a hand-blown vessel that emphasizes the effects clear glass has upon light passing through it. In counterpoint to the sensuous liquid forms of the bowl, a sharply incised edge adds a calligraphic quality to the piece.

Contemporary Glass Work

Utilizing a full range of historic techniques—and inventing a few of their own—contemporary glass artists are creating a variety of beautiful works that make stunning use of this material's inherent qualities.

207. John Nickerson. *Vessel.* 1981. Glass, blown, cut, ground, and polished; 9 × 10″ (23 × 25 cm). Private collection.

One artist who uses the patterns of light resulting from prismlike shapes is William Carlson. Carlson has created a whole group of small bottles like the one shown in Figure 208 and calls these miniature bottles the *Compression Series*. As one views the bottles from different angles constantly changing visual effects become apparent.

To create these multihued, jewel-like perfume bottles, Carlson first fuses randomly stacked colored glass rods by heating them in a furnace. When they have completely cooled, he sections them—as when a geode is cut—to reveal this exotic, swirled interior. He then polishes the sections to achieve a mirrorlike surface and encases them in a vessel of optical glass.

Carlson's technical and aesthetic virtuosity has reached new heights in his recent *Pragnanz* series (Pl. 25, p. 216) of cast, laminated, and polished glass table sculptures. *Pragnanz*—a German word meaning "conciseness"—certainly fits the visual qualities expressed by this particular work. To fabricate these pieces, Carlson combs salvage and wrecking companies for architectural glass from the 1930s such as plate glass, glass brick, and safety glass. Then through a laborious process, he cuts, laminates, and polishes these materials until they reach a perfection of form and finish. Each separate element may undergo up to forty different operations on his diamond saws and lapidary polishing machines before it is deemed "right." So extraordinary is the final result—and so far removed from ordinary glass—that it defies technical explanation. Carlson's work seems to embody the many physical qualities possible to achieve with glass: clarity, opacity, translucency; dense colors, opalescent pastels, and reflectiveness. This work is a perfect example of how consummate craftsmanship and sensitivity to the properties of materials can be elevated to high art.

As we have seen in the work of William Carlson, there are many ways to combine techniques to enhance the versatility of glass as a material. Romans, Venetians, and modern artists have even made vessels out of multicolored glass mosaics fused together. Objects with two or more layers of different colors have been carved in cameo fashion; and ornamentation has been sandwiched between two layers of glass.

Tom Patti, another contemporary glass artist, introduces gas bubbles to his work and achieves distinctive results through this method (Fig. 209). *Compacted Green with Gray* is a 5-by-3½-inch (13 by 9 centimeters) sculpture created by stacking commercial plate glass sections into a cube, fusing them in a furnace, and producing a large interior bubble. To achieve this effect Patti has sealed in two or three drops of a liquid before refiring the glass sections, causing the fluid to become a gas, expand, and create this natural inner bubble.

FIBER ARTS

Just about every minute, day or night, we are in visual and physical contact with fabrics. The clothes we wear, the bedsheets we sleep on, the carpets that cover our floors, and the upholstery of furniture are but a few examples of the many usable items made of fabric. Ever since humankind learned to weave natural fibers into pliant cloth, textiles have served important utilitarian needs, such as providing warmth, as well as satisfying aesthetic ends.

Contemporary textile designers and weavers have at their command many materials and processes with which to create fabrics that meet a wide range of needs. Threadlike fibers can be knitted, stitched, or knotted but most of the fabrics we come in contact with are *woven*. All weaving is based on the principle

of tightly interlacing lengthwise fibers, the *warp*, with cross fibers, the *weft* (also called the *woof*). Designs are created by changing the color and placement of the fibers.

Fibers

Until the development of synthetic fibers in the 19th century, natural fibers were all we had. Of the hundreds of fibrous materials found in nature, four are the most useful. Two of these, cotton and wool, enjoy the widest application; no synthetic filaments yet developed are so useful. Although somewhat more limited in range, linen and silk are also valued for their unique qualities. Often these natural fibers are mixed together in *blends*.

Cotton, used in more than two-thirds of today's textiles, comes from the fibers covering the seeds of cotton plants. The short fibers are separated from the seeds, carded and drawn to clean them and to make them parallel, spun into threads and yarns, and then woven into textiles. Cotton is relatively inexpensive, wears fairly well, and is versatile; it is found as cool summer clothes, easily laundered "linens," thin curtains, and heavy draperies.

Wool comes from the fleece of certain sheep—one of the few animals that bears this material and not hair. Wool fibers vary in thickness: Some are thin as a spider's web, while others are as coarse as hair. They also vary in length, growing from about 1 inch (2.5 centimeters) to over 18 inches (46 centimeters) a year. Like cotton, wool fibers are combed out, twisted into yarns, and woven into textiles of remarkably varied qualities. We have thin challis; smooth, firm gabardines; or rough, loose tweeds and homespuns. Its durability, resiliency, and soft luster have made wool a standard fiber for rugs. Dyes penetrate deeply

above left: **208.** William Carlson. *Compression Series.* 1980. Laminated and polished glass, 9 × 5 × 4″ (23 × 13 × 10 cm). Private collection.

above: **209.** Tom Patti. *Compacted Green with Gray.* 1981–83. Glass, 4½ × 3⅜ × 3⅝″ (11 × 9 × 9 cm). Collection the artist.

to give unequaled richness and subtlety of color. Much less widely used are the fibers obtained from such animals as alpacas, camels, goats, rabbits, and vicuñas.

Linen comes from the fibers around the woody pith of flax plants, which have been cultivated for some 7000 years. One stem may yield as many as 25,000 fibers, each averaging one thousandth of an inch (250 micrometers) in diameter and measuring up to 3½ feet (1.07 meters) long. Linen is the strongest, most pliable *vegetable* fiber. Because of its strength, linen can be spun into extremely fine threads and woven into thin and durable textiles, such as those used for handkerchiefs. Linen tablecloths and napkins look and feel smooth and fresh even after years of use. Heavier yarns are used for draperies and upholstery and in the past were used for pictorial weaving, or **tapestry** (Fig. 210). Today linen can be processed so that it resists soil and wrinkles.

Silk is the luxury fiber without equal because of its unique luster and crunchy softness. It has the greatest tensile strength of any *natural* fiber, is somewhat elastic, and resists abrasion. The way in which silkworms transform mulberry and oak leaves into this remarkable fiber is quite as wondrous as the processes by which artificial fibers are made, and basically it is similar to the processes used in making rayon. Because silk fibers are long and strong, they can be spun into very thin yarns and woven or knitted into gauzy textiles, such as translucent chiffon. Also, silk yarns give shimmering satins and rich velvets and can be woven into complex decorative tapestries (Fig. 211). Coarser silk fibers, from worms fed on oak leaves, are woven into the pleasantly rough textures of shantung and pongee.

Making Fabrics

Animal skins and the bark of trees were the forerunners of fabrics, but at some early time people discovered that they could make their own fabrics, which were more adaptive to their needs. Felts probably came first, then knitted fishnets and

210. Egyptian. Greco-Roman style tapestry weave. c. A.D. 200–400. Wool and linen tapestry, 25¾ × 25½″ (66 × 65 cm). Cleveland Museum of Art (purchase from the J. H. Wade Fund).

The Artist-Craftsperson

textiles, as well as baskets or mats woven of grass and rushes. The controlled spinning of fibers into yarns led to more pliable and diversified cloths. As with ceramics and glass, few basic changes have been made in the making of fabrics from natural fibers, but there have been technological refinements. Today the fabric industry is one of the three largest in the world. Designers and engineers have invented new processes and refined old ones to produce a seemingly inexhaustible variety of fabrics at great speed. Relieved of the necessity to hand produce mass quantities of cloth, designer-craftspeople are free to experiment in new directions.

Most fabrics are designed for specific purposes. Cotton denim is an attractive utilitarian cloth intended for work clothes and heavy wear; finely woven white translucent cotton fabric might, by contrast, be used only as curtain material. Often the factor of *use* determines the choice of materials and how they are organized. The major factors in fabric design are, therefore, the intended *purposes* of the fabric, the *fibers* out of which it is made, and the *processes* by which it is fabricated.

The range of possibilities that exists through these three variables is staggering. The textile field produces endless varieties of cloth from inexpensive cottons to the most elegant and costly silk brocades. Trained textile designers now work with technical and engineering staffs at all of the major fabric corporations to make available to the public cloth that fits both practical and aesthetic needs.

One of the best-known and highly regarded designers in the textile business is Jack Lenor Larsen. Larsen was originally trained as a hand weaver but now applies his extensive background in this traditional craft to the processes of industrial production. Because of his thorough knowledge of fibers, design, and fabricating methods he is able to use contemporary machine-driven looms to produce fabrics of exceptionally high quality. He is the only American textile designer to have been honored with a one-person show at the Louvre in Paris: In 1982 a show of his work was installed there, titled "Thirty Years of Creative

211. Loire Valley (French). Tapestry (detail). 1500–10. Wool and silk, 11'1½" × 14'5" (3.4 × 4.4 m). Cleveland Museum of Art (purchase, Leonard C. Hanna, Jr., bequest).

212. An assortment of fabrics designed by Jack Lenor Larsen.

Textiles." Although many of Larsen's designs make use of subtle textures and muted color schemes, some are quite exuberant in their brilliant color and patterns. Recently, this designer has turned away from the subdued colors and patterns usually seen in contemporary textiles and has looked for inspiration to traditional hand-woven fabrics found in the Middle East, India, Thailand, and Africa. A selection of recent designs appears in Figure 212 revealing the influence historic ethnic sources have had on his work. Many of his fabrics are used for very special custom installations where the client is interested in creating a highly fashionable, exclusive, style-conscious mood. No one fabric can easily suit every application. This brings us back to our previously mentioned guidelines, which emphasize *purpose, materials,* and *processes.* We certainly would not choose a fine silk weave for athletic wear, nor would we feel particularly comfortable in a cotton tee-shirt at a formal occasion. For these reasons designers carefully consider these three factors in the textile design process.

Printed Fabrics

Fabrics ornamented with print are so abundant that they deserve special attention. Little is known about when and where they first appeared, but evidence indicates that the Egyptians stamped designs on cloth as early as 2100 B.C. Apparently, though, it was many centuries before this process was widely known and used.

Block printing, the oldest fabric printing process, is done from blocks, usually of wood, into which a design has been cut (Fig. 213). A coloring agent is applied to the block, which is then pressed onto the fabric, and the raised portion of the block prints the design. Usually, each color requires a separate block. And since block printing is usually a laborious hand process, it is suited to relatively simple designs in which the repeated motifs are not large and the colors are few. It can, however, go beyond these limitations in some circumstances.

213. American. Textile with bird
and foliage design. 18th century.
Hand-blocked cotton, repeat
11⅛ × 17¾″ (28 × 45 cm).
Museum of Fine Arts, Boston.

Screenprinting is a stencil process sometimes referred to as silkscreen. The
basic procedure is to force a thick, pasty dye through the uncovered mesh of a
stencil screen. Nowadays an electronically controlled mechanism prints up to
seven times as fast as the older hand process. Although slower and more expen-
sive per yard than other mechanical processes, screenprinting easily permits
larger runs and heavier pigments that give the fabric a rich look.

Silkscreen technology is so advanced today that fiber artists can even incorpo-
rate full-color photographic imagery into their textile designs. Wenda von Weise
imaginatively combines the historical form of quilting—which goes back hun-
dreds of years—with the latest advances in photo silkscreen to produce a work
titled *Fabricated Cityscape: Four Patch* (Fig. 214).

214. Wenda von Weise.
Fabricated Cityscape: Four Patch.
1982. Photo screen and photo brown
prints on cotton with pigments
pieced and hand quilted,
5′ (1.5 m) square.
Courtesy of the artist.

Von Weise explains her dual interest in photographic imagery and quilts:

I use photographs of the textural elements of water, grass and leaves or photographs of city vistas to fabricate landscapes or cityscapes. This imagery is related to the ideas and traditions of surrealistic photography. I print photographs on fabric and then piece them together to create reality as partially remembered from dreams. The photographic imagery is organized like old pieced-quilt patterns, following the straight furrow system and variations of the three-, four- and nine-patch systems. Because quilts were originally intended to cover beds, and people generally dream while in bed, I feel that my surrealistic imagery is well suited to quiltmaking. (*American Craft*, June–July 1983, p. 24)

Fiber Arts Today

Trude Guermonprez (1910–1976) was an inspired fiber artist who came to the United States in 1947 from Holland and taught weaving at Black Mountain College's Bauhaus-influenced program in the late 1940s. There she continued to work in hand-loomed textiles for unique architectural applications but also became interested in developing new techniques to be used in modern tapestries. Guermonprez began to paint directly on the warp with textile dyes and explored how this brush-applied color interacted with the interlacing of the weft. This technique later became known as "textile graphics," because many of the pieces produced by this method were as imagistic as paintings. *Our Mountains* (Fig. 215) is a remarkable synthesis between painting and weaving. Without playing down the role of the fiber, it achieves many of the graphic qualities of a painting or print.

215. Trude Guermonprez. *Our Mountains.* 1971. Linen, silk, and wool tapestry with stenciled resist dyed warp, twill, inlay, and plain weave; 5′5″ × 3′7″ (1.65 × 1.09 m). Collection Alan W. Ford.

Another innovative textile designer was Dorothy Liebes. Many of her original fabric designs were a far cry from the traditional product of the weaver's loom. As we can see from the detail of the drapery material shown in Figure 216, Liebes made use of an assortment of fiber textures, colors, and metallic braiding. According to her artistic philosophy, fabrics should complement architectural settings and furniture rather than fade into the background. To implement this upbeat, aggressive aesthetic philosophy, she often included unexpected and unusual materials in her fabrics—ribbons, braids, beads, and even wooden dowels.

Fiber artists, like artists working in any tradition, rely upon historic precedent for inspiration. American folk textiles motivate many contemporary fiber artists. From colonial needlework samplers to intricate prairie quilts, these sources have formed the basis for much contemporary fiber art. Alma Lesch's cloth construction *Like Father, Like Son* (Fig. 217) makes a nostalgic reference to 19th-century rural America. Significantly, this art piece features blue denim, a fabric long associated with "folksy," homespun virtues.

Although fabric is intrinsically flat, it can be stretched and shaped into large, lightweight sculptural forms. Bill Moss is the founder and owner of a remarkably successful company called Moss Tent Works, which manufacturers some of the most innovative and beautiful portable fiber shelters to be found anywhere. Before starting this company, Moss was a magazine illustrator and art director for a consumer publication. His interests and concerns as an artist actually led to his present business success. In the 1950s Moss's canvases became more and more three dimensional, finally resulting in a 360-degree stretched fabric artwork. This eventually became the "Pop" tent, a tent supported by a flexible

above: 216. Dorothy Liebes. Detail of drapery weave with chenille, synthetics, and other fibers. Lowie Museum of Anthropology, University of California, Berkeley.

left: 217. Alma Lesch. *Like Father, Like Son.* 1967. Fabric collage, 32½″ (83 cm) square. American Craft Museum, New York (gift of Johnson Wax Company).

exterior framework. It revolutionized the camping industry.

One of the best-known and most beautiful designs to come out of his workshop is the *Optimum 350* (Fig. 218). This organically curved cotton duck tent, supported by aircraft alloy aluminum tubing, measures 24 feet by 24 feet (7.32 meters) with a 12-foot (3.66 meters) ceiling at the center; yet it weighs less than 60 pounds (27 kilograms). This structure is a model of beauty, efficiency, and economy.

Although Moss's tents are technically accomplished, his approach to design does not stem from a scientific direction based on physics or geometry. "I am an artist," he says, "not a mathematician, engineer or architect. All of my designers have artistic training too. I like to work with artists because they have a broader sense of materials than industrial designers." Recently Moss has been experimenting with large, solar-heated fabric tents, which can keep their occupants warm during the day, even in below-zero weather.

Other contemporary artists are employing fibers and woven fabrics in ways that challenge our preconceptions about the differences between traditional craft and art. Magdalena Abakanowicz, a contemporary Polish artist, is considered to be one of the most challenging fiber artists working today. For over twenty years Abakanowicz has approached the process of weaving from a non-utilitarian point of view. She believes that fiber, creatively used, is as significant a sculptural material as bronze and marble. Although her weaving methods go back to the Middle Ages, Abakanowicz has created fiber works that are particularly relevant to the 20th century. Many of her pieces seem to express powerful

218. Bill Moss. *Optimum 350* tent. 1978. Cotton duck, 12 × 24 × 24′ (3.7 × 7.3 × 7.3 m). Courtesy Moss Tent Works, Inc., Camden, Me.

The Artist-Craftsperson

Plate 24. Niccolo da Urbino. *The Adoration of the Magi.* c. 1525. Tin-glazed earthenware, polychrome decoration; 8¾ × 6½" (22 × 17 cm). National Gallery of Art, Washington, D.C. (Widener Collection).

Plate 25. William Carlson. *Pragnanz* series. 1982. Cast, laminated, and polished glass; 18 × 9 × 5″ (46 × 23 × 13 cm). Private collection.

219 Magdalena Abakanowicz.
Embryology. 1982.
Fabric construction.
Collection the artist.

feelings often associated with the art of tribal peoples (Fig. 219). Stacked on top
of each other or positioned in regimental rows, her ritualistic sculptures conjure
up many associations with nature. Abakanowicz, however, does not imitate
objects in nature; she alludes instead to elemental forces of the natural world
Above all, her fabric works have an overpowering *organic* quality. Despite their
imposing scale, they remain as fragile and vulnerable as eggs—and as pregnant
with life. Abakanowicz has written:

I see fiber as the basic element constructing the
organic world on our planet,
as the greatest mystery of our environment.
It is from fiber that all living organisms are built—
the tissues of plants, and ourselves.
Our nerves, our genetic code,
the canals of our veins, our muscles.

We are fibrous structures.
Our heart is surrounded by the coronary plexus,
the plexus of most vital threads.

Handling fiber, we handle mystery.
A dry leaf has a network reminiscent of a dry
mummy.

(Magdalena Abakanowicz [New York: Abbeville Press, 1982], p. 94)

Using traditional weaving materials, Abakanowicz has created an unusually personal artistic statement that is a bold departure from the history of woven fabric. Ultimately her work offers a synthesis between the methods of craft and the concerns of contemporary art. As such it easily fits into the diverse and multidimensional art world in which we live today.

In May of 1983 Christo, a Bulgarian-born American artist known for his temporary large-scale fabric works of art and his wrappings of everything from motorcycles to museum buildings, finished an installation in Florida. After two years of planning and study he surrounded eleven islands in Biscayne Bay with "skirts" of pink woven polypropylene that floated on the water and extended precisely 200 feet (61 meters) from the shore of each island (Fig. 220). Seen from the air, the *Surrounded Islands* looked like flowering water lilies floating in a gigantic blue-green pond. Christo commented that the lush color was chosen because "It is in harmony with the tropical vegetation of the island, the light of the Miami sky and the colors of the shallow waters of Biscayne Bay."

The technical and financial aspects of this project are as fascinating as the artist's unique aesthetics. Christo has appropriated the modern organizational structure of the corporation to work in the service of art. Before he begins any

220, 221. Christo.
Surrounded Islands, Biscayne Bay, Fla. 1980–83. 6,500,000 sq. ft. (603,580 sq. m) of floating pink woven polypropylene fabric.

220. Aerial view showing the finished installation.

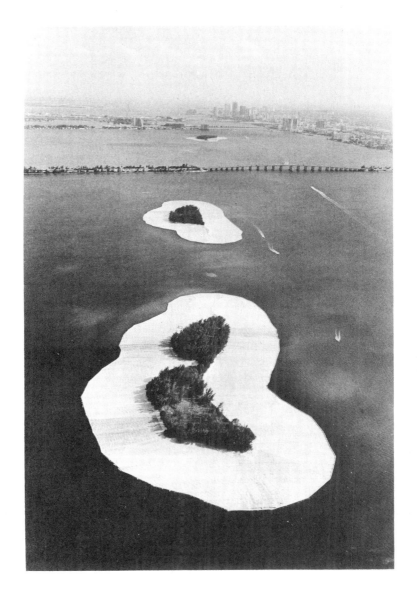

221. Work crews towing the boom-and-cocooned fabric rafts to the islands for unfurling and installation.

project, he and his wife and partner, Jeanne-Claude, form a corporation to handle the logistics of engineering, construction finances, and legal matters. All of this remarkable artist's projects are funded through the sale of his drawings, collages, and sculptures—no government or private grants are sought. With this self-generated money, experts are hired to solve a variety of complex problems. On this project alone Christo employed four consulting engineers, a building contractor, 430 workers to install the fabric (Fig. 221), two lawyers, a marine biologist, two ornithologists, a mammal expert, and a marine engineer.

Aerial surveys of all islands were undertaken; and, for the gathered data, 79 individual cloth patterns were cut and sewn to create eleven fabric compositions: to hold up the fabric, 12-inch-diameter (30 centimeters) booms of the same pink color were put together in sections and attached to the outer edges of the cloth. To keep the booms in place, 610 anchors were firmly attached to the limestone seabed at the bottom of the bay.

Although this project was in place for only two weeks, thousands of curious visitors viewed it from the shore, in planes and helicopters, and from large and small pleasure boats that thronged around the temporarily transformed islands. Its impact on the life of the community is likely to be more lasting; many people in the area have gained a greater appreciation for this beautiful bay and the power of art to heighten our perceptions of the environment. (Christo's most recent work is shown on the cover of this text.)

Fifteen hundred years separate the intricate Greco-Roman tapestry (see Fig. 210) shown at the beginning of this section from Christo's bold environmental project, which incorporated millions of square feet of synthetic fabric. Although these two works of art are worlds apart in terms of artistic concept, they illustrate the enormous range of creative options textiles offer us. No doubt they will continuously evolve to satisfy our changing needs and aesthetic perceptions.

Chapter 10

Film, Video, and Computer Art

Although earlier in Part III we have discussed some of the oldest materials and processes known, it is important to remember that technological progress and development is ongoing, not static; new tools for the artist are constantly being developed. When bronze casting was first invented in the Middle East sometime around 3500 B.C., this was a "state-of-the-art" achievement in terms of technology and art. Despite the fact that metal-forming processes have proliferated since the Bronze Age, this archaic casting method still produces some of the most viable contemporary art. What determines artistic quality is not necessarily the sophistication or complexity of the processes artists use but the skill and insight that go into the shaping and organization of the materials they choose to work with. With the invention of motion pictures and, more recently, the development of video and the computer, artists now have at their command vast resources in terms of photographic and computer-generated image manipulation. It is both interesting and revealing to examine these new technologically based mediums and discover how their processes affect their final form.

MOTION PICTURES

Perhaps no other medium has affected the lives of so many people so dramatically as the motion pictures. Over 14 million people per week attend film showings in their local theaters. During the 1940s and 1950s, however, this figure hit the 80 million mark. This period was the golden age for Hollywood, when a record number of big studio films were released monthly. Watching films, however, has not dropped in popularity, as these figures might suggest. Only the viewing site has changed. Television enables untold millions to watch feature films conveniently and comfortably at home. Today, over 14 million people regularly watch *one* show weekly during *one* hour of prime time television. Film and videotape—the electronic brother of film—fill up the greatest part of broadcasting time. If anything, viewers are watching more film today than they did during the boom years of Hollywood in the late 1940s. Because of this there has been a redefinition of sensibilities in the theatrical film industry. No one can predict with any kind of accuracy—much to the dismay of studio executives—

222. *Trajan's Campaign Against the Dacians,* detail of Trajan's Column, Rome. A.D. 106–113. Marble, height of frieze band 4'2" (1.27 m).

whether a movie will be a box office success or not. However, technical virtuosity teamed with lavish fantasy has proved to be a popular combination of late—witness the amazing popularity of George Lucas' *Star Wars* (see Figs. 223, 224), films which have earned more money than any other series in history.

At the same time, independent producers, depending more on imagination, creativity, and wit than on large bankrolls, often garner large audiences with relatively inexpensive films. Like all of the art forms today, film is making a variety of aesthetic statements that appeal to many segments of the mass audience: foreign film addicts who haunt "art" theaters; campus intellectuals with their craving for Bogart festivals; action films; and car chase extravaganzas.

Why the overwhelming popularity of this relatively new medium? It is the closest thing to magic available to us in the technologically advanced world. Going to the theater is modern ritual. Filing into a darkened, plush movie house, buying popcorn, and sitting enthralled alongside many other people is a powerful means of experiencing a mythic, larger-than-life world. As in a dream—only sharper, brighter, and infinitely more expensive—images come to life in the darkened space of the theater and move about; we can be transported to other continents, other times, even imaginary worlds. These images and their accompanying sounds sweep us away in such an all-encompassing way that we are transformed in the process. Each film that greatly affects us changes us in some way. We have in a sense lived out some other life, experienced another time, and thought about something that we never considered before

Historically, the film is humanity's latest achievement in the age-old attempt to make permanent records of action. Many prehistoric murals in caves, paintings in Egyptian temples, Greek and Roman carved friezes (Fig. 222), and Oriental scrolls portray sequential events by a series of successive, static forms.

Having no control over the way in which observers would look at the work, the artist could only hope that due time would be given to each part and that the intended order would be followed. In motion pictures, the action unfolds before the observers' eyes, and each part is seen in the order and for the exact amount of time that the director thinks is best. The feeling of immediacy is also augmented by the addition of sound, the human voice synchronized to moving lips, music underscoring the mood, and offstage noises extending the scene. Thus, time—the fourth dimension of our existence—and our sense of hearing, reinforcing that of sight, draw us into the picture and surround us with it, often to the degree that we seem no longer viewers but participants emotionally involved in what is taking place.

Time and Space in Film

The motion picture can be considered an extension of the still photograph. It consists of a series of still pictures, supported by a continuous film of cellulose acetate, usually projected at a rate of 24 frames per second. The illusion of motion that the moving picture produces from a sequence of related images in frames on a continuous strip of film is dependent on the phenomenon of *persistence of vision*. Persisting or lingering visual awareness is the retention by the retina of an image after the stimulus has disappeared. Most of us have experienced **afterimages**—the shapes and outlines of objects that we "see" immediately after we close our eyes or transfer them to other objects. This, in effect, is the persistence of vision. It enables us to make a visual linkage between the images framed in a film sequence so that we perceive not a series of discrete and jerkily joined pictures but continuous action. The ability to fuse the images filmed on a strip into a visual continuum is essential to the motion picture medium, for in actual fact the film spectator sits almost half the time in darkness peering at a blank screen, at the intervals separating the filmed images.

When motion picture films, as we know them, were first exhibited in 1895, the basic theoretical and practical requirements for making pictures move had been understood in a general way for some time. The Alexandrian astronomer and mathematician Ptolemy (A.D. c. 150) recognized that vision could persist in afterimages, and the persistence of vision had been under systematic scientific investigation since the 18th century. By the 1830s, it was recognized that producing "moving" pictures would require a means of effecting *intermittent* movement—of alternately blacking out and illuminating "still" pictures so that the spectator could distinguish clear, stable images in a series rather than the blur of photographs that themselves move.

The illusion of movement is produced by still "frames" flashed serially; the film moves during the blackouts. The genuinely modern development that made possible the unification of all the ideas into working motion pictures was the invention of a strong, flexible support for the image sequences—the photographic *film* or celluloid. This was developed in 1887–1889.

Although generally we tend to think of space and time as separate realities, they are in fact more closely related than is readily apparent. In discussing an airplane trip to Europe, we might comment to a friend that "It takes quite a while to get there." The distance or *space* over which we travel—along with the speed—determines the *time* or duration of the trip. The greater the speed of the plane, the shorter the trip. Thus the elusive entities of space and time are inextricably bound. No medium in the visual arts is better able to play with these elements than film and its electronic counterpart, video.

The Artist-Craftsperson

Since the film's image is two dimensional, depth is communicated to the viewer largely by perspective and scale—two means long employed in painting and drawing. But space unique to film also can be created by means of the extreme close-up, which leaves us with no sure way of determining true scale. Meticulously constructed models of spacecraft, only inches in length, can be made to appear thousands of feet long when they are filmed in special effects studios such as George Lucas' Industrial Light and Magic Company (Figs. 223, 224). Another cinematic means of affecting perception is to use slow-motion

photography. A slow-motion scene of a horse running along a beach changes our perception of both time and space. At a ponderously slow gallop the space of the beach is enlarged because we see it longer; the beauty of the horse's movement is also magnified and intensified.

The essence of effective film is in *movement*. At least five types of motion are possible in film: the motion of the people or objects being filmed; the motion of the film in the camera as it records the scene; the motion of the camera as it moves to follow the subject or swivels on the tripod; the movement of a variable-focal-length "zoom" lens as it seems to bring the subject closer; and the effect of motion achieved through editing, when various pieces of film footage are joined together.

Film is not the only art form to incorporate time directly; dance, music, and live theater to some extent all manipulate time. Motion pictures seem to structure our perception of time in much the same way as our memory, dreams, and fantasies do. Unlike the linear progression of everyday events, film often introduces and juxtaposes nonrational vignettes, fragments, and visual associations. Many of the structural devices of film seem directly related to the life of the unconscious—our dream world. For instance, film makes extensive use of *jump cuts,* which rapidly shift from one scene to another. *Flashbacks* are the narrative cinematic device of recalling actions that took place in the past. *Flash forwards* project us into the future, theatrically enabling us to view the consequences of an act. Both devices are used in the film versions of Charles Dickens' *A Christmas Carol,* in which ghosts of Christmas Past and Future reveal what was and what will be. Other traditional means for structuring film and our time perception are the *dissolve* (simultaneous fading out of one image and fading in of another), the *fade in* and the *fade out* (gradual appearance or disappearance of images), the *iris in* and the *iris out* (expansion of an image from a point to the full screen, or contraction from the full screen to a point), the *wipe* (the pushing of one shot off the screen by another). Each of these relates to a period of time. The cut is immediate, the dissolve somewhat longer, and the fade, the iris, and the wipe still more leisurely.

The Film-Making Process

Because the making of a successful film involves mastery of complicated technical processes as well as a firm grasp of aesthetic issues, film making is a demanding profession. With the exception of independent and experimental productions, few films are made by one or two individuals working in isolation. Almost all of the films that we view—from big studio productions costing tens of millions of dollars to short film clips on the nightly news—are made by collaborative teams or production crews. It is very difficult for one person to produce a professional-quality film singlehandedly: He or she would have to conceive, write, light, photograph, record the sound, edit the footage, score the film, process the raw footage, and see to its distribution. Therefore the help of many skilled professionals is called upon in the making of a modern film. Although artists working in more traditional media such as painting do have more complete control over the finished product, even they rely on other people for technical support: Few painters weave their own canvas, cut down trees and shape the wood for stretcher bars, make their brushes, and grind the pigments for their paints. Life in general has become more interdependent for everyone, artist and layperson alike.

The process of making a film can be divided into three distinct phases: *preproduction, production,* and *postproduction.*

Preproduction involves those activities that establish the nature of a film, its task to communicate facts or to entertain, and the means conceived for it to attain its goal. All work done prior to the actual shooting of the film is preproduction activity. Most films begin with the writing of an outline or summary, called the *treatment.* Often this is used as a means of selling the film and gaining the support of financial backers. The treatment defines everything from the mood of the film and its desired special effects to budgetary costs of the actors, film crew, the film stock used, locations, and a shooting timetable. If backing is secured, a writer or team of writers is hired to produce a script, which is taken through several drafts, becoming more and more specific. Perhaps more than any other single factor the writing of the screenplay determines the outcome of the film. Much more than dialogue appears on the manuscript page: Writers can specify the location (exterior or interior), lighting (twilight), and type of camera shot (close-up, medium, or long). Despite the relatively specific nature of the shooting script, it might be changed by the *director,* who bears the responsibility for overall interpretation of the written material. Ours is an age that has glorified the role of the director, much to the disappointment of many skilled writers. Hollywood legend has it that one highly accomplished writer, tired of hearing the director he had regularly collaborated with take all the credit for *their* work, once handed the director a stack of blank typing paper and said, "Here, let's see you put your famous stylistic touch on that."

Production activities are concerned with the actual filming. Watching a film being shot is by turns exciting, mysterious, and boring. Frantic physical activity with people running everywhere, shouting and hastily moving equipment, alternate with long periods in which most of the crew and cast lounge around with nothing to do, while the director and camera operator set up the next shot. Often, the scene will last only a few seconds and seem totally incomprehensible to the onlooker. The director's job throughout the film is to *interpret* the film script and treatment visually and dramatically and to solve all of the problems that occur during the actual shooting. If the writer's concept is impossible to achieve, the script must be changed and rewritten during production. Depending on the relationship of the director to the film, he or she may also be involved in preproduction decisions and postproduction work such as editing. Scores of people—unit managers, electricians, camera crews, sound technicians, actors, and make-up people—all contribute their skills, but the director assumes ultimate responsibility for the film's success or failure.

The shooting itself proceeds slowly. Each shot is painstakingly figured out in terms of lighting, acting, and camera position. Much conceptual leeway is possible at this time. Given the same shooting script, two experienced directors with mature styles would no doubt produce two remarkably different films. In many ways film is an art form similar to collage. Many bits and pieces of discontinuous action are put together during editing. It is not like filming a live stage play, in which every scene unfolds logically and linearly. A shooting schedule aims for the most efficient use of cast and crew. On a big studio film the combined costs of equipment rental, actors' fees, and technicians' salaries amount to several thousand dollars an hour! With this kind of money at stake, scenes are shot in the most financially advantageous order. Actors who appear in the opening scene together may be filmed the next shooting day in the final scenes of the film, since assembling them months later would prove far more costly. The

product at the end of this *production* stage will be thousands of carefully labeled and separately catalogued lengths of film.

Postproduction activities consist of assembling these separate pieces of celluloid into a smoothly flowing and coherent final print of the film. Many film professionals consider the *editing* process to be one of the most demanding and significant aspects of the cinematic art. It is certainly the most visual. At this stage, the film editor (sometimes working closely with the director) decides which shots are used—sometimes several different angles of a scene are photographed by the director—and the order of sequence of scenes. Using a "moviola," or editing machine, the editor gradually reduces the long, generalized "rough cut" to a final version, or "fine cut." At this point the film is usually considered finished; but if the director or producers feel it needs more work, it will sometimes be reedited. In extreme cases additional footage might be shot and included. Sound editing is as crucial to the success of the film as the visual editing. Titles and background music are synchronized to the visual action. A master print is then created from which release prints are made and sent simultaneously to theaters around the country.

Each of the three phases—*preproduction, production,* and *postproduction*—are crucial to the success of the film. And in each phase of the film's development, one job assumes primary importance: First, the *writer* contributes a script or blueprint; next, the *director* interprets it; and, finally, the *editor* organizes the discontinuous scenes into an integrated whole. Sometimes jobs overlap, as when directors oversee or do the editing themselves, or when writers are hired to work on the set with rewriting; but, as a rule, because of the specialized and broadly technical nature of film, those tasks are performed by different individuals. The success of the film project, however, greatly depends on the ability of these key figures to work together harmoniously to produce a coherent vision—visually, technically, and conceptually.

Classic Film

In film, as in any other art form, a classic is a memorable work that has withstood the test of time. Although the history of film is comparatively short compared to that of architecture or painting, some films and film makers stand out because of their unique contribution to the development of a filmic language. This section will examine three significant historic films that are unique in vision and for their time innovative in terms of technique, concept, and style: Georges Méliès' *A Trip to the Moon* (1902), an early film of great charm; Sergei Eisenstein's *The Battleship Potemkin* (1925), which reveals a more complex and sophisticated filmic language; and Orson Welles' *Citizen Kane* (1941), which develops multiple levels of narrative meaning and technical virtuosity that few recent films have attained.

Méliès' *A Trip to the Moon* At the turn of the century Georges Méliès' light-hearted fantasy films enjoyed great popularity, both in his native Paris and, in pirated prints, throughout the United States. Méliès was by no means the first person to present film works to the public, but he soon developed a reputation by producing entertaining cinematic tricks of illusion. The films of the Lumière brothers preceded Méliès, but their films focused on everyday events such as people playing cards, trains arriving at stations, and views of bicycle riders. They relied on the inherent wonder of the technological process itself to entertain the audience. Because of Méliès' prior experience in the theater producing magic

shows and theatrical stage illusions, he was predisposed toward more imaginative uses of this new medium. Although his first films were similar to the Lumières' works, a happy accident helped him realize his vision for the potential of film. While filming a street scene, Méliès' hand-cranked camera jammed momentarily; and when he started it a few seconds later, the position of the moving vehicles had drastically changed. Later, when he viewed the processed footage, it appeared as if a bus had—seemingly by magic—turned into a hearse. Unintentionally, Méliès had discovered *stop motion*, a standard device of contemporary film. During the course of his career, in which he made over a thousand films, this early pioneer developed and used such commonplace devices as the fade in, the dissolve, superimposition, reverse motion, and a host of other cinematic "sleights of hand." Méliès thus opened up the inherent potential of the cinematic process itself to tell a story creatively.

His most enduringly popular film is *A Trip to the Moon* (Figs. 225–227), which is based on the 19th-century Jules Verne science fiction novel. Briefly described, the film shows scientists launching a rocket that hits the Man in the Moon literally in the eye, to great comic effect. The scientists battle moon crea-

225–227. Film stills from Georges Méliès' film *A Trip to the Moon,* 1902. Elaborate sets were constructed to create an effect of fantasy. Film Stills Archive, Museum of Modern Art, New York.

tures called Selenites, which look like a cross between lobsters and humans. Eventually, the earthlings escape and make their way back to Earth. Many of the scenic devices used by Méliès make strong contributions to the overall aesthetic effect of his films. This early film maker was quick to realize the primary role visuals play in the successful development of cinematic form. Méliès can be credited with rescuing the motion picture from the domain of mere technical curiosity and catapulting it into the realm of a powerful art form. Essentially, the Lumière brothers were industrial inventors who overlooked the creative possibilities of film. In fact, Antoine Lumière pessimistically cautioned Méliès in 1896 that "the cinema has no future at all." Luckily for the history of film, Méliès refused to believe him.

Eisenstein's *Potemkin* In every poll of professional film makers and film critics in recent years, Sergei Eisenstein's *Potemkin* has been nominated as one of the ten best films in the history of cinema. Eisenstein is considered by many to be the greatest theoretician and practitioner in the history of this relatively young 20th-century art form. He was born to a sophisticated and culturally active family in what is now the Soviet Union. Quite early in life Eisenstein displayed an interest in drawing and the arts; he was also a voracious reader of everything from Greek classics to popular literature of the day. Although, like Méliès, he enrolled in a civil engineering school as a young man, his consuming interest was the theater. After working for a time as a director of an avant-garde theater, Eisenstein became discouraged with the limitations of the stage, and turned his energy to film.

Although film makers before him had produced accomplished work no one had fully developed a well-thought-out, comprehensive *theory* of film that took into account the aesthetic consequences of such intrinsic devices as the joining together, or *montage,* of pieces of film. Eisenstein saw montage as the essence of film and film philosophy. He conceived of each filmic scene as a montage *cell* that took its greater meaning from the way it was fused to the whole of many scenes. According to Eisenstein's published film notes, the principles of visual montage were suggested to him by the pictographs of the Chinese language. For instance, the Chinese combined the idiograms for *dog* and *mouth* to create the word *bark*. Each picture symbol by itself conveyed one thing, but montaged,

below and opposite:
228. Sergei Eisenstein.
Film stills from "Odessa Steps
Sequence," *Potemkin*. 1925.
Film Stills Archive,
Museum of Modern Art, New York.

or combined, they created the idea of something new—barking. Eisenstein adapted these concepts to film and in the process altered the language of this new artistic medium for all time.

Another important element in Eisenstein's concept of filmic montage is *conflict*. The conflict or juxtaposition of two widely varying elements creates a desirable tension in a film; this corresponds to a philosophical discourse that is referred to as *dialectic*. It contains a *thesis*, which is followed by the *antithesis*, or counterstatement; the process leads to a *synthesis*, a statement of meaning that encompasses or harmonizes both of them. Such a process occurs when the ideogram "to bark" is created out of the symbols for dog and mouth.

Eisenstein's work also shows more direct Oriental influences, particularly in *Potemkin*, a film that chronicles the mutiny aboard a czarist battleship. One scene in particular was inspired by a Japanese Kabuki play Eisenstein saw in Russia. During one fight scene on stage the action was stopped inexplicably, a scenic landscape without people was shown, and then the struggle resumed. Eisenstein discovered that bringing an unresolved bit of action to a halt increased the psychological tension. During one tense scene in *Potemkin* when marines are ordered to execute mutinous sailors, Eisenstein inserts nondescript static scenes of parts of the ship. Enormous visual and psychological tension is created by this disruption of the ordinary flow of theatrical time. Eisenstein consciously exploited the ability of film to manipulate both time and meaning through montage.

Another sequence much admired for the genius with which the full technical range of the film medium was exploited to high dramatic purpose is the famous "Odessa Steps Sequence" (see Fig. 228). Here, through the selection and arrangement of shots into a sequence of no more than a few minutes, the horror of both group and individual tragedy is produced with unsettling impact. On a series of very high and broad steps at the port city of Odessa, a great crowd of citizens is massed to cheer the victory of the mutineers aboard the ship *Potemkin*. Above them, at the top of the steps, appear ranked Cossacks, who march relentlessly down the steps in a total, sweeping slaughter of the defenseless people. The disaster is recreated on film from an immense array of well-conceived shots brilliantly edited into what has been called "one of the most influential few minutes in cinema history."

While the frames reproduced from the sequence in Figure 228 give effective expression to dreadful violence, the sequence is not an explicit illustration of violence. These stills show the confrontation on the steps between a Cossack and an old woman. Eisenstein edited the sequence to omit the frame that would have had the saber actually strike the woman's face and concentrated on the expressions of the assailant and his victim just before and just after the blow fell. Surrounding this moment of specific, personal catastrophe are the shots of the crowd, the Cossacks in formation with guns cocked, and the steps littered with butchered bodies.

The "Odessa Steps Sequence" is an example of how separate scenes, imaginatively montaged, can create a relationship in space when none, or a different sort, may actually have existed. By shifting from one head to another and from the crowd to the individual, and by creating a rhythm among static and action shots of long and short duration, Eisenstein has, even in the few frames selected for reproduction here, demonstrated the breadth and the extreme concentration of space and time that are possible in the film medium.

Welles' *Citizen Kane* Orson Welles was the cowriter, principal actor, and director of the remarkable film *Citizen Kane*. He once described the film as

the story of a search by a man named Thompson, the editor of a news digest (similar to the *March of Time*), for the meaning of Kane's dying words. He hopes they'll give the shot the angle it needs. He decides that a man's dying words ought to explain his life. Maybe they do. He never discovers what Kane means, but the audience does. His researches take him to five people who knew Kane well—people who liked him or loved him or hated his guts. They tell five different stories, each biased, so that the truth about Kane, like the truth about any man, can only be calculated by the sum of everything that has been said about him. (Quoted in Ronald Gottesman, ed., *Focus on "Citizen Kane"* [Englewood Cliffs, NJ: Prentice-Hall, 1971], p. 68).

Citizen Kane made several major contributions to modern cinema, not the least of which was the use of complex narrative structure. Released in 1941, it caused quite a stir for two reasons: First, it was rumored to be about the life of newspaper publisher William Randolph Hearst; and—more important—visually, conceptually, and technically it was unlike anything Hollywood had ever seen. For months prior to the actual filming of *Citizen Kane* Welles prowled around the technical studios of RKO talking to experts about every aspect of lighting, cinematography, and sound recording. Through his superb understanding of technical means he was able to advance the language of contemporary film.

Among the many distinguishing features of *Citizen Kane* is the remarkable cinematography under the inspired direction of Greg Toland. Welles and Toland wanted to achieve new heights of filmic realism in this production and used special equipment such as super wide-angle lenses, which greatly increased depth of field. Until *Citizen Kane,* most Hollywood films compositionally focused on a center of interest and allowed the scene in front and back of this point to go out of focus. But Welles wanted visual effects that approached the focus of the human eye, in which everything appears to be sharp. By means of specially coated lenses, which allowed more light to enter, as well as newly developed high-speed films, Toland was able to shoot many important scenes at lens apertures much smaller than the norm. At these new apertures everything could be in a focused zone extending from inches from the camera lens to 20 feet (6 meters) beyond it.

Citizen Kane was so thoughtfully planned and well executed that even the angle of the camera was calculated to contribute to the film's psychological effect. Kane was portrayed as an individual who gained great power through his wealth and reveled in using it. Figure 229 shows the effect of photographing a person with a wide-angle lens from below eye level. Kane stands high above his newspaper employees in this scene as he tells them about his idealistic "Declaration of Principles," which he intends to publish as a manifesto in his newspaper. To create a similar effect another scene in Kane's office was shot from an unusually low level; the camera was placed literally on the floor and a special set built on stilts for this particular scene.

The technical and aesthetic grammar of the film is so dense and complex that it would take a book-length work to do it justice. At least a brief mention, however, should be made of the use of continuity, both visually and on the soundtrack. Welles was a master of understated and efficient compression of details to achieve powerful visual results. One deservedly famous sequence— which lasts for only a few minutes on the screen—shows the disintegration of his first marriage. The "breakfast montage" presents several scenes over time, all filmed at the same table. The young couple are first shown in animated conversation and obviously very much in love. The next scene shows them together again at the breakfast table, but now having polite disagreements. Short scene after short scene follows, each more discordant than the last; finally, the two are shown not talking to each other, each silently reading a newspaper. This scene is held longer than the others, allowing us to notice that Kane's wife is reading the morning newspaper put out by his hated competitor.

Sound and image are orchestrated and coordinated in *Citizen Kane* to a degree never before achieved in film. Because of Welles' pioneering work with radio drama he was particularly sensitive to structural devices that could achieve great effect economically. Many aspects of the film highlight the passage of time and persistence of social rituals in a particularly creative way. In one scene the youthful Kane wishes his banker-guardian "Merry Christmas"; this scene cuts

abruptly to another one years later, with Kane finishing the sentence to the noticeably older figure with the words ". . . and a Happy New Year."

One sequence which demonstrates Welles' control of lighting, camera angle, dramatic timing, and the use of sound to punctuate a scene is where Kane's political opponent visits him with damaging information that could end his ambitions for elected office. Figure 230 shows his rival, Gettys, leaving Kane's apartment after he confronts him with the devastating news. Kane is seething with rage. The angle of the camera shows a field of vision in which ceilings, walls, and banisters are at oblique, unsettling angles, signifying instability and tension. The lighting on Gettys' face is equally sharp and angular, in order to reinforce the mood of the scene. Kane chases the slowly departing figure, reaches the landing, and screams after his rival threateningly: "I'm going to send you to Sing-Sing, Gettys. Sing-Sing! Sing——." At this point Welles' enraged voice is sharply cut off by the closing door, and instead of hearing the last word we hear the faint, mocking "beep" of an automobile horn.

Méliès, Eisenstein, and Welles are but three of many important contributors to the development of film as a significant 20th-century art form. The more we can learn about the technical processes involved in cinema and how they contribute to the total aesthetic impact of the medium, the better we can appreciate the contribution they make to our culture. In recent times technology has given birth to an electronic means of creating and playing back moving images—video and videotape. The next section will examine the process and theory behind this most recent means of recording motion and controlling light.

230. Film still from Orson Welles' *Citizen Kane*, 1941. Kane threatens Gettys. © RKO General Pictures.

231. Panasonic PV200 Omnimovie videotape recording system. 1985.

VIDEO ART

During the early years when cinema was hailed as the most significant new art form of the 20th century, some practitioners and critics observed that its ultimate artistic potential would not be realized until the materials and processes were available to many people, not just to a select few. They were talking about accessibility; it is a fact that expensive and complicated equipment and materials have prevented many people from learning how to manipulate film.

The operating costs of most filming processes are staggering. Even 16mm film stock, which can be purchased and processed for a fraction of the cost of professional 35mm film, runs into hundreds of dollars for only a half hour of showing time. Equipment can also be prohibitively expensive. Even moderately priced 16mm equipment, capable of making lip-synchronized film, can cost ten thousand dollars. To operate such equipment properly, at least two people skilled in film technology are needed. The exposed stock has to be sent to a processing laboratory where the separate film and soundtrack are combined. Several days later the film with accompanying soundtrack arrives, along with a substantial bill.

In the last decade technological breakthroughs in the field of video and video recording have made the dream of easy access and availability of sight- and sound-recording equipment more of a reality. For about $1000, lightweight, video equipment is available that can record synchronized sound images anywhere there is light enough to see (Fig. 231). Not only is this equipment completely portable, it is also quite easy to operate. The results of the taping also can be played back and reviewed on the spot. The sound track does not have to be recorded separately and processed at the laboratory; instead, it is incorporated

into the tape. To cap off the many advantages, an entire hour of recorded material can be made with about ten dollars' worth of tape—which, unlike film, can be used again and again.

Although this kind of equipment may never achieve the "paper-and-pencil" level of availability hoped for by early pioneers of cinema, more people than ever can secure "hands-on" experience with equipment capable of recording light, motion, and sound. In large part because of this economic factor, video is extensively used when independent artists wish to work with images and movement.

Although film and video both record light and motion, their aesthetic properties are quite separate and distinct. For example, the environments in which we usually view these media could not be more different and cannot help influencing the artistic nature of these new art forms. Films are regularly projected on screens measuring up to 50 feet (15 meters) across; we view them in large, darkened theaters along with hundreds of other cinema patrons. Going to a movie is a *communal* experience. By contrast, video is usually seen in the home or in small public viewing rooms, often by people alone or in small groups. Because of its small screen, video becomes a more intimate, *personal* experience.

Aside from the previously mentioned economic advantages of video, media artists are attracted by the *immediacy* of working with this medium. Unlike film processing, with its long delays, video offers immediate results. As soon as a scene is shot, the artist can review it. Futhermore, artists can view the final image on a television monitor while the image is being generated. Many video cameras, in fact, use as a viewfinder a miniaturized television screen only one inch across. This special aspect of video allows for an unusually high degree of feedback and ongoing manipulation of the image while it is being recorded. Thus we can see that while film and video are both time-based media that deal with images in motion, they are aesthetically and conceptually quite different.

Like film, video is a technological process that transforms light into two-dimensional images by means of optics. Video differs from the preceding technologies in the way it converts light energy into an image. No film is used in the television process. Video systems operate by electronically encoding the optically focused image into electrical signals, which are amplified and transmitted over the air much like radio signals. Home television sets are able to receive, decode, and convert these signals into an image on a "picture," or cathode-ray, tube.

Video recording in theory is much like audio recording on magnetic tape. Instead of being broadcast, the signal from the camera is sent by cable to the video recorder, where it is stored on magnetic tape for later playback. Before the development of magnetic video tape recording by the Ampex Corporation in 1956, television networks had to use motion picture film to record live video broadcasts. This film was extremely costly and produced visual records that were far from satisfactory. The first machine to record television signals electronically cost tens of thousands of dollars, measured 6 feet (1.8 meters) across and made use of 2-inch-wide (5-centimeter) magnetic tape, which traveled across the recording head at a high speed of 15 inches (38 centimeters) a second. Today a home video recorder costs as little as $250 and uses an inexpensive cassette system of half-inch-wide (1.2-centimeter) tape.

Video Works

In general, **video art** falls into three categories of concern: installation work, tapes composed largely of documentary material, and narrative performance

pieces. Video art is significantly different from broadcast television, which is produced by large, commercial networks and is transmitted directly into our homes. Artists involved with the medium of *video*, however, for the most part work independently, outside the networks' mass distribution systems. One is far more likely to view their work in art galleries, museums, and public spaces devoted to the showing of nontraditional art.

In the mid-sixties, Korean-born Nam June Paik was one of the first artists to experiment with Sony's portable consumer television recording equipment. When the first advertised units went on sale at a large retail electronics store in New York, he was literally first in line to buy a Porta-Pack. Since 1965, Paik has produced scores of video tapes, several National Educational Television programs that introduced millions of viewers to video art, and a host of special video installations.

One particular fascination of Paik's is the impact new technology has on the way we think and act in the modern world. He is a theorist as well as an artist; and Paik's ideas about our information age are considered so original that he is retained as a communications consultant by the Rockefeller Foundation. Some of Paik's perceptions are expressed by his **installation piece** titled *TV Buddha* (Fig. 232). Here, a 16th-century sculpture of the Buddha contemplates its own

232. Nam June Paik. *TV Buddha*. 1974. Installation view, Museum of Modern Art, New York, August 29–October 9, 1977.

image on closed-circuit television. Curiously, Paik interfaces a religious icon thousands of years old with a powerful icon of the late 20th century.

Bill Viola's video works fall into the category of artworks inspired by documentary material. "My goal," states Viola, "is to produce audiovisual compositions in time using the language of experience, the sounds and images of the real world collected on videotapes."

Chott el-Djerid (A Portrait in Light and Heat) (Fig. 233) was taped in the snowbound plains of Canada and Illinois and in the searing heat of the Sahara Desert of Tunisia. Viola is fascinated with the perceptual aspects of light as they are recorded and modified by the video camera on tape. *Chott el-Djerid* is a study in contrasts: the frozen, empty void of Canada's province of Saskatchewan and the image-distorting heat waves of Tunisia. In order to emphasize the miragelike visual distortions of the heat, Viola uses an extreme telephoto lens, which compresses the space. Although the video camera remains still, undulating waves create a sensuous, fluid effect. Through the technical means of optics and electronic image recording, *Chott el-Djerid* expresses an ethereal, otherworldly mood despite its documentary origins.

Most of Vito Acconci's work in video art explores the inner world of the human mind through compelling psychodramas that feature the artist as performer. *Undertone* (Fig. 234) reveals Acconci sitting at the end of a table, delivering a monologue. He begins by saying directly to the video viewer, "I need to look you straight in the eye to prove I'm not hiding anything." Acconci then goes on to spin a tale that entraps the watcher in contradiction and deceit. Schizophrenically, he shifts from one point of view to another. Unlike broadcast television, Acconci presents us with highly charged thematic material impossible to watch passively. It is performance theater, but unlike traditional drama his

233. Bill Viola. *Chott el-Djerid (A Portrait in Light and Heat).* 1979. Videotape. Museum of Modern Art, New York.

The Artist-Craftsperson

ending does not tie things into a neat conclusion: Abruptly, he simply dissolves in a cloud of television static, or "snow," when the thirty-minute tape ends.

COMPUTER ART

Although the computer has been around since the end of World War II, few artists, even as recently as ten years ago, could obtain access to these remarkable image-producing and enhancing machines. But due to the dramatically lowered price and availability of computers, this situation has been reversed. Computers are everywhere today—in homes, offices, schools, and factories—and promise to be even more widely used in the future.

Essentially, computers are electronic devices capable of performing series of calculations, or logical operations, with lightning speed. Furthermore, the ability of computers to carry out mathematical processes is greatly enhanced by their ability to store, retrieve, and process large amounts of digital information, or data.

At the heart of the computer is a central processor—circuit boards containing microchip electronics that decode the operating instructions, or *program*, and control the entire operation. Information is fed into this central processor through a keyboard or other electronic means, and the results are seen on a *video monitor* (special television) or *plotter* (mechanical drawing instrument). Since, as we have noted in the section on video, the cathode-ray tube of a television set is designed to convert coded electronic impulses into coherent images, it is not

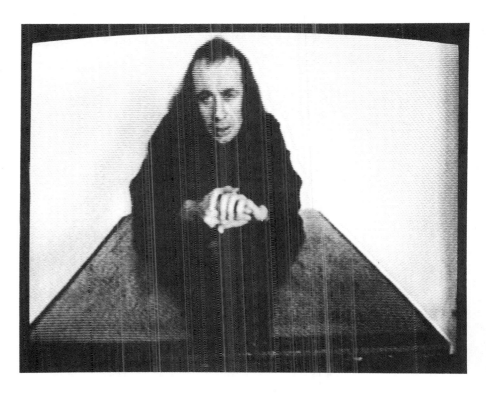

234. Vito Acconci. *Undertone.* 1972. Videotape, 30 minutes, sound, black & white. Museum of Modern Art, New York.

difficult to conceive of the computer as an extraordinary new creator and manipulator of video images.

After a decade of work in experimental film making, Ed Emshwiller, a painter by training, began his involvement with **computer art** in the 1970s. At this time he used a video synthesizer (a rudimentary type of computer), which combined live action and manipulated images. Due to the recent tremendous advance in the computer graphics field, he can now "paint" with a digital palette and realize possibilities undreamed of a decade ago. One of his most recent works is a computer-animated work titled *Sunstone* (Fig. 235). Using state-of-the-art facilities at the New York Institute of Technology, Emshwiller worked eight months with a team of artists at the school to produce this three-minute color tape. The computer-generated video opens with a cool gray rock surface, which slowly transforms into a sun face that radiates intense colors. Suddenly, realistic eyes open and it smiles; at this point, the essentially two-dimensional image becomes one face of a revolving cube whose other surfaces reveal a variety of still and moving images. Besides showing technical mastery of three-dimensional illusion, *Sunstone* is an effective work of art using surrealistic imagery.

Computers are also used as aids by many people in the design and scientific worlds. "How do complex weather factors affect patterns of rainfall, drought, and hurricanes in various parts of the world?" asks the meteorologist. "What support shape offers optimum strength, yet is the most visually pleasing?" asks the architect. Computer Assisted Design (CAD) and Computer Assisted Manufacturing (CAM) play an essential role in the world of commerce today.

The large architectural firm of Skidmore, Owings, & Merrill used computer graphics to explore the many variations possible in the design of a large, innovative fiberglass roof for an airport in Jedda, Saudi Arabia (Figs. 236–238; see

235. Ed Emshwiller.
Sunstone. 1979. Videotape.
Museum of Modern Art, New York.

The Artist-Craftsperson

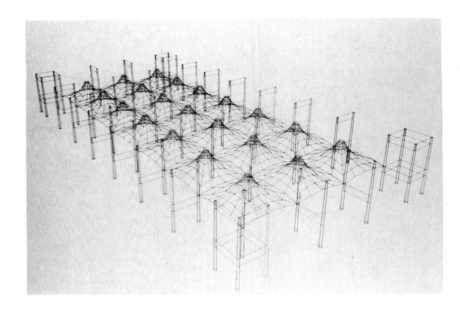

236–238. Skidmore, Owings & Merrill. Computer-generated studies for roof design, Haj Terminal, King Abdulaziz International Airport, Jeddah, Saudi Arabia. 1981.

The Artist-Craftsperson

also Fig. 381; Pl. 37, p. 369). Using CAD, the architects could simultaneously examine structural engineering problems as well as aesthetic concerns.

Since the computer is such a relatively new tool, it is impossible at this point to predict with certainty how it will be used by artists in the future. But, considering the creative uses to which recent artists have put a variety of old and new processes, anything is possible; and if artificial intelligence becomes a reality, artists may become *partners* with computers rather than their operators.

Consider, for example, the unusual relationship between AARON, a Digital Vax 11/75 computer, and former painter Harold Cohen. After learning computer programming from a musician friend, Cohen created AARON in 1973 and began to write the software (or operating instructions) to teach "him" how to draw. A mechanical drawing device called a "turtle" (Fig. 239) is connected to the computer by black wires and crawls, seemingly with great purpose, over the paper, generating distinctive, uncomputerlike drawings. Working with a set of about twenty "rules" and some random factors, AARON creates open and closed planes, simple textures, complex and simple shapes, and knows the difference between large and small (Fig. 240). Even Cohen, the creator of AARON, is at a loss to explain the "personal" imagery produced by his computer; he does not know how to change the program to produce a different drawing style.

It is the unknown that makes the future use of new materials and processes for the artist so exciting: One never knows what lies around the corner in terms of cause and effect. Throughout history, the invention of new materials and processes has significantly altered the way we, as a society, think and act. The same dynamics exist in the world of art.

opposite above: **239.** Harold Cohen. AARON. 1979. Computer-controlled mechanical drawing device. San Francisco Museum of Modern Art.

opposite below: **240.** Harold Cohen. Computer-generated drawing. 1982–83. India ink on paper, 22 × 30″ (56 × 76 cm). Courtesy the artist.

242 *The Fine Arts*

Part IV

THE FINE ARTS

The first three sections of this book focus on such issues as the organizational means used by all visual artists, the influence designers and art professionals have on our environment, and the various techniques and materials they employ. This final section will explore the fields of drawing and printmaking, painting, sculpture, photography, and architecture, forms that have traditionally been called the *fine arts*.

The final chapter, "Style, History, and Meaning," is a brief historical framework through which the issues of visual style and the evolution of world art may be better comprehended. This chapter, together with the time line that follows, should help provide an understanding not only of historical developments but of the broad social, psychological, and economic conditions that have played important roles in the formation of artistic concepts. Having this historic perspective also aids in the appreciation of works of art produced during our own era: Through an increased awareness of the past, we come to realize how contemporary artists are expressing the spirit of the times in which *we* live.

All of the many visual works we have examined so far communicate ideas and reveal a high degree of organization. However, because such forms as painting, drawing, and sculpture are less affected by utilitarian considerations, they offer the greatest freedom in terms of expression. Because of their independent, philosophical inquiry, they open perceptual and conceptual doors, which reveal how we can *think* and *feel* in special ways.

This division between the nonfunctional, more speculative nature of the fine arts and the utilitarian demands placed on applied art is a fairly recent one. Throughout most of the long span of art history, painting and sculpture have also been assigned practical roles, primarily because they have been supported by and placed at the service of the church and the state. In the past, artists were commissioned to create paintings and carvings for cathedrals, temples, palaces, and civic spaces. Through their art, they visually instructed people in the beliefs of various religions and showed them the wisdom and power of the state. Artists were viewed for centuries as gifted craftspeople who had a clearly defined social

role. Until the Renaissance many great works of art were unsigned; to this day the authors remain anonymous. These works were commissioned and paid for by some institution or patron, and artists unpretentiously made these objects for a living. In the past no unbreachable gulf existed between so-called commercial artists and fine artists, and work was judged on the merits of its *concept* and *technical skills*—all work was done essentially with some utilitarian purpose in mind.

We inhabit a vastly different world today. New economic, social, and aesthetic patterns have altered historic guidelines and have transformed our world, both physically and conceptually. The industrialization of the world has placed new demands on the artist and opened up new opportunities. But, as in many other professional fields, it has also brought about job specialization. The concept of the artist as a heroic "loner" working independent of outside influences and unconcerned about financial gain is a phenomenon of modern times.

Today studio artists struggle to produce meaningful art that corresponds to their own interests and passions, with the hope that these works can be sold to a museum or art patron. Few works are commissioned because it is the artist's *personal* viewpoint and perceptions that our age values. The benefit of this approach is that unparalleled freedom of expression is available to the independent artist. The cost of this personal freedom, however, is often quite high. Deprived of a ready market for their work, fine artists work for years on low incomes before establishing themselves in the art world. Many never earn enough money to support themselves from their work and supplement their income through part-time jobs.

This freedom for artists occurs at a time when our culture has become extraordinarily complex and diversified. As a result, the works of painters and sculptors have never in history been so mixed and varied in form, content, and materials as now, nor have they dealt with so broad a range of human, aesthetic, and technical problems. When artists had patrons—the church, the state, or wealthy individuals—their work was generally sympathetic to the ideas and purposes of those patrons. Now, independent of traditional patronage, artists are frequently strong social critics and explorers of modes of thinking that are often quite speculative. In a sense, the fine arts can be viewed as the innovative research division of the visual arts. Often painters, sculptors, mixed-media artists, and architects on the cutting edge of recent developments seek to challenge established rules and expectations. Sometimes history vindicates the pioneering work of avant-garde artists who, through their work, reveal new ways of thinking, feeling, and seeing. Because of the dynamics of modern life, we are constantly exposed to social change and the transformation of ideas; contemporary art embodies many of these developments and thus offers unique insights into the workings of our world.

In this concluding section of *Art Today*, we look at the processes of drawing and printmaking, painting, sculpture, photography, and architecture from the points of view presented in the three preceding parts: their visual elements and their organizational means, their relationship to the environment; and their materials and techniques.

Chapter 11

The Drawing and the Print

Drawing is one of the oldest visual art expressions of humankind. Certainly the prehistoric cave art found in Spain and France is dependent to a large degree on linear means rather than processes of painting. In that prehistoric past, humans quite naturally discovered that the burnt end of a stick made a convenient drawing instrument. Although drawings were used for centuries as a preliminary means of planning and organizing finished work in other media, from the 14th century on, they began to take on an independent status of their own as works of art.

The history of printmaking is inexorably bound to that of drawing: From the beginning a print was viewed as a means of reproducing drawinglike images; the essence of printmaking is thus connected to the idea of multiplicity. Some of the printmaking processes, particularly etching and lithography, are so similar to pen and ink and wash drawings that it is hard for the novice viewer to tell them apart. Skills developed in drawing are quite adaptable to printmaking (at least those of a nontechnical nature); therefore, it makes sense to examine these art forms together.

THE ART OF DRAWING

Two of the most distinguishing qualities of drawings are their intimacy and immediacy. Unlike most works of art, which are polished to a high degree of finish, drawings usually offer us special insights into the *process* of visualization. They are usually executed in minutes or hours rather than days or weeks and thus become, to use a literary analogy, poems rather than prose works, possessing an effective economy of means. Little stands between us and the perception of the idea. The artist cannot help revealing to us his or her concerns regarding the organization of space and the concept behind the work; furthermore, most drawings are utterly simple in technique—many are merely a series of black lines and marks on a white piece of paper. This is not meant to suggest, however, that producing a masterful drawing is simple. On the contrary, because the means

are so limited, the absolute control of a few elements becomes crucial. Drawing is a high-risk art, demanding the strict coordination of eye, hand, and mind. Mistakes cannot be covered easily, as they can be in painting. Greater aesthetic demands are placed on drawing, simply because many of the visually rich elements of painting such as color, texture, and large scale are usually absent. The artist working in a drawing medium must hold our interest and gain our approval through inspired mastery of line, tone, and composition.

Drawings are like X-rays in that they allow us to study the internal workings of a two-dimensional work of art. A fine drawing has an intimacy and immediacy that compels us metaphorically to enter it and unlock its secrets; and, in doing so, it connects us to the artist's personal vision. Because drawings offer us these special insights into the creative act, never before has our appreciation of them been greater.

Master Drawings

Historically, at least in the West, drawing has sought to represent three-dimensional space illusionistically on a two-dimensional plane. With the development of the Renaissance space notation system called perspective (described in more detail in Chapter 2), artists found an effective means to create illusions of deep space. Francesco Guardi, a 16th-century Italian artist, was a master of perspective, as we can see from his pen and wash drawing *Loggia of a Palace* (Fig. 241). The powerful thrust of the diagonal ceiling beam, which races away from us, helps to create a convincing feeling of depth. Scale changes in this drawing also contribute to this effect: People in the distance are small dots compared to the carefully articulated figures in the foreground. Carefully placed ink lines receding toward the vanishing point evoke great depth, and Guardi's subtle use of tonal contrast reinforces this effect. In all, the visual effect is one of deep shadows and sparkling highlights set in an illusion of three-dimensional space.

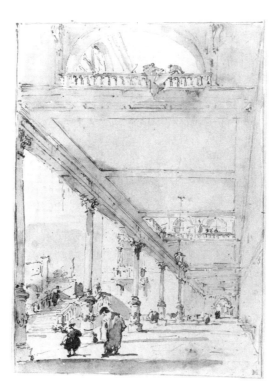

241. Francesco Guardi.
Loggia of a Palace.
18th century.
Pen and bistre wash,
$10\frac{7}{8} \times 7\frac{5}{8}''$ (27 × 19 cm).
Metropolitan Museum of Art,
New York (Rogers Fund, 1937).

Rembrandt van Rijn's reed pen and ink drawing *Winter Landscape* (Fig. 242) is an example of the economy of means that distinguishes the art of drawing. With a few deceptively simple, flowing ink lines, Rembrandt captures the frozen stillness and expanse of the flat Dutch landscape. To reinforce the feeling of depth the artist achieves through use of perspective, the very boldest and darkest lines are placed in the foreground, creating atmospheric perspective. This device exploits a phenomenon we see every day: Distant objects appear less distinct and have less contrast than do those nearby.

If we were to view this work of art in person rather than in reproduction, we would be struck by its small size—about 2½ by 6⅜ inches (5.4 by 16.2 centimeters). Yet within this severely limited physical space Rembrandt has re-created the vast, flat expanse of the Netherlands. Certainly his choice of a long, horizontal format reinforces this spatial effect.

Jean-August Dominique Ingres, a 19th-century French artist, was one of the world's greatest masters of portrait drawing. Using only an ordinary graphite pencil, he makes a compelling visual statement in his portrait of Doctor Robin (Fig. 243). Certainly the detail and anatomical accuracy of this sensitive portrait

distinguish it; yet if we examine it closely, we find that, unlike a photograph, this drawing does not give equal visual emphasis to all parts. Ingres focuses our attention on the face of Doctor Robin by describing his features with great fidelity and by using heightened contrast between light and dark tones. His hair, clothing, and hat are rendered with sketchy, faint lines. Even the background of St. Peter's Basilica in Rome is played down so as not to distract from the penetrating features of Dr. Robin.

Drawing: A Modern Vision

Although modern artists have cultivated many of the special qualities that distinguish master drawings, such as spontaneity and economy of means, their search for a new vision to fit the realities of a new world are revealed in their work. Auguste Rodin, a late 19th-century sculptor, created a pencil and watercolor drawing, *Nude* (Fig. 244), to explore the expressive possibilities of the body in movement. A solid, subtly changing mass of watercolor contrasts with the burst of lines at the bottom of the drawing that signify movement. Rodin was philosophically concerned with the idea of movement and change; he believed that a "frozen" image did not represent the forces of life. The difference between the sensuous, translucent mass of the nude and the dynamic pencil lines seems to set the drawing in motion.

Edgar Degas' *Portrait of Diego Martelli* (Fig. 245) reveals a new awareness of the lines themselves of a drawing. If we compare this portrait with Ingres' drawing of Doctor Robin, we will find some important differences. In the Ingres portrait the individual drawing marks are carefully blended so as not to be noticeable in themselves. In the Degas study, bold diagonal lines delineate Martelli's dark vest and are echoed in the depiction of his hair and beard. Unlike the Ingres portrait, the features of Diego Martelli do not particularly stand out but are treated as one part of the whole drawing. Above all, this drawing has a "looseness" and spontaneity that contrasts with the formally elegant use of line and tone in the Ingres portrait. In keeping with the changing concept of space in the modern era, Degas does not try to disguise the inherent flatness of the picture plane; he shows no image in the background to imply deep space.

The French postimpressionist Georges Seurat is known as much for his remarkable drawings as for his paintings. In fact, the modern concept of the drawing as a complete and unique art form in and of itself, rather than a preliminary study, can be traced to Seurat. His drawing *Place de la Concorde, Winter* (Fig. 246) is a mysterious and compelling vision that makes use of a distinctive drawing technique: Perhaps more so than many artists, Seurat employs the paper itself as a means of making a mark. By using a rough-textured paper and conté crayon (a kind of hard chalk), he creates the effect of dark marks on a white surface on the lower half and reverses this on the upper half, where the recesses of the white paper can be read as white on black.

Contemporary Drawing

One of the most typical characteristics of recent drawing activity is the enormous range of techniques, visual concepts, and aesthetic awareness we can find represented in this medium. Every style from abstract to realist to conceptual art can be and is expressed in drawings. Often contemporary artists combine many materials in a rich mixture of new and traditional drawing techniques. Robert

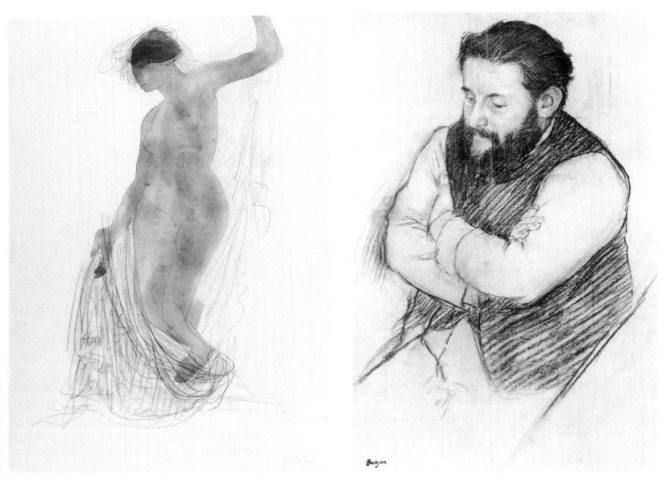

above left: **244.** August Rodin. *Nude*. 1908. Pencil and watercolor, 17⅝ × 12½″ (45 × 32 cm). Art Institute of Chicago (Alfred Stieglitz Collection).

above: **245.** Edgar Degas. Study for a portrait of Diego Martelli. 1879. Black chalk heightened with white chalk on gray-brown paper, 17¾ × 11¼″ (45 × 29 cm). Fogg Art Museum, Harvard University, Cambridge, Mass. (bequest of Meta and Paul J. Sachs).

left: **246.** Georges Seurat. *Place de la Concorde, Winter*. 1882–83. Conte crayon, 9⅛ × 12⅛″ (23 × 31 cm). Solomon R. Guggenheim Museum, New York.

247. Robert Rauschenberg.
Canto XXXI:
Illustration for Dante's Inferno.
1959–60. Red pencil, gouache,
and pencil (transfer drawing);
14½ × 11½″ (37 × 29 cm).
Museum of Modern Art, New York
(given anonymously).

Rauschenberg's *Canto XXXI* (Fig. 247) is a particularly effective example of mixed-media work. At the heart of this drawing is the *transfer technique* pioneered by Rauschenberg. The distinctive image of the wrestlers in this drawing was created from a color magazine photo that was transferred onto the paper by applying a solvent to the surface of the printed photo, placing it *face down* on the drawing and rubbing across the back with a blunt stylus. The pressure transferred the softened printing ink onto the drawing. Rauschenberg unifies these transferred photo images by working into the drawing with colored and graphite pencil and **gouache**, an opaque watercolor paint.

In striking contrast to the complexity of image and mixed-media materials found in *Canto XXXI* is Ellsworth Kelly's elegant pencil drawing *Briar* (Fig. 248). Most of this artist's minimal paintings make use of severe, highly refined geometric shapes. In *Briar* Kelly has brought his concern for simplification into the organic world and has created a drawing of both simplicity and complexity. Although the outlined edges of the leaves create simple shapes, the negative spaces between the forms are complex; the sharp thorns and thin stem also offer visual counterpoint to the rounded leaf shapes.

Eva Hesse's untitled drawing (Fig. 249) makes use of wash and pencil. A **wash** is simply a layer of watercolor so thin it becomes translucent, allowing the paper to show through. This work of art is a fine example of *serial imagery*, a visual device that makes use of a repetitive theme and variation. No two concentric circular forms are alike; each one is subtly different, and comparing them becomes hypnotically pleasant.

Compared to many art forms, drawings offer us unparalleled opportunity to gain insight into the creative process; little is concealed, and much information remains immediate and accessible. This medium also allows artists to go directly from concept to realization more efficiently than most others. The next section

above: **248.** Ellsworth Kelly. *Briar.* 1963.
Pencil on paper, 22⅜ × 28⅜" (57 × 72 cm).
Whitney Museum of American Art, New York
(Neysa McMein Purchase award).

left: **249.** Eva Hesse. *Untitled.* 1966.
Wash and pencil, 11⅞ × 9½" (30 × 23 cm).
Museum of Modern Art,
New York (gift of Mr. and Mrs. Herbert Fischbach).

of this chapter will deal with **printmaking**, a medium that is very much dependent on effective drawing skills. Despite the complex and laborious technical demands of printmaking, many of the best prints preserve the same qualities as unique drawings.

PRINTMAKING

At one time it was thought that the relative ease and sophistication of commercial photoreproduction processes would reduce the market for prints made by hand in small quantities. In fact, however, demand for contemporary hand-processed prints has steadily increased over the last fifteen years. The personal expression and unique visual effects embodied in many of these works of art are increasingly valued in our heavily mechanized age.

What is meant by an "original" fine art print? In what sense can a duplicated image be original? Most of the graphics we see in everyday life—such as posters, magazine photographs, and illustrations in books—are produced in the tens of thousands on large, mechanized presses. Once the artist submits the artwork or illustration, technicians completely take over. By contrast, fine art prints are usually drawn by hand and printed in small editions (or print runs) by the artist or someone who works closely with the artist, to achieve his or her desired results. It is this personal intervention at every stage of the process that distinguishes the fine art print and makes it an "original" graphic.

In the 1950s, the Print Council of America was formed to foster appreciation for prints—old and new—and to end the confusion in many people's minds between original prints and reproductions. Toward this end, the Print Council published these guidelines:

> An original print is a work of graphic art, the general requirements of which are:
> 1. The artist alone has made the image in or upon the plate, stone, wood block, or other material for the purpose of creating a work of graphic art.
> 2. The impression is made directly from that original material by the artist or pursuant to his directions.
> 3. The finished print is approved by the artist.

These guidelines were formulated to educate the public and to prevent unscrupulous dealers from selling photomechanical reproductions produced in large quantities at exorbitant prices. Recently the State of New York enacted legislation further to control and prevent misrepresentation in the art marketplace. Legitimate examples of graphic art usually have several qualities in common: For the most part, they are not photomechanically reproduced like this book (viewed with a magnifying glass, this printing process reveals scores of tiny dots, or "half-tones"); an *edition number* appears in pencil on the lower left of the margin. This tells us which *impression* in the series we are looking at. For instance, it might read "24/35" or "3/100." In these two sets of numbers, we would be looking at the twenty-fourth impression from an edition of 35 and the third impression from an edition of one hundred. Finally, since artists usually supervise the printing of the edition, they sign it in pencil on the bottom right to indicate their authorship and approval of the work. Sometimes dubious "artists" team up with greedy dealers and produce photomechanical prints in large editions of a thousand or more, which are signed and sold to the public as valuable original prints. Premium prices are charged for what is little more than inexpensive posters. It is important to know enough to avoid this deception.

Most significant printing techniques fall into four major categories: *relief printing,* which includes woodcuts and wood engravings; *intaglio* processes, such as engraving and etching; *planographic* printing, done on stones and special zinc plates; and *stencil* processes, such as silkscreening.

Relief Processes

The process of *relief printing,* or **block printing,** is one of the simplest and easiest to understand of printing methods. One of the oldest processes known, it was first used in China in about A.D. 100.

Almost everyone has at one time or another made a relief print, either in grade school through potato prints or later with rubber stamps used to print dates or names. Relief prints are so named because the actual printing surface is raised above its background and stands out in relief. The artist cuts away the surface he or she does not want to print. The most common form of relief prints are **woodcuts** and **wood engravings.** Woodcuts are carved into a plank of wood with the grain running lengthwise. Wood engravings (rarely seen today) are done on the end-grain of the wood, but since it is difficult to get pieces of any size this limits the usefulness of the process.

To make a woodcut, the artist cuts out the design (in reverse, for in printing it will come out in reverse). Then he or she inks the raised surface of the block with a gelatin roller called a brayer. A soft, absorbent paper, such as rice paper, is then placed on the block and rubbed with a smooth wooden spoon to transfer the ink to the paper. To make another impression, the process is repeated.

One rare, partly finished 16th-century woodcut by Peter Bruegel the Elder has luckily survived (Fig. 250). This piece gives us a rare glimpse of how blocks were first drawn upon by the artist in preparation for the woodcutter, who interpreted the cartoon. Most surviving blocks have been carved and printed, thus destroying in the process the original drawing upon the wood surface.

250. Pieter Bruegel the Elder. *The Marriage of Mopsus and Nisa.* 16th century. Woodcut (half-completed), 10⅜ × 16½" (27 × 42 cm). Metropolitan Museum of Art, New York (Harris Brisbane Dick Fund).

Certainly one of the greatest early masters of the woodcut was Albrecht Dürer, a 16th-century painter from Nuremberg who was first trained by his father as a goldsmith. No doubt Dürer's sculptural skill learned from metalwork aided him in the refinement of the woodcut as an artistic process of great fluency. After all, cutting the wood accurately is a sculptural process. Before Dürer no one had achieved such complex textures and detail as he was able to accomplish in prints such as *The Last Supper* (Fig. 251). Dürer achieved this incredibly fine tonal range by introducing variable-thickness lines that thicken and thin, a technique easy to achieve in drawing with a chisel-nib pen but requiring consummate skill in woodcuts. Partly to signal his pride, Dürer introduced his distinctive monogram, which can be seen bottom center.

By printing different-colored areas of the block in *registration* (accurate overlaying), multicolored prints such as Hokusai's *The Great Wave of Kanagawa* (Fig. 252) can achieve rich tonal and dramatic effects. This well-known Japanese artist lyrically depicts one of the enormous waves that periodically strike the coast of this island nation. In the distance Mount Fuji appears serene and almost aloof, in contrast to the turbulence and visual activity of the ocean.

Japanese prints are among the many sources that have inspired contemporary printmakers such as Helen Frankenthaler to evolve new modes of expression in this ancient medium (Fig. 253). Frankenthaler is well acquainted with historic examples of woodcuts and has been particularly successful in adapting modern aesthetic sensibilities to a relatively old and simple graphic process.

251. Albrecht Dürer.
The Last Supper. 1510. Woodcut,
5½ × 11¼″ (14 × 29 cm).
Metropolitan Museum of Art,
New York (Rogers Fund, 1922).

above: **252.** Katsushika Hokusai. *The Great Wave of Kanagawa.* 1823–29. Color woodblock print, 10 × 15″ (25 × 38 cm). Metropolitan Museum of Art, New York (Howard Mansfield Collection, Rogers Fund, 1936).

above right: **253.** Helen Frankenthaler. *Essence Mulberry.* 1977. Woodcut on handmade paper, edition of 46; 39½ × 18½″ (100 × 47 cm). Printed and published by Tyler Graphics, Ltd. © Helen Frankenthaler/ Tyler Graphics Ltd., 1977.

Intaglio Processes

Line engraving, drypoint, and **etching** are the major hand intaglio processes. Instead of printing from raised surfaces, intaglio processes print from the *depressions* of plates, usually but not necessarily made of metal. Everyone carries around examples of this form of printmaking. Take a dollar bill out of your wallet. You are looking at an example of steel-plate line engraving mechanically printed by an intaglio process called *gravure.* If it is a fresh new bill, you can even feel the subtle texture of the raised lines of ink.

To make an intaglio print a thin, smooth, flat metal plate is beveled, or angled, on all four edges, and lines or grooves of varying widths and depths are cut into its surface. Every tiny scratch will print. Ink is rubbed over the plate and into the recessions; then the surface is carefully wiped clean with horizontal strokes, leaving ink behind in the recessed lines. The plate is now ready to print. It is placed face up on the flat bed of a mechanical press that uses a metal roller to exert great pressure on the plate surface. A thick printing paper is dampened, placed on the inked surface of the plate, and run through the machine. The pressure of the press squeezes the pliable, damp paper into the grooves, picking up the ink. Since the surface of the intaglio plate was wiped clean, this area does not print. Only the ink-laden depressions show up as colored marks.

Line engraving is perhaps the most technically difficult intaglio process to master. A sharp, V-shaped cutting tool called a *burin* is used to incise a channel in the plate. Controlling this tool takes strength and skill, but the end result, as seen in Martin Schongauer's engraving of the late 1400s, *The Temptation of Saint*

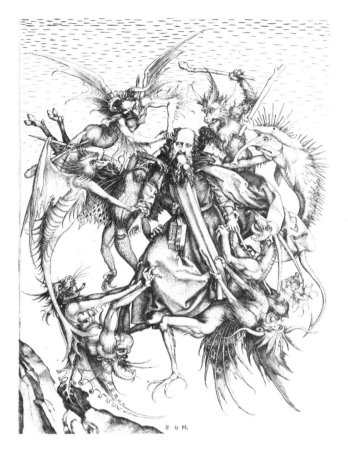

above: **254.** Martin Schongauer.
The Temptation of St. Anthony.
c. 1480–90. Engraving,
12⅜ × 9⅛″ (32 × 23 cm).
National Gallery of Art,
Washington, D.C.
(Rosenwald Collection).

above right: **255.** Mary Cassatt.
La Caresse. 1891. Drypoint,
10⅞ × 15⅜″ (28 × 39 cm).
Metropolitan Museum of Art,
New York (gift of Arthur Sachs,
1916).

Anthony (Fig. 254), is a clean, crisp, well-defined line difficult to achieve with other intaglio methods.

Drypoint engravings are only slightly different from line engravings. In making a drypoint, lines are cut into a copper plate (zinc, aluminum, or Lucite are also used) with needlelike points of sharpened steel or with points made from diamonds or rubies. These, in general, make a finer indentation than the engraver's burin and suggest a freer, sketchier line. A second important distinction is that the drypoint needle throws up tiny, irregular edges of metal, called *burrs,* that are left on the plate. In contrast, the engraver's burin, if sharp, leaves no burr, and any edge left by a dull tool is scraped off. Printing drypoints is much like printing line engravings. Ink is rubbed onto the plate—but in wiping it off, some ink is inevitably left in the burr to give the drypoint a characteristically soft, velvety line. Also, a light film of ink is usually left over the whole surface to give the background a pale tone.

Thus, drypoints are generally distinguished from line engravings by these characteristics: The line quality is less sharp and precise, heavier, and fuzzy; and the print generally has a toned background. Mary Cassatt's drypoint engraving *La Caresse* (Fig. 255) illustrates the soft, informal line quality that can be achieved with this special technique. Had this subject been carried out in line engraving, it would have been harder and sharper and less suitable a means of expression.

Editions of drypoints are limited in number (unless the printing surface is steel coated) because the burr wears off in the printing. The first ten to twenty prints have the greatest tonal richness, but from then on the quality declines.

Etching represented a technological breakthrough in the intaglio process of printmaking. Instead of carving a line in the plate with an engraver's burin, a method was developed whereby acid selectively reacts with the metal, eating it away to form the depression or recessed line. A plate of copper or zinc is first coated with a thin, acid-resistant *ground;* then, by gentle scratching through the ground with a blunt needle, the metal is exposed to the acid's bite. Because of the subtle irregularity with which the acid eats the metal, the line achieved with this process does not possess the precision of engraving, but etchings allow a far more spontaneous drawing approach. The depth of the lines on the plate—and the consequent darkness of the lines on the print—is determined by the length of time the plate remains in the acid bath. A single immersion gives lines of equal depth. Line variety is achieved by removing the plate from time to time and covering with an acid-resistant *stop-out* varnish those depressions that are deep enough. The plate is then immersed again for further biting. The printing process is identical to that of drypoint.

Rembrandt's etching *Christ Healing the Sick (The Hundred Guilder Print)* (Fig. 256) is a stunning example of how a variety of visual effects can be achieved with this relatively simple graphic medium. Rembrandt achieves many tonal effects with the etched line, ranging from the delicacy of a beam of light to dark shadows implying deep space. At the extreme left, sparse lines describe a host of individuals in an economical fashion. As our eye moves toward the center of the picture, the lines are woven into a complex pattern of textures and dense tonal values so that we are less conscious of individual lines. At the extreme right no lines are discernible, only a rich range of varying tones. Through a process of etching the plate, proofing it, and re-etching, Rembrandt achieved tonal effects as subtle as those of any drawing.

Edgar Degas' *Self-Portrait* (Fig. 257) is an etching on copperplate that compares favorably to the rich tonal quality of the Rembrandt print. Degas was less interested in depicting deep space, however, and presents us with a carefully

below left: **256.** Rembrandt. *Christ Healing the Sick (The Hundred Guilder Print).* c. 1649. Etching, 10⅞ × 15⅜" (28 × 39 cm). Metropolitan Museum of Art, New York (bequest of Mrs. H. O. Havemeyer, 1929, H. O. Havemeyer Collection).

below: **257.** Edgar Degas. *Self-Portrait.* 1855. Etching, 9 × 5⅝" (23 × 14 cm). National Gallery of Art, Washington, D.C. (Lessing Rosenwald Collection).

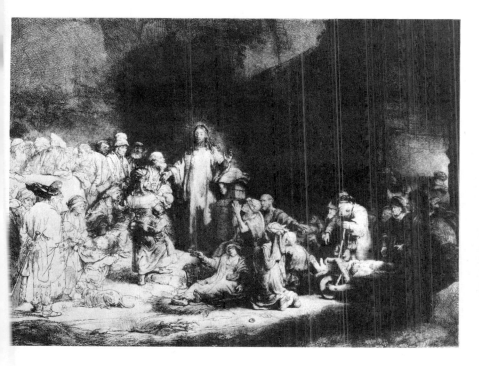

modulated form of shallow illusionistic depth. It is interesting to compare this etching with his chalk drawing of Diego Martelli (see Fig. 245). Certainly differences exist, but great similarities link printmaking to drawing.

Other intaglio processes used alone or, more often, in combination include the following:

The **aquatint** process is a means of achieving solid areas of tone by giving the plate a uniformly pitted surface. Powdered rosin is dusted over a heated plate; each particle of rosin becomes fused to the hot surface and resists being etched by the acid. Depending on the size of the particles, their spacing, the strength of the acid, and how long the plate is immersed, a variety of tones is created that ranges from the lightest gray to pure black.

A soft-ground etching is made by coating a metal plate with a greasy ground that does not harden. A sheet of paper is laid on the ground, and the artist draws on top of it with a pencil or presses anything he or she wishes into the ground. When the paper is removed, some of the ground comes off with it. Then the plate is immersed in acid that eats into the metal in direct proportion to the amount of ground that has been removed. This technique is also called the *crayon,* or *pencil manner,* because it emulates the soft effect of a pencil drawing on paper. William T. Wiley's amusing soft-ground etching *Line Fever* (Fig. 258) achieves the look of an inspired pencil doodle carried to great heights. Wiley has chosen the soft-ground process as the best means to express his visual concept for this print because of the soft line it produces. Buried in this complex, linear web are a variety of images and symbols that have become trademarks of this California artist.

Few of these intaglio processes are used alone; in fact, many prints make use of several of these methods to achieve the desired visual effects. It is not rare to find that engraving, hard-ground etching, drypoint, aquatint, and soft-ground techniques are used in a single plate. What counts is the success of the print.

The Planographic Process

Lithography is the only important planographic type of printing used in the fine arts. In terms of technique, it differs greatly from relief and intaglio printing. The image is neither below nor above the surface of the plate but *on* it (hence the term planographic—printing from a flat surface). Lithography is one of the newer printing processes, having been discovered and perfected in the 1790s by a young German playwright turned inventor, Alois Senefelder. Senefelder discovered that if he wrote or drew with a greasy pencil directly on a type of Bavarian limestone, treated it with nitric acid, and applied a coat of gum arabic, he could obtain prints of his drawn images.

Lithography is based on *chemical* rather than mechanical processes. The essence of the technique depends on the fact that grease and water do not mix. Technically, the lithographic process begins with either a slab of Bavarian limestone, like Senefelder's, or a specially treated zinc or aluminum plate. To prepare the stone, it is ground level with carborundum powder and given a fresh tooth, or texture, to properly receive the drawn image. Lithographic crayons, pencils, and liquid "ink" called *tusche* can be used to draw and paint on the stone. All of these drawing materials have a high grease content, which is necessary for the process to work. A wide variety of drawing and painting techniques can be achieved in lithography, which accounts for its popularity as an artistic medium. Once the drawing is finished, the stone is treated. This is a complex process

involving mixtures of nitric acid, gum arabic, and water. Simply put, the treatment chemically alters the surface of the stone so that, during printing, areas that were drawn upon with a greasy material accept ink; areas untouched by grease repel the ink.

When ready for printing, the stone is moistened with a wet sponge. The water soaks into those parts not drawn upon and is repelled by the areas once covered with lithographic crayon or tusche. An inked roller covered with soft leather or made of rubber is passed over the wet surface, applying ink to those portions of the stone that have not absorbed water. As the stone is inked, the original drawing, which was washed away in the etching process, appears once again.

The lithographic press is similar to an etching press in that it has a movable bed, but it uses a *scraper bar* instead of a roller. Damp paper is placed on top of the stone, a few blotters are put on top of the paper, and a smooth-surfaced piece of fiberboard called a *tympan* on top of that. The scraper bar clamps down on the lubricated tympan, and the bed is cranked, moving the bar across the surface of the stone, pressing the ink into the paper. Other impressions can be made by repeating the inking and printing processes. Multicolored effects can be obtained in lithography by printing each color separately and, through registration, combining them into one finished print.

The expressive and technical scope of lithography is vast. Lithographic pencils and crayons give soft and grainy lines which can be either delicate or boldly laid down, depending on the artist's intention and technique. Brush and lithographic ink give artistic freedom akin to that of painting; the De Kooning lithograph in Figure 259 is an excellent example of this approach.

below left: **258.** William T. Wiley. *Line Fever.* 1978. Soft-ground etching from copper plate, 26 × 32½" (66 × 83 cm). Courtesy Crown Point Press, Oakland, Calif.

below: **259.** Willem de Kooning. *Untitled.* 1960. Lithograph, printed in black, 42¾ × 30¾" (109 × 78 cm). Museum of Modern Art, New York (gift of Mrs. Bliss Parkinson).

By using lithographic crayons and small brushes or pens with tusche, it is possible to produce printed renderings of the greatest accuracy and refinement. Claudio Bravo, a Chilean artist, illustrates this technical approach in his *diptych* (two-part work) titled *Fur Coat Front and Back* (Fig. 260).

Stencil Processes

Silkscreen printing, also called *serigraphy*, is among the newest of the fine art graphic processes. But stencil methods, in simpler forms, go back far in time. The earliest were used as a means of transferring images to fabric. Although silkscreen printing was firmly established in commerce by the 1930s, it was not until a few decades ago, when "pop" images and **hard-edge** painting were in vogue, that it substantially gained in popularity.

Since silkscreen is the least equipment- and technique-intensive form of printing, it has been widely used in recent years. Essentially, the concept is a simple one: A special silk or synthetic open-mesh textile is tightly stretched onto a wooden frame; the screen is left open in those areas that are to print and blocked out elsewhere. Because the stencil is created on a screen surface, it is possible to block out areas in the middle of an open space—something that could not be done if the stencil were made of thin cardboard.

A variety of means is available to the artist to block the screen selectively and create the stencil, but essentially methods fall into two basic categories: painting an ink-resistant substance, such as glue, directly onto the screen or adhering a special film to the screen that prevents ink from passing through.

260. Claudio Bravo.
Fur Coat Front and Back. 1976.
Lithograph on two sheets, each
22⅜ × 37⅞" (57 × 96 cm).
Museum of Modern Art, New York
(Latin American Fund).

In printing, the surface on which the image is to be screened is placed below the stencil, and a highly viscous ink, which will not flow through the screen by itself, is poured along the edges of the printing frame. The ink is pulled across the screen with a rubber squeegee and forced through the porous sections. A separate screen is required for each color.

Silkscreen prints can be produced from designs that feature flat geometric shapes, as in Edward Ruscha's print *Standard Station* (Fig. 261); or they can be given complex textures and made to look as if they were drawn spontaneously (Fig. 262). Some prints require as many as twenty or thirty separate stencils or screens—one for each different color.

261. Edward Ruscha. *Standard Station*. 1966. Serigraph printed in color, 19½ × 37" (50 × 94 cm). Collection, The Museum of Modern Art, New York (John B. Turner Fund).

262. Larry Rivers. *French Money*. 1965. Serigraph on acrylic with acrylic collage, 32 × 30" (81 × 76 cm). Courtesy Multiples, Inc., New York.

263. Red Grooms. *Gertrude*. 1975. Color lithograph on arches cover, cut out, glued, and mounted in acrylic; 19¼ × 22 × 10″ (49 × 56 × 25 cm). Courtesy Brooke Alexander, Inc., New York.

Screenprinting is also used for posters and other commercial art when relatively small quantities of the print are needed, since the initial cost of preparing the stencils is much less than that of the plates for most other printing methods. The silkscreening process is also used in the printing of "limited editions" of textiles, either by hand or by semimechanical means.

Expanded Techniques

Like other media, printmaking has undergone transformation and redefinition in light of new technological materials and processes. Artists during the last two decades have combined a wide variety of traditional and experimental printing processes: inkless embossing of intaglio prints, photomechanical methods, xerography, rubber stamps, printing on three-dimensional surfaces, and diecutting. The three-dimensional print *Gertrude* (Fig. 263), created by artist Red Grooms, was printed in six colors from two aluminum plates, which were then diecut, folded, and glued together to form the warm and amusing sculptural print of Gertrude Stein holding court in an overstuffed, floral-print chair.

Artists also have experimented recently with printing on unusual materials. Because screenprinting does not necessarily need a paper surface to print on, it lends itself particularly well to nontraditional processes. Pop artist Claes Oldenburg's witty *Teabag* (Fig. 264) is a bas-relief print created by silkscreening onto clear thermoplastic, which was then vacuum formed. Roy Lichtenstein's *Moonscape* (Fig. 265) also involves serigraphy on plastic. Lichtenstein used a special multilayered plastic that appears to shimmer and change—much as moonlight on clouds does—and incorporated this quality into the composition.

264. Claes Oldenburg. *Teabag.*
1967. Serigraph on Plexiglas,
39 × 28″ (99 × 71 cm). Courtesy
Multiples Inc., New York.

With the vast array of sophisticated processes and advanced technology available to contemporary printmaking, artists are now limited only by their aesthetic imaginations and technical skills.

265. Roy Lichtenstein. *Moonscape.*
1965. Serigraph on metallic
plastic, 20 × 24″ (50 × 61 cm).
Ruder & Finn, Inc., New York,
for Philip Morris, Inc., New York.

Chapter **12**

Painting

Most Western painting, particularly from the Renaissance to the middle of the 19th century, can be considered *illusionistic;* that is, it creates an illusion of people and objects in a readable space. Many of the paintings of the last hundred years, by contrast, are *allusive* or *self-referential:* Some distort and alter the appearance of the world but still allude to people or to things (Fig. 266); others use abstract geometric shapes, referring to themselves essentially rather than describing the outward appearance of objects in the world (Fig. 267).

In traditional paintings, the artist chooses a subject and interprets it illusionistically so that the viewer can recognize the visual reference and aesthetically enjoy the experience. By contrast, the artist working with self-referential forms

266. James A McNeill Whistler. *Old Battersea Bridge: Nocturne—Blue and Gold.* c. 1872. Oil on canvas, 26¾ × 20″ (67 × 51 cm). Tate Gallery, London (reproduced by courtesy of the Trustees).

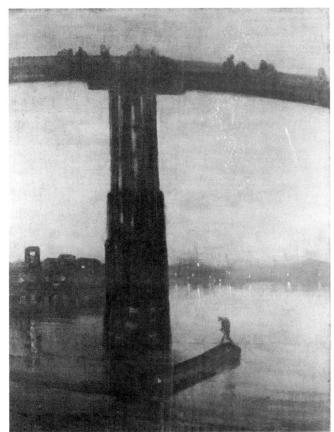

267. Frank Stella. *Tuftonboro I.* 1966. Synthetic polymer paint on canvas, 8'3" × 9'1" (2.5 × 2.7 m). Collection Mr. and Mrs. Victor W. Ganz.

wishes to create objects that are themselves as real, and that speak to us as directly, as the things with which we live. Many contemporary "abstract" painters are uninterested in creating a visual *illusion* and wish to present us with a physical *actuality*. Frank Stella's painting *Tuftonboro I* (Fig. 267) does not so much describe something as it is something—a dynamic organization of interlocking shapes and intriguing color relationships. Many modern paintings such as this one are touchstones for thought. This type of painting asks us to respond directly to the perceptual experience it provides. Because the artist does not offer us a recognizable image, we are forced to scrutinize the painting for meaning. In this sense we are driven inward and forced to "create" the meaning within our own psyche. Viewers thus confront themselves, through the work of art, in unique and thoughtful ways.

Two important aspects of *Tuftonboro I* that are not conveyed by the illustration but should be mentioned are its colors and size. The colors, in order of their values from dark to light, are lustrous black, brilliant cardinal red, tan, and bright yellow, each separated from the other by a fine line of unpainted canvas. The colors, like the forms, are self-referential. The physical size (over 8 feet high by 9 feet wide, or 2.4 by 2.7 meters) is impressive, and the viewer feels a *presence,* a visual confrontation that he or she cannot avoid. Giant scale is a characteristic of much painting and sculpture produced during recent decades. This quality is related to the nonillusionistic *role* of much new art.

Because Western painting has for much of its history been dominated by illusionistic subject matter, let us continue our investigation of painting by looking at two types of representational styles from just before the turn of the century.

REPRESENTATION IN PAINTING

Two Representational Styles

Edward Hopper, an American, painted *Early Sunday Morning* (Pl. 26, p. 281) in 1930. Vincent van Gogh, a Dutchman working in France, painted *Starry Night* (Pl. 27, p. 282) in 1889. The paintings provide strong contrast in subject and in treatment. Both depict ordinary subjects. The Hopper cityscape is an unpretentious row of small shops with living quarters above, still typical of the inner core of many American cities. The van Gogh landscape is dominated by a brilliant, star-filled, moonlit sky. Hopper's subject is so commonplace that in daily life it is something we would scarely notice; van Gogh's subject is compelling for its intrinsic beauty and grandeur. *Early Sunday Morning* shows the clear, steady light of day; *Starry Night* evokes the mystery and awesomeness of the night. Both artists were faced with the necessity of transformation: Hopper, to take an ordinary and unattractive subject and make it a work of art; van Gogh, to capture within the limits of a small canvas the great energies and vastness of the universe.

Hopper's *Early Sunday Morning* At first glance we might say that in *Early Sunday Morning* Hopper has done nothing with his subject but record it. Such a reaction, however, ignores the fact that even the simplest painting requires the artist to make many decisions. Hopper, first of all, had to determine what he wanted to paint. Among the questions he could have posed for himself are these: Should I give the subject, once chosen, a vertical or a horizontal format? If it is a group of buildings, should I include people? How much space should I give to sky, to foreground? These questions, and many others, must be answered in some way before work is begun. Sometimes the artist will make small sketches to assist in arriving at decisions. It is essential, or course, that the artist have some kind of feeling about the subject if he or she is to produce a painting with vitality; the attraction cannot be half-hearted or casual. We might then ask why Hopper chose such an ordinary subject. Rather than answer that question directly, let us look closely at the picture he produced and some of its features.

The most notable organizational element of *Early Sunday Morning* is its horizontal format. The compositional structure of the picture is reinforced by horizontal bands running lengthwise across the painting. The narrow top band, the sky, extends the width of the picture, unbroken except by a small, dark rectangle at the right that suggests a taller building nearby. This visual arrangement prevents the composition from becoming too symmetrical and uninteresting. The barber pole and fire hydrant have the same purpose.

To provide contrast to the horizontal thrust of the painting, Hopper divides the building itself into smaller, mostly vertical rectangular shapes that serve as foils for the major horizontal areas. The second-story windows, in a two-two, three-three grouping, alternate with the cornice brackets above them. (The brackets occur in pairs at two points.) On the ground floor, in somewhat larger scale, the openings are more varied, being both doors and windows. The painting is essentially organized by long, narrow forms and nearly square shapes. These rectangular forms run like themes throughout the picture. Their variety and continuity add to the structural richness of the composition. Shadows are thrown across the façade of the buildings, adding diagonal forms to the composition. The longer we look at the painting, the more we will see.

The identity of the subject is never in doubt, and *Early Sunday Morning* is readily classifiable as "realistic." Yet a strong suggestion of mystery and uncertainty can be seen in this meticulous portrayal of a building façade. Although many elements of the painting allude to occupants and workers, no people are visible. Along with the general air of calm and repose, we might feel a certain sadness.

Van Gogh's *Starry Night* By contrast, *Starry Night* impresses us by its tremendous vitality and sense of movement. A restless, dynamic energy pervades the canvas. Van Gogh portrays the universe as a system of mighty forces, making our planet, exemplified by the church and houses, appear static, small, and unimportant. Van Gogh's art is responsive to the might and laws of nature that order the physical world and determine the forms of hills and the growth patterns of trees.

Anyone who views a clear evening sky in the country away from the star-dimming light of the city perceives a universe that is awesome in its magnitude and magnificence. It is these feelings that van Gogh captured in *Starry Night;* he accepted the fact that the magic of a starlit night can no more be portrayed by literal painting than by literal photography. To convey his idea he distorted sizes and shapes. Movements of light pattern the sky with all the energy and much of the form of nebulae. Individual stars in their brilliance take on tremendous size (compare them with the buildings). The moon, usually the dominant feature of the night, is given a lesser place in this heaven. On the painting's frontal plane the giant cypress tree—also a part of nature—is filled with the same restless energy as the sky. The small village in the foreground seems secure and protected, and both the conventional forms of the buildings and their stability are in sharp contrast to the almost explosive vigor in the rest of the picture. *Starry Night* is full of emotion, straightforward both in its content and in the means used to convey its ideas. It is the work of a gifted individual who deeply felt the wonder of nature and developed a painting vocabulary to express his awe.

In *Starry Night* every paint stroke is visible, and each is part of the larger forms that make up the composition. The areas occupied by sky and ground are basically horizontal, as are many of the smaller shapes. Contrasting with these, both in direction and color value, is the form of the cypress tree (with a faint echo in the church spire). Its startling darkness adds brilliance and luminosity to the sky; its vertical shape makes the hills appear more stable and placid. The tree's restless quality, which links it with the sky, gives the two a basis for unity, even though in direction, hue, and value they are drastically opposite

It is within the sky, appropriately, that we see the most compelling and unusual forms. Almost directly in the center are two large, interlocking spiral shapes (with a smaller one slightly below and to the right) that are the climax of a great movement entering the picture at the left. The spiral, with its constantly changing direction and speed, is an admirable form for conveying a sense of movement and energy. Filling the rest of the sky are the circular stars and the moon, all burning with a terrible intensity. These restless forms contrast sharply with the stable, rectangular shapes of the buildings. The gently rounded hills serve as a transition between earth and sky. The hot, piercing yellow of the moon and stars is in strong opposition to the cool greens and blues in the tree, sky, and land.

Another compositional arrangement that should be observed is based on a system of diagonals. A strong line along the lower right edges of the cypress tree extends generally to the upper left-hand corner. Note in how many places this

direction is repeated in the forms of the buildings, the ground, and the sky. The diagonals are opposed by other diagonals set at right angles to them. These structural lines are sharpest in the contours defining the tops of the hills and appear in other parts of the composition. The picture involves horizontals, verticals, opposing diagonals, circles, spirals, rectangles, and triangles, all skillfully interwoven and further unified by the bold painting technique.

Early Sunday Morning and *Starry Night* illustrate different facets of modern painting. Hopper's work is a calm, reasoned, analytical, yet compassionate portrayal of the American urban environment. Van Gogh's painting is intensely emotional, a passionate outpouring in response to natural phenomena. Hopper chose a more realistic mode, yet he structured and selected details carefully. Van Gogh, by contrast, went beyond the literal appearance of his subject to make a subjective—often called **expressionistic**—statement. Both artists, by different means, show that "reality" is interpreted, shaped, and expressed by the mind.

MATERIALS AND PROCESSES IN PAINTING

The visual and thematic effects painters wish to achieve in their work are determined largely by the choice of **medium** and how it is used. Each medium exerts a pronounced effect on the finished product, yet each material responds to varied and individual treatment. Painters must have an intimate knowledge of the qualities and characteristics of the medium they choose, for it is only by learning to control and exploit it that they can gain full mastery of expression. Until the recent development of synthetic paints and the utilization of new materials, all paintings could be classified under three main headings: oil, watercolor, and fresco.

Painting in Oil

Ever since oil paints were developed around the beginning of the 15th century, painters have used them more frequently than any other medium. They have many advantages. Oils offer an enormous range of hues, values, and intensities; they blend together easily and lend themselves to extraordinarily varied handling; they can be worked and reworked many times; and they are durable.

In *View of Toledo* (Fig. 268), El Greco fully utilized the potential of oils to achieve in a vivid and dramatic manner his monumental conception of a landscape. Within the forms of the painting we can see how the artist has used the medium to achieve a wide range of effects. The ominous sky has been rendered in great, sweeping passages of color that are in sharp contrast to the fine detail of the buildings. In the lower left, the paint has been applied in small areas of varying color and value to describe the leafy details of trees. These form another contrast, with the feathery, flamelike foliage to the right, where the colors have been subtly blended with the brush. The artist's blending of pigment is also strikingly apparent in the swelling hill forms toward the upper right, where gradations of color and tone give the effect of massive solidity. Through a masterly use of the medium, El Greco created a complete array of effects in color and value, form and texture, all assimilated into a unified whole.

In looking at *View of Toledo*, we are barely conscious of the paint *as paint*. It has been applied to make a relatively smooth surface and used to simulate the colors and textures of the forms depicted. However, as we examine *Sunflowers* by

above: **268.** El Greco. *View of Toledo.* 1604–14. Oil on canvas, 47¾ × 42¾"
(121 × 109 cm). Metropolitan Museum of Art, New York (H. O. Havemeyer Collection,
bequest of Mrs. H. O. Havemeyer, 1929).

above right: **269.** Claude Monet. *Sunflowers.* 1881. Oil on canvas, 39¾ × 32"
(101 × 82 cm). Metropolitan Museum of Art, New York (H. O. Havemeyer Collection,
bequest of Mrs. H. O. Havemeyer, 1929).

Claude Monet (Fig. 269) we are immediately conscious of the thick paint itself
and the way it has been applied to the canvas. The individual brush strokes are
clearly visible, and the **painterly** texture they create becomes, in itself, a major
ingredient of the work. This is an impressionist painting, in which an overall
visual impression of a scene was sought rather than detailed description. Even in
a black-and-white reproduction it is clear that the artist has used "broken" color.
Each surface is painted with independent strokes of varying hues that mix in the
eye of the observer. The petals of the flowers, for example, take their very form
from the thick, buttery strokes of yellow, orange, and red pigment. The back-
ground is made shimmering and luminous by the juxtaposed patches of cool and
warm hues. Impressionist paintings are undisguised celebrations of the splendor
of nature. Curiously, when they first exhibited their works in the late 1800s, the
impressionists were accused of being inept technicians!

The Process There is no limit to the ways in which oil pigments can be
handled, and in no other paint medium is it possible to get a wider range of
effects. The pigment can be applied in separate strokes, in thick and heavy
opaque masses, or in washes almost as transparent as watercolor. Variations and
nuances of color and subtle modeling of form are restricted only by the painter's
ingenuity and skill. Another characteristic is also important. In watercolor paint-

ing the artist begins with white paper to which he or she applies color, and each touch of pigment darkens the paper. Thus, unless opaque white pigment is added to watercolor, the painter necessarily works from light to dark. The same is true of fresco. In oil painting, however, it is possible to work either from light to dark or from dark to light because, as typically used, oil paint is opaque enough to cover what is beneath it.

Technically, the painter using oil has remarkable freedom, yet one important rule must be remembered: Because oil paint can be thinned to various degrees, the painter must be careful not to paint a "lean" or less oily pigment over a thicker or "fatter" pigment. Peeling or cracking will result because of the different drying times of the two layers. In working with oils the artist needs a suitable surface on which to paint—one that will receive the paint freely and yet not absorb it, can withstand temperature changes, and will not crack the pigment on it. Canvas is the most widely used **support**, although wood, paper, and metal have been used. In traditional oil painting, the artist must **prime**, or prepare, the support before working on it. Many of the great paintings up to the time of the Renaissance were painted on wood, but the lightness, cheapness, and flexibility of good cotton duck or linen canvas have made painting on wood a rare practice. Recently, there has been an increased use of hard-pressed wallboards, as well as other materials, in oil paintings.

Pigments Colors come from many sources: minerals, vegetable matters, coal tars, and other chemical combinations. These are ground until the grains are extremely fine; then they are mixed with oil (linseed usually) and sometimes with wax to bring them to a suitable consistency. For oil painting the pigments are mixed on the **palette** with oil and turpentine to whatever degree of thinness the painter may wish. Colors vary in their permanence. Some, particularly earth pigments, never fade; others, including several very desirable ones, are impermanent. Oil pigments dry quite slowly; over a long period of years they tend to darken in color as the oil yellows.

Some painters do not use brushes but apply their pigments with a palette knife or with other tools, or even directly from the tube or can. In this way they can apply the paint thickly and produce a bold, textural effect.

Painting in Watercolor

In its broadest sense, the term **watercolor** refers to any paint medium that is soluble in water and uses water as a thinner. More often, however, it refers specifically to a kind of transparent paint that is applied to paper. *Lower Manhattan* (Fig. 270), by John Marin, is a watercolor of this type. It is a view of the financial center of New York City as it appeared many decades ago, with lower Manhattan's distinctive skyline in the background and the elevated railroad (now gone) in the foreground. With its headlong diagonals, its sharp contrasts, and its impetuosity, the sketch captures the dynamic quality characteristic of a throbbing business and commercial center. It would be difficult to get the effects Marin achieved in any other medium than a watered pigment applied freely on paper. Good watercolor paintings are not easy to make, despite their spontaneous appearance. Watercolor painting, as much as any other medium, requires a high degree of technical dexterity.

The Process The most notable characteristics of the watercolor medium are fluidity and transparency. The pigments come in tubes or in cakes that are

soluble in water, hence their fluidity. They are available in a wide range of colors, but sumptuous and varied effects can be achieved from a few basic ones.

The transparency of watercolor gives a special importance to the surface on which it is painted, and most painters use a paper that is rich in texture. In oil painting the surface is selected primarily for the way it responds to the strokes of the brush and holds the paint, but in most oil paintings the surface itself is almost completely obscured by the opaque pigments. With watercolor, however, the surface of the paper is visible through the transparent pigment, and in many watercolors, parts of the paper are left untouched. The paper thus becomes integral to the painting, for the surface texture comes from the paper to which the medium is applied.

The watercolorist's brushes are also carefully selected. Generally, "soft" brushes are used, made from the hair of such animals as camels, oxen, and red sable. Brushes made from sable are expensive but work best. They are very pliant yet spring back to their original shape as soon as pressure is released and they are lifted from the paper. Hard, bristle brushes are also used, and these are best suited to paintings in which dry textural effects are wanted.

The fluid and transparent qualities of watercolors exert a pronounced influence on the methods of working with them. They must, for example, be mixed on a white palette, since any color in the palette would distort the color of the transparent pigments. When colors are mixed on the palette and applied in a "wash," they produce an even, ungraded tone. Colors can be blended on the paper by allowing them to flow into each other, or the artist can load the brush with two or more colors by pressing it directly into the undiluted pigments and then applying it to the paper to produce a stroke that is varied in color. He or she can achieve gradations in value by putting a stroke of full color on the paper and then brushing clear water into the edge of the stroke, thereby spreading the diluted color over a larger surface.

270. John Marin. *Lower Manhattan*
1920. Watercolor,
21⅞ × 26¾″ (56 × 68 cm).
Museum of Modern Art, New York
(Philip L. Goodwin Collection).

271. Paul Cézanne.
Mont Sainte-Victoire.
c. 1900–06. Watercolor,
16¾ × 21⅜″ (43 × 54 cm).
Museum of Modern Art, New York
(gift of David Rockefeller).

Each of the many ways of painting with water-soluble pigments has its own merits. A great contrast to the Marin is provided by Paul Cézanne's *Mont Sainte-Victoire* (Fig. 271). Here the medium is used with restraint. Actually, only small areas are painted, and the blank paper carries most of the responsibility of the painting. However, an effect of great scale has been achieved, and the mountain towers massively over the trees and buildings in the foreground even though it is mostly flat white paper. Note how both the forms of the painted areas as well as the brush strokes within them suggest the basic structure and nature of the various objects of the painting.

Other Types of Watercolors So far we have discussed only transparent watercolors, but many contemporary painters prefer to use one of the several types of opaque water-soluble paints. Far from being new, opaque watercolors are among the most ancient of painting mediums. **Tempera** is a mixture of pigments in a **vehicle**, or liquid substance, of egg, gum, or glue, usually used on a surface prepared with a base of **gesso**. It was employed by Egyptian, medieval, and Renaissance painters. Tempera is still used today when sharp and precise details are required.

Gouache, another type of watercolor, is made by grinding opaque colors with water and mixing the product with a preparation of gum, or by adding Chinese white, which is opaque and water soluble, to transparent watercolors. *Poster paints* are the most familiar, least expensive and least satisfactory (as far as permanence and flexibility are concerned) of the opaque watercolors. *Casein* paints, which have an alkaline solution of casein (a milk product) as their vehicle, are comparatively new and hold many possibilities. They can be used as transparent washes or as thick, opaque areas, either smooth or textured.

Painting in Fresco

Fresco, an Italian word meaning "fresh," is a technique of painting on fresh, wet plaster with pigments that have been mixed with water. A finished fresco

has something of the transparent, fluid quality of watercolor, but there the similarity ends, because fresco is a medium for painting in monumental scale. Relatively few contemporary painters use the process of fresco because newer, more flexible and convenient methods have been developed. However, some artists today, perhaps in response to renewed interest in large-scale public art, have rediscovered fresco.

Fresco is an ancient process, one that can be found in wall paintings unearthed on the island of Crete and dated to about three and a half millennia ago. From a later period of antiquity, A.D. c. 70, we have frescoes preserved in the remains of Pompeii and Prima Porta in Rome. Their remarkable freshness attests to the extraordinary durability of fresco. The most brilliant use of fresco was during the **Gothic** and **Renaissance** periods, especially in Italy, where the walls and ceilings of countless cathedrals, churches, chapels, and palaces were covered with frescoes of exceptional beauty and grace.

Sixty-three feet (19.2 meters) above the floor of the Sistine Chapel in Rome, Michelangelo, in the early 16th century, painted a monumental series of scenes illustrating the ideas and events of the Hebrew-Christian traditions. To cover the ceiling's 7000 square feet (650 square meters) of surface, the artist worked almost entirely alone and completed the cycle after four years of appallingly hard labor. Today, more than four centuries later, the Sistine ceiling remains one of the truly remarkable achievements of world art. The medium Michelangelo used for painting the Sistine vault is fresco, whose characteristics can be seen in the *Creation of Adam,* a detail from the scenes of the Old Testament (Fig. 272).

The Process For the fresco painter, faced with the problem of covering a large area of wall or ceiling while working on a high scaffold, it is advisable that a project be well planned before beginning to paint. Usually, the artist makes

272. Michelangelo.
Creation of Adam, detail of
Sistine Ceiling. 1511. Fresco.
Vatican, Rome.

preliminary sketches that, once perfected into a design, are enlarged to full size. Such full-scale sketches are called *cartoons,* and for a large fresco they are cut up into pieces, each of which represents a day's work. Fresh plaster is applied over the area to be painted, the cartoon is fastened to it, and the necessary outlines and details are transferred to the wet plaster. (Michelangelo used an iron stylus.) Plaster beyond that which has been painted in a single session is cut away. The requirements of painting in wet plaster are such that the artist must be careful to make the limits of each day's work coincide with the edge of a figure or of some prominent feature—to search for lines and formal needs of the composition so that the characteristics of the medium can be placed at the service of the artist's aesthetic purpose.

Pigments are mixed with water and applied to the damp plaster. As the water evaporates, the lime in the plaster absorbs carbonic acid gas from the air, and a thin transparent layer of crystalline carbonate of lime forms on the surface. This protects the fresco to the degree that it will not deteriorate as long as the plaster is not damaged. Frescoes cannot be reworked the way oils or watercolors can. If a major change is to be made, the artist can only remove the plaster that has been painted on and redo the unsatisfactory portion on a fresh base. A certain amount of touching up with tempera paint is frequently done, but colors applied to dry plaster, or in *secco*, lack the permanence of those bonded into it. Leonardo da Vinci painted his *Last Supper* (see Fig. 393), and the deterioration of that masterwork, already a ruin in the artist's own lifetime, is evidence of the inadequacy of painting on dry plaster.

The composition of the *Creation of Adam* consists of two masses, each of which stands out clearly against the background. The event is conveyed by Michelangelo's rendering of the figures. While one side remains inert in a smooth, simple curve, the other is a complex of contours quickening to the suggestion of life and movement. On the left, Adam rises from a sloping land form in response to the shock of life God has given him. On the right and against the sky is God, both borne and surrounded by heavenly creatures, his arm embracing the yet-uncreated Eve. It is at the tips of the index fingers of God and Adam that the two masses in the composition are brought together, and each of the extended hands reflects its possessor. The hand of Adam is limp with the first stirrings of life; the hand of God bristling with creative energy.

Synthetic Paints

In addition to oil paint, a variety of new paints are available to the artist, each with advantages of its own. The most widely used synthetic mediums today are polymer temperas. They are of two distinct types—a polyvinyl acetate and an **acrylic resin**—but there are only minor differences in the way they behave. In both types a synthetic emulsion, or base medium, acts as the **binder** to which dry pigments are added. Applied to a surface without the addition of pigment, the emulsion dries to a tough, transparent film. Also, because synthetic paints are inorganic and will not rot the canvas, they can be applied directly without an isolating **ground**. The paints are water compatible, that is, water is used for thinning them and for cleaning brushes and palettes. However, once they have dried they are completely resistant to water; thus, overpainting may be done without any possibility that color will bleed through from the underpainting. Although the working texture of the polymer paints is very different from oils, they can, like oil paint, be thinned to the consistency of transparent watercolor or be applied in a thick impasto. They have the great advantage over oil paint of

273. Al Held. *Hadrian's Court I*.
1982. Acrylic on canvas,
7 × 6′ (2.14 × 1.83 m).
Courtesy of André Emmerich Gallery,
New York (Mr. and Mrs. Harry W.
Anderson Collection).

drying rapidly. Oil painters may have to wait days, and sometimes weeks, before overpainting, but new layers of polymer tempera may be applied in from twenty minutes to two hours, depending on the thickness of the underpainting.

Al Held takes advantage of the quick-drying qualities of acrylic paint in his highly complex, geometric paintings (Fig. 273). Unlike oil paint, most synthetic polymers do not blend easily to create smoothly graduated transitions; thus they are particularly appropriate for paintings that make use of sharply defined edges and areas of flat tone. The short drying time allows the artist the opportunity to try many combinations of colors and shapes until the right effect is achieved. While it is conceivable that oil paint might be used to secure the same results that Al Held did in *Hadrian's Court I*, acrylic paint is an appropriate choice in terms of efficiency and control.

Also, the necessity of painting oils "fat over lean" need not concern the artist in working with polymer tempera. Acrylic paint, unlike oil, dries as a homogeneous mass, for as each new layer is applied it forms a chemical bond with the layers beneath it. This remarkable characteristic also makes possible the use in a polymer tempera painting of materials that otherwise would be incompatible.

Furthermore, numerous tests have indicated that the polymer tempera mediums are quite resistant to light, heat, and exposure. They resist yellowing and darkening, and because of the uniformity and flexibility of the paint film, they are not easily damaged.

Collage

Collage is a recently developed painting medium that first gained acceptance during the cubist era. The term is derived from the French *papiers collés*, which means pasted papers.

Georges Braque—the cofounder of cubism—created the collage *Le Courrier* (Fig. 274) in 1913 by gluing together a variety of "nonart" materials such as wood-grained paper, a section of newspaper headlines, and part of a tobacco wrapper. In doing so he created a painting based on nonillusionistic, *flat space*—space so real one could place objects on it. Collage techniques were used by the cubists to change the emphasis of painting from the *representation* of reality to the *presentation* of reality through physical materials that exist on a flat picture plane.

Romare Bearden is a contemporary artist who extensively employs collage in his paintings. Because of the sharp, fractured forms that result from cut-out shapes, this technique seems particulary suited to work of a cubist nature. Bearden, a black artist, often makes use of images of black culture, particularly from the rural South where he was born. *Watching the Good Trains Go By: Cotton* (Fig. 275) offers a kaleidoscopic view of people picking cotton much as they might have at the turn of the century. These collage paintings no doubt function for Bearden as a means of recollecting memories of his youth. Bearden, however, evokes powerful visual myths in these lyrical collages rather than presenting us with documentary evidence.

New Materials

Artists have been particularly inventive in extending the range of materials they find useful. In looking at many recent works one is tempted to say that in the last several decades there are few materials that artists have not used or even made central to the aesthetic significance of their work. They have drawn not only on the great store of natural materials generally found in the world about us—twigs, leaves, stones, sand, soil, seeds—but also on the products of modern

below: **274.** Georges Braque. *Le Courrier.* 1913. Charcoal, gouache, and printed paper; 20 × 22½″ (51 × 57 cm). Philadelphia Museum of Art (A. E. Gallatin Collection).

below right: **275.** Romare Bearden. *Watching the Good Trains Go By: Cotton.* 1964. Collage, 11 × 14″ (28 × 36 cm). Hirshhorn Museum and Sculpture Garden, Smithsonian Institution, Washington, D.C.

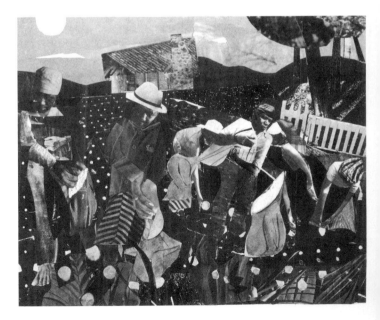

276. Mary Bauermeister.
Progressions. 1963. Stones and sand
on board, 4'3¼" × 3'11⅜" × 4¾"
(1.3 × 1.2 × 0.12 m).
Museum of Modern Art, New York
(Matthew T. Mellon Foundation
Fund).

life—photographs, paper pulp, metals, maps, wood, fabrics, and plastics. The
use of such common but untraditional materials has done much to give modern
art its unique quality. It has also raised problems in the classification of works
incorporating such elements. Now, even basically two-dimensional creations
can no longer be properly identified by the simple term "painting."

Progressions by Mary Bauermeister (Fig. 276) is made entirely of stones and
sand mounted on board. It is, actually, four distinct but related compositions
combined into one work. What strikes us initially is the extent to which the raw
materials have been transformed, and it is only on a second or third look that we
realize the nature and presence of the raw materials making up this work. On
two of the square areas the stones, meticulously graded in size, have been ar-
ranged to suggest deep perspective, and the differing horizon lines create a
tension from one to the other. The other two squares are less clearly ordered.
We sense no regular progression here but a feeling of eroded and restless forms,
which, although made of identical materials, provide a contrasting effect. In
each of the four panels the artist has left uncovered a small square of the board
on which the stones are mounted. As we discover it in each of the panels the
flatness of the exposed board causes us to perceive another kind of tension—

between the raw board and the patterns and illusions of the covered areas. The stones have their individual colors and values but these remain within the warm and gray part of the spectrum.

Recently, while Chuck Close, a photorealist artist, was working on a series of paper pulp prints, he discovered a new painting process. The prints were originally made by filling in a plastic armature grid with various standard shades of white, black, and gray pulp. When the grid was removed, Close found he could manipulate the still wet pulp to distort the image.

Jud, illustrated in Figure 277, was made from leftover remnants of paper pulp. By applying the wet pulp with his fingertips onto a large 8- by 6-foot (2.44 by 1.83 meters) canvas, Close developed a new technique and achieved a distinctive image in the process (Fig. 278). Encrusted, layered chips of colored pulp—revealing the indentations of the artist's hand—give the portrait an unusual scalelike texture.

Frank Stella's recent *South African Mine Series* combines elements of relief sculpture and painting to produce hybrid artworks of singular power. "In order to start painting," Stella noted, "I have to have a structure worth painting on."

For many years Stella has been working on fabricated three-dimensional metal surfaces. Honeycomb aluminum, used by the aircraft industry, is a favorite material of his because of its interesting textures and its high tensile strength to weight ratio. For most of his work with this material Stella has sent drawings or small *maquettes* (models) to the factory as patterns for fabrication. In this series, however, he made use of the scraps and remnants of metal lying about his

left: **277.** Chuck Close. *Jud.* 1982. Pulp paper collage on canvas, 8 × 6′ (2.44 × 1.83 m). Courtesy of Pace Gallery, New York.

above: **278.** Chuck Close in his studio working on *Jud.* 1983. Courtesy of Pace Gallery, New York.

279. Frank Stella.
Eastern Rand. 1982
Aluminum and etched magnesium with
mixed media, 8'10" × 7'8" × 4'7"
(2.69 × 2.34 × 1.42 m). Courtesy of
Leo Castelli Gallery, New York.

studio. *Eastern Rand* (Fig. 279) is a fascinating and complex art work in this group that is made up of wildly gyrating interlocking forms and painted areas. Curves and zig-zag patterns in the three-dimensional metal shapes are echoed in the painted areas in the central region of the artwork. A dynamic interplay of materials is created by the contrast of gleaming metal finishes with multicolored painted surfaces. Although the three-dimensional presence of this piece is formidable, Stella's principal interest is in the object's relationship to the wall, and the way paint can transform materials and affect our perception

Robert Longo's work is directed toward an even more unusual mix of sculptural and painterly possibilities. *Noweverybody* (Fig. 280) is a large, four-panel

280. Robert Longo. *Noweverybody.*
1982–83. Charcoal, graphite, and
ink on paper; 8 × 16' (2.44 × 4.88 m).
Figure, cast bronze bonding;
6'7" × 2'4" × 3'9" (2 × 0.71 × 1.14 m).
Courtesy of Metro Pictures, New York.

charcoal drawing of bomb-torn Beirut combined with a contorted life-size bronze male figure placed approximately 15 feet (4.6 meters) out from the left panel. An unusual effect is produced by the juxtaposition of a flat image and a three-dimensional sculpture seemingly frozen in a posture of pain. It is as if the artist is saying that we cannot distance ourselves from this scene; the figure, trying to escape from the maddening scene of destruction, confronts us in a powerfully real way. Within the charcoal image—continuous but physically divided into four sections—the apartment buildings in the foreground are completely demolished, while the row of buildings in the background are untouched, thus underscoring the random and illogical nature of war. Longo employs both elements of specificity (the Beirut street scene) and ambiguity (the unidentified bronze figure), which greet every viewer on his or her own turf. Although the pictorial means may appear at first representational, the ultimate effect is not quite so simple. We are faced with elements of **realism** and abstraction that commingle in thought-provoking ways.

As a means of extending his aesthetic concerns, Longo has recently turned to a form of art known today as **performance**. This type of live-action event evolved from the **happenings** presented by New York painters in the 1950s. Basically, happenings evolved out of the idea that the meaning of a work of art resided in the *act*, or process, of art making rather than in the finished product.

Empire was a three-part series of performances Longo originally presented at the Corcoran Gallery of Art in Washington, D.C., over a period of several years. The three pieces were *Sound Distance of a Good Man* (1978), *Surrender* (1979), and *Empire* (1981). These performance works were complex theatrical/visual events that incorporated music, dance, film projection, and sculpture—all set within the dramatic **neoclassic** atrium of the Corcoran Gallery.

In *Surrender* various actions and visual events were presented to the audience simultaneously: A saxophone player appeared and walked like a robot down a long black runway; a film image of a motionless figure, wearing classical Greek clothes was projected on a screen (creating tension between the inherent film movement and the stillness of the image); and a couple danced along the runway in a direction opposite to the saxophone player (Fig. 281).

Probably the most spectacular scene of all occurred in *Empire* and was saved for the finale. Eric Bogosian—a performance artist himself—acted as master of ceremonies throughout the performances. He informed us ominously at this point: "Culture is not a burden, it is an opportunity. It begins with order, grows with liberty, and dies in chaos." This was the cue for sixteen powerful spotlights to be turned on while the air filled with smoke and the sound of organ and brass music. Longo has likened the music, written by Joe Hannan, to a cross between Wagner and the soundtrack for the popular science fiction movie *Close Encounters of the Third Kind*. Amid the swirling smoke, dancing couples slowly filled the space until the floor was a mass of bodies. Abruptly the music and lights were cut, and the work ended with a wailing air-raid siren, followed by a martial flourish of trumpets.

Often painters, sculptors, and mixed media artists make use of the many combinations possible in performance by using live action, film, music, costumes, sets, and choreographed movement to extend their aesthetic boundaries further.

281. Robert Longo. *Surrender* (detail), from *Empire*. Performed at Corcoran Gallery of Art, Washington, D.C., 1979.

The Fine Arts

Plate 26. Edward Hopper. *Early Sunday Morning*, 1930. Oil on canvas, 2'11" × 5' (0.89 × 1.5 m). Whitney Museum of American Art, New York.

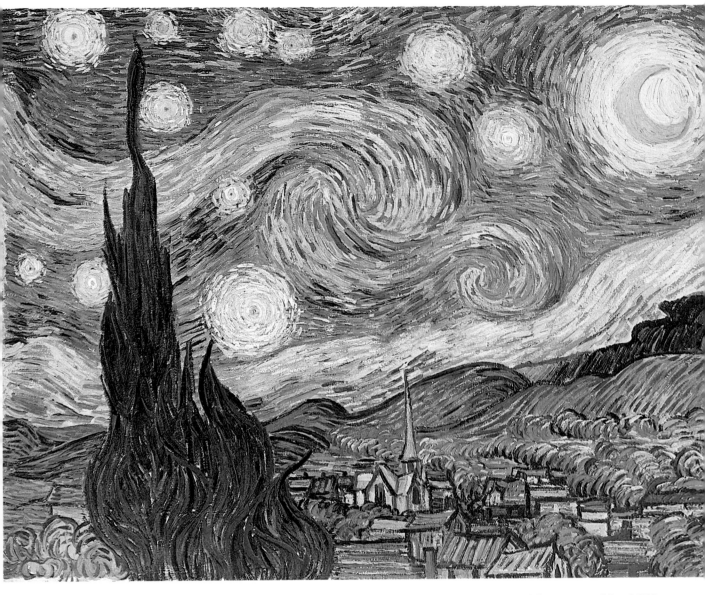

above: **Plate 27.** Vincent van Gogh. *Starry Night.* 1889. Oil on canvas, 29 × 36¾″ (74 × 93 cm). Museum of Modern Art, New York (Lillie P. Bliss bequest).

opposite: **Plate 28.** Paul Cézanne. *Mont Sainte-Victoire.* Oil on canvas, 27⅞ × 36⅛″ (71 × 92 cm). Philadelphia Museum of Art (George W. Elkins Collection).

above: **Plate 29.** Richard Estes. *B & O.* 1975. Oil on canvas, 4 × 5′ (1.22 × 1.52 m). Private collection. Courtesy Allan Stone Gallery.

below: **Plate 30.** Melissa Miller. *Anticipation.* 1981. Oil on canvas, 4′2″ × 6′8″ (1.27 × 2.03 m). Private collection.
Courtesy of Texas Gallery.

ORGANIZING A PAINTING

Considering the many forms art takes today and the many materials and processes available, it is no wonder that artists use a wide variety of organizational means. The traditional approach to organizing has been for artists to make dozens of sketches to explore the overall composition as well as clarify details before starting to paint. This method has been used by most artists of the past, for it enabled them to develop, refine, and intensify their ideas before beginning the serious and final work of painting itself. For projects of great scale, such as ceiling and wall murals, extensive preplanning is imperative.

A common method of working on small canvases or sketches is to draw in the major outlines of the compositions and, with these as guides, to develop the smaller areas in the process of painting. In his watercolors, the pencil lines John Marin sketched in to guide his painting are often still visible (see Fig. 270).

Many contemporary artists have rejected the approach to painting that requires the establishment of the major areas of a picture before beginning to paint. Robert Rauschenberg, in commenting on his own method of working, has said:

> I'm opposed to the whole idea of conception-execution—of getting an idea for a specific picture and carrying it out. I've always felt as though, whatever I've used and whatever I've done, the method was always closer to a collaboration with materials than to any kind of conscious manipulation.

What Rauschenberg suggests is a method that is improvisational and spontaneous, and these traits are clearly evident in his work. His reference to "collaboration" suggests an interaction and a working with his media, but he would not view this as an essentially conscious process. But, whether artists use logical, calculated methods or intuitive, spontaneous approaches, the point is that organizing principles govern the creation of all works of art.

Three Examples of Organization

We will now examine three paintings closely, with particular attention to the organization imposed upon them. Of the three works, one is distinctly realistic in its treatment of subject matter; a second is somewhat abstracted through its use of recognizable forms that have been reordered and modified; and a third is a fusion of both imagistic and abstract elements.

William Harnett's "Realism" In 1892 William Harnett created a masterful painting titled *Old Models,* reproduced in Figure 282. Looking at this illustration, we might almost be fooled into mistaking it for a photograph. This type of painting is often called **trompe l'oeil** ("fool-the-eye"), and its objective is to create a strong illusion of actual objects. Although this type of art fell out of favor during the early modernist era, it has made a comeback in recent years and might now be called *superrealism.* Most superrealist painters today work from photographs, but Harnett painted from the actual objects. Thus, he was responsible not only for the selection of the subject matter but also for the arrangement of its individual parts.

282. William Harnett. *Old Models.* 1892. Oil on canvas, 4'6" × 2'4" (1.37 × 0.71 m). Museum of Fine Arts, Boston (Charles Henry Hayden Fund).

However, Harnett's task went far beyond choosing the objects, arranging them, and copying them with fidelity; painting the picture involved considerable modification of what he saw. It is obvious that while most objects exist in three dimensions, the artist painting them on a flat surface has only two dimensions to work with. To arrive at three-dimensionality with only two dimensions, Harnett used color and value to create an illusion of forms in space. The framing of the composition within the limits of a rectangular shape also involved conscious selection and a modification of what the painter actually saw. The boundaries of our vision are circular, and what we see at the periphery of the visual field is soft and indistinct. Thus, when the artist puts a frame around a selected segment of the visual field and excludes what is beyond it, he or she chooses to modify what is seen. Furthermore, because the range of values in nature is many times that which can be achieved with pigments, the artist must make changes to suggest with the limited value range available the value contrasts in the object in the painting. Every painting is to a degree an abstraction, by virtue of the changes the artist must make in the economy of materials and means. This is true of works such as *Old Models,* even though it was Harnett's purpose to imitate as closely as possible the actual appearance of the objects he painted.

Cézanne's Structured Vision By contrast, in *Mont Sainte-Victoire* (Pl. 28, p. 283), Cézanne set out to make major modifications in his subject matter. The extent of his changes can be appreciated by looking at the photograph of the same subject in Figure 283; this view, while scenic, is certainly not aesthetically distinguished. A sense of clutter and arbitrariness pervade; it is just a snapshot of an ordinary mountain.

In relation to the haphazard character of the photograph, the painting has striking clarity. The foliage and ground shapes have been presented in an orderly arrangement; the sky, instead of being merely a light area, has become an integral part of the picture, with variations of both value and form. Set off and dramatized by the ordered foreground, Mont Sainte-Victoire becomes the dom-

283. Photograph of Mont Sainte-Victoire, near Aix-en-Provence, France.

inant feature of the painting and thus achieves a noble grandeur. In particular, the viewer experiences the sense of organized space, for the voids are as carefully structured as the forms. Whereas the photograph appears to be a jumbled mixture of many kinds of trees, the foliage in the painting has a pleasing visual rhythm, an effect produced by the shapes of the masses and the consistent brush strokes. Throughout the painting, movements and forces have been organized in relation and in opposition to one another.

Classified as a postimpressionist, Cézanne is generally regarded as the father of modern art. Among his many contributions are his treatment of all forms in terms of their basic geometric shapes, his use of color to show form, and his invention of forms to suit the purpose of his work, rather than to show what the eye actually sees. The influence of these innovations has been apparent in many subsequent developments of Western art.

Rauschenberg's Synthesis When Rauschenberg painted *Barge* (Fig. 284) in 1962, **abstract expressionism** was at the height of its influence in the professional world of art (see Fig. 86). So strong was this movement's hold on aesthetic fashion that for an artist to paint a figure or recognizable image would have been cause enough to have him or her branded a reactionary artist. Yet Rauschenberg, who was schooled in painterly abstract modes of art, felt that the expressive and thematic possibilities of recognizable images were too great to ignore. A return to Harnett's brand of realism, however, would not have allowed him to explore the contemporary aesthetic territory he was interested in surveying.

How could he combine the rich visual effects of abstract expressionism with contemporary imagery? The answer lay in the use of photographs that appeared in popular media. Through the use of photo-silkscreen graphic processes, Rauschenberg could choose any newspaper or magazine image, blow it up, and transfer it to a screen. He could then print it directly onto the canvas with any combination of colors he desired. Then he could paint over this image or around

284. Robert Rauschenberg. *Barge*. 1962. Oil on canvas, 6′8″ × 32′5″ (2.03 × 9.88 m). Courtesy of Leo Castelli Gallery, New York.

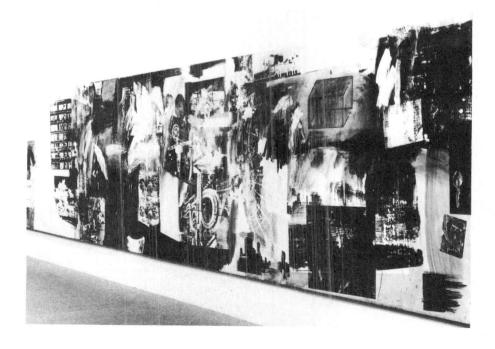

it, using freely brushed oil paint much in the style of the abstract expressionists.

In the monumental painting *Barge*, Rauschenberg was able to incorporate a variety of 20th-century photographic images, along with sections of hand-brushed paint that visually connect and unite the silkscreened areas.

Barge presents us with a panoramic image of contemporary life that unfolds in a super Cinemascope-type format extending 32 feet (9.75 meters)! Photographs of clouds, car headlights, army trucks, freeway cloverleafs, satellites, and a single dangling key combine with mysterious abstract passages of paint. Structurally, the canvas is based on an organization of space that can be related to the pioneering work of Paul Cézanne, particularly in the way components are fragmented into cubelike forms. Rauschenberg creates a powerful, kaleidoscopic portrait of the modern world in *Barge*—one that cannot fail to make us think about the ways in which technology and mechanization have affected our lives.

Harnett, Cézanne, and Rauschenberg all used different forms, colors, and relationships in their paintings. They created works that are indeed different from each other. Each artist organized his painting in terms of the aesthetic and spatial problems he was dealing with, aided by an understanding of and feeling for his subject matter.

DIVERSITY IN CONTEMPORARY PAINTING

Unlike art from the first half of this century, which more than likely fell into the categories of "abstract," "representational," "cubist," or "expressionist," much of today's most exciting art defies labeling. A single painting may simultaneously exhibit aspects of realistic, abstract, and expressionistic art. For people accustomed to older, clear-cut art movements, this diversity might appear confusing within the context of today's multidimensional world. However, this activity could also be seen as appropriately mirroring our society.

One important development of contemporary painting is a strong return to imagistic art after decades of predominately abstract work. One of the prime characteristics of *photorealist* art is its attention and fidelity to detail—much like the image sharpness a photograph provides. Like many photorealists, Richard Estes makes use of photographs in this artistic process. But unlike many of the others, he does not simply copy a single photographic image. Instead, he uses composite views of a subject to gather visual information that he will use in the final organization of the painting. Because of this open-ended approach, Estes is quite often able to capture a great sense of reality and verity in his cityscape canvases.

B & O (Pl. 29, p. 284) is one of the artist's paintings that in many ways evokes the melancholy, haunting street scene of Hopper's *Early Sunday Morning* (see Pl. 26, p. 281). Despite the stores and parked cars, not one person is in sight. But the presence of people is implied in every inch of the painting—by their striking absence. Estes is up quite early on many clear Sunday mornings to photograph the empty streets and closed shops of New York City while its inhabitants sleep.

Unlike Hopper's painting style, Estes' vision is razor sharp. He delights in painting the reflections of clouds on car windows and the large plate-glass store windows that mirror the street scene. No doubt the advantage of using a sophisticated recording device such as the camera enables him to incorporate much convincing detail in his painting. One could not imagine Estes setting up his

easel on the sidewalk and spending weeks there to complete a painting. The technical development of photography now enables painters to accomplish visual tasks that would be difficult, if not impossible, without it.

Artists today are experiencing a sense of freedom and playfulness in their work that was unheard of a decade ago. Themes that might have been rejected in the past as inappropriate for "serious" art are readily incorporated into contemporary painting—sometimes with surprising results.

Melissa Miller is best known for her brightly colored, narrative paintings featuring some of the more exotic members of the animal kingdom. Bears, tigers, leopards, and snakes play symbolic roles in these colorful visions of the natural world.

Her images seduce us at first with their unabashed coloristic beauty and sensuous handling of paint. Neon-bright hues create familiar contemporary harmonies. As in much modern music, a subtle interplay of blending and discordant elements creates strangely haunting and ambiguous effects. Psychologically they are equivalent to Rorschach ink-blot tests: They mirror our state of mind and are open to a variety of interpretations.

Anticipation (Pl. 30, p. 284) reveals Miller's use of thematic and visual complexity. At first glance this painting might appear to be an innocent animal painting featuring the beauty of wild creatures in their natural habitat. But the longer we look at this painting, the more unsure we are of its intent. Like certain drawings used in perceptual psychology experiments, this painting has two simultaneous meanings; it flips in our mind from silly to scary and back again. Miller's menagerie in *Anticipation* collectively seems to be forewarning us of impending doom.

The coloristic effects of this painting are remarkable. It looks as though the control knobs of a television were turned up, producing chromatic distortion and a kind of heightened, phosphorescent intensity. Through this purposeful exaggeration, Miller achieves spectacular results. Because the color is "pretty" (in a self-conscious and unsettling way) we are not sure how to react to the thematic content of the painting: Two bears and two upright cobras anxiously watch a turbulent purple, green, and black cyclone approach through a glowing yellow-orange sky. Many of the visual elements—lush color, beautiful animals— are pleasantly reassuring, but the overall feeling is ominous and foreboding. We almost might think a Walt Disney cartoon—normally the height of nonthreatening entertainment—had been produced by someone gone slightly mad. In a sense, Miller's animals are metaphorical stand-ins for us. Miller uses these creatures as a means of allowing us the protective distance to gain new perspectives. This saves the painting from a self-righteous, heavy-handed stance, yet makes us aware of certain feelings which may otherwise remain unconscious.

Andy Warhol—famous for his pop soup-can images of the early 1960s—has emerged in recent times as a contemporary portrait artist of unusual brilliance. All but abandoned by early modern artists as too irrelevant and conservative an art form, the portrait has been resurrected by Warhol in a new and particularly exciting way through photo-silkscreen and hand-painted methods. The invention of photography has had much to do with the general decline of the traditional painted portrait. Photography can deliver an uncanny likeness at a much lower price; multiple copies are available simply by printing from the negative. But the unique quality and personal interpretation of a painted image has been missing. Now, through mastery of the silkscreen medium Warhol has created portrait paintings that synthesize the fidelity of image found in a photograph with the unique aspects of hand-painted works of art.

Mick Jagger (Fig. 285) is a work of art that mixes a black and white silkscreened photograph of rock singer Mick Jagger with expressionistic slashes of paint that remind us of abstract expressionism. Although these two visual concepts are at opposite ends of the aesthetic spectrum, it is precisely this tension between mechanical image and "expressive" abstraction that allows this work to hold our attention. Warhol creates harmony out of these opposing ideas.

The technical process involved in this portrait is quite interesting. Although his pop icons of the 1960s relied on photographs culled from the media, Warhol's recent series of celebrity portraits are derived from Polaroid snapshots the artist himself takes. From an average of fifty pictures taken during a sitting, Warhol selects one and sends it to a custom laboratory where it is rephotographed and transferred to a 40-inch-square (102 centimeters) silkscreen. Warhol then carefully plans where the image will be printed on the canvas; but, before printing the silkscreen, he paints in those solid areas which will generally correspond to various areas in the photograph image such as face, torso, and background. Then he screens on the image with black ink. What results is a compelling juxtaposition of black and white photograph and painted sections. The image of Jagger that stares out at us through the paint—and yet strangely seems to be part of the paint—conjures up complex notions of fantasy and fact, abstraction and representation. Through a combination of technical prowess and conceptual insight, Warhol has reinvented portrait painting in 20th-century terms.

Another contemporary portrait painter is Alex Katz. Since his marriage in 1957, Katz has completed more than eighty painted portraits of his wife Ada. Unlike Warhol, who creates mixed-media artworks, Katz employs traditional materials such as oil paint on canvas. He also relies on direct observation of the sitter to arrive at his finished work: Katz begins by painting small portraits from life, followed by larger drawings of his subject. Finally, on the basis of this preliminary work, he completes a large finished painting.

All of Katz's many portraits of Ada comprise a large body of work based on this theme and variation. Each portrait of his wife has elements of the familiar and unique. Ada is portrayed in a variety of settings such as at the beach, driving an Impala, or bundled up in warm clothes during the winter months. Despite the constant presence of Ada in these paintings her physical appearance constantly changes. Anyone who has taken snapshots knows how mutable the human features are. Many people, not satisfied with one photographic angle, will approve another. In a sense Katz is involved with the exploration of how we appear visually to others and how our appearance varies.

Striped Jacket (Fig. 286) portrays Ada in a casual, candid pose as if she had just turned to acknowledge us. Striking graphic use of her striped top contrast with Katz's flat, simplified style of painting, which minimizes extraneous details. Prominent features such as eyes, eyebrows, and locks of dark hair play important visual roles in this painting. In all of Katz's portraits of Ada she confronts us in a way that is both disarming and mysterious.

Artist Joan Semmel is also interested in painting the figure. Her oil painting titled *Willful Willendorf* (Fig. 287) makes use of an unusual combination of realistic and semiabstract painting styles. The central portion of this canvas is carefully painted to create the visual illusion of a nude woman. Echoing the shapes in the realistic section are details of a hand and legs painted in a more abstract, brushy style. The tension between these two styles makes us more aware of the visual elements used in this painting.

bove: **285.** Andy Warhol. *Mick Jagger.* 1975. Acrylic paint and silkscreen enamel on canvas,
0″ (102 cm) square. Private collection.

bove right: **286.** Alex Katz. *Striped Jacket.* 1981. Oil on canvas, 4 × 5′ (1.22 × 1.52 m).
Courtesy of Marlborough Gallery, New York.

elow: **287.** Joan Semmel. *Willful Willendorf.* 1981. Oil on canvas, 4′2″ × 5′8″ (1.27 × 1.72 m).
Private collection.

Social Commentary

On April 26, 1937, Nazi planes in the service of Spanish fascists bombed the Basque village of Guernica for over three hours. Never before had a civilian target been subjected to such complete destruction in so short a time. As a strongly nationalistic Spaniard living in France, Picasso was outraged by this event and believed it marked the beginning of an unprecedented era of technologically sophisticated destruction. From photographs published in *Ce Soir,* a Parisian newspaper, Picasso began work on sketches that were to lead to the completion, little more than a month after the tragic event, of the roughly 26-foot-long (7.9 meters) painting *Guernica* (Fig. 288).

Although Picasso was an active follower of political events and by nature an outspoken social critic, until this event his art could not be categorized as being politically inspired. But the systematic destruction of this defenseless town galvanized Picasso into action. He used all of the earlier formalistic devices of cubism in this painting to achieve great emotional effects.

Every element of this composition helps to express this horrific event: The color orchestration is somber and foreboding in mood, made up entirely of grays, blacks, and whites; piercing, angular lines race wildly through the painting; the interrupted cubistic space expresses the explosions that took place that fateful day. Several heads and detached arms—still firmly grasping broken swords—lie at the base of the canvas.

Compositionally, many elements of the painting direct our eyes upward in the direction of the destruction raining down from above. The figure to the far right looks up screaming, arms outstretched. The same image is repeated, more poignantly, on the left, as a woman with a dead child in her arms screams skyward. Animals share the same fate as people in *Guernica*; a horse and a bull—images of great mythological significance to Picasso—figure prominently in the com-

288. Pablo Picasso. *Guernica.* 1937. Oil on canvas, 11′6″ × 25′6″ (3.5 × 7.77 m). Prado, Madrid.

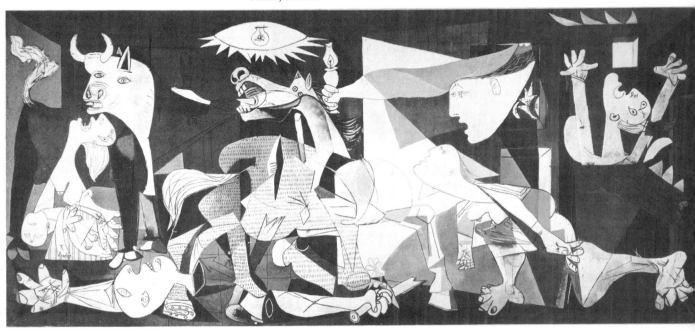

position. Picasso perceived this event as an outrage against nature itself rather than against humankind in particular. The new technology making this carnage possible is symbolized by the electric light bulb at the top of the painting. It seems to burn with an unusually brilliant, harsh light. Jagged, shrapnellike rays surround the fixture and radiate downward—much like the aerial bombs that fell. Just to the right of center Picasso places a hand-held fuel oil lamp symbolic of the previous century, its gentle light lost in the violent commotion taking place.

Without Picasso's monumental artwork calling attention to this modern atrocity, *Guernica* would be a meaningless word. Instead, this painting serves to remind us of an aspect of humanity that otherwise would remain shamefully hidden.

Contemporary artists also express their concern about social and moral issues. Leon Golub's recent paintings have focused on the themes of violence and unbridled political power. His *Mercenaries* series (Fig. 289) shows armed figures anonymously dressed in battle fatigues against equally anonymous backdrops. The featurelessness of these paintings calls attention to the international problem of hired "warriors" who sell violence and death to the highest bidder.

Many of the visual elements of this painting reinforce this thematic content: the stark placement of light figures against the dark ground; the rough, smudged paint quality and agitated lines; and the leering and distorted features of the men. In sum, Golub's painting is unsettling from both a visual and psychological point of view. Golub's stance, however, is not heavy handed. He presents us with the evidence and allows us to form our own conclusions.

Black artist Robert Colescott also is concerned with social issues. For years Colescott has commented on racial prejudice in his work. But unlike Golub's foreboding images of injustice, this artist's work makes use of wit and sardonic humor as equally powerful ideological weapons. Colescott's painting titled

289. Leon Golub. *Mercenaries II*. 1979. Acrylic on loose canvas. 10′ × 14′4″ (3.05 × 4.37 m). Montreal Museum of Fine Arts (Purchase Horsley and Annie Townsend bequest).

Auver sur Oise: Crow in the Wheat Field (Fig. 290) combines references to art history with visual and verbal puns. Looming over the horizon of this painting is the image of Vincent van Gogh with a bandaged ear. By now, thanks to popular movies and literature, the tragic details of this well-known postimpressionist's life are common knowledge, especially the fact that he cut off his ear in a fit of madness. This painting directly refers to the last painting completed by van Gogh before his death by suicide: *Crows over a Wheatfield*. Colescott has paraphrased major elements of this painting and incorporated them into his own thematic framework. He places an image of himself in a sunflower print shirt (sunflowers were a favorite subject of van Gogh's) painting on an easel set up in a wheatfield. Dancing female skeletons—their racial identity undeterminable—flank the artist as he paints the landscape. The title of this painting—*Crow in the Wheat Field*—is important to its thematic content. Colescott subtly makes reference to the fact that "Crow" was a derogatory racist term used against blacks. Instead of directing caustic rage toward this ugly prejudice, Colescott makes us aware of social problems with mocking humor.

290. Robert Colescott. *Auver sur Oise: Crow in the Wheat Field.* 1982. Acrylic on canvas, 7 × 6′ (2.13 × 1.83 m). Courtesy of Semaphore Gallery, New York (collection of Mr. and Mrs. Morton J. Hornick).

Some contemporary painters are uninterested in issues of social commentary or figure painting. They view their work as an extension of 20th-century scientific and philosophic thought. Often this **genre** (which relates to **conceptual** art) deals with visual ideas and concepts that have little precedent in Western art. Arakawa is a Japanese-born artist living in the United States whose work centers around linguistics and the relationship between visual and verbal information. His sparse, diagramlike canvases are filled with configurations of stenciled words, pseudoscientific graphs, arrows, drips, straight lines, spectral color charts, and messy fingerprints. For several years Arakawa has been working on a series of paintings collectively titled *Properties of Blank,* which he maintains will occupy him for the rest of his working life. The painting shown here is titled *The Forming of Nameless* (Fig. 291). Essentially Arakawa is interested in the interplay between word and image, sense and nonsense. Contemporary philosophical thought, with its concern for the complex implied intentions and thought process of the conscious mind, forms the backdrop and provides the creative impetus for much of Arakawa's work. Despite the serious interest this artist has in these fields of scholarship and thought, it is important not to view these paintings as dry discourses or academic treatises. They are amusing and witty *denials* of "universal truth"—the kind that often appears to accompany the linear logic of scientific inquiry. Problems arise when viewers of his *Properties of Blank* paintings take them to be serious statements of established truth. Conceptual confusion can occur when one tries to figure them out logically. They are meant to be looked at, read, and meditated on with a sense of openness and good humor. Only then do they become what they are intended to be—visual metaphors for reflective thought. As Arakawa has stated, "to seek what you cannot know, that is the subject of my painting."

At the present time throughout the contemporary art world there is a marked tendency to combine and juxtapose elements of the past with recent innovations. Often something familiar is presented freshly so that we feel we are viewing old things in a new way. Just such a feeling is produced by Julian Schnabel's

291. Arakawa. *The Forming of Nameless.* 1983–84. Oil and acrylic on canvas, 4 panels, each 8'4" × 5'8" (2.54 × 1.73 m); overall size 8'4" × 22'8" (2.54 × 6.91 m). Courtesy of Ronald Feldman Fine Arts, New York.

painting *Death Takes a Holiday* (Fig. 292). Thickly encrusted oil paint covers an unusual painting surface of stretched velvet. In large part it is the *physicality* of this work of art that gives it visual strength and evocative power. This focus on physical properties is central to Schnabel's work. "All my images are subordinate to the notion of painting," Schnabel states, "and basically they are not about anything except painting. . . . It's not what is painted, it's how it's painted."

Despite Schnabel's interest in the physicality of paint, *Death Takes a Holiday* suggests a strong thematic interest in popular and contemporary folk themes. The painting's use of velvet makes reference to the inexpensive bullfight scenes on velvet hawked to tourists in Mexican border towns (Schnabel grew up in Texas not far from these cities). Furthermore, the theme of the painting calls to mind a popular Mexican holiday—the Day of the Dead (or All Souls Day, November 2). To celebrate this religious holiday, masks and candies shaped like death masks and skeletons are sold throughout the countryside in Mexico. All of these references surface in *Death Takes a Holiday* and combine in fresh and unusual ways to create a work of art both contemporary and traditional in viewpoint.

Perhaps no single contemporary painter capture's today's eclectic, divergent moods in the art world better than David Salle. His large-scale painting *Poverty Is No Disgrace* (Fig. 293) is a broad, sweeping visual statement that incorporates

the greatest variety of styles imaginable: realism, expressionism, assemblage, cartoons, and purely abstract images. The wonder is not so much that Salle includes all of them into one painting but that he manages to fuse them all into a coherent work of art. In this synthesis, the artist does not merely quote past works of art but creates an original vision. Its complexity and use of popular images resemble our present-day society. Like many contemporary artists, Salle does not offer us easy answers to hard questions. Instead, he relies on us to question the strange combinations of imagery and media that confront us so squarely in *Poverty Is No Disgrace*. The spotted, biomorphic shapes to the left collide with the huddled mass of people in the central panel and lead us to the academic nude painting on the far right. But perhaps the most unusual visual element in this whole complex is the bent plywood chair section that protrudes from the bottom of the central panel. There is no rational explanation for this object to be attached to the canvas—which may be precisely Salle's point. The normal flow of events in the world has no intrinsic meaning except that which we read into it. There does not have to be a correct interpretation of meaning in this painting. Each person brings his or her own life experiences, beliefs, and perceptions to this work of art and determines its meaning for himself or herself.

As we have witnessed throughout this chapter—and particularly in the last work—painting was changed radically within a relatively short span of time. Contemporary painting is concerned with many aesthetic issues and addresses many thematic concerns. No one can predict the direction of future developments in art, but it is safe to say that painting will continue to evolve in response to changing cultural, environmental, and social conditions. In this way works of art reflect and show us more fully our condition—the human condition—which paradoxically changes and yet remains the same.

293. David Salle. *Poverty Is No Disgrace*. 1982. Oil, acrylic, chair, and canvas; 12.8 × 11.2′ (3.9 × 3.4 m). Courtesy of Mary Boone Gallery, New York.

Chapter **13**

Sculpture

Robert Mallary's sculptural wall assemblage *In Flight* (Fig. 294) appears to defy both gravity and time. Minute splinters, dust, and sand are suspended in mid-air beneath a battered section of a 12-inch (30-centimeter) wooden beam, apparently salvaged from a demolished building. Through the careful composition of these found materials, Mallary has created a dynamic organization of splintered forms and natural colors. He has taken materials of the most ordinary sort—literally wreckage and dust—and has transformed them into a work of art.

The use of common, even "unartistic," materials as the basis for sculptural works of art has been an accepted practice for several decades and has created whole new genres for artistic exploration. These new modes of working happily coexist with the most traditional of sculptural means, such as wood carving, bronze casting, and stone carving. Like painting, the world of sculpture has exploded in a multitude of aesthetic directions and artistic processes.

Because modern sculpture and painting are related in a variety of ways, many of the ideas presented in the preceding chapter on painting can apply to sculpture. The most obvious differences between painting and sculpture, however, are that painting traditionally has had only two dimensions, relies heavily on color, and suggests form and space through a skillful use of hue and value, while sculpture is three dimensional and gains its effects primarily from actual form

294. Robert Mallary.
In Flight. 1957. Relief of wood, dust, sand, synthetic polymer resin on painted plywood; 3′7½″ × 6′7⅝″ × 4⅜″ (1.1 × 2.02 × 0.11 m). Museum of Modern Art, New York (Larry Aldrich Foundation Fund).

and genuine relief or space. Thus, even though painters and sculptors may work with the same ideas, the objects they create—and their effect on us—will not be the same. *Relief sculpture*, of which *In Flight* is an example, is a form that finds its place somewhere between painting and freestanding sculpture and has some of the characteristics of both. It often claims about the same range of subject matter as painting, and, like painting, it is almost invariably designed to be viewed from a single angle, usually the front.

Again like painting, sculpture has for most of its history dealt with recognizable forms; the human figure has been, by all odds, the favorite subject of sculptors. Since the beginning of the 20th century, however, abstraction has proved to be just as relevant for sculpture as it has for painting. Recently, following the movement of contemporary painting, many sculptors have decidedly moved back toward recognizable imagery after remaining in the nonimagist camp for decades. As in any genre, some sculpture is authentic and some is ineffective work; one must be careful not to dismiss completely any general approach. This chapter will examine a variety of abstract and imagistic sculptural work.

In dealing with identifiable subject matter sculptors are more limited than painters in the kinds of subjects they can treat effectively. The reason is simple. Because sculpture (with the exception of reliefs) *can* be seen from all sides, those subjects that involve perspective from a fixed viewpoint, such as landscapes and interiors, are seldom suitable for treatment in a sculptural medium. Although sculptors often design their freestanding works to be seen from a single, or fixed, viewpoint, there are in sculpture, as well as in architecture, problems that relate to three dimensionality, especially the problem of composing works so that they can be viewed with satisfaction from all sides.

THE FEMALE FIGURE IN SCULPTURE

Throughout history, in non-Western as well as Western cultures, the female form has always held aesthetic appeal. Across continents and centuries one can find many interpretations of women in sculptural works of art, all are shaped by the prevailing social customs and the individual artist's own perceptions and inspirations. Although all three of these works of art portray the female form, they are quite different in terms of their visual appearance; each of their creators expressed different aesthetic purposes. Therefore despite the same subject matter they represent varied ideologies and beliefs.

Of the three sculptures illustrated in this section, one has survived from classical antiquity. The so-called *Hera* of Samos (Fig. 295) is by an unknown Greek sculptor who worked in the 6th century before Christ. The other sculptures were created by 20th-century artists who interpret the female form differently.

Hera is a religious statue carved over 2500 years ago for a Greek temple on the island of Samos. The sculpture is of a type called *kore*, or maiden, that was designed for a temple enclosure and showed a female figure bearing a votive offering. It is not known precisely if this kore was to portray Hera, the wife of Zeus and queen of the skies, but the commanding and austere character of the sculpture suggests no ordinary woman. The figure is carved from marble, a fine-grained material that can be worked in infinite detail. The statue has many details but they are all subordinated to the columnar form. The arms are held close to the body. The folds of the garment, highly stylized, reinforce the vertical line of the figure. The lower edge of the dress curves outward and, by repeating the line of the feet, provides a transition from the mass of the figure to the

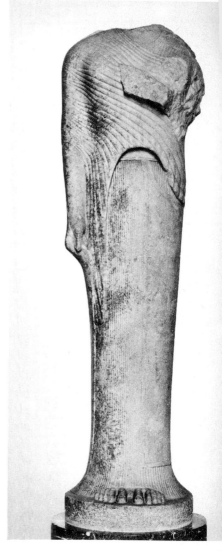

295. *Hera* of Samos. c. 550 B.C. Marble, height 5'3" (1.6 m). State Museums, Berlin.

circular base. The general symmetry of the form, the patterning of the folds of the garment, the consistent tapering of the figure from the shoulders to the base all create a sober, regal presence. The facts of *Hera*'s anatomy and dress have been generalized according to the archaic style of 6th-century B.C. Greece. The effect of the stylization is one of power, control, nobility.

Wilhelm Lehmbruck, a German, created the graceful bronze called *Standing Woman* (Fig. 296). Unlike the Greek ritual figure, this statue is an easily recognizable female form. It has nothing of the rigidly stylized stance or subordination to the column form that appears in the *Hera*. Instead we see a more naturalistic generalization—a woman of timeless and mature physical beauty. The idealized figure gazes at the world calmly, with perhaps a touch of knowing melancholy. The sculpture, in its great dignity, has a remote antique quality, but the sensitively modeled surfaces and its suggestion of pensive emotion prevent it from being an empty copy of neoclassic sculpture.

Walking (Fig. 297), by the Russian-born American Alexander Archipenko, has, like *Standing Woman*, captured the full, rounded curves of the female form. In certain details the resemblance between the two sculptures is remarkable, especially in the form of the legs and in the shape of the silhouette created by the line connecting their heads and shoulders. But whereas *Standing Woman* is realistic and explicit, *Walking* is generalized and abstract. In addition, the latter is presented not at one instant in the process of walking but at several instants somewhat after the cubist manner of Marcel Duchamp in *Nude Descending a Staircase* (see Fig. 81). It also has the complexity of two kinds of form: The forms toward the edges of the sculpture are convex, or positive, while those in the center are concave, or negative. Part of the figure, therefore, is seen in a reverse impression, yet it is both attractive and convincing. Several such oppositions are presented—concave and convex, the smooth and the rough, advancing and receding. Archipenko has presented us with a work of art that celebrates, in an abbreviated style, the female form.

Walking is a terra-cotta sculpture, that is, one made of clay that has been fired at a low temperature. The nature of the material and the process the artist used are evident in the finished work, especially in the coarse texture of the outermost areas, where pieces of the soft clay have been pressed onto the basic surface. The placement and sequence of the textures also reveal the artist's intentions toward his work. In all, the elements and their treatment in *Walking* constitute an aesthetic purpose quite distinct from that in *Standing Woman*.

The nature of the various materials the artists have used in their works accounts in part for the stylistic differences we can identify among the three sculptures of female figures. More fundamental, however, are the distinctions among the moods, attitudes, ideas, and purposes for which the artists have required their materials to serve as vehicles. We can see from only these three works that sculpture has no less potential as an expressive form than painting.

PROCESSES IN SCULPTURE

Sculpture traditionally has been executed by three major processes— *subtraction, addition,* and *replacement*. The carving of stone is an example of the first, a process in which unwanted material is cut away. The construction of a sculpture by putting together bits of clay or by welding together pieces of metal typifies the second. Sculpture cast into molds where a more permanent material replaces that with which the sculptor worked is the third major process.

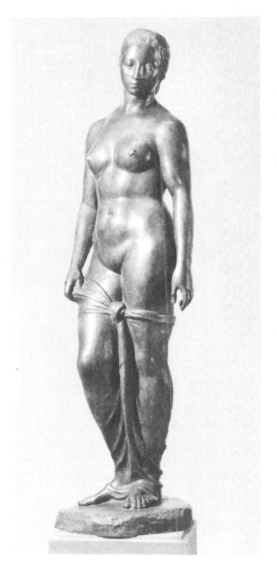

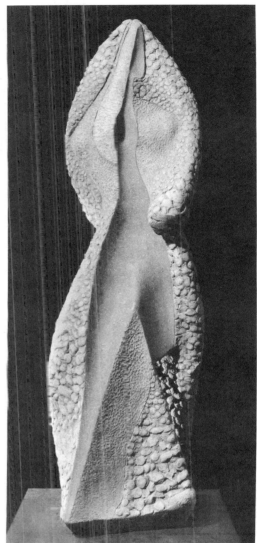

Sculpture by Cutting Away: The Subtractive Process

In the subtractive process the sculptor begins with an unformed mass and by the removal of material brings into being the finished sculptural form.

The Materials Stone and wood are the two major media used to make sculpture by the subtractive process. Both materials exist generally throughout the world, and both occur in diverse types. However, in many respects they are quite different.

Wood is relatively soft and subject to decay. It is an organic material, showing through its grain the fact that it came into being by a process of growth. Furthermore, wood is limited in the size of the pieces it can offer.

Stone, on the other hand, is hard and durable, inorganic, and almost without limitation in size. Indeed, many hundreds of years ago entire temples were carved out of cliffs in both Egypt and India. More recently, at Mount Rushmore in South Dakota and at Stone Mountain in Georgia, whole mountainsides have been carved into gigantic portrait heads of famous Americans.

above left: **296.** Wilhelm Lehmbruck. *Standing Woman.* Cast 1916–17. Bronze. height 6′4″ (1.93 m). Museum of Modern Art, New York (given anonymously).

above: **297.** Alexander Archipenko. *Walking.* 1936. Polychromed red terra-cotta. Present location unknown.

Stone is extremely varied in all respects—in color, hardness, and texture. Colors tend to reds, browns, and grays, although there are white, blue, and green stones. In hardness stone ranges from soapstone, so soft it can be scratched with the fingernail, to granites, which are harder than many metals. In texture it can have the fine, even grain of marble or the coarseness of sandstone. Many stones are streaked, mottled, or otherwise variegated. In all, stone offers the possibility for a considerable array of effects in sculpture.

During the 19th century, white marble was especially favored because its fine grain could support the detailed carving current taste demanded. In this century sculptors have generally found marble too cold, even lacking in character, and they have preferred stones with pronounced color and texture. Moreover, contemporary interest in such new materials and processes as plastics and welding has drawn many sculptors away from the tradition of stone carving. Still, a modern sculptor like Constantin Brancusi (Fig. 298) has found marble an eminently successful material for his work. Whatever the future may hold for these materials in art, stone and wood have over the centuries been the two major materials of sculpture.

The Tools and Processes Chisels and hammers are the sculptor's basic tools in the subtractive process, although those for wood are different from the implements used for stone. The task of chipping and carving even a modest piece of sculpture demands not only artistic judgment but great physical stamina. Power tools have greatly lessened the physical effort required of the sculptor, but the very resistance of the material has an effect on the result. The artist is, in a real sense, pitted against the stone or wood he or she is working on, and the toughness of the material makes its own special demands. Time, space, and energy make carved sculpture possible, and unless the artist has a strong commitment to carving, work is not even begun. This, in part, accounts for the historic prevalence of painting over sculpture, although the very hardness of the materials of sculpture has caused statues and reliefs to survive from antiquity, while virtually all Greek painting (except that on pottery) and most Roman painting perished long ago. It is also one explanation for a difference in the kinds of ideas that are developed in sculpture and painting. Since stone and wood sculpture are produced only by sustained physical effort and cannot be "dashed off" like a pencil or watercolor sketch, the subjects treated by carving sculptors tend to be monumental and more serious.

When stone sculpture assumes monumental proportions, it becomes necessary to do a preliminary study of the ideas for the sculpture in a small model made of some easily worked material, such as wax. In sculpture this is the equivalent of a sketch in which the sculptor plans in a small scale the basic organization of the large work. An often-used term from Italian for the preliminary model of a sculpture is *bozzetto*. Because wood sculptures are generally smaller in size and the material is more readily worked, they are rarely prestudied with wax or clay models. Often the artist makes the initial sketch directly on the block of wood, then begins carving.

In both materials the sculpture is first "roughed out" in general masses. At this stage attention is given only to the major proportions, the general movement, the overall relation of parts. As the cutting continues, the work becomes more careful and precise. Details begin to emerge—the swell of a muscle, a fold of drapery, the curl of a lock of hair. In the ultimate finishing the sculptor treats the surface to bring out the qualities wanted in texture, light, and reflection. Many stones and woods can take a high polish that emphasizes subtleties of

form and modeling. It is then that some of the special characteristics of the material become most apparent—the fineness of marble, the crystalline sparkle of granite, the grain of wood.

Carving in Stone and Wood　In Figure 299 we see the portrait head of the Egyptian Queen Nefertiti, who, along with her husband King Akhenaten, reigned during the 14th century B.C. The head is made of limestone that, once carved, was coated with a sealing ground and then painted. The right eye is inlaid with crystal set in black paste. The socket of the left eye is empty. The left eye may not have been finished, for the bust was discovered in 1912 during excavation of what had been the studio of a sculptor. That the head was buried for so many centuries accounts for its excellent condition.

Limestone, a fine-grained material, is, as the bust shows, subject to subtle modeling. Much of the detail, such as that in the necklace, is painted on the surface rather than carved in relief. The head is of an extraordinary beauty; the forms are all strong yet highly refined, the expression both regal and serene. The long, graceful neck with its slightly swollen form responds to the thrust of the crown. In fact, seen in profile, the two major forms—the crowned head and the

below: **298.** Constantin Brancusi. *Mlle. Pogany.* 1912. Marble on limestone base, height 17½″ (44 cm). Philadelphia Museum of Art (Louise and Walter Arensberg Collection).

below right: **299.** Queen Nefertiti. c. 1360 B.C. Carved and painted limestone, height 20″ (51 cm). State Museums, Berlin.

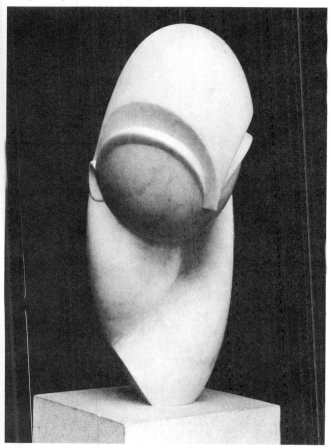

300. Constantin Brancusi.
King of Kings. c. 1930–40.
Wood, height 9′10″ (3 m).
Solomon R. Guggenheim Museum,
New York.

neck flowing into the shoulders—are closely related in their trapezoidal outlines.

Constantin Brancusi was remarkably sensitive to the nature of a variety of sculptural materials and finishing processes. Many of his bronze and marble sculptures are polished to a degree of perfection rarely seen in past or present work. In *King of Kings* (Fig. 300) Brancusi used wood to achieve a rough-hewn effect that conjures up images of primitive gods. Working from a massive wooden form once used in a wine press, the artist has carefully reshaped it and transformed it in the process. By leaving much of the wood's surface and pronounced chisel marks uncovered by paint, Brancusi reveals the process and calls attention to the materials used in the fabrication of the work of art. Like many substances, wood is remarkably adaptable to the expressive needs of the artist: It can be shaped and smoothed in a refined way or roughly worked as shown in *King of Kings.*

Kuan Yin (Fig. 301) is a 12th-century *polychromed*, or painted, wood carving that provides a striking counterpart to Brancusi's wooden totem of the modern age: The Chinese sculpture conveys elegance, repose, and calm meditation. The expressive qualities of these two works—the one disturbing, the other almost supernatural in its tranquility—can be attributed to the different times and cultures in which they were created.

The *Kuan Yin* is a Buddhist religious figure, a seated female *bodhisattva,* a person who has attained enlightenment but who postpones Nirvana so that he or she may help others to attain it. Two traits, therefore, are clearly to be expected in the figure—repose and gentleness. One arm supports part of the weight of the seated figure. The other is extended across a raised knee. The relaxation of the hand, the downcast eyes, the hanging garments, the sense of undisturbed weight all convey a feeling of utter peace and quietude. Gentleness is also conveyed in the soft curves that give the work a calm energy. This feeling is reinforced by the warm tones with which the sculpture has been painted. The openness and detail of the figure are attributes of the material the figure is carved of. Because wood is not brittle, it will permit the sculptor to work thin and extended forms, such as in the hands of Kaun Yin. Since it is fine grained, much detail is also possible.

The dissimilarities between wood and stone sculpture derive largely from differences in the physical substances. Artists generally have great respect for their materials and use them with a sense of their natural integrity. Wood and stone sculpture are related in that for both media the finished product is brought into being by a process of removing material, that is, the sculpture emerges as the sculptor cuts away unwanted stone or wood from the original block.

Sculpture by Joining or Combining Materials: The Additive Process

In sculpture that is built up, the sculptor achieves the expression of his or her idea by joining or combining separate pieces of material, usually small ones. These can be very pliable, such as moist clay, but rigid or semirigid materials—metal wire, rods and plates, as well as wood—are combined in additive sculpture by such processes as riveting, soldering, welding, nailing, and gluing.

Sculpture in Terra-Cotta Few materials are as immediately responsive to a sculptor's hands and tools as clay. A very soft substance when moist, clay yields readily to the slightest pressure. Sculptors model in this medium by adding and

pressing small bits of clay together, sometimes over a framework, or **armature,** until the desired form has been built. Once it has dried, clay becomes brittle and is a very impermanent material in this form. If remoistened, unfired clay can, however, be worked and reworked many times.

Sculptors can make durable a work constructed from wet clay in several ways. They can fire the original in a kiln by a process discussed in the materials and techniques section. To be suitable for kiln firing, however, the work must have been built so that the clay in its various parts is of a relatively uniform degree of thickness. Large clay figures are generally made ready for firing by building around a hollow core. Should the sculptor want to obtain a number of replicas of a sculpture, he or she may make a plaster of Paris mold similar to those discussed in Chapter 8, cast the replicas in it, and then fire them. In either case the result is usually referred to as *terra-cotta,* an Italian term meaning "cooked earth" that describes a coarse earthenware clay product fired at comparatively low temperatures. Although much more durable than unfired clay, terra-cotta is not strong. It breaks and chips easily and cannot survive any great strain or weight. It is a risky medium for very large works (although even in antiquity the Etruscans could fire life-size statues from clay), and it is not suited to the sharp and thin shapes in which metal behaves so well. Terra-cotta, nonetheless, is a handsome, relatively inexpensive medium for sculpture.

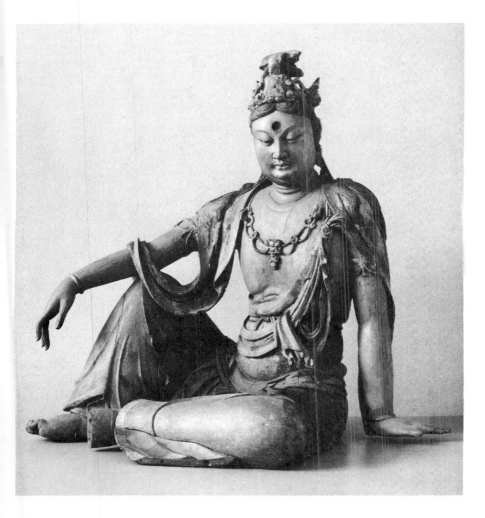

301. Chinese. *Kuan Yin.*
12th century. Polychromed wood,
height 47½" (121 cm).
Rijksmuseum, Amsterdam.

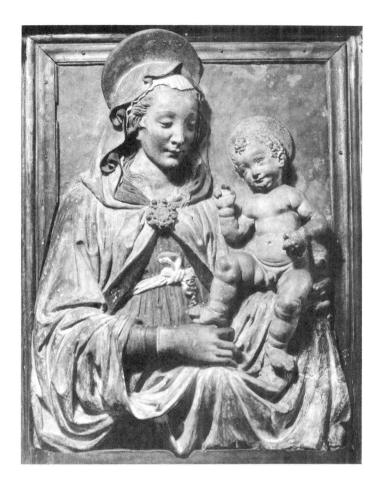

302. Andrea del Verrocchio.
Virgin and Child. 15th century.
Terra-cotta, polychromed and
gilded; 30½ × 23″ (77 × 58 cm).
Metropolitan Museum of Art,
New York (Rogers Fund, 1909).

Archipenko's *Walking* (see Fig. 297) and Andrea del Verrocchio's *Virgin and Child* (Fig. 302) demonstrate the results of working in clay and finishing in terra-cotta. In *Walking* Archipenko has exploited the soft, plastic quality of clay. He created the coarse, pebbly texture on the outside of the figure by pressing on and flattening small lumps of clay. The finer texture next to the rough surface comes from the artist's use of a modeling tool. Both *Walking* and Verrocchio's *Virgin and Child* have a predominance of bold relief and rounded forms, characteristics that appear as naturally in clay sculpture as they do in pottery. The Verrocchio relief is also notable for its variety of forms. The softly rounded shapes of the Madonna's face and hands and the Child's body are accentuated by the crisp, somewhat angular treatment of the clothing. Fine detail contrasts with broadly handled, simple masses. Like the Egyptian head (see Fig. 299) and the Chinese figure (see Fig. 301), this Renaissance work is painted and gilded, the polychrome enlivening the underlying forms of the relief. Verrocchio's terra-cotta sculpture relates to the Mallary piece (see Fig. 294) in that both are relief sculptures. *Virgin and Child* is not a freestanding sculpture; its forms are attached to a background, and it is meant to be seen only from the front. In fact, a frame, complete with moldings, has even been made a part of the composition. The Verrocchio work is what is known as *high relief*; that is, its forms project boldly from the background, but compared to sculpture in the round they have less body and depth. Relief in this kind of sculpture can range from very low to very high, and given the interest and the skill, a sculptor can achieve in relief an uncanny sense of form and space.

Sculpture Built Up from Rigid Materials A second kind of built-up sculpture requires forming and joining of rigid materials. The use of metal enjoys unprecedented popularity among contemporary artists. An important reason for the popularity of metal sculpture is that it utilizes both materials and processes of the machine age—iron, steel, copper, and brass worked by cutting and welding and by brazing with oxyacetyline torches. The results thus achieved could have emerged only in the 20th century.

Alberto Giacometti, an artist connected with the surrealist movement of the 1930s, fabricated *Chariot* (Fig. 303) out of bronze, one of the most popular metals used in modern sculpture. *Chariot* portrays one of Giacometti's characteristically spindly figures perched on top of a chariot, calling to mind similar poses in Etruscan bronzes. Critics read his distinctive figures in terms of existential philosophy: humanity reduced to survivors in a void.

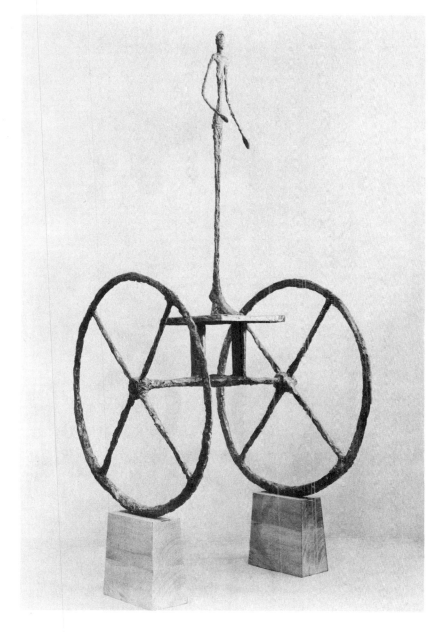

303. Alberto Giacometti. *Chariot.* 1950. Bronze, height 4′9″ (1.45 m). Museum of Modern Art, New York (purchase).

John Chamberlain is a contemporary sculptor who has derived inspiration and raw materials from the numerous automobile wrecking yards throughout America. By welding together and bending smashed car parts (Fig. 304), Chamberlain has created the sculptural equivalent to the paintings of the abstract expressionist movement. Multicolored side panels, hoods, and chrome trim are transformed by this artist into active, creative works of art that we can relate to in formalistic as well as thematic terms.

Certainly the availability of materials derived from a highly industrialized society such as our own has profoundly affected the processes and look of modern sculpture. Anthony Caro, a British artist whose work is inspired by European constructivists of the 1920s, creates some of the most vital abstract sculpture of our day. *Midnight Gap* (Fig. 305) is all the more remarkable since it is created almost entirely from metal rods and beams available "off the shelf" from industrial suppliers. By carefully organizing and welding together this assemblage of large steel plates, beams, and rods, Caro has created a composition of ordered elegance and dynamic vitality.

Louise Nevelson's *Sky Cathedral* (Fig. 306) is a construction of wood over 11 feet (3.35 meters) high made of a large number of variously sized and proportioned rectangular boxes and crates fitted together and filled with a miscellany of forms, many of them the "found" wood products of commercial industry. Some of the boxes are open to reveal interiors with meticulously arranged contents. A

304. John Chamberlain.
Essex. 1960.
Automobile parts and other metal, relief; 9′ × 6′8″ (2.74 × 2.03 m).
Museum of Modern Art, New York (gift of Mr. and Mrs.
Robert C. Scull and purchase).

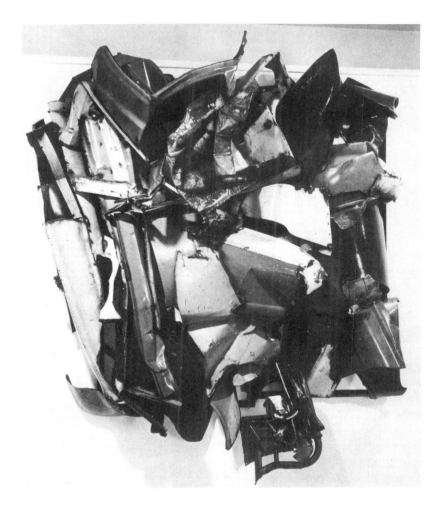

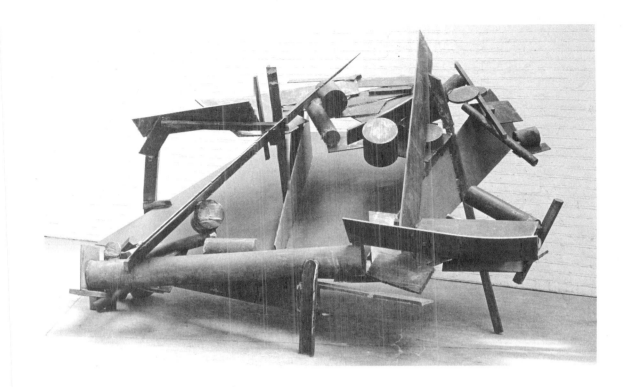

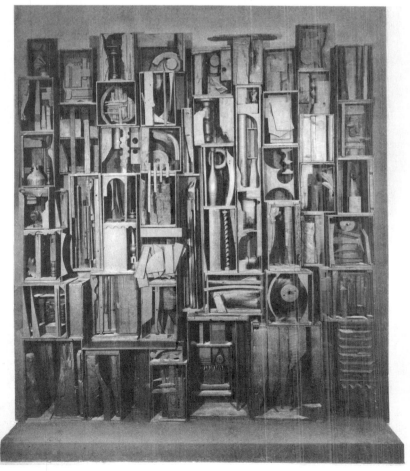

above: **305.** Anthony Caro. *Midnight Gap.* 1976–78. Steel, rusted, varnished, and painted green; 5′11″ × 11′10″ (1.8 × 3.61 m). Courtesy of André Emmerich Gallery, New York.

left: **306.** Louise Nevelson. *Sky Cathedral.* 1958. Painted wood construction, 11′3½″ × 10′¼″ × 1′6″ (3.44 × 3.05 × 0.46 m). Museum of Modern Art, New York (gift of Mr. and Mrs. Ben Mildwoff).

few are almost closed and exclude our view. In the assemblage we recognize bits and pieces of familiar forms—chair and table legs, balusters, arms and splats of chairs, discs and cylinders, as well as planks and shafts of raw and finished wood. The boxes at the base are somewhat larger than those farther up, and the arrangement of objects within them is somewhat simpler. A coat of black paint coordinates the hundreds of disparate parts into a somber unity.

Each of *Sky Cathedral's* boxes, with its mixed contents, provides a complete and self-contained rectangular relief composition. More important, however, is the interplay throughout the construction among forms rounded and flat, thick and thin, open and congested, revealed and masked, horizontal, diagonal, and vertical. It is a manufactured world that we view, with each part expressing its own history and purpose.

Even without the title, the construction would probably call to mind the richness and intricacy of Gothic carving. But this is a cathedral of modern times, an assemblage of the uprooted and discarded ends and scraps of our environment treated with remarkable lyricism and magic.

Because of the availability and ease with which various modern materials can be worked, many sculptors today build up their works rather than carve or cast them. Sheet metal, plastic, plywood, and found objects are such a part of our environment it is no wonder that artists have extensively used such materials in built-up construction.

The Replacement Process: Casting

Even in this age of high-technology materials and forming methods, the ancient process of metal casting is, for some artists, as relevant today as it was in the past. This process was used by such diverse groups as the ancient Greeks and Romans, the Chinese, and certain African tribes (this process is outlined in Chapter 8). From about 1500 to 1900 at Benin in Nigeria, bronze casting was developed to a high level, and the head in Figure 307 is a superb example from

307. Benin (Nigerian). Altar head. 16th century. Bronze, height 8⅜″ (21 cm). Metropolitan Museum of Art, New York (Michael C. Rockefeller Memorial Collection (bequest of Nelson A. Rockefeller, 1979).

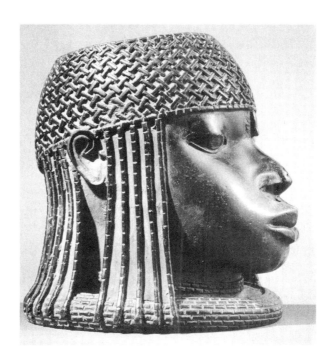

the 16th century. Bronzes such as this exemplify a court style and were dedicated to the ruler's glorification. As in most African sculpture, the features of this head have been distorted for expressive purposes. The abstraction is especially apparent in the forward thrust of the lower part of the face. The forms that connect the head covering with the ornament around the neck give the piece a simple, basic shape. But our attention is directed chiefly to the features, which are full and bold in form, making a strong, regal image.

There are few sculptors working in bronze casting today who have influenced the field of art as much as Henry Moore. Although he was academically trained in classical sculpture, Moore nevertheless sought much of his early artistic inspiration from non-European sources such as pre-Columbian American Indian art. During the early 1930s he was exposed to the work of the surrealists and incorporated this influence into his work. Moore is best known for his semiabstract bronze castings of figures, which express his unique way of dealing with solids and voids. Moore is as interested in the negative spaces, or voids, of the sculpture as he is in the solid areas. *Interior-Exterior Reclining Figure* (Fig. 308) is an intricate arrangement of interpenetrating spaces and forms which create the illusion that we are viewing both the inside and outside of the sculpture simultaneously.

Part of the aesthetic freedom of our age is the opportunity for some artists to give new meaning to timeless traditional techniques such as figurative bronze sculpture, while others explore the most recent forms, attitudes, and fabrication methods. This diversity is ultimately enriching and benefits us all by adding to

308. Henry Moore.
Interior-Exterior Reclining Figure
(working model for *Reclining Figure:
Internal and External Forms*).
1951. Bronze, height 14″ (36 cm).
Hirshhorn Museum and Sculpture
Garden, Smithsonian Institution,
Washington, D.C.

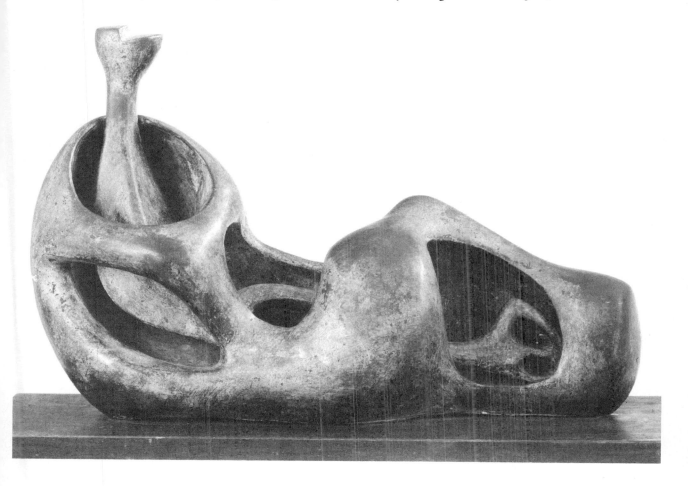

our aesthetic awareness. One outstanding contemporary artist doing figurative bronze casting today is Robert Graham. Working in his special studio/foundry in Venice, California, over the past decade Graham has produced a series of cast bronze figures that are masterful in their detail, presence, and symbolic overtones.

Stephanie and Spy (Fig. 309) are large, cast bronze sculptures that portray a young woman standing next to a magnificently detailed horse. Both pieces are set on fabricated copper bases, and together they project a strong feeling of refined, elemental **primitivism**.

Much of Graham's success with the figure has to do with his tireless commitment to the human form. This artist generally works with one particular model for months at a time before a work is brought to fruition. Although Graham's figures of the girl and horse are meticulously crafted, the otherworldly quality of *Stephanie and Spy* transcends the ordinary depiction of the visible, everyday world and offers us a heightened aesthetic vision rather than a mundane copy of reality.

DIVERSITY OF CONTEMPORARY SCULPTURE

In ways similar to the development of modern painting, sculpture has undertaken profound investigations of form and expression. With the full scope of contemporary perception, sculptors have been exploring the subjective realms of feeling, the materials and processes of modern technology, and the philosophical concepts of the late 20th century.

This section will examine the work of a diverse group of contemporary sculptors whose art represents the many aesthetic viewpoints and fabrication techniques being used today. Although their works vary greatly in style, each of the artists profiled here is committed to excellence and is distinguished by the development of unique personal visions.

Duane Hanson is a sculptor who makes great use of painterly skills and new materials to produce life-size figurative artworks that take realism to the brink of deception. On seeing Hanson's works for the first time, the mind refuses to believe that they are made essentially of polyester resin and fiberglass. So strong is the illusion that we wait breathlessly for them to move. Hanson is the sculptural counterpart to superrealist painters such as Richard Estes profiled in the preceding chapter (see Pl. 29, p. 284). In fact, at one point in his career Hanson conferred with Estes about techniques that would enable him to make his fiberglass constructions almost appear to breathe.

To achieve such a high degree of three-dimensional fidelity, Hanson makes sectional casts directly from the model's body. This process is quite demanding physically and emotionally; Hanson must reassure the sitter at every stage of the process. After the models disrobe to their underwear, they apply a thin coating of petroleum to their bodies to prevent the plaster from sticking. Hanson uses flexible plaster-impregnated dental bandages to form the light but rigid cast. Once in place the moistened bandages need about 45 minutes to fully set. In a catalogue on Hanson's work, author Martin Bush describes the whole process quite thoroughly:

> One leg is completed first, then the other; next comes the body itself (it looks like a plaster jacket); then the arms; and, finally, the model's head. Five to six flexible molds are needed for each figure. Before each mold is removed, however, another mold is

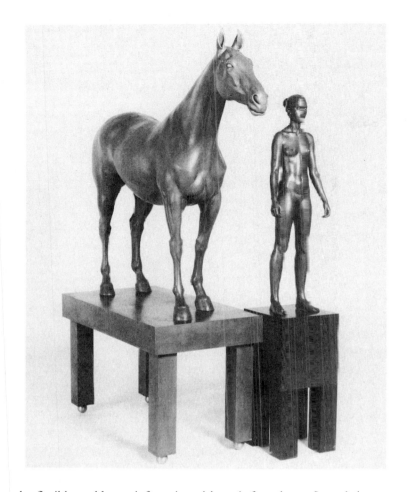

309. Robert Graham.
Stephanie and Spy. 1980–81.
Bronze, two-part piece;
Stephanie 5'1½" × 1' × 1'
(1.56 × 0.3 × 0.3 m);
Spy 5'10¾" × 4'6" × 1'9"
(1.79 × 1.37 × 0.53 m).
Whitney Museum of American Art,
New York (promised gift of
Tony and Carol Doumani).

placed over the flexible mold to reinforce it and keep it from becoming misshapen while the artist is working with it. Flexible molds, unfortunately, have a tendency to take on qualities similar to those of a rubber glove. They have no permanent shape by themselves and need reinforcement.

After the leg mold has dried, it is cut up the back; tape is applied to it; the mold is opened; and it is removed from the body. The artist follows the same procedure with the remaining molds. Sometimes the flexible mold comes away from the mother mold with a flaw—part of the face might be missing, or little air pockets might be visible in the forehead or chin. If there is considerable distortion, too many flaws or too little detail, the artist must make another cast. When the molds have been completed, they are repaired—when cracks have appeared, they are cleaned and coated with a thick gelatinous substance to prevent sticking. Next, the image is brought into being with successive layers of flesh-colored liquid polyester resin poured into the mold. This is immediately reinforced with fiber glass. The polyester resin picks up detail from the mold, and the flesh coloring helps to give the body a natural tone, making it a little easier for the artist to paint the sculpture. The positive mold is then removed from the negative mold, cleaned and repaired, and the details are reworked in preparation for the assembling of the figure. The sculpture is thus created in much the same way as it was originally cast, one part of the body at a time.

Although accurate details such as the face and hands are extremely important to the work, actual clothes and personal articles such as watches and shoes are used to give an extremely realistic appearance to these sculptures. Hanson's *Man with Handcart* (Pl. 31, p. 317) is a case in point. The sculptor makes use of appropriate clothing and artifacts; and, to reinforce the realism further, he places

Sculpture

310. Joel Shapiro. *Untitled.*
1974. Bronze, 12 × 2½ × 28″
(30 × 6 × 71 cm).
Museum of Modern Art, New York
(purchased with the aid of funds
from the National Endowment for the
Arts and an anonymous donor).

the work within the context of a specific environment through the use of props like the handcart. Hanson's sculptures are so thoroughly deceptive that placed in the right setting (a warehouse, for example) they would probably not be noticed at first. In terms of thematic content Hanson is moved by the social realities of our culture. By creating a superrealist sculpture of a warehouse worker Hanson calls our attention to the economic and social realities of modern life. Ironically, we take more notice of this imitation figure than we would of a real worker with a handcart. By allowing us the distance of viewing art, Hanson transforms our social and aesthetic conscience and enlarges our view of ourselves.

By the end of the 1960s, *minimalism,* a highly refined and abstract form of art, had significantly affected our ideas of sculptured space and had made extensive use of architectural building materials and factory fabrication methods. Joel Shapiro appeared on the scene during this period and adopted many of the minimalists' aesthetic concerns and spatial interests. Throughout his development as an artist he has retained some aspects of minimalist ideology while forging a new, more personal interpretation of its concerns.

Shapiro's *Untitled* (Fig. 310) is a cast-bronze wall-hung sculpture that embodies certain minimalist features: Metal is a favorite industrial material of this movement; its shapes are geometric, simple, and primary; and this work has the cool, understated, refined tone typical of minimalism.

In equally important ways Shapiro's sculpture diverges from the tenets of minimalism. First, minimalist art does not portray specific objects. *Untitled* (despite its title) makes a significant symbolic reference to a house, a tangible structure loaded with many personal feelings and ideas. Second, the modest size of this sculpture is counter to the enormous, larger-than-human-size dimensions characteristic of most minimalist art. *Untitled* is quite human in scale, measuring only 12 by 2 ½ by 28 inches (30 by 6 by 71 centimeters). Placed at eye level, this work invites us to examine it at a personal level. In other words, it has a human psychological dimension not found in classic abstract minimalism. Many of Shapiro's diminutive sculpture objects, such as *Untitled,* stimulate our curiosity. They are neither entirely narrative nor entirely abstract. Instead they embody a *synthesis* between formalist and psychological concerns. Minimalist art sought distance and detachment; Shapiro seeks both refined form and involve-

ment with his subject. As is the case with many of today's artists, sculptors are making creative, personal connections between old and new sensibilities, thus broadening the aesthetic base of contemporary sculpture.

Pop art, a movement that takes its ideas and forms from everyday aspects of culture, has had almost as many sculptors as painters among its practitioners. The use of found objects, the technique of assemblage, and the conscious breaking down of the barriers between art and life all suggest three dimensionality, the true realm of the sculptor.

Although it would be a mistake to label Donna Dennis a pop artist, her work seems to exude much of the energy and vibrancy of actual life. This artist works in the genre of *environmental art*—a form of art making concerned with the total ambience of a *space* rather than the effects of an *object.* Dennis makes scaled-down architectural versions of outdoor structures, such as houses and buildings which are installed indoors. Most of them are too large to be considered sculptural "objects" and too small to be confused with their source of inspiration. They fall into a special physical and symbolic space that is hard to describe but easy to experience. *Subway with Silver Girders* (Fig. 311), measuring 12 by 12 by

311. Donna Dennis. *Subway with Silver Girders.* 1982. Mixed media, 12 × 12 × 12' (3.66 × 3.66 × 3.66 m). Collection Martin Z. Margulies. Courtesy of Holly Solomon Gallery.

12 feet (3.6 meters), is just such a mixed media environmental sculpture. Many of the visitors who viewed this piece when it was on display at the Holly Solomon Gallery in New York had, no doubt, just emerged from the real subway on their trip downtown. Dennis' subway is accurately replicated in every detail. The intention, however, is not to create an illusion, as in Duane Hanson's work. The effect instead is to suggest an air of *unreality* so that we doubt the verity of the scene we are viewing. Because of the significant shift in scale and dislocation of place that the sculpture represents, we end up questioning what we see. It is like suddenly waking up from a dream, with vivid recall of the convincing details experienced moments ago. By reducing the scale—considerably but not dramatically—and placing this architectural complex in a gallery, Dennis allows us to enter a particularly beautiful "dream space" where we can switch with ease between believing in the sculpture's "reality" or in its "unreality." Dennis' mixed-media work provides a special experience, one that erodes the otherwise firm barrier between art and life and makes us look more closely at the usual reality we take for granted.

Along with the ever-widening interest in the visual arts that we have experienced in the last several decades has come a rebirth of interest in public sculpture. Not since the neoclassic bronze-horse-and-rider school of sculpture, which filled city parks prior to World War I, has there been such a flurry of civic art activity. But much recent public art is a far cry from the familiar traditional forms; many artists today explore new concepts of siting and thematic content.

George Segal's *Next Departure,* illustrated in Figure 312, is a splendid example of this new public art. In the first place we have a different idea nowadays of what constitutes a public space. In addition to park settings, sculptures are now appearing in downtown civic centers, office building plazas, and even, as is the case of *Next Departure,* in bustling public bus stations.

Following the lead of Philadelphia in the late 1950s many cities (and the federal government) have instituted a 1-percent-for-art law, which mandates that 1 percent of new building costs be earmarked for art. Public transportation systems in particular fascinate Segal. Recently, when the offices of the Port Authority of New York and New Jersey were enlarged, Segal won the commission with his painted bronze, mixed-media sculpture. Many major sculpture awards are determined by juries that review proposals or small-scale models before determining which artist would best suit the situation.

For many years Segal has been using plaster and found materials to create haunting tableaux that evoke a mysterious surrealistic world—one that seems to operate on a level parallel to everyday perception. Long before he created *Next Departure* for the Port Authority building, he built *The Diner* (Pl. 32, p. 317), a mixed-media environmental sculpture that made use of life-size plaster figures and implements from a real diner. Unlike Duane Hanson, Segal does not try to fool the eye. Roughly worked white plaster gives the figures a slightly expressionistic look for a direct semblance to reality. By contrast, the environmental artifacts such as stools, counter, sugar container, coffee maker, and drink dispenser are authentic objects bought from a secondhand restaurant supply house.

Although Segal generally prefers the lusterless, brittle look of plaster for his figures, he applied a white **patina** to cast bronze in order to make *Next Departure* more durable; in the Port Authority building the sculpture is not placed behind protective rails, nor does it exist in the enclosed environment of a museum. Amazingly, it can be found in the middle of the open floor in the main waiting room of the Port Authority building. It is just this interplay with life

left: **Plate 31.** Duane Hanson. *Man with Handcart.* 1975. Polyester resin and fiberglass, polychromed in oil; life size. Collection Sydney and Frances Lewis, Richmond, Va.

right: **Plate 32.** George Segal. *The Diner.* 1964–66. Plaster, wood, chrome, formica, masonite, fluorescent lamp; 8'6" × 9' × 7'3" (2.59 × 2.75 × 2.14 m). Walker Art Center, Minneapolis (gift of the T. B. Walker Foundation).

318

Opposite: **Plate 33.** Nancy Graves. *Colubra.* 1982. Bronze with polychrome patina
35¾ × 28 × 22½″ (91 × 71 × 57 cm).
Collection, Mr. and Mrs. Barry Berkus.

Above: **Plate 34.** Sandy Skoglund. *Maybe Babies.* 1983. Mixed-media installation,
10′4″ × 16′2″ × 41′7″ (3.15 × 4.9 × 12.67 m).
Courtesy of Leo Castelli Gallery, New York.

top: **Plate 35.** Cindy Sherman. *Untitled.* 1981. Color photograph, 2 × 4′ (0.61 × 1.22 m). Courtesy of Metro Pictures, New York.

above: **Plate 36.** Cindy Sherman. *Untitled.* 1981. Color photograph, 2 × 4′ (0.61 × 1.22 m). Courtesy of Metro Pictures, New York.

312. George Segal. *Next Departure*. 1979. Bronze, metal, plaster, wood, paper, and vinyl; 7 × 6 × 8′ (2.13 × 1.83 × 2.44 m). Installed 1982 at Port Authority of New York and New Jersey Bus Terminal, New York. Courtesy of Sidney Janis Gallery, New York.

that interests Segal. In his opinion, public transit places such as this one are perfect for the contemplation of modern sculpture, since people usually become introspective while waiting for the bus or subway. In a manner similar to that of Donna Dennis, Segal manages to disrupt the normal continuum of life and gives us a new perspective on ourselves and our environment.

In the recent polychromed bronze sculptures of Nancy Graves, scientific analysis and notation of biological forms are joined with a tendency toward fanciful invention. Admittedly there are dangers inherent in the attempt to synthesize scientific and decorative art principles. But Graves manages to combine rational and aesthetic interests with great sensitivity. This juxtaposition of unlikely

sources and attitudes is characteristic of much of the most interesting artwork being done today. It is to Graves' credit that she manages to fuse the positive elements of these two approaches into one appealing, balanced, artistic whole. *Colubra* (Pl. 33, p. 318) is an exuberant assemblage of shapes taken from or inspired by nature: giant seed pods, elongated gourds, coral, small tropical fish, and palm fronds. But Graves does not make a mere collage of diverse elements; she reinterprets them in a particularly inventive, *fictive* way.

Although the sculptural shapes themselves are remarkably tactile and rich, Graves further enlivens them through a special process of surface coloration, or *patination*. By utilizing the primary colors with contrasts of secondary hues— blue-green, red-orange, and purple—she achieves a polychrome vibrancy that works with the twisting, writhing forms. Instead of applying ordinary paint to the bronze surface, Graves mixes pigments with certain acids that, when heated, fuse the color to the metal. In keeping with the organic inspiration of the forms, Graves' color forms a bonded skin that becomes an integral part of the artwork.

Graves has symbolically expressed the *energy* inherent in biological life itself. The form grows from a convoluted, rootlike base anchoring the structure to a powerful upward movement that culminates in a star-burst, radiating crown. Graves' strength lies in her ability to transform literal biological forms into allusive metaphors of many possible meanings. *Colubra* dazzles us with its lively presence and evokes both the feeling of nature and imaginative possibilities of purely abstract art.

Kiosk by Jackie Ferrara (Fig. 313) represents a search for rational, sequential form. This sculptural awareness relates in many ways to the constructivist movement, which emerged in Europe during the early part of this century. Basing their aesthetic ideas on an optimistic acceptance of scientific thought and technological progress, constructivists sought to celebrate empirical and rational elements in both life and art. Consequently their work shunned illusionistic images and gravitated toward abstract, self-referential forms of machinelike precision.

Although *Kiosk* embodies some of the lucid and orderly formal aspects of constructivism, like many artworks today, it also encompasses a *variety* of attitudes assembled in an open, imaginative way. For instance, contrary to the tenets of constructivism, *Kiosk* makes obvious reference to utilitarian architectural forms and spaces. Yet the ambiguity of the shapes are such that the viewer cannot pinpoint an exact building or structural complex. This sets up an intriguing psychological dialogue about architectural space that gives *Kiosk* great power.

Prior to the actual construction of her works Ferrara makes detailed drawings of every aspect of the sculpture on engineering graph paper. Cross-sections and side elevations are worked out well before she starts precisely cutting the pine and poplar wood planks which form the structure. What prevents this work from becoming a mere exercise in formalist art is Ferrara's sensitivity to the lyrical ambiguity of architectural form. Mysteriously, *Kiosk* alludes to a variety of ancient and modern building forms: Temples and ziggurats come immediately to mind as well as elements such as courtyards, windows, and stairs. Through meticulous craftsmanship and inspired design Ferrara has created open-ended forms that evoke many potential meanings.

Over the past decade and a half, Charles Simonds has constructed hundreds of tiny clay sculptural "dwellings" for a mythical band of Little People on New York street corners, window ledges, and vacant lots; the *process* of building these

313. Jackie Ferrara, *Kiosk*. 1982. Pine and poplar, 7′8″ × 2′9″ × 2′9″
(2.03 × 0.84 × 0.84 m). Courtesy of Max Protetch Gallery, New York.

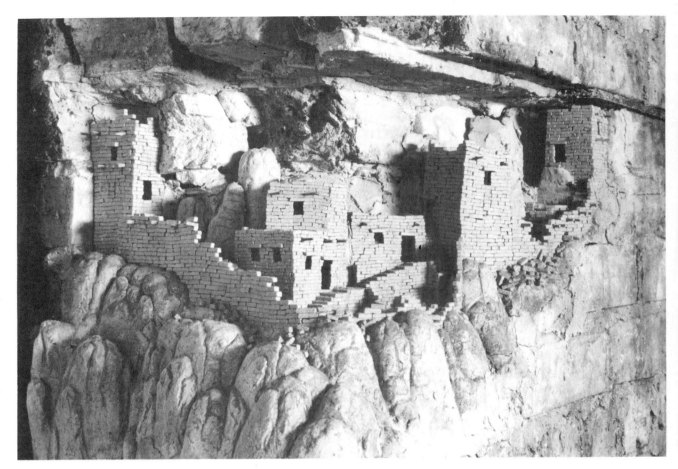

314. Charles Simonds. Detail of *Dwelling, Chicago*. Clay,
entire work 8 × 44′ (2.44 × 13.41 m).
Museum of Contemporary Art, Chicago.

diminutive dwellings is as important to the artist as the final result. In a way his
acts are sculptural performance pieces that need an audience to make them com-
plete. After they are completed the artist abandons them to fate—which for the
most part is destruction. Typically, Simonds arrives unannounced at the chosen
site and may spend up to eight hours slowly and carefully crafting small clay
structures that closely resemble Pueblo Indian architecture (Fig. 314). When
Simonds first started doing these dwellings, he found that the energy of the
street and the constant parade of passers-by constituted an enriching experience.
This artist believes that the boundaries and limitations of the professional art
world are too confining to contain and define his interests. By building these
dwellings out in the open and in constant contact with people who stop for a
while, talk with him, and share ideas, Simonds finds that he becomes connected
with important social concerns he might not be aware of through traditional
approaches to art. Through his interaction with the Lower East Side commu-
nity in New York (where most of his dwellings were built), Simonds became
concerned with the lack of play space for children. He collaborated with various
neighborhood groups to turn an abandoned city lot into a park. The resulting
La Placita Park is a magical space with large, gently curving mounds of earth, an
inviting contrast to the harsh geometric shapes of the city which surrounds it.

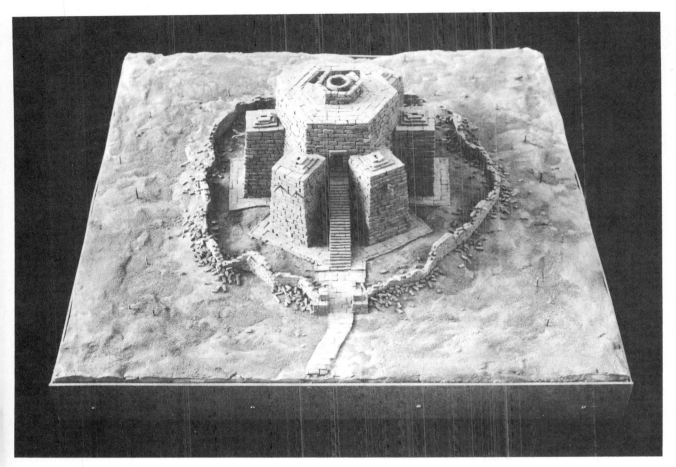

315. Charles Simonds. *Ritual Furnace*. 1978. Clay on plywood base, 30″ (76 cm) square. Collection Dr. Jack E. Chachkes.

The same involvement that went into the creation of his tiny mythical dwellings was channeled toward the renovation of a public space. In both cases he was interested in bringing back the elemental experience of nature on a human scale— all but lost to urban dwellers today. In this sense much of Simonds' outdoor work can be seen in a larger context than most professional art; his art functions within society itself.

In order to support himself financially, Simonds has recently been constructing studio pieces which are sold to art collectors and museums. Most of these dried clay artworks measure about 30 inches (76 centimeters) square and are mounted on transportable shallow plywood bases (unlike his site pieces, which are destroyed if someone tries to move them). Working on these permanent pieces gives Simonds the time to develop ideas and further evolve his mythological and aesthetic beliefs. *Ritual Furnace* (Fig. 315) is part of a larger group called *Circles and Towers Growing*. Through the building of these tiny sets Simonds constructs in his mind "the story of civilization." Although the tale told by his mythical constructions is fictional, it can and does apply to the origins of many civilizations. Seeing one of his dwellings for the "Little People" makes us stop and consider the beginnings of our society and brings into better focus civilization as it exists today.

Throughout this section on sculpture (as well as in the other fine arts chapters) we have witnessed an emerging awareness among many contemporary artists to combined aspects of the old with the new. Out of this exciting synthesis, dynamic works of art are created that address timeless concerns within a modern context. Art today is characterized by the greatest diversity seen to date—in media, in methods of working, and in subject matter. The earlier era of formalist, self-referential art has been supplanted by a more open dialogue that allows images and narrative elements to coexist meaningfully with abstract art of quality.

Given the curiosity and sense of exploration shown by sculptors in this technical age, no doubt we can expect future artists to surprise us even more with exciting and unusual combinations of form, materials, and personal concerns.

Chapter 14

Photography

Today's newspapers, magazines, and books carry so many photographs that one tends to look at them only long enough to identify the subject. This is perfectly natural, since the majority of photographs that we see are essentially journalistic images. But from time to time a photograph—sometimes of a commonplace subject—proves to be electrifying because the photographer has probed below surface appearances and offers us a more personal and creative vision of the world. Through lighting, composition, and a sharply focused conceptual viewpoint, the artist with a camera unveils feelings and perceptions usually hidden. When this happens, photography provides us with an experience comparable to that produced by traditional forms of art such as painting, drawing, and sculpture.

Although photography was invented in the first half of the 19th century, countless artists throughout history dreamed of using apparatus that would help them objectively record what they saw around them. By the 16th century the *camera obscura* (Fig. 316), which literally means "dark room," was developed as a scientific and artistic means of investigating the relationship between light and visual image. Light entered through a tiny hole in one side of this darkened room; and an inverted image was cast on the opposite wall by this primitive "lens." To record any image an artist merely traced the outlines cast upon a piece of paper placed on the wall.

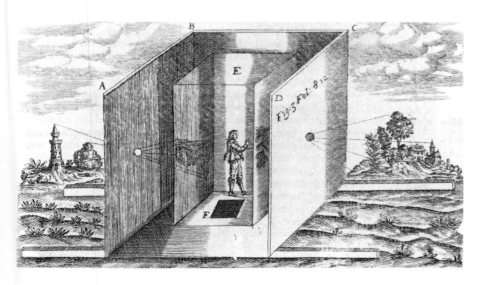

316. Camera obscura, a cutaway view. Engraving. 1646. International Museum of Photography, George Eastman House, Rochester, N.Y.

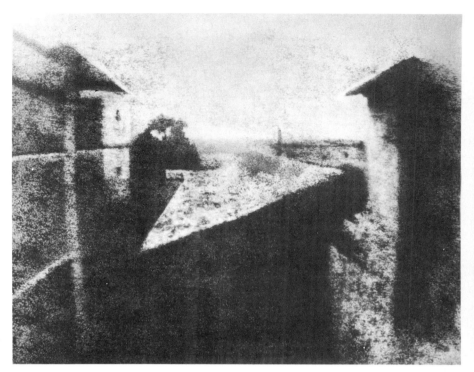

317. Joseph Nicéphore Niépce.
View from Window at Gras.
1826. Heliograph,
8 × 6½″ (20 × 17 cm).
Gernsheim Collection, Harry Ransom
Humanities Research Center,
University of Texas, Austin.

Technical modifications of the camera obscura were made slowly over the years. By the early 1800s its size had been reduced to that of a cardboard packing carton. It was also outfitted with a glass lens to focus the light and a ground glass sheet to receive the image. In spite of these technical refinements this apparatus was little better than the original camera obscura—artists still had to trace the image on translucent paper. Some means was needed to "fix" the image and make it permanent without tracing it by hand; then the world would have drawings made by light.

It was not until 1826 that the first practical experiments with permanent light-sensitive materials were carried out. Joseph Nicéphore Niépce, a French inventor, discovered that a certain kind of bitumen, or asphalt, is rendered insoluble in lavender oil after it is exposed to light; conversely, the same material is dissolved in the oil if no light strikes it.

Coating a pewter plate with a layer of bitumen, Niépce made an eight-hour exposure of the view from his window at Gras. After washing the plate in lavender oil and white petroleum, a granular and fuzzy image was produced—one that was both recognizable and permanent (Fig. 317).

Except for the discovery of more efficient light-sensitive emulsions and the refinement of equipment, modern photography still relies on the basic principles that Niépce discovered and used.

MATERIALS AND PROCESSES

The Camera

Despite the fact that complex, expensive apparatus enables photographers to have more control over their work, some of the greatest photographs have been

318. Laszlo Moholy-Nagy.
Photogram. 1926.
©William Larson.

made with simple equipment. The basic equipment consists of a camera, usually with a lens, shutter, and diaphragm; films or plates; filters; paper on which the image is printed; and the paraphernalia needed to develop the negative and make the print. It is even possible to dispense with the camera and the film altogether. Figure 318 is a photogram made without cameras or lenses by putting objects directly on photosensitive paper, exposing the paper to light, and then developing the print to make the result permanent.

The simplest camera, nothing more than a lightproof box with a lens and shutter at the front and film at the back, is appropriately called a nonadjustable camera. Designed for amateur use under average conditions, it records well-lighted, stationary objects with minimum effort. But if a photographer wishes to take pictures with sharp detail, with near and far objects in focus, with a full range of values from black through all the different grays to white or with the complete spectrum of color; or if he or she wishes to work under poor light or with atmospheric effects or record rapidly moving objects, more precise and complex equipment is necessary. We have an ever-increasing, ever more sophisticated array of cameras and accessories from which to choose. With the proliferation of new photographic equipment and with advances in technology, it is now possible to buy a high-quality 35mm camera for a few hundred dollars that outperforms the best equipment of a few decades ago, which cost far more.

The most important part of the camera, at least as far as image formation is concerned, is the lens. Good glass lenses must be precisely ground and free from defects so that they produce corner-to-corner sharpness throughout their focusing range. Lenses of various *focal lengths* have been developed to perform various tasks. Telephoto lenses (with longer focal lengths) magnify distant objects and allow the camera to get a close look at anything far away; often, space appears compressed with these lenses. Wide-angle lenses (with shorter focal lengths) are

above: **319.** Photograph taken with a 50mm lens. By Charles Swedlund.

above right: **320.** Photograph taken with a 200mm lens. By Charles Swedlund.

used when a photographer cannot back away from the subject far enough to include all that he or she wishes. The photographs in Figures 319 and 320 were taken from the same spot and with the same camera, but with lenses of different focal lengths.

Basically, the camera has two devices to control the amount of light that strikes the film: the *shutter* and the lens *diaphragm*. The *shutter* is a mechanical device which controls the duration of time light is allowed to enter the camera through the lens; the *diaphragm*, or aperture, which acts like the iris of the eye, determines the amount of light that enters (Fig. 321).

Films

Film for black-and-white photography is a thin, multiple-layered sandwich. The layer that does the work is the *emulsion*, a thin coating of gelatin in which millions of tiny silver halide crystals are suspended; these particles react when light strikes them. During development, those particles struck by various amounts of light darken to produce the gradations in the negative. Under the emulsion is the *support*, which provides a strong yet flexible transparent base for the emulsion. The bottom layer, or *antihalation* backing, absorbs any excessively

321. The diaphragm of a camera, like the iris of an eye, changes the size of the opening to admit varying amounts of light.

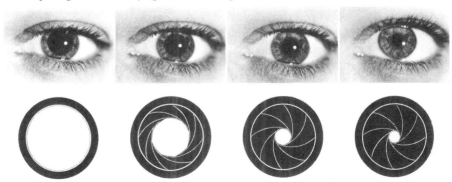

bright light that might scatter and produce haloes around bright points. Manufacturers can control the light sensitivity of film or *film speed* by the size of silver particles used; the larger the crystal, the greater the sensitivity. In this country film is tested and rated by its ASA number, established by the American Standards Institute. A film rated at 200 ASA is twice as fast as an emulsion of 100 ASA. Today, an extremely wide range of film speeds is available to both professionals and amateurs. Choosing a film speed involves a trade-off between speed and image definition. Figures 322 and 323 graphically illustrate the difference between 1000 ASA and 32 ASA film.

Color Films The story of the invention of color film is long and complex, but these are the basic facts. Color films typically have three layers of emulsion, each of which is affected by one primary color of light. When developed, color films produce either "positives" or "negatives." The most common type gives a positive transparency or "slide" that, when looked at through a viewer, pro-

top: **322.** Fast film (1000 ASA) has a pronounced grain.

bottom: **323.** Slow film (32 ASA) has almost no grain; the image is sharp and clear.

jected on a screen, or engraved in four colors for printing, reproduces the colors approximately as the photographer saw them. The other type gives a negative transparent film in which the colors are represented by their opposites. When printed on special paper, the colors are again reversed so that the subject is seen in its natural colors.

Developing Exposed Film

Although chemical changes occur when film is exposed to light, the latent image is not visible until the film is developed. In total darkness, exposed films are first immersed in a developer, a solution of several chemicals that transforms the unexposed light-sensitive particles to bromide, which is then washed away; the light-struck particles are turned to blackened metallic silver clusters, which adhere to the film backing. This is why the image on the film is negative. The lightest areas of the scene are quite dark, and the very darkest ones are clear. Some kinds of developers yield negatives with strong contrasts of dark and light, while others give a long scale of grays, from almost black to almost white. The film is then rinsed either with cool *water* or a mild acetic acid solution to halt the action of the developer, and then bathed in a *fixing agent*, commonly called *hypo*, that prevents light from making any further chemical changes. After being thoroughly rinsed again in water, the film is dried, and the image, in reversed values of the original subject, is ready for printing.

Printing

Printing is the process whereby the negative image from the film is transformed into a positive photographic print. It is not unlike exposing and developing a negative. In a darkened room the negative is placed into an *enlarger*, an upright projector that passes light first through the negative and then through the lens to produce an enlarged, focused image on the light-sensitive printing paper. Depending on the varying density of the negative, lesser or greater amounts of focused light strike the paper, exposing it. The more light that hits it, the darker that section turns when the print is developed (remember that the film responds conversely—the more light that hits it, the darker that section of the negative becomes). Thus the values are again reversed so that the finished print has a light-and-dark pattern similar to that of the original subject. The length of exposure required depends on such factors as the brightness of the enlarger light, the density of the negative image, and the sensitivity of the enlarging paper. Figures 324 and 325 show the different effects obtained from the same negative by varying the time of exposure.

PIONEERS OF PHOTOGRAPHY

Since the history of this new technological art form is relatively short (at least compared to those of painting and architecture), we can briefly trace its development and acknowledge some of its pioneers.

The Artist's Studio (Fig. 326), taken by Louis Jacques Mandé Daguerre in 1837, is one of the first aesthetically successful photographs. Daguerre had established his reputation as a painter who could depict with astonishing accuracy natural scenes, but he wished to go farther and make light paint the picture. After much experimentation, he succeeded in recording on a silver-plated piece

324, 325. The length of exposure during enlargement can dramatically change the mood of a photograph.

above left: **324.** 10-second exposure (normal).

above: **325.** 25-second exposure.

of copper what he saw. The still life is remarkable for its composition, its sculptural three-dimensionality, and its varied textures. The photographic process Daguerre used was slow and complex, but a remarkably beautiful image was captured. Following his example of high standards of excellence, other men produced outstanding *daguerrotypes*. Later, to satisfy the public craving for pictures, chiefly portraits, the process was modified and cheapened to produce thousands of commonplace *tintypes*.

With the introduction of a new, easier-to-use method in photography—the collodionpocess—the way was paved for many more people to participate in this new art form. Rather than be content with merely recording reality, some photographers painted on the negative or made composite images by combin-

326. Louis Jacques Mandé Daguerre. *The Artist's Study.* 1837. Daguerrotype. International Museum of Photography, George Eastman House, Rochester, N.Y.

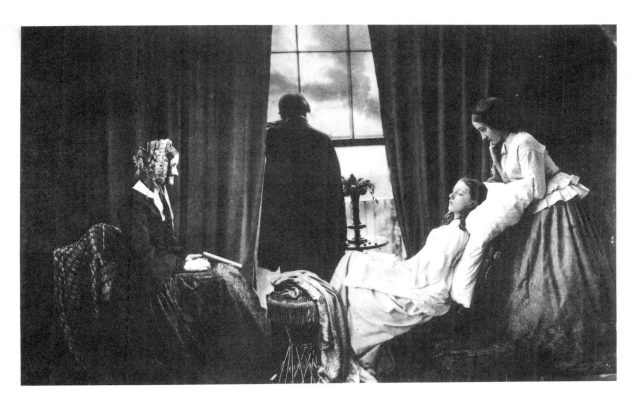

327. Henry Peach Robinson. *Fading Away.* 1858. Composite photograph. International Museum of Photography, George Eastman House, Rochester, N.Y.

ing two or more negatives. This last technique came about because the collodion emulsion was highly sensitive to blue light—skies, for instance, appeared bleached white. For people accustomed to paintings with dark, lush, cloud-filled skies, this washed-out color was disappointing. To solve the problem, photographers took two photographs from the same camera position. One was a short exposure to preserve detail in the sky, and the other was a longer exposure to record the landscape. Through negative masking of both images, a composite print could be achieved with the desired visual balance. This multinegative technique was called *combination printing,* and it soon became popular for creating complex allegorical compositions that dealt with ponderous, romantic themes.

Henry Peach Robinson's *Fading Away* (Fig. 327) is a prime example of this type of highly theatrical, posed work. By skillfully combining five separate negatives, Robinson tells the story of a young girl on her deathbed, attended by several members of her family. In today's terms, we would relegate this work of art to the level of visual soap opera—victorian sentimentality, to be exact. At the same time, the composition, lighting, and technical mastery revealed in this print are quite sophisticated. In a sense, this photograph has much to do with acting; it is a form of theater which is brought to life and frozen through photographic means. Commenting on this aspect of his work, Robinson observed that the principal model in *Fading Away* "had three years' practice in expression for photography before a satisfactory picture was taken."

By staging and controlling the visualization of the subject matter, Robinson imitated more manipulative forms of art like painting and sculpture. Yet what he produced photographically has come to be seen as a unique contribution to the world of art, despite its attempt to mimic painting. Until quite recently Robinson was viewed as a quaint photographer whose work was aesthetically dishonest because it did not embody strict documentary methods. Today this artist is enjoying a revival. Many young photographic artists—not content with purely

328. Julia Margaret Cameron.
Sir John F. W. Herschel. 1867.
Wet collodion-carbon print,
13¼ × 10⅜" (34 × 26 cm).
Museum of Modern Art, New York
(purchase).

documentary approaches—are turning to staged, allegorical set-ups to convey their personal interests and aesthetic concepts. No doubt they welcome the opportunity to pursue a level of personal expression they feel is missing from documentary modes.

Not every early photographer's work, of course, embodied the theatrical artificiality of Robinson's *Fading Away*. On the opposite end of the aesthetic spectrum is the portrait work of Julia Margaret Cameron. The wife of a well-to-do British civil servant, Cameron turned at mid-life to the pursuit of portrait photography with a passion that bordered on the obsessive. Long fascinated with the parade of illustrious people who visited her household, she trained her camera on these personalities with the intent of capturing with lens and film, as she put it, "the greatness of the inner as well as the features of the outer man." During the course of her photographic career, such famous 19th-century figures as Darwin, Longfellow, Tennyson, and Browning passed through her living room and sat patiently before her lens. One of her most famous portraits is of Sir John Herschel (Fig. 328), a noted astronomer and scientist.

Because of Cameron's interest in bringing out the personality of the sitter, the composition of this photograph is simple and direct in comparison to Robinson's elaborate tableau. Dark clothing, hat, and background dramatically highlight Herschel's wispy locks of hair and sharp, angular features. Cameron made particularly appropriate use of the limited depth of field and soft focus of her lenses to achieve compelling visual and psychological effects. Looking at this early photographic portrait, it is difficult not to feel the presence of a distinguished and remarkable human being, a portrait of wisdom, old age, and humanity. In keeping with Cameron's aim of revealing the psyche of the subject, Herschel seems to be completely absorbed in his own inner world and oblivious to the presence of the camera. Coincidently, Herschel made a great contribution to the technical progress of photography when he discovered a means of "fix-

ing" photographs from the further actions of light with hyposulphite of soda. To this day almost all photographic processes still make use of Herschel's basic discovery.

By the end of the 19th century, steadily advancing technical refinements in photography made the medium simpler for people to use, thus broadening its aesthetic possibilities. Up to this time photography required the kind of determination and perseverence few people could muster. Glass plates needed to be sensitized with messy liquid emulsion right on the site; and large, heavy equipment called for tripods and subjects that would hold still long enough for the exposure to be completed. The invention of more sensitive dry-plate emulsions quickly changed the methodology of this emerging art form and enabled artists working with a camera to push the range of possibilities beyond previous limits.

In 1893 Alfred Stieglitz photographed *The Terminal* (Fig. 329) using the new dry-plate film and a hand-held 4- by 5-inch (10 by 13 centimeters) camera he borrowed from a friend. Previously, smaller-format cameras such as this were looked down on by serious "art" photographers. Stieglitz waited hours in a heavy snowstorm one day in February to photograph the horse-drawn trolleys; the next day he captured the steaming horses seen in *The Terminal* as they were turning the Harlem-bound streetcar around. Using the newly developed hand camera for outdoor work, he championed the "straight" or "pure" approach, establishing a tradition of realism in American photography. Not imitative of painting or burdened with tricks, his photographs seem to let the observer see the subject through the camera lens but in a new, more vivid way. *The Terminal* transforms a commonplace scene. The large, powerful curve of men, horses, and tram boldly unifies an intricate composition of many interdependent parts. Atmospheric conditions and movement are captured in an instantaneous vision.

329. Alfred Stieglitz. *The Terminal.* 1893. Photograph. San Francisco Museum of Modern Art (Alfred Stieglitz Collection, reproduced by permission of Georgia O'Keeffe.)

THE DOCUMENTARY TRADITION

With the development of more portable camera equipment and the invention of much faster film emulsions, serious photographers abandoned the "painterly" approach to image making. Many adopted an aesthetic that saw the development of photographic art strongly connected to *documentation* rather than to the artificial creation of paintinglike compositions.

One of the most celebrated early practitioners of this form of documentary realism was Eugène Atget, a Parisian who for thirty years chronicled every aspect of French life. When Atget died in 1927, he left behind a priceless legacy of about eight thousand negatives, many of which are preserved in museums and private collections.

Although Atget was unrecognized during his lifetime, today his work forms a striking collection of images that are important both in historical and aesthetic terms. Since this photographer, with characteristic humility, believed he was essentially providing an image bank for painters, he grouped his photographs according to subject: historic buildings (many of which no longer exist), public statues, fountains of Paris, street vendors, store window displays, people outside their homes, churches, and even iron grillwork. He was a visual collector of things. But more important, he was an inspired maker of images who appropriately used the camera's inherent recording accuracy to create lyrical documents of enduring beauty (Fig. 330).

When the disturbing social and economic upheavals of the Great Depression hit the United States, many artists of that generation reacted with a keen sense of responsibility. During this trying time, purely aesthetic goals in art appeared meaningless in the face of hunger and deprivation. Photographers believed that

330. Eugène Atget.
Femme de Verrières. 1922 (?).
Gold-toned printing-out paper,
9½ × 7½" (24 × 18 cm).
Museum of Modern Art, New York
(Abbott-Levy Collection, partial
gift of Shirley C. Burden).

331. Walker Evans. *Domestic Interior, Scott's Run Mining Camp, near Morgantown, West Virginia.* 1935. Photograph, 8 × 10″ (20 × 25 cm). Library of Congress, Washington, D.C. (Farm Security Administration).

the compelling veracity of their medium could be put to good use documenting conditions throughout the country. One government agency, the Farm Security Administration, directed by Roy Stryker, shared this belief and hired many fine photographers to record rural farm conditions, particularly in the hard-hit dust bowl region. Walker Evans and Dorothea Lange were two distinguished photographers whose work reveals with touching candor the conditions and human tragedy of the Depression era.

Because he believed that his job was to document accurately the social conditions rather than to make "art pictures," Evans' photograph of a West Virginia coal miner's house (Fig. 331) reveals, without showing the inhabitants, the discrepancy between the promise of American life and its hard realities in the thirties. Commercial advertising signs with their smiling figures—representing hope and prosperity—are strategically placed in a cardboard shack to keep out the cold and rain and to offer something more than the wall to look at. Every detail of this sharply focused, well-composed photograph offers graphic testimony to the painful reality of people trapped in poverty living in a country of immense power and wealth. The bentwood rocker offers the only decorative relief in an environment of economic deprivation. As such it symbolized to Evans the indomitable spirit of these proud people to maintain vestiges of beauty and hope in an otherwise bleak existence.

Dorothea Lange's photograph, *Migrant Mother* (Fig. 332) records with great emotional power the plight of one hapless migrant family during the Depression. Lange's original field notes tell with understated, terse language of the economic disaster these people faced: "Camped on the edge of a pea field where the crop had failed in a freeze. The tires had just been sold from the car to buy

food. She was 32 years old with seven children . . . There she sat in that lean-to tent with her children huddled around her, and seemed to know that my pictures might help her, and so she helped me. . . ."

Although photographers such as Lange and Evans were vitally concerned with the thematic and emotional content of the image, they realized that to communicate their concerns to other people they must make use of the basic organizing principles of art. The compositional arrangement of *Migrant Mother* is well suited to its communicative needs. The strong angular movement created by the woman's forearm leads the viewer directly to her face, which vividly expresses the anxious state of her mind. Facing away from the camera, and therefore not distracting us from the mother's powerful facial expression, are the heads of her two young boys. Details like the tattered and frayed cuff of her jacket add immeasurably to this sadly compelling social document. Many photographs from the F.S.A. were used by people in Washington, D.C., to awaken the public and legislators to the realities of the Depression. Pictures such as this one proved to be a great tool for education and reform, going far beyond what words alone could say.

Other less socially related forms of photographic realism also were prevalent during this era. Responding in part to developments in the fields of painting and sculpture, some photographers in the 1930s such as Paul Strand, Charles Sheeler, and Edward Weston experimented with semiabstract images of objects rather than people. By carefully choosing their subject matter, angle, lighting, and cropping, these photographers could transform a cloud or side of a barn into an amorphous form or a complex geometric composition. One particularly successful example of this dual aesthetic—abstraction and realism—is Weston's

332. Dorothea Lange. *Migrant Mother, Nipomo, Calif.* 1936. Photograph. Oakland Museum, Calif.

photograph of an artichoke half (Fig. 333). By showing us a close-cropped, carefully lighted image of this ordinary vegetable, he succeeds in lifting the organic form out of the commonplace into a world of sensuously layered parallel forms. Weston's superb technical control over his photographs was due, in part, to his choice of equipment—a large, 8- by 10-inch (20 by 25 centimeters) view camera that allowed him to study the full-sized image upon a ground glass back before taking the picture. Since the camera produced an 8- by 10-inch negative, enlargement was unnecessary. In many of Weston's photographs everything is in focus, from the immediate foreground to the most distant point. He accomplished this feat by setting his aperture to the smallest opening his lens would allow, f64, and by using fairly slow shutter speeds. Weston's work with sharp-focus realism was so influential that a group of young photographers banded together in the early 1930s and formed a society called the "Group f64," referring to the aperture used to achieve the most finely detailed images.

35mm Photography

During the 1930s a small, light, easy-to-hold camera called the Leica gained in popularity and greatly changed the aesthetic nature of photography. Journalists in particular were quick to adopt this equipment because of the freedom of movement it allowed them in documenting fast-moving events. The new camera could be used in places and ways undreamed of before, such as unposed theater performances, night pictures, or children at play. Soon the name "candid" photography was attached to small-format photography.

Bill Brandt was an English photographer who studied with Man Ray in Paris before returning to London and specializing in documentary imagery. Brandt realized that to use this new tool successfully, he would have to take into account its drawbacks as well as its advantages. Despite the improvement of lenses and film emulsions, this system did not have the resolving power and tonal subtleties of cameras with large negative formats. Simple bold images and clear

333. Edward Weston. *Artichoke, Halved.* 1930. Gelatin-silver print, 7½ × 9½" (19 × 24 cm). Museum of Modern Art, New York (gift of David H. McAlpin).

compositional designs were therefore necessary to take full advantage of this equipment. Brandt's *Coal Searcher, East Durham, England* (Fig. 334) makes use of a powerful diagonal organizing element in the form of the prominent footpath. The stooped figure with his sack of coal gleaned from the waste heaps of the mine is boldly outlined against the light-reflecting path. This same individual photographed from a position to the left or right would have been lost against the dark grasses. Only with an easily maneuverable, hand-held camera could such an unposed image be taken. The speed with which the film could be advanced and the shutter tripped also enabled the photographer to capture the image at the exact instant of correct composition. Brandt may have taken several exposures of this man wheeling his sack of coal along the path and chosen this one as the best image of the series.

The concept of time in photography was also greatly modified by the new cameras. Small precision instruments like the constantly improving 35mm Leica enabled photo artists such as the Frenchman Henri Cartier-Bresson to use the camera as an extension of his eyes. Cartier-Bresson realized that the ability of the miniature camera to freeze instantaneously the constantly flowing events of life enabled us to perceive new relationships of form and content in the world. *Abruzzi* (Fig. 335) is a remarkable photograph; the figures in this Italian village seem to be carefully arranged in terms of placement and composition. But Cartier-Bresson refuses to pose subjects, believing that the natural order of objects and people offers far more exciting aesthetic possibilities than artificial placement could ever achieve. Capturing these "decisive moments" on film enables us to share with the artist mysterious ways in which the visual world continually reshapes itself before our eyes.

above left: **334.** Bill Brandt. *Coal Searcher, East Durham, England.* September 1937. Gelatin-silver print, 9 × 7¾' (23 × 20 cm). Museum of Modern Art, New York (gift of Robert M. Doty).

above: **335.** Henri Cartier-Bresson. *Abruzzi.* 1953. Photograph.

336. Robert Frank.
Number 2, Hoboken. 1955.
Gelatin-silver print,
8½ × 12⅞″ (22 × 33 cm.)
Museum of Modern Art, New York
(purchase).

With the publication in the late 1950s of a book of photographs titled *The Americans*, 35mm candid photography reached its zenith. This comprehensive photographic essay of images lays bare the many moods of a country and its people. To photograph this book Robert Frank, a Swiss citizen, loaded his car with film and 35mm cameras and set out on a modern-day odyssey to photograph every aspect of U.S. life: small towns in the South, northern industrial cities, the young, the old, motorcycle gangs, the American's obsession with the automobile, Las Vegas, and scenes showing the political system. *Number 2, Hoboken* (Fig. 336) makes effective use of the flag to comment on the patriotic feelings of citizens during a Fourth of July parade. Frank has composed this image so that the powerful graphic elements of the flag are juxtaposed with the isolated figures standing sentinellike in their respective windows. A great psychological tension and ominous quality is achieved by the cropping off of the head of the figure on the left. Even the woman on the right merges into the shadows and is overpowered by the strong visual and symbolic presence of the flag. Much of the aesthetic beauty of this artist's photography lies in his ability to combine striking graphic images with subtle sociological observations. Frank showed us a vision of America which was more revealing—and unsettling—than most romanticized images that found their way into print.

CONTEMPORARY PHOTOGRAPHY

Along with the acceptance of photography as an important medium in the fine arts has come a profusion of techniques, materials, and aesthetic positions. Like other forms of contemporary art, this field can be characterized as being highly diverse and eclectic in nature. While some photo artists are content to work with formal elements such as abstract composition, lighting design, and sharpness of detail, others are aggressively exploring the limits of photographic aesthetics: Artists such as Lucas Samaras and David Hockney approach the medium much as they might a painting or construction. Other artists, such as Sandy Skoglund and Cindy Sherman, have returned—in a sense—to the "pictorial" practices of such early photographers as Henry Peach Robinson, with nar-

rative and carefully posed images. Whatever their philosophical position or technical means, today's contemporary photographers are producing a wide variety of images that combine traditional techniques with unique individual perceptions.

William Wegman is an interesting figure in the photographic world because of his deliberate rejection of established traditions. For a long time his work in this medium was characterized by his lack of interest in the normal aesthetic features of photography: sharpness of image, composition, and meticulous printing technique. Instead, Wegman approached the photographic process from the viewpoint of a minimalist sculptor or conceptual artist. But the significant twist that he provided was that of parody—Wegman was clearly using humor both to participate in these genres and in a good-natured way to make fun of their sometimes overly serious stance. Wegman's black and white photograph *To Hide His Deformity He Wore Special Clothing* (Fig. 337) facetiously comments on minimal art, body art, and conceptual art all at once. But Wegman does not catagorically reject all of these genres out of hand; rather, he suggests that humor be used as an ingredient to help us appreciate the special perceptions these types of art make available to us. One of the major contributions of this artist was to open the way for subject matter of a whimsical and engaging nature—in other words, serious art need not be grim and humorless.

One of Wegman's prime foils in his pursuit of humorous, nonformalist conceptual art was his pet Weimaraner, Man Ray. Until his death in March 1982, Man Ray was the star performer in hundreds of Wegman's amusing and improbable set-ups (Fig. 338). Through the use of his dog Wegman was able to produce a body of conceptually oriented photographs that avoided the self-conscious stance often accompanying this aesthetic. Wegman himself has commented that, by using Man Ray, he sidestepped the problem of narcissism that was a distracting element for him in conceptual art. Undeniably, the poignancy of Man Ray trustingly sitting under a sifted shower of white powder in *Dusted*

below left: **337.** William Wegman. *To Hide His Deformity He Wore Special Clothing.* 1971. Photograph, 14 × 11″ (36 × 28 cm). Courtesy of Holly Solomon Gallery, New York.

below: **338.** William Wegman. *Dusted.* 1982. Color Polaroid photograph, 24 × 20′ (61 × 51 cm). Collection Gifford Myers. Courtesy of Holly Solomon Gallery, New York.

TO HIDE HIS DEFORMITY HE WORE SPECIAL CLOTHING

affects us and makes us think of the many roles animals play in our lives. Behind the slapstick humor of much of Wegman's art lies a perception of the world as profound as "serious" art.

Lucas Samaras is an artist from a multimedia background who has recently turned his interest to photography as a means of realizing highly personal imagery. This artist refuses to be pigeonholed into any one category; instead he works in a constantly shifting, inventive manner, using objects such as colored yarn, straight pins, **pastels**, sculptural assemblages, fabric collages, and specially manipulated SX-70 Polaroid prints. Photography for this artist is a means of exploring his own psyche by means of "docudrama" actions enacted in front of simple home-made sets. By the use of a self-timer on his camera, Samaras is able to work singlehanded on these photographic set-ups, thus retaining a great degree of control over the finished product. Once the props and background are chosen, Samaras places the camera on a tripod, composes the background image in the viewfinder, trips the 30-second delayed action shutter, and enters the camera's field of vision. This artist always appears in his photographic performances because he believes that the "self" is an irreduceable element in his art. Sometimes he uses such photographic tricks as double or triple exposure to achieve a desired effect—which might be an image of himself facing himself. Often, as the SX-70 print is developing, he will alter the image by disturbing and shifting the emulsion with a stylus. Later, after peeling the print off the backing, he often paints and draws on the photo surface to change its appearance further (Fig. 339). The results are quite magical and strange; here, Samaras is transformed into a "wolf-man" by his manipulation.

David Hockney is perhaps best known as a contemporary painter, draftsman, and printmaker. Recently he has turned his creative thinking toward photography with interesting results. Hockney had for years used his camera as a means of making visual notes for his paintings or documenting travel sights. Using a series of Polaroid prints of a subject to study various compositional possibilities, Hockney discovered he could achieve interesting cubistic effects through photographic collage.

Gregory Loading His Camera, Kyoto, February 1973 (Fig. 340) was created by printing multiple images of a young man loading his camera. It is a photo **mosaic** that achieves visual effects similar to that of a cubist painting: Many points of view are simultaneously presented to us on a two-dimensional plane. Through the use of this multiple perspective and collage technique, Hockney is able to break away from the limits of "straight" photography to create a complex, uniquely conceived photographic work of art. Looking at *Gregory Loading His Camera* is a disorienting experience; we feel as if various prisms, which bend and distort light, are placed between us and the subject. Hockney uses photography not to capture a realistic image but to create a fictive reality of great tangibility and presence.

For years Sandy Skoglund has been building complex, lavish environments that set the stage for her surrealistic photo fantasies. *Maybe Babies* (Pl. 34, p. 319) is a 30- by 40-inch (76 by 102 centimeters) color print that evokes deeply disturbing feelings and thoughts. Twenty cast-epoxy babies appear to crawl, walk, float, and fly across a black sand landscape with a clapboard house in the background. The colors of the babies range from dark purple to violet-pink; some are splotched and mottled. Many have their mouths open in a silent scream. Through a window in the house a middle-aged man, bathed in a soft orange light, watches impassively as this horrific scene unfolds outside his window.

Maybe Babies is deliberately open ended in terms of how we might thematically interpret it. Just enough visual information is given to provoke our curiosity and arouse our interest. By not providing all of the answers to our questions, Skoglund makes us turn inward and meditate on its meaning to us; this piece is capable of being understood in a myriad of ways. For the first time in history governments have the capability of destroying not only millions of lives in the present but also of adversly affecting the future procreative process itself. Although her exact intention is not certain, nevertheless *Maybe Babies* presents us with a socially relevant tableau that puts us in touch with the world's precarious situation. Yet Skoglund avoids a heavy-handed, propagandistic approach. Instead she allows us to explore this work of art and discover our own private meanings. In the end much of the power and emotional impact of *Maybe Babies* stems from the sheer visual wonder of this preternatural stage set swarming with multi-colored babies. Such an image is not easily forgotten.

Cindy Sherman is another contemporary photographer who creates fictional narratives with her camera. The sociological myths Sherman is interested in exploring center on the mass media—Hollywood movies. All of her recent large-scale color photographs appear to be greatly enlarged frames from films that might have been made in the 1950s (Pls. 35 and 36, p. 320). Beginning with the Cinemascope format of this recent 2- by 4-foot (.61 by 1.22 meters) image every thematic aspect of these photographs suggests the archetypal roles assigned to women in Hollywood films. Sherman calls attention to the way the media portrays women and how we take this manufactured image for granted: the frightened helplessness, the passive eroticism, the artificiality of the poses.

above: **339.** Lucas Samaras. Photo-transformation. October 28, 1973. SX-70 Polaroid print, 3″ (8 cm) square. Courtesy of Pace Gallery, New York.

right: **340.** David Hockney. *Gregory Loading His Camera, Kyoto, February 1973.* Photographic collage, 21 × 14″ (53 × 36 cm). © David Hockney, 1983, Petersburg Press.

She also points to the technical means that highlight women's place in the movies: the dramatic lighting and the emotional power of the close-up. Even symbolic details such as messy hair and carefully chosen articles of period clothing subtly reinforce her theme.

Sherman herself appears in these photographs, as she does in most of her set-ups; through a variety of wigs and changes in makeup, costume, and lighting she is able to assume the role of many female characters. Despite the physical differences in her appearance, she essentially plays only one role: the stereotypical Hollywood starlet. Since Sherman's prints are like frozen movie images seen out of context from the film, we have no clear idea exactly who these people are; but like familiar faces from the past that we cannot quite place, they tantalize our memories and haunt us. Perhaps the most significant cultural effect of Sherman's photographs is that they invite us to reflect on the pervasive role of the mass media in our lives and the powerful effect the medium of film has on our consciousness.

Although most contemporary photographic work might appear to offer us a choice of either "manipulated" or "straight" imagery, some work happily combines elements of both. Lewis Baltz is a photographer who has sought to create pictures that, while seeming to use a specially fabricated set, are in actuality purely documentary. His *Construction Detail, East Wall, Xerox* (Fig. 341) clearly illustrates this point. In this particular series of photographs, Baltz searched for industrial buildings under construction in southern California. During the building of a new Xerox Corporation facility in a Santa Ana industrial park, Baltz discovered this particular viewing angle, which offered a variety of remarkable forms, textures, and tones. Through the careful placement of his camera, the artist was able to transform the ambiguous construction details of an uncompleted building into a composition of well-integrated visual elements and tonal gradations. In some ways the results resemble a painting or a set-up that might have been created to be photographed; other elements, such as the cinder blocks and iron ladders in the center of the composition, lend an air of documentary realism to the photograph. By carefully choosing his subject matter and compo-

341. Lewis Baltz. *Construction Detail, East Wall, Xerox, 1821 Dyer Road, Santa Ana.* Photographic silver print, 9⅝ × 6⅜″ (24 × 16 cm). Courtesy of Eaton/Shoen Gallery, San Francisco.

sition, Baltz has created a work of art that strikes an aesthetic balance between the manipulated and the documentary approaches to photography.

Robert Mapplethorpe is another talented contemporary photographer who, like Baltz, succeeds in blurring the boundry between personal expression and documentary forms. Because of today's proliferation of reproduced photographic images—essentially performing journalistic tasks—fine-art photographers now are free to explore other aesthetic avenues besides straight documentation. Consequently much work is directed toward personal expression even within documentary limits. In *Tulips* (Fig. 342) Mapplethorpe is able to combine elements of photographic realism with formal elements of composition developed by modern abstract painters. The more we look at this seemingly realistic, masterfully organized image, however, the more ambiguous the space and visual elements appear. At first glance this photograph is easily classified as a traditional **still life**. The tulips are compositionally placed off center and are exquisitely modeled by the strong directional lighting. But when we "read" the surrounding space of the composition, the figure-ground relationship is unclear. The odd reflective square that emerges to the right of the vase and the strange angles of the table cast doubt on the space in which the flowers appear. Because of these spatial uncertainties, Mapplethorpe has endowed this image with great mystery. The rounded organic forms of the flowers offer striking contrast to the abstract geometric space. More important, he has transformed the substance of photographic reality through lighting and camera placement; in this sense he has *created* the still life rather than merely recording it.

Although our everyday concept of photography has been based on the notion that it is primarily a means of recording images realistically, obviously it can play other aesthetic roles. Contemporary photographers, as we have seen in our representative sampling, are constantly redefining in personal terms just what photography can do. Although this constant change might make photography hard to classify, it also makes this medium one of the most exciting art forms of the 20th century.

342. Robert Mapplethorpe. *Tulips.*
1977. Gelatin-silver print,
14 × 13⅞" (36 × 35 cm).
Museum of Modern Art, New York (acquired with matching funds from David H. McAlpin and the National Endowment for the Arts).

Chapter **15**

Architecture

Of all the arts, architecture is the most technically complex, socially interactive, and widespread. In literally every corner of the world homes, churches, temples, and governmental buildings tell us as much about the people who built them as about the nature of the activities they shelter. Architecture functions in ways that are both symbolic and utilitarian, aesthetically expressive and highly practical; architecture also nourishes the spirit by vividly embodying human ideals and aspirations.

Often, because we lack the benefit of historical perspective, we fail to recognize in today's architectural structures and styles elements of symbolism so apparent in older forms. The pyramids of Egypt offer a clear example of how significant architecture goes beyond utilitarian concerns to express important values of its time. The rulers of ancient Egypt were obsessed with the concept of the hereafter. Since they believed that after death their souls would once more return to their bodies, they constructed massive, largely solid stone pyramids and funerary temples in which departed royalty would be housed and preserved against decay. The great temple complexes of Egypt were in fact necropolises—whole cities for the dead, complete with food, implements, and furniture. The Great Pyramid of Khufu, with the nearby Sphinx (Fig. 343), is a spendid exam-

343. Sphinx (c. 2520–2494 B.C.) and Great Pyramid of Khufu (c. 2551–2528 B.C.). Giza, Egypt.

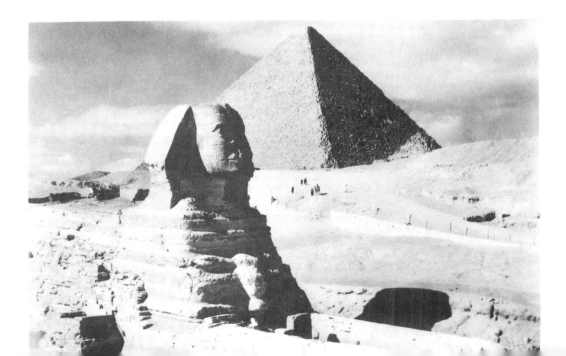

344. Henry Hofmeister,
H. W. Corbett, Raymond Hood,
and others. Rockefeller Center,
New York. 1931.

ple of this form of funereal architecture. These massive structures contain little
or no *usable* space—at least by contemporary definitions of this term—yet their
visual presence and psychological effect is enormous.

In apparent contrast, the buildings of Rockefeller Center in New York City
(Fig. 344) are thin shells of steel, concrete, and stone that provide vast amounts
of utilitarian space for thousands of workers. Whereas the Great Pyramids exist
today as symbolic rather than purposeful structures, Rockefeller Center might
appear to be only concerned with practical, useful space that can be rented at a
profit to business concerns. These two complexes are, however, more closely
related than we think. In 1931, during the depths of the Depression, the Rocke-
feller family commissioned this grandiose project as a symbol of faith in the
economic future of the United States. Because of their immense personal wealth
and power, the Rockefellers may be viewed as latter-day pharaohs, whose build-
ing programs coincide with their personal values and beliefs. Like the pyramids,
these monumental works are designed to memorialize the builders' name and
thus conceptually extend their life beyond death.

It may be argued that the symbolic value of architecture has changed little over the past four thousand years. Humanity still constructs buildings to fulfill psychological and cultural needs as well as for practical concerns of shelter and usable space.

In the preceding chapters we have used some examples of architecture to discuss a variety of concerns, including personal dwellings, community environments, and visual communications. Here we will focus on problems of design, construction methods, and the spatial expression of buildings. The discussion will begin by reviewing the evolution of a modern architectural form.

THE SKYSCRAPER

Modern high-rise office buildings, or *skyscrapers,* represent our continued efforts to conquer space through the use of new technologies and materials. They certainly can be considered a new form of architecture, yet their underlying essence—verticality—can be traced to the soaring spires of Gothic cathedrals in the 1300s. Architecture, like other art forms, cannot help but express the preoccupations of society. In the Middle Ages, when religion was a dominant force, the cathedral was the cultural and visual center of the community. In 20th-century America, the "cathedrals of commerce" tower above all else and reveal our concerns, not with spiritual values but with business and technology.

What should a skyscraper look like? Does the architect, like the painter and sculptor, have problems of expression? What is the relation between structural systems and the appearance of a skyscraper? What are the effects of technological developments? Such questions have been the preoccupation of architects since steel construction and elevators first made tall buildings possible.

Beginnings of the Skyscraper

One of the earliest skyscrapers was the Wainwright Building (Fig. 345). Although built in 1891, it has a remarkably "modern" look. It was designed by Louis Sullivan, a member of the "Chicago School" and one of the great architects of modern times. Sullivan was the first to realize that the skeletal frame of a skyscraper should be reflected in the design—that a tall office building should look like what it is and not like a Greek temple or a Gothic cathedral.

In retrospect it makes sense that modern architecture would begin with a new type of commercial building rather than with an established genre. Chicago was also a logical place because of its burgeoning in the late 1800s as a mercantile center. When the Great Fire swept this city in 1871 it created opportunities for architects to rebuild large portions of the downtown area.

Sullivan recognized that skyscrapers are *lofty steel structures* typically used as *office space.* In the Wainwright building height is stressed by emphatic vertical *piers.* The nature of the interior space, which is a series of small rooms similar in size and shape, is expressed by an organization of windows that is regular but subtly proportioned. Sullivan's organic view of architecture embraced the idea that the outer surfacing of a building is the "flesh," which is attached to the "bone" or skeletal structure underneath. According to this philosophy there were various expressive possibilities for the facade, and Sullivan explored many of them. In the Wainwright building, he was concerned with the relationship of the structure to the street, particularly the way in which it turned the corner.

Sullivan's design pays great attention to the longitudinal flow of the building along its flanks but emphasizes, as well, vertical elements in the corner.

The building has several other features that should be observed and kept in mind when comparing it with later skyscrapers. It has three major horizontal divisions: a base (the two bottom floors), a shaft (the seven identical floors making up its main mass), and a cap, or cornice. This is a design concept that developed originally in antiquity, and it is exemplified in the classical column. Second, even though the Wainwright building is multistoried, it remains human in scale. In many recent tall structures these concepts have been rejected, but demonstrating Sullivan's links to the past does not in any way lessen the magnitude of his contribution.

The Glass Skyscraper

For decades architectural debate has centered on the relation of spiritual and aesthetic values to practical concerns. Some people believe that architecture is the result of formal solutions to problems of structure, use, and construction materials. Others believe strongly in the human need for spiritual values that can be expressed through architectural forms. Obviously, both points of view have validity; admittedly, it is difficult to integrate them. However, exemplary architecture balances both *utilitarian* and *aesthetic* concerns—elements that are by no means intrinsically at odds.

Ludwig Miës van der Rohe's drawing of an unbuilt glass skyscraper project (Fig. 346) is an inspired vision of how modern materials and building techniques can function in the service of contemporary spiritual values. From this

below left: **345.** Louis Sullivan. Wainwright Building, St. Louis. 1890–91.

below: **346.** Ludwig Miës van der Rohe. Friedrichstrasse Office Building project. 1921. Charcoal and pencil on brown paper mounted to board, 5'8¾" × 4' (1.73 × 1.22 m). Museum of Modern Art, New York (Miës van der Rohe Archive, gift of Ludwig Miës van der Rohe).

347. "Butter Tower," Rouen Cathedral, France. 15th century.

drawing it appears that Miës conceived of the glass-sheathed skyscraper as the heir to the upward-yearning spires of 15th-century Gothic buildings such as the "Butter Tower" of Rouen Cathedral (Fig. 347). Essentially expressing a vertical movement, the Gothic style imparts a feeling of aspiration entirely in keeping with the religious fervor of the period. Miës' unbuilt project, conceived in 1919, makes use of crystalline, soaring forms that thrust upward with great power and certainty. By making the façades as transparent as possible, Miës sought to reveal the inner "truth" of this structure and thereby to proclaim that its "beauty" was founded on a machine age aesthetic. Like Sullivan, Miës was a strong believer in the need for architectural concepts that could succinctly express our era. In what could easily be taken for a Louis Sullivan quote, Miës wrote in 1923 that architecture should "create form out of the nature of our tasks with the methods of our time." Although many of the high-rise, glass-sheathed office buildings built by Miës van der Rohe and his followers do not measure up to the vision presented to us by his drawing in 1919, he did much to develop and define the skyscraper as a genuinely modern architectural form.

Lever House Lever House (Fig. 348), designed by Gordon Bunshaft of Skidmore, Owings, and Merrill in 1952, is a high-rise building in New York City that represents the mature, late style of modern architecture. The stainless steel and glass surfacing of the building mark it as a product entirely of the machine age. It has nothing of the masonry tradition that for thousands of years characterized most Western architecture. Here is an uncompromisingly frank and lucid architectural statement for its day. It is a steel and concrete *cage* that has been sheathed in a glass and stainless steel *envelope*. The walls, or *skin*, constituting the envelope have been separated from the structure.

The Lever House design has a forceful clarity. At the base of the building a horizontal unit is supported one story above the ground on gleaming metal piers to create an unbroken pedestrian space extending over the entire plot, except for the area occupied by the glass-enclosed lobby directly beneath the main mass of the building. Above the horizontal form, but separated from it by an indentation or "notch," rises a handsomely proportioned rectangular solid that is encased in green-tinted glass and stainless steel. The two major forms are opposed and sharply articulated. The free walkway at street level, the concentration of the tower in no more than 25 percent of the available air space, and the disposition of the slab structure along one edge of the site all invest the Lever House with an extraordinary lightness and clean, immaculate grace. It seems to float on its platform, well above the ground. On the sunlit side of the slab the horizontal bands dividing the floors are visible. On the shaded side the sheathing serves as a gigantic, reflecting surface for adjacent buildings and passing clouds. The depth of the reflected images makes the Lever House seem almost transparent. This, too, heightens the impression of lightness.

The Lever House set a new style in skyscraper design, but many of the "slab" buildings imitating it use glass and metal sheathing to encase structures of indifferent, often inferior, design. Nonetheless, the Lever House and buildings like it represent a meaningful exploitation of 20th-century technology in skyscraper design.

Reinterpreting the Glass Skyscraper Recently, some critics of architecture have been announcing, and even promising, the end of the modern era. Architects such as Michael Graves and writers such as Charles Jencks have been predicting that the international style of building is over; as its replacement they are

championing "postmodern" architecture—a loosely defined style that often makes reference to historic forms such as Greek columns or Renaissance arches. This raises some interesting questions: Has the aesthetic backbone of modern architecture been broken? Does this mean that certain tenets of modernism—such as "form follows function"—are invalid? Has architecture given up the idea of progress? Will it return wholesale to the past—in retrograde fashion—for interpretation of architectural form?

Certainly something significant is happening on the architectural scene, but it may not be the death of modernism. What has happened is that once-rigid formulas and formalist doctrines have become less pervasive. The widespread acceptance of divergent ideas has opened up the marketplace to a myriad of *individual* architectural directions, resulting in a pluralistic rather than unidirectional approach. Personal interpretations are replacing anonymous designs. For example, two dazzling new high-rise buildings, both built in 1983, offer clear examples of the latitude today's best designers enjoy and signal the evolutionary changes taking place in modern architecture. These structures are the sleek and luxurious 2 United Nations Plaza by Kevin Roche John Dinkeloo and Associates (Fig. 349) and Philip Johnson/John Burgee's American Telephone and Tel-

below: **348.** Gordon Bunshaft of Skidmore, Owings & Merrill. Lever House, New York 1952.

below right: **349.** Kevin Roche John Dinkeloo and Associates. 2 United Nations Plaza, New York. 1983.

350. Johnson/Burgee. AT&T Corporate Headquarters, New York (model). 1985.

egraph Corporation headquarters at 550 Madison Avenue (Fig. 350). Both buildings are decidedly contemporary in spirit: While the AT&T building looks to the past for inspiration, 2 United Nations Plaza extends the vocabulary of modern architecture in a new, more personalized way.

In 1976 Kevin Roche and John Dinkeloo designed a glass high-rise at 2 United Nations Plaza; and in 1983 they added to this large hotel and office complex with a restrained yet forceful building characterized by light-blue reflective glass and crisply angled facets. What architects Roche and Dinkeloo have done is to provide us with a more personal, sensuous interpretation of the often dry international style. When light reflects and plays off this building—as it often does—we are afforded a glimpse of the original vision Miës van der Rohe may have had in mind when he conceived of his glass skyscraper project in 1919. This structure has a clarity and lucidity that conveys the feelings embodied in the best examples of the international style; but it also has a more picturesque, almost romantic quality that points the way to a new interpretation more relevant to the latter half of the 20th century.

At first glance the AT&T building by Philip Johnson and John Burgee might be viewed as a less "modern" building than 2 United Nations Plaza. Yet the AT&T building also derives much of its power from the modern spirit. Roche and Dinkeloo have reacted to the persuasive legacy of modern architecture by advancing its ideals but modifying its severe style. Johnson and Burgee pursue another dream of modernist philosophy, the dream of freedom—the freedom to employ creatively *any* element in one's work, even classical forms of the past. What the pioneers of modernist thought have given us is not so much a basic building idiom—such as glass and steel, boxed—but the courage to go beyond

codified thought and ideology. Through the incorporation of such historical architectural references as Renaissance arches and a split-pediment top (which caused the building to be labeled "Chippendale Modern"), Johnson and Burgee have created a distinctive postmodern skyscraper.

Although the unusual top of the AT&T building enlivens the Manhattan skyline in a way that few buildings have in the past decade or so, it is the relation of the base to the street that deserves the highest praise. Most buildings on Madison Avenue, a relatively narrow thoroughfare, meet the street timidly through small, finely detailed lobbies. The AT&T building, however, features an 80-foot (24.4-meter) entrance arch and open **colonnades,** which create an impressive and dramatic space into which one enters.

Both the new United Nations Plaza building and AT&T's corporate headquarters are representative examples of the meaningful diversity now found in modern architectural design. No longer is there a single aesthetic viewpoint for the construction of significant new buildings. Each of these buildings makes a distinctive artistic statement about what the designers personally feel a modern skyscraper should look like. Together they add immeasurably to the visual enrichment of the community environment within which they function.

ARCHITECTURAL CONSTRUCTION

In general, architecture has three components directly comparable to the human body: the *skeleton,* or frame, which supports the building; the *skin,* which encloses it; and the *equipment,* or "vital organs," through which air, light, sound, and sanitation are controlled. In early architecture little distinction was made between skeleton and skin, and little provision was needed for equipment. Today each of these components has been the subject of careful study, although in some recent work the distinction between skeleton and skin is again disappearing as new materials and techniques make possible new methods of construction.

Historic systems of architectural construction are generally classified in four categories:

Post-and-lintel, in which horizontal beams are laid across the spaces between upright supports (Fig. 351). If the upright support is a continuous wall instead of separate posts, the system is more aptly called *wall-and-lintel.*

Cantilever, in which load-carrying beams, or members, project beyond their supports (Fig. 352).

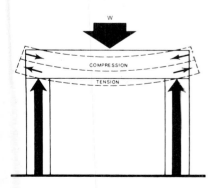

351. Post and lintel.

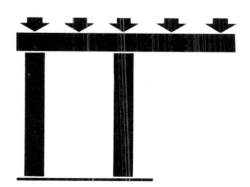

352. Cantilever.

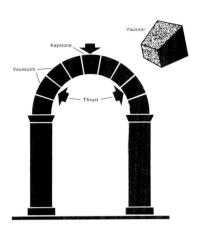
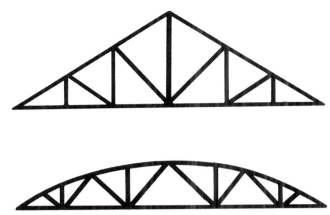

above: **353.** Round arch.

above right: **354.** Trusses: Howe truss (*above*), bowstring truss (*below*).

Arch, in which small, wedge-shaped pieces of material are placed with joints at right angles to the curve (Fig. 353). This defines the *true,* or *radial,* arch, but the term has come to describe any structure with curved elements.

Truss, in which members such as beams and bars are assembled into a rigid triangular framework (Fig. 354).

Many architectural styles have developed throughout the world from these basic systems. But because of the refinement of building methods and the invention of new materials, two other categories need to be mentioned: *bearing-wall construction,* in which the wall supports not only itself but the floors and roof as well; and *skeleton-frame construction,* in which a framework supports the building, and the walls (or skin) are merely fastened to it. Both systems are used extensively in modern architecture.

The following section will examine architecture in relation to the four principal materials that have shaped it—stone, concrete, wood, and steel—for it is out of the properties of these materials and their uses that the basic structural systems have been developed. A general understanding of the primary building materials and systems can help explain all building forms, whether contemporary or historic.

Building in Stone

Because of its availability and permanence, much of the world's great historic architecture, public and private, has been constructed from stone. Thus, the stone tradition has permeated even contemporary architectural thinking and has determined much of today's taste and judgment.

The United States, however, has never had a genuine stone tradition. At first, the need for quick shelter led the colonists to use wood. By the time brick became common, colonial architecture was a reflection of English work, and stone was not used extensively until the revivals of Greek, Roman, Gothic, romanesque, and other styles set in. For the most part, the stone and masonry we see in today's buildings does not perform any structural role but rather is used as surfacing over metal skeletons. Original Greek and Roman buildings, however, relied heavily upon these materials to support and bear structural loads.

Post-and-Lintel: The Parthenon Post-and-lintel construction was effectively employed in one of the most famous buildings in the Western world—the

Parthenon on the Acropolis in Athens, Greece (Figs. 355–357) Built about 2500 years ago (448–432 B.C.) as a temple in honor of Athena Parthenos, the patron goddess of Athens, the Parthenon remains the crowning glory of the Athenian Acropolis. The illustrations are of the building in its present state and of a floor plan and model that attempt to show its original appearance.

With the advent of Christianity the cult of Athena was replaced by dedication to the Virgin Mary. After the Turkish conquest, the Parthenon became a mosque. During a conflict with the Republic of Venice the Turks stored gunpowder in the building, and in 1687 a random bomb set off the ammunition that blew out the central section. From 1801 to 1803 much of the sculpture was removed by the British diplomat Lord Elgin to England, where it now is displayed in the British Museum (the Greek government is now vigorously legislat-

below: **355.** Ictinus and Callicrates. Parthenon, Athens. 448–432 B.C.

bottom: **356.** Model of reconstructed Parthenon. Metropolitan Museum of Art, New York (purchase, 1890, Levi Hale Willard bequest).

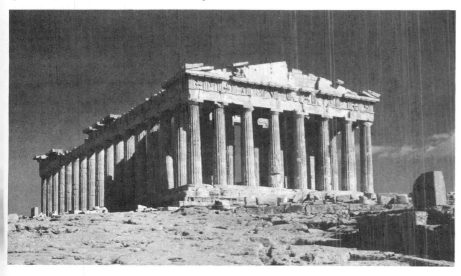

below: **357.**
Plan of Parthenon.

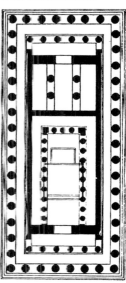

ing to have it returned). As it exists today the Parthenon is an enduring reminder of the social, political, and aesthetic roots of Western civilization.

The floor plan shows the rectangular simplicity of the building. It was surrounded by a colonnade, with a second row of columns at each end. Of the two rooms composing the interior, the larger housed an ivory and gold statue of Athena, the smaller was a treasury. The temple, as the plan makes clear, was not designed to hold large groups of worshipers, for the religious festivities of the Athenians took place mainly outside the building.

The Parthenon is built on the basic post-and-lintel system. The structural logic of the upright posts supporting horizontal beams can be demonstrated readily by standing two books on end and bridging the gap with a third. Through this system builders and architects have given us some of the world's most distinguished buildings. The Parthenon, however, reveals one of the major limitations of post-and-lintel construction when stone is used. Notice that the columns (posts) are set relatively close together, not necessarily because the designers, Ictinus and Callicrates, wanted that visual effect but because stone lintels of great length are not feasible. As a building material, stone is strong in compression but weak in tension (that is, when stretched or strained). Stone posts can be high because the weight above merely compresses them. Lintels, however, are another matter. The upper half is in compression; the lower half is in tension. Therefore the tensile strength of the material used is a determinant of the design—lintels of wood or steel can be much longer than those of stone.

One of the most convincing theories about the origin and development of the Parthenon's form, now considered the height of classical perfection, is that the parts of the building and their interrelationship derive from earlier constructions in wood. Columns are natural forms in wood, for a straight tree trunk provides one ready made. The translation of wooden columns into stone is less natural, because to make a tall column, marble must be built up in separate pieces called *drums*. The vertical **fluting,** or channeling, on the columns could have originated in the woodsman's adze marks. In marble the flutes serve to integrate the several drums visually into a single shaft. The triglyphs—the rectangular forms that appear directly above the columns in the frieze—are modified beam, or lintel, ends. The Greeks employed stone because it was a more durable material, especially since Greece itself is blessed with some of the finest types of marble in the world.

A brief description of the parts of a classical building such as the Parthenon is pertinent because the forms themselves have been in use ever since they were developed, and few towns in the Western world do not have one or several buildings that are classical in design. The temple rests on a sturdy base of three high steps, called the *stylobate*. Above this rise the *columns,* vertical *shafts* surmounted by simple but delicately curved *capitals;* the columns are *channeled* to make them seem more slender, and the capitals form an admirable transition between the vertical columns and the horizontal *entablature*. The *architrave,* adorned with bronze shields, acts as a good foil for the sculptured panels in the *frieze,* above which is the *cornice*. Architrave, frieze, and cornice make up the entablature, just as the shaft and capital make up the column. Surmounting all is the *pediment,* filled with sculpture subtly adapted to the triangular space. The Parthenon is built in the Doric Order—a style of classical architecture that is identifiable by the style of its column and the entablature it supports. The other classical orders are Ionic, Corinthian, Tuscan, and Composite.

Few people in recent times have walked around on the rocky hilltop in Athens surveying this romantic ruin without feeling the Parthenon's immense power.

Apart from the beauty of the building materials and the harmonious relationships found in this building, there are other reasons for the compelling attraction of this structure. Much of the magic derives from the site, a position that commands the countryside for miles around, and part from the careful refinements of architectural form.

The more the Parthenon has been studied, the more its technical design has come to be admired. Wisely, the planners of the Parthenon recognized that buildings with certain *exact* forms and lines do not always appear to the human eye as we know them to be. Through several centuries, Greek builders observed these phenomena in their temples and developed means of overcoming them. The architects of the Parthenon used a number of refinements to help give the building a vibrant, living, perfectly integrated quality that accounts, in part, for its enduring reputation.

Greek builders noticed, for instance, that long, perfectly straight horizontal buildings appeared to sag. To correct this effect, all the long horizontals on the Parthenon, such as the steps and the cornice, are higher in the center by about 2½ inches (6 centimeters). Vertical columns with straight sides appeared concave; to counter this, the posts were given a slight bulge or swell, called **entasis.** This also made the material appear to be responding organically to the heavy load placed upon it. In order to rectify the illusion that a building rising straight up from the ground is leaning forward, the whole front of the Parthenon is tilted slightly backward (about 2½ inches, or 6 centimeters) Builders noticed that long rows of columns in a colonnaded front do not appear equidistant from each other. Therefore distances between columns in the Parthenon are adjusted to make them all appear equal. The space at the center is the largest, and the spaces are progressively smaller toward the corners. The list goes on, further increasing our admiration for these engineers and architects who worked without benefit of the sophisticated surveying and measuring tools we have today. These examples give us a good idea of the sensitivy and discernment of early classical builders, who achieved significant results with post-and-lintel stone construction methods.

The Round Arch: The Roman Aqueduct at Segovia The aqueduct built by the Romans at Segovia, Spain, shows clearly the characteristics of arch construction (Fig. 358). Unlike the Parthenon, in which each opening was spanned by a single beam or piece of material, each opening in arch construction is spanned by a number of pieces of material. The advantages of the arch are immediately apparent. An opening is not limited by the length of a beam, and, through the use of relatively small pieces of material, areas of great dimension can be spanned. The Greeks knew the principle of the arch, but they made little use of it. Perhaps the more visually active arch form was incompatible with their ideals of calm beauty and repose. It was the Romans, their immediate followers in the evolution of Western architecture, who exploited the possibilities of arch construction. Indeed, the arch and its perfection in varied forms were a central preoccupation of builders for about two thousand years.

The type of arch the Romans used was the round or semicircular one (see Fig. 353), and it became so integral a part of their building that arches of this form are still referred to as Roman. Its development was intimately related to the development of the Romans as a people. We know that they were more aggressive and materialistic than the Greeks. Their commercial activities, big public assemblies, fabulous banquets, and renowned trials demanded buildings with

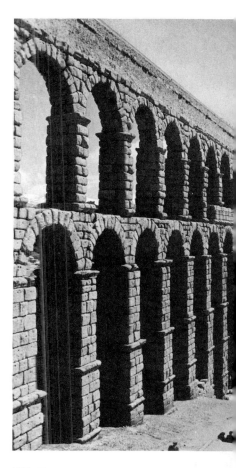

358. Roman aqueduct, Segovia, Spain. A.D. 10.

larger, more flexible interiors. The arch provided a structural basis for such buildings, but the Romans found other uses for it as well. Monumental arches commemorated the conquests of triumphant leaders. Vast amphitheaters permitted multitudes to enjoy circuses and pageants. Arched bridges over rivers, together with good roads, enabled armies to march swiftly. And arched aqueducts, built so well that some are still standing, brought water great distances to key cities. The arch was a dominant motif in Roman architecture.

As can be seen in the Segovia aqueduct, an arch is made up of wedge-shaped pieces of materials (*voussoirs*) with joints at right angles to the curve. Stone is a material uniquely suited to arch construction because all material in an arch is in compression. Stone can withstand great pressure and is, of course, extremely durable.

The arch, by its nature, is subject to lateral thrust, or *spreading*. This may be demonstrated easily by arching a piece of paper and then slowly bringing weight to bear on top of it. The arch, when depressed in the center, spreads at the sides. These movements, indicated by the arrows in Figure 353, are characteristic of all arches. Furthermore, the flatter the arch, the greater its tendency to spread. Tall, pointed, or parabolic arches have less tendency to spread and therefore need less support. To counteract this lateral thrust, arches need to be supported or braced at the point of weakness. This is done in various ways—with a solid wall, with another arch, or with a **buttress**.

The introduction of the arch in the construction of buildings dramatically changed the face of architecture. Whereas the Parthenon, composed of balanced horizontals and verticals, seems almost inert or static in its equilibrium, the later buildings based on the arch suggest energy and movement. The dynamic effect of the arch stems not only from it shape but from the fact that it is a basically unstable architectural form. For this reason, structures such as St. Peter's in Rome, supported mainly by arched forms, are likely to present a visually vigorous, active image.

The Vault and the Dome: St. Peter's in Rome The principle of the arch gave rise to **vaults**, which are arched coverings in masonry. The most basic form of vaulting, the projection of a simple arch, is a *barrel vault* (Fig. 359). The name is an apt one, since in appearance it looks like a barrel cut lengthwise. The barrel vault has the characteristics of the simple round arch. It is, in fact, an arch repeating itself along a passage. It has the same tendency to spread, the same need for support at the place where the lateral thrust makes for weakness. In the interior of St. Peter's (Fig. 360) the spacious quality of a large barrel vault is evident. Here the surface is enriched with *coffers*, depressed rectangular forms that lighten the weight of the vault and articulate it in both color and shape.

There are many variations of vaulting. When vaults intersect each other, **cross vaulting** results (Fig. 361), and the support can be localized rather than continuous, as it is in a barrel vault. The development of vaulting will be discussed briefly in the section on the pointed arch.

The **dome** is also an extension of the principle of the arch (Fig. 362). In the instances where semicircular arch forms are used, the dome is a hemisphere—like a ball cut in half. A dome is a round arch that has been rotated, using the midpoint of the arch as the center. It becomes, in a sense, a multitude of arches so arranged that all the bases rest on a circle and the tops all cross at a common point. In the dome all the characteristic weak points of the arch remain, and consequently, it requires support at the points of lateral thrust. Usually, but not

359. Barrel vault.

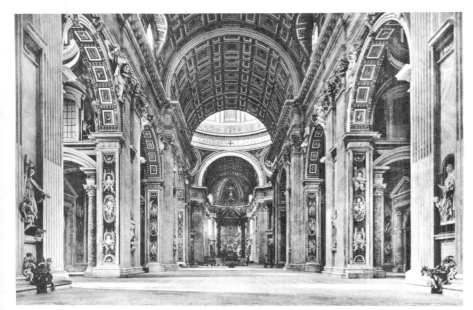

360. Michelangelo and Carlo Maderno. Interior, St. Peter's Basilica, Rome. Begun 1547.

361. Cross vaulting.

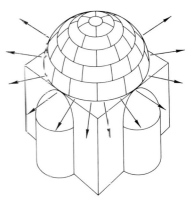

362. Dome.

always, this is taken care of by properly designed **pendentives**, which can become a decorative feature of the exterior.

The dome of St. Peter's (Fig. 363) crowns this largest of all churches. Here, the intent was to design a dome that would be impressive both as a culminating exterior form and as an interior space. Designed by Michelangelo and completed after his death in 1564, it is the ultimate realization of the type of dome developed in Italy during the 15th and 16th centuries. It is also the prototype of most of the monumental domes subsequently constructed, including the dome on the United States Capitol in Washington D.C. (which is formed of cast iron).

363. St. Peter's Basilica, Rome. Apse and dome by Michelangelo, 1547–64. Dome completed by Giacomo della Porta, 1588–92. Nave and façade by Carlo Maderno, 1606–26. Colonnades by Gianlorenzo Bernini, 1656–63.

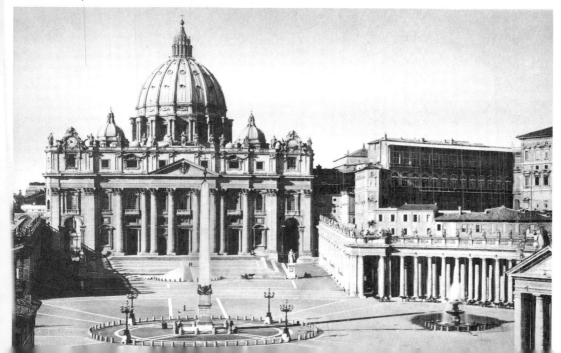

Domes, especially those raised high above the main mass of the structures supporting them, are imposing, and they have been much favored as crowns for important public buildings. As powerful forms, they are potent symbols. Their interior spaces, lofty and free of supports, create a sense of soaring infinity.

Although few domes today are constructed on the true arch principle, they continue to be useful in the design of buildings that must hold great numbers of people for public events. Modern roofed athletic stadiums are good examples of how contemporary building materials such as steel and concrete can reinterpret the historical shape of the arch to fit contemporary needs.

The Pointed Arch: Rheims Cathedral Scarcely any record of human accomplishment is more dramatic than the development of the Gothic cathedrals, of which Rheims Cathedral (Figs. 364–368) is a representative example. Like the Parthenon, it is the result of many factors—of climate and geography, of belief and spiritual aspirations, of knowledge of architectural construction. As we look at Rheims Cathedral, we are impressed chiefly with its ascending, aspiring, uplifting character, the product of people who were eager literally to reach heavenward with their lofty houses of worship.

The Gothic period was a deeply religious one; people were intensely interested in all matters related to salvation. Most of the people were illiterate, and in order that they might know more of the life of Christ and of other holy persons, biblical incidents and stories from the lives of the saints were depicted in richly carved stone and in colorful stained glass. The glass windows and stone images integral to the Gothic style were developed not as technical flourishes but as direct answers to deeply rooted human interests and needs.

Climate was still another factor affecting the construction and the appearance of Gothic cathedrals. The Greeks did not have to build against the rigors of bitter winter weather, and they took advantage of the mild climate by erecting buildings with open porticoes and colonnades. But farther north architects had to reckon with severe weather. Northern France has long periods of driving rain

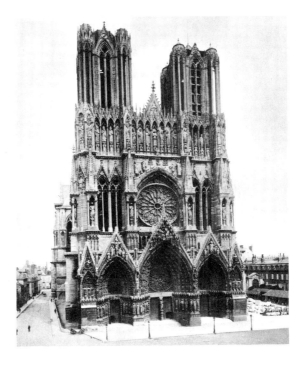

364. Rheims Cathedral, west front. 1211–90.

and cold, dark, sullen days. Chill, wet, and gloom had to be kept out of the buildings, not only physically but psychologically. Architects made windows richly colored so that the dull light from the outside was transformed into warm, glowing tones. The windows also expressed medieval notions about heavenly light, its appearance and transmission.

In Rheims the pointed arch was used (Fig. 365)—a form found in all cathedrals that can be considered Gothic. It possesses structural advantages in having less lateral thrust than a round arch and greater flexibility. Whereas the height of a round arch is determined by its width, the height of a pointed arch can be altered readily by changing the curve of the sides. Thus, the Gothic style, far from being characterized merely by details, is primarily a system of construction. Most of the characteristics of arch construction in the seasoned Gothic system can be seen in Rheims Cathedral.

Note in the picture of the interior (Fig. 366) that the **nave**, or central aisle, of the cathedral is defined by two corresponding series of piers that support the vaulting over the nave and the side aisles. By following two of the adjoining piers up into the vaulting, one can see that these, with the two corresponding ones across the nave, define a rectangular area, or *bay*, and that the outer edges of the bay in the vaulting are defined by pointed arches that connect the piers. In addition, arches are sprung across the bay, dividing it into four areas that are filled in with masonry. The **groin vaults** (at the intersection of the cross vaults) are marked with protruding masonry called *ribs*. All of these features can also be observed in the plan (Fig. 367).

The piers at each corner of the bay bear the weight of the masonry above them. As we know from our earlier discussion, arched vaulting exerts an outward thrust that must be countered if the building is to stand. The pointed arch has less lateral thrust than the round one, but its thrust outward is still considerable. Italian builders often "tied" arches together with iron rods to keep them from spreading. This solution was unacceptable to the French, who instead developed a more organic solution to this difficult problem. The lateral view of

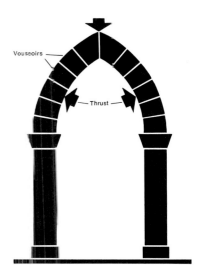

365. Pointed arch, Rheims Cathedral.

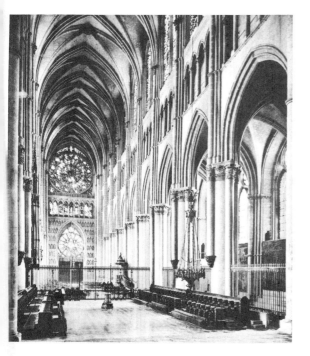

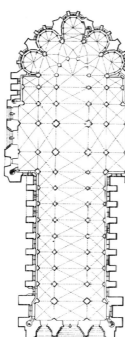

far left: **366.** Rheims Cathedral, interior view toward west. 1211–90.

left: **367.** Plan of Rheims Cathedral.

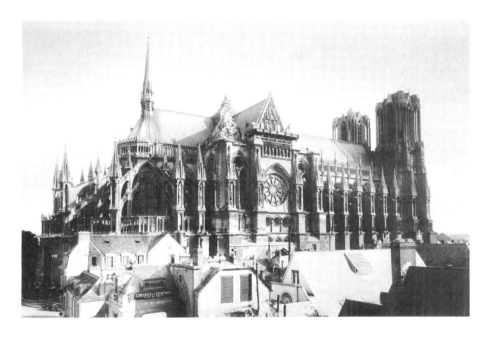

368. Rheims Cathedral, lateral view. 1211–90.

the cathedral in Figure 368 reveals how the thrusts from the vaulting in the interior are met by the construction or arches outside the building whose thrusts counterbalance those from within. These exterior arches are great soaring constructions that span the side aisles and become in their bases part of the outer wall of the cathedral. These are **flying buttresses**, for they "fly" over the side aisles to perform their structural function of providing support from the ground up to the top vaults. They create for Gothic structures a feeling of freedom, daring, and movement.

Gothic buildings are not inert. Rather, they are structures in which the forces and counterforces within the structure are given expressive form. The thrust-counterthrust that exists in nearly every part of a Gothic cathedral means that it is in a delicate and amazingly complex state of equilibrium. Theoretically, at least, the removal of one of the arches would mean the collapse of the whole building, because every part depends on every other part for support. Thus, the term *organic* is often used to describe the Gothic style.

In stone construction, Roman and Renaissance architects used the round arch and Gothic builders the pointed arch. Arch forms have also been developed in concrete, wood, and steel. An elementary principle is that forces, like water, tend to flow more easily around smooth bends than around sharp angles. Thus, the arch, minimizing the break between vertical and horizontal elements, represents an important structural development. This principle is further developed in modern structural skin construction methods.

Building in Concrete

Concrete, often regarded as a new material, was used regularly by the Romans more than two thousand years ago for large, imposing buildings.

Structures built from concrete differ significantly from stone buildings in that they are *monolithic* (the material is homogenous and continuous). Masonry constructions are built up of relatively small pieces of stone that, even in the finished structure, retain separate identities. The concrete structures of the Romans depended for structural strength on bulk and mass rather than on precise knowl-

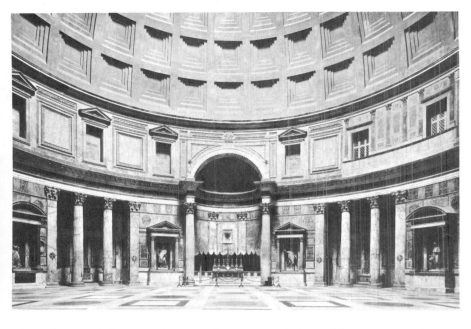

369. Interior of the Pantheon, Rome. A.D. 120–124.

edge of material. Concrete is a conglomerate made by uniting cement and water with sand, broken stone, slag, cinders, and similar materials. It withstands great compression but very little tension. Also, like stone, it does not rot or corrode and is fire resistant. Beginning in a liquid state, concrete assumes the contours and textures of any "form" into which it is poured. It can be given the massiveness of the Pantheon or the slender rectangularity of cage construction, the continuous ribbons of our highways and sidewalks, or the small building blocks in common use.

The Romans were the first to perfect the dome as well as the arch, and in the Pantheon (Figs. 369–371) they have left us one of the most remarkable concrete-based structures of all time. In form it is extremely simple, the interior

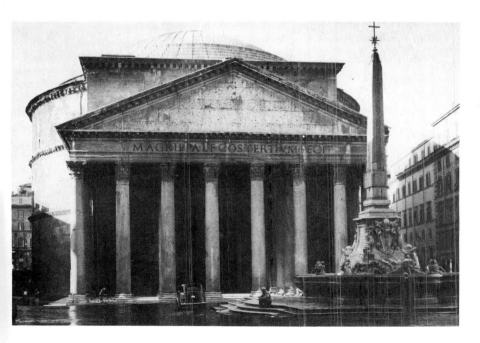

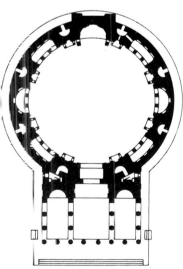

left: 370. Exterior of the Pantheon.

above: 371. Plan of the Pantheon.

being almost exactly as high as it is wide (140 by 142 feet, or 42.7 by 43.3 meters). The interior of the dome is a perfect half-sphere resting upon a circular wall. It has only one entrance, and the remainder of the circular wall in enlivened and adorned with seven large niches. The light comes from a single source, a great "eye", or *oculus* opening, 29 feet (8.8 meters) across, in the center of the dome. Built in A.D. 120–124, it was originally a temple to all the gods, but in 609 it was dedicated as a Christian church in memory of all the martyrs. The altars now in the Pantheon date from the Renaissance.

The base of the Pantheon's dome is a 20-foot-thick (6.1 meters) concrete wall. The dome itself, the thickness of which continually diminishes as it rises to the "eye," is of brickwork with heavy mortar joints. Embedded in it are arches that relieve and transmit the thrust of the giant structure. The exterior is sheathed in brick, the lower part of the interior in richly colored stone. The interior of the dome is decorated with coffers that provide decoration and lessen the weight.

The Pantheon's simple forms are monumental. The geometric character of the interior seems fundamental, the scale is impressive, and the progression of the coffers in the dome, with their diminution in size as they extend up into it, gives the interior a sense of vitality. The thickness and height of the supporting walls, however, almost conceal the dome on the exterior, where, quite unlike St. Peter's, it appears as a low, saucerlike form. The Pantheon, however, was a source for the domes that architects fashioned during the Renaissance, including that over St. Peter's.

The following two buildings represent recent constructions in concrete whose architects used the material in ways that are new and quite fundamentally different.

Notre-Dame-du-Haut, Ronchamp The Chapel of Notre-Dame-du-Haut at Ronchamp, France, designed by the Swiss architect Le Corbusier, exploits both the heavy and the fluid nature of concrete (Fig. 372). The massive exterior

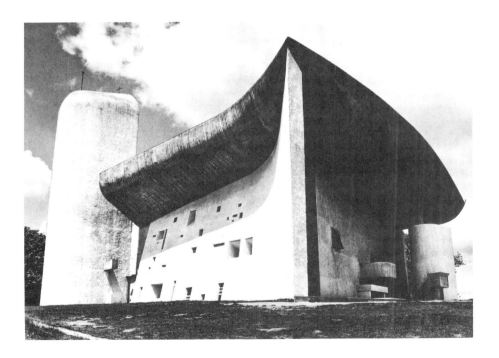

372. Le Corbusier. Notre-Dame-du-Haut, Ronchamp, France. 1950–55.

The Fine Arts

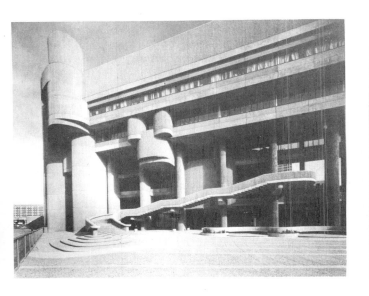

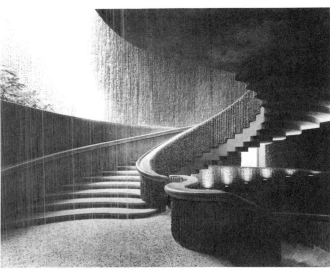

wall (composed partially of brick) is perforated by windows of varied sizes, asymmetrically but precisely organized. The tall towerlike form houses a small chapel above the roof. The structure is covered with a great roof form that swells and lifts as it leaves the supporting wall. Actually, the roof is built much like an airplane wing, which it strongly resembles. It has two thicknesses of poured concrete, and the space between is braced with struts. A uniformly rough surface has been given to all the walls by spraying them with a coarse stucco. In the interior the window openings are broadly splayed, and the deep geometric forms thus created provide different views of the stained glass set in the windows. It has been said that the Ronchamp chapel is more a piece of sculpture than architecture. Clearly, the nature and disposition of the forms produce a building that is structurally dynamic and spiritually moving.

Paul Rudolph's State Service Center in Boston (Fig. 373), like Le Corbusier's chapel, relies on a massive sculptural design program that makes appropriate use of its main building material. Because concrete is weak in tension, the distance it can span is limited. To give concrete the needed tensile strength, it has become a common practice to reinforce the material with metal beams and rods. *Prestressing* is one of the techniques used for reinforcing concrete. In this method metal rods, cables, wires, bars, and so on, which are under *tension*, are embedded in concrete and arranged in ways to cause the structural forces to flow in predetermined directions. If weight is placed on a beam between the uprights that support it, the lower part of the beam will be in tension. When the concrete is cured (set), the forces holding the bars in tension are removed, and the tension is distributed along one edge of the beam, causing it to deflect (bend) slightly. When such beams are placed on supports so that the edge containing the bars is on the top, with the deflection upward, they are capable of carrying greatly increased weights. Prestressing can be used in beams, cantilevers, flooring slabs, vaults, domes—in fact, in almost all structural forms. In particular, it makes possible forms of great length that are strong but relatively light.

Without the use of this metal reinforcing, such forceful elements as the flowing entrance stairway (which is suspended out from gigantic columns) would not be possible (Fig. 374). Rudolph has set baroque elements such as jutting medieval-type towers against impenetrable walls of concrete to create complex harmonies of light, shadow, texture, and space. Rough, vertical patterns in the

above left: **373.** Paul Rudolph. Boston State Service Center, Boston.

above: **374.** Paul Rudolph. Interior stairwell, Boston State Service Center, Boston.

cement—like corduroy—appear in the piers, contrasting with the smooth, horizontal lintels. Rudolph cast the outer surface with square-edged corrugated forms and employed stonemasons to hand-chip the molding to give it a less mechanically smooth surface. Besides visually enlivening the building, this textural element has a highly practical aspect. The use of steel reinforcing rods in the concrete usually leads to rust stains on the exterior surface. In this instance, the chipped and rough "organic" surface helps to minimize this occurrence.

In light of current economic restrictions the possibilities of concrete are now being explored with greater vigor than ever. Before the 20th century, architects generally ignored concrete as a building material; now they find it applicable to a wide range of buildings and budgets—large public structures, in particular. Working with engineers, contemporary designers have discovered new structural capabilities in concrete and have extended its versatility. After centuries of oblivion, concrete has become one of the great building materials of the modern era.

Building in Wood

The plentiful supply of wood in the United States has made it our most common building material; it accounts for over 80 percent of our structures. Most of us are familiar with the wood-frame house, in which a frame of studs and joists (a skeleton) is erected; the exterior (the skin) of wood, brick, or plaster is added; and the interior wall finish is applied. Called *balloon framing* or *light frame structure*, this is a type of *skeleton frame construction* developed in Chicago in the 1830s (Fig. 375). Its invention was a major factor in the rapid development of the land beyond the Alleghenies, for it permitted much more rapid construction than did the older heavy frame structure. Even before Sullivan's time, Chicago was a center of architectural innovation. In contrast to masonry structure, in which the wall is both load bearer and surface, balloon framing is closely related to steel construction in its separation of structure and surface. Wood is also suited to *cantilever construction*, as in the eaves projecting beyond the walls of buildings; to *trusses*, as found in wooden barns and contemporary structures; and to *structural skin construction*, similar to that in the molded plywood chairs by Charles Eames (see Fig. 178). One of the major uses of wood in large contemporary construction is as a material for forms into which concrete is poured such as Paul Rudolph's State Service Center (see Figs. 373 and 374).

During the last several decades of unprecedented technological development, synthetic materials and high-tech construction techniques have dominated the field of architecture. But recently we have learned a valuable lesson: The myth that scientific "progress" and technological discoveries would automatically lead to a utopian society has proven to be just that—a myth. Along with this realization has come a new, more sober attitude toward architectural forms, materials, and processes. New is not necessarily better.

Jerry Lunow, an architect with the firm of Charles Tapley Associates, was aware of these factors when he designed the wooden boathouse shown in Figure 376 for an employees' association near Rockport, Texas. With respect for the traditions and history of this site, Lunow's main concern was to provide the necessary recreational facilities without visually disturbing the picturesque surroundings. The extensive use of natural wood in this complex—it is constructed out of treated pine with cedar lap siding and cedar shingles—connects it thematically with the waterfront fishing sheds and inland barns that dot the region. In

375. Balloon frame.

The Fine Arts

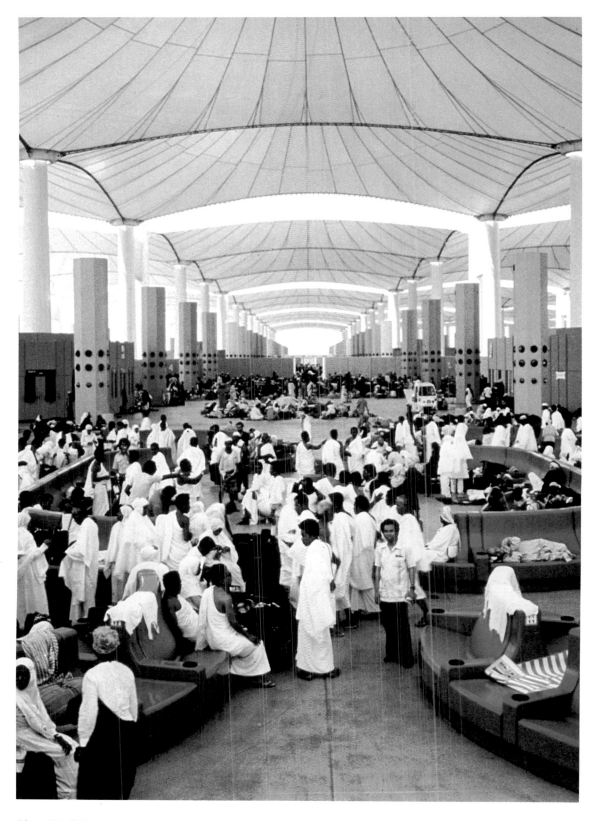

Plate 37. Skidmore, Owings & Merrill. Interior, Haj Terminal, King Abdulaziz International Airport, Jeddah, Saudi Arabia. 1981.

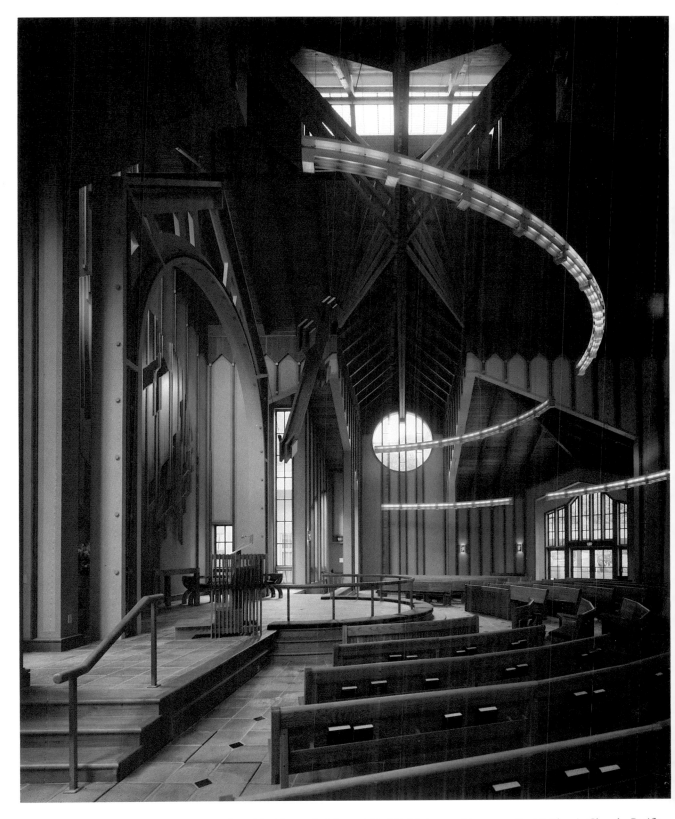

Plate 38. Moore, Ruble, and Yudell. Main worship room, St. Matthew's Church, Pacific Palisades, Calif. 1984.

376. Jerry Lunow. H. E. B. Live Oak Point Recreational Retreat, Rockport, Tex. 1982

many ways this building represents the new spirit and guiding direction of architecture: a willingness to rediscover meaning and enjoyment in building forms that celebrate our sense of *place* and geographical identity, and the use of materials that fulfill utilitarian needs yet provide us with a sense of security and psychological comfort. Certainly Jerry Lunow's Texas boathouse celebrates in a particularly relevant way the practical and aesthetic properties which have made wood a popular building choice for centuries.

Natural wood has great potential, but also limitations, as a building material. Technological developments have greatly extended its uses. Increasingly, laminated wood, especially plywood, is being used in construction, for it possesses remarkable and highly predictable strength. When bonded with synthetic resins it is made weatherproof. In contrast to metals, which require high heat for shaping, plywood can be shaped permanently at low temperatures. Fabrication is thereby greatly simplified. In relation to its weight, it is probably stronger than any known material. It can be a moldable "skin" material of considerable structural strength. Architecturally, molded plywood has not as yet found wide application—but it has the potential and holds promise for use in *structural skin construction*.

Plywood sheets are not the only new development in wood. Related to these are larger laminated structural members in wood, such as beams and trusses, of great size and strength. A *beam* is typically a large single piece of wood (or metal) much longer than it is wide or thick. It is used horizontally to bridge the gap between upright supports; thus, it is the same as a *lintel*. Beams of single pieces of wood are limited in length and known strength, but lamination makes possible beams and other structural members of increased size and efficiency. Like plywood, these structural members become precise building materials.

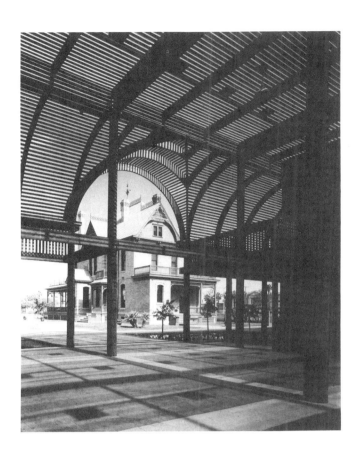

377. Robert R. Frankenberger. Lath Pavilion, Phoenix, Ariz. 1983.

A striking example of the use of laminated wood beams occurs in the Lath Pavilion (Fig. 377) in Phoenix, Arizona. Designed to provide shade from the summer sun, this open wood-lath building can accommodate as many as 1000 people for outdoor events such as fashion shows, dinners, and concerts. Another design concept behind its lattice structure is to provide views of the historic buildings that surround the downtown park in which it is located. The wood frame house in the background of Figure 377 reveals the extent to which the Lath Pavilion blends with its historic neighbors.

Building in Steel

Steel is perhaps the most quintessentially modern of all building materials. Without steel, it would be hard to imagine what the face of contemporary architecture would look like. The importance of steel in present-day life is all the more remarkable when we realize that its manufacture began just a few years before the Civil War. In the first half of the 19th century iron was used, although not widely, as a building material; but steel—finer and denser in structure and stronger in compression and tension than iron—was seized upon for widespread use as soon as it became available. Since then, it has been under constant study and development.

378. Steel-cage construction.

Steel-Cage Construction It is only logical that steel was first channeled into *steel-cage construction* (Fig. 378), which is found in most tall buildings. Like balloon framing, it also was developed in Chicago. The first multistory steel-frame covered with a nonstructural skin was built there in 1883, approximately

half a century after the invention of balloon framing. At first called "Chicago construction," steel-cage construction received most of its early attention in that city.

It is the great strength of steel that makes skyscrapers possible. When load-bearing walls are built of stone, the base must become thicker as the walls increase in height. One of the early Chicago skyscrapers, the sixteen-story Monadnock Building, completed in 1891, is of stone construction and has ground-floor walls 6 feet (1.83 meters) thick. If a stone structure thirty stories high were to be built, most of the space on the ground and lower floors would be taken up with walls and supports. With steel-cage construction, the supports take surprisingly little space, and even on the ground floor of very tall buildings they are not large. In addition, steel buildings resist the forces of wind and earthquakes with a resilience that stone structures do not have. Steel-cage construction, like the older post-and-lintel system, leads to architecture that is basically boxlike. However, as the United Nations Plaza (see Fig. 349) and other buildings indicate, it can be treated in a more modulated form. Nevertheless, large contemporary structures are assembled from many prefabricated parts that must relate to the repetitive grid of the steel cage. To make this unified, but essentially monotonous, framework into a satisfying work of art is the challenge presented to architects by modern technology.

Although many architects strive to overcome the structural limitations of the "steel cage," architects Renzo Piano and Richard Rogers have gone in the opposite direction with their Pompidou Center in Paris (Figs. 379, 380). It appears to be one giant, cagelike steel structure, as if it were a large organic machine. The Pompidou Center houses many artistic areas such as an art museum, a

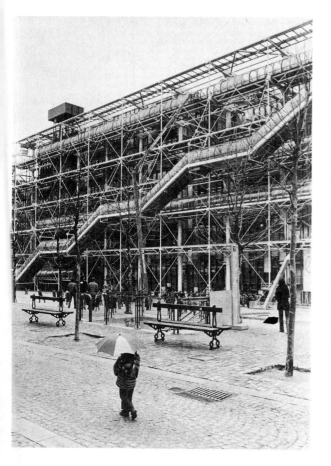

379, 380. Renzo Piano and Richard Rogers. Georges Pompidou National Center for Art and Culture, Paris. 1977.

movie theater, a library, and an industrial design center; on a busy day it attracts as many as twenty-five thousand people, many of whom come as much to experience the building as to view the displays it houses. This avowedly modern building—some contend it is the first art center disguised to look like an oil refinery—depends wholly on steel for its structural support. Large steel trusses specially fabricated in Germany by the Krupp Company are used to form thirteen bays, which make up the macrostructure of the building. These trusses are so long—they measure 156 feet (47.5 meters) in length—that they had to be moved to the site by truck during the early morning hours so as not to disturb traffic flow. Along the outer perimeter of the building, cantilevered escalators—looking like angular worms—zig-zag up the side of the structure, allowing many exciting views of Paris. Compositionally, this diagonal upward movement gives visual interest to the steel-cage grid structure and accents the extensive tubular cross-bracing.

Controversy has surrounded the building design from its inception; some hate it, some love it, but nobody ignores it. Whatever one's impression of the building, it provides a rallying point for visual arts activity in Paris. During the weekends a veritable carnival atmosphere prevails for blocks around its border. Jugglers, street musicians, fire eaters, and sellers of a variety of crafts items are attracted by the large crowds that throng around the building and contribute, in turn, to the large turnout.

The underlying aesthetic of the center, in fact, was the creation of an environment that was culturally unimposing and therefore conducive to the viewing of art by the widest range of individuals (not merely the traditional art authorities). From the start, this building was intended for the enjoyment of people from every walk of life. Judging by the crowds that congregate at this site daily, the Pompidou Center is a dramatic success.

Suspension Construction Even greater utilization of the tensile properties of steel is made in *suspension construction*, where *all* the material is in tension. The possibilities of suspension construction were demonstrated by John Roebling in the Brooklyn Bridge he designed and built during the years 1869 to 1883. Architects generally ignored this great achievement, and almost fifty years elapsed before tension construction was seriously developed. There are now a good many magnificent and exciting suspension bridges throughout the country, such as the Verrazano-Narrows Bridge in New York. This construction principle has often been applied to buildings spanning large public spaces.

Recently the architectural firm of Skidmore, Owings & Merrill designed and built an impressive airline terminal at Jeddah International Airport in Saudi Arabia. The structure consists of 210 semiconical fiberglass roof units suspended by means of steel cables attached to 75-foot-high (45 meters) steel piers, or pylons. In all there are ten large modules, totaling 21 translucent roof units (Fig. 381). Each unit is a self-contained airline terminal, containing a baggage claim area, waiting zones, ticketing areas, rest rooms, restaurants, shops, and information counters (Pl. 37, p. 369). Hundreds of thousands of people can be handled adequately by these facilities, but they will be used only once a year for a period of six weeks: This facility was built to accommodate the huge numbers of Moslems who fly to Jeddah to make their religious pilgrimage to the holy city of Mecca about 40 miles (64 kilometers) away.

Skidmore, Owings & Merrill's designers discovered on a fact-finding trip that most natives of the area preferred being under an umbrella in the open shade to sweltering in a hot, stuffy building. Since the cost of air-conditioning such a

large facility and lighting it would be prohibitively expensive, they devised this series of tentlike facilities. These factors led the design team to their particular solution. The thin, translucent but insulative fiberglass roofs allow enough light to enter to avoid the need for artificial lighting during the day and also effectively reduce heat transmission. Large mechanical fans, placed between the supportive columns, help circulate air and avoid heat build-up. Acoustical problems caused by thousands of congregating people are avoided by the great roof height and semiabsorbent nature of the fiberglass.

In all, the structures are extremely cost effective and utilitarian in operation; they also make use of the tent form, a structure indigenous to the Middle East. However, the most significant feature of the complex may be the floating, transcendental quality with which it welcomes and shelters throngs of faithful Moslems embarked on the most important spiritual journey of their lives.

Energy Conservation in Buildings

During the 1950s and 1960s concern over electrical and petrochemical energy supplies was almost nonexistent. Buildings were constructed with little real regard for heating, cooling, and lighting expense. Since the oil embargo and sharp energy cost increases of the 1970s, few buildings have been designed without giving great thought to these factors. Sometimes energy concerns today even dictate the way a building looks and how it functions.

381. Skidmore, Owings & Merrill. Haj Terminal, King Abdulaziz International Airport, Jeddah, Saudi Arabia. 1981.

382. Michael Jantzen and Ted Bakewell III. Autonomous dwelling unit, 1979. 14 × 32′ (4.27 × 9.75 m).

One of the most interesting experimental research structures built to explore low-energy living systems is the collaborative project of Ted Bakewell III and Michael Jantzen. Their autonomous dwelling unit (Fig. 382) was designed to be a transportable dwelling unit, entirely self-contained in terms of water supply, heating, and electricity. Measuring 14 feet (4.27 meters) in length and weighing 10,000 pounds (454 kilos), the structural form of the unit is based on interlocking prefabricated silo domes mounted on a mobile office chassis.

In order to maintain self-sufficiency in terms of electrical power, stringent limits were placed on energy consumption. Photovoltaic cells, in the shape of small round discs, are mounted on a ramp in front of the entrance. Since they can provide only a limited power supply through storage batteries, low-wattage bulbs developed for the space program are used. (Drawing only 20 watts, these special bulbs are as bright as conventional 100-watt devices.) Many functions performed electrically in conventional designs are accomplished here by means of human power and manual adjustment: Pressure to move water through taps is generated by hand pumping; some manual control of the active solar heating system is also necessary to save energy. Back-up heating systems during cloudy weather include a miniature water heater that ingeniously provides warm showers from the burning of unwanted junk mail and a small wood-burning potbelly stove placed in the center of the living room.

Designers Bakewell and Jantzen are quick to point out that this particular model is not a prototype dwelling for the average U.S. family; it was built to try out new ideas and concepts that might have useful future applications. No doubt as our energy conservation needs increase, many of these ideas might be adapted for the design of new houses and used in the renovation of existing dwellings.

CONTEMPORARY ARCHITECTURAL DESIGN

In 1960, just before Ludwig Miës van der Rohe's seventy-fifth birthday, an interviewer asked him to describe a typical working day. He answered: "I get up. I sit on the bed. I think, 'What the hell went wrong? We showed them what to do.'"

Miës was making a poignant observation. By the 1960s international style architecture—which was based on a formula of austere functionalist form—had run its course. Younger architects reacted to the constraints of early modernist dictates and began to include in their work all of the influences expunged by classic masters such as Miës van der Rohe: symbolism, regional building forms and materials, historical references, and—worst of all in the eyes of formalist architects—ornamentation. No wonder Miës was bewildered and disillusioned. Everything he fought—and supposedly vanquished—was coming back to haunt him. His was a world turned upside down.

Certainly this turn of events does not cast doubt upon the significant contribution Miës and the best of his illustrious colleagues made to modern architectural form. Aesthetic modes run in cycles of thesis-antithesis: Each generation redefines its artistic parameters, often doing an about-face and embracing the very values the previous generation rejected. Events occur that irrevocably alter our consciousness, change our thinking, and cause us to *see* things differently. Contemporary architecture has become more concerned with human scale and symbolic meaning and is moving away from the technological monumentality that characterized the international style. Some of the most exciting and relevant architects today believe that a building has to signify more than a sense of its function—it must inspire us as well. Indeed, it is the desire to broaden the ability of architecture to communicate to its audiences that is such a major issue today.

This last section will examine the unique design and planning process that allowed architectural clients and users the opportunity to participate in the rebuilding of their church.

Participatory Architecture: St. Matthew's Church

When a raging fire swept through Pacific Palisades—a beautiful wooded section of the Los Angeles Basin near Malibu—it consumed the wooden A-frame church of St. Matthew's Parish. The congregation was unanimous in the desire to rebuild. There was no consensus, however, as to what kind of building would be appropriate. Some members wanted a bigger church; others desired the intimacy of their old one. They even debated as to where it would be located on the beautiful 37-acre (15 hectares) site. Because of these differences of opinion the architectural search committee wrote into its rules the condition that major aspects of the new building design would need to be approved by two-thirds of the congregation. Charles Moore and his partners John Ruble and Buzz Yudell were selected partly because of their unique planning methodology: Essentially Moore allows his clients to have an unprecedented role in the planning of their building. Unlike many illustrious architects, Moore has learned to listen to and learn from his clients. He recently stated: "At this point in my career, I'm coming to a new appreciation of my role as architect with my clients. I'm learning to suppress my ego, to not get defensive when a client is not thrilled with one of my ideas. In school, in the jury atmosphere, we're taught to defend with tooth and nail our designs. Now I find I'm more interested in helping my clients give shape to their own visions." Of course, it is important to realize that only the basic scheme is decided upon by clients, the all-important *interpretation* of the concept is quite rightly left to the architects.

To start, four all-day Sunday workshops were arranged about one month apart; of 350 church members, an average of 150 to 200 people attended each session. The first meeting was devoted to what Moore wryly calls an "awareness

383. Charles Moore and clients with developmental model of St. Matthew's Church. c. 1983.

walk." Armed with notebooks, attending church members combed the grounds, making observations about the site and desired features of the church. Later that day parishioners were given—to their delight and amusement—a set of "sixth-grade" materials such as parsley, Fruit-Loops, and cellophane with which to make diagrammatic models of their future church.

A month later, Moore, Ruble, and Yudell returned with modular model parts: altars, pews, belltowers, and other elements that had been outlined by church members in their previous workshop (Fig. 383). Groups of fifteen to twenty parishioners gathered around seven folding tables and collectively worked on basic design for the church. Surprisingly, all seven groups came back with the same basic plan—a half-circle of pews around the altar. Everyone wanted to be as close to the altar as possible; yet the pews could not go more than halfway around, since the church members did not wish to be distracted by viewing other parishioners.

By the third meeting the architects asked the parishioners attending to develop further the concept of the plan they wanted. Significantly, five of the six groups working picked the same roof, a modified cross which symbolically and physically sheltered the main body of the church. In the final design Moore, Ruble, and Yudell put a Latin cross roof over a half-elliptical floor plan and added a chapel, baptistry, and outdoor event patio (Fig. 384).

Viewed from the outside (Fig. 385) St. Matthew's resembles traditional forms of architecture, yet avoids the feeling that it is copying any one style. Elements from many sources blend smoothly in this building. The nave enclosure is reminiscent, formwise, of weathered barns one finds just north of the church along the wind-swept coast. Yet the bell tower and other features give special ecclesiastical significance to the church. The interior, however, particu-

larly the main room of worship (Pl. 38, p. 370) is a spectacular blend of forms and spaces that could not be anything but the interior of a church.

Surprisingly, the biggest issue that divided parishioners had more to do with acoustics than visual design. Some church members were interested in providing good acoustics for their new custom-made organ; this necessitated hard walls mostly of plaster with little glass. Another faction, recalling with pleasure the old wooden church, wanted wood beams and large glass windows with a view. Moore, Ruble, and Yudell's response was to design a lively, decorative pattern of natural wood battens that extend from the plaster wall by about 24 inches (61 centimeters). From an oblique angle the wood predominates; the plaster walls were painted in soft colors that would blend and harmonize with the natural tones of the wood.

During the fourth workshop the architects presented a detailed plan to the congregation for the site and building design. After some discussion and debate, a vote was taken. It is no wonder that with the involvement of so many people in the design process the plan was accepted by 83 percent of the voting members, a good deal more than the 66 percent needed to pass.

Moore, Ruble, and Yudell's design for St. Matthew's Episcopal Church symbolizes a growing concern among today's innovative architects: to design buildings that embody a keen sense of place and fulfill human needs for symbolic *and* utilitarian functions. "The Modern Revolution," Moore said, "like any puritan revolution, has run its course. The attempt to remove history can't persist in time. Time finally catches up with you. With the wiping out of historical refer-

384. Moore, Ruble, and Yudell. Diagram of St. Matthew's Church. 1984.

385. Moore, Ruble, and Yudell. St. Matthew's Church, Pacific Palisades, Calif. 1984.

ences, we architects bored people. Architecture no longer meant much to people; they didn't see themselves in it."

Significantly, Moore's concern for social relevance and historical meaning in architecture is echoed in the recent work of a host of contemporary designers, painters, and sculptors. Much of their art expresses a strong desire to contribute to human understanding and increased social awareness. The struggle of modernist thought, waged at the beginning of this century, has been largely won. What we are witnessing in the work of Charles Moore and other artists who have gone beyond strictly formalist ideas is not the end of modernism but a new, optimistic beginning. In place of look-alike conformism, they offer invention; instead of basing work on one strict aesthetic model, these contemporary artists synthesize a variety of cultural influences and personal preferences to awaken our senses and stimulate our minds. Thus, what we have today are approaches that complement each other in their diversity and provide a plurality that is the mark of vigorous cultural health. One hopes that out of this vast panorama of recent aesthetic activity everyone can find works of art that take on special meaning and thereby enrich their personal lives.

Chapter **16**

Style, History, and Meaning

Herbert Read was an English critic and interpreter of modern art who brought to his discipline an intimate knowledge of recent art activity and a keen historical perspective of cultural traditions. Read was able to make connections between the stylistic development of modern art and the dramatic social changes of the 20th century. His approach to problems of artistic style and content stems from his belief that art is a *visual* means of communicating perceptions and concepts. Different styles of art, therefore, represent various *visual languages* that use specific combinations of visual elements, thematic content, and rules that structure their relationships. Artistic styles vary considerably from era to era and from civilization to civilization, because cultural perceptions and values do not remain constant. In *The Meaning of Art* Read succinctly commented on this important relationship between conceptual belief and visual perception when he wrote:

> The whole history of art is a history of modes of visual perception: of the various ways in which man has seen the world. The naive person might object that there is only one way of seeing the world—the way it is presented to his own immediate vision. But this is not true—we see what we learn to see, and vision becomes a habit, a convention, a partial selection of all there is to see, and a distorted summary of the rest. We see what we want to see, and what we want to see is determined not by the inevitable law of optics, or even (as may be the case in wild animals) by an instinct for survival, but by the desire to discover or construct a credible world. What we see must be made real. Art in that way becomes the construction of reality. ([London: Faber & Faber, 1969], p. 49)

This concluding chapter of the fine-arts section will examine a representative selection of major styles that have evolved throughout history. It will discuss how they reflect the social and ideological realities of their respective cultures. A more comprehensive chronological and historical approach to art is beyond the means and scope of this book. To aid the further study of art, a diagrammatic time line outlining the high points of art history is included in the back of the book.

PREHISTORY

Many works of art created during the prehistoric period have vanished—destroyed by breakage and deterioration. But some, because of their sheer size and the durability of materials, have survived.

Stonehenge (Fig. 386), a Neolithic site near Salisbury, England, was constructed between 1800 and 1400 B.C. out of stones laboriously transported from their source 134 miles (215 kilometers) away. The expenditure of human energy and ingenuity necessary to move these 13-foot-high (4 meters) monoliths such a great distance is remarkable. Stonehenge is believed to have been built as a setting for religious observances and rituals, but the exact nature of the activity that took place there will never be fully known. No doubt it played a central role in the spiritual life of its builders.

One distinguishing feature of prehistoric art was its preoccupation with concerns of life and death. Ritual and the creation of magical objects were vitally concerned with manipulation of the environment and therefore control of one's fate. Issues of "beauty" and "form" were secondary to the central concern for survival. Art served as a means of organizing life and reassuring people with its message that the world could be ordered and made manageable.

Recently, with the aid of computers, an astronomy professor was able to demonstrate that the placement of stones in the ring-shaped monument correspond to seasonal risings of the sun and moon. His evidence suggests that Stonehenge was used to chart the movements of celestial bodies. On the first day of the summer solstice, for example, the sun seems to rise directly over a certain "sunstone" when an individual stands in the exact center of the 97-foot-diameter (29.6 meters) circle. No doubt the ability to chart and predict celestial phenomena accurately was psychologically reassuring; perhaps this early observatory even played an important practical role in people's lives by helping them decide when to plant and harvest crops for optimum results.

Although contemporary scientific knowledge has far outpaced the astronomical capabilities of Stonehenge and we no longer rely on religious ritual to influence agricultural production, the need for magic and wonder in our lives per-

386. Stonehenge, Salisbury Plain, Wiltshire, England.
c. 1800–1400 B.C.
Height of stone 13′6″ (4.11 m).

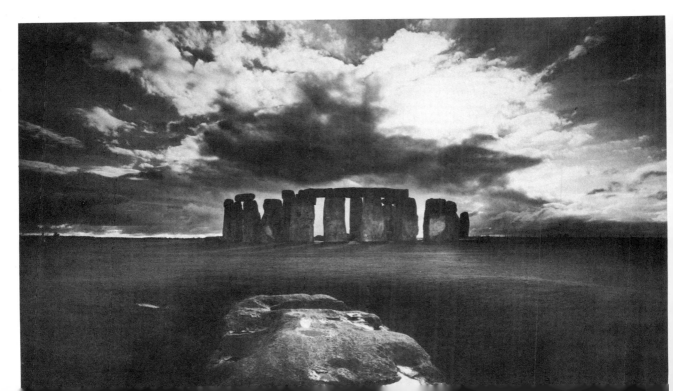

left: **387.** Alice Aycock. *Maze.* 1972. Wood construction; height 6′ (1.83 m). diameter 32′ (9.75 m).

below: **388.** Egyptian. *King Mycerinus and His Queen, Kha-merer-nebty II.* From Giza. Fourth dynasty, 2599–2571 B.C. Slate schist, height 4′6½″ (1.38 m). Museum of Fine Arts, Boston.

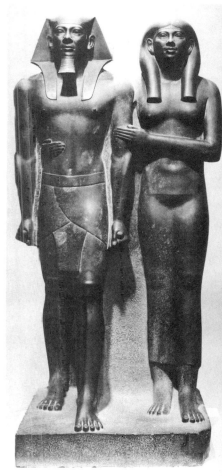

sists. Some contemporary artists are still exploring the concept of ordering a plot of land and endowing it with special meaning. In 1972, Alice Aycock built an environmental artwork, titled *Maze* (Fig. 387), which relates in many ways to Stonehenge. Inspired by aspects of 14th-century English mazes, American Indian stockades, and African Zulu *kraals*, Aycock created a 32-foot-diameter (9.75 meters) 6-foot-high (1.83 meters) wooden structure that one can enter and walk about in. Like Stonehenge, this work of art was designed to respond to human movement: One walks through it and *experiences* it rather than merely looking at it. Aycock intended *Maze* to represent symbolically "the path of life" complete with false starts, complex turns, and unclear goals—elements that appear in all our lives. Although thousands of years separate the construction of these two environmental structures they are similar in that they enable us to enter and experience special places.

EGYPT

About 5,000 years ago a civilization arose in the Nile Valley of Egypt that developed the ability to record speech. Writing enabled the ancient Egyptians to organize their society to a remarkable degree and marked the beginning of history: Achievements and conceptual beliefs could now be recorded and literally made *memorable*. Perhaps in response to this ability to accurately record past events the early rulers of Egypt, called pharaohs, were obsessed with their own history and set up dynasties that ruled in close succession for thousands of years. Continuity and endurance were concepts of primary importance to the pharaohs; much of their official art embodies these values and has physically endured to this day.

King Mycerinus and His Queen, Kha-merer-nebty II (Fig. 388) is a sculptural work that expresses the religious beliefs of the rulers by whom it was commissioned. Pharaohs—acknowledged to be gods themselves—were obsessed with

death. But rather than living in constant fear, they were reassured by their religion. If after death the *ka,* or spirit, was provided with a suitable body to dwell in (mummified remains or a portrait statue), they would enjoy a happy afterlife. The sculpture of King Mycerinus and his queen radiates a feeling of serenity and assurance. The massive, block-shaped figures, arms securely interlocking, seem to be patiently waiting for the arrival of the *ka.* Every stylistic aspect of this Egyptian sculpture expresses monumentality, order, and stability—features central to the beliefs of the people who commissioned this work of art.

Despite the Egyptian rulers' fixation on the shadowy world of death, they must have led a curiously carefree life secure in the knowledge that spirit vessels such as this sculpture stood ready to sustain them in the afterworld.

GREECE

The ancient Greek civilization did not occupy a clearly defined geographical area and was composed of many small city-states often at war with one another. However, the Hellenic world was conscious of its common heritage—all Greeks worshipped the same gods, spoke the same language, and practiced similar customs. Despite the fact that the Greeks owed much to the influential civilizations of Egypt and the Near East, their civilization embodied a significantly different psychological and aesthetic sensibility. Upon this early cultural bedrock was based the foundation of European civilization.

In spite of the fact that they were physically close and culturally influenced by the highly refined societies of Egypt and Persia, the Greeks believed they were different from, and even superior to, these foreign civilizations. Anyone whose native language was not Greek was referred to as a "barbarian" because of what the Greeks considered the unintelligible *bar-bar-bar* patterns of their guttural speech.

Early Archaic Greek statues—called **kouroi,** which means "youths"—clearly reveal both the cultural debt owed to Egyptian art and the budding originality of Hellenistic artistic concepts. The symmetrical, frontal rigidity of the sculpture in Figure 389 certainly harks back to Egyptian influences; yet the warm, mysterious smile and more naturalistic rendering of anatomical features point to the development of mature features of classical Greek art—more humanistic and less austere in spirit. Unlike the Egyptians, the Greeks never intended their sculpture to be "spirit vessels" for immortal spirits. The aesthetic function of these sculptures was the celebration of the human body in the bloom of youth.

Two centuries later the rigidity of archaic *kouroi* was replaced by a more relaxed interpretation of the body and a more anatomically naturalistic rendering (Fig. 390). In contrast to the Egyptians' preoccupation with death and the afterlife, the Greeks were vitally concerned with the perfection and enjoyment of their physical life in the present world. This attitude is expressed by the appearance of more pronounced realism in their sculpture and relaxed, less formal poses of the body. Although many Greek sculptures of the classical period portray gods, they are often interpreted as idealized versions of human beings. In fact, it is just this psychological tension between the divine pefection of human form and a humanistic naturalism that characterizes Greek art of this period.

The sculpture of the Greek god *Hermes and the Infant Dionysus,* believed created around 340 B.C. by the master sculptor Praxiteles, combines elements of idealized physical perfection with humanistic qualities absent in the awe-inspir-

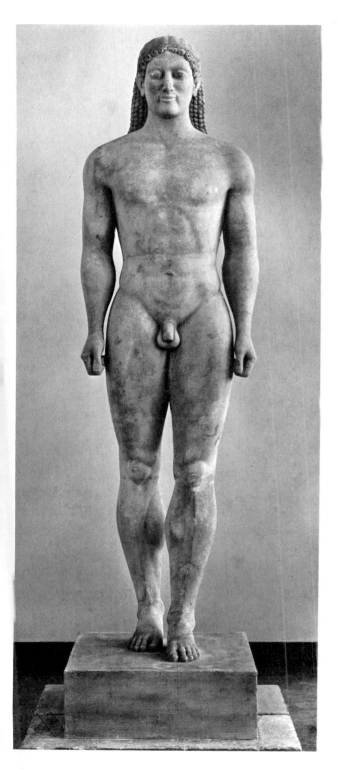

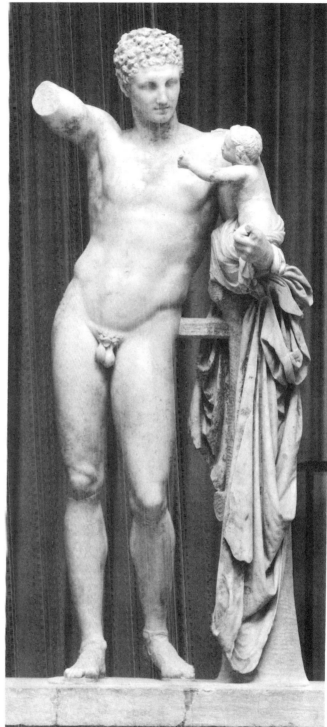

above: **389.** Anavysos, Greece. *Kouros.* c. 530 B.C. Marble, height 6′4″ (1.93 m). National Archaeological Museum, Athens.

above right: **390.** Praxiteles. *Hermes and the Infant Dionysus.* c. 340 B.C. Marble, height 7′1″ (2.16 m). Museum, Olympia.

ing formalism of Egyptian funereal art. For one thing, the body of Hermes is nude and celebrates the beauty and heroic nature of the unclothed form—something never seen in Egyptian art. Unlike the frontal pose and formal stylization of *King Mycerinus and His Queen,* Hermes casually leans against a support which enhances the sensuous curves of the torso as he looks down at the infant Dionysus on his arm. A faint, self-assured smile crosses the face of this human-like god. Emotional warmth is radiated by the silky surface of the marble body. In contrast to the fine finish of Hermes' body, the roughness of his hair and the sharply undercut textures of the drapery offer contrast to the ethereal nature of this god. Through the visual idealization of the human form and its humanistic expression, the Greeks viewed themselves as a vital link between heaven and earth.

ROME

By the end of the second century B.C. much of the art made in Greece was commissioned by Rome, the ascending political power of the Mediterranean. Since the Romans had the greatest respect for Greek art, it was natural for them at first to import it in great quantities and to instruct their artists to imitate it closely in visual style and thematic content. During the early stages of the Roman Empire much of their own work is indistinguishable from that of the Greeks. But, because the Romans were a more worldly and pragmatic people, eventually their art gained stylistic maturity and reflected their own cultural history and traits.

Roman custom dictated that at the death of a revered family figure a waxen cast be made of the face of the deceased. This image was carried in the funeral procession and kept in a family altar. Of course, the soft wax mold picked up every wrinkle and wart on the subject's face. No godlike images of perfection were derived from this process. To preserve the fragile wax image duplicate copies were commissioned to be made out of marble. In part this custom, along with the more worldly nature of this society, led to a heightened concern for realism in Roman portraiture.

The life-size portrait of Philippus the Arab (Fig. 391) is a splendid example of this realistic direction. Unlike the dreamlike, distant expression of Hermes—who looked down upon humanity from the heights of Olympus—Philippus' face reveals the face of a mortal man beset by the troubles of a crumbling world. By the third century after Christ, the overextended Roman Empire was in a state of revolution and turmoil. Successful generals periodically gathered their loyal forces and overthrew the ruling emperor. Philippus was just such an opportunist, but he reigned for only five troubled years. On the face of this sculptured portrait are mirrored fears, distrust, and suspicion. One of the most appealing characteristics of mature Roman portraiture is its psychological truthfulness. The face of Philippus could be the face of a contemporary man beset with modern problems—a failing business or a painful divorce.

THE MIDDLE AGES

The stage for the development of medieval art in Europe was set when tribes north of the Alps (called *barbarians* by the Romans) encountered the Greco-Roman art traditions of the Mediterranean region. Through the synthesis of this

391. Philippus the Arab (detail). A.D. 244–249. Marble, life size. Vatican Museum, Rome.

The Fine Arts

392. Limbourg Brothers. *February* from *Les Très Riches Heures du Duc de Berry*. 1416. Manuscript illumination, 8⅞ × 5⅜″ (23 × 14 cm). Musée Condé, Chantilly.

meeting, the center of European art activity shifted northward toward what had been the outer reaches of the Roman Empire.

During this medieval period art gradually evolved from symbolic visual statements of religious faith to highly refined paintings dependent on keen observation of nature and knowledge of painting skills. Around 1400 the merging of Northern and Italian traditions produced a movement called the **international style.**

Although panel painting was growing in popularity during this international period, book **illumination** in Northern Europe was still the leading form. Few manuscript painters could match the virtuosity of the Limbourg brothers of France. *The Very Rich Book of Hours (Les Très Riches Heures)* was produced for the Duke of Berry, the brother of the king of France and a lavish art patron of his day. The most remarkable pages of this manuscript are those of the calendar section chronicling the changing face of nature. *February* (Fig. 392) depicts the frozen stillness that envelopes Northern Europe during the winter. Rather than presenting us with a postcard view of a winter scene, the artists have created a kaleidoscope vision of the interaction between nature and people. A cutaway view of a snug interior showing people comfortably gathered around a roaring fire is strikingly contrasted with lone figures plodding across the snow-covered

ground; a woman hurries to join her friends in the cottage, blowing on her frozen hands to warm them. Symbolically placed above the naturalistic scene is a semicircular calendar with signs of the zodiac for February. This painting combines early medieval symbolism with an increasing interest in perceptual realism and accurate detail. Truly effective single-point perspective—the illusion that you are viewing a scene through a window—was to be perfected during the Renaissance.

THE ITALIAN RENAISSANCE

The word *renaissance* means "rebirth," and during the early 15th century in Italy artists were conscious of the glories once associated with Rome and the classical period. Blaming their downfall on the northern tribes, the Goths and Vandals which invaded the Roman Empire, these Italian artists set about to revive the classical past and bring about a new era of learning and achievement. In fact the medieval period, or Middle Ages, gets its name because it was an era believed to exist between the classical age and the rebirth of classicism.

Although many famous Italian artists made contributions to Renaissance history—Donatello, Raphael, and Botticelli to name a few—Leonardo da Vinci stands out as one of the major artistic figures of the period. Not only did he excel in painting and drawing but he was also an accomplished engineer, scientist, musician, and naturalist. As such, he symbolizes the revival of learning associated with the Renaissance. Leonardo believed that the artist's business was to explore all aspects of the visual world; and he did so with relentless energy.

In Leonardo's famous mural *The Last Supper* (Fig. 393) many accomplishments of High Renaissance art are clearly articulated. Unlike earlier artists, who thought in terms of individual outlines and flattened shapes, Leonardo presents us with a unified pictorial vision achieved through the careful modulation of

393. Leonardo da Vinci. *The Last Supper.* c. 1494. Oil and tempera on plaster, 14′5″ × 28′¼″ (4.39 × 8.54 m). Santa Maria delle Grazie, Milan.

The Fine Arts

light and dark shapes that was called *chiaroscuro*. Forms no longer stand isolated but appear linked through the consistent interaction of light.

The laws of single-point perspective are also masterfully expressed in this painting. In the Limbourg Brothers' illumination we are presented with multiple perspectives, aerial and ground level—even the symbolic inclusion of the diagrammatic circular calendar. But Leonardo's *Last Supper* illusionistically appears to be like a window through which we view a scene from the single perspective of where we are standing at the moment. The vanishing point in this example of liner perspective is directly behind Christ's head and draws our attention to this important figure. Also the center window forms a halo around Christ setting him off from the other figures. Leonardo used the newly perfected illusionistic devices of the Renaissance to support the thematic program of this painting. The apostles gathered around Christ fit comfortably within the architectural perspective system and further reinforce the way our eye is forcefully directed to the central figure. Every visual aspect of the painting provides a perfect setting for the drama of the religious event taking place: Christ has just told the disciples, "One of you shall betray me," and they were asking, "Is it I, Lord?"

Unhappily, the deteriorated condition of *The Last Supper* makes it difficult for us to see all its details with much clarity. During its painting Leonardo experimented with an oil-tempera medium that adhered poorly to the wall. Despite its present condition, however, it still reveals some of the most important aspects of High Renaissance art.

Another Italian Renaissance artist whose name is synonymous with this golden era is Michelangelo. Unlike Leonardo, who viewed painting as the highest form of art, Michelangelo was primarily a sculptor. Because he believed that the human image was the noblest means of expression in art, most of his sculpture was figurative.

Perhaps nowhere do we find the embodiment of creative genius in art more clearly expressed than in the tempestuous personality of Michelangelo. He was moody, proud, difficult to work with, and at times unsociable to the point of rudeness. Normal social conventions and traditions were something other people observed—Michelangelo, guided by an inner vision, was obsessed with the achievement of perfection in his art. In part, Michelangelo's independent and proud nature can be explained by the fact that he was born to an impoverished Florentine family that claimed descent from royalty. Lacking the economic means of the aristocracy, but nevertheless believing himself to be of noble birth, Michelangelo held himself aloof from other artists and became a fiercely individualistic figure. "I was never a painter or sculptor like those who set up shop," he explained to his nephew in 1548. In this sense he unwittingly anticipated the movement art was to take toward the cult of individual expression and increasing independence from a patron.

No sculptural work better reveals Michelangelo's unique artistic qualities more than *David* (Fig. 394). Commissioned when Michelangelo was only 26 years old, this larger than life-size statue of David took three years to complete. It originally was meant to be mounted high over head on the city cathedral, but town officals felt that it symbolically and spiritually represented the Florentine republic so well that it was placed outside the main entrance of the Palazzo Vecchio. (In modern times it was replaced by a copy.)

Just prior to beginning *David* the artist had spent several years in Rome studying classical art. However, although Michelangelo was greatly inspired by classical art, the artistic effect of *David* is in many ways unclassical. A remarkable

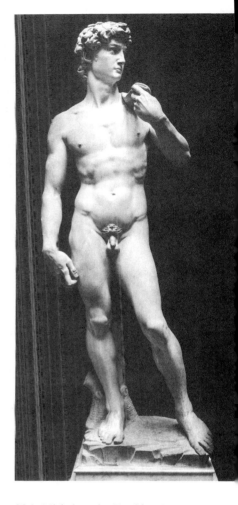

394. Michelangelo. *David*. 1501–04. Marble, height 18′ (5.49 m). Academy, Florence.

dualism energizes this beautiful sculpture and sets it apart from early Greek sculpture: *David* is at once placid and tense. The oversize hands with their protruding veins and the swelling muscles marvelously contradict the elegance of proportion and the finely chiseled details of the body. However, the defiant facial expression and the shifting stance of the limbs (known as **contrapposto**) endow this figure with feelings never expressed in classical art. Michelangelo's art begins to reveal the inner turmoil and struggle humanity faced when it renounced the security of unquestioning religious faith and exalted its own godlike qualities and expressive power.

THE RENAISSANCE IN THE NORTH

Until about 1500, artists in Northern Europe were only moderately interested in the developments of Italian artists. They were much more likely to turn toward Flemish masters than to their southern counterparts. But suddenly at the start of this new century, Italian stylistic influences began to play an important role in the evolution of art north of the Alps.

Two concerns central to 16th-century Northern European painting were to incorporate Italian art styles and to develop secular thematic subjects that would eventually replace traditional religious images. Both attributes can be seen in Pieter Bruegel the Elder's *Hunters in the Snow* (Pl. 39, p. 403). Bruegel was a Netherlandish painter of remarkable ability who chronicled, through his art, the life of village peasants and the landscape of the North country. Unlike many of his contemporaries Bruegel did not dryly imitate the Italian style of painting; rather, he translated many of its pictorial innovations into a uniquely personal style. During a trip to Italy in 1552 Bruegel was impressed by Venetian painting, which smoothly integrated figures within the landscape in an original way; he also took note of the way in which illusions of great depth were created by juxtaposing sharp, well-defined foreground figures with soft, hazy vistas in the background. Both qualities can be seen in *Hunters in the Snow*. This particular painting is part of a series depicting the months and seasons of the year. In terms of theme it is a direct descendant of the previously discussed February page of *The Very Rich Book of Hours* (see Fig. 392). Unlike the earlier illumination, however, Bruegel's painting describes a more natural illusionistic space in which his players act out their assigned roles. The psychological and pictorial elements of this scene are compelling. Bruegel positions the viewer's perspective above the heads of the returning hunting party, thus dramatically contrasting their dark silhouettes against the white snow. This vantage point (the viewer's perspective) also gives us the feeling that we are suspended in air, like the bird in the painting caught in mid-glide. Despite the boldness of the composition, the painting chronicles a wealth of captivating detail: the costumes of the tired hunters; the village architecture; birds perched on naked trees; the geography of the terrain; even the sign advertising the inn to the far right is broken and hanging by one hinge.

Bruegel has captured the feeling of subdued light and color one experiences during the winter months in Northern Europe. In terms of chromatic range this painting bears little resemblance to the bright, hot scenes of Italy. The gray-green overcast sky is echoed by the frozen ponds. Accenting the overall scheme of white snow, blue-green sky and ponds are the subdued earth reds of the buildings and architectural details. The most intense yellow-orange colors are

reserved for the blazing fire to the far left, which is tended by several well-bundled figures.

More and more, as the new learning and humanist sensibility from the south spread north, artists adapted its visual inventions to their own particular visions.

THE BAROQUE STYLE

By about 1600 the Renaissance dream of harmony and classical unity had been shattered by Martin Luther's religious reform movement, which had divided Europe into Reformation and Counter-Reformation camps. The Catholic Church decided that the best defense was a well-planned offense; expressing a renewed spirit of confidence in its history and teachings, the Church commissioned a host of lavish, expressive works of art designed to reinforce the principles of the Counter-Reformation. A new style of art developed in response to these new demands; it has since been labeled *baroque*. In contrast to the calm balance and order Renaissance artists sought, baroque artists were attracted to flamboyant expressions of form and feeling. Often their paintings portrayed intense spiritual experiences. Peter Paul Rubens' painting *Descent from the Cross* (Pl. 40, p. 404) is an example of the heightened psychological expressiveness found in this style of art.

Rubens' life, like his paintings, was characterized by exuberant energy. Along with his prolific output of art, he pursued a career in diplomacy and maintained his academic study. It is believed that he spoke and wrote fluently in six languages and was well versed in the ancient Greek and Roman classics. *Descent from the Cross* seems to visually embody the intensity of his active life style—new thresholds of technical virtuosity and heightened emotional states are achieved in this work of art.

The body of the dead Christ sinking into a white shroud rivets our attention and involves us in this important religious event. Rubens achieves masterful control of light and color in this painting to create compelling dramatic effects. The figure in red receiving the body of Christ radiates intensity. The lighted shroud and Christ's pale body illuminate the surrounding figures, uniting the group in an emotional relationship. Every part of the painting is filled with movement. Each of the eight figures is carefully positioned to create one smooth diagonal motion; the knotted, twisting folds of the cloth add to and reinforce this visual flow. *Descent from the Cross* aptly illustrates the desire of baroque artists to express intense emotional states of mind through active, writhing forms and powerful use of light and color.

TOWARD THE EAST

Before we continue with the evolution of art forms in the West we must briefly turn eastward to view important developments outside Europe. Two great religions play a dominant role in the history of Eastern civilizations: Islam and Buddhism.

During the seventh and eighth centuries after Christ the armies of the followers of the prophet Mohammed swept through Persia, Mesopotamia, Egypt, North Africa, and Spain. Artists of these conquered areas were required to submit to the demands of their Arab patrons, who banned the making of all

395. Mahmud Muzahib or follower. *Bahram Gur in the Turquoise Palace on Wednesday,* page from the Khamsa of Nizami. 16th century. Manuscript illumination, 12¾ × 8¾″ (32 × 22 cm). Metropolitan Museum of Art, New York (gift of Alexander Smith Cochran, 1913).

images. Early disciples of Mohammed rejected painted and sculpted images, which they believed distracted people from the true spiritual path of life. The word of God as stated in the Koran was the reality they believed in, not illusionistic worldly images.

Consequently, artists and craftspeople turned to abstract, decorative patterning as a clever way out of the image ban. Beautiful forms of calligraphic script were developed to a degree rarely seen outside the Orient. But from the 14th century on, particularly in Persia, the ban on images was relaxed, and secular scenes became popular.

The Persian miniature painting in Figure 395 reveals how much Islamic art forms were affected by the early emphasis on patterning and calligraphy. Rather than attempting to depict people and objects in an illusionistic three-dimensional space, Persian artists envisioned the surface of the painting as an opportunity to organize colors and shapes into complex, delicate visual textures. Flowing Arabic text is inserted in the pictorial space but blends in easily to achieve an effect of overall unity and abstract pattern.

The influence of Buddhism on the art of China in the Far East was as strong as Islam's impact on the Middle East. The Chinese did not view the artist as a

menial maker of goods; instead they placed the accomplished painter on the same level as an inspired poet. Buddhism values the inner spiritual awakening that could be achieved through intense meditation on one idea—sometimes for hours on end. In many ways this trait runs counter to the quick pace of life found in the West. Objects in nature often provided the focus for such meditation. Mountains shrouded in mists, trees set in a field, and swirling currents of water were popular meditative scenes found in Chinese art. Li Sung's ink painting on silk *The Red Cliff* (Fig. 396) is an example of the Buddhist meditative style. This work depicts the 11th-century poet Su Shih and two friends boating down the Yangtze River in the moonlight past a towering red cliff. This work is visually both quiet and active. The soft, muted tones of the cliff and rocks contrast with the subtle but hypnotic water patterns. It is easy to imagine how this painting could be used as a means of inducing meditative thought: the longer and more carefully we examine it the more we feel drawn into a world where nature and humanity coexist in balanced harmony.

Lu Xinzhong was a mid-13th-century Chinese artist of remarkable talents who specialized in Buddhist subjects. Many of his works are preserved today in Japan; as fervent Buddhists, the Japanese openly traded with southern China and bought religious paintings for their shrines.

396. Li Sung. *The Red Cliff.* 1190–after 1225. Ink on silk, 10⅛ × 9⅝" (26 × 25 cm). Nelson-Atkins Museum of Art, Kansas City, Mo. (Nelson Fund).

An Arhat Contemplating a Lotus Pond (Fig. 397), a painting attributed to Lu Xinzhong, clearly illustrates the Buddhist belief that nothing is more important for spiritual enlightenment than meditation. The arhat, or holy man, is revealed in this scroll painting to be so absorbed in contemplating a lotus flower, a Buddhist symbol of purity, that he fails to notice the approach of the servant bearing food. Unlike many religious paintings of the West, which illustrated the legends and personalities of Christianity, Chinese art focused on the *process* of Buddhism, which was in essence meditative. This painting itself, outside of its subject matter, inspires quiet, careful viewing. The willow tree, with its graceful, sinuous curve and delicate hanging leaves, grows upward from the base of the pond. The horizontal rhythms of the bridge that spans the lotus pond balance this vertical movement. Open spaces and the lively but controlled curves of the arhat's robe combine to make this painting at once both pleasantly active and quietly meditative.

In many ways Japanese art followed the development of Buddhist art from China. But, although the influence of Buddhism persisted for a long time in Japan, its power to inspire artists gradually diminished after the 13th century. Thereafter, the history of art in this island nation was to be essentially secular.

397. Attributed to Lu Xinzhong. *An Arhat Contemplating a Lotus Pond.* 12th century. Silk panel painting, 31½ × 16⅜″ (80 × 42 cm). Museum of Fine Arts. Boston (Bigelow Collection).

398. Toshusai Sharaku. *Close-Up Portraits of the Actors Segawa Tomisaburo II and Nakamura Mansei.* Polychrome woodblock print, 14¼ × 9″ (36 × 23 cm). Art Institute of Chicago (Clarence Buckingham Collection).

Japanese prints of the late 1700s express a great interest in popular themes drawn from everyday life. In many ways they anticipate the imagery found in popular magazines of today such as beautiful women, erotic scenes, flowers, and popular theater actors. These prints were called *ukiyo-e* and reflected the taste of common citizen rather than upper-class Japanese. The word *ukiyo-e* refers to a "painting of the floating world"; in other words, the fashionable events of the social scene.

The technique of woodblock printing made these images widely available. This process was introduced from China in the 8th century and later was used for the illustration of printed Buddhist texts. Originally prints were made with black ink on white paper, but by the mid-18th century a process of multicolored printing was refined that widened the appeal of these prints.

Close-Up Portraits of the Actors Segawa Tomisaburo II and Nakamura Mansei (Fig. 398) is a polychromed woodblock print by Toshusai Sharaku, an artist specializing in depicting actors who performed in *kabuki* theater. The figures are portrayed in a bold, highly stylized manner with delicate visual details such as the graceful curved lines describing the actors' hair and the subtle floral print in the center. These images are richly expressed caricatures revealing the development of a popular and accessible form of art unlike the visually restrained aristocratic paintings of the past. Despite the broad appeal of these prints and their sometimes trivial subject matter, they have a dynamic beauty that injects a modern vigor to traditional Eastern styles.

PRIMITIVE AND MODERN

On the surface perhaps no style of art is as misunderstood as what we usually refer to as *primitive*. This term came into common use due to 19th-century explorations by Darwin-inspired evolutionists. Believing that the tribal societies they encountered in Africa and the Pacific Ocean were frozen in an early cultural phase, through which the great civilizations of the world had already progressed, they judged them to be primitive. Today, enlightened scholars realize that the native cultures of Africa, the Pacific Ocean, and North and South America are neither at an early stage of development nor in a late, stagnant phase. Instead they have achieved stability and maturity within the context of their own beliefs and institutions, not ours. For the most part these non-European societies have pursued a course of development based on social tradition and continuity rather than a disposition toward "progress" and technological change. Although many non-Western societies lack written language and organized scientific research, it would be a mistake to view them as simple or unsophisticated. The complex psychological, ethical, and spiritual dimensions of these cultures might by comparison make our own society appear shallow and one dimensional.

Perhaps because of primitive cultures' lack of advanced technology and their emphasis on tradition, their art holds a special fascination for Western audiences—at times, no doubt, weary of electronic gadgetry and the rapidity of change. Since the discovery of primitive art by vanguard artists of the modern movement the popularity of this work has grown considerably.

Another misconception about primitive art is the notion that tribal artists lack refined technical and perceptual skills; it is often thought that the seemingly crude finish and rough-hewn nature we generally associate with such work represents their "best effort." Although many effective styles of primitive art certainly do make striking use of rough forms and natural materials, some works exhibit sophisticated fabrication techniques and carefully detailed shapes. The cast-bronze head of Olokun (a divine king) from Nigeria in Figure 399 reveals the aesthetic range and technical virtuosity that can be found in primitive work.

The Nimba dance headdress illustrated in Figure 400 exhibits characteristics we associate more closely with tribal art. Its stylized, exaggerated forms and roughly finished surface strikes a familiar chord in most of us. It was this type of work that impressed the early modernists with its raw visual power and emotional intensity.

Much primitive art was created for a specific purpose and fulfills a utilitarian cultural need within the society. The Nimba dance headdress, made by the Baga people living along the west coast of Africa, is no exception. It was used for the protection of pregnant women. Members of a secret society, known as the *Simo*, wore this mask during ceremonies while the women of the tribe danced around them.

Every visual element of this piece holds some cultural significance for the Baga tribe. The prominent ridge on the skull relates to hairstyle; the sagging, milk-laden breasts signify pregnancy; the large protruding nose becomes a fertility symbol; and the swelling form of the entire headpiece alludes to ripeness and abundance.

When not being worn during the special ceremony, the Nimba is enclosed in a ceremonial hut built at the crossroads of the village, where it is believed to ward off evil spirits and protect the community. In essence this object was not created as a work of art—at least not as we might generally define the word

399. Ife, Nigeria. Head of Olokun. c. 12th–14th centuries. Bronze, height 13½″ (34 cm). National Museum, Lagos.

400. Nimba, Guinea.
Dance headdress. 19th century.
Wood, height 46½" (118 cm).
Metropolitan Museum of Art,
New York (Michael C Rockefeller
Memorial Collection; bequest of
Nelson A. Rockefeller, 1979).

today—but as a means of rallying and focusing the psychological power of *belief* and religious faith to be used for the benefit of all the tribal people.

At the beginning of the 20th century certain artists, Pablo Picasso in particular, were drawn to primitive artwork such as the Nimba ceremonial mask and used them to help redefine the nature of Western art making in the modern era. William Rubin, a curator at the Museum of Modern Art, recalls a conversation about primitive art with Picasso shortly before his death:

> What Picasso told me was exactly the opposite of what I expected. The received wisdom was that he was interested in primitive art because of its abstract nature, as a kind of proto-Cubism. What he made clear to me, though, was that he was even more interested in its magical force, its sense of the irrational, which he found very strong. He believed that Western art had gotten too far from what might be called the magical roots of image-making. (John Russell, *New York Times*, September 28. 1984)

In 1907, after visiting the ethnological museum in Paris, now called the Musée de l' Homme, Picasso had a "revelation" about primitive art that was to have a profound influence on his own work and the ideas of the early modernists. In this museum devoted to tribal art Picasso perceived a world of visual and emotional experiences quite different from European traditions. Picasso's *Bust of*

401. Pablo Picasso. *Bust of a Woman (Marie-Thérèse Walther).* 1931. Cast bronze, life size. Musée Picasso, Paris.

a Woman (Fig. 401) clearly reveals the direct influence works of primitive art such as the Nimba headdress had on Picasso's art (a piece strikingly similar to this one was in his personal collection). Although Picasso was already moving away from traditional Western artistic concerns, studying works of tribal art such as the Nimba mask helped define his position. Viewing these two sculptures side by side makes us aware of the common human denominators that influence all works of art.

THE ROMANTIC ERA

During the late 1700s the American and French revolutions signaled a fundamental change in the concept of social rights and political institutions for the Western world. Scientific knowledge expanded rapidly and resulted in the invention of steam power, which led to rapid industrialization. "Man is born free but everywhere is in chains," observed the French social philosopher of the era, Jean-Jacques Rousseau. Together these social and technological developments brought about new sensibilities in art—the yearning for individual freedom and the craving for heightened emotional experience. No doubt these concerns were stimulated by the perceived erosion of individuality in an industrialized world,

and the realization that the utopian dream of liberty, equality, and fraternity failed to materialize in the aftermath of the French Revolution.

Théodore Géricault's painting *The Raft of the Medusa* (Fig. 402) reveals the love of heroic drama and exotic themes which characterize much of the art of this era. The *Medusa* was a French government ship that sank off the West African coast—only a handful of the hundreds of men on board were rescued. To Géricault, the event symbolized the floundering of democratic ideals taking place in his day: At that time, the monarchy was restored in France after Napoleon, much to the dismay of liberal thinkers such as Géricault.

The artist's search for accurate detail to heighten the emotional impact of this scene was exhaustive. Géricault viewed corpses in the Paris morgue, interviewed survivors, and even built a scale model of the raft. All of the many accurate visual details of this canvas contribute to the remarkable sense of human drama expressed by the painting. The people pictured are not an anonymous group but *individuals* whose collective suffering is raised to a fever pitch. As we move upward from the dead and dying figures in the foreground the composition reaches a climax with the uppermost figure frantically waving to the approaching rescue ship.

During the **romantic** era artists such as Géricault made use of Renaissance techniques of visual illusion to reflect the emerging social realities of the modern world: political events; the problem of individuality in an increasingly collectivized world; and the continued appreciation of nature's immense power even in the face of technological advancement.

402. Théodore Géricault. *The Raft of the Medusa.* 1818. Oil on canvas, 16′ × 23′6″ (4.91 × 16 m). Louvre, Paris.

BEGINNINGS OF MODERN ART

Although it is impossible to point with certainty to any one person as the first modern artist, Edouard Manet is generally thought of as one of the earliest individuals to clearly express the emerging attitudes of the modern era. Two aspects distinguished his art from much of the work being done in the mid-1800s. In his paintings, Manet played down post-Renaissance illusionistic devices such as the accurate modeling of light and dark and the use of perspective and foreshortening; he rejected as themes the motifs and subject matter of the romantic age.

Manet's deviations from historical precedent represent the first glimmerings of a revolutionary modern manifesto for artistic freedom. Instead of striving for illusionistic control of the outside world artists could now explore the quest for a new *inner* reality—the world of personal vision and individual aesthetic choice.

Le Déjeuner sur l'Herbe (*Luncheon on the Grass*) (Fig. 403) reveals Manet's effort to redirect artistic sensibilities. Instead of rejecting historical precedent completely, however, *Luncheon on the Grass* manages to combine elements of traditional art with new visual perceptions. In terms of general composition and subject matter the painting draws considerably from European art history. The stiffly posed arrangement of the nude woman and clothed men (a scandal in its day) can be directly traced to an intaglio print by Marcantonio Raimondi—after an original composition by Raphael (now lost)—titled *The Judgement of Paris* (Fig. 404); even the image of a woman in the background demurely lifting her skirt and wading in the water can be seen in many older classical paintings and sculptures. But the illusionistic *space* and the way in which paint is handled in this artwork clearly sets it apart from older paintings. The painting remains perceptually flat although it alludes to deep space. Things do not easily fall into

403. Edouard Manet.
Le Déjeuner sur l'Herbe. 1863.
Oil on canvas, 7′ × 8′10″
(2.13 × 2.69 m). Louvre, Paris.

404. Marcantonio Raimondi. *The Judgement of Paris* (detail). 1520. Engraving after Raphael. Metropolitan Museum of Art, New York (Rogers Fund, 1919).

perspective as they did in paintings of the past. The woman bending in the background seems to hover above the trio in the foreground; even the landscape setting of the painting does not convincingly set back in space. We get the distinct feeling that the nude model and two men are posed in front of a flat theatrical backdrop. This painting represents the beginning of an artistic attitude that openly acknowledges the intrinsic *flatness* of a painting: It is after all, Manet reminds us, colors applied to a two-dimensional surface. The sketchiness of the painting technique further reinforces this element of the work. Manet's awareness that painting is ultimately patches of color organized on a flat surface represented an important concept in the history of modern art. Significantly, *Luncheon on the Grass* is a work of art that looks simultaneously toward the past and future. It dynamically combines memories of history in a visual format that also confronts the emerging realities of its own time. Thus Manet was one of the first pioneers who led the way toward the formation of a new aesthetic reality that mirrored the modern world.

IMPRESSIONISM

Like several other terms used to describe modern styles of art, *impressionism* was coined by a hostile art critic who reacted adversely to a painting done in 1874 by Claude Monet titled *Impression: Sunrise*. What prompted the irate outcry by establishment critics was the clear assertion by Monet and other impressionists such as Pierre Auguste Renoir and Alfred Sisley that a painting was inevitably a two-dimensional surface with applied paint, not an illusionistic "window." Through the work of these artists Manet's initial perceptions about modern space in painting were more clearly defined. No doubt the impressionists were reacting, consciously and unconsciously, to the invention of the camera, which flawlessly recorded the appearance of objects and scenes. But along with this scientific means of recording light came the realization that modern reality was based on shifting perceptions, not a frozen image The power of the machine and technological progress had created a new perception of reality— one based on change and metamorphosis rather than stability. Monet's painting

405. Claude Monet.
Gare Saint-Lazare, Paris. 1877.
Oil on canvas, 32¼ × 39¾"
(82 × 101 cm). Fogg Art Museum,
Harvard University, Cambridge, Mass.
(Maurice Wertheim Collection).

Gare Saint-Lazare, Paris (Fig. 405) clearly illustrates this emerging sensibility. The impact of the industrial age is beautifully conveyed by this work of art. Massive dark locomotives are poised in this large train station, actively belching smoke and steam. Monet's painting achieves a remarkable synthesis between a pastoral vision of the past and a powerful image of the present; smoke from the idling engines curls upward to be transformed into picturesque clouds in an idealized industrial landscape.

The inherent dynamism of the scene, the quality of shifting light and the sketchy paint application point to Monet's view of the world as a constantly shifting panorama of moving machines, people, clouds, light, and shadow. The impressionists rejected the dark muddy tones of 18th- and 19th-century paintings and replaced them with fresh, bright colors to express the excitement of the new era.

Gare Saint-Lazare expresses Monet's belief that the industrial age could produce new images as vivid and beautiful in their own way as the traditional landscapes of sun, sky, field, or ocean. He held on to this hope for years until the encroaching reality of polluted rivers, industrial slums, and expanding population eclipsed his wished-for vision. Monet was part of the emerging age and wanted to record it in a positive way. But illusion gave way to reality. Before long he moved to an isolated rural region, where he devoted the remainder of his life to painting the local landscape and the ponds, bridges, and water lilies in his beloved gardens.

What Monet sought in the tranquil beauty of his elaborate garden was a sealed refuge and an opportunity for peaceful meditation. Far from the outside world of commerce and industry, his garden and beloved lily ponds became motifs in his art. Over and over again he painted these familiar scenes in a way that stripped them bare of mere illusionistic effects—flowers, sky, water, and plants merged into one compelling celebration of nature. *Nymphéas* (Pl. 41, p. 405) is but one of hundreds of paintings Monet produced during the latter

Plate 39. Pieter Bruegel the Elder. *Hunters in the Snow.* 1565. Oil on panel, 3′10″ × 5′3¾″ (1.17 × 1.62 m). Kunsthistorisches Museum, Vienna.

Plate 42. Pablo Picasso. *Les Demoiselles d'Avignon.* 1906–07. Oil on canvas,
8′ × 7′8″ (2.4 × 2.34 m). Museum of Modern Art, New York (Lillie P. Bliss bequest).

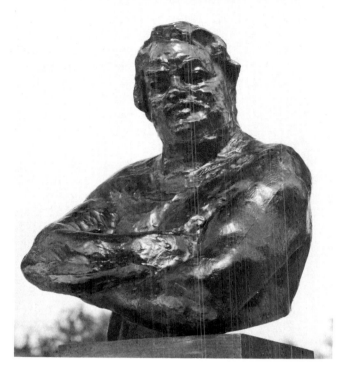

406. Auguste Rodin.
Half-Length Portrait of Balzac.
1892. Bronze, height 18½" (47 cm).
Hirshhorn Museum and Sculpture
Garden, Smithsonian Institution,
Washington, D.C.

part of his long life. Reflections blend and merge with shimmering images of flowers, lily pads, and grassy banks. Dark blues and greens in this painting contrast vividly with lighter pastel tones of violet and purple. Instead of depicting deep space, Monet creates the ambiguous effects of a flat screen. We are not quite sure about the nature of the space we are viewing. Monet has purposefully played down three-dimensional illusion in order to enhance the transcendental effects of pure color and light. His contribution to the vocabulary of modern art was substantial; many aspects of contemporary painting derive from and are indebted to Monet's vision of space, scale, and handling of paint.

MODERN SCULPTURE—ITS ORIGINS

No one figure in the early development of modern painting stands out so clearly as does Auguste Rodin in the history of modern sculpture. Almost singlehandedly he thrust sculptural concerns into the arena of modern thought with his expressive, boldly modeled portraits and figure sculptures. Most academic sculpture of Rodin's time amounted to little more than imitations of Renaissance work: fantasy visions that bore little resemblance to the original work of artists such as Donatello and Michelangelo. But Rodin carefully restudied these masters and tried to evoke in his work the *essence* of their artistic thought and spirit, recast in modern terms. One sculptural quality that obsessed Rodin was the concept of movement. But, unlike past sculptors, who tried to freeze movement, Rodin achieved an *illusion* of movement and dynamics through expressive modeling of form.

His sculptural portrait of the French writer Balzac (Fig. 406) reveals this interest; Rodin achieves a feeling of probing psychological restlessness through freely modeled rippling forms and surfaces. His *Balzac* presents us with a spiritual portrait of the individual, not merely his lifeless mask. Rodin evokes,

through an image of gleaming bronze—like light on a fast-moving stream—the expressive power of the individual in an industrial age. By concentrating on the symbolic meaning of his subject matter and focusing on the abstract nature of his forms and materials Rodin did much to establish the basis for many sculptural innovations in the 20th century.

POSTIMPRESSIONISM

By the early 1880s impressionism was well established as a viable and even respectable form of art: Manet had been awarded the coveted Legion of Honor by the French Government for his contribution to national cultural life. A group of artists called *postimpressionists* emerged at this time, however, to challenge and extend thinking beyond the developments of the impressionists; by the turn of the century, collectively they were to establish firmly the foundations upon which the modern era was built. The four most significant figures in this circle were Georges Seurat, Paul Cézanne, Vincent van Gogh, and Paul Gauguin. Together they represent many of the diverse concerns and attitudes that took root and developed in the twentieth century.

For purposes of comparison these four artists can be divided into two camps of contrasting attitudes and methodologies. Seurat and Cézanne represent a conscious analytical approach to art making that mirrored the age of rapid technological progress and scientific thought in which they were immersed. The work of van Gogh and Gauguin, however, championed deeply rooted spiritual and psychological needs, particularly in an era dominated by economic materialism and the breakdown of traditional social institutions. This quartet established the *analytical* and *expressive* duality of modern art—themes that even today, a hundred years later, are still relevant issues in contemporary art.

The Analytic Approach: Cézanne

Because of the profound and direct influence Paul Cézanne's thought and work exerted on the development of cubism, he is often regarded as the single most significant figure in the evolution of 20th-century art. A solitary and tenacious individual, Cézanne, like the impressionists before him, turned to the analytic study of nature as a means of describing reality. But, unlike the impressionists—who, Cézanne believed, were recording only the surface appearance of things—he sought to reveal the *underlying* perceptual and conceptual structure of the visual world. Cézanne believed that all forms in nature could be reduced to three basic forms: the cone, the cylinder, and the sphere. Yet his many paintings and drawings do not overtly exhibit these elemental shapes. Cézanne's art is based on a fine balance between the abstract, conceptual patterns of pure form (the cone, cylinder, and sphere) and the optical appearance of nature. Thus his artworks are both expressions of his thought and visual re-creations of the outer world. Cézanne's work clearly points the way toward the recognition of modern art's new-found power to create new realities in art not entirely dependent on illusionistic representation.

In Cézanne's late watercolor *House Among Trees* (Fig. 407), we can clearly see his striving toward a new abstract order in art. With a few carefully placed strokes of translucent paint he has delineated the essential visual elements of a house nestled among the trees and also has called attention to the fact that this painting is a flat surface with color on it. In *House Among Trees* Cézanne presents

us with an interesting duality: The work is at once a study of volume and space from nature and an abstract arrangement of shapes on a two-dimensional surface. Cézanne makes us work at *seeing* as no artist had before him. *House Among Trees* is, in a sense, an incomplete work; it requires our active perceptual and conceptual participation in order to complete it. Heroically, through his dogged determination to *represent* and not merely *copy* nature, Cézanne made us keenly aware of one important issue: In the 20th century the power of conceptual thought is the greatest determinant of visual form.

407. Paul Cézanne.
House Among Trees. c. 1900.
Watercolor, 11 × 17⅓"
(28 × 44 cm).
Museum of Modern Art, New York
(Lillie P. Bliss Collection).

A Return to Origins: Gauguin

Paul Gauguin, the son of a fairly well-to-do journalist, spent the early part of his life as a sailor in the merchant marine and navy before settling down as a stockbroker in Paris. During his life as a businessman he took up painting first as a hobby and diversion. But soon his interest in art grew so strong that he eventually left the world of commerce and devoted himself wholly to painting, eventually abandoning his wife and five children.

During his early years as an artist, Gauguin became increasingly estranged from the values of European society; he firmly believed that modern life was hopelessly corrupted by lust for money, power, and material goods. He longed to return to the original sources of life and art, which he believed could be found only in the tropics of the South Seas on Tahiti. Here amid the pleasures of dreamlike island paradises untouched by civilization, among the company of native peoples he fondly referred to as "savages," Gauguin lived, painted, and searched for the true origins of art, which he no longer believed could be found in European society.

408. Paul Gauguin.
Where Do We Come From?
What Are We? Where Are We Going?
1897. Oil on canvas,
4′7½″ × 12′4¼″ (1.41 × 3.77 m).
Museum of Fine Arts, Boston
(Tompkins Collection, Arthur
Gordon Tompkins Residuary Fund).

Gauguin's painting *Where Do We Come From? What Are We? Where Are We Going?* (Fig. 408) illustrates many of his thematic concerns and vividly reveals the visual means he used to express them. Gauguin, along with fellow artist Émile Bernard, had proposed a theory of art called *synthetism,* which emphasized the synthesis of nature through *remembered* images, rather than perceptual experience. *Where Do We Come From? . . .* is a flowing, visual "stream-of-consciousness" painting that makes effective use of nonnaturalistic, symbolic color to communicate Gauguin's obsessive desire to rediscover primal forces.

Traditional Western concerns for the representation of deep space are abandoned in this painting; instead we *simultaneously* witness a series of events that are compressed in time. Both our mind and eye wander over this vast panorama dedicated to the myth of paradise on earth. Brilliant sun-drenched colors combine with dark, mysterious background tones; surely this painting critically questions the direction of European "progress" as it left behind the agrarian past and entered the technological future. Gauguin's search to rediscover the origins of art led to a greater awareness of the importance symbol and expression played in modern life.

CUBISM

In Paris around 1907 the artistic collaboration of two remarkable 20th-century figures—Pablo Picasso and Georges Braque—gave rise to what has been deemed the most significant style of art in the last century: *cubism.* Certainly this important style has greatly affected the development of modern art, perhaps more than any other single movement. Today's architecture, product design, and graphic communications all owe a great deal to the development of cubism. In fact, it would be hard to imagine the contemporary world without the influence of this unique style.

A New Artistic Language

One of the most important paintings in the development of 20th-century art is Picasso's *Les Demoiselles d'Avignon* (Pl. 42, p. 406) completed between 1906 and 1907. Significantly, Picasso departed even further from nature than Cé-

zanne did and established an even greater visual and conceptual freedom for art. Cubism was the search for a visual vocabulary and methodology with which to express new thematic concepts and pictorial space.

Les Demoiselles d'Avignon—which, by the way, Picasso never regarded as a finished work—reveals the enormous struggle and effort taking place in Picasso's mind as he began to forge the new visual language of cubism. Cézanne had provided the foundation for this new art with his interlocking, faceted structures, but Picasso clearly wanted to go beyond the representation of the natural world into a self-enclosed world of abstract shapes and symbols. *Les Demoiselles* is not a perfectly resolved work, yet even this aspect clearly reveals the conflicting concerns Picasso had for both representation and abstraction.

Les Demoiselles is precariously balanced, both pictorially and thematically, between these two worlds. The trio of women to the left is reminiscent of the Three Graces—a popular classical theme. But the figures to the right occupy a different, more highly energized pictorial and psychological space. Their faces resemble African masks; they become potent signs and symbols rather than representations of figures. The visual rhythms underlying this painting are charged with a restless expressionistic energy. Picasso borrowed heavily from sources of art outside the mainstream of 19th-century European realism: Iberian sculpture, and idols from more distant, primitive cultures. Cézanne's influence can also be felt keenly in this painting through the use of sharp, angular, faceted forms that unify the entire pictorial space. Background and foreground become blurred; we are presented with a complex, *multidimensional* sense of reality rather than a simple one-directional point of view. Although later work further refined the characteristics of cubism, *Les Demoiselles d'Avignon* offers unparalleled insights into the origins of this most influential 20th-century style.

GERMAN EXPRESSIONISM

In Dresden, Germany, in 1905 three young artists, Schmidt-Rottluf, Heckel, and Kirchner, formed the first group of *German expressionists*. Reacting to the scientific investigation of illusionistic phenomena found in impressionism, this group—called *Die Brücke* or "The Bridge"—set out to create works of art in which the representation of reality was deliberately distorted to communicate an *inner* vision. The formation of *Die Brücke* coincides with the founding of another group called the **fauves,** who worked mainly in France. Both movements were greatly influenced by postimpressionism and by primitive art.

Perhaps the most effective and dominent artistic personality of *Die Brücke* was Ernst Ludwig Kirchner; for him as well as the other expressionists printmaking was as important as painting. In the woodcut they found a medium that suited their interest in strong visual forms and objects. In Kirchner's polychromed woodcut *Street Scene (Two Ladies in the Street)* (Fig. 409), the wildly distorted perspective and angular, bold shapes thematically transform what might be an ordinary street scene into a mysterious, foreboding event. Rejecting all the subtleties of impressionist art, the graphic woodcuts of the expressionist artists made appropriate use of crude and powerful forms to create works of a compelling psychological nature.

409. Ernst Ludwig Kirchner. *Street Scene (Two Ladies in the Street).* 1922. Color woodcut, 27¼ × 15″ (69 × 38 cm). Museum of Modern Art, New York (purchase, 1945).

FUTURISM

Unlike many movements in the art world that are loosely organized and that evolve slowly, **futurism** had a precise date of birth: On February 11, 1910, Italian artists Carra, Russolo, Severini, and Boccioni signed a manifesto boldly proclaiming its existence. Futurism developed in Italy concurrently with cubism. It consciously expressed an open admiration for the scientific and technical developments of the modern age; in fact, mechanization was at the heart of its aesthetic beliefs and inspiration. Speed and motion were two attributes glorified above all else in the futurists' philosophy. Furthermore, they celebrated the quick pace of contemporary life, reveled in the new, and aggressively lashed out at the ancient culture of Italy, which they viewed as weak, decrepit, and degenerate. The aesthetics of the machine promised them a new and prosperous age free from the sentimental worship of crumbling ruins and dusty antiquarian libraries. Their rallying cry was: "We maintain that the splendors of the world have been enriched by a new beauty: the beauty of speed."

Reaching toward this kinetic ideal Umberto Boccioni, one of the original signers of the first futurist manifesto, created the bronze sculpture illustrated in Figure 410. In order to create the *feeling* of movement and to render this experience visible, Boccioni broke down the components of the work into streamlined forms connected through rhythmic repetitions. These elements constantly shift in perspective, thus illusionistically setting the figure in motion. Like the cubists, futurists did not view the world as a static entity that could be adequately described from a single point of view. For this reason, they developed complex ideologies and new visual realities in order to represent the abstract experiences and scientific concepts of the early 20th century. Their art was a mirror image of the inevitable progress of mechanization and the physical power of technology.

TOWARD THE ABSOLUTE

The development of modern art was by no means a neat, orderly, linear progression going forward logically from movement to movement. Diametrically opposed styles often emerged, ran parallel, and eventually merged in the quick flowing stream of history and ideas. This multifaceted basis of modern art is what makes it so expressive of our era; in many ways its diversity and dynamics beautifully mirror the complexity and contradition of our own contemporary, pluralistic society.

At the height of the cubist movement, Constantin Brancusi, the son of Rumanian peasants, was working on a series of elementally simple sculptural forms that would later exert a profound influence on 20th-century art. Brancusi's **nonrepresentational** work in marble and bronze during the 1920s was far removed from the complex cubist theories of form and space; he was searching for *essences* in art rather than formal space relationships. To this end Brancusi eliminated superfluous elements to arrive at sculptures that were striking in their simplicity and purity of form. Although Cézanne searched for a geometric order underlying the natural world, Brancusi reasoned that these elemental forms could be used as building blocks in the creation of fully *autonomous* works of art: He believed that a work of art should represent an artistic reality in its own right, not the abstracted *illusion* of one. *Bird in Space* (Fig. 411) illustrates this idea beautifully. This sculpture does not present us with a stylized image of a

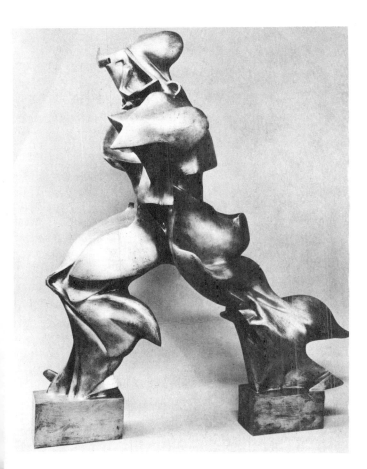

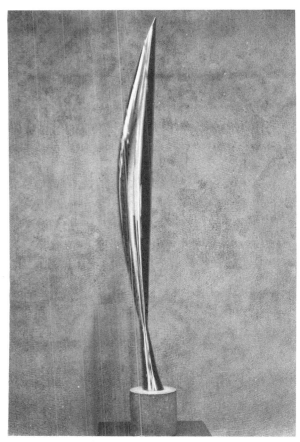

bird; its entire form and feeling communicates the essence of *flight* and *soaring*, two abstract spiritual concepts that fascinated Brancusi all his life. Other groups of artists who sought absolutes in the visual arts during this period (1915–1922) were the Russian constructionists and a Dutch group called *De Stijl*. Later these groups would exert powerful influences on the development of fully abstract art.

ABSTRACT ART

Although it would be difficult to single out one painter in the 20th century as the first completely abstract artist of significance, a Russian artist, Wassily Kandinsky, certainly comes as close as anyone. Kandinsky's early work was influenced by impressionism and characterized by an intense love of color, but by 1910 he was working with "pure" shapes, lines, and colors with no specific reference to the observed world. His intent was to awake in the viewer *feelings* (not visual images) similar to those evoked by nature.

Music was an important model in the development of Kandinsky's work. This artist believed that if musical tones, harmonies, and rhythms alone could evoke satisfying emotional responses, the same effects could be achieved with "abstract" paintings. As a young student in Moscow, Kandinsky attended a performance of Wagner's *Lohengrin*, which had a profound effect on him. He wrote of this concert: "I could see all my colors; I realized that painting possesses the same power as music."

above left: **410.** Umberto Boccioni. *Unique Forms of Continuity in Space.* 1913. Bronze (cast 1931), 42⅞ × 34⅞ × 15¾" (111 × 89 × 40 cm). Museum of Modern Art, New York (Lillie P. Biss bequest).

above: **411.** Constantin Brancusi. *Bird in Space.* 1913. Bronze, height 4′6″ (1.37 m). Museum of Modern Art, New York (anonymous gift).

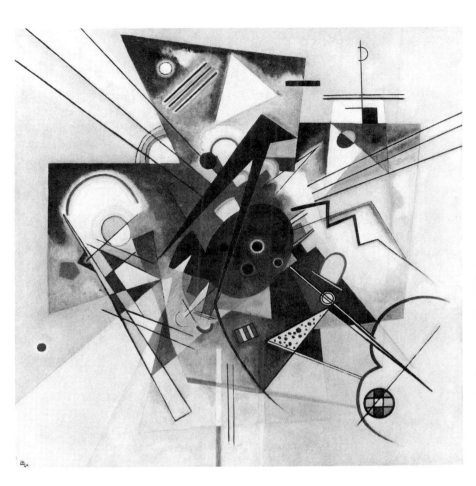

412. Wassily Kandinsky.
Yellow Accompaniment. 1924. Oil on
canvas, 39⅛ × 38⅜″ (99 × 97 cm).
Solomon R. Guggenheim Museum,
New York.

Kandinsky's painting *Yellow Accompaniment* (Fig. 412) is a key step in the
movement of art toward a completely self-referential abstract identity. Its title
omits any reference to a subject and surely suggests a musical inspiration. The
structure of the painting is self-contained; it relies on the intrinsic harmonies of
color and the orchestration of the linear elements for visual effect. Prompted by
these cues, with a little imagination one could almost "hear" music emanating
from this pictorial space: modern strains of restless, strident tones. High notes
might be expressed by its shrill yellow colors; the lowest bass tones might be
communicated by the dark blues and blacks. Syncopated rhythms emanate from
thin, criss-crossing lines and triangular shapes. Above all, Kandinsky believed
that his paintings represented a dramatic inner state of mind that could be
interpreted *individually* by each viewer. For this artist the basic aim of the paint-
ing process was the "purposeful stirring of the human soul."

DADA

In 1916, at the height of World War I, a multinational group of European
artists assembled in Zurich, Switzerland, and formed an absurdist, antilogical
school of art called **dada.** The name of this movement is curious, and its origin is
shrouded in mystery. A charter member, Richard Huelsenbeck, a German
writer, claimed that a French-German dictionary was opened at random by
inserting a penknife between the pages. The first word noted was *dada,* which

means "child's rocking horse" in French. Another member of the group traces its origin to the habit of two Rumanian artists who chanted incessantly "Da da da da . . . " (meaning "yes, yes, yes," in their native language). This air of obscurity and absurdity surrounding the origins of dada aptly fits its aesthetic characteristics. But despite the disputed origins of its name, dada was clear on one point: The mechanization of the modern world had led to global madness; progress meant that instead of killing people by the hundreds, the new technology could massacre tens of thousands of individuals quickly and efficiently. Poison gas, airplanes, motorized artillery, and rapid-fire machine guns were perceived as the deadly fruits of industrialization and science. Dada therefore rejected all logically based thought in art and life; anarchistic liberty—the freedom to say and do anything in the name of dada—was its creed. The dada movement produced a series of wild performances, concerts of noise, and poetry readings comprised of free word association. The basic aesthetic outlook was directed inward like Kandinsky's but without his optimism: The dadaists' work was skeptical of all Western art and beliefs, including those of the modernists who came before them. In a sense dada was less an artistic movement than an attitude and state of mind brought about by social upheaval. It was deeply pessimistic, rejecting many previously accepted tenets of Western art such as the importance of order, cultural meaning, and even the need for beauty in art.

One of the most compelling artworks of the dada movement is Man Ray's *Gift* (Fig. 413). This sculpture wryly expresses the bitterness with which the modern world was viewed. Dada artists, in a spirit of ironic, desperate humor, were fond of appropriating manufactured goods such as urinals and bicycle wheels and claiming them as works of art. Man Ray bought this ordinary flatiron from a shop selling household appliances and transformed its meaning and function by gluing a row of upholstery tacks to the bottom. Any attempt to use this iron in a normal way would hopelessly shred and tear the clothing being ironed. A normally useful household appliance has been transformed by the artist into a destructive device that symbolically mirrors the way scientific technology had been ingeniously and diabolically turned toward the killing of humans. Even its title cynically reflects on the discrepancy between industrial technology's promise and its nightmarish reality. Viewed in this light, *Gift* takes on an ominous, frightening character; its apparent humor rapidly fades and we are left with a deeply unsettling 20th-century icon representing death and destruction.

413. Man Ray. *Gift*. Replica c. 1958 after 1921 original. Painted flatiron with metal tacks, heads glued to bottom; 6⅛ × 3⅝ × 4½" (16 × 9 × 11 cm). Museum of Modern Art, New York (James Thrall Soby Fund).

SURREALISM

Like dada, *surrealism* was conceived more as a philosophical attitude toward life than as a neatly codified visual style of art. In essence its originators were literary artists such as André Breton and Paul Eluard, rather than painters or sculptors. But visual artists were quick to adopt its beliefs and aesthetic characteristics. During the mid-1920s a small but influential group of avant-garde artists such as Picabia, Ernst, and Magritte were producing art works that probed the previously hidden depths of the unconscious mind. Surrealism's purpose, in the words of André Breton, was "to resolve the previously contradictory conditions of dream and reality into an absolute reality, a super-reality."

The earlier psychoanalytic discoveries of Freud had shown the unconscious mind to be a vast, hitherto unexplored frontier. Free association, chance relationships, the interpretation of dreams, and nonrational aspects of the thought

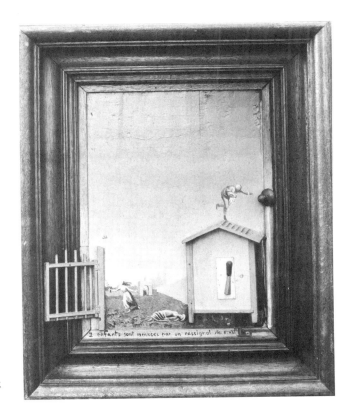

414. Max Ernst.
*Two Children Threatened
by a Nightingale.* 1924. Oil on
wood with wood construction,
27½ × 22½ × 4½"
(70 × 57 × 11 cm).
Museum of Modern Art, New York
(purchase).

process were all utilized by the surrealists as important means of revealing the "super-reality" behind normal perceptions. In terms of art making, rational control, logic, and conscious meaning were rejected by this group of artists. Instead, a psychological automatism was cultivated in order to achieve liberation from the limitations of conscious thought. The surrealists believed that a "poetic objectivity" must replace logic; and the actual functioning of free-associative thought was considered far more revealing than conscious manipulation of form.

Max Ernst's construction-painting titled *Two Children Threatened by a Nightingale* (Fig. 414) establishes many of the precepts of the surrealistic style. Through the suggestive incorporation of the title directly within the artwork, Ernst pays homage to the literary origins of this influential movement. Thematic and visual contradictions abound in this intriguing cross between two-dimensional and three-dimensional formats: the gate on the left physically extends beyond the picture plane, and the house to the right also comes forward in space; but the background and figures are flat, illusionistic images. Breton's professed desire to fuse dream and reality is admirably achieved in this work.

ABSTRACT EXPRESSIONISM: AN AMERICAN STYLE

Isolated both physically and ideologically from Europe during World War II, U.S. artists had the opportunity to consider introspectively the evolving nature of society and art. During the booming postwar rebuilding period, an intoxication of spirit fostered the belief among some artists that freedom of expression was the ultimate criterion of meaningful art. Also, many of the European surre-

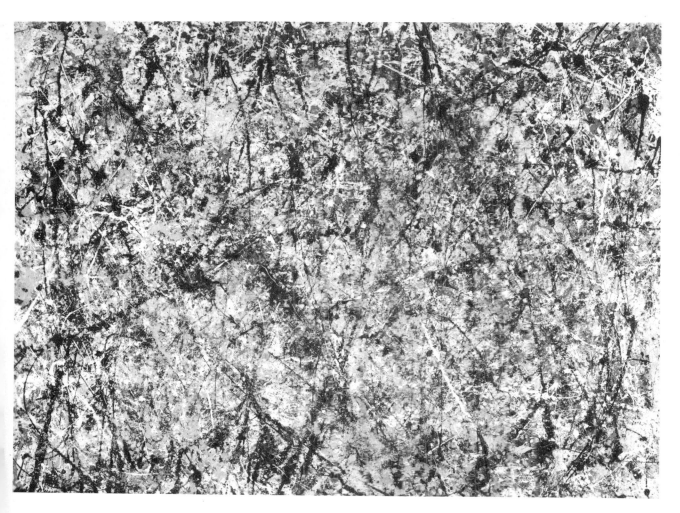

alists emigrated to the United States during the war. Their ideas about the power of the unconscious mind, dream images, and improvisation proved influential to a new generation of artists. Out of these circumstances a new style developed—*abstract expressionism*. A key attribute of this movement was its obsession with the act of painting itself. Spontaneous, unconscious methodology was overwhelmingly preferred over conscious planning of artwork. Above all was the belief (surrealist in origin) that only through the expressive *gesture* of painting could the artist communicate higher truths. For abstract expressionism the subject matter of the canvas was "the act of painting."

Perhaps no artist of this period epitomizes its visual style and sensibilities better than Jackson Pollock. His painting *Number 1, 1950 (Lavender Mist)* (Fig. 415) illustrates the fluid, graphic "writing" style Pollock used to create his large, dramatic canvases. By placing the canvas on the floor of the studio and walking around it and over it while he painted, Pollock entered into a new conceptual relationship with his art. Through this method Pollock explained he could "literally be *in* the painting." Pollock's *Number 1, 1950* totally energizes space in a way unlike any work of art before it. Surging forms activate the environmentally scaled canvas and create dramatic visual effects. In terms of space Pollock used what has since been called an "overall" or "field-effect" composition through the use of continuous patterns formed by interlocking networks of line. His work had no background, foreground, or central focus. American artists had absorbed

415. Jackson Pollock. *Number 1, 1950 (Lavender Mist)*. 1950. Oil enamel and aluminum on canvas. 7'3" × 9'10" (2.21 × 3 m). National Gallery of Art, Washington, D.C. (Ailsa Mellon Bruce Fund).

the surrealist obsession with the unconscious and transformed it into a home-grown style of art exalting personal expression.

POP ART

During the late 1940s and the 1950s when the abstract expressionism movement dominated the art world, some artists and critics were calling for a return to traditional subject matter and methodologies in art. During the 1960s realism and recognizable imagery were revived but with an ironic twist that startled many observers of the art scene. In 1962 the Sidney Janis Gallery staged an important exhibit called "New Realists"; very little in this controversial show, however, was "realistic" in the traditional meaning of this word. The artists shown at the Janis Gallery were realists in that they responded to the *environment* of the contemporary world by producing works of art based on comic-strip imagery, packaging design, and advertising billboards. This movement, called *pop art* because of its adaptation of popular sources, ignored the subject matter of "high" museum art; furthermore, it celebrated the poetry of everyday life and elevated commonplace imagery to new heights. In terms of responding to the dynamic visual forces of the 20th century it certainly was a form of realism—social and environmental realism.

In many ways pop art represented the artistic opposite of abstract expressionism and played an important role in enlarging the thematic field art has come to encompass during our time. These two movements clearly illustrate the duality of thought that forms the basis of the modern sensibility. Cézanne's analytic reasoning and Gauguin's rejection of logic in favor of a return to primitive "origins" firmly lay out the diametrical energies of modern art. Abstract expressionism rejected images; pop art glorified them—the more popular and recognizable, the better. Basically the aesthetic attitudes and working methodologies of the two camps were at opposite extremes: Pop art was consciously conceived and carefully crafted; abstract expressionism emphasized the unconscious and believed in the "truth" of the spontaneous gesture. In sum, pop art was a strong reaction to the circumscribed philosophy of the nonrational surrealists. It opened the way for a far more varied range of thematic concerns and formal options in the visual arts.

Although Jasper Johns' bronze sculpture *Painted Bronze (Beer Cans)* (Fig. 416) is not historically considered pop art (it predates this movement by two years), it illustrates many of the attributes of this new attitude toward art making. What Johns presents to us in this artwork are sculptural replicas of common beer cans—objects invariably perceived (at least when they are empty) as worthless trash. Not only did the artist duplicate the size and shape of the cans in bronze but he carefully duplicated their labels with paint. Although the cans appear identical, on close inspection they potentially are as different as night and day: the can on the right has two punctured openings signifying that it is "empty"; the other can is sealed and no doubt "full." Perhaps this subtle but significant detail comments on the rapidity with which a product is transformed from a valuable commodity (when one is thirsty) to worthless trash in our industrialized society.

Pop art, with all of its inherent meanings and cultural implications for an age of mass production, calls on us to examine, with fresh eyes and mind, the world we live in—its technological wonders, advertised specials, and new expressive opportunities for visual artists.

MINIMALISM

The modern era, encompassing as it does now about a hundred years of art making, expresses an inherent interest in a *variety* of aesthetic styles and philosophies about life and living. New innovative ideas are constantly being brought forward and combined with traditional concepts; history is constantly reinvented and reinterpreted to suit the needs of the moment. *Minimal art,* an influential art movement of the late 1960s (also referred to as *primary structure*), drew heavily on the simple geometric style of the constructionists of the 1920s for inspiration. Aspects of historic styles, seemingly buried for decades, can in today's world suddenly emerge from hibernation with vigorous energy and take on new significance.

Like pop artists, the minimalists reacted against the idea of "visual expression" and the notion of art making as an unconscious art. But, instead of turning to the mass media or to popular culture for inspiration, minimalists were attracted to simple geometric forms, repetitive imagery, and, in the case of sculpture, the use of industrial materials that had architectural applications. Robert Morris' environmental sculpture *Untitled* (Fig. 417) is a clear example of *minimalist* or *primary structure* art. It consists of nine steel units, each made by fastening together at right angles three 36-inch-square (91 centimeters) steel plates. This artwork questions the traditional idea that a sculpture is an isolated object placed on a pedestal for our viewing. Morris' work of art becomes instead an *environment* through which we can walk and in which we can literally become immersed. In this sense minimalism is a response to those powerful aspects of the visual environment that surround and greatly affect us: modern architecture, cities, industrial designs, and the level of logical organization we view in the world.

below left: **416.** Jasper Johns. *Painted Bronze (Beer Cans).* 1960. Painted bronze, 5½ × 8 × 4¾" (14 × 20 × 12 cm). Courtesy of Leo Castelli Gallery, New York.

below: **417.** Robert Morris. *Untitled.* 1967. Nine steel units, each 36 × 36 × 36" (91 × 91 × 91 cm). Solomon R. Guggenheim Museum, New York.

PHOTOREALISM

Before the development of the camera, realist artists either painted directly from life or later in the studio used drawings done on site to reconstruct accurate imagery. Today *photorealist* artists use the camera and the photograph to gather

information that is accurately transferred into painting. But, rather than use the photograph as a form of visual note taking—to be loosely translated into paint— the photorealists make use of the image frozen by the camera as the *subject*. In essence they copy the look of the photograph. Photorealists are interested in the rendition of superaccurate detail, detail that only a photograph can supply. Certainly no human subject can pose for hundreds of hours without moving; and even cityscapes and landscapes are in constant flux due to ever-changing light conditions. But the photograph has an unflinching memory that is permanently fixed in the blink of a shutter.

Chuck Close (see Figs. 277, 278) is an artist who works intimately with the photograph to create large-scale photorealist paintings. When Close is satisfied with the composition of the photographic image he will use as his subject matter, he carefully draws an equally spaced grid of fine lines over the surface of the photo. His primed canvas has the same proportions as the photo but is much larger; this surface is also covered with a pencil-line grid but of proportionally greater scale. Close then proceeds to "enlarge" the photograph onto the canvas by painting each grid to look like the smaller corresponding grid of the photo image. In essence he analyzes each square of the photo in terms of color, contrast, and shape. The result is a remarkable painterly translation of every visual aspect of the photograph (Fig. 418).

CONCEPTUAL ART

By the early 1970s a widely varied group of artists called *conceptual artists* emerged. Their concerns were motivated by the *idea* or *concept* of the artwork rather than merely its visual presence. In part, conceptual artists were reacting to the materialistic concerns of the day and the surge in prices commanded by fashionable contemporary paintings and sculpture; in response they created works of art based on philosophical and ideological concerns that by their very nature could not become commodities on the art market. Like many avant-garde movements of the recent past, conceptual work sought to create a radical redefinition of the nature of art. Marcel Duchamp, a European dadaist who settled in the United States, was a major influence on this diverse movement. Duchamp believed that essentially only the *idea* of the artist was important; the work of art or *object* was the proof of the idea but the *concept* was its soul. This aesthetic belief threw open the artistic arena to the widest range of activity imaginable; artists typed verbal statements on standard sheets of white paper and exhibited them in galleries; unusual and mundane actions or performances were staged; blocks of ice were left in museum courtyards to melt and eventually evaporate without a trace; mile-long shallow ditches were dug in the Mojave desert as *land art* (a form of conceptual art); artists even made use of their bodies in symbolic, ritualized actions. What bound all these diverse actions together under the heading of conceptual art was an interest in the dematerialization of the *art object* in favor of emphasizing the *idea* or *concept* behind it.

One example of how conceptual art departed from the notion of collectability and ownership was Dennis Oppenheim's *Canceled Crop* (Fig. 419). Oppenheim had a cooperative farmer in Europe drive his harvesting equipment diagonally through a field, thereby creating a gigantic *X* shape and "canceling" his crop. Many conceptual artists made use of linguistics, puns, and wordplay in their work (Duchamp's influence). What fascinated them was the way language could function as a catalyst, affecting the way we think and thus changing our visual

perception. In terms of Oppenheim's *Canceled Crop,* the function of language is subtle and revealing. "Canceling" in this case refers to the removal, or harvesting, of a crop. In any case the grain is cut and processed, a procedure that creates food for human sustenance. Although "canceling" has a negative connotation, it is only through this act of removal—or in more positive terms, "harvesting"— that we obtain food for survival. Like many of the most provocative conceptual artworks, Oppenheim's work puts us in touch with specific information, thoughts, and feelings that traditional works of art rarely convey.

TODAY'S DIVERSITY

During the last ten years trends in contemporary art appear to be turning away from strong group movements toward *individual* styles and personal contributions. Our awareness of the history of art and the many aesthetic options open to us may preclude choosing any *one* course. Perhaps in this age of instant information retrieval we have too much data to sort and sift through. But the fact remains that many art styles and methodologies do exist viably today in a dynamic atmosphere of personal discovery and growth. Synthesis, the combining of divergent forms and styles, has in many cases replaced the strong reactions between opposite styles (abstract expressionism and pop art, for example).

Jonathan Borofsky is an individual working today who embodies in his art many aspects of our multifaceted cultural world. His work manages to incorporate and integrate smoothly a variety of modern attitudes and aesthetic currents. Aspects of surrealism, conceptual art, expressionism, and figurative art simultaneously run through his work.

above left: **418.** Chuck Close. *Robert/104,072.* 1973–74. Synthetic polymer paint and ink with graphite on gessoed canvas, 9 × 7′ (2.74 × 2.13 m). Museum of Modern Art, New York (gift of J. Frederic Byers III and promised gift of an anonymous donor).

above: **419.** Dennis Oppenheim. *Canceled Crop.* 1969. Direct seeding, Finsterwolde, Holland.

420. Jonathan Borofsky. *Five Hammering Men.* 1982. Aluminum, steel, composition board, paint, motor; approximate height of each figure 16′ (4.88 m). Courtesy Paula Cooper Gallery, New York.

For an international art exhibition in Kassel, Germany, in 1982 he entered a work titled *Five Hammering Men* (Fig. 420), composed of five 16-foot-tall (10.6 meters) ominous black metal figures with hammering arms set in motion by motors. The effect of these five figures in the large exposition hall was hypnotic and imposing; these gigantic figures were perpetually engaged in some form of symbolic hammering work that could be thematically related to factory occupations or perhaps to prison. Viewers were greatly affected by the figures' physical size and mysterious actions. In terms of artistic style it would be hard to classify this particular work of art; many aspects of aesthetic thought flow through and around it. It was environmental in the way it captured and transformed the space; yet each individual part could be viewed separately as in traditional sculpture. Even surrealist qualities could be seen in the dreamlike vision it presented. Borofsky, like many of his contemporaries, is synthesizing a variety of styles and sensibilities into his works, which express both personal and social concerns.

CONCLUSION

No one can predict the path that art will follow in the future, but all signs point toward a process of thought and exploration as diverse and fulfilling as the past several thousand years have proved to be. The visual arts will remain important to us no matter how much the exterior world changes because all of these art forms generate richly rewarding dialogues among the people who create, use, and enjoy them. After all, the basis of all visual art is human experience, and much of its special function is to aid in greater self-awareness and lend meaning to our lives through cultural awareness. For these reasons the arts are central to the well-being of society. Each of us plays a role in this process, and each of us bears responsibility for its outcome.

CHRONOLOGY

Chronology

Periods or Styles	Events	Major Artists and Artworks
30,000–3000 B.C.		
Paleolithic, or Old Stone Age (30,000–10,000 B.C.)	Stone tools developed by chipping process Nomadic hunting life, no agriculture	*Venus of Willendorf*, female fertility figure, c. 30,000–25,000 B.C. *Venus of Willendorf*
Neolithic, or New Stone Age (10,000–4000 B.C.)	Villages formed; domestication of animals; cultivation of crops. Pottery invented, c. 5000 B.C.	Stonehenge constructed, England, c. 1800–1400 B.C. Cave painting in Spain (Altamira) and France (Lascaux), c. 15,000–10,000 B.C
3000–1000 B.C		
Sumerian civilization (3000–2800 B.C.)	Invention of cuneiform writing by Sumerians	Brick temples with colored pillars in Uruk, Sumeria, c. 3000 B.C.
Old Kingdom of Egypt (2815–2294 B.C.) Beginning of "Sage Kings" in China (c. 3000–2500 B.C.)	Egyptians invent papyrus Pyramids	Cheops Pyramid at Gizeh, c. 2500 B.C.
Beginning of Middle Egypt Kingdom (c. 2100–1700 B.C.)	Code of Hammurabi, first legal system, c. 1760 B.C.	Tapestries made in Egypt
New Kingdom, Egypt (1567–1085 B.C.)	Beginning of true Iron Age in Syria and Palestine, c. 1500–1000 B.C.	Tomb of Tutankhamen, c. 1340 B.C. *Queen Nefertiti*
Blooming of Cretan-Mycenaean civilization (c. 1700–1200 B.C.)	Decimal system developed in Crete	Palaces built at Knossos, Crete, c. 1500 B.C. *Snake Goddess*, Crete

Periods or Styles	Events	Major Artists and Artworks

1000 B.C.–A.D. 1

Beginning of Mayan civilization in Mexico (c. 600 B.C.)

Mayan stone carving

Phoenicians develop alphabetic writing, c. 1000 B.C.

Archaic Period, Greece (c. 600–480 B.C.)

First Olympic games, c. 750–700 B.C.

Buddha, c. 563–483 B.C.
Confucius, c. 551–479 B.C

Temple of Artemis at Ephesus (Asia Minor), 550 B.C.

Classical Period, Greece (c. 479–323 B.C.)

(In Confucius, Buddha, Greek poets, artists, philosophers, and scientists, the 6th century B.C. represents a milestone for human achievement)

Parthenon, Athens, 447–432 B.C

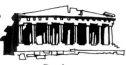

Parthenon

Temple of Olympian Zeus at Athens, 174 B.C.

Hellenistic Period, Greece (323–146 B.C.)

Romans sack Corinth; Greece becomes Roman province, c. 146 B.C.

Praxiteles, Greek sculptor, 400–330 B.C.

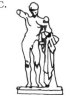

Han Dynasty, China (202 B.C.–A.D. 220)

Burning of the Alexandrian library, 47 B.C.

Praxiteles, *Hermes and Dionysos*

A.D. 1–1000

Roman Empire (30 B.C.–c. A.D. 500)

Crucifixion of Jesus, c. A.D. 30

Destruction of Pompeii, A.D. 79
Trajan emperor, A.D. 98–116 (under him the Roman Empire reached greatest size)

Building of the Pantheon, Rome, finished in A.D. 124

Pantheon

Head of Constantine, Rome, 324–330

Constantine the Great

Periods or Styles	Events	Major Artists and Artworks
Byzantine Empire, Europe and Asia (c. 400–1453)	The Vandals sack Rome, 455	Basilica of S. Maria Maggiore, Rome, started 432
	Justinian, Byzantine emperor, 527–565	Hagia Sophia, Istanbul, 532–537

Christ mosaic

Hagia Sophia

Periods or Styles	Events	Major Artists and Artworks
Islamic Empire (c. 622–900)	Mohammed, c. 570–632	Mosque of Mutawakkil, Samarra, Iraq, 848–852
T'ang Dynasty, China (618–907)	European plague, which ran for 52 years and cut the population in half, ended in 594	Chinese bronze sculpture
Nara Period, Japan (645–794)	Book printing in China, c. 600	Building of the Horyu-ji Temple in Nara, Japan, 585
Middle Ages, Europe (c. 650–1400)		

Horyu-ji Temple

Periods or Styles	Events	Major Artists and Artworks
Carolingian Period (768–1000)	Monasteries become centers of learning, c. 800	Palace and chapel of Charlemagne at Aachen, c. 795
		8th–9th centuries, Irish Book of Kells

Book of Kells

Periods or Styles	Events	Major Artists and Artworks
	Death of Charlemagne, 814	Founding of monastery at Cluny, 910

1000–1400

Periods or Styles	Events	Major Artists and Artworks
Middle Ages Romanesque Period (1000–1140)	Norman Conquest of England, 1066	
	Abbot Suger rebuilds Abbey Church of Saint-Denis; Gothic style evolves, 1140	
Inca Empire, Peru (c. 1100–1532)		
Gothic Period (1150–1500)	During 12th century, Crusades become popular	Chartres Cathedral, France, c. 1194–1260; stained-glass windows

Periods or Styles	Events	Major Artists and Artworks
	Universities of Paris, Bologna, and Oxford founded, c. 1150	Cathedral of Notre-Dame, Paris, c. 1163–1250
	Chinese use explosives in warfare, 1151	Notre Dame
	Marco Polo returns to Italy from China, 1295	Giotto, Italian, *Lamentation*, 1305
Ming Dynasty, China (1368–1644)	Chaucer writes *Canterbury Tales*, c. 1385	Simone Martini, Italian, *Annunciation*, 1333
	Florence is the European center of commerce and banking	Martini, *Annunciation*
International style, Europe (c. 1390–1425)		Limbourg Brothers, French, *Très Riches Heures du Duc de Berry*, 1413–16

1400–1600

Periods or Styles	Events	Major Artists and Artworks
Renaissance, Italy (c. 1400–1600)	Return to classical ideals of beauty and proportion; development of linear perspective to create illusions of three-dimensional space	Masaccio, Italian, *The Holy Trinity with the Virgin and St. John*, 1425
		Donatello, Italian, *David*, c. 1430
		Donatello, *David*
	Constantinople falls to Turks, 1453	Botticelli, Italian, *Birth of Venus*, c. 1480
	Botticelli, *Birth of Venus*, detail	
	Columbus discovers America, 1492	Leonardo da Vinci, Italian, *Last Supper*, c. 1495–98
		Raphael, Italian, *The School of Athens*, 1510–11
		Michelangelo, Italian, Sistine Chapel ceiling, 1508–12
		Michelangelo, *Creation of Adam*

Periods or Styles	Events	Major Artists and Artworks
Renaissance, Northern Europe (c. 1500–1600)	Martin Luther challenges the practice of indulgences in 1517—the Protestant Reformation begins	Dürer, German, *Self-Portrait*, 1500
Aztec Empire, Mexico, at height (1500)	Magellan sails through the Straits of Magellan into Pacific Ocean, 1519–22	Hieronymous Bosch, Netherlands, *The Garden of Earthly Delights*, c. 1500
Benin "Classical Period," Africa (c. 1550–1680)	William Shakespeare, 1564–1616	Matthias Grünewald, German, *Isenheim Altarpiece*, c. 1510–15

Shakespeare

| | Availability of books increases in the 16th century—interest in science and humanistic study spreads | Peter Bruegel the Elder, Dutch, *Hunters in the Snow*, 1565 |

1600–1700

| Baroque Period, Europe (17th–18th centuries) | Catholic Counter-Reformation in Europe | Peter Paul Rubens, Flemish, *Descent from the Cross*, 1611–14 |

Rubens, *Descent from the Cross*, detail

	Thirty Years' War begins in Germany, 1618	El Greco, Spanish, *View of Toledo*, 1604–14
	English Pilgrims land at Plymouth Rock, 1620	
	Galileo, founder of modern physics, is tried and condemned in 1633	
Edo Period, Japan (1615–1868)	Declaration of Rights establishes constitutional government in England, 1689	Rembrandt, Dutch, *The Night Watch*, 1642
Qing Dynasty, China (1644–1912)		Bernini, Italian, *Saint Teresa in Ecstasy*, 1645–52

Bernini, *St. Teresa in Ecstasy*, detail

Diego Velázquez, *Las Meninas*, 1656

Periods or Styles	Events	Major Artists and Artworks

1700–1800

Rococo Style, Europe (early 18th century)	Reign of Louis XV in France, 1715–74	Benedictine Basilica at Ottobeuren, Germany, 1767
Colonial Period, North America	American Declaration of Independence, 1776	Antoine Watteau, French, 1684–1721
	First performance of Mozart's *The Marriage of Figaro*, 1786	Giovanni Battista Tiepolo, Italian, 1696–1770
	French Revolution begins, 1789	François Boucher, French, 1703–70
		Jean Honoré Fragonard, French, *The Swing*, 1766

Fragonard,
The Swing, detail

	Rise of Prussia and Russia, 1710–95	Francisco Goya, Spanish, 1746–1828

1800–1850

Neoclassicism, Europe, United States (c. 1750–c. 1820)	Napoleon rules France as emperor, 1804–14	Antonio Canova, Italian, *Pauline Borghese as Venus*, 1808

Canova, *Pauline Borghese as Venus*

Jacques Louis David, French, 1748–1825

Federal style and Greek Revival, United States	Industrialization of France and Belgium, 1820–60	Thomas Jefferson, Rotunda, University of Virginia, Charlottesville, 1819–26

Jefferson, *University of Virginia Rotunda*

Romanticism, France (1800–c. 47)	Revolutions throughout Europe, 1848	Théodore Géricault, French, *The Raft of the Medusa*, 1818
Realism, France (c. 1848–c. 86)	Daguerre and Niépce publish findings on photography, 1839	Eugène Delacroix, French, *Liberty Leading the People*, 1830
	Marx and Engels, *Communist Manifesto*, 1848	

Delacroix,
Liberty Leading the People, detail

	Reign of Queen Victoria in England, 1837–1901	Honoré Daumier, French, 1808–79

Periods or Styles	Events	Major Artists and Artworks
1850–1900		
Impressionism, France (c. 1870–85)	American Civil War, 1861–65	Édouard Manet, French, *Le Déjeuner sur l'Herbe,* 1863
	Origin of the Species, by Charles Darwin, published 1859	James A. McNeill Whistler, American, 1834–1903
		Edgar Degas, French, 1834–1917
		Degas, *Little Dancer,* 1880–81
		Berthe Morisot, French, 1841–95
		Claude Monet, French, 1840–1926
	Alexander Graham Bell invents the telephone, 1876	Auguste Rodin, French, 1840–1917
		Mary Cassatt, American, 1845–1926
Postimpressionism, France (c. 1880–1900)	Dedication of Statue of Liberty, 1886	Vincent van Gogh, Dutch, 1853–90; *Starry Night,* 1889
	Gauguin settles in Tahiti, 1891	Paul Gauguin, French, 1848–1903; *L'Appel,* 1902
		Georges Seurat, French, 1859–91; *Sunday Afternoon on the Isle of La Grand Jatte,* 1884–86
		Seurat, *La Grande Jatte,* detail
	Queen Victoria crowned empress of India, 1877	Paul Cézanne, French, 1839–1906; *Mont Sainte-Victoire,* 1904–06
	Spanish-American War, 1898	Louis Sullivan, American, Wainwright Building, St. Louis, 1890
1900–1950		
Expressionism, Europe (c. 1900–20)	Sigmund Freud formulates psychoanalysis, 1905	Edvard Munch, Norwegian, 1863–1944
		Munch, *The Cry,* 1893
		Ernst Ludwig Kirchner, German, 1880–1938
		Emil Nolde, German, 1867–1956
Fauvism, France, started 1905	Einstein researches the theory of relativity, 1900–05	Henri Matisse, French, 1869–1954
		Georges Rouault, French, 1871–1958

Periods or Styles	Events	Major Artists and Artworks
Cubism, France (1907–14)	World War I, 1914–18	Pablo Picasso, Spanish-French, 1881–1973 Picasso, *Les Demoiselles d'Avignon*, detail, 1907
	Russian Revolution, 1917	Georges Braque, French, 1882–1963
Futurism, Italy (c. 1909–15)	Bauhaus, influential art and design school, 1919–33	Käthe Kollwitz, German, 1866–1944 Frank Lloyd Wright, American, 1867–1959 Umberto Boccioni, Italian, 1882–1916 Boccioni, *Unique Forms of Continuity in Space*, 1913
		Gino Severini, Italian, 1883–1966
Dada, Europe (c. 1916–22)		Georgia O'Keeffe, American, 1887–1986
	Great Depression, 1929–41	Marcel Duchamp, French, 1887–1968
Surrealism, Europe, begun 1924	World War II, 1939–45; first atomic bomb detonated near Alamogordo, New Mexico, 1945	Salvador Dali, Spanish, b. 1904 Alberto Giacometti, Italian, 1901–66 Giacometti, *City Square*, 1948

1950–PRESENT

Abstract expressionism, United States (c. 1945–58)	Korean War begins, 1950 Beat writers Kerouac and Ginsberg deal with themes of alienation and anxiety	Willem de Kooning, American, b. 1904 David Smith, American, 1906–65 Smith, *Cubi XVII*, 1963
	Sputnik, first earth satellite, launched by USSR, 1957	Franz Kline, American, 1910–62 Lee Krasner, American, 1908–1984

Periods or Styles	Events	Major Artists and Artworks
Op Art, Europe and United States (1960s)	Vietnam War c. 1961–73	Jackson Pollock, American, 1912–56
	President John F. Kennedy assassinated, 1963	Victor Vasarely, American, b. 1908 Richard Anuszkiewicz, American, b. 1930 Joseph Albers, American, 1888–1976

Albers, *Homage to the Square*, 1953

Periods or Styles	Events	Major Artists and Artworks
		Louise Nevelson, American, b. 1900 Frank Lloyd Wright, 1867–1959
International style of architecture started 1927		Le Corbusier, Swiss, 1887–1965 Alvar Aalto, Finnish, 1898–1976 Louis Kahn, 1901–74 James Stirling, British, 1926
Postmodern architectural style started c. 1975		Charles Moore, b. 1925
Pop Art (1960s)	First landing on the moon, 1969	Robert Rauschenberg, American, b. 1925 Andy Warhol, American, b. 1930
Minimal Art, United States (1960s)		Tony Smith, American, b. 1912 Donald Judd, American, b. 1928 Robert Morris, American, b. 1931 Frank Stella, American, b. 1936

Stella, *Empress of India*, 1965

Periods or Styles	Events	Major Artists and Artworks
Earthworks, United States (1960s)		Christo, American, b. 1935 Robert Smithson, American, b. 1938 Michael Heizer, American, b. 1944
Conceptual Art (1970s–80s)	Oil embargo precipitates an energy crisis, 1973	Joseph Kossuth, American, b. 1945
Performance art, video art, environmental art (1970s–80s)	U.S. unmanned spacecraft begin exploration of outer solar system, 1977 U.S. population reaches a high of 216 million, 1977	Nam June Paik, American, b. 1932 Alice Aycock, American, b. 1946 Laurie Anderson, American, b. 1947
Neo-expressionism, Europe, United States (1980s)		Georg Baselitz, German, b. 1938 Enzo Cucchi, Italian, b. 1950

GLOSSARY

Glossary

Words in italics indicate words defined elsewhere in the glossary. Consult the index for terms defined in the text and figures that illustrate them.

abstract A type of art in which shapes and forms have no reference to the natural world. Often these shapes are simplified and are self-referential rather than three-dimensionally illusionistic.

abstract expressionism A style of painting and sculpture important as an aesthetic force in the decade 1950–60. It was characterized generally by large scale and evidence of spontaneous invention, suggesting the creative experience sought by the artist involved in the process of forming the image.

acrylic, acrylic resin A clear plastic used as a *vehicle* or *binder* in paints and as a casting material in sculpture.

aesthetic Having to do with the pleasurable and beautiful as distinguished from the useful, scientific, and so on. The distinctive vocabulary of a given style. An aesthetic response is the perception and enjoyment of a work of art.

afterimage A physiological phenomenon in which the retina of the eye becomes fatigued after viewing any *hue* for a sustained period of time, causing the *complementary* hue to be seen.

analogous colors In artists' pigments, those *hues* that are formed by the mixture of colors close to one another on the standard color wheel.

aquatint A form of *intaglio printmaking* in which the artist uses resin dust to resist the biting action of the acid so that tonal areas can be produced when the plate has been printed.

arch In architecture, a curved structural member that spans an opening and is capable of transmitting laterally the downward pressure from the loadstone, or central block; often composed of wedge-shaped blocks (voussoirs) cut and positioned to hold each other firmly in place.

armature In sculpture, a skeleton-like framework made of metal or wood to *support* material being modeled.

art nouveau In French, literally "new art," a decorative style dominant in Europe and America in the 1890s. Though most notable in architecture and the decorative arts, the long, sensuously curving lines of art nouveau also appeared in much significant painting and sculpture of the period. Art nouveau remains influential in the visual arts of the 1970s.

assemblage The technique of creating three-dimensional works of art by combining a variety of elements—such as found objects—into a *compositional* whole.

atmospheric perspective A means by which three-dimensional depth is suggested on a two-dimensional surface. Distant *forms* are represented by blurring, indistinct, and misty shapes.

axis An imaginary line passing through a figure, building, or group of *forms* about which component elements are organized, their direction and focus actually establishing the axis.

baroque A period and style in European art generally corresponding to the 17th century. In the baroque, often the arts of painting, sculpture, and architecture were united in a theatrical way to fool the eye with soaring spatial illusions, exuberant, full-blown *forms*, and curvilinear designs, all intended to surround the spectator with color, movement, and light in an unabashed appeal for emotional involvement.

bas-relief Sculpture that is not freestanding but projects from a surface of which it is a part, as on a coin.

bauhaus A school founded by Walter Gropius in Germany in 1919, known for its adaptation

of science and technology to art and for the use of glass and metal in unornamented buildings.

binder A substance in paint that holds the *pigment* together and helps adhere it to a *support*.

biomorphic In the visual or plastic arts, *imagery* derived from, but not necessarily an imitation of, the forms of living things.

block print A form of graphic art in which an image is transferred to paper or cloth from the surface of a flat wooden or linoleum block that has been carved so that the printing surfaces stand in relief above the nonprinting areas.

buttress A *support*, usually an exterior projection of masonry or wood, for a wall, *arch*, or *vault*, that opposes the lateral forces of these structural elements.

calligraphy Handwriting, or letters formed by hand. Usually describes elegant penmanship featuring a flowery, precise line.

cantilever In architecture, a *lintel* or beam that extends beyond its *supports*.

capital The upper member of a column, serving as transition from shaft to *lintel* or architrave.

ceramics Objects made of clay that have been baked into a permanent form; often decorated with *glazes*, then fired to fuse the glazes to the clay body.

chiaroscuro From Italian meaning "light-dark"; in art, the use of *value* contrasts to represent the effects of light and shadow.

classical All that relates to the civilizations of Greece and Rome, as well as subsequent stylistic imitations of Western antiquity. Classic can also mean established excellence, whatever the period, style, or *form*.

collage From *papiers collés*, the French for "pasted papers"; a composition deriving from *cubism* and made by pasting together on a flat surface bits of newspaper, wallpaper, cloth, or other material.

colonnade A row of *columns*, usually spanned or connected by *lintels*.

column A cylindrical *post* or *support* that often has three distinct parts: base, shaft, and *capital*.

complementary colors Two contrasting *hues* that are found opposite each other on a color wheel that neutralize each other when combined (such as red and green) and mutually intensify when placed adjacent to each other.

composition An organization or arrangement imposed upon the component elements within an individual work of art.

computer art Art generated electronically through the use of a computer.

conceptual art An art object or event that in its total or essential *form* is conceived in the mind of the artist before it is fabricated. For some conceptual artists, the conception of the work of art is more important than its manifestation.

contrapposto The disposition of the human figure in which one part is turned in a direction opposite that of the other (usually hips and legs one way, shoulders and chest another); a counter-positioning of the body about its central axis.

cross-hatching A system of lines drawn in close parallel order, crossed at an angle by another similar system. Used in drawing and *printmaking* to provide the effect of changes in tonality in works drawn with lines of uniform *value*.

cross vault The intersecting and joining of two barrel *vaults* at right angles.

cubism One of the original *ab-stract* styles of the 20th century, cubism was developed in Paris by Picasso and Braque, beginning in 1907, from Paul Cézanne's late-19th-century achievements in *representational* systems. Though based on physical phenomena, cubism replaced a concern for the surface of objects and natural appearances with a more intellectual conception of the reality of *forms* and space and their interrelationships on the flat surface of a canvas. Seeking to express the totality of an object and in respect for the two-dimensionality of the picture surface, the cubists represented several views of a subject in the same *composition* (simultaneity) and, instead of modeling in the round, superimposed one view over another in a dynamic spatial perception.

dada A movement begun during World War I, in which artists expressed their feeling of futility in a war-ravaged world by exhibiting creations designed to shock or ridicule existing standards.

design The planned organization of visual elements such as line, *shape*, color, mass, and space in a work of art. Also referred to as *composition*.

dome A hemispherical vault; theoretically, an arch rotated on its vertical axis.

drypoint An *intaglio printmaking* method that utilizes the burr thrown up when lines are cut into a metal plate to give the printed image a softened, atmospheric character.

earthenware *Ceramic* ware made from natural clay that is usually soft and porous and fired at a low temperature.

entasis In *classical* architecture, an almost imperceptible swelling in the shaft of a *column*.

etching A form of *intaglio print-making* requiring a metal plate

coated with an acid-resistant wax, which is scratched to expose the metal to the bite of the acid. Lines eaten into the plate by the acid are subsequently filled with ink and transferred to paper after the surface of the plate has been wiped clean of excess ink.

expressionism A form of art developed at the end of the 19th and the beginning of the 20th century that emphasized the expression of the artist's subjective or emotional response to experience through the use of color, the direct, vigorous exploitation of media, and the formation of evocative and symbolic *representational imagery*. See *fauvism*.

fauvism A style of painting introduced in Paris in the early 20th century, which used seemingly arbitrary areas of brilliant contrasting color for structural and expressive purposes. Henri Matisse was the leading *fauve*.

fenestration The arrangement of windows, or all openings, in the walls of a building.

figure-ground In the pictorial arts, the relationship between *imagery* and the plane, background, or generalized space against which the images are seen. Modern *abstract* artists tend to regard figure and ground as a relationship between positive and negative *volumes*.

fluting Vertical channeling, concave in *shape*, used principally on *columns*.

flying buttress A masonry strut or segment of an *arch* that carries the thrust of a *vault* to a *buttress* positioned away from the main portion of the building; an important structural element in the architecture of *Gothic* cathedrals.

foreshortening The representation of an object or figure on a two-dimensional surface by the diminishing of certain dimen-sions in order to create the illusion that it is in a correct spatial relationship.

form In the visual arts. a *shape* or mass or, more comprehensively, the total configuration of shapes, structure, and expressiveness to give shape or style to something.

fresco A process of painting on plaster, either wet or dry, wherein the pigments are mixed with water and become integral with the plaster; a medium perfected during the Italian *Renaissance*.

futurism A style of painting originating in Italy during the first decade of the 20th century that endeavored to represent a dynamic, modern, machine-powered world of moving subject matter.

genre In the pictorial arts and sculpture, the realistic *representation* of everyday life and surroundings. Also, a type, style, or category of art.

gesso A mixture of chalk and glue used as a ground for *tempera* and other paints or as a surface for wooden polychromed sculpture.

glaze In oil painting, a transparent film of paint laid over dried underpainting; in *ceramics*, a thin, vitreous coating fused to a clay body by firing in a kiln.

Gothic A style in European art and architecture that prevailed from the 12th through the 15th century. The highest achievements of Gothic architecture are the great cathedrals of England and the Continent, with their cross-shaped plans, ribbed *groin vaults*, and *flying buttresses*.

gouache *Watercolor* made opaque by the addition of chalk.

groin vault A *vault* formed at the point where two barrel vaults intersect at right angles.

ground A coating, such as priming or sizing, applied to a *support* to prepare the surface for painting; also background.

happening An event conceived and performed by artists utilizing light, sound, human and mechanical movements, and a great deal of chance, as well as improvisation.

hard-edge painting A style of painting developed in the mid-20th century in which objects or *forms* are depicted in a meticulous style, or, in the case of *abstraction*, with geometric accuracy.

hue The property of color that distinguishes one color from another, as red, green, violet, and so on. See *saturation*, *value*.

iconography In the pictorial arts and sculpture, the meaning of the images and symbols depicted.

illumination The medieval art of decorating the pages of manuscripts with ornamental initials, patterns, and illustrations, often in gold, silver, and bright color.

illusionism The endeavor of the artist to represent, as completely as formal means permit, the visual phenomena of the real world.

imagistic Pertaining to the image or picture represented by the work of art.

impasto Paint laid on in richly textured quantities.

impressionism A style of painting developed in France during the second half of the 19th century and characterized by a concern for the fleeting effects of light as it played on forms in nature. Monet, Renoir, Pissarro, and their group employed individual, juxtaposed brushstrokes of color to form a vibrating surface on the canvas, enhancing the *representation* of the natural luminosity of the subject matter.

installation piece A contemporary form of multimedia art created or "installed" on a specific

site. Usually installation pieces cannot be moved easily and exist as site-specific works of art.

intaglio A type of carving that cuts into a flat surface to *shape forms* lower than the level of the original plane. In *printmaking*, a technique that requires that lines and areas to be inked and transferred to paper be recessed beneath the surface of the printing plate.

intensity In the visual arts, the relative purity or brilliance of a *hue*. See *saturation*.

international style A 14th-century Gothic style that fused Northern and Southern European artistic elements; also a modern movement in architecture that developed in the 1920s emphasizing the standardization of *form* and a utilitarian philosophy.

kinetic art Art that incorporates components capable of being moved by the action of air, gravity, or mechanical power. Kinetic art may also use changing light patterns controlled by electric or electronic switching.

kouros (plural kouroi) In Greek statuary, a nude, standing male youth.

line engraving A form of *intaglio printmaking* in which grooves cut into a metal plate with a burin are filled with a viscous ink and the plate pressed against absorbent paper after its surface has been wiped clean.

lintel A structural member that spans an opening between posts or *columns*. See *post-and-lintel*.

lithography A *printmaking* medium based upon the antipathy of grease and water. With a grease crayon or waxy liquid, a drawing is made on a slab of grained limestone or on a grained metal plate. The drawing is treated chemically so that each grain of the plate touched by the drawing medium can accept a greasy ink and each untouched grain can accept water and repel the ink. When the plate has been wetted and charged with ink, an image in ink is retained that essentially replicates the drawing. The printmaker then covers the plate with a sheet of paper and runs them through a press, which offsets the drawing onto the sheet, thus producing the print.

lost wax A method of casting metal sculpture requiring a wax version of the original model. The wax form is encased in a heat-resistant molding material. Baking the mold causes the wax to melt and run out, leaving a cavity in its place. The cavity is filled with molten metal, which solidifies to become the sculpture when the mold has been broken open. Also called *cire-perdue*.

medium In general, the process employed by the artist; in a more strict sense, the binding substance used to hold *pigments* together, such as linseed oil for oil paint.

minimal art Usually refers to metal or wooden sculptural constructions employing linear and planar components in seemingly simple, geometric *compositions*. By extension, any *nonrepresentational* art form using severely restricted *forms* and colors.

modeling In the visual arts, the working of soft, pliant material, such as clay, so as to give it a desired three-dimensional *form,* or the depiction on a flat surface of three-dimensional *forms* by means of variations in the use of such color properties as light and dark.

mold A hollow, or negative, container that produces a cast by giving its *form* to a substance placed within it and allowed to harden.

mosaic An art *medium* requiring the use of small pieces of colored glass or stone (*tesserae*) fired to or imbedded in a background material such as cement or plaster.

mural A painting on a wall, usually large in size.

nave The great central space in a church; in basilican plans, the space extending from the entrance to the apse, or to the crossing or choir, and usually flanked by aisles.

negative space The space not occupied by an object itself but circulating in and around it, contributing to the total effect of the *design*.

neoclassicism "New" classicism, a style of 19th-century art that refers back to *classical* styles of Greece and Rome.

nonrepresentational Descriptive of works of art that make no reference to the world of images. Often *shapes,* lines, and colors are arranged to exploit their own visually expressive potential.

op (or optical) art A style of two-dimensional art that uses juxtaposed areas of contrasting color to generate optical vibrations and ambiguous or undulating spatial relationships.

painterly Painting in which the buttery substance of the *medium* and the gestural aspect of paint application constitute a principal characteristic of the art's quality.

palette A tray or shaped flat surface on which a painter mixes colors; also, the characteristic range and combination of colors typical of a painter or a style of painting.

pastel Finely ground pigments compressed into chalklike sticks, giving chalky, high-*saturation* colors and high-*value* tints.

patina A surface finish of metal caused by natural oxidation or the careful application of heat,

chemicals, and polishing agents.

pediment In architecture, the triangular space or gable at the end of a building, formed in the entablature by the sloping roof and the cornice.

pendentive In architecture, a triangular segment of masonry whose plane is hemispherical, and four of which can form a transition from a square to the circular base of a *dome*.

performance art Works of a theatrical nature performed by the artist before an audience.

pigment Finely powdered coloring matter mixed or ground with various *vehicles* to form paint, crayons, and so on; also, a term used loosely to mean color or paint.

plane A surface that is defined and measurable in two dimensions.

porcelain *Ceramic* ware made from a specially prepared body composed of kaolin, ball clay, feldspar, and flint. It fires at the highest temperatures of all pottery wares.

postmodern A 20th-century style of painting and architecture that combines aspects of modern art—noteably the concept of simplicity—with traditional decorative elements.

post-and-lintel In architecture, a structural system employing two uprights or posts to support a member, the *lintel* or beam, that spans the space between the uprights.

primary colors In artists' pigments these are red, yellow, and blue; in natural light they are red, green, and blue.

prime To prepare a canvas or panel for painting by giving it a *ground* of white paint or a glue or resinous substance called size. Also see *gesso*.

primitive Descriptive of the art produced by untrained, naïve artists; also, the native arts of Africa, the Americas, and the Pacific Islands; also, an anachronistic adjective for European painting of the 13th, 14th, and 15th centuries.

print An impression made on a surface from a master plate, stone, screen, or block created by an artist, usually repeated many times to create identical images.

printmaking The process of realizing art works by making a drawing on a plate and treating the plate so that once inked it can be made to impress, usually by a mechanical printing technique, the drawing onto another surface, typically paper. Because the process permits the duplication and multiplication of the same drawing, an impression from the process, print, may be regarded as a multiple.

realism A mid-19th-century style of painting and sculpture based on the belief that the subject matter of art and the methods of *representation* should be true to life without stylization or idealization. *Impressionism* emerged from the desire to achieve in art an absolute fidelity to the artist's perception of physical reality.

Renaissance The 15th-century "rebirth" of interest in classical art, philosophy, and literature. Beginning in Italy this movement spread northward throughout Europe.

representation The depiction or illustration by the graphic means of the visual arts (lines, *values*, colors, and so on) of *forms* and *images* in such a way that the eye would perceive a correspondence between them and their sources in the real world of empirical experience.

rhythm In the visual arts, the regular repetition of a *form*.

rococo From the French for "rock work." A late *baroque* style (c. 1715–75) that domesticated and made private, pretty, and diminutive the monumental theatricality of 17th-century Counter-Reformation and absolutist art and architecture.

romanticism A style of art that commenced about the middle of the 18th century and endured until well into the 19th century. A movement concurrent and closely interrelated with *neoclassicism*, romanticism emphasized the personal, the emotional, and the dramatic, often expressed through landscape and exotic, literary, and historical subject matter.

saturation The purity, vividness, or *intensity* of a color.

scale Relative or proportional size

secondary colors In painters' colors, orange, green, and violet, or those *hues* that result from a combination of two *primary colors*. In natural light, the secondaries are cyan, magenta, and yellow.

serigraphy See *silkscreen*.

shape A two-dimensional area or plane with distinguishable boundaries, such as a square or a circle, which can be formed whenever a line turns or meets, as in an S-shape or a T-shape.

silk screen A *printmaking* method in which the image is transferred to a surface by forcing ink through a fine mesh screen on which nonprinting areas are "blocked out" to prevent ink penetration.

still life In the pictorial arts, an arrangement of inanimate objects—fruit, flowers, pottery, and so on—taken as the subject or motif of a work of art.

stoneware *Ceramic* ware made sometimes from natural clay and sometimes from prepared clay bodies. It is hard and vitreous

and fires at a relatively high temperature.

structure The *compositional* relationships in a work of art; a building or other constructed architectural unity; the operative framework that supports a building.

style The identifying characteristics of the work of a single artist, a group of artists, or an entire society. Style also signifies a sensitive, knowing, trained, and controlled shaping and ordering of ideas, feelings, elements, and materials.

support The surface that serves as a base for a two-dimensional work of art—such as paper for drawing or canvas and board panels for painting.

surrealism A painting style of the early 20th century characterized by dream-world fantasy and a hallucinatory juxtaposition of *images*.

symbol A *form, image,* sign, or subject standing for something else; in the visual arts, often a visible suggestion of something invisible.

tapestry A textile with a pictorial *composition* woven into it, the whole designed to provide a decorative hanging for a wall, especially in medieval castles and *Renaissance* and *baroque* palaces.

tempera A painting technique using as a *medium pigment* mixed with egg yolk, glue, or casein.

tertiary colors In artists' pigments, those *hues* that are formed by the mixture of a *primary color* and an adjacent *secondary color* on the standard color wheel.

thematic That having to do with the subjects or themes of a work of art.

trompe-l'oeil French for "fool-the-eye"; a type of representation in painting in which the *illusion* of *form, space,* light, and texture has been so cunningly contrived as to convince the observer that what he or she perceives is the actual subject matter and not a two-dimensional equivalent for it.

value The property of color that makes it seem light or dark; shading.

vanishing point In linear perspective, that point on the horizon toward which parallel lines appear to converge and at which they seem to vanish.

vault A masonry or concrete roof constructed on the principles of an *arch*.

vehicle The appropriate liquid or solvent used to thin paints and to clean brushes. Two of the most common vehicles are water and turpentine.

video art Works of art that make use of broadcast television or the process of live or recorded television images.

volume Any three-dimensional quantity that is bounded or enclosed, whether solid or void.

wash A thin, transparent layer of paint. Wash drawings combine thinly painted areas of color with linear elements.

watercolor Broadly, any paint that requires water as a *medium*. In a narrower sense, paint that uses gum arabic as a *vehicle* and water as a *medium*.

woodcut A *printmaking* process using a plate that is a wooden block on whose surface the *design* has been isolated in relief by the carving away of the surrounding areas. Once the surface in relief has been inked, it can be printed like a rubber stamp.

wood engraving A relief print made from a design cut into the end grain of a laminated wooden block. Also, the block from which the print is taken.

BIBLIOGRAPHY

Bibliography

GENERAL READINGS AND REFERENCE

Cage, J. *Silence*. Middletown, Conn.: Wesleyan University Press, 1961.

Cone, M. *The Roots & Routes of Art in the 20th Century*. New York: Horizon, 1975.

Cummings, P. *Dictionary of Contemporary American Artists*. New York: St. Martin's Press, 1977.

Davis, D. *Artculture*. New York: Harper & Row, 1977.

Encyclopedia of World Art. 12 volumes. New York: McGraw-Hill, 1960–1969.

Fiedler, C. *On Judging Works of Visual Art*. Berkeley and Los Angeles: University of California Press, 1949.

Fleming, W. *Arts and Ideas*, 7th ed. New York: Holt, Rinehart and Winston, 1985.

Gombrich, E. *Art and Illusion*. New York: Phaidon, 1962.

Grun, B. *The Timetables of History: A Horizontal Linkage of People and Events*. New York: Simon & Schuster, 1979.

Harris, Ann Sutherland, and Nochlin, Linda. *Woman Artists: 1550–1950*. New York: Knopf, 1977.

Janson, H. W. *History of Art*, 2d ed. New York: Abrams, 1977.

Lucas, E. L. *Art Books: A Basic Bibliography on the Fine Arts*. New York: New York Graphic, 1968.

Lucie-Smith, E. *Art Now*. New York: Morrow, 1981.

Osborn, H. *The Oxford Companion to Art*. New York: Oxford University Press, 1970.

Panofsky, E. *Meaning in the Visual Arts*. Chicago: University of Chicago Press, 1983.

Read, H. *The Philosophy of Modern Art*. Cleveland: World, 1959.

Rosenberg, H. *Art on the Edge*. New York: Macmillan, 1975.

Russell, J. *The Meanings of Modern Art*. New York: Museum of Modern Art, 1981.

Smagula, H. J. *Currents: Contemporary Directions in the Visual Arts*. Englewood Cliffs, N.J.: Prentice-Hall, 1983.

Steinberg, L. *Other Criteria: Confrontation with Twentieth-Century Art*. New York: Oxford University Press, 1972.

Tomkins, C. *Off the Wall*. Garden City, N.Y.: Doubleday, 1980.

——— *The Bride & the Bachelors*. New York: Viking, 1965.

Vasari, G. *Lives of the Most Eminent Painters, Sculptors, and Architects*, Volumes 1–3. New York: Abrams, 1979.

Wittkower, R., and Wittkower, M. *Born Under Saturn*. New York: Random House, 1963.

CHAPTER 1

Clark, K. M. *Civilization: A Personal View*. New York: Harper & Row, 1969.

Elsen, A. E. *Purposes of Art*, 4th ed. New York: Holt, Rinehart and Winston, 1981.

Hauser, A. *The Social History of Art*, Volumes 1–4. New York: Vintage, 1958.

Kris, E., and Jurz, O. *Legend, Myth and Magic in the Image of the Artist*. New Haven, Conn.: Yale University Press, 1979.

Martindale, A. *The Rise of the Artist in the Middle Ages and the Renaissance*. New York: McGraw-Hill, 1972.

Pfeiffer, J. E. *The Creative Explosion: An Inquiry into the Origins of Art and Religion*. New York: Harper & Row, 1982.

Pelles, G. *Art, Artists and Society: Origins of a Modern Dilemma*. Englewood Cliffs, N.J.: Prentice-Hall, 1963.

CHAPTERS 2, 3, AND 4

Albers, J. *Interaction of Color.* New Haven, Conn.: Yale University Press, 1975.

Arnheim, R. *Art and Visual Perception: A Psychology of the Creative Eye.* Berkeley: University of California Press, 1974.

————. *Visual Thinking.* Berkeley: University of California Press, 1969.

Ballinger, L. *Perspective: Space and Design.* New York: Reinhold, 1969.

Bevlin, M. *Design through Discovery,* 5th ed. New York: Holt, Rinehart and Winston, 1984.

Birren, F. *Color, Form, and Space.* New York: Reinhold, 1961.

————. *Color Perception in Art.* New York: Van Nostrand Reinhold, 1976.

Brodatz, P. *Textures: A Photographic Album for Artists and Designers.* New York: Dover, 1966.

Critchlow, K. *Order in Space: A Design Source Book.* New York: Viking, 1970.

Elffers, J., and Leeman, F. *Hidden Images: Games of Perception, Anamorphic Art, Illusion.* New York: Abrams, 1976.

Gombrich, E. H. *Art and Illusion: A Study in the Psychology of Pictorial Representation.* New York: Pantheon, 1960.

————. *Art, Perception, and Reality.* Baltimore: John Hopkins University Press, 1972.

Garrett, L. *Visual Design: A Problem-Solving Approach.* New York: Reinhold, 1967.

Gatz, K., and Achterberg, G. *Color and Architecture.* New York: Hastings, 1967.

Goethe, J. *Theory of Colors.* Cambridge, Mass.: MIT Press, 1970.

Huntley, H. E. *The Divine Proportion: A Study in Mathematical Beauty.* New York: Dover, 1970.

Itten, J. *Design and Form.* New York: Van Nostrand Reinhold, 1975.

————. *The Art of Color.* New York: Van Nostrand Reinhold, 1973.

Kandinsky, W. *Point and Line to Plane.* New York: Solomon R. Guggenheim Museum, 1947.

Kepes, G. *Language of Vision.* Chicago: Paul Theobald, 1949.

Moholy-Nagy, L. *Vision in Motion.* Chicago: Paul Theobald, 1964.

Pevsner, N. *The Sources of Modern Architecture and Design.* New York: Oxford University Press, 1977.

Pile, J. *Design: Purpose, Form and Meaning.* New York: Norton, 1982.

Sommer, R. *Personal Space: The Behavioral Basis for Design.* Englewood Cliffs, N.J.: Prentice-Hall, 1969.

Strache, W. *Forms and Patterns in Nature.* New York: Pantheon, 1956.

Zelanski, P., and Fischer, M. P. *Design Principles and Problems.* New York: Holt, Rinehart and Winston, 1984.

Serial Publications

Design
Design Quarterly

CHAPTER 5

Bacon, E. N. *Design of Cities.* New York: Viking, 1967.

Blake, P. *God's Own Junkyard.* New York: Holt, Rinehart and Winston, 1964.

Choay, F. *Le Corbusier.* New York: Braziller, 1960.

Crosby, T. *Architecture: City Sense.* New York: Reinhold, 1965.

Gibberd, F. *Town Design.* New York: Praeger, 1967.

Gibson, D. *A Citizen's Guide to Community Development.* Princeton, N.J.: Peterson's Guides.

Goodenough, W. *Cooperation in Change: An Anthropological Approach to Community.* New York: Russell Sage Foundation, 1963.

Gruen, V. *The Heart of Cities.* New York: Simon & Schuster, 1965.

Halprin, L. *Freeways.* New York: Reinhold, 1966.

Hilberseimer, L. *The Nature of Cities.* Chicago: Paul Theobald, 1955.

Howard, E. *Garden Cities of Tomorrow.* Cambridge, Mass.: MIT Press, 1968.

Jacobs, J. *The Death and Life of Great American Cities.* New York: Random House, 1961.

Jackson, J. B. *Landscapes: Selected Writings of J. B. Jackson.* Amherst: University of Massachusetts Press, 1970.

————. *The Necessity for Ruins and Other Topics.* Amherst: University of Massachusetts Press, 1980.

Johnson-Marshall, P. *Rebuilding Cities.* Chicago: Aldine, 1966.

Koolhaas, R. *Delirious New York.* New York: Oxford University Press, 1978.

Le Corbusier. *The City of Tomorrow and Its Planning.* London: Architectural Press, 1947.

Lynch, K. *The Image of the City.* Cambridge, Mass.: MIT Press, 1968.

Moholy-Nagy, S. *Matrix of Man: An Illustrated History of Urban Environment*. New York: Praeger, 1968.

Mumford, L. *The City in History*. New York: Harcourt, Brace & Co., 1961.

———. *The Urban Prospect*. New York: Harcourt, Brace & Co., 1968.

Reps, J. W. *The Making of Urban America*. Princeton, N.J.: Princeton University Press, 1965.

Tunnard, C., and Pushkarev, B. *Man-Made America: Chaos or Control*. New Haven, Conn.: Yale University Press, 1963.

Weaver, R. C. *The Urban Complex: Essays on Urban Life and Human Values*. Garden City, N.Y.: Doubleday, 1964.

Whiting, P. *New Houses*. London: Architectural Press, 1965.

Wright, F. L. *The Natural House*. New York: Horizon Press, 1954.

Yoshida, T. *The Japanese House and Garden*. New York: Praeger, 1955.

Serial Publications

Abitare
Architectural Record
Domus
Interiors
Interior Design
Progressive Architecture

CHAPTERS 6 AND 7

Ballinger, R. *Layout and Graphic Design*. New York: Van Nostrand Reinhold, 1980.

Banham, R. *Design by Choice*. New York: Rizzoli, 1981.

———. *Theory and Design in the First Machine Age*. Cambridge, Mass.: MIT Press, 1980.

Caplan, R. *By Design*. New York: McGraw-Hill, 1983.

Constantine, M., ed. *The Package*. New York: Museum of Modern Art, 1959.

———, and Fern, A. M., eds. *Word and Image: Posters from the Collection of the Museum of Modern Art*. New York: Museum of Modern Art, 1968.

Craig, J. *Designing with Type*. New York: Watson-Guptill, 1980.

Demoney, J., and Meyer, S. *Pasteups and Mechanicals*. New York: Watson-Guptill, 1982.

Drexler, A., and Daniel, G. *Introduction to Twentieth-Century Design*. New York: Doubleday, 1959.

Dreyfuss, H. *The Measure of Man*. New York: Whitney, 1967.

Ferebee, A. *A History of Design from the Victorian Era to the Present*. New York: Van Nostrand Reinhold, 1980.

Glaser, M. *Graphic Design*. Woodstock, N.Y.: Overlook, 1983.

Goldberger, P. *Design: Vignelli*. New York: Rizzoli, 1981.

Henry, W. *Buildings for Industry*, 2 vols. New York: Hayden, 1965.

Hulten, K. G. P. *The Machine—As Viewed at the End of the Mechanical Age*. New York: Museum of Modern Art, 1968.

Hutchinson, H. F. *The Poster: An Illustrated History from 1860*. New York: Viking, 1960.

Kaspar, K. *Shops and Showrooms: An International Survey*. New York: Praeger, 1967.

Loewy, R. *Never Leave Well Enough Alone*. New York: Simon & Schuster, 1951.

Mumford, L. *Technics and Civilization*. New York: Harcourt, 1934.

Munari, B. *Design as Art*. Baltimore: Penguin, 1971.

Munce, J. F. *Industrial Architecture*. New York: McGraw-Hill, 1960.

Panero, J. *Anatomy for Interior Designers*. New York: Whitney Library of Design, 1967.

Papanek, V. *Design for the Real World: Human Ecology and Social Change*. New York: Pantheon, 1971.

———. *Joys of Design*. New York: Van Nostrand Reinhold, 1984.

Pevsner, N. *The Sources of Modern Architecture and Design*. Oxford: Oxford University Press, 1977.

Read, H. *Art and Industry*. London: Faber & Faber, 1966.

Spencer, H. *Pioneers of Modern Typography*. Cambridge, Mass.: MIT Press, 1983.

Wallace, D. *Shaping America's Products*. New York: Reinhold, 1956.

Wingler, H. *Bauhaus*. Cambridge, Mass.: MIT Press, 1969.

Zapf, H. *Manuale Typographicum*. Cambridge, Mass.: MIT Press, 1970.

Serial Publications

Communication Arts Magazine
Design
Design Quarterly
Graphics
Industrial Design
Print

CHAPTERS 8 AND 9

Albers, A. *On Weaving*. Middletown, Conn.: Wesleyan University Press, 1965.

American Federation of Arts. *Threads of History*. New York: Whitney Library of Design, 1965.

Billington, D. M. *The Technique of Pottery*. New York: Hearthside Press, Inc., 1962.

Brady, G. S. *Materials Handbook*. New York: McGraw-Hill, 1963.

Bress, H. *The Weaving Book*. New York: Scribner's, 1981.

Brown, R. *The Weaving, Spinning and Dyeing Book*. New York: Alfred A. Knopf.

Burton, J. *Glass: Hand Blown, Sculptured, Colored: Philosophy and Method*. Philadelphia: Chilton, 1968.

Choate, S. *Creative Casting*. New York: Crown, 1966.

Diamond, F. *The Story of Glass*. New York: Harcourt, 1953.

Dow, F. *The Arts and Crafts in New England 1704–1775*. New York: Da Capo Press, 1968.

Foley, S. *Ceramic Sculpture: Six Artists*. New York: Whitney Museum of American Art, 1981.

Gardi, R. *African Crafts and Craftsmen*. New York: Van Nostrand Reinhold, 1970.

Holden, G. *The Craft of the Silversmith*. New York: Viking, 1954.

Hughes, G. *Modern Silver Throughout the World: 1880–1967*. New York: Viking, 1967.

Hughto, M. *New Works in Clay by Contemporary Painters and Sculptors*. Everson Museum of Art: Visual Artists Publications, 1976.

Koch, R. *Louis C. Tiffany, Rebel in Glass*. New York: Crown, 1964.

Labino, D. *Visual Art in Glass*. Dubuque, Iowa: Wm. C. Brown Company, 1968.

Leach, B. *A Potter's Book*. Levittown, N.Y.: Transatlantic Arts, 1965.

———. *Beyond East and West*. New York: Watson-Guptill, 1978.

Lucie-Smith, E. *The Story of Craft: The Craftsman's Role in Society*. Ithaca, N.Y.: Cornell University Press, 1981.

Marshall, R., and Foley, S. *Ceramic Sculpture: Six Artists*. Seattle: University of Washington Press, 1981.

Meilach, D. Z. *Contemporary Art with Wood*. New York: Crown, 1968.

Mosely, S., Johnson, P., and Koenig, H. *Crafts Design*. Belmont, Calif.: Wadsworth, 1962.

Munsterberg, H. *The Ceramic Art of Japan*. Rutland, Vt.: Tuttle, 1964.

Nelson, G. *Ceramics*, 5th ed. New York: Holt, Rinehart and Winston, 1984.

Newman, J., and Newman, L. *Plastics for the Craftsman*. New York: Crown, 1973.

Newman, T. *Plastics as Design Form*. Philadelphia: Chilton, 1972.

Rhodes, D. *Clays and Glazes for the Potter*. Philadelphia: Chilton, 1957.

Savage, G. *Glass*. New York: Putnam, 1965.

Slivka, R., Webb, A. O., and Patch, M. M. *The Crafts of the Modern World*. New York: Horizon Press, 1968.

Tovey, J. *The Technique of Weaving*. New York: Reinhold, 1966.

Wildenhain, M. *Pottery: Form and Expression*. New York: American Craftsmen's Council, 1959.

Zielinski, S. W. *Encyclopedia of Hand-Weaving*. New York: Funk and Wagnalls, 1959.

Serial Publications

American Craft
Ceramics Monthly
Crafts
Design
Design Quarterly
Fiberarts
Fine Woodworking
Shuttle, Spindle & Dyepot

CHAPTER 10

Arnheim, R. *Film as Art*. Berkeley and Los Angeles: University of California Press, 1967.

Belazs, B. *Theory of Film*. London: Dobson, 1952.

Bidsvik, C. *Cineliteracy: Film Among the Arts*. New York: Random House, 1978.

Bishop, J., and Bishop, N. *Making Home Video*. New York: Putnam, 1980.

Cheshire, D. *The Video Manual*. New York: Van Nostrand Reinhold, 1982.

Cocteau, J. *Cocteau on the Film*. New York: Dover, 1972.

Decken, J. *Computer Images: State of the Art*. New York: Stewart, Tabori and Chang, 1983.

Dudley, A. *The Major Film Theories*. New York: Oxford University Press, 1976.

Eisenstein, S. *Film Form: Essays in Film Theory*. New York: Harcourt, Brace & Co., 1942.

———. *The Film Sense*. New York: Harcourt, Brace & Co., 1942.

Fiske, J., and Hartley, J. *Reading Television*. New York: Methuen, 1978.

Herdeg, W., ed. *Film and TV Graphics*. New York: Hastings, n.d.

Lanzendorf, P. *The Video Taping Handbook: The Newest Systems, Cameras, and Techniques*. New York: Crown, 1983.

Laughton, R. *TV Graphics*. New York: Reinhold, 1966.

Levitan, E. *Handbook of Electronic Imaging Techniques*. New York: Van Nostrand Reinhold, 1977.

Murray, M. *The Videotape Book: A Basic Guide to Portable TV Production*. New York: Taplinger, 1975.

Newcomb, H. *Television and the Critical View*. New York: Oxford University Press, 1979.

Renan, S. *An Introduction to the American Underground Film*. New York: Dutton, 1967.

Sigel, E., et al. *Video Disks: The Technology, the Applications and the Future*. New York: Van Nostrand Reinhold, 1981.

Youngblood, G. *Expanded Cinema*. New York: Dutton, 1970.

Serial Publications

American Cinematographer
American Film

CHAPTER 11

Ackley, C. *Printmaking in the Age of Rembrandt*. Boston: New York Graphic Society, 1981.

Castleman, R. *Prints of the Twentieth Century*. New York: Oxford University Press, 1976.

————. *Printed Art: A View of Two Decades*. New York: Museum of Modern Art, 1979.

Chaet, B. *The Art of Drawing,* 3rd ed. New York: Holt, Rinehart and Winston, 1983.

Chieffs, C. *Silk Screen as a Fine Art*. New York: Reinhold, 1967.

Cox, R. *Printing Processes*. New York: Van Nostrand Reinhold, 1984.

Craven, T. *A Treasury of American Prints*. New York: Simon & Schuster, 1957.

Escher, M. C. *The Graphic Work of M. C. Escher*. New York: Meredith Press, 1967.

Griffiths, A. *Prints and Printmaking*. New York: Alfred A. Knopf, 1981.

Ivins, W. N. *Notes on Prints*. New York: Da Capo Press, 1968.

Johnson, U. *American Prints and Printmakers*. New York: Doubleday, 1980.

Longstreet, S. *A Treasury of the World's Great Prints*. New York: Simon & Schuster, 1961.

Mendelowitz, D. M. *Mendelowitz's Guide to Drawing,* 3rd. ed. revised by Duane Wakeham. New York: Holt, Rinehart and Winston, 1982.

Melot, M., et al. *Prints: History of an Art*. New York: Rizzoli, 1981.

Robertson, R. G. *Contemporary Printmaking in Japan*. New York: Crown, 1965.

Sacilotto, D. *Photographic Printmaking Techniques*. New York: Watson-Guptill, 1982.

Simon, H. *Introduction to Printing: The Craft of Letterpress*. New York: Faber & Faber, 1980.

Sternberg, H. *Modern Methods and Materials of Etching*. New York: McGraw-Hill, 1949.

Zigrosser, C. *The Book of Fine Prints*. New York: Crown, 1956.

Serial Publications

The Print Collector's Newsletter

CHAPTERS 12 AND 13

Armstrong, T. *Two Hundred Years of American Sculpture*. New York: Godine, 1980.

Arnason, H. H. *History of Modern Art*. New York: Abrams, 1968.

Ashton, D. *American Art since 1945*. New York: Oxford University Press, 1982.

Berger, J. *The Success and Failure of Picasso*. New York: Pantheon, 1980.

Burnham, J. *Beyond Modern Sculpture: Effect of Science and Technology on Sculpture of This Century*. New York: Braziller, 1968.

Cooper, D. *The Cubist Epoch*. New York: Phaidon, 1971.

Cummings, P. *Twentieth-Century Drawings*. New York: Dover, 1981.

Elsen, A. *Origins of Modern Sculpture: Pioneers and Premises*. New York: Braziller, 1974.

Fleming, W. *Arts and Ideas,* 7th ed. New York: Holt, Rinehart and Winston, 1985.

Goldberg, R. *Performance: Live Art 1909 to the Present*. New York: Abrams, 1979.

Hamilton, G. H. *Painting and Sculpture in Europe: 1880–1940*. Baltimore: Penguin, 1967.

Henri, A. *Total Art: Environments, Happenings and Performance*. New York: Praeger, 1974.

Kaprow, A. *Assemblage, Environments and Happenings*. New York: Abrams, 1966.

Kramer, H. *The Age of the Avant-Garde*. New York: Farrar, Straus & Giroux, 1973.

Krauss, R. *Passages in Modern Sculpture*. Cambridge, Mass.: MIT Press, 1981.

Kultermann, U. *The New Painting*. Boulder, Colo.: Westview Press, 1976.

————. *The New Sculpture: Environments and Assemblages*. New York: Praeger, 1968.

La Liberté, N. *Collage, Montage, Assemblage*. New York: Van Nostrand Reinhold, 1971.

Lippard, L. *Pop Art*. New York: Praeger, 1966.

Mathey, F. *American Realism*. New York: Rizzoli, 1978.

Mayer, R. *The Painter's Craft: An Introduction to Artists' Methods and Materials*. New York: Penguin, 1979.

Munro, E. *Originals: American Women Artists*. New York: Simon & Schuster, 1979.

O'Connor, F. *Jackson Pollock*. New York: Museum of Modern Art, 1967.

Pignatti, T. *Master Drawings: From Cave Art to Picasso*. New York: Abrams, 1982.

Prown, J. D. *American Painting, from Its Beginnings to the Armory Show*. New York: Rizzoli, 1980.

Read, H. *Art of Sculpture*. Princeton, N.J.: Princeton University Press, 1961.

————. *A Concise History of Modern Sculpture*. New York: Oxford University Press, 1964.

Rewald, J. *The History of Impressionism*. New York: Museum of Modern Art, 1962.

————. *Post-Impressionism from Van Gogh to Gauguin*. New York: Museum of Modern Art, 1962.

Rose, B. *American Art since 1900*. New York: Praeger, 1967.

Rubin, W. S. *Dada, Surrealism, and Their Heritage*. New York: Museum of Modern Art, 1968.

Seitz, W. *The Art of Assemblage*. New York: Museum of Modern Art, 1961.

Spies, W. *Christo: Running Fence Project*. New York: Abrams, 1978.

Solomon, A. R. *Robert Rauschenberg*. New York: Jewish Museum, 1963.

Stern, H. P. *Sculpture at Storm King*. New York: Abbéville Press, 1980.

Tomkins, C. *The Bride and the Bachelors*. New York: Viking, 1965.

Tuchman, M. *American Sculpture of the Sixties*. Los Angeles: Los Angeles County Museum of Art, 1967.

Vasari, G. *Vasari on Technique*. New York: Dover, 1960.

Whitney Museum of American Art. *200 Years of American Sculpture*. New York: Godine, 1976.

Wittkower, R. *Sculpture: Processes and Principles*. New York: Harper & Row, 1977.

Serial Publications

Art in America
Art International
Artforum
Artnews
Arts

CHAPTER 14

Adams, A. *The Camera*. New York: New York Graphic Society, 1980.

Barthes, R. *Camera Lucida: Reflections on Photography*. New York: Hill & Wang, 1982.

Cartier-Bresson, H. *The Decisive Moment*. New York: Simon & Schuster, 1952.

————. *Photographs by Henri Cartier-Bresson*. New York: Grossman, 1963.

Daval, J. *Photography, History of an Art*. New York: Skiva/Rizzoli, 1982.

Diamonstein, B. *Visions and Images: American Photographers on Photography*. New York: Rizzoli, 1981.

Doty, R. M. *Photography in America*. New York: Greenwich House for the Whitney Museum of Art, 1974.

Eder, J. M. *History of Photography*. New York: Dover, 1978.

Evans, W. *Walker Evans: First and Last*. New York: Harper & Row, 1985.

Frank, R. *The Americans*. New York: Pantheon, 1986.

Gernsheim, H., and Gernsheim, A. *A Concise History of Photography*. New York: Grosset & Dunlap, 1965.

Held, M., and Naylor, C. *Contemporary Photographers*. New York: St. Martin's, 1982.

Kertész, A. *A Lifetime of Perception*. New York: Abrams, 1982.

Lyon, D. *Pictures from the New World*. New York: Aperture, 1983.

Malcolm, J. *Diana and Nikon: Essays on the Esthetic of Photography*. New York: Godine, 1980.

Meyerowitz, J. *Cape Light: Color Photographs by Joel Meyerowitz*. Boston: New York Graphic Society, 1979.

Mozley, A. V. *American Photography, Past into Present*. Seattle: University of Washington Press, 1976.

Naef, W. J. *The Collection of Alfred Stieglitz*. New York: Metropolitan Museum of Art–Viking Press, 1978.

Newhall, B. *The History of Photography*. Boston: New York Graphic Society, 1982.

———. *Photography: Essays and Images.* Boston: New York Graphic Society, 1981.

Shore, S. *Stephen Shore: Uncommon Places.* Millerton, N.Y.: Aperture, 1982.

Steichen, E. *The Family of Man.* New York: Simon & Schuster, 1967.

Swedlund, C. *Photography,* 2nd ed. New York: Holt, Reinhart and Winston, 1981.

Szarkowski, J. *Looking at Photographs.* New York: Museum of Modern Art, 1973.

———. *Mirrors and Windows: American Photography since 1960.* New York: Museum of Modern Art, 1978.

Van Haaften, J. *From Talbot to Stieglitz: Masterpieces of Early Photography.* New York: Thames & Hudson, 1982.

Serial Publications

Aperture
Artforum
Art News
Arts

CHAPTER 15

Banham, R. *The Age of the Masters: A Personal View of Modern Architecture.* New York: Harper & Row, 1975.

Burchard, J., and Bush-Brown, A. *Architecture of America: A Social and Cultural History.* Boston: Little, Brown, 1961.

Collins, P. *Changing Ideals in Modern Architecture.* London: Faber, 1965.

Diamonstein, B. *American Architecture Now.* New York: Rizzoli, 1980.

———. *Collaboration: Artists and Architects.* New York: Watson-Guptill, 1981.

Drexler, A. *Transformations in Modern Architecture.* New York: Museum of Modern Art, 1979.

Fitch, J. M. *America Building—The Historical Forces that Shaped It.* Boston: Houghton, Mifflin, 1967.

Elffers, J., and Shuyt, M. *Fantastic Architecture: Personal and Eccentric Visions.* New York: Abrams, 1980.

Floethe, L. L. *Houses Around the World.* New York: Scribner's, 1973.

Giedion, S. *Architecture and the Phenomena of Transition.* Cambridge, Mass.: Harvard University Press, 1971.

———. *Space, Time and Architecture.* Cambridge, Mass.: Harvard University Press, 1967.

Halprin, L. *The RSVP Cycles.* New York: Braziller, 1969.

Hamlin, T., ed. *Forms and Functions of Twentieth-Century Architecture,* 4 vols. New York: Columbia University Press, 1952.

Jacubus, J. *Twentieth-Century Architecture: The Middle Years, 1940–63.* New York: Praeger, 1966.

Jencks, C. *Architecture Today.* New York: Abrams, 1982.

Millon, H. *Key Monuments of the History of Architecture.* New York: Abrams, 1964.

Nervi, L. *Aesthetics and Technology in Building.* Cambridge, Mass.: Harvard University Press, 1965.

Neutra, R. *Survival Through Design.* New York: Oxford University Press, 1954.

Pevsner, N. *The Sources of Modern Architecture and Design.* New York: Oxford University Press, 1977.

Rasmussen, S. E. *Experiencing Architecture.* New York: Wiley, 1959.

Rudofsky, B. *Architecture Without Architects.* New York: Museum of Modern Art, 1964.

Scully, V., Jr. *Frank Lloyd Wright.* New York: Braziller, 1960.

———. *Modern Architecture: The Architecture of Democracy.* New York: Braziller, 1982.

Sharp, D. *Modern Architecture and Expressionism.* New York: Braziller, 1967.

Smithson, A., and Smithson, P. *The Heroic Period of Modern Architecture.* New York: Rizzoli, 1981.

Sullivan, L. *Autobiography of an Idea.* New York: Dover, 1956.

Venturi, R. *Complexity and Contradiction in Architecture.* New York and Greenwich, Conn.: Museum of Modern Art, New York Graphic Society, 1967.

Venturi, R., and Brown, D. *Learning From Las Vegas.* Boston: New York Graphic Society, 1972.

Serial Publications

Abitare
Architectural Design
Architectural Digest
Architectural Record
Domus
Progressive Architecture

CHAPTER 16

Aldred, C. *The Egyptians.* New York: Praeger, 1961.
Baker, J. S. *Japanese Art.* London: Thames & Hudson, 1984.

Battcock, G. *Super Realism: A Critical Anthology.* New York: Dutton, 1975.

———. *Minimal Art: A Critical Anthology.* New York: Dutton, 1968.

Benesch, O. *The Art of the Renaissance in Northern Europe.* London: Phaidon, 1965.

Canaday, J. *Mainstreams of Modern Art,* 2nd ed. New York: Holt, Rinehart and Winston, 1981.

Clark, K. M. *Leonardo da Vinci.* New York: Phaidon, 1955.

Emmerich, A. *Art Before Columbus.* New York: Simon & Schuster, 1983.

Fraser, D. *Primitive Art.* New York: Doubleday, 1962.

Goldwater, R. *Symbolism.* New York: Harper & Row, 1979.

Goldwater, R., and Treves, M., eds. *Artists on Art: From the Fourteenth to the Twentieth Century.* New York: Pantheon.

Hale, W. H. *The Horizon Book of Ancient Greece.* New York: American Heritage, 1965.

Hawkins, G. S. *Stonehenge Decoded.* New York: Delta, 1965.

Holmes, U. T. *Daily Living in the Twelfth Century.* Madison: University of Wisconsin, 1966.

Honour, H., and Fleming, J. *The Visual Arts: A History.* Englewood Cliffs, N.J.: Prentice-Hall, 1983.

Hood, S. *The Arts in Prehistoric Greece.* Baltimore: Penguin, 1978.

Hughes, R. *The Shock of the New.* New York: Knopf, 1981.

Hunter, S. *Modern Art from Post-Impressionism to the Present.* New York: Abrams, 1976.

Kramrisch, S. *The Art of India through the Ages.* New York: Phaidon, 1956.

Lange, K., and Hirmer, M. *Egypt.* London: Phaidon, 1956.

Lee, S. *A History of Far Eastern Art,* rev. ed. New York: Abrams, 1964.

Leonardo da Vinci. *Notebooks of Leonardo da Vinci,* ed. E. MacCurdy. New York: Braziller, 1955.

Levey, M. *Rococo to Revolution.* New York: Praeger, 1966.

Lippard, L., ed. *Surrealists on Art.* Englewood Cliffs, N.J.: Prentice-Hall, 1970.

Mendelssohn, K. *The Riddle of the Pyramids.* New York: Praeger, 1974.

Rawson, J. *Ancient China: Art and Archaeology.* New York: Harper & Row, 1980.

Rose, B. *American Art since 1900.* New York: Praeger, 1975.

Rubin, W. R. *Dada, Surrealism and Their Heritage.* New York: Museum of Modern Art, 1968.

Simson, O. *The Gothic Cathedral.* New York: Harper & Row, 1964.

Vickers, M. *The Roman World.* Oxford: Elsevier-Phaidon, 1977.

INDEX

Index

References are to page numbers, except for color plates and black-and-white illustrations, which are identified by plate and figure numbers. Titles of works of art are printed in italics; descriptive citations and titles of examples in architecture, in roman type.

woods, characteristics of, 180–181
wool fibers, characteristics of, 207
Wright, Frank Lloyd, Guggenheim Museum, New York, 42, Fig. 41; Taliesin North, 102, 103, Figs. 94–96

Xinchong, *An Arhat Contemplating a Lotus Pond*, 393–394, Fig. 397

Yellow Accompaniment, Kandinsky, 413–414, Fig. 412

References are to figure numbers unless indicated plates.

PHOTOGRAPHIC CREDITS

The authors and publisher wish to thank the custodians of the works of art for supplying photographs and granting permission to use them. Photographs have been obtained from sources listed in the captions, unless listed below:

A/AR: Alinari/Art Resource, New York
AR: Art Resource, New York
BPK: Bildarchiv/Preussischer Kulturbesitz, West Berlin
G/AR: Giraudon/Art Resource, New York
GC: Geoffrey Clements, Staten Island, N.Y.
H: Hirmer Photoarchiv, Munich
HB: Hedrich-Blessing, Chicago
LCG: Leo Castelli Gallery, New York
M: Magnum Photos, Inc., New York
PR: Photo Researchers, New York
RM: Robert E. Mates, New York
SR: Steve Rosenthal, Auburndale, Mass.
TSP: Tim Street-Porter, Hollywood, Calif.

Color Plates: 9: Courtesy Mrs. Anni Albers and the Joseph Albers Foundation. 11: Alan Zindman. 12: G/AR. 15: LCG. 16,17: © Maris, Ezra Stoller Associates (ESTO). 18: TSP. 20: Lawrence Schiller/PR. 21: McCann-Erickson Advertising, New York. 22: Pace Advertising. 23: SR. 25: Steve Myers. 31: Dennis McWaters, Richmond, Va./OK Harris Works of Art, New York. 33: Ken Cohen, New York. 34: Dorothy Zeidman/LCG. 38: The Arkansas Office, Little Rock. 39: AR. 40: Louis Loose, Brussels. 41: Georges Routhier, Studio Lourmel.

Chapter 1 8: Robert Capa/M. 9: © Achille B. Weider, Zurich. 10: A/AR.

Chapter 2 21: Colonial Williamsburg Foundation, Va. 24: RM 25: Rudolph Burckhardt. 27: Marjorie Laurent. 28: The Museum of Modern Art, New York. 29: Joseph W. Molitor, Valhalla, N.Y. 31, 33: GC. 37, 38: A/AR. 40: Gianfranco Gorgone/Contact Press Images, New York. 41: Ezra Stoller © ESTO. 44: Runco Photo Studios, Tonawanda, N.Y. 45: Solomon R. Guggenheim Museum, New York.

Chapter 3 50: René Burri/M. 51: © Audrain Samivel/PR. 53: Ed Stewart.

Chapter 4 60: © R.D. Ullmann/Taurus Photos, New York. 66: I.W. Bailey/Courtesy of Professor E.S. Baghoorn, Cambridge, Mass; Harvard University Wood Collection. 67: A/AR. 69: Bruce C. Jones, Dobbs Ferry, N.Y./LCG. 70: © Teri Leigh Stratford/PR. 71: Palomar Observatory © California Institute of Technology, Pasadena. 74, 78: A/AR. 81: A.J. Wyatt, Philadelphia. 82: Wim Swaan, Riverdale, N.Y. 84: H. 87: Institut Royal du Patrimoine Artistique, Brussels. 90: GC.

Chapter 5 91–93: © Clemens Kalischer, Image Photos, Stockbridge, Mass. 94: Pedro E. Guerrero, New Canaan, Conn., 95: Bill Hedrich/HB. 97: Ezra Stoller © ESTO. 99, 101: TSP. 103, 104: Joshua Freiwald. 105: George Carr, New York. 107, 108: TSP. 109–111: David Hirsch, Brooklyn, N.Y. 112, 113: Robert Perron, Branford, Conn. 115: George Holton/PR. 116: Susan Kuklin/PR. 117:

HB. 118: © Eugene Cook, Harnden, Conn. 119: © L. Andrews/M. 123: Nathan Farb, New York/Xavier Fourcade, Inc. 124: John Marchael.

Chapter 6 125: Carmelo Guadagno, New York. 135, 136: From Victor Papanek *Design for the Real World.* © Pantheon Books, a Division of Random House, Inc. 138: Hewlett-Packard Company. 139: Centrokappa. 140: Aldo Ballo, Milan. 146: Sony Corporation of America.

Chapter 7 151: The Coca-Cola Company, Atlanta, Ga. 162: © Creative Marketing Group. Inc., Curtis Publishing Company, Indianapolis. 166: Ally & Gargano, Inc. New York. 167, 169: SR.

Chapter 8 171: Richard Gross, Los Angeles. Ca. 173: Kathleen Lindqust/Lindquist Studios, Henniker, N.H. 174: George Erml. 175: Eeva-Inkeri, New York. 179: H. 180: Scala/AR. 181: © OMIKRON/PR. 184: © Hans Namuth, New York. 187: GC. 188: Aldo Ballo, Milan.

Chapter 9 193: Schopplein Studio, San Francisco. 196–199: Jack Hunsley/Josiah Wedgwood and Sons, New York. 200: William H. Allen, Syracuse, N.Y. 201: Susie Cushner. 202: M. Lee Fatherree, CA/Allan Frumkin Gallery, New York. 203: M. Lee Fatherree, Berkeley, CA. 204: Vernita Mason. 206: Steuben Glass, New York. 207: Michael Kitely. 209: Paul Rocheleau. 214: Wenda F. von Weise. 215: The Oakland Museum, Ca. 216: Ed Rossbach, Berkeley, Ca. 219: Museum of Contemporary Art, Chicago. 220, 221: Wolfgang Volz.

Chapter 10 222: A/AR. 223, 224: Terry Chostner/ © 1977 20th Century Fox Films Corporation. 229, 230: © 1941 RKO Pictures, Inc. All rights reserved. 232: Kate Keller. 233: Kira Perov. 234: Gwenn Thomas/Castelli-Sonnabend Tapes and Films, New York. 235: Barbara London, New York. 239, 240: Becky Cohen, Leucadia, Ca.

Chapter 11 246: RM. 248: GC. 253: Barbara Crutchfield. 258: Colin McCrae, Berkeley, Ca.

Chapter 12 271: Bertha Saunders, New York. 272: A/AR. 274: Eric E. Mitchell, Philadelphia. 277: Zindman-Fremont, New York. 278: © S.K. Yaeger. 279: Bruce C. Jones, Rocky Point, N.Y. 280: Pelka/Noble, New York. 281: Metro Pictures, New York. 283: P. Jahan, Paris. 285: © 1985 Harry Shunk, New York. 287: Eeva-inkeri, New York. 289: Diana Church. 291: Jon Abbott. 293: Zindman-Fremont, New York.

Chapter 13 295: H/BPK. 299: Walter Steinkopf, Berlin/BPK. 300: Carmelo Guadagno and David Heald. 305: Carlos Granger, London © Floyd Picture Library. 309: GC. 311: Peter Aaron © ESTO 1983. 312: Allan Finkelman, Dobbs Ferry, N.Y. 313: Roy M. Elkind, Jackson Heights, N.Y. 314: Tom van Eynde. 315: Rudolph Burchkardt.

Chapter 14 322, 323: Charles Swedlund. 324, 325: Oscar Bailey, Lutz, Fla. 333: © 1981 Arizona Board of Regents, Center for Creative Photography. 334: Courtesy Mrs. M. Brandt. 335: M. 337: Eeva-inkeri, New York. 338: D. James Dee. 339: Al Mozell, New York.

Chapter 15 343: Hamilton Wright, Inc., New York. 344: Rockefeller Center, Inc., New York. 345: Bill Hedrich/HB. 347: G/AR. 349: Edward Hausner © The New York Times. 355: Alison Frantz, Princeton, N.J. 358: Spanish National Tourist Office, New York. 360, 363: A/AR. 364, 366; 368: Archives Photographiques, Paris. 369: A/AR. 370: Fototeca Unione, American Academy, Rome. 372: George Holton/PR. 373, 374: Robert Perron, Branford, Conn. 376: Gerald Moorhead. 377: Wayne Thom Associates, Los Angeles. 379, 380: © Richard Frieman/PR. 381: Jay Langlois/Owens-Corning Fiberglas Corporation. 382: Kristen Peterson, Krispet Studios. 385: © Timothy Hursley/The Arkansas Office, Little Rock.

Chapter 16 386: © Fritz Henle/PR. 389, 390: H. 392: G/AR. 393, 394: A/AR. 402, 403: G/AR. 410, 411, 414: Soichi Sunami, New York. 417: RM.

Works by Brancusi, Albers, Arp, Chagall, Kandinsky, Calder, Duchamp, Cassatt, Braque, Giacometti, Man-Ray: © A.D.A.G.P. Paris/V.A.G.A., New York, 1986. Works by Picasso, Vasarely, Monet, Le Corbusier, Ernst: © S.P.A.D.E.M., Paris/V.A.G.A., New York, 1986. Works by Stella, Rickey, Johns, Warhol, Smith, Rivers, Namuth, Lichtenstein, Rauschenberg: © V.A.G.A., New York, 1986.